W9-BAH-572

MIDNIGHT MAVERICKS
REPORTS FROM THE UNDERGROUND

First published by FAB Press, January 2007

FAB Press
7 Farleigh
Ramsden Road
Godalming
Surrey
GU7 1QE
England, U.K.

www.fabpress.com

Text copyright © 2006 Gene Gregorits.
The moral rights of the author have been asserted.
Gene Gregorits can be contacted by e-mail: mrbadvibes@gmail.com

Edited and Designed by Harvey Fenton,
with thanks to Francis Brewster for production assistance.

This Volume copyright © FAB Press 2007

World Rights Reserved

No part of this book may be reproduced or transmitted in any form or by any means, electronic or mechanical, including photocopying, recording, or by any information storage and retrieval system, without the prior written permission of the Publisher.

The CD 'Sounds of the Underground' was mastered by Stephen Thrower.
All tracks remain the property of the copyright owners, and have been reproduced by kind permission of the artists.

Copyright of illustrations reproduced in these pages is the property of the duly credited owners. These illustrations are reproduced here in the spirit of publicity, and whilst every effort has been made to trace and credit the appropriate copyright owners, the author and publishers apologise for any omissions and will undertake to make any appropriate changes in future editions of this book if necessary.

Front cover illustration
Original artwork by Larry Wessel.

Back cover illustrations (top to bottom)
An image from *God's Little Girl*, directed by Mitch Davis (courtesy of Infliction Films), Tim Roth in Buddy Giovinazzo's *No Way Home*, Jörg Buttgereit (photo by Uwe Arens), Vanessa Skantze (photo by Lisa Seminoff).

Frontispiece illustrations (top left to bottom right)
Simon Stokes (courtesy of the artist), Stuart Gordon (photo by Harvey Fenton), John Callahan (courtesy of the artist), Steve Wynn (courtesy of Down There Records), Larry Wessel (photo by Eva Ford), Joe R. Lansdale (courtesy of the artist), John Waters (courtesy of Phony Lid), Andrew W.K. (courtesy of R.C.U. Audio, Int'l), Lech Kowalski (courtesy of the artist), Richard Stanley (courtesy of the artist), Detail from *Spider Baby Comix #1* cover art by Stephen R. Bissette (courtesy of the artist), Cynthia True (courtesy of HarperCollins), John Dullaghan (courtesy of the artist), Adele Bertei (photo by Stephanie Chernikowski), Jörg Buttgereit (courtesy of Matuschka), Mary Woronov (courtesy of the artist), Artwork by J.K. Potter (courtesy of the creator), Johnette Napolitano (photo by Michael McGrath), Nick Zedd (courtesy of the artist), Dan Fante (courtesy of the artist), Joseph De Leo (courtesy of the artist), Nico B (courtesy of the artist), Ben Meade (courtesy of the artist), The final scene from Buddy Giovinazzo's *Combat Shock* (courtesy of Troma Films), Rennie Sparks (photo by Darin Back), An image from *Subconscious Cruelty*, produced by Mitch Davis (courtesy of Infliction Films), Dave Schramm (courtesy of the artist), Lloyd Kaufman's *The Toxic Avenger* (courtesy of Troma Films), Jim Goad (courtesy of the artist), Carla Bozulich (courtesy of the artist), T-shirt design artwork by Chas. Balun (courtesy of the artist), Chris D. (photo by Lydia Lunch), Vanessa Skantze (photo by Lisa Seminoff), Rockets Redglare (photo by Luis Fernandez de la Reguera), Luis Fernandez de la Reguera (photo by Dominic Thackray), A scene from the British miners' strike, used to illustrate David Peace's novel *GB84* (courtesy of Serpent's Tail), Larry Fessenden (courtesy Glass Eye Pix), Jennifer Miro (courtesy of the artist), Ron Athey (courtesy of the artist), Jim Van Bebber (courtesy of the artist), Jack Ketchum (photo by Douglas E. Winter), Stugis Nikides (courtesy of the artist), Mike Diana (courtesy of the artist), A scene from Abel Ferrara's *Ms.45*, Nick Tosches (courtesy of the artist), Alison Mosshart and Jamie Hince (courtesy of The Kills), Patton Oswalt (courtesy of the artist), Lydia Lunch (courtesy of the artist).

Contents pages illustrations:
Left column, top to bottom: Vanessa Skantze (photo by Lisa Seminoff), A scene from Abel Ferrara's *Ms.45*,
Artwork by J.K. Potter (courtesy of the creator), Lloyd Kaufman (*right*) during the making of *Citizen Toxie*.
Right column top: A scene from Nick Zedd's *War Is Menstrual Envy*.
Right column bottom: A scene from Richard Stanley's *Hardware*.

A CIP catalogue record for this book is available from the British Library.

ISBN 1 903254 34 5

MIDNIGHT MAVERICKS

REPORTS FROM THE UNDERGROUND

BY GENE GREGORITS

A FAB
PRESS
PUBLICATION

contents

contents

Introduction

"I'm going down, to the underground…
as deep as I can go."
- Primal Scream -

PART ONE: Bitch, bitch, BITCH

The selection of subjects discussed within these interviews is completely based on my feeling that dishonest art does not matter. Art, in my opinion, should play by the rules of the street, the soul, the human heart… or not play at all. Films, for example, can take us a million places in a million different ways. But without emotional truth, and the credibility that comes with it, I'd just as soon not come along for the ride. I don't have the time to waste. Every second squandered on superficial entertainment shames me, for it is a second I could have spent discovering truer, and more legitimate work, work that does not take me outside, where most people seem to prefer going, but further in. It's funny to look back and realize that almost every instance of my having paid to see Hollywood snot was during a period in which I felt particularly lousy about the world and my place in it. I took in well over 100 cheesedick spectacles during 2004, at a second-run cinema where I soon found myself hooked on the strange peace that exists only within the multiplex grindhouse (corporate-owned second-run theatres are the closest thing to the 1970s 42nd Street experience you're going to find today). That junk food/junk film Zen-state was the result of a very deliberate self-subjugation. Imagine a spectral, jaundiced Mr. Bad Vibes, sick on popcorn, hiding from streets and bars and telephone calls *at the movies*… with 16 screens of megabuck remakes and gross-out comedies. Total surrender… the luxuriant sensation of brain-death. Could it be the same for others who lack the ambition to investigate the possibility of films that treat their audiences with respect? Is it possible that in some dim part of themselves, the target audience of a film like *Little Black Book* or *Meet the Fockers* realizes that they truly *love* being condescended to?

My main motivation in conducting interviews was not, as I thought previously, to entertain, but to sway those who are normally closed off to serious-minded, reality-based art to put down the popcorn once in a while, and perhaps take their preconceptions a few steps beyond. Art and entertainment do not necessarily have to be at odds with one another. That said, I do also believe that there are two kinds of audiences: truth-seekers and escapists. Religion is not the only opiate of the masses, there is also MTV, Hollywood, the Oprah Book Club. The mainstream audience, those scarfers of fallacy, do not enjoy having their cages rattled… they'd prefer to have liquorice sticks slipped through the bars on a regular basis. They'd prefer that big questions were not posed, unless they *must* be, and in that case, those questions are expected to be resolved in a sanitary and grossly pandering manner.

Truth-seekers, however, don't really enjoy the bitter pill either; it's just that, for some esoteric reason, they *require* it. The acute discomfort experienced when one's intelligence is dismissed, or, as is usually the case, outright assaulted, might just be the reason why some of us have such a drastically low tolerance for sugar-titty or morphine, whether that drug comes in the form of some splatter-pimp's hardcore violence or Steven Spielberg's fairy tales. I don't believe that *everything* has to have some deep meaning, but that said, it is entirely unnecessary for *any* work to spoon feed you its own inhuman barbarity, postured nihilism, or impossible resolutions in such a flagrantly infantile manner that you are left feeling somehow unclean, as if you'd allowed the artist's hand down your pants.

Human emotion – love, pain, euphoria, hope, despair – is universal, and humanist art – art which takes a brave gaze into the fragility, the hell, the perpetual struggle of men and women, ordinary and extraordinary alike – can only bring us closer together.

Russian novelist Alexander Kuprin once wrote: "The only horror is in this: that there is no horror." That applies directly to where we are as a society today, especially in relation to this doom-stricken pop culture which lines pockets, skyrockets Nielsen ratings, and gives the rest of us another reason to dig our own holes a little bit deeper. The desensitization of anyone who would rather consume another mouthful of cheese curls than give the geek show nightmare an ounce of responsible thought, in terms of what it is and what it says, about themselves, the world, and their own place in it, is every bit as horrific and threatening a reality as the current conflict in the Middle East. ("Honey, quick, get me a beer! If she can eat another aardvark turd, she gets to go to Disneyland!")

Given that the most heinous of all possible human degradation and defilement has already been shown, described, or suggested, is it really necessary to keep mining the sewers for yet another taboo to break? I'm no more interested in happy endings than I am in snuff, porno, ultimate dare television, shock-art, or atrocity footage. What I want to see is the human experience intelligently, honestly, and sensitively explored, examined through the eyes of go-for-broke auteurs (not to be confused with the bratty, button-pushing transgressives that subculture has been plagued by in recent years).

When the World Trade Center was destroyed, I predicted that the ensuing paranoia so many people dealt with daily might influence a change in this current morass of sarcasm, crassness, and negativity. 9-11 seemed like the ultimate wake-up call; along with the towers, the American delusion of omnipotence also fell. (That *could* have been a good thing.) But I have to admit, my focus was on the arts. I took absolutely nothing in pop culture seriously from that point on, and very little in the underground. Your average rock'n'roll punk or heavy metal messiah looked twice as ignorant as before. Many previously thought to be Antichrists or corrupters of youth could now be seen as mere grandstanding irritants. Whatever taste I had for schlock, camp, or punk rock was nearly diminished. I suspected that the sneer, the swagger, the shriek, of these retards would not remain unchecked much longer. It became increasingly hard to trust anyone or anything; only the most psychotic or desperate of voices could convince me of their sincerity, of their commitment to the reflection of a virulent zeitgeist that I was and still am doing everything in my power to distance myself from, much as I sought asylum from Generation X bitch-weeping when Kurt Cobain blew his skull apart in a fit of heroin-induced impotence. I wanted nothing to do with the implications of that scenester suicide, as much as I resisted affiliation with the red, white and blue lynch mob on September 11th. The microcosm which I inhabit grows smaller every week, as decent, law-abiding society, those gutless, gluttonous cowards, have me living in fear of violent attack. The contempt I feel is an indisguisable stench which can fill a room within seconds. Why? Do I just need Prozac, Lithium, Klonopin, Zoloft? More fibre in my diet? Or is this a real-life invasion of the body snatchers?

The trouble we are all in is not as tangible as a terrorist threat, because it does, in fact, come from within. As the days dropped off one by one towards the eve of the 2004 election, I realized that the morbidly absurd predicament was exciting as hell. It's time to act. If a buffoon like George W. Bush can be puppeted all the way through a successfully waged American *coup d'état*, then democracy as it was once known has taken a near fatal blow. I can think of no better reason to create than the possibility that the very FREEDOM to create might one day soon be so limited as to make it worthless. Being that

grants, traditionally, are only given to the already privileged, it is plain to see that the only course of action is to take matters into your own hands, while you still can. Art, in it's most basic form, doesn't cost anything but time and energy. Publishers and distributors do not take the chances they once did. Computers, the Internet, and digital technology, however, put the power of expression firmly in the hands of the people at a cut-rate cost. It's never been cheaper to create. Nor has it ever before been as urgent to express truth. Under a true regime, the artists profiled in Midnight Mavericks would be considered enemies of the state. Our pre-fascist regime is now in its formative stages. That rare impulse to create work which does not pander or pacify is the antithesis of the sociopathic instinct which facilitates high-level fraud and corruption. When we are living in a kingdom of lies and deceit, why deceive ourselves? And why waste any more time? We should be tapping into our psyches, digging deep, and sparing nothing, no one, not even ourselves. We should be giving these white-collar crooks, these homicidal cowards a REASON to make our very existence illegal. In five years, it'll be that much harder to bare your ass in art, to let your proverbial dick dangle in the breeze. So now more than ever, I demand an expressiveness that slices right through every layer of bullshit; I demand sentiment so personal I get red in the cheeks, characters who are so real I can smell their armpits stink, images so raw my eyeballs throb. The art that feels – not exploits, but *feels* – the pain of the dehumanized man, the deviant man, the isolated man, and the impoverished man, is the only art I care about.

Reading from the unpublished novel *Johnny Behind the Deuce*. Somewhere in Europe, 2001. Photo by Lydia Lunch.

PART TWO: The Fine Art of Xerographic Blood-letting

Much of the material in this book was published in a fanzine entitled *Sex & Guts*, which I started in 1996, and continued publishing sporadically until 2002. I had, up until that point, been creating hand-done layouts and writing reviews for my first 'zine, *No Future*, which lasted four issues. *No Future* was a micro-press tribute to the ill-fated Sex Pistols bassist Sid Vicious, coupled with verbose appraisals of violent and amoral films… and not much else. It was deliberately anti-social, and as a teenage experiment which won me a few supporters and exile from the local scene, it worked.

I began to take writing seriously when I was 12 years old. Non-conformist art was the one fire I had going then, and it pushed me into purchasing my first typewriter; it was art that eventually led me to the grimy twilight zone endeavour called self-publishing. I dove into the process head-first, knowing nothing of computer programs or mailing lists. Even now, I am not capable of independently publishing my work in any way which does not require jockeying a Xerox machine in multiple six-, eight-, or twelve-hour sessions. Without capital, there's no way to do a full print run, and I haven't the first clue how to write HTML. In ten years, nothing has changed. And to be honest, I'm too tired to give a fuck.

My layouts were always skid-row ambitious: *Sex & Guts #2*'s illustration for the Johnny Thunders film report, an interview with Lech Kowalski, needed to depict a junk-tableau, which would consist of a syringe, a spoon, matches, and blood drops. Having no luck in finding images in my collection of old magazines pulled from Brooklyn trash bins explicitly for this purpose, I simply pasted the real items right onto the galley sheet. (The blood drops were also real, as an in-joke only the editor would get, which was fine because I was about 10 percent of that issue's readership anyway.)

I was born in November, 1976, the same month in which the Sex Pistols' debut single 'Anarchy in the UK' was released, and grew up in a series of small towns in rural Pennsylvania. Publishing a personal journal of what was infecting and informing my inner-life was my own feeble attempt at discovering the rest of the world. I was throwing myself out there, via my opinions and obsessions, in a most uncouth manner. I was first reviewed by Joe Bob Briggs, who called *No Future* "ambitious and inspired." It was only because of Joe Bob's kindness and empathy that I continued to count the Xerox machine as my most trusted confidante. The prospect of discovering new forms of expression and experience – and they *all* seemed new at the time – made me high. This is reflected in the rather lenient submission policy of *No Future #1*: "Poems, reviews, stories, I don't care what, just send me your shit and I'll print it."

I can't be proud of such naiveté, but I'm not gonna lie, either: I was indeed a teenage Xerox punk. What I knew of subculture came to me via US Mail, in the form of letters, Xeroxed magazines, and bootleg cassette tapes. I had yet to encounter the true freaks first-hand, and was eager to break into their circles. I was not only poor, but abnormally shuttered. My life consisted of a bed, a stereo, and a television.

My first live interview was conducted in New York City in 1996, with the man who remains to this day my favourite songwriter. I was 19 and undergoing messy and protracted divorce proceedings. Hunger stung my guts; I was a malnourished nervous wreck but determined as all hell. Steve Wynn sat with me in the basement of the Mercury Lounge, on Houston Street in the lower east side of Manhattan, and I vividly recall the immediate numbness I felt, sitting in front of him as he tuned his guitar. I was numb because I couldn't believe this was actually happening. I'd crossed over in a big way. No longer was I holed-up in a room, spinning records and pondering the appearance and personality of the man who made them; I was in the backstage of a big city club *with* him, and finding out for myself what this brilliant and amazing dude was really like.

In this state of numbness and disbelief, I found myself endowed with a completely false sense of confidence. There was no one to cheer me on, but it was as if I was graduating, in real time, from my squalid PA origins. I had willed myself to that club, fearing nothing but a junk food and malt liquor induced dumbness. I snuck in without I.D., lost in a huge city where I knew virtually no one and armed with only limited knowledge of the songwriter's past work (many of his records were out of print, and without Internet access or an automobile, I had no way of doing research). I kept my best non-poker player poker face on and based my questions not on a meticulously prepared outline, but on an overwhelming sense of what the man meant to me, based on the records I had managed to hear.

So I can't say I was on top of my game, but I was most certainly desperate, and desperation will cut your losses and focus your energies on what you have to work with. The interview that resulted wasn't great. I was using a handheld microcassette recorder which was later damaged, requiring me to play the tape some 50 or 60 times until I'd haphazardly turned the muddy noise into text. It was like translating the Dead Sea Scrolls.

But my saving grace, in regards to my first encounter with a famous artist, was in knowing that the interview could have gone a lot worse. I was confident enough to attempt a second interview, then a third, and a fourth. Nearly ten years later, I've conducted as many as two hundred, and while it never gets easier, it can, depending on the circumstances and, of course, the individual, actually be a weird kind of fun.

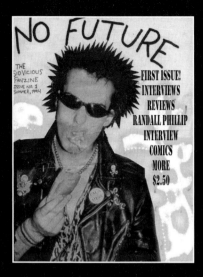

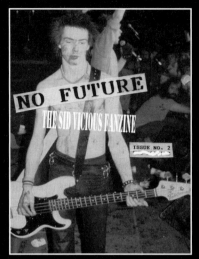

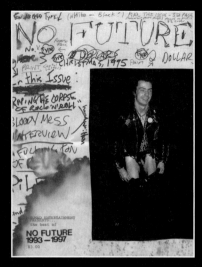

Some of the interviews included in this volume were done out of a sense of personal obligation, some based on sloppily-made promises, and some occurred for no other reason other than the experience itself. Most of the time, I was simply infatuated. But no matter the relevance of the artist to me personally, I was seeking the same answers, seeking *affirmation* as it were.

I am not a journalist. There have been times in the past when I aspired to a similar calling, but I'll refuse any such invitation. The problem is that journalism is rarely passionate, nor is it often personal. My motivation for speaking to people on the record is partly because I'm turned off by small talk. It seems as if I can find a reason to participate in a dialogue, or even function within one, only when the microphone is in hand and the tape rolling because then, it's all *meat*. If you've digested the work of a person, and come to respect it, there's a reason to be polite, and to listen. Yet, I deny myself the respectability of a real 'journalist' because that too is an arduous and rather thankless job. So I talk about myself too much when I conduct interviews, and am not always very well informed. I suspect that these things are calculated attempts to resist ever being given the opportunity to go professional. I get by on minimum wage jobs or by pawning my possessions, and I've rarely been paid for my work. I'm not only terrified of the responsibility which comes with bestowing upon oneself any tag or function, but also of basic boredom. Articles, essays, and interviews become hack jobs the minute an editor steps in with rules and regulations. Halloween 2004 saw my 4-month run as freelance film critic for the Detroit Metro Times voided on the grounds of public intoxication. The only genuine affront of that evening was the film itself, and they actually expected me to *write* about it. If I have to starve to avoid another predicament like that one, so be it.

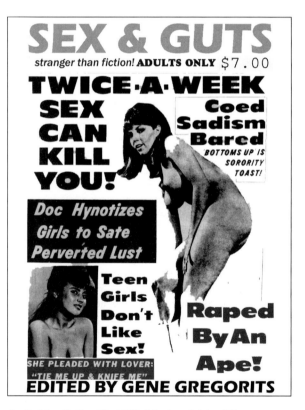

Top: **No Future #1**, **#2**, and '**Best Of No Future**' one-shot zine, 1996. People actually bootlegged No Future in Europe and the midwestern US.

Above: **Sex & Guts 5**, which remains unpublished. Cover assembled from sordid '50s and '60s tabloid newspapers. I someday hope to publish a real article using one of the bogus news items featured on this cover as a title.

Opposite: **Sex & Guts 2**, **3**, and **4**: A step up to magazines I could be proud of. The final **Sex & Guts**, published as a trade paperback, got me laid a few times, maybe because it had a barcode and real binding.

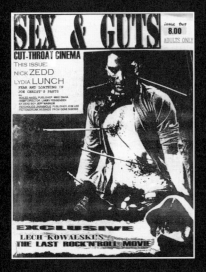
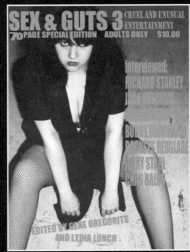
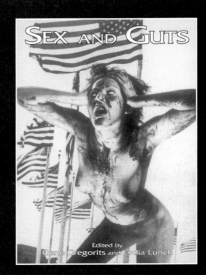

PART THREE: Hollywood Fanzine Deathtrip

In 2000, my cats and I moved from Brooklyn to Los Angeles. Notorious poet, sculptress, singer, and spoken word pioneer Lydia Lunch agreed with my artistic ideals. [A reluctant affection for messianic white-trash criminals was something we shared.] It was due to Lydia that after three years of dormancy, and a failed novel, I made the decision to resurrect *Sex & Guts* with a third issue. She paid for this project; I named her co-editor and used her gorgeous/evil image on its front cover in return. No one does the sex and guts better than Miss Lunch. And so it was: the mag was back on the map, *my* map. The interviews probed further and the theme this time was real-life horror, as opposed to the 'punk rock' first issue and 'NYC underground' follow-up. Seven chats, which included Lydia one-on-one with Hubert Selby, and myself with Richard Stanley. Add a few dozen film reviews, a colour cover, the name 'Lydia Lunch' and suddenly *Sex & Guts* held the potential of being read by more people than the average occupancy of a city bus at 2a.m. After an unprecedented level of interest in the magazine, I envisioned a bigger and better fourth issue. Instead of seven interviews and 70 pages, I came up with a goal of 50 interviews and 500 pages. Strangely, it took a while for this proposition to be taken seriously.

Enter Kelly Dessaint, president and founder of Phony Lid Books.

He saw where I was going with *Sex & Guts*, and heard me out on my concept of a 500 page 'art-buster'. He went for it. There was no money. It took a year of interviews… 75 of them completed by the fall of 2002. I'd overestimated the range of personalities I could gain access to, and after failing to convince Mickey Rourke to have a *Sex & Guts* sit-down, I lashed out by interrogating an endless stream of underground notables and non-notables. Many of them were so dispassionate, and the conversations so lacklustre (aside from my own verbal clusterfucks), that they wound up scrapped. For the first time, I was collaborating with a PUBLISHER, and this, when combined with ungodly amounts of 90% pure cocaine, created a tidal wave of paranoia from which I was not to surface. (Not *that* year, anyhow.) I was evicted from my home and flown to back to Harrisburg on a one-way ticket. Kelly and Lydia decided it would be easier to deal with me if I was 3,000 miles away.

They sent me a pile of galleys to examine and approve, but I returned it all to Lunch and Dessaint with nothing but vicious comments in lieu of corrections. The majority of my 'edit' was conducted on a couch in my father's living room, my face in stitches and my brain full of high-strength painkillers.

Many months later, I received several 100 pound boxes via US freight. Much to my surprise, this book had been completed for me in absentia. Ever the ingrate, I attacked my underlings for their casual dismissal of the man who had created and conceived the thing called *Sex & Guts*. The hijack has left me heartbroken until this very day, starkly certain of nothing so much as the one gleaming inevitable fact: there will never be another *Sex & Guts* magazine.

(Before you begin shedding tears for Mr. Fenton, owner of FAB Press, please know that I was nothing less than a perfect gentleman during this tome's relatively problem-free production. However, this is despite the fact that he did unceremoniously scrap my original and far better title of *Rapists, Rippers, and Rottweilers*.)

PART FOUR: The Scene hates you.

Here, you have four dozen interviews, edited down from the originally-published transcripts for maximum readability. It's what I always wanted... but I fear I've lost track of what it all means. My point is that without a mission statement or a manifesto, this is just a bunch of subterranean yacking. It's got to connect... come together... really say something! It might do all of that, and if it does I'll be gloating for the next decade because there ain't nothing else that I'm doing. If not, I've always got my Michigan car wash gig.

I'm not sure what else to say about the material in this book, or where to go from here, or what all of this meant, beyond what I have tried to explain already, except to say that I'm glad I had an agenda and pursued it (even if I often lost sight of it). I'm flattered as hell that all these people gave me such large chunks of their time, and I'm sometimes amused to read this stuff, to find that I may get right to the heart of the matter in one breath, then make a gibbering cretin of myself in the next. All the while, I'm goading someone into a monologue about the things that I think matter. I did these interviews for myself, and maybe that's selfish, but I believe such an approach can make for better journalism. Assuming that that's what it is, which of course, it isn't. It's just sloppy, crude talk with really great people. It's digression and obsession, it's a goofy twat with a microphone, it's a joke and it's all deadly serious.

I bluffed Steve Wynn that night in New York, much as I bluffed every other artist in this book. But it was worth it, because I was there for a valid reason, maybe even a noble one. I urge all fans who feel themselves somehow unprepared to do the same. And have fun with it. Remind yourself that schools are for fish... you learn more and learn better this way – straight from the horse's mouth – than in a fucking classroom. And best of all, it's free. Abandon your inner (and outer) nebbish. Go for broke. Go for blood. Fuck the sterilized media coverage of pompous ego-casualties and flavour-of-the-month publicity whores who do not matter.

There's more than one or two base-level geniuses out there who have no fame, who live like rats, who sustain themselves – like old ladies eating cat food – on woefully minor levels of appreciation. If people like you and I don't make an effort, no one will. And they will go on, invisible, while careerist creeps crank out Hollywood snot, and the rabble continue to suck it down, gulping this goop like cheap champagne, never knowing the psychic price we all pay for it in the end. What's worse, the culture based around the proliferation and support of renegades is itself often terminally disinterested in the very best work happening. The underground is a fucking lie, friends, it has been for many years. Make your own if you want the hot action.

In any given underground scene, there are often less than a few dozen hell-bent hearts keeping the battery charged, so to speak. Many are there for the show, the credibility, the sense of belonging, the drugs, the sex, or something else which immediately benefits them perhaps more so than those at the deep centre. A scene needs numbers in order to survive as something which may eventually become a blip on the radar screen of history, but what I've noticed since I started publishing *Sex & Guts* is a dissipation of those central energy sources, even at times a disposal of them. Standards have dropped. It's barely even considered hip to have heroes anymore. Too often, the stage is inhabited by scenesters, not psychotics... the screens are occupied by movies about other movies... the pages are regurgitations of other better pages. But we *do* need heroes, we need excessive mutants to remind us what danger looks, smells, and tastes like. I don't know about you, but for me the fun doesn't really start until someone breaks something. There's no point in turning against the status quo only to create another one on a smaller level, because that will only inspire preachers and zealots and *nobody* likes those fuckers.

Maybe the new 'scene' doesn't have a city, and maybe it doesn't need one. I'd like to imagine an entirely new species of subculture, one populated entirely by dyed-in-the-wool outsiders. What is ultimately necessary is not only support for the aberrant and culturally progressive individual but an acceptance of the possibility of a brave new world, even if that world is a microcosmic one that we invent for ourselves.

Midnight Mavericks is the suggestion of a more Utopian arts community, a post-millennial response to Warhol's Factory, which that massive 4th issue of *Sex & Guts* was originally imagined as. When this book is on shelves and I can see it there, know it all amounted to something final, then I can officially retire from these investigations of artistic mercenaries. I think I've done my share of stirring the embers... I'm ready to embark on more selfish adventures, and besides, I'm now far too banged-up from the years of trying to take it all in, of trying *TOO FUCKING HARD*. That overcompensation is still going on in these pages, but for the most part, all further work will be done independent of any culture, and from the safety of my own home. My own big hope is that *Midnight Mavericks* can have an impact somehow, on you and your art.

So here is a ruder, weirder, and more varied attempt to aggravate the minds of those readers who have grown far too accustomed to complacent journalism, complacent art, and complacent art scenes. It combines damn near the entire catalogue of my *Sex & Guts* interviews, with more than a dozen others which appear here for the first time in print anywhere. Here's hoping that you have fun with them. I'll be watching the skies from my bunker's bullet-proof window, for further signs of life.

fuck art / let's kill-

Gene Gregorits
Detroit, Michigan, USA

MOTEL

PHONES
KITCHENETTES
HEATED T·V
POOL

THE ULTIMATE NECRO-VILLE:
Creeps, perverts, scenesters, ferocious big-money ego-sickness and the most
aromatic of coked-up street trash. **Sex and Guts** was ill at ease in Hollywood.
Photo by Lydia Lunch.

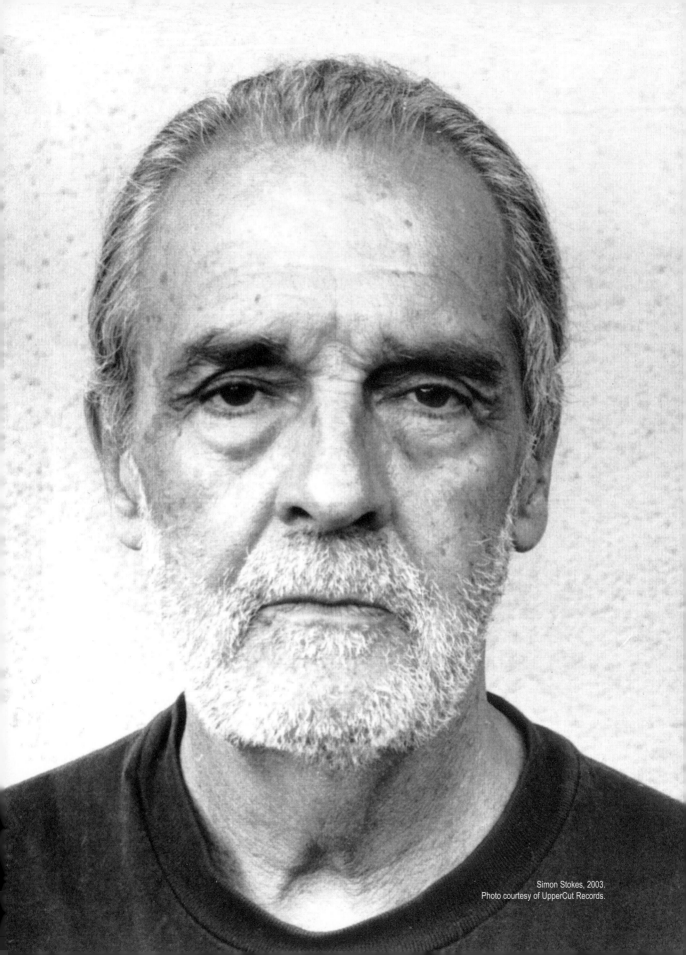

Simon Stokes, 2003.
Photo courtesy of UpperCut Records.

It Ain't Easy Bein' a Honky

- Simon Stokes -

"Did you eat the cookies, I was saving for our child's lunch
When you came home from drinking, with that no good bunch?
I don't know what I ever saw in you in the first place
and that life you're leading is beginning to show on your face
Call out the gendarme, call out the border patrol
Tell 'em old Simon's missing
He was last seen in rock'n'roll
Oh, I don't know where it started or ended
I'm lost in space, everything is suspended
Dreaming of you, girl
All through the night."
- 'Mystery', by Simon Stokes and Harry Garfield -

Simon Stokes is one of God's chosen freaks, an American original and dyed in the wool rebel whose past is largely shrouded in mystery. A biography I found on the Internet reveals that he was raised by his grandparents in a town near Boston, Massachusetts. As a child, he had few friends and isolated himself deliberately from peers. He moved to Los Angeles in the mid-'60s, and by 1973, with his *Black Whip Thrill Band* album, had already made a name for himself: that record's cover was to be the first banned from public display in US history.

I was told by a guy in a record store once that Stokes disappeared for 20 years. I have no explanation for why it never occurred to me to ask *"disappeared where?"*, except perhaps something to do with Simon's unique presence, his humour, and his sensitivity, the sum impact of him being such that I felt an unconscious impulse to hear it only from him or not at all.

Even now, after many conversations, there's plenty about Simon Stokes that I don't know. Most of his records, regardless of their formidable reputation among a wide variety of hard living rock musicians, remain out of print.

I was shamefully ignorant about Stokes until recently, but with a past like his, there was no shortage of subjects to talk about. He's got some of the best anecdotes, from his rock'n'roll beginnings as a signed Elektra Records songwriter, to his 2002 return, with the album *Honky*. A natural comic, he had me in stitches. Whatever scars the Luciferian malaise of Los Angeles have left upon him are barely visible. I hate to blow his image for him, but Stokes is blissfully sweet natured, tirelessly enthused, prone to rattling off a litany of cultural references in staccato bursts. His attention span drifts quickly; he seems too excitable to stick to one topic for more than a few minutes. From a distance, you'd probably take him for a Hell's Angel.

The opening grooves of *Honky*, on the song 'Amazons and Coyotes', promise a deliciously low-down tour of all the places your mama warned you about… comedic, violent, working class noir soaked in raw whiskey and ill will. 'Amazons and Coyotes' lands somewhere between Waylon Jennings and Warren Zevon.
"You're gonna lose that girl of yours / keep her inside man, don't let her outdoors / we're gonna steal that girl of yours!"

But the eleven songs which follow are remarkably varied in theme and tone. Backed by a motley assemblage of icons including the MC5's Wayne Kramer and Texas Terri from The Stiff Ones, Stokes covers it all here: crooning bad break-up songs, high-octane action-swing, bleak meditations on overly domesticated sex. In his trademark rumble, he narrates episodic tales of murder and undoing, throwing in a couple of unabashed country ballads. It doesn't get much better than the sardonic 'No Confidence'.

"The girl next door says I'm a bore / she sees me coming and she slams the door / I'm out of luck, I'm in a rut… pardon my French but I'm really fucked!" Hearing his wild-ass delivery of just one such line is worth your standard garage rock outfit's entire album. Last I heard from Simon, he was writing a new batch of songs, one of which – a revenge tale involving shotguns, thugs, and a bathtub suicide – he graciously played for me over the phone from somewhere in southern California at 3a.m.

Gene Gregorits: You started playing rock'n'roll when you were a teenager.

Simon Stokes: Yeah. That was when I was using the name of Count Cool Breeze, The Baron of Bop. That's how I got into music, because there was a band then called Johnny Mann and the Tornados, they used to play live. I always loved music, from the beginning. But I never thought about writing it or anything like that. There was this contest on the local radio station, which everyone listened to. Hundreds of people were submitting songs. The winner would get their song recorded. The Tornados asked me if I would write some lyrics for a song for them, and I said "sure." I wrote it on the way there, it was called 'Breaker of Dreams'. And I forgot all about it. Then one day I was driving down the street, with my girlfriend, and they announced the winner. They started playing the song. Halfway through the song, I just stopped dead right there in the street. I didn't even pull over. I just stopped. Because it was my song. That is what led me then, to start doing music as a writer. That's how it started. Then I started coming to Los Angeles. For about two years, I was coming out here, staying a couple days, then drive back to Boston. I lived on the road for years, just travelling. Picking up jobs as I went. And in fact, later on when I did my first album, I dedicated it to Jack Kerouac. His book *On the Road* had a big, literal influence on me. Funny how that, and writing one song, changes everything in life. It's amazing, isn't it?

GG: So it was the early '60s when you came out here.

SS: It was either the early '60s or the late '50s. *On the Road* opened up a lot of things I felt and had thought about, then decided to do. It's funny because I don't know how I would react to it today. Most of the friends I travelled with died young. Fight, drugs, a lot of car crashes. I had a friend who was decapitated.

GG: So when did you begin playing live music?

SS: When I first got out here, I was writing a lot of R&B songs with a writer by the name of Alonso B. Willis III. I love R&B, I have since I was a kid. When I was a kid, they used to call it race music. I'm talking about old R&B, the Midnighters. I'm talking about Johnny Ace. Big Mama Thornton. People like that. I did about 20 songs and it was great, they were out on the Veejay label, which was big. When did I wanna start singing? Well, there's a guy I really like called Rambling Jack Elliot. When I heard him, and Dylan too, in the beginning, I said, "you know what man? I'm just gonna pick up a guitar." And I learned about three chords, haven't learned any more since then. I'd like to learn more chords, but I don't even know the names of them. But I played anyway. Sometimes I'd use four, but I would have considered that to be a symphony. I think my first released song was called 'Pow Zap, I Am the Bat'. It was about Batman. I was completely out of it, but having fun. It meant a lot to me at the time. I'd written a lot of other things too. 'Toys of War'. It progressed from there, I guess. I was in a group called the Heathen Angels, with David Briggs who produced Neil Young. I then did a record called *The Perpetual Motion Workshop*. We did a thing called 'Infiltrate Your Mind'. The other side was 'I Won't Come Down'. We did one song under the name of Flower Children. That was called 'Mini-Skirt Blues'. Years later, I found out that it had been covered by both Iggy Pop and The Cramps. That was great because you know what? My name was on the records. Then I had to hunt it down and register it. The other side of the record, I could honestly say, is the *Plan 9 from Outer Space* of rock'n'roll. It was called 'Marching Lovers', and in order to do the one song, I agreed to the flip side. Part of the group walked out, and I was left with this awful track. It was like three or four words. "Marching! Marching lovers! Marching to victory!" [*laughs*] So we did that, and I later found out it was written by Morton Downey Jr. Go figure.

GG: I heard about one band you had that was making a lot of hippies, very, very angry.

SS: It was actually two bands, I suppose. The first band I ever recorded with was The Nighthawks. Simon Stokes and the Nighthawks. At the time, I was writing with Randall Keith. I signed up as a writer with Elektra records. I wrote there for two years. I signed the same day as the MC5, to Elektra! But I didn't know them and they were in different places. But we signed the same day. You know, I have written and recorded with Wayne Kramer. And Iggy cut a song I wrote with Randall Keith and David Briggs. In the '70s, I had the Black Whip Thrill Band. We did alienate the hippies! I remember one time I had done a single at Elektra called 'Brutal Woman', with Randall Keith and Lonnie Mack, the blues guitar player. That became a hit. It was #90 on the Billboard charts, for six to eight weeks, It was the longest any record, at that point, had ever been at #90, without moving up or down. It was only equalled by my second single, a while later. That was 'Captain Howdy', which also wound up at the

same number. 90. I think for five or six weeks it tied it. It was actually two of my records that held the #90 spot for weeks! I tied myself at 90! When we would play… I don't know why… but people always booed me. I would always get booed, or have no reaction whatsoever. To this day, I wonder. It just was what it was. I remember one time we played with a bunch of people. Janis Joplin was there. A big festival up in Portland. Janis. Ravi Shankar. The Burrito Brothers and all those guys. The place was huge. The first day, we received a very poor reception. Everyone was into peace and love, so everyone just hated us! They were giving us the finger. But the second day, it turned really bad, because people were rushing the stage. People were rushing the stage to *get us*, because they were about peace and love. [*laughs*] We didn't give a shit! But at one point we had to get off the stage. When we left, a magic thing happened. At the back of the stage were a bunch of guys in motorcycle jackets. And there was a little guy with a cape, who I guess was the leader of the motorcycle group. He introduced himself, his name was Presley Zoom. I'll never forget his name. That's the coolest name ever. Presley Zoom. And he said, "man…you fucking guys are great!" The cycle gang escorted us out of the auditorium. And at that point, I said to myself, "you know, there is an audience, and there are people who appreciate it. It's just that we've been going to the wrong places. Actually, I didn't even think that. I take that back. I say that now… but I was just happy that these people really loved us. It kept us going for a long time. I have played a lot of biker bars. Yeah! I always got a bigger thrill when people were booing. So when people started cheering, I began to miss the fever of that. That was one of the things that I always felt was special about me and the band. That I could elicit that kind of a reaction.

GG: Amen to that. How close was the Black Whip Thrill Band in style to the stuff you did on *Honky*, the new album?

SS: Have you heard the Nighthawks album?

GG: The only thing I have heard by you is *Honky*, which I absolutely love. I haven't heard anything else. It's very hard to find your stuff, man.

SS: [*pause*] I know… A lot of people like the Nighthawks just as well as the Black Whip Thrill Band. It's a total even split. The Nighthawks stuff was on a tape the other day I was playing. And I realized… Jesus, this really was good! I really liked what it had to say. I have to say, that if you're gonna be in music, and write music, you must never be restricted or censor yourself in any way. I believe that if you limit what you do, it's *not* you. You're reaching out to the public, but it isn't you. So when I got to the *Black Whip Thrill Band* album, the music became much more overtly dark. The Black Whip Thrill Band dealt mostly with death. The first song was called 'Black Whip Thrill Band', and another song on that album was, 'The Boa Constrictor Ate My Wife Last Night', which was a sing-a-long! We did a song called 'Waltz for Jaded

> ## "I don't think about things when I write music… you have to follow your gut. I do not second guess. If you second guess, you are fucked."

Lovers', which is about a very vicious suicide, where a girl goes into the bathroom and slits her wrists. The lyrics were, "'I hate you, you bastard, I wish you were dead' / the venom in her eyes was like a snake / I said 'you drunken pig, get outta my way' / I don't remember feeling such hate." It was, to me, dialogue. The dialogue people have in their lives. In this case, it blew up and became a suicide. It took a whole turn. I wasn't aware of it, I don't think about things when I write music. It is what it is, and you have to follow your gut. I do not second guess. If you second-guess, you are fucked.

GG: You have to edit your writing sometimes, but what matters is that you're going where you're going.

SS: I try not to edit that much. Like 'Honky', that song that I sang…

GG: At the Bigfoot Lounge!

SS: Yeah. That was on the spot.

GG: That's not on the album, you just made that up…

SS: I had written one lyric with Harry Garfield, who I write a lot with. I just used that one verse, and the rest of it was off the cuff.

GG: "It ain't easy bein' a honky."

SS: Yeah! And I'm glad you reminded me of that because I was trying to think of what I'd said. The problem is that when you do that, unless it is recorded I have no idea what I said. I don't even remember the lyrics to my own songs, I have to study them a lot.

GG: Do you write songs every week?

SS: I can write one a day, I suppose… But you just go with your instincts. My instincts are usually right. But really, I'm gonna hit it hard, and I wanna record every day.

GG: Do you think *Honky* is one of the best things you've done?

SS: Yeah! I do. But I look back, and you know, I don't criticize. I kind of like everything I've done. I went to see a movie which I loved, called *Night at the Golden Eagle*. At the theatre, this guy came up to me and he started talking. He had loved the movie. His name was Bill Paxton.

GG: WHAT?!

SS: He came up to me afterwards. I knew him, and I had seen him, and I really respected him. But he started talking about the film. I said, "you'll have to excuse me. I don't remember people's names. I don't know anyone's name. But I've seen you in a lot of movies." He was very cool about it. He's a really cool guy. He's really a great actor. He was saying that he doesn't like to look back upon his work. He asked me how I felt about that? I said, "man, everything I've done and I'm sure everything you've done was our best. If you've done your best at the time, fuck man, you've done your role. You've done it." So… the only thing I've ever done is my best. If it sucks, that's okay. That's all I could do. [laughs] I'd be pissed off if I just walked through it. Eric Burden once said this thing, and I have always thought this too. He said, "if you're gonna sing a song, whether it's here, or if no one's around, or if you're onstage… realize that you're gonna die at the end of that song." It's gonna be the last song you're ever going to sing. So just make that thing count. It may not come out that way to whoever is listening, but to you, it matters. Life is about art. That's how friends are made. That's how people know each other. You have a mutual thing.

GG: I love this new record. Especially, I like 'No Confidence'. These songs are all really hateful, nasty songs… but also really funny!

SS: I never think of things that way. Maybe they are!

GG: What about 'Johnny Gillette'? Isn't that about a hit-man?

SS: No, it's about a serial killer. It's about a serial killer who is actually… eliminating bald people. He doesn't like baldies! Seriously, if you listen to it, he refers to them as "chrome domes" and so forth. The whole story is is brought out in the third verse. After the first two verses where he kills his boss, and he and his girlfriend get insulted at *Spago's*, of all places, by a *maitre d'*. So they kill the *maitre d'*… The third verse introduces the cop. "He's a cop who was a priest / and the killing of the beast / has always been his major line of business. Each night before he goes to bed / he puts a shotgun to his head / falls down on his knees to beg forgiveness. Bodies everywhere / and none of them have hair."

GG: [laughing]

SS: *"Why, oh why are bald men dying?"* Then it comes to the real crux! *"It started long ago / when Gillette went to the show / The King and I and then he started crying."* That is what that's about. It's about a guy killing bald people because he simply didn't like them! See, now I'm becoming a baldy and that's cool.

GG: That's weird… I always assumed it was something about a hit man everyone was looking for!

SS: In the last verse, the cop gets a note and he goes into the church. Gillette is holding the entire choir and the organist hostage.

GG: *"I'll kill the whole goddamned choir."*

SS: That's right, if they don't sing 'Light My Fire'! Then "the cop walked in, two shotguns held above him like a cross. Then he ripped off his toupee / and he blew Gillette away / said 'that's for all the bald headed cops.'"

GG: [laughs] 'Sleeping with the Enemy' is a very serious song.

SS: That's the first song I ever wrote with Wayne Kramer. On this record, the two people I have been with the longest are Harry Garfield and Randall Keith. Did you ever hear the Timothy Leary record I did?

GG: No.

SS: I did a record with Timothy Leary, along with Randall Keith once again, from the Black Whip Thrill Band. I was up at Leary's house. We were talking. There were a lot of people that had wanted to work with him. But we got along instantly. I didn't want to get into his record concept, because Paul McCartney and other people had been calling and I didn't know what he was going to do. He always wanted to do rock'n'roll. He said to me, "what is your favourite scene in a movie?" So I said, "I think my favourite scene is from a movie called *True Romance*, between Dennis Hopper and Christopher Walken. Are you familiar with the scene?" So he yells out, "EUREKA!" And Tim starts dancing around the hall. And he says to me, "that's *my* favourite scene! Let's roll on an album!" And that is how that album came to be. It was released, but by the wrong label. I'm not a good business person. We gave it to the first label we contacted. After all the great reviews came out, we could never reach them, we never got a statement. It was a horror story. I'm really happy with the label I'm on now. It's small, but we talk a lot. There's real communication and that's important if you're an artist. But with both Russell Means and Tim Leary… I really wish that both those records could be heard. Timothy, when he heard it, he said, "maaan! I love this. I have a rock'n'roll album!" He sounds pretty good on it!

GG: When were you born?

SS: June 10th. Same day as Judy Garland and Howlin' Wolf. Howlin' Wolf was my idol. I hung around a lot with Lightnin' Hopkins. He was born the same day as my wife Maria. But you mentioned 'No Confidence' earlier…

GG: Yeah, which is great, right next to a song like 'Sleeping with the Enemy', which is a terribly dark song.

SS: Okay, let me tell you about 'Sleeping with the Enemy'. I wrote that with Wayne Kramer of the MC5. Him being him, and me with my background, I didn't expect that we would write a love song. It's the most traditional song on the album. 'No Confidence' was the first song I wrote with Brad DelleValla and Jim Weston. Brad's a really good songwriter. The first two verses were basically Brad's. I came in and wrote the last two verses, which, for whatever reason, changed the whole thing, because it was originally the story of a lesbian love affair that went bad. Then, there was the thing about the masturbation before your wife returns home – *"I've got a bone / she's coming home! / now I don't have to have sex alone!"*

I think that's a great line! People say to me, "how could you write a line like that?" But I don't understand why you *wouldn't* write something like that!

GG: Have you been working on any prose writing or anything like that?

SS: I wrote a script called *Hot Nuts* with Joe Renzetti. This guy wanted me to write a family film. I don't know how to write a family film, so what I wrote was what I thought families would go see. *Hot Nuts* probably turned out more like *Porky's*! It had a sex crazed gorilla that escaped from a local zoo, and I thought that would be really funny for kids. He was always peeking through windows at women and things, getting into trouble. I really laughed at it, I really liked it. I love movies. I spent my childhood alone, at films. The greatest thing was *Mom and Dad*. [The most notorious sex and hygiene exploitation film ever made! –ed.] You had to have a signature or something, from your parents, to get in. Somehow I got in, and it was this whole film about sex. The final scene was the birth of a baby. It was shocking! I was in there [*laughs*]… at the age of eight, all by myself! There was blood all over the place! I thought it was the worst thing I'd ever seen, I didn't want to have anything to do with sex at all!

GG: What was the first movie you ever saw that really deeply influenced you, or the way you looked at the world?

SS: This film with Robert Montgomery. It was called *Ride the Pink Horse*. But there were many. I love the movie *Dracula*. I always thought vampires were very exciting and cool. They lived at night. My favourite movie of all time is *The Wild Bunch*. I've seen that so many times. I also liked *The Ruling Class*, with Peter O'Toole. *Taxi Driver*. *On the Waterfront*.

GG: Are you working on a new album right now?

SS: Well, I finished a couple of things. I recorded a new thing called 'Apocalypse Girl'. It's about the end of the world. *"It is the end of the world / you are my girl / my apocalypse girl."* They end up in a bomb shelter together. It's really *love*. And for them, that bomb shelter is a palace, because they're there together. But I tend not to write for very long periods of time. A friend of mine who died last year, who I miss very much… his name is Michael Hazelwood. He wrote 'Gimme That Thing', the Benny Hill theme song. He wrote 'It Never Rains in Southern California'. He wrote 'The Air That I Breathe'. He was truly one of my very best all-time friends. He died in Italy. I went to his funeral in England. And when we got back, there was a postcard waiting for me, after he died: "Dear Simon and Maria, Really love it here…" And the last few words were, "life is great." And I thought that was so cool. I had it framed. We both always went to a lot of films… even if we weren't writing. Because films was like pre-writing, because you're actually storing things up, whether you know it or not. And when you start writing, you've got a lot more inventory to write from. I

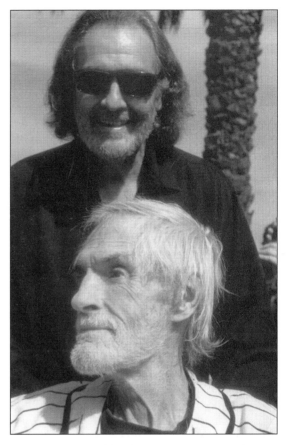

Simon Stokes and Timothy Leary, 1996.
Photo courtesy of Simon Stokes.

wish I could write happy stuff. I very seldom write happy songs. But I feel that a lot of songs on this project are basically happy songs. 'No Confidence' had a nice moral. The wife left, but they get back together at the end. 'Sleeping with the Enemy': they were still in love…

GG: Okay, well… I gotta tell you, if there was anything happy in that song, I missed it!

SS: But they still had the sex! That's what "sleeping with the enemy" means… you're fighting like mad, but the bedroom becomes like a church! It becomes a place where all is forgiven, until you leave. Until you leave the bed. Then things go right back to normal. But that one space in time may hold you together forever because it is so wonderful with that person.

GG: That's a pretty weirdly optimistic way to look at what would be a terrible nightmare to most people.

SS: Well, even though it's the enemy, you're sleeping together, and that's because you're drawn together. God knows, every one of us have had that in our lives, where everything is wrong, but when you hit the church, which is the bed, then everything is wonderful, and sacred. And when you leave… well, everything can go to hell again.

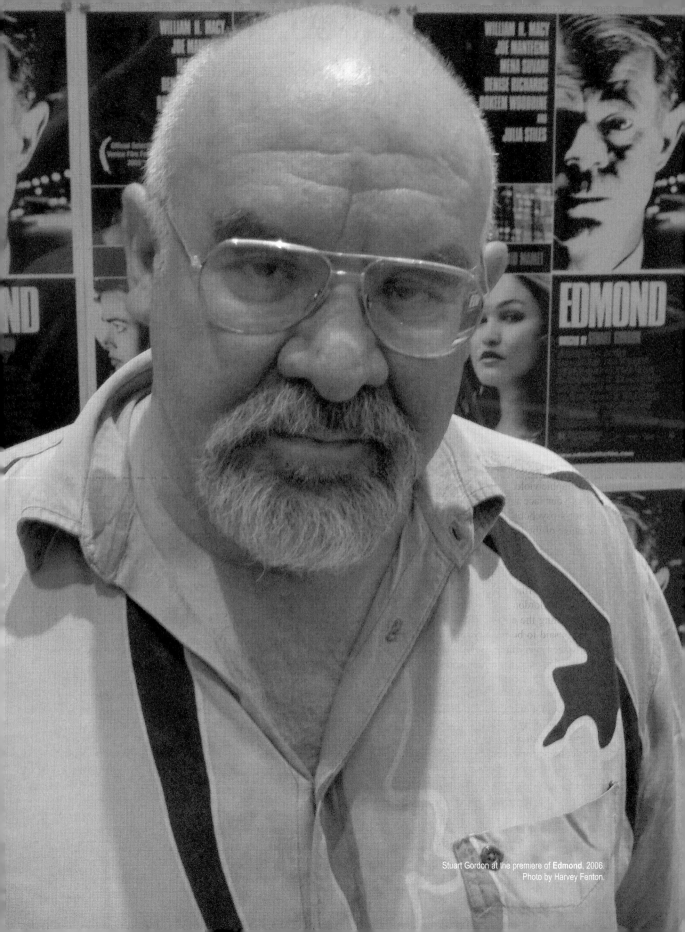

Stuart Gordon at the premiere of **Edmond**, 2006.
Photo by Harvey Fenton.

Organic Lovecraft

- Stuart Gordon -

Principal photography on Stuart Gordon's film *King of the Ants* was only weeks away when I took a bus to Burbank, CA for a mid-afternoon appointment at his production office. He'd recently completed another over-the-top H.P. Lovecraft adaptation called *Dagon*, which I'd caught a screening of the day before. The film had really gotten to me, not only due to its oppressively Satanic tone, but one particular scene in which an old man has his face carved and then removed, in close-up, with a large knife. It was as cruel and violent an image as I'd seen in any of Gordon's films. Had I known for certain what kind of depths he'd be exploring a year later in *King of the Ants*, perhaps I would have been better prepared for *Dagon*.

Where Gordon stands apart from virtually any other horror director is the degree to which he challenges the viewer. He does that by mingling monstrous or obscene images with absurdist slapstick or, sometimes, sincere compassion. He drives these irreconcilable juxtapositions like a car hurtling at ever increasing speed towards the edge of the abyss. Sometimes he hits the brakes and, as in certain films by Wes Craven or John Carpenter, we are left jittery and dosed with mild fear. At other times, he floors the gas pedal and hurtles right over the edge, taking you with him. To me, that's what horror is really about... work that scares the shit out of you with all the force of an upside-down rollercoaster.

In *Re-Animator*, *The Pit and the Pendulum*, and particularly *Dagon*, Gordon intentionally fails to make a strong distinction between the pedantic gross-out, the bait-and-switch peak moment, and pathologically aggressive, stripped-down graphic violence. This unpredictability has a profound effect, because after Gordon pulls a real bastard move and knocks your face in, it's impossible to settle gently back into the story. You are left powerless, at the mercy of this director's psychotic whims. I'd say that Gordon is a man who takes his job pretty fucking seriously. He takes full advantage of the fact that horror is the one genre where a director can completely betray the trust of his audience and not only win them back in the end, but also establish the experience as one which is actually superior to its competition.

It takes a rare skill to pull off this kind of stunt successfully, as Wes Craven did in *The Last House on the Left*. Without a perfectly controlled awareness and a sense of either mirth or sympathy, you're just a pornographer with a grudge. And in film, the only thing worse than boredom is contempt.

When Gordon stands at the brink of nihilism, he's taking the prescribed role of a horror film director to another level, pushing the envelope, and teasing us, essentially... with one foot over the line, but never both. An adrenaline charge is said to be the key ingredient in all successful horror movies, but these days, your average 15-year-old has already seen everything. But has he felt it? It is that feeling, inherent in the high velocity of Gordon's best work, which defines it as smarter, weirder, and more dangerous.

King of the Ants, a terribly unpleasant movie about torture and murder, goes far beyond your typical criminal psychodrama. Finally released to DVD during the summer of 2004, *Ants* is easily his most serious work to date. It plays with limits in a dramatically different manner, acting as antidote to both Hollywood violence and the predictable last frontier of atrocity footage. We've already seen countless examples of sadistic gore-porn and staged snuff, often made by spoiled children and defiantly anti-intellectual splatter-creeps masquerading as demonic nihilists. Such people lack the intelligence and sensitivity to place violence in any sort of moral or psychological context. Their element is unnervingly prevalent in a new horror movie underground informed only by the most negative aspects of punk rock.

In the face of such humiliating infantilism, there is Stuart Gordon, a man with enough respect for his audience to meet them halfway, offering real substance along with all the perverted thrills. *King of the Ants*, although at times very uneven, shocks on a level that underground geek shows like the *Guinea Pig* films never could, simply by trying to comprehend and digest its own subject matter, instead of exploiting it. Out of what could only be a sense of social responsibility and the dread unavoidable in imagining what it is like to have one's body brutalized, Gordon has achieved one of the most intensely realistic examinations of physical violence, and its psychological aftermath, since *Henry: Portrait of a Serial Killer*.

Gene Gregorits: When I interviewed Chas. Balun, one thing he remarked upon was the summer of 1985, when *Re-Animator*, *The Return of the Living Dead* and *Day of the Dead* came out – all during the same summer. Chas. felt that that was the last great moment for horror films, or for the age of seeing them in theatres. Has the horror film been in a state of decline?
Stuart Gordon: No, not at all! I would agree though, that that was the end of the splatter film. But horror takes so many forms, and splatter was just one style of horror moviemaking. I think that there have been some great horror movies that have been made since then.

GG: What are some of your favourite horror films?
SG: Well, I liked *Se7en*, I thought that was a really great film. That's a movie that didn't show anything on screen, except for the results of the carnage. I thought *The Others* was really scary. That was a ghost story and there's absolutely no blood in that film. I just saw *Audition*, a movie that is, I guess, a return to splatter, sort of, which I thought was very strong. So I think horror changes with each generation. The things that scare us change a lot. Movies that scared our parents don't always scare us, and our kids will probably find our movies kind of tame.

GG: Do you see anything ominous about that? Your film *Dagon* was absolutely your most disturbing film yet. In some ways it doesn't go as far over the top as *Re-Animator*, but in other ways it goes a lot further. It's a very nasty piece of work. Part of me doesn't want to imagine things getting nastier than that. How much further can you go?
SG: Well, I think that there are always ways to go further. But not necessarily going further in the same direction. Sometimes, different things scare us. And it's interesting to me that you start seeing certain themes coming through, when you look back and analyze society by the movies they make, horror movies especially. What's very interesting to me is that in Spain there is a series of movies now that are being made which deal with the murdering of children, which is a very scary idea. So maybe that's the direction we'll be seeing next. It's funny that one of the MPAA's rating restriction categories is child endangerment. That is something that they don't want to see.

GG: The child murder themed films that are coming out in Spain... that reminds me of a Spanish film called *In a Glass Cage*. It's a really morbid film about child murder and the cycle of abuse. Actually, in a good way, *Dagon* is one of the most evil films I've seen since *In a Glass Cage*. What made you decide to do such a literal translation of Lovecraft, as opposed to the out-of-control party atmosphere of *Re-Animator*?
SG: [*smiles*] I think *Re-Animator* is a pretty faithful adaptation of Lovecraft's story, 'Herbert West: Re-Animator', which is very different from a lot of his other work. He gets very obsessive in those stories. And it wasn't like we were just making up this stuff. The

headless doctor and the people coming back to life, all of this is in his original stories. We were trying to be faithful to Lovecraft when we did *Re-Animator*. Lovecraft actually disowned *Re-Animator*. Those were the only stories he ever wrote for hire. And because of that, he felt that he had been whoring. But there is a lot of humour in those stories! The recurring line that you get in my film, when Herbert West keeps failing, he says, "I guess he just wasn't fresh enough!" Which – [*laughs*] – is great! There is comedy in Lovecraft. People think of him as a very serious writer, but he had these in-jokes. You have to read a lot of his stuff to start picking up on his sense of humour. *Dagon* is based on two of his stories. One of them was called 'Dagon', and the other one is 'The Shadow Over Innsmouth'. Those two stories are my favourites, actually. I've been wanting to make 'Innsmouth' particularly, for years.

GG: When that went into pre-production, which was a disaster I heard, it was described in Fangoria as "the greatest movie never made."
SG: Yeah. That was actually a different script. The script was written right after *Re-Animator*, it was the first script written after that came out. We wanted to do it as the follow-up to *Re-Animator*. We took it to Charles Band at Empire Pictures. He did not respond to us. He suggested we do *From Beyond* instead. So we put the script aside, and a few years after that, we started creating a new script based on 'The Shadow Over Insmouth'. It wasn't until a few years ago that I was going through some papers and I found an outline for *Dagon*. I was looking at it, and I called Dennis Paoli. I said, "This outline is terrific, you should write this!" He said, "Stuart, I did write it. Fifteen years ago." [*laughs*] So, he sent me a copy of it and revived the project. Brian Yuzna has a company in Spain called Fantastic Factory. It's a division of Filmax. He was very excited about the idea that we could get this movie made.

GG: There's a certain kind of intensity in the film, where an audience might think that you're going to back off. That you're going to relent, and you just don't. Have you seen people getting up to leave during screenings of the film? Because it definitely pushes the envelope.
SG: You know, I never have seen anyone leave. I was expecting that people would, especially the scene where the old man is punished. But actually I've never seen anyone get up and leave the screenings.

GG: Let me tell you, I'm a hardened viewer. I've seen everything, but that certainly opened my eyes pretty wide. I was traumatized and sickened. Thanks!
SG: It was when we were shooting it that I realized, "This is the roughest thing I have ever shot." I was expecting that it would not make it into the finished film, that the MPAA was going to go crazy when they saw it. But they passed *Dagon* without a single cut.

GG: That's incredible!

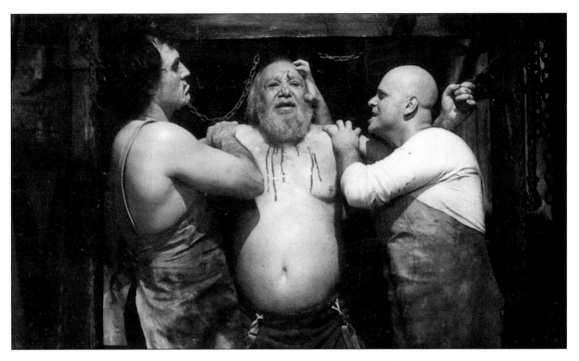

The infamous 'punishment' scene from Stuart Gordon's **Dagon** (2001).

SG: I know. [*big laughter*] Hey man, I'm not going to complain! I'm glad. I've had fights with the MPAA over the years and one of the things I had started to realize was that if they like the movie, they tend to be a little bit more lenient. I have a feeling that they may have liked this film.

GG: How did you handle the shooting of that scene, especially with the older actor? It must have been very difficult for the cast and crew.

SG: It was very intense. Paco was kind of frail. The only time he ever complained during the entire production was about having to wear some of the prosthetic devices, which were necessary for that sequence. It had a very strong effect, on all of us, when we were shooting.

GG: I'm by no means an expert on Lovecraft. I read maybe 8 or 9 short stories when I was a kid. But didn't he get a lot of his fear and inspiration from the ocean? And doesn't a lot of the film basically dwell on fear of the watery depths?

SG: Well… he hated fish. That's one thing. He thought they were the most disgusting creatures on Earth. And if anyone ever tried to serve him fish, he would get up and leave the table. But I think that the fear of *Dagon* extends a lot deeper than that. Lovecraft's parents both went insane and had to be committed to institutions. Lovecraft, throughout his entire life, was afraid that he had inherited those genes. He feared that the same fate awaited him. That fear of the idea of being trapped by your own genetics is something that figures into a lot of his stories. That is the central fear of *Dagon*. And that you have to eventually come to grips with who you are. It takes a while when you're working on a script to finally realize what it is about. What I finally decided is that it is a story about destiny versus free will. All through the movie, Paul is going, "I can do this," or "I can do that." He's got two possibilities, as he keeps saying. His girlfriend kids him that he thinks like a computer. Computers are always on or off. Yes or no. It's always these two options he thinks he has. What he ultimately realizes is that there is only one possibility, not two. Or, as he puts it in the movie, there are no possibilities. It's out of his hands and out of his control.

GG: It's terrifying for the audience, who realize this at the same time. Of course, at that point, I had developed an affection for the female lead, and I don't want to give anything away, but it puts you through an incredible wringer, just to watch what happens.

SG: Right.

GG: I'd like to get back to fear of the ocean. See to me, the greatest fear in the film was the size and depth of the ocean, and that you never know what could come crawling out. It's so big, and the only thing bigger than the ocean is the universe itself. But the ocean is here, we can actually imagine the ocean, we can taste it, we can smell it. There was something hideously evil that Lovecraft does with the ocean almost as a character in his stories, and you do this also, in *Dagon*. And what remains most bothersome to me is the way in which Lovecraft turns the ocean into the void of the universe.

SG: That's true. And that's very well put. Yeah, we know less about the bottom of the ocean than we do about what's on the moon.

GG: Do you plan on doing any more Lovecraft films?
SG: Yeah, I would like to. Lovecraft wrote so many great stories. I feel like we've barely scratched the surface here. Dennis Paoli wrote an adaptation of another great Lovecraft story called 'The Thing on the Doorstep'. I'm hoping that we can get that made soon.

GG: What was your involvement with the Organic Theater in Chicago? Could you talk a little about that, and your beginning in Chicago?
SG: I was the artistic director at the Organic Theater for about fifteen years. My wife and I started the theatre in 1969, in Madison, Wisconsin. Then we moved to Chicago. Our mission was to do original work through the use of an ensemble company. We were lucky enough to have in our company people like Joe Mantegna, Dennis Franz, André De Shields. It was an amazing group of actors. We created a great body of work. Among our productions was David Mamet's first play, 'Sexual Perversity in Chicago'. It was a very exciting time. We were able to tour Europe and the United States. On tour, I was able to meet Ray Bradbury. Got to be friends with him.

GG: Didn't John McNaughton come from the Organic Theater?
SG: No, he didn't come from the Theater, but when he did *Henry: Portrait of a Serial Killer*, he used a lot of members of the Organic Theater company. It's funny how things work out sometimes. *Re-Animator* was originally designed to be a production for the Organic Theater. I wanted to use our actors and I wanted to shoot it in our theatre, using it as a soundstage. When the time came, when the production was ready to go, the board of the theatre got horrified by the idea, and said, "Organic should not be doing a horror movie. We should be doing an art film." They did not want us to use the theatre to do this, or to attach Organic to it in any way. So I ended up leaving – I took a leave of absence, came out here, and started shooting the movie in Hollywood. The members of the company felt like they had lost an opportunity. Then, Richard Fire, a member of the theatre company, wrote *Henry: Portrait of a Serial Killer* with John McNaughton. For John McNaughton. They used members of the company, including Tom Towles, Tracy Arnold…

GG: All good actors.
SG: Oh yeah! All great actors. They even used our production designer, Rick Paul to do that film. So *Henry: Portrait of a Serial Killer*, is more of an Organic Theater movie than *Re-Animator* is, although I was able to use my wife Carolyn in the film and one other member of the ensemble, Ian Patrick Williams. He plays a very brief role in the beginning, the Swiss doctor who discovers one of West's experiments in the pre-title sequence.

GG: You never directed a film before *Re-Animator*? It was your first film?
SG: Yes.

GG: Meeting Jeffrey Combs for the first time must have been very interesting. He has an incredible charisma.
SG: Well, Jeffrey came in for an audition and within five minutes I knew he was the guy to play the role. And it was funny, because originally, Herbert West, as Lovecraft describes him, is a very Aryan character, doesn't look anything like Jeffrey Combs. But Jeffrey had that intensity, that sense of genius. And all of a sudden, I didn't care what colour his hair was, what colour his eyes were. He was Herbert West.

GG: When *Re-Animator* came out, people had never seen anything else quite like that. There had been years and years of trash films and exploitation films, with lots of graphic violence. But *Re-Animator* had its own sense of the gruesome. It did something different. What was the public's general reaction to it at the time?
SG: It was a great reaction, because they didn't know whether to laugh or scream. I really like that, when you get to a situation where your circuits are overloaded, and you don't know exactly how to respond. What was good about it was that the laughter never was at the expense of the movie. The thing that I learned, while making *Re-Animator*, is that laughter is the antidote to fear. When you laugh, you are no longer afraid. So, you have to be careful not to let the laughter destroy the tension of the movie. So what I tried to do in *Re-Animator* was to alternate between the fear, to build tension, then let there be a laugh. Then dissipate the laugh, and start cranking it up again. The first audience's reaction to the movie was terrific! I remember that during one screening I went to, the audience started yelling at the screen, at the end, "USE THE JUICE! USE THE JUICE!" [*laughter*] Yeah, they got involved. And that was fantastic.

GG: Was it a smooth production overall?
SG: It was smooth, and it was a very short shoot. We shot the whole movie in 18 days. The last day of shooting was one of those never-ending days that went on way beyond the 12 hours that we were allotted. I remember, after we finished, I was driving home with my wife, and I had to pull off the road. I just couldn't see anymore. [*laughs*] My eyes stopped working. She then had to take the wheel, and get us back to our apartment.

GG: Did you know, immediately after shooting *Re-Animator*, that you wanted to do another film?
SG: Well, I really had a great time, and I was hoping that I would be able to. I felt good about the movie. The first time it was shown to an audience was at the Cannes Film Festival. It was not in competition but it was shown in the market, at a midnight screening. I wasn't even there. I got a call from [producer] Brian Yuzna, who was ecstatic. He told me that the audience just loved this movie, and that additional screenings were requested because so many people wanted to see it. We ended up wining the Critic's Prize at Cannes. It wasn't until last year that I found out what that meant. It is a prize given by the critics to their

favourite film shown at Cannes, whether it's in competition or not. So I was more honoured at that time then when I heard it originally.

GG: Then you did *From Beyond*. Was that a good experience?

SG: We had a good time. The difference though, is that we shot that movie in Italy. We shot it in Rome. So I wasn't able to use the same crew. It was a very different experience. We had a lovely crew, a great production designer.

GG: When watching that film, I can see certain spots where some gore and sex appears to be cut. How much really is missing from the 'R'-rated print?

SG: I think that they cut about three and a half minutes out of the movie.

GG: *Dolls* was the next film?

SG: Actually, *Dolls* was shot before *From Beyond*. It was released after *From Beyond*. *Dolls* and *From Beyond* were shot on the same set, which is interesting. It was like a Roger Corman approach. They just re-painted the walls and re-dressed it. The reason *Dolls* took longer was because it had so much stop motion work, to make the dolls come to life. It had a much longer post-production schedule.

GG: I liked that film a lot. It's very sweet, and very endearing. And at the same time, macabre. It shows that you are interested in other sides of the human experience, not just twisted men, psychos, and gory S/M. You're interested in youth and innocence too! Are there any plans for a sequel to that?

SG: We talked about doing a sequel at the time we were shooting it. I had some ideas for it. It's funny, I ran into somebody very recently who was talking about wanting to do a sequel to *Dolls*. He had some great ideas. It would be terrific if we could. Of course, the problem is that I'm not sure who owns *Dolls* at this point, and then we'd have to convince them that it would make sense to do it. In a sense, the *Puppet Master* movies that Charles Band did for Full Moon were sort of like sequels to *Dolls*. They have a similar quality. He even used Guy Rolfe to play the doll maker in *Puppet Master*, so there was a connection there. I had been reading a book at the time called *The Uses of Enchantment* by Bruno Bettelheim. It's a book about the importance of fairy tales. One of the points he made in response to people who say that fairy tales are too scary for children, was that fairy tales are supposed to be scary. And that what they are basically doing is preparing a child for going out into the world, which can be a scary place. And that the lesson of a fairy tale is, "If you are brave and you are good and you are strong, you can overcome the bad things that are out there." So his feeling was, rather than play down the scarier aspects of fairy tales, you should present them as written. So I thought it would be very interesting to do a horror movie based on that idea. Rather than doing a Disney version, we would go the opposite direction, and go for scary.

GG: I think that there should be more films like that. I think that that sense of innocence and wonder is really missing in the culture of today, and more films like *Dolls* could be a much needed shot in the arm.

SG: Oh yeah, it would be great. There are so many great fairy tales that could be lovely movies. Well, I have to say that Walt Disney did make his movies scary. If you look back at some of his movies, like *Snow White* or the Bald Mountain sequence in *Fantasia*, you see that he did not hold back.

GG: Walt Disney's films would be looked at as grim, or politically incorrect one way or another, if made today. Where do you think mainstream movies are at today? Are you happy with what's coming out? How often you do go to the theatre?

SG: I go fairly often. I get, sometimes, very disappointed in movies today because so many of them feel like they've been written by a committee. There's no real personal vision. They are almost interchangeable. The directors don't ever put their stamp or their personalities into the movies. So many movies are so predictable that you know everything that's going to happen within five minutes. Lately I've been enjoying foreign films more than American movies, I have to say.

GG: Do you have a favourite of your own films?

SG: Well, I'm going to use Billy Wilder's answer and say, "My next film."

GG: In *The Pit and the Pendulum*, you adapted Poe. Poe and Lovecraft are very similar writers. In fact, it's been acknowledged that Lovecraft was directly inspired by Poe.

SG: Right.

GG: What differences did you come to discover between the two writers, in terms of bringing their works to the screen?

SG: I think Poe is much more involved with the here and now, whereas, as Lovecraft puts it, "Man lives on an island of ignorance surrounded by unseen forces." In Lovecraft's stories, there are always these things which are beyond our senses. Poe was much more about man living within his senses, even though in Poe's world, very often his characters' senses were heightened. They're much more sensitive to things. His stories, such as 'The Pit and the Pendulum', are very subjective stories of a man dealing with being tortured by the Spanish Inquisition. Or a premature burial, being buried alive. Or the sense of guilt in 'The Tell-Tale Heart'. I think that the worlds of Poe and Lovecraft are very different. The writing styles are similar though. And I think that you are right when you say that Lovecraft was very influenced by Poe. Poe was a guy who basically invented the rules of short story writing. Lovecraft followed those rules.

GG: Do you have a dream project, Lovecraft or otherwise?

SG: Well, as long as we're talking dreams, I'm going to give you the big dream, which is a book called *The King Must Die*, by Mary Renault, which I can't believe has never been made into a movie. It's a fantastic book. It's about Theseus and the Minotaur. It's set in Ancient Greece. It's a tremendous story. What she does is she tells the story, the true story of what happened, to later inspire the myth. She makes it absolutely believable. She followed it up with a second book, containing the life of Theseus. It's all written in the first person. It's called *The Bull from the Sea*. It would be a great follow-up. The two books, if you were to do two movies based on these books, it would be like *The Godfather I* and *II*.

GG: I really liked one film of yours called *Space Truckers*, which I thought was just a lot of fun. A very cool sci-fi comedy. *Space Truckers* had what was probably the highest profile cast that you have ever worked with.

SG: Yeah.

GG: So what's the basic back story of *Space Truckers*?

SG: *Space Truckers* came about when I had a conversation with a writer named Ted Mann. We've gotten to be friends… since we discovered that we were both frustrated astronauts. [*chuckles*] That when we were kids, we both wanted to be astronauts. Some things happened, and in my case it was the fact that when I was ten years old, I was near-sighted and was told I would have to wear glasses, which disqualifies me as an astronaut right there. And in Ted's case, it probably was that the space program basically came to an end. After we got to the moon, they just shut it down. So we started talking about the idea of doing a space movie. I had always thought that it would be fun to do something about working class guys in space. [*laughter*] You know, at some point, if they're going to colonize our solar system, then there are not going to be astronauts anymore. They'll just be regular working guys who are doing a job. And they're going to see it in a very matter-of-fact kind of way. It's not going to be the Star Trek command, or the Star Wars Jedi warriors. They'll just be regular guys who drink beer, and listen to country & western music and do their job.

GG: So how did you get the cast? Dennis Hopper was funny as hell.

SG: He was! He was great. I think Dennis was the one who really helped us get the movie made, because we were trying to find a lead actor that would encourage studios to give enough money to make this movie. It's the most expensive film I've ever done. Dennis really loved the script. He appreciated the comedy. He also appreciated the fact that he got to play a good guy for a change, and isn't the mad bomber anymore. So, he enjoyed it. We ended up shooting the film in Ireland which is a kind of crazy thing. It was based on the fact that the Irish had a tax benefit program, in which they basically give you 20% of your budget if you shoot your movie there. It was very funny, because here we are in Ireland, and we're shooting the entire movie on soundstages and making absolutely no use of the fact that we're there. Stephen Dorff came on board, and he did not like the title 'Space Truckers'. He had it in his contract that he had to approve the title of the film. [*laughs*] Well, what was funny though, was that the studio always lists the movies that they're shooting, and we couldn't call it 'Space Truckers'. So we called it 'Untitled Irish Space Movie'. [*laughs*] And at the very end, by the time the movie was done, Stephen came up to me and he said, I think I figured out what we should call this movie. I said, "What?" He said, "Space Trucker." And I said, "Well, if it's called 'Space Trucker', then it kind of leaves you out of the movie, in the title." He says, "Oh. Oh yeah. 'Space Truckers'." So it ended up going back to the original.

GG: What a jerk! But he did okay with his role. What was he like to work with?

SG: Well… I think that Stephen was kind of a handful, but he did a terrific job in the movie.

GG: What are some of your favourite films, non-genre especially?

SG: One of my all time favourite films is *2001: A Space Odyssey*. And in *Space Truckers* I got my chance to do my version of some of those scenes. That was fun. But that movie really knocked me out when I first saw it. As a matter of fact, I went back to see it later that same week and discovered that Kubrick had cut fifteen minutes out of it in the meantime. It was amazing. I had never had that experience before, when a movie changes within one week's time. I love that film. It's hard for me to say that I'm a big fan of Hitchcock, but *Psycho* had a big effect on me. What I liked about that film was that he kept breaking all the rules. When you kill the star of the movie thirty minutes into it, anything is possible. I love that feeling. Cronenberg's work is like that for me. He terrorizes me. Because with Cronenberg, you never know what he's going to do next.

GG: You're a modern practitioner of that too, which is… again, back to *Dagon*, what made that film such a difficult and intense experience. You break a lot of rules in that film. And you've done it before, quite often. You allow the audience to really get seduced by someone, or fall in love with someone, and then yank us completely in another direction.

SG: Yeah. But that's important. You've gotta get the audience to care. I don't like movies like *Friday the 13th*, where you're just waiting for these kids to get killed. Me, I don't wanna be on the side of the monster. I want to be with the kids. I like *Satyricon*, you know, Fellini's movie. That movie is really great because he creates an entire world. I think Harold Pinter once said, "The past is another country." And in that movie, the past is another planet. It's so bizarre. But somehow it seems the most realistic depiction of ancient Rome I have ever seen in a movie. There's something about it that rings very true. I'm a big Peckinpah fan. I like *The Wild Bunch*. That's a

great movie. I like the toughness in his movies. And he's another one of these guys that makes you care about people, and then does them all in and breaks your heart. And also, his depiction of violence is genuinely terrifying. This is the guy who really invented the squibs, that we see so often nowadays. But when seen for the first time in a movie, the effect was devastating. No one had ever seen anything like it before. In those old cowboy movies, people would just kind of clutch their chest and fall over.

GG: Violence should look like real violence.

SG: Yeah. What I like about Peckinpah is that he makes it seem very upsetting and painful. Shocking. It's not fun. I also felt the same way about *Reservoir Dogs*. Quentin Tarantino got it. That opening scene made me physically sick, watching it. In the back seat. Tim Roth has been shot, he's bleeding to death, in great pain. It made me think, "How many movies have I seen where people have been shot?" None of them ever affected me like that movie did. Tarantino really played up the reality of violence. If you're going to show violence in a movie, it should never look clean, or easy, or fun. You have to show it as it is.

GG: Do you have anything in production right now?

SG: The next film for me is called *King of the Ants*, which is based on a novel by Charles Gibson. He did the adaptation, and it's also a very violent piece. It's like *Reservoir Dogs*, in a way. It's not a horror film, it's a crime story. It's about a housepainter who becomes a hit man. The thing about both the book and the script that I found amazing is that it is much like the modern equivalent of *Psycho*. The main character gets hired to kill an innocent guy, and does it, and he's still around somehow. It's very interesting. I'm not even sure how Gibson accomplished that.

GG: Are there any other genres you've thought about experimenting in? You've rarely worked outside the horror and sci-fi genres.

SG: Well, I did *The Wonderful Ice Cream Suit*, which was a Ray Bradbury story, a comedy, although there is a fantasy element to it. It's about five Mexican Americans who are very poor, and they chip in five bucks each for one white suit, which they share. When each guy puts on the suit, it makes his dreams come true. It's a terrific and very sweet story. It even has a musical number in it, which was fun for me to do. It's a feature, which was released direct-to-video by Disney. I had the best time working on it. Edward James Olmos, and Esai Morales are in it, as well as Sid Caesar and Howard Morris, who are heroes of mine. Great comedians. I would love to do more comedies, those are great fun. And it would be one of my dreams to do a western, although no one seems to be making them anymore.

GG: You were credited with the story on *Honey, I Shrunk the Kids*.

SG: Well, I was originally going to direct that film. I did all of the prep on it. We got the green light from Disney

The physically ravaged hitman of Stuart Gordon's **King of the Ants** (2003).

and after seventeen drafts of the script, we did all the special effects designs. Two weeks before we were supposed to start shooting, I got sick and had to drop out. I was replaced by Joe Johnston. I ended up executive producing the sequel. It's a project that came about basically because Brian Yuzna, who produced *Re-Animator*, and I were moaning about the fact that our kids couldn't see any of our movies. So we decided to come up with something that they could actually go and see. That was the beginning of *Honey*. Originally it was called *The Teenie Weenies*.

GG: [*laughs*]

SG: Jeffrey Katzenberg hated that title. He came up to me and he said, "this Teenie Weenies thing… is that autobiographical?" [*Loud laughter*]

GG: Okay. This is really the last question. What was the last great book that you read?

SG: I guess the last great book I read was Jack Ketchum's book, *The Lost*. I picked it up coming back on a flight from New York, and read the entire book on the airplane. I just could not stop.

GG: That book's mean as hell.

SG: Yeah. It's a fantastic book. A real page-turner.

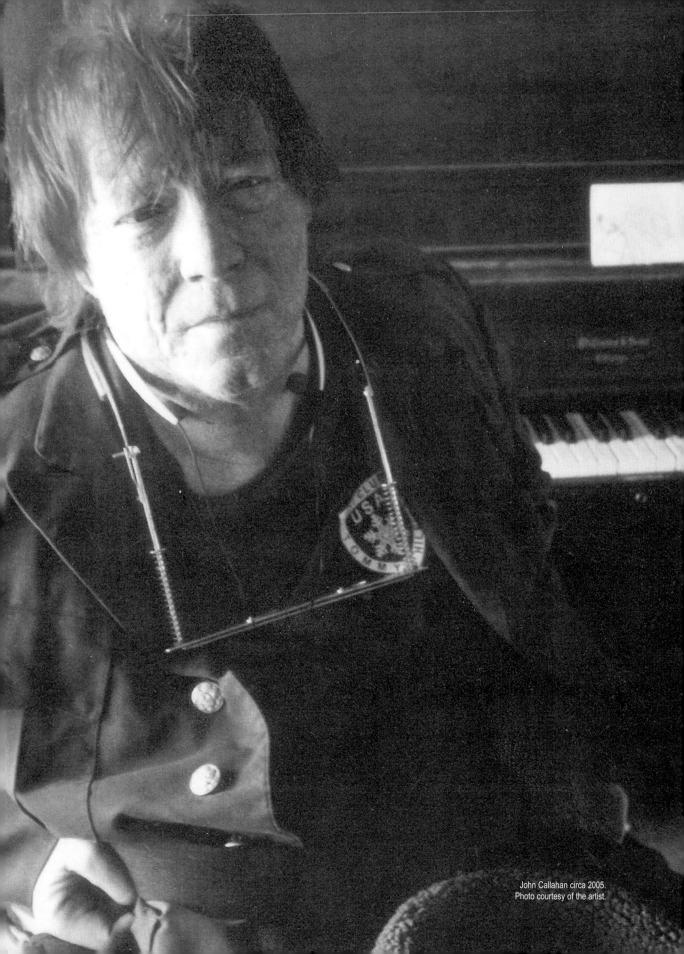

John Callahan circa 2005.
Photo courtesy of the artist.

Anti-Quad

- John Callahan -

"Screw the critics. I love Callahan. His cartoons are like tongue-kissing your grandma.
If it's so bad, why does it feel so good?"
- Dave Attell, writer and host of Comedy Central's *Insomniac with Dave Attell* -

John Callahan, one of the funniest cartoonists in cartoon history, likes to piss-off feminists. Let's not forget those bleeding-heart Democrats. Or those reptilian Republicans. Or those sanctimonious Christians. Or those Satanic CEOs. Or you. The list could go on for ten pages. His controversial sense of humour can't be called apolitical, but John appears to see both sides of most divides as being populated by self-congratulating hypocrites. He is the consummate non-partisan, whose substantial artistic output functions like the spray of a maniac's Uzi at the Macy's Day parade. While all civilization exists in a permanent grey area, few are willing to step outside its law of automatic acceptance. Callahan takes great delight in doing just that. He by no means contributes to the mess, but simply finds ways to make you laugh at it.

No matter where your sympathy lies, be it with syphilitic Vietnam vets or overtaxed self-made millionaires, his stuff is downright worrisome when consideration is applied. A moral vision will not pardon either Callahan or his audience, but neither will it deny the work its truthfulness. The anger expressed by him is defined by its scope, and perhaps it is God himself who is ultimately savaged here. The world of Callahan celebrates laughter, as a means of brutal insurrection against the Creator, a double-shot of death-defying arrogance which the moral majority would rather we didn't allow ourselves. Into this vicious life we are born only to die, this life where the masses look to pop stars and self-help gurus to soothe their fears. Callahan is the raw flipside of such disingenuous positivity: he attacks everyone from AIDS patients to corporate criminals with the same hellish loathing. If Louis-Ferdinand Céline were alive today, he'd certainly be a fan.

Callahan's craggy conviction rests purely in a humour that is wise beyond any conventional sense of established decency, and which in no way reflects a lack of soulfulness in the man himself. Those short on mind power may get the joke while some intellectuals refuse to see past its nihilism. In a sense, both sides are missing something. The vitriol of Callahan is worthy of contemplation on multiple levels. The person who thinks not in socio-economic terms, who comes to philosophical conclusions pieced together not out of familial indoctrination or classroom lectures, but rather base-level life experience, will be overwhelmingly receptive to him. There's a furtive empathy and desperation crying to be answered within John Callahan. He keeps his mind free of any synthetic goodwill towards man… forever looking beyond the superficiality of the present, beyond the toxic swill, at the long-term inevitabilities. You cannot hide in government lies, in television, in punk slogans, or in your own ersatz 'scene'. Callahan reminds people of that, existing as he does for the rest of us, who think above, outside, beyond.

His life story only serves to enrich the deliriously nasty situations he muses upon. Callahan told that story brilliantly in *Don't Worry, He Won't Get Far on Foot: The Autobiography of a Dangerous Man*. First published in hardcover by William Morrow and Co. in 1989, the book communicates in uninhibited detail the struggle of a lost soul against a physically devastating tragedy. In this, Callahan dissects himself, his artistic approach, and his critics, while offering an alternative to generic self-help for those who need it.

"DON'T WORRY, HE WON'T GET FAR ON FOOT."

Gene Gregorits: You've been called a lot of things by critics. Sexist. Fascist. Communist. Ageist. Anti-quadriplegic. You've had it all thrown at you. It would be very easy for someone who didn't know you to call you a nihilist, too. But anyone who had read your autobiography knows that you do have a good heart. What is interesting to me is that you might be attacked by someone, for the viciousness of your cartoons, but you never resort to your disability as an excuse, or a validation. Why not?

John Callahan: It's just not part of the equation. It's just not important. My disability is not important at all. I think people give me a license to kill, because of the disability. That's their own foolishness. They want to give me some special right. It's like, 'he suffered a lot', or something like that. 'Because he suffered a lot, he's pitiable… so we can let him get away with murder, because he's not a complete entity'.

GG: Well, what is your defence, when you're accused of being cruel or heartless in your work?

JC: There's no defence at all. I just figure that it's a forum that I am lucky enough to have… to express my madness to people. If people want to respond, it is absolutely of no import to me. People have all kinds of feelings, one way or another. They're all valid. What can you say?

GG: We are living in a much more politically correct climate than we were 20 or 30 years ago. Your autobiography came out in 1989. So how has your work changed since? How do you differ today, from the Callahan of 1989?

JC: I guess I would not be as open or as candid in a book that I would write now. I am shocked when I look back at that book, and realize how completely open I was. For whatever reason. I find it much easier to just do cartoons now, to create them. I've been writing songs for several years. Tom Waits sung one of my songs onto my answering machine once. That's my other claim to fame.

GG: Do you regret being as candid as you were, in that book?

JC: I don't regret it, no. Because the book was helpful to people. And I meant for the book to be helpful. People all over the world wrote letters to me, saying it helped them. I'm just not as open now. As you get older, you get more protective. I had a hardcover coffee table book come out five years ago called, *Will the Real John Callahan Please Stand Up?* It was full of artwork, angry letters, letters from famous people.

GG: What is the angriest letter you can recall getting from a reader?

JC: The angriest ones usually come from feminists. They have the most negative things to say. I did a cartoon about Patti Smith, and one of the local weeklies here got eight weeks of solid letters, people rallying against me.

GG: What was the cartoon?

JC: Well, it's the Pope, with Patti Smith. Patti Smith used to sing a song called 'Rock'n'Roll Nigger'. In my cartoon, the Pope was singing the lyrics.

GG: Didn't Robin Williams buy the rights to your life story?

JC: Yeah.

GG: Do you think a film will ever get made?

JC: It's hard to say. They just keep buying it every year. Robin Williams gets very hot about it sometimes, I think he got a screenplay together. The director, the actors, and everyone else all have to be lined up at the same time.

GG: So, any other encounters with Hollywood, or the entertainment industry?

JC: I have two shows on Nickelodeon. One of them is called *Quads!* It plays in Europe, Australia, Canada. The other show is called *Pelswick.* It's about a 12-year-old boy in a wheelchair.

GG: What's *Quads!* about?

JC: It's about these disabled guys. They are run over by a wealthy agent out in Hollywood. He runs over them and paralyzes them. Then he has to buy them a mansion.

GG: [*laughing*] It's weird, because these are very conservative times, in one way, and in another, it's become very popular to go 'too far', in recent years. Youth culture, films, teen comedies, all that stuff has moved very much into gross-out humour. You were doing that long before it was generally acceptable to push the envelope that far in mass media. What do you think about that?

JC: I find it somewhat interesting. It's not very edifying. I don't think most of those people are very talented. But hey, if someone is brave enough to jump off a building and light their nuts on fire, that's cool with me.

GG: There's a very fine line between intelligent satire and mean-spirited exploitation. Does being misunderstood ever lead you to think that there's something wrong with people if they can't get the joke?

JC: Yes, but what balances that out is the amount of people who come up to me, who like my work, who

have had such a strong reaction to it. When people come up, and want to put you on their shoulders and carry you away, that makes me happy. The cartoons are a release for people. But people that hate you… someone once literally spit in my face. It's intense. It's gratifying either way. I'm the kind of person that enjoys negative reactions. I don't know what the fuck that's all about…

GG: People seem to be very deluded by this Hollywood mentality. They're desperate to be lied to in a way. I think that the mockery of real life that you see in Hollywood movies, and in a lot of independent movies is very upsetting, and I'm also very bothered by the fact that people seem to prefer that. That they can't deal with honesty in movies.

JC: It's very interesting, what you're saying there. Because Hollywood films have become so much more of a joke, in the last 10 or 15 years. Aside from a very few films… I mean, I thought *The Sixth Sense* was cool. It seems like they're prepared as these packaged pieces, that only illegal aliens wouldn't get or something. I don't know. They are so dumbed-down, and always with a nice, strong lead male like Michael Douglas. Your typical film has to contain compulsory bombs and explosions, cars blowing up. And they are obsessed with the gender thing, where they always have to show exact, equal power. Or a superiority by the female. I don't like to be preached to, or socially engineered. And when these idiot Hollywood stars speak up politically, it makes me nauseous. I will not see a Susan Sarandon movie. I don't even care if it's a film about me, if Robin Williams ever makes it. If she is involved, I will boycott it. And these other assholes, like Barbra Streisand, or that fuckin' idiot Michael Moore.

GG: What? You don't like Michael Moore?

JC: No, I don't like him. I think he's a hypocrite. He's making millions and millions of dollars, but he always complains about these corporations. That's who his books are published by! Does he give all his money away? He's a sanctimonious motherfucker, marching around, getting in people's faces, playing games. It's like he never grew up. I just think he's a hypocrite.

GG: Well, then who do you think is doing something good right now? Are there any current social commentators that you're interested in?

JC: Look, I realize that it is very politically incorrect to dislike Michael Moore. Liberals worship Michael Moore. But I don't at all. I am neither a Republican nor a Democrat. I just get so sick of political correctness, and Michael Moore is SO politically correct. The guy just rubs me the wrong way. It's the knee-jerk mentality of the left wing that bothers me. They're so unbelievably naïve. And the far right wing, they're just as deluded. They both miss the big picture. It's the world view that I am interested in. [*pauses*] I'm sorry about that tirade. I sound a little unreasonable.

GG: I understand where you're coming from though. I can see why you'd feel that way.

JC: Well, the guy's doing a lot of good for people. The activist stuff he does is interesting to me. But all this stuff about hating corporations… he's stuck in the '60s.

GG: What do you see as being a better approach?

JC: All different people bring different things to the table. People that are interesting to me are people who seem to be thinking. But what's going on now, I just can't take much more of it. It's very scary right now. There's so many things going on at once here. Things are moving very quickly. The rights of citizens are being squelched. There's less possibility to speak out. There's more police intrusions. People are drugged with their DVDs and their porno, and sports. People don't want to know the truth. They don't want to know about the real forces that drive governments. These politicians, like Bush, they are just pawns. Who knows what money really buys this country, and drives it, in the Middle East. A lot of people seem to know, and everybody's afraid to say anything. But… this rounding up of Arabs… this big song and dance in the Middle East, who is it really benefiting? It's a tough time to be alive, if you can see what's behind the media, what's running the media. It seems to be beginning to crack more and more. We're beginning to see that something is wrong. I can't imagine that people sitting at home, watching NBC or CNN, are believing this crock of bullshit that we're receiving about the war. That they're not seeing any of the darker implications. It's impossible for me to watch it, because it's just so full of lies.

GG: Maybe people will start caring when their hi-speed internet porno is taken away.

JC: Yeah.

GG: I haven't noticed much direct political commentary going on in your work. Do you consciously avoid it?

JC: I do political stuff once in a while, but not so much any more. There are certain groups of people who you

"BASICALLY, MR. WILSON, WHAT I SEEM TO BE HEARING YOU SAY IS 'HELP'!"

cannot criticize as a writer or as a cartoonist, even. You risk losing your job. There's so many things going so fast right now, on the international scene, and if anyone has any sensitivity to it, it's a very freaky time. It's hard to know what to do.

GG: Did you enjoy *Fight Club*?

JC: Oh yeah.

GG: What kind of books do you read?

JC: I was reading some Camille Paglia. She's a friend of mine, and I like her stuff a lot. I read a lot of junky, weird novels. I read a good book about Bob Dylan recently, called *Positively 4th Street*. As far as things that have political bearing, I just do a hodgepodge of reading on the Internet. *The Progressive*. All kinds of news. I try to read alternative stuff, because the party-line is just too sickening to me. The mainstream papers are bullshit. You hear people talking, and flapping their mouths about the latest things they're being fed. This guy Stanley Cohen is interesting to me. He's an activist and a lawyer. A left wing kind of guy. He defends Arabs and stuff like that. Howard Zinn. That guy who sang for the Dead Kennedys…

GG: Jello Biafra.

JC: He's cool. I'd love to meet him sometime. I wish I could.

GG: One of the original 'sick cartoonists' was Sam Gross. Do you know him well?

JC: Oh yeah. He was my mentor. He's a kind of crusty New Yorker. He's a very deep character. He's got a thoughtful and poetic quality. He has this ball-busting sense of humour. But he's very charming. He's like a genius. He speaks in riddles.

GG: You had some cartoons in a great National Lampoon anthology called *Cartoons Even We Wouldn't Dare Print*. They were all 'sick cartoonists'.

JC: Another guy in there I liked was Peter Vey. I like his work a lot. The current cartoon editor of *The New Yorker*, Robert Mankoff. He really helped me out.

GG: There's this one guy who came before you, I can't remember his name. He did this cartoon where this guy is sitting in a chair straining to read an eye chart, while the eye doctor is lunging towards him from behind with a knife. The eye chart says, 'I am an insane eye doctor and am about to kill you.'

JC: Oh, that's funny! Would that be Gahan Wilson…

GG: YES! Was he a really big influence on you?

JC: He was in *Playboy* when I was just a little kid. I'd imagine he's 70 or 80 years old now. One of my big honours was when Charles Addams bought one of my cartoons for $150, when I was a brand new cartoonist.

GG: Is there much of a discernible difference, at least to you, in the tone or mentality of your cartoons now, as opposed to five years ago?

JC: I think they're much more of a social commentary now, than before. Before, they were just about lifestyle, or sick jokes about blind people. People with no legs. I've been drawing naked women lately. I had a gallery show. That was kinda fun. As far as cartoons go… I've thought about doing a novel, with little drawings and stuff. I'd like to get a national gig. A national newspaper or magazine, where I could do my regular sick cartoons once a week. Something that covers more than just one city. That's when my cartoons work best, when I'm hitting week after week, with a string of them. With a particular theme.

GG: Okay, let's go into your favourite movies.

JC: I would say… *Henry: Portrait of a Serial Killer*. I met this guy one time from England, he was doing a story on me. I said, "what movies do you like?" He said, "I don't like any movies. I don't go to any of them. I like just one." I said, "what's that?" He said, "*Henry: Portrait of a Serial Killer*." I thought that was interesting. My two favourites are *Old Yeller*, and *Henry*.

GG: What do you think of *Taxi Driver*?

JC: I like the film. I was surprised that the director

"YOU'LL FIND WE DON'T STAND ON FORMALITY AROUND HERE."

didn't get an Oscar, that's such a great film. It's my favourite of all De Niro's roles I think. Now that he is in action movies, running around with a Glock, chasing people with this intense grimace on his face… what happened? This is the same guy who did *Taxi Driver* and *Raging Bull* and *The Deer Hunter*? My theory about why he is doing so many cop movies now, is that he actually is a cop!

GG: [*laughing*] The fact that you like *Old Yeller* and *Henry*… that does sum up your work, in a sense, or you as a person. Those two opposites. The tough sweetness, that people never get.

JC: I think that I am a master of the double message, because I had such a strange childhood. I was sexually abused at the age of ten by a woman. And it turned my life so upside down… it gave me a very weird kind of sex orientation.

GG: You've written about that, and about women. You come across very sensitive, but I remember, in the book, that there was always a certain point with them where you would just shut down.

JC: With women, I'm sort of a misogynist. I admit it. The thing is, women like me. And I basically like women. There's just this certain part of me that doesn't trust them, because I got so shafted, as a little boy.

GG: Do you have any lyrics of yours laying around? I thought that would be a great way to close the interview.

JC: I have this song called 'Goodbye Julietta' that I've been writing. *"They're tearing down the monuments / and putting up a tomb / they're rounding up the rodeo / and draggin' down the moon / they're going through your pockets, too / there's nothing left to give / it's just that I'm alone tonight / defending how you lived. Goodbye Julietta, goodbye, goodbye / the bells of the city are strong in the sky / the people are laughing but it's only a lie / all they are saying is goodbye, goodbye."* It's a pretty song.

GG: Wow, you wrote that? That's really beautiful. It reminds me of Leonard Cohen. Do you like him?

JC: I love Cohen. I love any poet-type of songwriter. I'm more of a poet-songwriter. That's why I despise this stuff, what they call… 'new country'?

GG: You'd really like this guy named Steve Wynn.

JC: Who's he?

GG: He was in a band called The Dream Syndicate, back in the '80s. An LA band. Very Dylan-influenced, with that kind of lyrical dandy-ism. But very dark lyrics. You'd love his stuff. He's solo now.

JC: Someone's been pushing Warren Zevon on me. I feel very sad for him. He was on David Letterman when he was terminally ill. What compels someone, when they're dying, to get on TV and do something like that?

GG: He's got a sick sense of humour. His music has always been very black humoured. You must know

'Werewolves of London'. It must be hard to live under the legacy of one amazing song, when it's the best one. That's a signature song. Your signature cartoon is the wheelchair on its side, and the men on horseback saying, 'he won't get far on foot'.

JC: That's very popular, yeah.

GG: Are there any cartoons of yours that stand out in your memory?

JC: The ones I like are just really fuckin' weird. There's just fucking thousands of them. I like the fly gags. Like the fly on the street corner, with a cup that says, 'will work for shit'. The one with Jesus Christ on a cross…

GG: Thank God it's Friday.

JC: Yeah, that one. And the feminist bookstore. 'This is a feminist bookstore, we don't *have* a humour section'. [*laughs*] But that's the truth, with those fucking feminists. I can't believe these young broads wanna be feminists. But they'll say, 'I'm a feminist, I come from a feminist upbringing'. I was talking to a little bar girl the other day, and she says, "well, I wanna go on the Suicide Girls site, and be a member of the Suicide Girls." She says, "I wanna get myself out on the Internet, to empower myself." [*laughs*] Empower herself by having naked pictures of herself up on the Internet. That's kinda cute, really.

GG: I stumbled onto a website today by women who are against blowjobs. They're rebelling against the tyranny of cocksucking. [*laughs*]

JC: That's so funny. The tyranny of cocksucking. I didn't understand there's a big movement against this. What's really killing me is women taking over society. They just don't do it very cool. The feminine energy is flowing through everything in our culture.

GG: It's a bad time to be a guy.

JC: It is politically incorrect to be male! I did a cartoon the other day with a school nurse. This little six year old kid is squirming around. The nurse is talking to the mother. She says, 'Unfortunately Mrs. Jones, your

child is acting like a boy. I'm prescribing Paxil'. If you notice, on TV, every other TV commercial now has a woman smashing a guy in the face. And in every trailer from every movie. It's the whipping down, the castration of the male. There is no use for a macho male. You don't even see one on TV now. If you do see a strong jawed, ruggedly handsome guy, who comes swaggering down the street, jacket over his back, he'll be made fun of. It'll show him that way. By the end of the commercial, he'll have been made a spectacle of. It's all designing us to make women have been empowered, and therefore to spend all the money.

GG: I think that even women, intelligent women, are getting sick of that now too. It's hard to retain your individuality today in general, but to retain your masculinity, I think that's actually respected by certain women. I'm not saying 'be a macho asshole', but if you let a woman walk all over you, she's going to keep doing it. If you have the courage to just go out there and be a guy nowadays, and not in that phoney sports-jock kind of way, but just being a guy, there's certain women, I hope, who respect that. I think that in the future, women will be the frustrated ones, because all the men will be pussywhipped.

JC: It's very interesting. I'd like to be a college student right now, or a sociologist. There seems to be a silence about it that is hard to penetrate. Camille Paglia talks about it. I should ask her about it, I'd like to write a book about it called, *Whose Balls Are They Anyway?* Or *Feminize THIS*. What about that movie where those guys fuck with the deaf girl?

GG: *In the Company of Men*. Yeah, I don't like movies like that.

JC: Yeah, that was really bad. I saw it.

GG: Though I can be critical of women, I don't see any point in watching two guys mistreat a woman for two hours.

JC: Yeah, it's just ridiculous. But as far as my opinion of women… it's complicated. I've spent my life bending myself into a pretzel to be noticed by them, and to be admired by them, to win them over. And to manipulate them. I got quite a bad reputation. But the thing is, you always wake up in morning, light a cigarette, you're sitting next to the woman… and there's always the inevitable part where she says, 'well, you don't *like* women very much, do you?' And then I have to defend myself. It's funny. Now I find myself feeling like I'm in my 20s again. I don't know if it's a mid-life crisis… I've put myself on a starvation diet for the last couple weeks. You know, when you lose a couple pounds, you always feel kind of high. All of a sudden, I have this feeling like I'm really young again. But I already went though the mid-life crisis when I was 40, so it's not that. I've just dropped a few pounds, got a new haircut. I'm in a wheelchair, I realize that I

am horrific looking. But there's a certain kind of thing that you can feel, and if you just put it out, it draws the weirdest things. I must have put fifteen phone numbers in my pocket, just today alone! I spent the whole day just going from one end of the city to the other, just looking at women, going up and talking to them, or ignoring them or whatever. It was just one of those days! I'm just feeling like this total sex addict. And I'm living it up, you know? Acting it out. Remembering the old days when I really was acting the shit out, in my 30s. Christ. It's kinda fun. It's all such a trick. And then when you don't give a fuck about them, they're all over you. Especially, when you've just gotten laid, or if you've just fallen in love, then they're all over you. I remember one time I got laid. She sat on my face for like four hours. I would just go out to get a pack of cigarettes, and people would just turn around, giving me big smiles. Of course, the old trick is to just go out with a beautiful girl and watch them all looking at you. That's the weirdest thing in the world! It just shows how superficial women can be. I think men like to be tortured by women. There's this guy who's on the radio this year, he's fun to listen to. A total misogynist. He's very funny. He blows the cover on women. I was going down the street today, and I saw these sweet fifteens. They were obviously very wealthy girls, really upper class. Even in jeans, they looked like doctor's daughters. Impossibly pretty, *Baywatch* pretty looks. Breathtaking, with this angelically childish look, but at the same time, with the full lips and the high cheekbones. Baby fat. The power of the pussy, is just amazing. The whole world stops for girls like that. It's like being a movie star. And especially when they have the sexy look. Not just pretty, but when they have the sex look, that vibe. That's rare. I remember when I went on *60 Minutes*, and everybody would recognize me. Everybody, in those days, watched *60 Minutes*. It was like this unthinkably weird feeling. I went into this disco, and someone said, "oh my god, he's so famous!" It was like something you'd expect out of a Howard Stern teenage dream. It just lasts a few months, then wears off. Unless you keep that spin up all the time. But this thing that happens for young girls… it doesn't happen for young males, I don't think. I don't know how they can not get fucked up from it. By the time they were 16 they'd just be warped. I always think I'm going to burn out on it. I'll have a bunch of sex and three or four days later, I'll feel completely renewed. It's dulled a little bit, so I think my hormones are dropping… and that's a relief to some extent. But it's spring, and I'm on a high.

All illustrations accompanying this article are taken from John Callahan's book **Do Not Disturb Any Further**, published by Harper Perennial, and have been reproduced by kind permission of the author.

Hard Boiled Bard

- Steve Wynn -

"I justify the worst of things
But I'm doin' my best to keep it clean
(I won't fade away)
I'm not the man that you once knew
But I could do an imitation if you want me to
I'm gettin' by
by gettin' mean
But I'm doin' my best to keep it clean
I lose myself in fields of white
And find myself against the night
My camouflage is dazz-a-ling
But I'm doin' my best to keep it clean
I'm cuttin' up the magazines
But I'm doin' my best to keep it clean
I slash the tires of limousines
But I'm doin' my best to keep it clean"
- 'Keep It Clean', from the *Static Transmission* album -

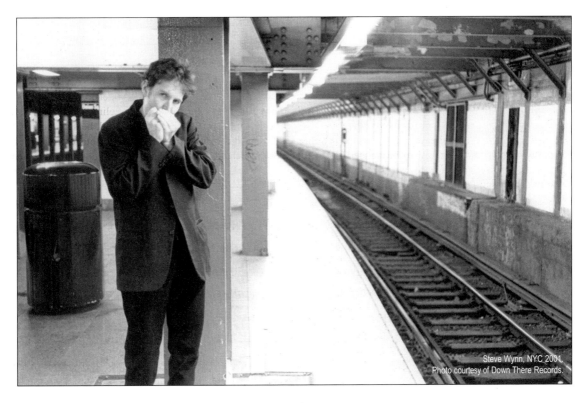

Steve Wynn, NYC 2001.
Photo courtesy of Down There Records.

The negatively charged surrealism found in the very bleakest of modern crime fiction, from Jim Thompson's grinding silhouettes of oil rigs in the rain, to James Ellroy's squalid, creepy crawl LA hell-scape, could be easily seen as lending itself to cinema, and then, by a further extension, cinematic song writing.

Conversely, it seems ludicrous to suggest that Bob Dylan would get along with James Ellroy if they were trapped in an elevator car together for an hour or two… but a lifetime in the dark, perverted mind of 'noir-pop' innovator Steve Wynn seems to have forced them, as two of his own dark muses, into an elemental co-existence.

In 1990, Wynn emerged from the long since faded embers of the incendiary outfit called The Dream Syndicate, having ended that reign of record-store legend with a pneumatically morose fourth LP entitled *Ghost Stories*, to open up the most important door he's since walked through: a solo career. His debut, *Kerosene Man*, was produced with a kid-in-a-candy-store grandeur, despite the often squalid realities that lived within its eleven tracks, especially 'Anthem'. This tune told the white-knuckle tale of a war veteran, alone in an apartment, grappling with some bad ideas in front of a battered television on which may have flickered a network affiliates' patriotic sign-off. It conjured up visions of Wynn-as-anonymous 'Nam vet, taunting invisible victims with very real, very physical threats:

"And if you were lookin' for a sign / a place to draw the line, well / there you are / The guns are loaded and there's gas in the car / play the anthem one more time."

It doesn't take a genius to predict what's brewing in the air above that psychotic man's head. For all intents and purposes, 'Anthem' stood as Wynn's *Taxi Driver*. And when it led to a follow-up track on his next album, with the phantom killer in "twin fin jive, blowin' black smoke on the 405", faithful listeners would have been correct in predicting a third track to somehow define the heart and soul of what Wynn has steadily been building towards, one ambiguous dirge after another, since the day his *The Days of Wine and Roses* hit the racks back in 1982. The 405 is a freeway in Los Angeles, and Wynn, a born and bred Angeleno, has been paying tribute to his homeland in one way or another, since the very beginning. For a man so fervently obsessed with mental calamity and the general malaise of love/death/crime, it only makes sense that a song like '405' should come to represent the ideals of his final will and testament.

Cars. Criminals. Freeways. Phantoms. Death, dissolution, and the fucking desert that is Los Angeles, California. Wynn hit his peak in defining with word and sound the true zeitgeist of that apocalyptic, pop culture wasteland.

His ninth solo album, a sprawling two-disc Los Angeles odyssey entitled *Here Come the Miracles*, rises up with wah-wah and sunstroke, bringing on the epic nightmare evocation of The Place. In the first song you're cruising low slung and easy in the greasy backseat of a red convertible, tasting the lights of the Ventura freeway and soon enough, hitting Hollywood and points north. You have enough adrenaline to power ten square blocks while bathing in barroom brannigan and electric blue porno-rush. Arrogant. Mean. Hungry. Ready to take the dive into some fathomless pit of neon and narcotic abandon. Ready to have FUN.

Don't get too comfortable back there, Wynn seems to want to say to the listener, his secret knowledge flashing a bright knife tip glint of pure menace. Sure, you'll have your fun one way or another. A few songs later, though, the illusion may be wearing thin. In fact, these songs crash down so hard, taking you lower and lower and lower, that you won't remember rolling into town high as a kite. You'll never remember being up at all, ever. You will know one thing: that very car is headed for a deep dark plunge, flanked by a hail of LAPD gunfire. Or the demonic ghost of Charles Manson and his Topanga Canyon Freaks. Or your own paranoia. *Here Come the Miracles* packs in nineteen perfect songs, and if you don't see your demon mentioned above, relax. Chances are, it's somewhere in that nineteen.

Never a man whose mind was meant to be picked or predicted, Wynn dodges any and all critical forecasts. His previous album, *My Midnight*, was supremely eclectic, and a vast improvement on 1997's *Sweetness and Light*. However, it wasn't exactly focused, and it's not necessary for any record to try to be focused. The miracle of *Miracles* is that it does tell some kind of zeitgeist-informed story. It retains the same scope while bleeding into all kinds of besotted asides and once-upon-a-time desert views and back alley visions. It is One Man's California Hell, and there's never been a window into those regions that rang true quite like *Here Come the Miracles* does.

In the year 2000, it seemed to be the final tombstone in that strange legacy that began with Death Valley heat- and murder-soaked The Dream Syndicate tracks like 'Until Lately' and 'Still Holding On to You'. However, while the album may be complete and organic enough to make a resounding resolution, never to return, I still have trouble imagining Wynn writing as deeply about his new hometown, New York City, as he has about Los Angeles. In that respect, he's done the impossible. He's had his cake and thrown it around the room in a drunken rage too. He's attended his own funeral and sneered at the tears of his enemies. He's beaten, and claimed as his own, that smog-bound fatherland LA.

Since then, from New York City, Steve Wynn re-emerged with *Static Transmission*, a characteristically psychotic, go-for-broke pop record which offered a gorgeous tribute to post-attack Gotham alongside feverish and/or hyper-stimulated meditations on Los Angeles freeways, drug abuse, and his own scabrous, explicit, unmistakably urgent urban dementia.

Steve Wynn during the recording of *Here Come the Miracles*, Tucson, AZ, 2001.
Photo courtesy of Down There Records.

Gene Gregorits: *Here Come the Miracles* **is a total California statement. It just feels like a dry, hot, West Coast vision. Did it come to you like that? As a California epic?**

Steve Wynn: Not at all. I just started writing. Most of the records I've made are a combination of old songs, new songs and other things I've dug up and revised. But unlike any other record I've written, I wrote this one all at one time. I came off tour… and I just wrote. Just churned it out, whether it was good or bad, whether I was inspired or not inspired. If you write that much in a short amount of time, whatever's on your mind is going to come out. There's going to be a cohesion there. I wasn't intending to write songs about LA or California. It just must have been what was on my mind. And towards the end, I began to see that these songs were all about California.

GG: The imagery of the album is almost like a post nuclear holocaust Los Angeles. It's like… if people in LA just woke up one day to find nothing but a desert. But you recorded it in a desert. Any significance there at all? Did you know that you wanted Arizona specifically as a recording spot?

SW: I knew that I didn't want to record in New York or LA. I was determined not to record in a place where I felt comfortable. After *My Midnight*, I like that record a lot, but this was a point where I started feeling like, I can get together the people I know, and go to the studio right now, and do it in my sleep. I wanted to throw roadblocks out there. I thought, one way to do it would be to go to a different city. I thought about Richmond. I've done stuff there before. I thought about New Orleans because I have friends there… Then I saw Howie Gelb at a show and he

Steve Wynn, Glendale, CA, 2002. Photo by Lydia Lunch.

GG: I don't know anything about the technicalities of making music, but one thing I did notice was that for the first time, after my whole life of hearing music, I was actually made to give a shit where and how the album was made. The studio. It was the first time I ever questioned the studio, as if it held some importance.

SW: It's a real big room, it had been a rehearsal room. An open space. There is no control room. Usually you have the person who's engineering, who's getting all the sounds… they're in a little room and everybody else is in another room and you're communicating through microphone or whatever. He was in the room with us. That means that he had to be into the whole thing. He couldn't talk, he couldn't sign papers, he had to be silent. We could see him from a few feet away. And that was a really good thing. I liked knowing that [Craig Schumacher] was part of the process. He approached every single song as its own thing. Each song, he would say, "Hey look at this shitty keyboard over here, this time we're gonna use this one," or "Have you ever seen a guitar like this?" He just kept throwing toys at us. And each time, we would use it. It would become the central point of the next song. He would show me some old amp he had, I'd plug in the guitar, and say "I love that sound!" "Okay, let's record the song, RIGHT NOW, and that's gonna be it." You know, a three dollar microphone in the middle of the room, and I'd hear the sound he was getting, and say, "Man, that's the direction I wanna go with this song." Usually, in the studio, somebody comes in and fine tunes all the individual sounds for a day or two, you get the optimum sound, then you try to get the best versions of the songs. That's fine, but this time, each thing was its own individual event. That's why it's a double album. It wouldn't work as a double album if everything sounded the same.

recommended this studio in Tucson. It's Craig Schumacher's studio, who's engineered records for Calexico, and the latest Giant Sand record. It's kind of the place where people in that circle have all been recording. He is really instrumental in the sound of those records, too. I don't know how much credit he gets… but it's the second album I've ever recorded with people who have worked a lot with Giant Sand. Because they tend to improvise, they look for the 'happy accident' all the time. And nothing can surprise them. I'm a little more methodical, and more to the point, a little less free form than they are, so it was a nice combination with engineers who already expect the unexpected all the time, and put some kind of order into things.

GG: *Here Come the Miracles* is The Great Happy Accident.

SW: I completely went out with the expectation that I wouldn't get anything. It's a cheap studio. Dirt cheap. I tour a lot so I had frequent flyer tickets for everyone in the band. We stayed in this Old West dumpy kind of hotel that cost only $25 a day for rooms. There wasn't much invested in going out there, so I figured we go out there, record, spend ten days, and come back with a couple of B-sides. Still woulda been a good experience, would have gotten a good vacation out of it. Good chance to hang out in the desert. And then, everything went right. Everything, in the session, went right! There wasn't a single moment of confusion, of things breaking down, or "I can't get what I'm trying to get"… every single thing… and I'm almost worried. Because going to the next record, I have to get used to the hard fact that things won't always be that way. I've made twenty albums and those kinds of things happen only a few times in a lifetime. I can look at *The Days of Wine and Roses*, or the first Gutterball album… those are the only other times that I ever made a record where nothing went wrong.

GG: Total serendipity.

SW: Yeah, yeah! Exactly.

GG: It's really remarkable that it would all just gel like that, when you have that much diversity. What about the order of the songs? Because your album does change, in the sound and moods of different songs, it seems you'd have to consider the sequencing.

SW: Funny you mention it because I'm very obsessed with sequencing. I was a DJ, before The Dream Syndicate, on college radio stations and things like that, so that's part of it. I was always obsessed with segue and things like that. I usually will spend a lot of time sequencing. I'll just sit with a dubbing deck, or whatever, trying different combinations, the spacing between songs, whether it's two seconds or three, all of those things matter. With this record, we had nineteen songs we'd done in ten days… I had to make something to take with me. And I realized that it was too long to fit on one CD. It was two in the morning. I was drinking, doing shots of tequila. I said, "I'll try that sequence." I spent five minutes making the sequence for a double album. This is before I intended on it being a double album and before I thought about using all the songs. I just said, "I'll write this thing out." I did the sequence, put it down, we burned it onto CDs, I left

the next morning, and that was it. I've never done that before. It was part of the whole thing of this record flowing so easily. Everything was like that. Even, that same night, when we worried about the first song not having a title, but I didn't even think about a title. I just wrote it down on a piece of paper, 'Here Come the Miracles'. It was that kind of thing. When that happens, it's great. It comes to you, without you even working. Unbelievable.

GG: What is it like being back in LA after so long?

SW: Yeah, I don't play LA often. I come here all the time though. I see family, my publisher's out here, and that's the major source of my income. I like the feeling of LA, I know the city better than I know any other place else. I wouldn't want to live here again though.

GG: You said you were sick of driving, and that made you want to go to New York...

SW: I like the 'walking culture'. I like people being out, I like being able to overhear conversations, because I'm a complete voyeur. And to be completely invisible... all of those things that are great about New York. In some ways, I can't imagine living anywhere else. I think LA is an alienating city... you're in your car most of the time. You're alone with your thoughts most of the time. You're startled when somebody crosses your space. It's the exact opposite in New York.

GG: Well, the negativity is so intense out here. Everything is exaggerated in LA. Including bullshit. It's easier to spot. Thing is, to me, if you're not doing well, the negativity in LA is going to get to you.

SW: Well, that's one of the reasons I moved away. I'd talk to people in New York, and they'd say that I really had to get out of here because it's not a good place to be a creative person. Unless, if you're riding really high. And even then, it's probably worse because you're very aware of your standing, in the level of success of people around you. It's brought back to you constantly.

GG: There's *Variety*, *Entertainment Weekly*, Hollywood in general.

SW: There's that, but even just the people you know, who you would think wouldn't be into that crap, still want to talk about who got signed to what label, who was dropped from what label, or who sold this many records, or who's making a record with so and so, who's on this new song, and all of these things, and you just think, "Do I CARE about this?" But still, you end up talking about it when you're here. In New York, it's just not part of my existence at all... all of my friends who are musicians, we never talk about the music business. We talk about music, we talk about who's doing what kind of music right now, and if it's good or if it's bad, or if somebody's onto something different, or making crap or whatever. Or, "I just saw somebody do something the other night that I've never seen anyone do before." We talk about "the one that blew me away." We talk about that stuff. But out here, it's, "Sooooo, what label are you on now?" It's really bad

because you either sell your soul so you get ahead, or you specifically do things so that you don't sell out. And one of the things that we did around the time of *Medicine Show* that I regret is that I never, back then, would even suck for a second to the machine. Then when we started getting attention for *The Days of Wine and Roses*, rather than say, "This is a step to the big time," I said "Fuck this! I want no part of this machine." And now, I think that's as much of a sell-out. Because, anything you do, creatively, that isn't what you're burning to do, is a sell-out. So if I would have made a Tom Petty record, or a Flock of Seagulls record, or whatever was popular at the time, that would have been the same kind of sell-out as intentionally sabotaging myself.

GG: Yeah, that kind of thing is just self-reflexive, a knee-jerk reaction. But it's ironic now, that back then, people who were hardcore fans of *The Days of Wine and Roses* were listening to *Medicine Show* and saying that it was a sell-out, a compromised record.

SW: Yeah, well, no one says that anymore, but back then people were saying that. And it blew my mind! I mean, you're telling me this record about... Arson, necrophilia, incest, and all of those things!... look, I was wallowing in complete self-degradation in that record. It was the equivalent of those pictures I've seen of you. Giving yourself black eyes. I was doing that as a performer and a songwriter, and in my life; I was seeing how much alcohol I could put in my body on a daily basis. I was writing about things that were not just dangerous subjects, but unpleasant...

GG: Distasteful. [*laughs*]

SW: Distasteful! Playing shows and saying things onstage that were completely confrontational. And I have seen other people do this. You get some attention, and you end up telling people, "No, you don't understand me."

GG: I have footage of a couple of shows during the *Medicine Show* period, and it was pretty intense. You were doing really long Jim Morrison improvisations on stage, and things to really rile people up. And I was shocked because up until that point, I had never thought of you as that type of performer. But you were a beast during that time.

SW: Yeah! And I hear about things that I've done that I am really proud of. Then I hear other things and I just want to cringe. Either I can say "that was my attempt to break through into something greater," or I can say, "I just wanted to destroy myself, one way or another."

GG: It's a really ugly record, in many ways.

SW: That's why I like it so much. I like it because, it's just brutal. Completely negative, and brutal.

GG: But the last Dream Syndicate album, *Ghost Stories*, is also very nasty, but mostly sad, because it was in essence a collection of songs about dead relationships. Whatever was happening there, it worked. It's the most depressing record I've ever heard.

SW: The thing about records you make… you tour those records for the next six months to a year. And you re-live it every night. I've looked back on the tours for each record, and I found that the tour reflected the record. See, *Dazzling Display* was a really fun tour. It was a lot of poppy songs. It was a carefree, wild time. The Gutterball shows were appropriately drunken, shambolic shows. *Ghost Stories* and *Melting in the Dark*, which I think are the two most depressing, kind of 'no light at all' records, were also really dark tours!

GG: But with *Dazzling Display*, there's some kind of weird difference.

SW: Yeah… *Dazzling Display*, I really like that one a lot. It's just so over the top! It's a fun record… there's a lot of things I tried on there for the first and last time. They are all exciting songs to hear now, and I think, making that record, I knew I might never have a chance to make a record like that ever again. So I did all the things I've always wanted to do. String things, horn stuff, and elaborate arrangements, which people who like what I do don't necessarily want to hear. I think it's misunderstood. A lot of fans say, "I like everything you've done, except for *Dazzling Display*."

GG: The joke is on them if they don't get it. But your songs do jump around a lot, even when you are sticking to your trademark subject matter. You go from punk to folk to country. Does it come naturally to you to be that unpredictable, or do you consciously throw the occasional curve ball just to trick people?

SW: I like to be surprised. So I try to be unpredictable. To a fault sometimes, but I try to shake things up, especially live, as much as I can. I improvise, I try to do things differently from night to night. I re-arrange things onstage. People that play with me know to watch my hands, to watch me carefully because I'll move things around, I'll stop things in the middle. And I like that! Not just for its own sake, but I think that making music should not be something you do on auto-pilot.

GG: We haven't talked about *Static Transmission* yet. Where did that come from? How did you arrive there after *Here Come the Miracles*?

SW: When I started that record, I just wanted to do a good follow-up to *Here Come the Miracles*. I was really happy with that record and I just wanted to do more of the same, which I've never done before. I felt that there was a lot more there to draw upon. Musically, the style of writing, the stories, the panoramic, variety-show thing. All those things, I wanted to go back there. Early in the writing of that record, 9/11 happened. I think that it had to be a more intense thing, obviously, being in New York, more so than anywhere else.

GG: Sure. Any New Yorker is owed that consideration.

SW: Yeah. It was really, really strange, being here. I didn't wake up on 9/11 and think, "okay, I've gotta do a record about this." When your mood is that heavy… *Ghost Stories* reflects a miserable break-up. *Medicine Show* reflects my alcoholism at the time. All these things come into the records. And *Static* reflected a very bummed-out city. The feeling that the end is coming. This time it's for real. This is just a preview of what's coming up next. I felt that way. I remember that the first thing I thought, after I'd digested the horror, was: the future just changed. And it turned out to be true. In ways we can't even imagine. But this was at that point a whole different world. All the terror and fear that is involved with that. I think that record reflected that. I didn't ever set out to write songs about it, but that mood of the end, of death, of uncertainty, of trying to rise above a disastrous situation, comes through in all the songs.

GG: The stylistic turnarounds were even more severe in a way, than on *Miracles*. I guess you could say it's a schizophrenic record. And also, it seems as though in some ways you were trying to have fun with it. In spite of the attack, and the panic. Maybe there was a need in you to break up the concentration of the last record and make this one a little bit more loose.

SW: I guess so. When I went down to Tucson to make the record, I had all these intentions to make a companion piece to the other record. More of the same thing, more of a straight ahead rock record. And none of that happened. It became what it was. I think it was a more difficult record to make. *Here Come the Miracles* was the easiest thing I've ever made in my life. The muse and all that stuff. This one was much more difficult once we got down there, because everyone had a different idea about what the record should be. It was a very co-operative thing, with the band, and Chris Cacavas, Craig Schumacher, the whole thing. We're like a team, working on it. But we had different ideas. It took a few days before we finally had to say, "okay, enough with the preconceptions, let's just make music." Once we dropped all the agendas, the agenda was to then just follow each song where it was meant to go.

GG: Where did 'Candy Machine' come from? That's a very interesting song.

SW: It had the riff, it had the melody, and it had some words that I hated. I was trying to write something about instant gratification, and how it eventually makes you numb. About how the world is that way right now, and you can get whatever you want but eventually you just become numb and nothing gets you off anymore. But everything I'd written, with that subject, seemed really heavy handed. I just gave up on it. We were in Tucson, I think it was the last day we were recording. And Linda [*Pitmon, drummer for Steve's backing band, Miracle 3*] was up all night writing. In the morning, when I woke up, she said "I don't wanna step on your toes here, but I wrote lyrics to 'Candy Machine'." So I checked 'em out, and they were perfect!

GG: Oh yeah? I didn't even know she wrote that song!

SW: Totally from scratch, took it in an entirely different direction.

GG: I always get the most obvious songs wrong, in theme or story, but that song seems like it's about a girl on a drug binge in a hotel.

SW: Yeah. And when I'm in Tucson, when we make these records, we stay at this hotel called the Congress Hotel.

GG: Oh, I've been there!

SW: You have? Really?

GG: Oh yeah.

SW: It's a great place right? They have that amazing bar, and it's got the whole history, of Dillinger being caught there and everything.

GG: Also, they've got The Troggs on the jukebox, which is my favourite thing.

SW: Oh that's right! They do. That jukebox… I've heard every song on that jukebox. [*laughs*] Yeah. So it's a combination of that. All the old timers, the down and outs over at the tap bar, then you got the trendy kids going into the disco in the big room, so people are constantly passing through. And that lobby's just a weird mix of jet trash, old timers, German tourists, the whole deal. I think Linda was reflecting on what she was seeing down there.

GG: That makes perfect sense. That lobby has a kind of Chelsea Hotel vibe, which is very cool. Come to the Congress, the Chelsea Hotel of Tucson, Arizona!

SW: Right, absolutely, and all the things that that implies! [*laughs*]

GG: What do you think you're gonna do for your next record?

SW: I don't know yet. I've got a lot of songs. I think I'm just gonna wait and see. From all the touring last year, I've got a really great rock band. We were getting harder and harder, and more frenzied, and just more explosive each night. I'd like to do something which captures that. I think there's definitely a punk rock record in my future.

GG: Oh Great!

SW: That's my roots! That was the music that turned my life around. And I have touched on it here and there in my records but never really got into it. That would be a lot of fun to do, and I've got a good band for it. So that might happen.

GG: You had mentioned a novel. I have a feeling you don't want to talk about it though.

SW: I don't think so. I had this discussion a couple nights ago, and I've always said, "I'm not sure if I want to write a novel, but I want to have written a novel." That's a whole different thing. The thing is, it's been a pretty strange couple of weeks. I just had that big article in the *Wall Street Journal*, and I got an e-mail with a literary agent. She said, "look, I don't know if you have representation, but I'd really like to talk to you about this." I was like, "Holy shit, I gotta go in there and bluff, or reconsider things." Because this person wants me to go in there and talk about writing a novel. I don't want to just say, "thank you, that's very nice, but I'm not a novelist." To hell with that! I'm gonna bluff. So we got together a couple of nights ago and we were talking about it. I think I'm gonna give it a shot. I don't think it would be a crime book, because what I love most of all is not necessarily the crime but the attitude. The language. The pace of the

language. The rat-a-tat-tat of noir writing. Also, uncovering the darkness which lies below people's skin, what you don't see. What people are afraid to say. The same way that I exploit that five percent of darkness, for what I record, the novel is definitely going to be the same thing. It's not going to be a self-help book or a love story.

GG: [*laughs*] What are you reading right now?

SW: Augusten Burroughs's *Dry*. It's a true story about a guy doing the AA thing. It's taken from his extreme drunkenness. But it's very irreverent, and full of attitude. Really digging that right now. Paul Auster's *Oracle Night* blew my mind. Great book. Richard Price has become one of my favourite writers, I read everything he writes. There's this guy Richard Yates, who wrote a book called *Revolutionary Road* about forty years ago. His one masterpiece. I really try to find books that deal with characters in a mid-life crisis point, where they lose faith in everything. I like seeing how far down they can go before they try to work their way out of it. Or if they'll choose to do it. I can read those over and over again. That's probably what I would do.

GG: There's a Steve Wynn tribute record coming out. And a party for it. You said they didn't tell you about the party or the record.

SW: No! [*laughs*] I'm glad I didn't know about the tribute record. I'm glad it was done without me. I'll be honest with you, I was always hoping somebody would do a tribute record but… I didn't want to be involved! You can't be planning your own tribute record. But I had no idea.

GG: That *Wall Street Journal* thing came out, with a big, full colour caricature of you. You're getting to a point now where… you've always had a cult following, you've always gotten great reviews… but you're starting to be seriously looked at now as an icon.

SW: Well, that party was celebrating my 25th anniversary. It's been 25 years since my first record release. Which I didn't even realize, but… that was the occasion.

GG: Congratulations.

SW: Thanks.

GG: Yeah, that's great. You've had plenty of songs covered by other artists. But a tribute, that marks a new era of your life, doesn't it? A double CD tribute…

> ## "I like to be surprised. So I try to be unpredictable. I think that making music should not be something you do on auto-pilot."

Steve Wynn, Glendale, CA, 2002. Photo by Lydia Lunch.

SW: …with people doing really interesting versions of my songs. Taking the liberty to turn them inside out, to see if the songs hold up to it. That's really nice. It fits in well with what I've been doing. This year, besides writing new songs, I've been organizing my history. The pace I've gone at in the last five years is ridiculously frenzied. I've put out five records in the last five years, and I was averaging a hundred shows a year. The thing about that is, it's very frustrating when you feel like you're doing your best, and people will say, "oh, he's prolific." And that's all they can say. Hey, anyone can be prolific and write crap. But I think that now maybe it's time to slow down, and let everything sink in. There's a 'best of' coming out, of the last 15 years, putting everything out there in context, so I can take a breath and see what I've done.

GG: Well, you're doing what so many people have not been able to do, or seem to have a hard time doing, which is enjoying your career.

SW: It should be that way, right? A big pet peeve of mine is when I read interviews with musicians, who sell many more records than I do, and they bitch about what a hassle it is to be on tour, the loss of privacy, the pressure of their career… and I'm like, "my God man. Get a JOB!" [*laughs*] You know? You don't have to do this. It's a blessed life. I know it is. You talk about soul-sucking jobs… fortunately, my last job wasn't soul-sucking, but it was as a clerk at Rhino Records. And I mean, it was a good job, but if someone told me I'd be doing this for the next 25 years, I woulda been pretty amazed.

GG: I think it's great, when you hear people whining like that, that there's people out there who really do appreciate everything for what it is.

SW: It's fun because you can challenge yourself, and find new things to do. That's exciting. That's something also that a lot of people don't realize, is that whether you're a novelist, or a songwriter, or whatever, you can do anything! And when people start asking, "what do people expect of me?", and "what does the market want?", and "will people get it?" Screw it, you just do what you want to do!

GG: You create better work that way anyway; most things if you try to have fun while you're doing it, you're going to create better work. Song writing can be done very quickly. In the city, there's so much going on, so it's to your advantage that you might be able to write a song in five or ten minutes. You don't always have to hibernate to get something done. Do you ever write in a bar?

SW: I've written in bars, I've written in coffee shops. Written on the subway. All over the place, and the thing that I've found – it's a lesson that I never fully learn because I come from having a big work ethic about things – is, I will sometimes, when I know I have to get a song finished, sit in the apartment. Stare at the notepad, or the recorder, or the computer screen, whatever I'm writing on. I'm just waiting for it to come. I've found that what works best, in New York, is to just go outside. Without fail, once I leave the apartment, go to some randomly chosen part of town, get on the subway, go somewhere I didn't know I was going… and that way, the song usually comes to you. It's a great city for that.

GG: What does your neighbourhood have for you?

SW: I like where I live. It's just below Columbia University, and just south of Harlem. It's an interesting mixture of families, very Hispanic, Dominican, Cuban, Puerto Rican family area, mixed with the yuppie crawl coming in. It's a good mixture of things. I like that there's nothing hip about my neighbourhood. It's kind of a vacuum from hipness. When I first moved here, I was disappointed to be so far from the East Village, all the clubs and bars and things like that. I realized though, that it's a good thing. I am inspired by hearing other bands play, and by hearing new music. I'm always checking stuff out. But I don't want to be immersed in it 24 hours a day. It's deadening! I think the way I have written is from an absence of sound. I write what's not there. I write what I want to hear that I'm not getting.

GG: So it would be a detriment to your art, living in the Lower East Side?

SW: If I lived anywhere where I'm surrounded by too much music, too much stuff. And that's why I don't write much on the road, because you hear the sound check, you're in the club, there's a DJ playing, and the opening band. Then you play your set. By the time you've finished, the only sound you're lacking… is silence. That's very soothing, but it doesn't make for much of a record.

Save the Planet, Kill Youself

- Larry Wessel -

Amore endearing – and enduring – aesthetic terrorist I have yet to meet. Southern California native Larry Wessel has plumbed the depth of that region over the course of his three decade-plus career as a filmmaker. His crazed passion for art in all its various forms eclipses your average devotee. A perusal of his list of loves and hates is in itself an undertaking, as that list is several yards long.

I became aware of his work as a teenager, reading old issues of the *Film Threat Video Guide*. But we were not to meet, nor was I to experience the artworks themselves, until roughly a decade later. Larry bought a videocassette I'd advertised on eBay, and the name rang a bell. "Are you Larry Wessel the filmmaker?", I asked.

Within a week, Larry's documentaries, among them *Taurobolium* (perhaps his most notorious) and *Song Demo for a Helen Keller World*, showed up in my mailbox. I watched them, and immediately realized what Larry Wessel represented: the freedom to express one's world-view through the moving image, at almost no cost. That package was followed by another, with *Ultramegalopolis*, *Sex Death and the Hollywood Mystique*, *Tattoo Deluxe*, *Sugar and Spice*, and *Carny Talk*.

Wessel is also an accomplished collage artist, having assembled some of the most graphic and unnerving Technicolor spectacles since Francis Bacon. His work in this medium has appeared in countless publications (most notably *Hustler*, where Larry was a regular freelance contributor), and provides a view of the human id as potent as anything by Joel-Peter Witkin or David Lynch. These hellish masterworks are based primarily on themes of sex, death, psychosis, disease, and overwhelming contempt. A few pieces come to mind which evoke a sense of psychological violation. The cover of this very book is a fine example, but outright tame compared to his assaulting meditation on the red light district of Tijuana, Mexico.

The films are micro-budget documentaries, mad, voyeuristic, and unflinching studies of low-life aberrants in Los Angeles (with the exception of *Taurobolium*, which showcases Tijuana bullfighting). Larry is obsessed with images, more so, I'd assume, than with literature or music, and his compassion for his subjects knows no bounds.

Gene Gregorits: When did it first occur to you that you were going to go ahead with an idea to make documentary films, despite the fact that you didn't have very good equipment?

Larry Wessel: I started shooting video when this artist approached me. His name was Raymond Pettibon. A mutual friend of ours introduced us. He came over and I was living in a guest house at the time. And he wanted to see my films. I had made short films prior to that. He said that he had written screenplays, and he was very curious about the kinds of films I made. I had some of these things that I had already transferred into VHS. These are things I shot in 16mm and Super 8 when I was a lot younger. I showed him these things and he just laughed his ass off. We had a really good time. And he told me that I have to shoot these two screenplays he had written. That he was going to buy a camcorder and everything, so we could shoot them. So what he did was, he went out and he bought a VHS camcorder. This was approximately 1986. The screenplays he had written weren't really screenplays

Larry Wessel, Tijuana Wax Museum. Photo by Eva Ford.

as such. They were just dialogue. They were just batches of dialogue, that he had written. One of them was called *The Whole World Is Watching: Weatherman '69*.

GG: You did that?!

LW: I didn't do the one that you've seen. I did the one that nobody's ever seen. *Weatherman '69* dealt with the terrorist group, from the '60s. A very real terrorist group. The other one was called *Sir Drone*. It was supposed to be the story of an LA punk band. A comedy. Anyway, he said, "man we're gonna make these!" I had never shot video before. This is how I dove into it. For the next year and a half, I shot these two films, simultaneously. *Weatherman '69* was completed first. Somewhere down the line, Raymond got really impatient with how long it was taking. He decided to bail out. I just kept shooting. Then he told me he wanted to collect all of the videocassettes and edit the things himself. He didn't trust me to edit the films. I thought that was really strange. He approached me. He had never made a film before. And I had spent almost my whole life making movies. I started when I was 11. So I very reluctantly put all the videos in a box, when I was done shooting. Gave him the collection of tapes. Then I hated myself for doing it. For the next several days I was really pissed off that I had relinquished to him all of these tapes, that I figured he was probably just going to tape over or destroy. I was also really uncomfortable with an amateur dealing with all of this really great material. And so one day I decided that I'm gonna go over there and get these tapes back. So I went over there, knocked on his door, and luckily he wasn't there that day so I didn't have to confront him. His mother was there, and I told her I came to pick up the videocassettes, and she gave me the whole box. I grabbed them, ran off with them and took them home. Got a telephone call at work the next day from Raymond. He was really pissed off and wanted the tapes. When Ray came down to the set of the films, he would stand there and never say anything. I just thought he was really quiet, a real sullen guy. Later, one of the other people in the film reported to me that he was a hardcore heroin addict. And he was loaded on heroin the whole time. That's why he was so quiet, why he sweated all the time. I was just very naïve and didn't realize that; thought he was just an introverted artist. But I respected him. I looked up to Raymond, and I thought that this would be a good thing, hooking up with Raymond. Thought this might pull me into the limelight a little bit, get me some attention. But the exact opposite happened. He ended up hating me. Anyway I got the original footage, and he re-cast the films, re-shot them in just a few weeks. He did a quickie job, released them both, very quickly, and so I was stuck with all this unedited footage of two films that, to this day, I still haven't put together because of the bad memories associated with it.

GG: Did you ever shoot another fiction film after that?

LW: Yeah. I shot this little thing called *Lipstick Liz*, which is like a music video based on a poem by Robert Service. Mainly I wasn't very interested in fiction after shooting the Raymond things, I started thinking in terms of documentary. At that point I borrowed a really crappy camera… it was a compact VHS camcorder that I got from a schoolteacher that I lived next door to. And I started shooting stuff in Los Angeles. That's how I shot *Carny Talk*, the Robert Williams video. That's why it looks so awful. But I'm proud of the fact that it's a very entertaining video and the budget was five dollars. I spent an hour with Robert Williams and ended up with an amazing tape. *Carny Talk* was going to be an opus, entitled *Yucky Secrets*. I had gathered these amazing people. A prostitute had told me all these great stories about her past. Williams. Transvestites. All these great people. It was going to be a six hour opus. Then I decided it was absurd to make a film that was six hours long. The only really great storyteller I had met was Robert Williams, so I decided to weed out everybody else and just release it as Robert Williams telling stories. It started with that. The look of *Carny Talk* was so awful that I started saving money. At the time – see this was 1990 – the best formats I could afford were SuperVHS and Hi8. I had heard that Hi8 degraded really easily, and that scared me so I bought a SuperVHS camcorder and started videotaping kids doing graffiti art. One day I was visiting my friend Brendan Leech, and he was showing me these photographs he had taken while watching the bullfights in Tijuana. That made me decide, completely, that I wanted to do a bullfight documentary. That I wanted to go to Tijuana. For the next three years, that's all I did. I went to every single bullfight for three years in a row, in Tijuana. I sat everywhere in the arena. I went all over, including the slaughterhouses. I documented everything that happens at the bullring. I became totally obsessed with bullfighting, and that was truly my whole world. I joined Los Aficionados de Los Angeles, which was like the oldest bullfight club in America. Every book I read was about bullfighting. I ended up with a vast library of books on bullfighting. All the ephemera. The posters. The music. The paintings. Anything having to do with bullfighting, I had to have it. I've been fascinated with bullfighting ever since I was a child. And I never got to see a live bullfight until 1990. But I used to see them on television all the time. They used to show them, live from Tijuana. Then they put the kibosh on it. There's been active censorship involved in the depiction of bullfighting in America. Across the world, there's an active effort to end bullfighting. I'm totally opposed to that. I consider myself someone who believes in animal rights, but to a degree. I eat meat, I wear leather, I use products that are tested on animals. Without animal testing we wouldn't have great breakthroughs in medicine. We must do that. I think that the animal rights groups are misdirected. They should really be going after

Above and Below: Stills from Larry Wessel's **Taurobolium**.

the people who produce meat. To me, that is the ultimate in evil as far as abuse of animals is concerned. I mean, the destiny of a bovine is pretty bad no matter how you look at it. A cow does not have a decent life. However, in the bullring – and believe me, my film *Taurobolium* can be enjoyed by bullfight enthusiasts and anti-bullfight crusaders alike. Because all it is, is a depiction of what it really is. I'm not glamorizing the act either way. But bulls that make it to the ring actually live twice as long as those that get ground up into Big Macs. And to me, the way bulls and cows alike get treated... we have these fairy tale ideas of what farms are like, but they're not like that at all. These animals live their entire existence penned up and crowded together in these horrible confines, and a bull that makes it to the arena for a bullfight, has been raised on open land. Gets to eat what it wants to eat. It lives twice as long. So my question to the animal rights activists is, whose destiny is preferable? The fighting bull or the meal bull? Personally, I'd rather be a fighting bull and be given the opportunity to kill a human being.

GG: Makes sense to me... I'm thinking of becoming a vegetarian!

LW: I tried eating only vegetables and I'm on a very strict diet now. I only eat fish, chicken, and turkey, in combination with vegetables and fruit. I've been losing weight drastically. I think all red meat should be abolished. It causes cancer. But I have to say to these animal rights people, please, stop going after the bullfights. This is an ancient tradition and should continue. I was actually very much on the fence about bullfighting until I finished the film and realized what an amazing thing it is. I promote it as an art form and respect it as such.

GG: I noticed that in a lot of your films, you tend to let the camera roll for extremely long periods of time, without cutting. Some of the shots in *Song Demo for a Helen Keller World* are just unbearably long, they just go on and on. What's your idea behind the extra-long shot?

LW: In my mind, my films are an antidote to the short attention span, due to a lot of television programming and MTV, especially video games…

GG: Don't forget *Requiem for a Dream*!

LW: Well, *Requiem for a Dream* is an exception because I think it is really well crafted. I really admire the editing of that film. But there are exceptions to everything, and I don't think I can generalize about everyone having a short attention span, even. But I don't have a short attention span and if I'm observing something – the sight of a beautiful woman, or the sight of a man with no arms and no legs breakdancing – I am frozen in my tracks and I become hypnotized by it. I think that there are moments in life where we need to be still, and observe, to soak up this kind of energy. A lot of feature films are two hours, and people are willing to sit in a movie theatre for two hours, and see some hogwash, some emotional pornography from a director like Steven Spielberg... why can't they sit through one of my films?

GG: Your films really have been an inspiration to me because... I didn't realize that you could make a good film with totally amateur equipment. Your cameras sucked for the first couple of movies you did, and yet they're still entertaining, they're still cool. There's this illusion that you have to have top of the line stuff to make a watchable film. Sometimes you haven't got a choice, you use what's available and it's good to be reminded of that fact. You could make a movie with Pixelvision if you had to!

LW: I absolutely agree with you! I really think it's a pretty shabby excuse, and I hear it a lot, that people need a certain budget, and need a certain actor in their movie in order to make a film. They spend their whole lives wasting time.

GG: Okay, you have said the most important thing of all is to just get out there and start shooting.

LW: Absolutely! Don't wait for the gravy train to come and don't wait for investors. That's nonsense. You just have to make do with what you have. Even if it requires

True crime author John Gilmore digs a shallow grave for murdered prostitute Kelly Monroe in **Sex, Death and the Hollywood Mystique**. Photo by Larry Wessel.

stealing. Werner Herzog stole his first camera from a German television crew to make his first film. You just have to do whatever it takes to make movies, and just to shoot material. Eventually, you'll get great footage for your documentary. Or whatever you want to do! I don't think waiting around for money is a good idea. In fact, money has never been an issue with me. I've been poor my whole life. I've had to work an eight to five job since I can remember and it's never really bothered me. I hate to think that I've acquiesced into this eight to five existence, but for me, the small amount of money I make as a telephone operator is enough to get by on. Luckily, I did work for a wealthy woman, who gave me a very expensive – in fact two very, very expensive digital cameras. Using those, I am able to shoot incredibly sharp images, and I'm so happy about that. But still, four thousand bucks... that really is a lot of money. But at the same time, it really isn't a lot of money. If you look at it in the context of Hollywood, it might be somebody's lunch expense or something.

GG: That's great because when everything is digitized, you can put your stuff on DVDs.

LW: Yeah! I'll be able to release everything on DVD, and release perfect images. And I won't have to worry about generation loss or any of that nonsense. So, we are in the digital era right now. And there's really no excuse for anybody to not do their own thing digitally, I think. At one time, when I was going to film school, I was really snobby. I thought video sucked, and that film was the way to go. But as I went along and got older, I slowly realized

that it is just so fucking prohibitive and expensive to shoot film that I saw very little point in choosing this expensive medium. It's like sculpting in gold when you could just sculpt in wood. You have to fit your budget! It's still going to be a great work of art, no matter what you make it out of.

GG: What's the first documentary you ever saw?

LW: I remember seeing *Nanook of the North* as a kid. I remember really enjoying every minute of *Nanook of the North*, which is considered one of the very first feature-length documentaries. To this day, it's just an amazing documentary. There's a lot of films that I've seen, that aren't even documentaries really. I don't know if you've seen – well, I'm sure that you have, Gene – the R. Budd Dwyer footage.

GG: Aw, man! Why'd you have to bring that up? Yeah, and I rue the day!

LW: This man held a press conference for his own suicide, and it was shot by all the media but they refused to show it on the air! [*laughs*] Amazing! That piece of footage circulated around the underground pretty fast, and it wasn't long before I got a copy of it. I remember the shock and total fright of seeing that for the first time. What I really like is that this cameraman zoomed in and got the details. He didn't just turn his camera off or do what he was told, to walk away. He got in there and he showed what was important to show. And when you see the blood draining out of poor Bud's nose, you realize that suicide is really a spectacular thing! And it's even more spectacular than any motion picture depiction of it!

Especially any Hollywood depiction you've ever seen. So that piece of footage, to me, is an extraordinary documentary in its own right. And it's just a simple series of images of a guy committing suicide.

GG: What did you learn from that as a filmmaker? Or I should ask, what films shaped you as a documentarian?

LW: There were two things that I grew up watching, and one of them was an amazing television series called *An American Family*. It involved a family in Santa Barbara called the Louds. I became totally fascinated with this *cinema vérité* documentary about the Loud family. At the same time, every single year, a documentary by a guy named Frederick Wiseman would come on the television and these were films that were just so bold and unnerving and shockingly violent, it made everything else pale in comparison. There was a film called *Hospital*, that took place at a New York metropolitan hospital, and you're watching people dying in the waiting room! While they were being asked to fill out their insurance papers with chopped off fingers and this kind of thing. Incredibly Violent! Incredibly Violent and Fucking Real! And to me, this was like the real stuff! I became addicted to reality. Wiseman was a filmmaker who didn't narrate his films. He didn't add music. And he didn't quick cut to prove a point, or to grind an axe. He just really wanted to show institutions for what they really were. By hanging out long enough, he would get these amazing scenes that would play out in front of him. They're all dramas. They're all these beautifully constructed dramas that have the illusion of being reality. And that's the beautiful part of watching a Frederick Wiseman film. And he is the Master! A lot of people use that term *cinema vérité*, and they don't even like to. It's a phrase that causes a lot of derision. I attended a retrospective of Herzog's stuff, and I really liked Herzog's documentaries, and his films. But he just absolutely loathes *cinema vérité*! He came on stage saying that he wanted to be the pallbearer of *cinema vérité*! He wanted to bury it. And he was really passionate about how much he hated it! I just shrank in my seat. I've always loved what Frederick Wiseman has done, what they call *cinema vérité*. But what he does is so far and above and beyond and better than what anybody else does. His masterpiece is *Titicut Follies*, which I saw at a psychology class at USC when I was a student. It just blew my mind. It's the most extreme Frederick Wiseman documentary. His films, they're all about hospitals, the military, asylums. He did a film called *Law and Order* about the Kansas City police! It beats *Cops* by about twenty years. *Cops* never shows you police brutality or anything. It doesn't show interrogations or what really goes on at police departments. But Wiseman showed it! There's another film he did called *Near Death* which is very good.

GG: I've seen half of *Titicut Follies*. It is impossible to sit through.

LW: Oh god! It is relentlessly terrifying! From beginning to end! By the end of it, you feel like you are trapped in a mental institution and you can't get out! And you're next in line for the electro-shock treatment! It's just horrendous! And it is so horrendous that it was banned by the state it was in. The United States Supreme Court ruled that the only way the film could be shown – this is in 1967 – to the general public, was if they took a psychology class at a major university. As luck would have it I went to USC, and the film studies were a joke, but I took an Introduction to Psychology by Dr. Scott Frasier.

GG: From the TV show?

LW: He was a great psychologist! He did a lot of pioneering studies. His lectures were fascinating and humorous. He made everybody watch *Titicut Follies*. After that course, I was completely enamoured of him. [*laughs*] Another film that he showed, and I would like to get my hands on this... I don't have the title of it... it's a film that he showed us which demonstrated the power of hypnosis. There is a film out there, it's for medical students, in which a woman is hypnotized into singing "Row row row your boat" while she gets a caesarean section. The whole thing is filmed. People were passing out in the audience. It was amazing! One of the most powerful documents I've ever seen.

[*Note: I turn to slide out of my booth, and blocking my route to the urinals, at the end of the table, is The Old Hag. –GG*]

The Old Hag: Sexual crap!

LW: Excuse me?

GG: What?

TOH: You'RE PERVERTS!

LW: Are you our waitress?

TOH: No I'm not! I'm at that table over there! I saw him talking with his mouth open! You two are talking trash, while eating! And he was chewing with his mouth open! What kind of talk is that?

GG: We're sorry, we'll keep it down.

TOH: What is this? I don't understand how you can...

GG: He's a filmmaker. I'm interviewing him.

TOH: Sexual crap! I'm going to see the manager!

[*Gene returns to the table a few minutes later. –ed.*]

GG: We freaked them out. We should get out of here.

LW: Oh Gene, that horrible old hag! Oh, am I talking too loud?

GG: Yeah, come on, let's just get out of here.

LW: Yeah, why can't people mind their own damn business? That's one of the central problems of our modern age. People don't mind their own fuckin' business!

GG: Shhhh!

LW: That's ninety-nine percent of the reason I despise all of humanity. But William Burroughs talks about this. See,

"I can't deal with other people and I can't deal with anyone messing with my creative thought. The minute you collaborate you infuse your project with the evil entity known as compromise."

that's one of the first rules of being a Johnson. The first rule of being a Johnson is to mind your own business.

GG: In order to be a Johnson and not a Shit.

LW: Yeah, that's right! See, she was a perfect example of a Shit. An anti-Johnson.

GG: She can hear you.

LW: Oh fuck, man. They're long gone. They split. I think they got fed up. Did we have anything about sex in our conversation at all?

GG: No, not at all.

LW: As long as we don't talk about the fist fuck movie, we'll be—

GG: SHHHHHH!

LW: Okay. [*laughs*] I was trying to think if there was any sexual content to our conversation. I don't recall even mentioning the fist fuck movie I saw when I was a kid.

GG: SHHHHH! You're going to get us thrown out of here!

Restaurant Manager: Ummm... okay. Look. You guys have to keep it down. People are complaining.

GG: People are complaining?

RM: That's what I said.

GG: Okay, well that's fine. Because, the thing is, I am trying to do an interview, and those people out there...

RM: Yes?

GG: ...are too loud.

RM: What do you mean?

GG: I mean, we're going to need a quiet table. This is intolerable.

RM: Yes, I understand... But you really have to lower it.

GG: We'll keep it down.

LW: We'll keep it down.

GG: Alright... [*laughs*]

LW: Unbelievable.

GG: [*laughs*] Your new film is about collectors and you have a lot of Bukowski-related footage.

LW: Yeah. I was lucky enough to have met Bukowski on two occasions. One was a reading of his at Cal State. It was wonderful. He brought an 8-pack of Budweiser with him to the reading. At the time, they had an 8-pack. I don't think they do anymore. He just laid the pack on the lectern he was standing at, and told me, "As soon as these are gone, I'm out of here." And he opened up one of the bottles, jerked his head back, and drained the entire beer. Until it was totally empty. He looked at the crowd and said, "This is going to be a short reading." Everyone exploded with laughter. I love Charles Bukowski. He is definitely one of the gods in my personal pantheon, and I've read all of his books. He made a big impression on me when I was sixteen – PBS, who I shouldn't mention because I hate that organization [*laughs*] – but they showed this Bukowski documentary by Taylor Hackford that really shook me up. At the time, I was reading *Erections, Ejaculations, Exhibitions and General Tales of Ordinary Madness*. That made an enormous impact on me. And I almost immediately became an alcoholic! He was just so romantic about drinking. I was definitely ready, and I take full responsibility. But Bukowski made it easy. I admired his style so much, and the brevity of his prose. He was a genius. None of my friends who are writers and who are publishers have any respect for him. Not many people I know like Bukowski. It's refreshing that we share a common interest in our favourite writer. Also, we share the same birthday; Bukowski and I were both born on August 16th. Which I really enjoy. If anyone ever asks me if a celebrity was born on my birthday, I tell 'em that Charles Bukowski was born on my birthday, and Elvis Presley died on my birthday. So every time my birthday comes around, I stay home and watch television. The only thing that's on are old Elvis movies all day. Oh yeah, and pilgrimages to Graceland.

GG: [*laughs*] So, you were telling me about Tijuana.

LW: Like I said, I spent three years going to all the bullfights in Tijuana, but I never went to the red light district. It never occurred to me. I was so obsessed about bulls. I wasn't thinking about sex! Well, one of my sidelines is that I'm also an artist. And I got an assignment from *Hustler* magazine to illustrate an article about the red light district in Tijuana. I had to see for myself. So I went down there with a camera to photograph all of the signs. The cantinas have these almost low-budget Vegas signs, these cheap signs that indicate all the bordellos in the red light district. I went down there to photograph them for the illustration that I did for *Hustler*, this article about Mexican prostitution. Of course, I knew I would have to sample the prostitutes there. This one bar, Adelita's, it's called. If you're on the internet and you do a search on Zona Norte and Tijuana, you'll learn all about Adelita's. It's the most wonderful cantina and bordello in Tijuana. That is a place where a man who likes to drink

doesn't ever want to leave. A man who likes beautiful women never wants to leave. A man who likes music never wants to leave. Ever.

GG: I... won't go there. I'd die!

LW: It is so wonderful! It gives you a whole *Under the Volcano* feeling. You will become John Huston as you drink your third Tecate and your third shot of Tequila. Sam Peckinpah! And it's heaven. The combination of the loud music, the dancing, the beautiful girls, the booze. The outside world just isn't as good as the interior of Adelita's. Especially if you love Mexican women.

GG: They're that good, huh?

LW: I could only report that I am a very lonely son of a bitch myself, and very horny all the time. And I love Mexican women. I love Mexican culture. Music. Booze. I might wind up in Mexico at the end of my days. I don't know. But I fantasize about that all the time. Another thing that I have always fantasized about is going to New Orleans, and it's been a big thing since I was a kid. I always wanted to do the Mardi Gras thing. Well, I started renting these "show your tits" videos, trying to get my interest level up, and it did the opposite! You see so many tits, after a while, what do you do? You start to criticize the tits! Not all of them are that attractive, and it becomes a let down after a while. Pretty soon, I put the kibosh on the whole trip. I'm not even going to go to Mardi Gras now. If I go at all, it won't be for "show your tits," it'll be for the architecture, or for the cemetery tours. Maybe a tour of the jazz clubs or something like that. The idea of being around a huge crowd of college students, and just everybody in the world showing their tits off is, to me, more horrible sounding than enticing.

GG: Drunk college students. There's a turn-on. About as sexy as rectal cancer.

LW: Yeah, I agree. The death of everything good in a child is when they go to college. There really was a conspiracy to destroy my creative spirit at USC. I thought that I had to go to film school, I thought that was the next step to Hollywood. I believed with all my heart that I was doing the right thing. I got three scholarships. Now, I think it was the biggest mistake of my life! I totally got de-railed by it. I think the only good I got out of my college education were the other courses I took outside of film. I had seen all the movies that they were showing in film school. I'd already made films. I knew how to make a film. So it was no big thing to make a film with other students. But there was always coercion involved in collaborating and emphasizing this collaborative process of film. And that just blew my fucking mind! I thought, "Man, I took the wrong path." I should have gone to art school. I should have gone to San Francisco where everyone was getting high and having fun, getting laid, instead of being with these spoiled rich brats at a major institution where the professors were all engaged in this horrible conspiracy to destroy everyone's creativity. Individuality was not to be tolerated. It was

Tijuana-themed photo collage by Larry Wessel.

like going to church. My folks didn't raise me in any kind of religion, so I didn't like that kind of mob mentality in a supposedly creative environment. I was taught to be a free-thinker. From the beginning. I was never baptized. Their attitude was, if I want to get caught up in religion, that's up to me. I could find it on my own. But they weren't going to force any shit on me.

GG: Rick Strange said, "Schools are for fish." There's never been a truer sentiment passed around.

LW: It's true. You can discover all the books you want to read on your own. Anybody can research what interests them. That's what I've been up to my whole life. I don't need anyone else telling me what to do. This whole collaborative process of filmmaking to me, is just a sham! And also this idea of the 'independent filmmaker' and these 'independent films'. What is that? Those are just like low-budget Hollywood movies. And they cost millions of dollars!

GG: Low budget Hollywood, or expensive indie, what's the fucking difference?

LW: They're wearing this badge that says they are independent, but it's utter bullshit, you know. The films I make are true independent films. I'm the only one making them. I am the director. I am the cameraman. I'm the editor. I write the thing. I interview everyone. I do everything myself, you see? There's no one else involved.

GG: Well, Larry, maybe documentaries can be made that way. But you can't make a feature length fiction film that way. That's absurd.

LW: Yes, and that's why I make documentaries.

GG: Larry Wessel, the Misanthropic Cameraman.

LW: I can't deal with other people and I can't deal with anyone messing with my creative thought. I'm more of an artist than a filmmaker and I can't imagine anybody coming over to Picasso to tell him that he can't put that third eye in the middle of a woman's forehead if he doesn't fucking want to. Should someone have guided his hand as he made a painting? I can't see that. The minute you collaborate you infuse your project with the evil entity known as compromise. This is part of the

reason I do documentaries. Anything can happen. You just have to be patient enough and keep shooting until something great happens. And miracles happen all the time. This is another instance of what keeps me going. I was visiting the Goddess Bunny, who is this amazing polio stricken transsexual, and she always lives with hustlers. They help her pay her rent so she can spend her welfare checks on booze and live a lavish lifestyle. I was visiting her, videotaping the Goddess, and this hustler who was sitting next to her, kept interrupting the conversation. He had some really amazing things to say about the California Youth Authority. So I turned my camera on him, and just let him go off. He was great! I had no idea that it was leading up to this, but he ended the whole dialogue by telling me that he saved Charles Manson's life. That he was cellmates with Charlie Manson. And he was in an art class with Charlie when a Hare Krishna prisoner walked up to Charlie, splashed him in the face with a flammable liquid, and torched him with a Bic lighter. Manson was on fire. Andrew, my new friend who I was videotaping, told me that he covered Charlie with a blanket, smothered the flames and saved Charlie's life. Anyway, I got this amazing confessional from him, just because I happened to be in the right place at the right time. It's these sort of situations that I find myself in, that make me continue being a documentary filmmaker. Lynch has described the creative process as fishing, and I look at it the same way. You must have the patience of a fisherman to catch those big ones. If you sit around long enough, the big ones will nibble on your line and bite eventually. It's worth it in the end. And the only way you can afford to do that is to shoot miles and miles and hours and hours of footage.

GG: Is there ever a topic you wanted to cover but couldn't?

LW: There are a couple of things I would love to do, but they would definitely require investors. I would love to do a documentary about Mexican murder magazines, to hang out with the Mexican police and newspaper crews, who show up at crime scenes. I find that endlessly fascinating. I'm a big collector of Mexican murder magazines.

GG: I went to that hideous Museum of Death once, in Hollywood, and I saw those pictures from Central and South America, and it was about the most pointless, disgusting, morbid, nihilistic and completely negative fucking display I've seen in my life.

LW: But on the other hand, Gene... death is part of life, and I think a more realistic look at death will make you realize that it is indeed part of life, and there is no life without death, and they can co-exist. They cannot exist without each other.

GG: Yes, but the excrementality of it is uglier and messier in those magazines. We know that rotted bodies stink. Everybody knows you shit your pants when you die. Why wallow in something that is completely wretched?

LW: I am opposed to censorship of any kind, especially when it involves death. Death is a very important subject to deal with and one of the essential problems with our culture is that we fail to deal with the realities of death. We see it every night played out in the form of these fictional cop shows on television, where people are getting shot constantly, and people like to bitch and moan about that. But we never really see actual death. All the Mexican reporter does is report what he sees. To hide that from the public is more pornographic to me, than to show it.

GG: Are Mexican death mags not the pornography of death?

LW: Well, it could be argued that yes, the tabloids exploit death in order to make money. You could criticize all yellow journalism and throw it all away. But they also report death uncut on the news. You'll see the body that got hit by the train on Mexican news in Los Angeles. It's part of the reason why I watch that news.

GG: But eventually, it just becomes an end in itself. "How much meat and gristle can we show before the lens gets wet." I'm not in the habit of poking dead animals with a stick just to see how many bugs come out.

LW: But Gene! We're all made up of blood and bones, that's what we are. There's nothing ugly to me about a corpse or a dismembered body. To me, that's what we're all made of. It is what it is. It's not pornographic, it's reality.

GG: Yeah, we are made of flesh. Living flesh. Not a pile of rotting shit. So anyway, that was one project you wanted to do.

LW: I'd love to do that but it would be very dangerous and perhaps a suicide mission for me to even consider it. Another thing I want to do... I would love to document all of the amazing violent amusement parks in Asia. They support all of the temples. There are these bizarre low-budget Disneylands all over Asia, that depict the torments and tortures of the afterlife. And they're just phenomenal! You can see a little of this in *Shocking Asia* and a few mondo films, but nobody's ever done a comprehensive documentary on the way that hell is depicted in these theme parks, for children!

GG: Let's end this with a quote. Do you have a favourite aphorism, or quote?

LW: Ernest Hemingway said, "Watching a bullfight is like having a front row seat at a war." Pablo Picasso said, "A good Spaniard goes to church in the morning, goes to a bullfight in the afternoon, and to the whorehouse at night."

GG: It's all bullfights with you, isn't it?

LW: Pretty much, Gene.

Please visit **www.unpopart.org** for more information regarding Larry Wessel's documentaries and artwork.

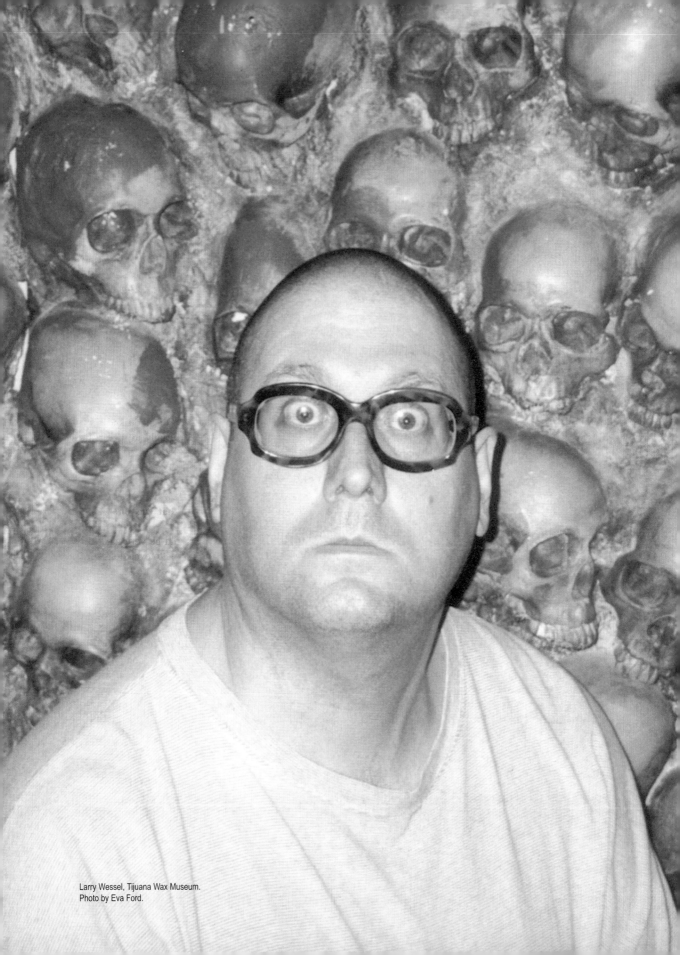

Larry Wessel, Tijuana Wax Museum.
Photo by Eva Ford.

Barbeque Noir

- Joe R. Lansdale -

Dusty roads, viciously homicidal perverts, spooky creek beds, sharp knives, pissed-off bullworkers, dirty dialogue and dirtier deeds… the human heart emerging intact after a hundred mean-ass steel-toed stompings. I can think of few things quite as satisfying as an entire month spent in a bar reading Joe Lansdale's novels, one after another. They're true hardcore Texas nasty; achingly world-weary and unapologetically sentimental. You can't help but adore the guy.

I met Joe for the first and only time when I was 12 years old, in a Central Pennsylvania comic book store where he was doing a signing. I'd already tracked down several of his out of print novels which I was undoubtedly far too young for, and even then was so mightily enamoured of his potential to move, amuse, and frighten me that I begged my mother to drive me to the event. I remember Joe as being intensely personable. He signed my books, and when I inquired as to the availability of his novel *The Drive-In*, he simply named a price and asked for my address. I wrote it down on a scrap of paper and he slipped that and my five dollars into his wallet. The book showed up in my mailbox a week later, along with its sequel, *The Drive-In 2*. Both were signed to me. I swooned.

Since then I've read most of Joe's novels, and they're so goddamn meaty, the only excuse for them all not having been adapted into hilarious, rude, ultra-violent Hollywood films is basic Hollywood ignorance. I can't think of another author whose work begs harder for cinematic adaptation than Joe R. Lansdale. If you're a stranger to it, seek his stuff out now, and read it drunk in bars. You'll have a hell of a time, you'll see what I mean, and you'll thank me.

Joe R. Lansdale circa 2002. Photo courtesy of the artist.

Gene Gregorits: Hi Joe! What are you working on right now?

Joe R. Lansdale: Well, I'm kind of between projects. I'm gonna start a screenplay here in about two, three weeks. After that I have a new novel to do.

GG: Have you written a screenplay before?

JL: I've written four, and all of them have either been optioned or sold.

GG: Most of your novels are very cinematic in nature. I've always thought it odd that there has never been an adaptation of one of your books.

JL: *Savage Season* was optioned by John Badham many, many years ago. Then *Mucho Mojo* was optioned, first by New Line and then by Canal Plus. They had a screenplay by Ted Tally, who did the screenplay for *The Silence of the Lambs*. It still didn't get made. *The Two-Bear Mambo* got optioned after that. I did the screenplay for that, for Propaganda Films. But the guy I was working with moved, and that killed that. *The Bottoms* just got optioned and *A Fine Dark Line* is just about to be optioned. *The Drive-In* is optioned, *Dead in the West* is optioned. On the whole, all of these things have been optioned and re-optioned, numerous times. And yet, the only film I've had is from a novella, *Bubba Ho-Tep*.

GG: Right, and we'll get to that in a bit. I don't know how the industry works, but do most books get optioned?

JL: No, I don't think most books do. I've been very fortunate in that respect. I think that they are cinematic, and I think people spring for that. As to why more of them have not been filmed… your guess is as good as mine!

GG: Where does the visual, action-movie kind of thrust come from? Do you see more movies than read books?

JL: I'm both. I'm more of a book person in many ways. I love books. I grew up on comics, which I think have a big influence on the visuals. But I love movies. If I had to choose one, it would be books. And short stories. And after that, it would have to be films and comics. I think that the way I write is far more out of novels than it is out of film, but the imagery is probably inspired by films and comics.

GG: Your writing differs from a lot of horror and crime writing. You created a genre of your own, in a way. This combination you have, of comic book adventure, with real world nastiness. You get into the minds, the pathology of your characters. They are all elements of your artistic world and the vulgarity exists right alongside the slapstick. When did you find that style?

JL: With comics, movies and books… all that being side by side as I grew up. I think it was formulating almost since birth. When I really began to get a handle on it was probably about 1986. Before that, I had had stories in a book here and there that had elements of that stuff. But for some reason, right about then, it all jelled. I think that I had had enough time and experience and water under the bridge so to speak, that I was able to do what I had always wanted to do, which was to bring that colour of the comics, and that excitement of films, that insight and characterization of the books, and bring them all into one package. Once in a while, I'll do something that is purely just fun. And sometimes I'll do something that's a little heavier. But most of my work I think hits that happy medium between. Because that's how I am as a person. I want to be entertained, but I would rather not have just tapioca pudding. To get through, I like for there to be some echoes beyond the reading of the page. I like for something to go on in the scene besides the scene! A feeling of texture, and some feeling that the characters existed before you knew about them, and that those who survive the novel will somehow, in some alternate universe, continue to go on.

GG: You always hated the "splatterpunk" tag. I think that's so cool. Someone needs to stand up and say, "that is not serious writing!" When it happened, was that your immediate reaction?

JL: Yeah. I never liked it. I was labelled into it immediately. But the problem I had with it was not the violence. I don't mind violence in novels, or violence in films. But I think you can do it in such a way where it is so over-the-top that nobody even sees it as violence. Or you can do it as real violence with real repercussions. The problem I had with being thought of as a splatterpunk, or with splatterpunk, was that I thought that it gave people *carte blanche* just to sit and figure out the nastiest way to kill somebody. The nastiest way to do this or that. To have no other substance other than that. The story, the book or the film, would be about that. And nothing else! There's no echo. And even if you're gonna make it just about that, I thought that it had to have some style, some originality. For me, I don't mean to say that I write message novels, but I like them to say something important.

GG: Well, it's very easy to just wallow in the grotesque. I think it's a lot harder to try to understand people. Your books do have a moral centre.

JL: Yeah, that is very important to me. People do, in reality, face repercussions. A lot of the stuff I read, in the splatterpunk genre, had no repercussions. The whole thing was a gimmick. It used the violence as a vehicle and expressed nothing beyond that. I didn't want to be part of that. I'm not knocking people who did it! I'm just saying that most of the people who were labelled that way – even some good writers – and people that embraced that flag, have disappeared! It was a fad. People move on. Tags like that are not helpful.

GG: Envelope-pushing is just part of our everyday mainstream culture anyway. That invalidates a lot… well, to be moral is subversive now! [*laughing*]

JL: It is! I like subtle stories, by the way! I've done a lot of those and a lot of people are unaware of them. I've done them, and some of the novels that contain the violence also contain a lot of subtleties. There was a trend then to do something different. Everything was vague. It was sort of a rebellion in horror fiction.

GG: Do you have a hard time writing when you're not in Texas?

JL: Yeah, but it's not just Texas. I prefer to write in my house. That's the thing. I wrote half a screenplay for John Irvin, who did *The Dogs of War*. I wrote half of it in England, and finished the other half when I got home. And I wrote part of *A Fine Dark Line* in Portugal. But I only did that because I had to. I think I'm gonna have to work on this screenplay I'm about to do in Alaska for a while. I work a very short period of time a day, but I like to have the same time of day, and I like to be able to go down to my study and work intensely. That's how I work best.

GG: You've been very prolific though. It would seem that you do write a good portion of the day.

JL: No, I write three hours a day. Now, when I was younger, I used to write 10, 12 hours a day, when I could. But I was usually working some other job at that time. And when I was working a job, I would get up in the mornings and write. Then leave for work at 2p.m. I'd get up at 6a.m., write until noon or so, eat, shower, and go to work. I'd get home at 10p.m., write another couple hours. On the weekends, I wrote as much as I could. But I also spent time with my family and later on I was a house dad while my wife was working. As time went on, I was able to have a little more family time, to balance it out. I actually love doing it, I adore writing. But I also do martial arts on a regular basis. It's hard to squeeze a lot of the time in. I do believe that people have a lot more time, more hours in the day, than they actually realize. Because they squander most of it.

GG: Writing isn't painful for you then. Some writers can sit there for hours without being able to click on.

JL: No. I usually just get up in the morning, go down, and within a few minutes I'm writing. I like to read a little bit in the morning, before I get started. Sometimes I'll read at night before I go to bed. It seems like, when I wake up, there it is. There have been some times when it's been a little harder than others. But on the whole, it generally comes relatively quick.

GG: I'd like to go into your background a little bit. What was your childhood like?

JL: I was born in East Texas, in 1951. I was born to a poor family. My father couldn't read or write. My mother had an eleventh grade education. They were really great parents. My father was a mechanic, a real hard worker, a great guy. He's my hero to this day. He learned to read a little bit, but not much. His whole life, you could honestly say that he was illiterate.

GG: He really comes through in *The Bottoms*.

JL: Yeah. But the dad in *The Bottoms* is different from my dad. There are a few similarities. The Depression era for one. My Dad, he was a good guy. My mother was a fine person. I had a very well grounded family life. My brother was seventeen years old when I was born. He actually recorded at Sun Records. He was there when Elvis was. His wife, who he met there, actually went to school with Elvis. There's this whole other generation thing going on between us. I think maybe it is due to the strength of our parents that we're very close. Even though there's a big difference in our ages.

GG: High school?

JL: I wanted to go to college. I worked in an aluminium chair factory at night when I was going to high school. I don't even know if child laws were supposed to allow you to do that. It wasn't just me, but a ton of my friends. Then I worked in mobile home factories, I did farm work. I was a bouncer. I did a lot of different things until I went to college. I went to Tyler Junior College a year, and I went to University of Texas almost a year. But I got a divorce at that time. I got married when I was 18. I dropped out for a while. I went back sporadically, after that. I met my current wife, we've been married 31 years. We met in anthropology class. But I never got my degree. The writing started selling when I was 21. And by the time I was 29, my novels were coming out. My wife decided, she said, "it's time to go full time."

GG: Do people ask you a lot of clichéd, Texas-themed questions? Do you find people making a caricature of you, as the "Tough Texan" or whatever?

JL: Yeah. I love Texas! And I feel bad to think that they think we're all a bunch of gun-totin' conservative nuts here. Well, we've certainly got a bunch of 'em! But I see those in California and New York too! It's funny, you can have something racial happen in New York or Los Angeles, and of course people yell about how foul it is. But it's like "oh gee, what an anomaly." But if anything like that happens in the South, even to this day, the reaction is, "look, it's business as usual." That doesn't mean that there isn't that bad side. That's what I write about. But if I'm writing crime novels, if I wrote about New York, Los Angeles, or Philadelphia, then I'm going to pick the bad side of human nature. Because it's a crime novel! That's what fascinates me, that's what disturbs me. But that doesn't mean that I think that's how all people are. It just means that the people I have created, in this universe, to make them interesting, and to focus on those particular social issues that do interest and disturb me, are like that for that reason.

GG: There's two other guys from Texas who I think are the most brilliant people, Bill Hicks and Alejandro Escovedo. Do you know their stuff?

JL: I'm familiar with Bill Hicks.

GG: His routines are not that unlike some of your work. The vulgar sincerity, offensive but endearing.

JL: There is a certain part of that that is pure Texas. And that's what I'm saying, it's not all cliché. There seems to be a storyteller tradition in Texas that I think has stayed with us. Although maybe in the generations behind us it's going to be left. I've already started to see it fade. But with me, and with my parents and on down, it was a storytelling generation. The ability to look at stupid stuff and say it's stupid.

GG: Human stuff. Like everybody goes to the bathroom.

JL: Exactly! One reason that in my novels people will do things like that is that I used to read novels and say, "well when the hell do these people *shit*?" Why aren't these things talked about? I mean, surely the guy's gotta pee by now! That doesn't necessarily mean it has to be on every page or anything. I think that when you do those things, you bring a human dimension to those books, that actually make them far more believable. Now, sometimes the language itself can be offensive to some, that's understandable. But it depends on the story. Not all my stories use that type of language, but a large percentage of them do, because the people I grew up with were blue-collar people, and they may not have cussed when women and children were around, but most of them cussed like the proverbial sailor the rest of the time. In fact, across the US, people use that language far more than the Christian right would have you believe.

GG: When did you first decide that you were going to do a fictional character modelled on yourself? And did you know at that time that you'd be bringing him back as a recurring character in a series?

JL: I never intended to make Hap Collins a recurring character. A friend of mine, Sam Griffith and I, had been through a lot of these experiences, living cheap. And he's a judge now, which is interesting. We'd lived on the edge, we'd both come from poor families. We'd gone through the sixties. I thought for a long time that I'd like to write about the sixties experience in some way, and at least touch on it. And I couldn't find a handle on it. One day I decided I'd just write about how I lived back then. I wasn't gonna bring in the whole counter-cultural thing, I'm just gonna write about how I lived then. We were more *The Return of the Secaucus Seven* than *The Big Chill*. So I started writing about these characters standing out back shooting skeet. As I was writing about it, it just unveiled… I didn't know there was gonna be a Leonard… Then when he came into it, I got the idea that he was gay. And then gradually, as time went on, I said "of course!" It's because I had seen some things about some black Republicans, which at that time was fairly rare. And I had a friend who was a gay Republican. And I thought, "that's odd. What the fuck are these guys doing for you?!" So it all kind of came together in this character. When I got through with *Savage Season*, it was three years until the next novel, because I never intended to write about 'em again. But I sat down and wrote *Mucho Mojo* in four months. Because Hap's voice just would not leave me. Then I did another Hap and Leonard novel the year after *Mucho Mojo*. I took a year break form them, then did *Bad Chili*. I skipped a couple years, and came back with *Captains Outrageous*. Now, I haven't done one for about three or four years.

GG: It's funny that in your version of the unsuccessful Lansdale, you imagine yourself married to this tough ass black guy, who is homosexual and votes Republican.

JL: [*laughs*]. They're not married. They're friends, which to me is even odder.

GG: Your experience in a dysfunctional, co-dependent bachelor relationship seems to be pretty extensive. The details are what make it work. That Leonard likes vanilla cookies and gets pissed off when Hap eats them.

JL: My friend Sam, I thought he was like a fussy old maid! He wasn't gay, but just that experience added to Hap and Leonard. Every time you live with somebody, be it a heterosexual relationship or a homosexual relationship, or just a friendly relationship, people develop certain ways of dealing with one another. And all these little things come out! I just thought that was funny. Here's these two guys. One's heterosexual and the other's homosexual. They don't have an intimate sexual relationship, but they have a relationship that's not too unlike husband and wife in some ways, and it's like brothers in another way.

GG: What the last thing that really inspired you? It could be something you saw in the street, or a headline, or anything. In terms of your writing.

JL: I won't say too much about this, I don't wanna give it away, but just recently I went to Houston to do a signing. I spent the night in the hotel there. There was so much noise on the highway, I felt like an illegal alien in a U-Haul trailer all night long. So when I woke up the next day, that gave me an idea for a story. It started coming to me in waves.

GG: Hap is a bouncer in your books. Did you experience the kind of violence he did, when you bounced? Are you as good a fighter, or did you play that up a little?

JL: I'm a ninth-degree black belt. I'm four-time inductee into the International Martial Arts Hall of Fame. Since ya asked! I've been doin' this 41 years. So… I'm pretty good at it. In bouncing I never had all the horrible things he had happen, but I had a few things here and there.

GG: Have you ever lost a fight?

JL: Well, so far, no. That doesn't mean I can't. But I certainly haven't, so far.

GG: Did anything you wrote ever bother you so much right then that you censored yourself?

JL: Nothing ever bothered me right then when I wrote it, if I felt it was proper for the story. I think that art doesn't always have to be polite. Art's often messy and it's not always about what you want to happen. It's about exploring ideas. A lot of my books, I think you can tell when I'm saying something that I believe in. Sometimes I'm playing with ideas. There have been many times when I've looked back on something and went, "whew! That was intense." There's a short story called *Drive-In Date* that I almost didn't write. It's probably the toughest story I ever wrote. It's in *High Cotton*. It's about two serial killers, but it's at a drive-in. It's just this casual conversation they have with the dead body in the backseat. My intent was not to be splattery. It was my intent to show how these people do not always have the obvious faces of monsters. They might be crude or rude, but they could be the guy next

door. That's the scary part, to me. I wrote it simply because it scares me that these people are around. It was one of those stories that really went to the edge. I decided that that is as far as it went, for me. Actually, from that point on, I have pulled away from that. If a story really called for it, if it was necessary, I'd put it in there. *Sunset and Sawdust* has some pretty violent scenes in it. But it is a really different kind of book. It's got wild scenes in it, it's got humour in it. 1930s female protagonist. It's an interesting book, I think. There are some scenes that are pretty violent.

GG: Has your wife ever objected to anything in your work?

JL: No, not really. She's read most of it. She proofs a lot of it and stuff. It may not all be to her taste, but I don't write for anyone but me. I am fortunate that she does like most of it. She really likes *Sunset and Sawdust*. She liked *The Bottoms*, *A Fine Dark Line*, and *Freezer Burn*, which is a very brain damaged novel.

GG: It's a strange suggestion perhaps, but have you ever thought of writing a romance novel?

JL: As a matter of fact I have! Isn't that strange? But if I did, it would still be peculiar. I don't think I could write anything traditional. Not straight.

GG: In many of your books you deal a lot with that. The romance between Hap and Brett. That's incredibly real. But there's always the bashings and stabbings to spice it up.

JL: Well, what's strange is that the Hap and Leonard novels really have a lot of female fans. And I think a lot of it is Brett. A lot of women readers like the books because of her, but they also like Hap! They say, "this is the guy that I want! This guy's sensitive." In spite of all the terrible things that go on in these books, they see him as a sensitive character. And you know what, he is! In his own way, he's just a big sap. That's what Bruce Campbell said about me, come to think of it. He said, "this guy's all rough and tough, but I think he's a SAAAP!" And I think he's right.

GG: What did you think of *Bubba Ho-Tep*?

JL: I adored it. It's about 95% of my story. Almost all the dialogue is my dialogue.

GG: It gets you right, in the sense of your atmosphere, and obviously the dialogue. The problem I had with the film was that… well, it kinda bummed me out to think that the first Lansdale film would be a feature length adaptation of this short story about two old guys and a mummy. I was hoping, really, for the big one. Do you see that happening?

JL: I told you about all the options. Ridley Scott has optioned my work. David Lynch has optioned it. I think it's just a matter of time, really. In some ways, you know, you could say that it is amazing: they've had all these options, and none of 'em have been filmed. And in another sense, it's amazing I've had that many options! Most writers, even good writers, never have anything optioned, and certainly not filmed. There are several things in the works right now which imply to me, that they will be filmed.

Joe R. Lansdale circa 2002. Photo courtesy of the artist.

Don Coscarelli and I just talked about a new project this morning. So who knows. [the second option being discussed here was *Incident On and Off a Mountain Road*, which has now been made, as Coscarelli's entry in the *Masters of Horror* series of TV movies.]

GG: When you first realized that they were gonna go ahead with *Bubba Ho-Tep*, were you surprised? The story is very you, it's very sentimental, but you know, it's kinda goofy.

JL: Yeah, When Don came to me and said he wanted to option this, I actually did tell him, "We're talkin' about old guys with cancer on their dick, and Elvis is such a foul-mouth fucker, ya know?" I said, "you're dealing with all these icons." I think it's actually very sweet to those icons. I think people may not see that, they may not understand that, on the surface. And visually, when there's a guy laying' around in a bed with a pus-filled dick? I said, "Don, what are we gonna do here?" He said, "I'm certain I can do it." So he optioned it, and the second time he came back I tried to almost talk him out of it, but I had to just take his check. And the third time I just said, "shit, gimme the money!" And then… damned if he didn't do it! He then asked me to do the screenplay and I turned it down because I didn't think it could be done! He turned around and did a great screenplay. I'm very happy with it. You can't beat Bruce Campbell and Ossie Davis! There just terrific. But the film was made on a shoestring.

GG: That's another thing. It would take quite a bit of money to do *Bad Chili* or something.

JL: I have heard people say, "well, you know this thing could have been a little bit better in the special effects department," or something like that. And I say, "well, if you'd have given him the money, I'm sure he woulda done that!" With the money he had… every time I see it I like it better. It really grows on me. I think he did a brilliant job. It was a very difficult job. But I'm amazed that it's my first film, and shocked, even. But later on, I got to thinking about it. This is the right one. I have such a connection to low-budget, B-films, in so many of my works, that it's only natural that this should happen.

Uncompromised Individuality

- John Waters -

As evidenced by the use of his own image on the poster for 2004's *A Dirty Shame*, John Waters has transcended the role of film auteur and come into his own as a classic anarchist symbol. This status is normally occupied by rock stars and political martyrs, determined by T-shirt sales in head shops and on college campuses. Having come of age during the '60s, observing drug deaths and the very real repercussions of that time, Waters couldn't be more lucid. One gets the sense that he is living reactively; he has a deep gratitude for his own health and success, having moved far beyond the grimness which claimed the lives of many friends. In Waters's case, dangerous laughter is the order of the day. In *A Dirty Shame*, dangerous ideas thrive. But it's a weirdly positive energy going on in that film, dangerous more to the majority than to those who truly matter. The freaks have taken more than their share of hits, Waters is saying. Let's enjoy ourselves, and make up for lost time, is the message I get. *A Dirty Shame* is not as angry as it is simply urgent: "fuck your friends, in the streets, now!"

John Waters is recognizable even to those who might still proclaim him Satan were they to take in a screening of *Pink Flamingos*. He is a household name even in households that demonize his kind. In the 21st Century, he need create nothing more to enhance his importance to what remains of true outlaw art culture. Fortunately for us, he's still hard at work, with no retirement plans. After four wild-ass decades of celebrating punk rebellion, uncompromised individuality, and all that is morally heinous to the establishment, Baltimore's Pope of Trash is as vital today as he ever was. The most valuable elements of underground film are evident in Waters's latest effort, easily his most confrontational since 1977's *Desperate Living*.

Lydia and I were both intensely giddy about tag-teaming John that day… who the hell wouldn't be?

Lydia Lunch: One of the most charming aspects of your personality is that in spite of all the difficulties, and they've been numerous, that you've encountered in getting your films made, you never appear bitter. And you've always managed to maintain a very enthusiastic disposition. How do you do it?

John Waters: Well, what do I have to really be bitter about? I've never had to get a job I hated. I've always been able to make movies. You know, I have other careers too. I'm a photographer, I get to do college lectures. But I always have to get up in the morning, think of something fucked up, and figure out in the afternoon how to make money from that. And that's not a bad job! In the morning I only have to walk through two rooms, from my bedroom to where I write, so it's not like I even have to go out and go to a boss, I don't even have to walk to work!

LL: You seem so easily amused and have an almost childlike awe, which is completely endearing. But what is exactly the best way to entertain you on a Sunday afternoon?

JW: Funny you would say that. That's the one day you would never find me. It's the one day I don't answer my phone, it's the one day I don't go out… I stay in bed and read all day. But the best way to entertain me? It depends

John Waters, circa 1994. Photo courtesy of Phony Ltd.

on what city we're in! Because in Baltimore I like it low, and in New York I like it fancy sometimes. In LA… everywhere's different. I have a different circle of friends in each city. But most of them I have known for a long, long time, and one thing that I can say, with my friends in each city, we don't talk about my career. Or theirs! Which is a relief to me. Because if people only talked about movies to me, what would I make movies about? I've gotta hear other people's stories. I've gotta hear their worst days. I've gotta hear about their lunatic struggles! It's just as interesting to me. I mean, that's entertainment. Mary Vivian Pearce once said to me, "Just think about all the horror stories that go on in other people's lives!" I wanna hear 'em!

LL: Well, no wonder you're amused! Being a naughty Catholic, you must be very thrilled at the recent controversy surrounding the Catholic church, which by now has implicated over a hundred priests.

JW: Well… first of all, I'm an ex-Catholic, and – oddly enough – I only went to Catholic high school, which was worse! I was in private grade school. Am I thrilled about it? To me, more guilty than the paedophiles are the priests that knew about it and kept moving them around. And unless they are fellow paedophiles, there is no excuse. They should be in prison. Paedophiles, I feel bad for sometimes. Because they don't choose to be one. Thank god I'm not one. I taught them in prison. They are impossible to make better. And they only learn to lie. And they basically think that the [kids] love them back. And what's most depressing about it, there was this very liberal Catholic magazine in Boston where this whole beehive of paedophilia seems to be centred…they did this cover story about trying to be very liberal or something, and [saying that] maybe it is the time now, for priests to be able to get married. That isn't going to solve anything! They still don't get it. That isn't going to solve paedophilia! People don't become paedophiles because they can't get pussy! It's not because they're horny. See, if all priests were allowed to be married, there still would be paedophile priests! So, even the liberal Catholics and the clergy don't understand it. To me, the people that should be in prison are the non-paedophiles that knew about them, and hid them, and moved them around, because they were letting them continue. They were encouraging it. You know, Catholicism… they are the enemy to me. Although my mother is a Catholic, she doesn't push it on me. Yeah, it's a very important part of her life, but she's not a fanatic! She's not anti-gay, she doesn't march or picket abortion clinics. That's fine. If it makes her happy, fine. I'm not against that.

Gene Gregorits: Have you ever thought about doing a real life, true crime bio-pic?

JW: Well, I think I already did it, twice in a way. *Serial Mom* was a parody of a true crime movie. It even started out with the time and the date, and at the end it said certain people "chose not to participate in the making of this film." And *Female Trouble* was, in a way, a true crime movie. But base it on a real case?

GG: Yeah.

JW: Yes, if I hadn't made *Serial Mom*, but since I did make *Serial Mom*, then no. I've done that genre.

GG: Right. *A Confederacy of Dunces* is the funniest book I've ever read... I heard that you had taken a meeting to discuss the possibility of directing a planned adaptation of that book, but in that meeting something went terribly wrong. Who was the producer at that meeting?

JW: [*irritated*] No way. I'm not going to say his name. It's a very, very touchy situation. If we're gonna get into that subject, of… the Manson Family, which I do believe you were leading to…

GG: No! I mean, I didn't know Manson was involved in that…

JW: This was before I knew how to pitch a movie in Hollywood. And I probably gave them a very bad pitch for one thing. I later found out that the producer who I was pitching… I left him a copy of *Shock Value*. And in that book is a picture of me and Tex Watson. I later discovered that this producer was the one who discovered the bodies. Talk about awkward. He didn't call me back. But I feel bad about that now, and also, I feel very differently now, about the Manson Family.

LL: Tell me about *Hairspray* on Broadway!

JW: Well, you don't get many of these in your life. I think nothing ever went wrong with it, from the moment I had dinner with the producer, who said she really wanted to keep the John Waters flavour, and honour that, and wanted to get me involved. I heard the music, it was great. It reminded me of when I wanted to be Captain Hook when I was a kid, and tied my father's ties to my head for long hair. It reminded me of that! It has great villains. When I saw Harvey Fierstein in it at first, I thought he was perfect. It's not like Divine, but he's a really good actor, and also a writer, so… writers are great with timing. He put his own two cents worth in, that I think made the character even better. We couldn't find any fat girls. We found Ricki Lake, the best fat girl of all, and she's not even fat anymore!

LL: This has a life of it's own, so who knows where it's gonna go!

JW: I think it will just continue for a long time. I am waiting to see if they will make a movie of the play. They did that with *The Little Shop of Horrors*, which was a Corman movie, and then it became a Broadway musical. Then they did a movie of the Broadway musical.

LL: Congratulations.

JW: It was exciting and really fun, they all made me look good. I was the amateur here. They had the best professional Broadway people, but in the right way. Because I fucking hate Broadway musicals.

LL: Hopefully the success of *Hairspray* will hurry along your next film project!

GG: I was wondering which, out of your last few films, has been the hardest to get off the ground and the hardest to release?

JW: *Cecil B. Demented* was the hardest to shoot, because I had thirty-one days. I had thirty-three days to make *Pecker*, which is basically a movie about the art world where people talk. And *Cecil B. Demented* has twelve major characters that were in every scene, and guns, and action. Car chases. They're all hard to get off the ground. I thought up *Cecil B. Demented* before *Pecker* and I couldn't get it made. So I made *Pecker*, then went back and made *Cecil B. Demented*. It just depends. Every year, the kinds of people who say "yes" change positions. They're never gone [*laughs*], they move to another place. Or they just had a hit, or they're making a movie, or they're not making movies now. So it's very political in a way, and I do read all the trade papers. I keep up on that. Because it's important, for when I'm going to make the next movie. Now, the difference between independent films and Hollywood films is very, very little. Hollywood's looking for the next weirdo movie, and the art distributors are looking for next movie that can cross over. So they are both looking for impossible things! [*laughs*]

LL: What is the last mainstream film that you saw?
JW: Let me look. I write down every movie I see. I might not have seen one. Oh! *Panic Room*.

LL: How was it?
JW: Fine! I love Jodie! I like that genre of movie. I remember *The Penthouse*. I remember *Lady in a Cage*, *Kitten with a Whip*! Woman left alone in her apartment. So that was the last mainstream movie. I thought it was fine.

LL: What do you think of David Fincher?
JW: *Se7en* and *Fight Club* were great. Really big budget, fairly radical movies.

GG: What are your basic feelings on *Fight Club*?
JW: Well, I love violence in movies. I hate violence in real life. I've never been in a serious fight in my life, probably because I'd lose. If I could beat people up, maybe I'd be the most violent person. But anyone could beat me up, basically. I haven't been in a lot of fights in my life. I'm not bad at a verbal fight. There, I win. But if it ever comes down to Friday night brawl, I hop in the car and peel out. There aren't too many people trying to get into fights with me. And I'm not walking around with a chip on my shoulder after two drinks. [*laughs*]

LL: Any other directors out there who you feel are doing something really original?
JW: Yeah! You know, I really like Todd Solondz. I like Todd Haynes a lot. I like Hal Hartley. I like Bruce LaBruce very much. François Ozon, this French director. I liked *The Piano Teacher* and *Y tu mamá también*; the two movies I most liked that I've seen recently. So, I think it's better than ever, I really do. I don't think my generation was better. I go to colleges and lecture all the time – still doing that. I feel the kids now are great. You don't have to move to LA or New York anymore. There's cute, cool kids everywhere. Because of the internet, they don't have to leave. Because, New York is... not so cutting edge these days! I have an apartment there and I love it there, but

"I'm always waiting to be surprised. I'm looking for that every time I go to the movies."

believe me, there's no Avenue D. There's no bad neighbourhoods anymore in New York. Which... is sad for young people. But yeah, I still go to the underground clubs and yeah, the kids still look great today. I guess if I was 18, would I be pierced and tattooed? I would like the piercing, I think, because you can take it out. But a tattoo is too butch for me, basically. And I never had a lot of muscle, so if I was going to get any tattoo, I would just get Popeye's anchor. You know, the most pitiful tattoo, you know, the anchor with the rope around it?

LL: As the mainstream and the media become more explicit – I call it the pornification of America – what with Gregory Dark directing Britney Spears, which is just amazing, insane... With *Mad TV* doing heroin spoofs... let me put it this way: is neo-conservatism next, as the backlash against this?
JW: Well, who makes gross-out movies now? Hollywood. It's come full circle. The only thing left, is for a Hollywood star to show penetration. And I said that at the Independent Spirit Awards. It did happen with European stars, in that movie *Intimacy*. And in *Fat Girl*, which is a movie I like very much too. That's the only thing left. Once that happens, the rating system will be over, because if it's in a serious film, that's going to win Oscars, believe me, they'll try to do that. Give the actor a bravery award for giving a blow job or something. Basically, then it'll be over, because that's the only taboo left. But the gross out stuff... the gore? I mean, what was *Saving Private Ryan*? The first twenty minutes was a Herschell Gordon Lewis movie. And then you have *Freddy Got Fingered* and all those movies, they're all gross-out movies. I would never use scenes like that anymore. I'm not against it! I thought *Scary Movie* was funny. But... it's over. As far as cutting edge or there being anything new. I don't think kids are even interested in that anymore. I think it's better, because they have to think of a new way. Because it's weird, and it's hard.

LL: Yeah, and that's what we need more of. It's like the Madonna theory. They will show us everything, and we're left with this spiritual and psychological void.
JW: But don't you find the new ones funny? Don't you find Andrew W.K. great? I love him. I think he's hilarious. He might only be here for five minutes, but I play his record loudly in my car. People give me dirty looks at every red light. I really feel like Don Knotts playing his

Above: Principal cast members of John Waters's **Cry-Baby** (1990). *Left to right:* Kim McGuire, Darren E. Burrows, Johnny Depp, Ricki Lake, Traci Lords.
Opposite: John Waters circa 1997. Photo courtesy of Phony Lid.

music. "Let's parrrrrty till we PUKE! Yeah!" He makes me laugh and puts me in a good mood.

GG: It's great. He's got that bloody nose on the album cover, the cocaine nose, which I think is pretty ballsy.

JW: It's funny to me! It's a joke, and I don't think he's in on the joke. I'm all for it.

GG: Do you feel a need for films which look at an everyday type of social pathology?

JW: Well, have you seen *Bully*?

GG: Yeah, loved it.

JW: That was my favourite movie of the year. I love the crotch-cam shot, where all of a sudden the camera just races up a young girl's skirt for no reason. That is a new style I very much approve of. And I'm hoping it is copied in Hollywood... for no reason the camera just runs up Julia Roberts's skirt... in the middle of a dramatic scene. *Bully*'s a movie that surprised me. I'm always waiting to be surprised. I'm looking for that every time I go to the movies. But I still think there are really good movies. *Fat Girl* is really one to watch. It's a French film made by a woman, and not only does it have underage sex in it, but it has incredible violence that is really surprising and well done. Did you see *Funny Games*?

GG: Yeah. *Funny Games* I despise. I thought it was just a really rude, pretentious practical joke on the viewer.

JW: Oh, I really liked it. I thought it was torture. It was like 'Andy Warhol's Torture.' That one scene that went on [for fifteen minutes], showing her in the agony of her child having just been murdered...

GG: Well, about psychological reasoning... in your films, there is usually a reason why someone goes apeshit. Dawn Davenport didn't get her cha-cha heels.

LL: Ha ha!

GG: But today, it's like the only real motivation is boredom. In *Bully*, it was mostly boredom, that seems to be the only excuse.

JW: Well, it's the excuse, and they were also very dumb. It is very appealing to sometimes see dumb people go crazy, in a movie. It's sexy.

GG: Right. Yet still, there's only that reasoning. Boredom. Nothing to do. Does that become boring in itself to you, after a while?

JW: That movie was anything but boring. In the middle, it did get boring, but in the right way. Just listening to their stupid conversations, saying "whatever" every five seconds. Being on acid and saying "Whatever" is a concept that is frightening! And interesting to watch.

GG: Well, *Cry-Baby*, as both tribute and parody of the fifties, has a real and authentic sense of rebellion, even though it was a comedy. I think that it

articulates that sense of rebellion even better than *Pink Flamingos* did. In general though, do you feel that there is a new age of McCarthy-ism coming up here, and if you do, what kind of rebellion would you imagine for kids today, besides becoming schoolyard snipers and suicide bombers? [*laughs*]

JW: Well, first of all, gay is not enough. It means nothing anymore. No one cares, and they don't even know. That's important. I think you can get on your parents' nerves easily. You know, a black kid can listen to Marilyn Manson. If you're a white kid just speak in Ebonics. Even that's old but it works, still. Race is still the best way to scare people. And sex. And I think kids today really don't care about that anymore. It's not even an issue, which I find really heartening. I mean, eventually, there will be no black magazines and no gay magazines. Because it won't matter. And maybe that's the best progress. When it's all one thing. When it's not good or bad because it's black or gay; it's just good.

LL: Do you feel safe in Baltimore, considering the crime rate?

JW: I know which blocks not to walk on. I feel safe everywhere, to be honest. I'm not scared in a ghetto, walking down the street. They start laughing sometimes when they see me. But when they recognize me, that is a certain protection I have. And if you look like you don't fit in, in an outsider world, but you aren't uptight, you don't get hassled. It's really when you're there and fear the people.

LL: What are you reading now?

JW: I'm reading, at this minute, the life of Brenda Lee. It's called *Little Miss Dynamite*.

GG: What are you working on these days?

JW: I really can't talk about it because I feel like if you talk about them before they happen it just makes them evaporate before they happen. I'm having a lot of photo shows. There's one opening in Seattle. One in New Orleans. Just had one in San Francisco.

GG: What kinds of photos are you taking now?

JW: Well, I've been taking these for a long time. I take pictures of other people's movies off the TV screen and re-arrange them in storyboards the way I think they should be. I make a new movie of other people's images.

GG: Do you ever get even a little pissed off that your films don't play as many screens as *American Pie 2*? Or don't you care?

JW: No! The kinds of movies I've always liked don't show in every theatre. My movies are foreign films, even in America. That's okay. I want them to succeed but I am a realist. It isn't going to play in every single movie theatre. But you have to play in one movie theatre, in each city, in each country. And they can work, if they don't cost too much money. I know they can break even. My films have what's called in publishing a good backlist. They stay in print a long time. Shelf life, in a

way. They keep coming out again, on new DVDs and that kind of stuff. I don't know that I'm that mad about that. Because look, you never know what's going to happen. Who would have thought that *Boys Don't Cry* would win an Oscar? Who would have ever thought that *American Beauty* could win? Things are very, very different now.

LL: The most important thing is, you just keep doing it. I mean that's all we can do.

JW: Exactly. And times change and you do have to change some. You do have to re-invent yourself – you know that, Lydia. You can't be the punk that you first were when you came out – it just doesn't work that way. Everything changes. You can be a great new version of that, and you've gotta keep shading it and keep going with it. But you always have to be a realist about that time you live in. And what the market is. It would be really dumb for me to make midnight movies; we don't have 'em. [*laughs*]

LL: Okay. My final question: John, what do I have to do to get on the casting couch?

JW: Oh you know, I've never used a casting couch, to be honest with you. I guess I have slept with people after the movie, but not during. It's not a good idea. Because the other cast members immediately realize it and hate you. Hahahahahhaha!

LL: I'll stay off the couch. I haven't found one yet that quite fit me anyway.

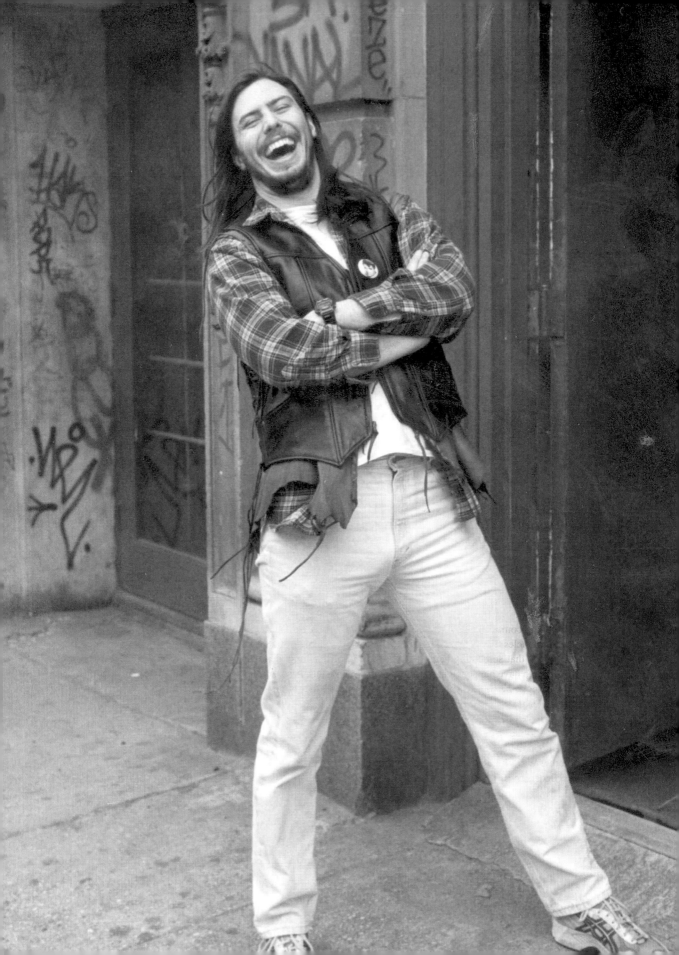

Pacifistic Revenge

- Andrew W.K. -

I'm tired of people telling me they don't give a shit. I hope I never meet another apathetic, cynical person as long as I live. Of course, I know that won't happen. I meet them all the time. I feel as if I am living in a world full of them. Cynics. Smartasses. Opportunists. Jerk-offs. Hipsters. Clowns.

Cynics are very close to me, always. My dilemma is in finding a reason to keep going, despite the odds that no one gives a shit; in knowing that much of the human race *is* cynical, holding back the believers and contributing to the long-term menace in today's culture, and especially in sub-culture. Such people, it could even be argued, are the very reason why influential scenes, projects, and ideas all die within relatively short periods of time.

I'm generally a sympathetic person, with a rather unfortunate knack for attracting desperate people. I allow drunk, inbred bar cretins to waste my time simply because I can relate to their poverty. Chances are, they won't say anything in the slightest bit interesting. Chances are, I've been giving the precious seconds, minutes, hours of my life on Earth away to imbeciles for quite a few years, but this guy slurring in my ear, let's call him Emmet... well, even he is preferable to some washed-up punk rock fashion victim or arrogant underground celebrity.

Emmet's company may well leave much to be desired, but at least he's *for real*. Regardless, he smells bad and has the vocabulary of an Adam Sandler or Ernest P. Worrell. I don't mean to sound arrogant myself, but I'd rather talk to someone who *gets it*. It would be nice to think that there are millions of these people in each and every major city... generally, you're lucky to even find a dozen.

The first time I heard Andrew W.K., I felt like I'd been injected with some kind of brand new drug. I *got it*, in the greater sense. I'd been waiting for this kind of purity, this kind of energy, this kind of honesty, for what seemed like decades. I fell head over heels in love with his debut record *I Get Wet*. Unlike a lot of nebbish music geeks, I took the record with an extreme seriousness. It was simply meant to be. It was not to be questioned. Hit me like a fucking sledgehammer.

After so many years of underground and mainstream rock icons feigning Ultimate Anguish And Intensity on stage (while amusingly Precious and Delicate in the flesh), I'd grown sick and tired of these skinny ass white boy whiners, these punk rock *enfant terribles*. I wasn't the only one who felt this way. But, as I say, we're a minority within several other ones.

Then along comes this guy Andrew. Since his full-length debut and follow up *The Wolf*, it is much easier for me to believe in miracles. I'm infatuated. In my own personal opinion, Andrew W.K. provides something that others can't, couldn't, won't: that something being light at the end of this long, depressing tunnel. He's one of the most visceral, exciting things to have happened in music since the Sex Pistols. Also, Andrew gave me great advice about women, and about just being a person in a world, a society, a culture, that is rapidly losing respect for its own artists, and for humanity in general.

I don't have much respect for humanity. *Homo sapiens* generally cause me fear, neausea, or depression. I'd like to be a better, kinder person. Andrew W.K. made me consider this. His music changed me, and knowing him, if only for an afternoon, that changed me too.

Andrew W.K will never give up on his music, which is to say, music itself. He speaks of music in much the same way churchgoers speak of God. All human beings, at some time or another, lose themselves in the fear and panic that result from questioning an existence which seems to lack all meaning. W.K.'s got a lot on his mind, probably a lot more than you do. W.K. is asking the big questions. And his approach is relatively fat free, compared to the whining of your average apathy-stricken twenty-something. Music is his way of both simplifying those larger questions, and answering them.

After reading this interview, you'll know that as well as I do. But let's just say, hypothetically, that he did give up on music. The strength and dignity and beautiful morality of this person damn near guarantees him a career in professional advice. I may not agree with everything he has to say 100%, but there's a bigger picture to consider here, and in that bigger picture, he's fundamentally aware of everything which would make this world a better place to live.

He's right fucking on.

Gene Gregorits: It seems that with you, intensity is an end in itself. To make the loudest and most powerful record.

Andrew W.K.: Yeah, and to find new ways to do it. There are things that are untouched, I think. By the very nature of our lives, it is original. If I can embrace that, and not even react to what else has happened or is happening, then maybe I can just do what I'm doing, and do it as *all the way* as I can. That will be my best shot at being me. It becomes a work ethic, where you say, "what's going to be original about this, is that I am going to work harder than anyone has ever worked." That, in itself, isn't original. But to think that I'm just going to do my best, for me, took a lot of the stress out of having to come up with some *idea*. I just said, "well, here's my idea, whatever it is. Good or bad, old or new. I'm doing it as much as it has ever been done, if it has been." That makes it more comforting, because it makes it more about me as a person, and other people, rather than written ideas or descriptions. More about experiences, and feelings, which makes it bigger and more relevant to reality as I see it… If there's an event that happened… the event itself is not so much what is important, as how people reacted and felt, when that event went down.

GG: How does the experience of your shows differ from the experience of hearing the record on a really good stereo at full volume? What would you like people to come away from the shows feeling?

A W.K.: Well, I do think that it makes things clearer, to see the show. I just base it on what people say, and I'm sure people have different views. It seems that when people see it live, they have an increased appreciation for it… see, that's the thing, I don't know if there is anything to understand. It's not whether you get it or not, you just feel how you feel about it. People are constantly trying to figure things out, and very often I think they figure them right out of being exciting anymore. If it can become something that is undeniable, or just takes over, overwhelms you, then you really become defenceless, and you don't have to worry about what it is.

GG: Being so primal that you don't have to think about it.

A W.K.: Yeah, and I think that the live thing really makes that clear, and very easy.

GG: You really tear yourself up doing those shows, I imagine. The intensity of them is widely known. How do you keep up the pace?

A W.K.: I don't know, because it's only been a very brief period so far. I see bands that have been playing concerts for twenty years and they're still pretty intense. You take it on a day to day basis. I think that there are people who play more intense shows than I do. I set a personal standard, that if I do not feel completely physically spent at the end of the concert, then I have not done well. If you have goals like that, that you can apply and achieve on a daily basis, it gives you, if not

satisfaction, then a sense that you're at least doing the minimum. There's bands that have made their *vision* in the spirit of GG Allin…

GG: It's strange to hear you talk about GG Allin, because there are similarities between you and him.

A W.K.: [*laughs*] There cannot be another one of him. Well… I guess there could be. I personally would be very impressed if someone simply took it upon themselves to do that. But he took being a human being to another place that hadn't been seen otherwise in… I think, in the twentieth century.

GG: What is valid about living that life, to you, and how does that kind of deliberate, constant self-punishment fit into your own philosophy? I mean, we're talking about the most flagrantly self-destructive man in rock history…

A W.K.: [*laughs*] I don't judge people based on their beliefs so much, but rather on their commitment to those beliefs. And with GG… man, you really couldn't ask for more commitment than that. There are so very few things that are as real as that. I consider GG to be one of the most important people of all time, in music. There's no one else like him. He's everything that I would never be able to do. Or would want to be. And yet, I do relate to him.

GG: What specifically do you relate to?

A W.K.: His lyrics are so good. But I have always made an effort to just be myself. That's a quality I always appreciate in other people. That's what I value and look for. It's not easy. And at the same time, it's *really* easy. He was captivating. He just seemed like the scariest person in the world. That was exciting! That's why anybody likes him. He decided to be somebody and just did that, all the way. People might say, "he used drugs and alcohol to make things easier." But I think that was the point, to use all those things, for what they were worth. It's not easy to do drugs and drink, at all times. I would just like to know more about what he was thinking. That's the mystery. We'll never know exactly what was running through his head. He was incredibly smart, you know he knew what he was doing, and you know that he had thought it up. His early visions, his early plans and early recordings, were all based on something. He saw it, and he planned it out. That's amazing.

GG: You're doing that. So… where do you go after *I Get Wet*? Some people, when that came out, immediately took the attitude of, "where could he possibly go from this?"

A W.K.: When I made that record, I had never gone on a full tour around the world. I had never played live concerts to more than fifty people at a time. That was the first time I ever recorded in a professional setting. It was all very new. That record was recorded without a band.

GG: It was all you, on the record?

A W.K.: There were other musicians playing, but it wasn't played *as a band*. A drummer played separately, the guitar player played separately. On this new record, I did

absolutely everything. Every single thing. That worked out good. Oh, we had one background singer.

GG: So you just use a band for gigs?

A W.K.: There is a band, but that's the fine line we walk. There aren't many live bands that I know of who would give the level of dedication and hard work that these guys give. So at the same time, it's not just a hired live band. It's my band, it just so happens that I made the records.

GG: So why did you use other people for *I Get Wet*?

A W.K.: I couldn't play drums well enough. I couldn't play guitar well enough, at that time. It was all about quality. I don't get excited by the fact of someone playing everything. I don't even like talking about that. You won't see anything on the record like, "everything on this record was played by me." I get a little uncomfortable, because it defeats the point of what this is about. It's not about me. My whole thing is, I just want it to be as good as it can possibly be. And on *I Get Wet*, I knew that to make it the best it could be, it'd be smart to use other people. It took a really long time, because of that. You have to show them the part, teach it to them a million times, 'til they get it right. That's what made it good. This one is good because of me doing everything. There's not a lot of integrity beyond quality, so I don't have hang-ups about equipment, I don't have hang-ups about how it should be played, or who should play it. Now, there's a bunch of people involved, and it's about more than just me. The more that this continues, the less important I become in it. That's exactly what I dream of. There was so much attitude that I faced, and still face, where people almost pride themselves on not caring about what other people think. Assuming that they are above the opinions of others, or above their input. And I think that it takes – and I don't know if I have it all right now, but I'm working on it – a lot more strength and courage to say, "I'm going to take on everybody else's cares, or as many as I can afford to. Their cares, their opinions, and their values… and try to include it in what I want to do." I can actually say that I do care what people think, and I do care that if they don't like this, I'm going to be bummed out. It's harder! It doesn't make it easier! It's so much easier to say, "fuck it, I don't care."

GG: Outside of just trying to make everybody happy, what I like so much about your approach is that you are obviously striving for some kind of united reality, where people don't have to have such shitty attitudes.

A W.K.: United reality. That's an amazing way to describe this thing that I've been thinking about, more and more. It *is* a united reality. Because I feel that young people are going in that direction, despite what other people may think. That young people suck, or are doomed. No. We're gonna be just fine. As a matter of fact, the sooner young people start taking over, as far as I can see, the better. Now, let's talk about this 'united reality' thing. I think that, with so much information, people identify themselves basically with how they react to what's presented to them, rather than just how they *are*. I do that too. You define yourself by

"I set a personal standard, that if I do not feel completely physically spent at the end of the concert, then I have not done well."

what you weed out of what is presented. Who I am is what I decide is okay, from what is presented. As opposed to who I am, maybe just amidst all this. It seems that there has been a resurgence of the defiant, because of how much has been shoved down your throat. Well, let me take that back. I don't think things are shoved down people's throats. I think it's all up to people, and if you can be strong enough to take it on, nothing's being shoved down. You allow it to be shoved down or you don't. I hear people priding themselves, in a glamorized way, that being apathetic to what's going on, while creating their own world, is somehow superior to those that just live in the world. That if I can make my own private little world, where everything I do is great, and I get to work on my stuff all the time, and I don't have to worry about what's going on outside of it, I'm going to be safe, I'm going to be good, and no one can touch me. That to me, seems like the biggest cop-out. It's so appealing though, because it *is* easy.

GG: Saying that would seem to alienate you from other performers. How do you feel about the fact that that attitude separates you from them, and from the very idea and definition of what it is to be a rock star.

A W.K.: I don't care personally for what the idea of a rock star means. Someone who lives very excessively for no other reason than to just do that. It doesn't accomplish anything except entertainment value for others witnessing it. But I don't have anything against rock stars. And I'll be that for someone, if that's how they want it to be. There are other people doing that. It's been done, it's covered. Great. Let it go. Like it, love it, whatever. But… *we're* doing *this*. And if this isn't quite as exciting in those ways, that's fine, because it's even more exciting in other ways. The same way as, it might be more exciting to go and hang out with some famous actress, but at the end of the day, you're always gonna want to go and hang out with your best friend. And that is what I want this music to be. And I would like to fill that role, and be that kind of guy. I wanted to fill that role, because to have those things in life is extremely rare, and also, I think, very important. It comforts.

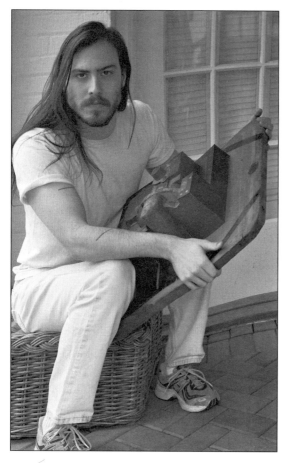

GG: I'm not a social person, so I was glad to get away. Living here made me terribly self-conscious.

A W.K.: Self-conscious is a *good* thing! Self-aware. 'I am conscious of myself'. I don't think that's bad. Being aware of yourself is the first step to knowing who you are, and improving on it. Hopefully, you never stop that.

GG: It's amazing that you were doing your stuff in New York, and managed to avoid getting bitter. That's miraculous, I think.

A W.K.: That's not even important anymore. What's important is that I have to get this recording thing done, tonight. I have a meeting tomorrow at noon. And I have to get groceries. Those kind of thoughts, that do nothing but slow you down, can be put on the back burner. What ended up becoming my entire mindset, was that there is no end result I was looking for. There's a lyric on the new album where I say, "I made a mission my goal, a vision my job." The mission of this *is* the goal, and the goal is not an end result. The mission itself, the undertaking in itself, *is* the goal, to just keep doing it every day. To keep working harder. There's nothing better than waking up in the morning, knowing that I can *do* things today, and put hard work into it. Hopefully it benefits someone other than myself. You can help yourself and help someone else, too. It's the beauty of being human.

GG: Okay, so how does an angry and hateful song such as 'Ready to Die' fit into your generally exuberant attitude? Is that song aimed at anyone in particular?

A W.K.: The way I thought of it was, this country's pretty easy. Most neighbourhoods and most cities and most towns don't deal with life or death situations, beyond car accidents and health issues. But there are certainly neighbourhoods and cities where people live in war zones. I thought that if you could apply that level of intensity into your daily life... as in, if I knew I'd die today, would I be living that day like it *was* the last? That's where the idea came from.

GG: "You're just a parasite, now close your eyes and say goodnight." Pardon me for saying so, but that sounds very personal.

A W.K.: Yeah. But I think I was talking to myself more than I was talking to somebody else. On that song, I wasn't thinking so much about what the lyrics meant so much as I just wanted to have something that felt good to sing. It was exciting to me to have a song that was very good natured... and then to have a song that completely flipped it. Just because it made it bigger... you know what? Everything I've been talking about for the last two years, and everything I've learned, because of what I've experienced, that's led me to become a different person, and a better person. That's what I want to sing about, and that's what I feel I owe to the people that have caused that to happen. And the people that support the same thing I love, which is music... I think there's a lot of people who somehow, despite a bloody nose on the cover... and

GG: People seemed to pick up on that pretty quickly. I've checked out some fan letters on your site, and I think people are getting what you do. And then there are people who just don't think you could possibly be serious. Does that frustrate you, that people won't just say, "it's great" or "it sucks", but "he's not for real"?

A W.K.: If I am too wrapped up in my own mind then yeah, I will get frustrated with that. I have no right to be frustrated by that though, because if I am going to be honest with myself, then I have to admit, I was not only anticipating that kind of response, but I was almost excited about it. Of course people are going to respond that way! I get driven by what I feel threatened by. I'm driven by what I don't like, and I'm driven by competition. Any negativity I find in the world or in myself, I use that to push forward. If I open a magazine... the bad things I used to avoid, because they'd put me in a bad mood. But now, I just use it to push me ahead, to stay up an extra three hours and get something done. New York has a ton of that. There are so many people here, of all different kinds, and you've gotta meet people that you don't care for, and it forces you to think about yourself a lot more... and become more accepting, at the same time. I just feel that from living here, I really learned a lot, about how to deal with stuff.

despite a song called 'Ready to Die'… they came away like you did. With "this makes me feel good", "this motivates me", "this inspires me." I have been as honest as I could possibly be on this album. People have said I am much more open on this album… see, I was trying to write lyrics that would make me break down and cry. That was the level of intensity that I wanted to be at. Then there are also people who will say, "I don't care for these lyrics. I'm not like that." That's the risk I took, because I know it's gonna make people uncomfortable. It challenges you to become better, if you're really gonna believe in it. The people I've met through doing *I Get Wet*… I am just floored by how much they love it, and how much they've put into it. I even feel awkward talking about it because I don't want it to seem like I'm bragging. But it has inspired me beyond any level of inspiration I've ever had in my life. How much this has meant to people. And how I didn't anticipate that at all. I would have been happy if I'd met a few cool fans. Talked to people who said, "oh yeah, great songs, and I love it." But the reaction I got was so intense, that it literally, fundamentally changed me as a person. I think that is a rare thing. I don't think that people are changed by other people very often. Again, it was coming from a somewhat lonely person. It was coming from someone who wanted nothing more than to be in a band, and play concerts with people. And we've gotten to do that. That dream was realized. I just wanted to give all that back. I am so flabbergasted by the level of intensity people who like this bring to the table… and I wonder, "is this normal? Do other people get this?"

GG: It's probably not normal. You didn't happen in a conventional way. You've been very expressive about your ideas and your world views. Your website is full of your writing, so… I think that people have had time, since that record, to absorb and process all that. I think you just broke through to more people over time. I've talked to people who've attended your concerts, and they rave about it like it was some kind of evangelical experience. Because your music seems driven by a desire to unite people.

A.W.K.: Does it? That's a great compliment. Thank you.

GG: Maybe you'll spawn a cult of nice, unconceited people! [*laughs*]

A.W.K.: Right. Well, it's getting going! There's these fans, who I can't say enough good things about. They're organizing this convention, and that's what I want this to be about. I want all the little things that even people I work with look at and say, "oh no! You don't wanna do that!" No. We gotta do everything! If I don't do everything, I'm going to know that I didn't do everything! If I *can't* do everything, that's one thing. But if I *could*, and I don't… that's when I'm not going to feel very good about myself. I am just obscenely fortunate to have people like something that I like… and that they like it this much. All the stuff I said on the first album, I had to explain it to people later. But now, this one doesn't even need an explanation. It's all said right up front. What I'm wondering is, how are people going to take it? I put it all out on the line. No holding back in any of these lyrics. The criticism I've already had is, "well, this is cheesy, these kind of lyrics." But the reason they think they're cheesy is because they don't have the strength to face something that is maybe more emotional…

GG: I imagine that you would be just as excessive even if you weren't successful right now. Is knowing that you're gonna die one day your main reason?

A.W.K.: That is exactly the reason! On top of that, I think that's the one thing that makes originality, or any of those things which are up for debate… it makes them obsolete.

GG: I think it's important to always be your own man, no matter what, but there's also something petty about that stuff.

A.W.K.: It makes them petty, because at the end, you understand that it is all about effort. It's all about how hard you try.

GG: What you get out of just being alive.

A.W.K.: Yeah. If you're a guy who is a bricklayer, you're a bricklayer! You're not changing the world. But you can say, "I'm going to be the best bricklayer that I can possibly be." That's what this comes down to. It just so happens that this thing which I have chosen to do is up for a lot more critique, when it comes to content. Because it *is* content. It has soul. See, people often ask me if I am religious. There's a lot of Christian hardcore people that identified with *I Get Wet*.

GG: They were drawn to you looking for a spokesman for their beliefs.

A.W.K.: Yeah! And I was blown away! I'm very honoured by that. I'm not a religious person, but I respect religion, and value all the good things that it has… and I abhor all the things it does that are absolutely absurd. But I understand where it comes from, and have compassion for even its bad qualities. Because it's *passion*. And whether it's GG Allin or a mass murderer…

GG: Or Jesus Christ.

A.W.K.: Right! It's passion that makes human beings so fantastic, and amazing. Whether it's those passions and emotions that drive people to do horrible things or not… I guess it's all relative. But that's what I appreciate about religion. It's die-hard! People go overboard with it.

GG: The most extreme people out there are often religious people.

A.W.K.: I'm only going to go more in that direction. Now it has a direction to go. And it will become more clear. At the same time, it will probably evolve on its own. I feel that as much as the last record was either loved or hated, I think this one's going to be even more extreme. I did not set out to do that, in fact I set out to make a more acceptable record, a record my mom would like more. I wanted it to reach more people. I can't deny that I am excited to see people start tearing into it and tearing it apart! Because then, it will be so obvious to me that, if

you don't like this, you're just not comfortable with these kinds of things! Which is straight up, unadulterated, uninhibited pleasure. As I see it.

GG: Do you ever want to have a mansion or a limousine? Are you an anti-materialist?

A W.K.: I don't have a lot of stuff. I find that things, for me, are easier without a whole lot of stuff. I found it's better to spend money on experiences. I put a lot of my own money into touring. I found that that benefited more people, other than just me. And I myself benefited, ultimately more deeply than buying stuff. At the same, I really appreciate and value something like a limousine. It's awesome! I've only ridden in one a couple times, and it's always been a fluke. When we went to the airport in LA, there was a limo parked outside our building. I was like, "is that *ours*?" I didn't order one, I would never order one! I never fly first class. Because I always feel like spending money in productive ways. Just because I wouldn't buy something doesn't mean I'm not gonna be like, "man, this is awesome!" I appreciate that stuff. For me to not appreciate it would be dishonest. Any person that likes this music, I would imagine that they would think it was pretty cool to ride in a limousine, or to live in a fancy house. But just because they don't have it doesn't mean they wouldn't appreciate it.

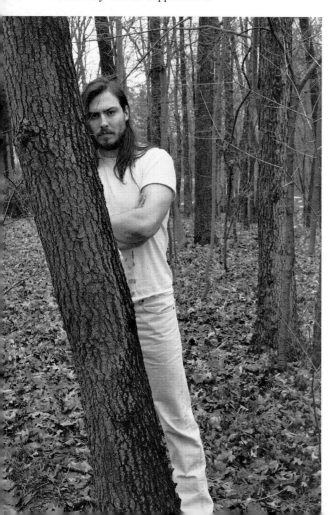

GG: It's not as if you haven't earned it. You were struggling for years. And what's more, you were doing the early records alone. *Girl's Own Juice* was 100% you, right?

A W.K.: That was 100% me. This new record sounds more like that one. I was worried, because there's so many great guitar riffs on *I Get Wet*. On this one, there aren't so many guitar chords. It's all about leads. it's all about melody.

GG: You're a classically trained pianist. You write your songs on the piano.

A W.K.: Yes! Yeah, I write all my sings on the piano.

GG: How do you think that affects the way that they eventually come out, as opposed to working them out on a guitar?

A W.K.: That's a very good point! And I never thought about that until the guitar players in my bands pointed these things out. "That's so weird", they'd say. "These parts are so weird!" The way I actually play guitar, and the way I played it on this album, entirely, is I take off the two thinnest strings, the highest ones, and leave the other four. I tune that to a chord. It makes this great chord that you can play with just one finger, basically, meaning that you're just sliding around on that neck. It's really hard to play that way, but I got really good over the years because I never had the patience to learn chords when I first started playing. That was really stupid, and I regret it, but I could still learn chords. At the end of the day, it was really good to just be able to play immediately. I can make a chord with one finger a lot easier than I can with three or four fingers. I think that the piano playing just gave the music the kind of sound that it has. What the left hand would play on the piano, that's what the bass would play, on a bass guitar. And that's what the guitars follow. And all these piano chords, they just voice out particular sounds that the music has. That's what makes my music sound the way it does. And you don't even really hear it. You hear it a lot more on this record though, because there are a lot more keyboards on this album. There's a lot more tracks, making this album thicker than the last one.

GG: I read about the recording process of *I Get Wet*. I'm alienated by technology, but for some reason I found that to be fascinating. Laying down these countless track layers. It seems you took that as far as it could go…

A W.K.: There's a lot of tracks, yeah. This album was like 100, 110 tracks. The guy who mixed it, Dave Way, has mixed stuff for Michael Jackson and Christina Aguilera. I chose him because he was very versatile, as well as being very technologically sound.

GG: To record each track separately… that must be time consuming as hell.

A W.K.: Oh yeah.

GG: But why?

A W.K.: It just sounds different. There's a certain thing about it, and what will sound confusing to most people, it

would seem like it defeats the point, is that you don't *hear* it! With fewer things, you hear more. With more things you hear less. But that's exactly the point. I don't necessarily want someone to hear a guitar part, and a bass line, and the little piano chords.

GG: But rather, just one mass thing.

A.W.K.: Not even as a wall of sound, but just something that is cranked up, like "REEEEEEEEEEEEE!" [*laughs*] You'll see. It happened in a really innocent way, it wasn't a theory or anything. But I'm the type of person who, if I had the ability to record a lot of tracks, I would. And I did. I could always find one more thing to put in there.

GG: So it's like a techno-alchemy, or a technological fusion... An independent force, a sound almost *without* instruments.

A.W.K.: Exactly! I don't want it to be about the instruments. I want it to be about this music. The song. As big and as loud as it could possibly be. And I don't mean loud as in punishingly loud, but like *glory*. Triumphant music, that just overwhelms, so you don't have the ability to use your brain, and pick out each part. It just does what it needs to do.

GG: Well, as someone who employs a lot of technological methods, what are your feelings about the role of technology in music, how it relates to your music, and to music in general?

A.W.K.: When music was first discovered by humans, it was probably as exciting as fire, and the wheel. Maybe not as crucial at that point, but equally mind-blowing. Here's a string they pluck, and there is a tone. Then they divide that string in half, and it's an octave higher, divided in other ways, it becomes different notes. They developed music. It must have been a non-stop commitment to progress, and make better music. Not just for the sake of progressing, but because they felt so honoured to hear it. To make it. They wanted to do right by it. They work on it, making different instruments, better instruments, to play different kinds of things. It evolves that way. Like, the pipe organ. I can't imagine what people must have thought when they first heard that. Using it to pay tribute to the divine, because this is probably our best connection to the divine, and the way this feels. So they just continue on that way, and continue to be inspired by it, and to make it better. They invent electronic instruments. That takes us up to now, where we have computers. And it is always to make it better. Pointing towards the possibility that maybe, if we just keep working at this, and we keep developing it, and letting it progress, someday maybe we'll get that one perfect song. Music purists who say that music reached a pinnacle at one time or in one place, basically are disgracing the entire concept of human progress. And to put a finite end on any human element, whether it be music, or any other creative production, or any humanistic quality, to put a finite limit on it and say, "this was where it was at its best", defies all logic, which is that everything is always moving forward. Whether it's an insect, or a

plant, or a human! Things will always reach an ultimate better end, and in the end, well, it won't even stop there.

GG: So it's about evolution... but also, you see the basic role of music in theological terms, almost.

A.W.K.: It's about finding something. Something that's bigger than you, and what you can conceive of at the time.

GG: For me, music is about the moments where I get a sense of something being pushed open. I have my favourite songs, like everybody, but most of my favourite songs are my favourites because they have a few of those moments. I may not like *all* of the song. I'll hear that moment, and think, "if they could just keep that, and hold that note, and push it further, that would be the perfect song."

A.W.K.: I agree. There are people that have actually said, "you gotta have parts in the song that aren't very good to make the really good parts stand out."

GG: But to have something that would hit you right there, every second of the track...

A.W.K.: Oh boy. Yeah. That's the goal.

GG: ...it'd have to be a totally new kind of music. It couldn't even *be* traditional rock music.

A.W.K.: Okay, then let's do it. I'm always behind. Meaning that... if I was going to sit down and write a new record now, it wouldn't sound like this. At the same time, this new one, I am absolutely dead set on putting it out. Because you can get so far ahead of yourself that you never end up doing anything. Because the minute you've stopped thinking on an idea, you've already thought up a

"The adrenaline you get from being scared? That's really empowering. You get high from it."

new one. So you've got to commit. You've got to put it down. So that's what I try to do. But man, the next album… I don't know what I'm gonna do. My goal isn't necessarily to make a structural breakthrough. I just want people to enjoy it, and not be confused about the fact that it isn't a simple structure. I was asking a lot of people during the making of this record, "Does this make sense to you?" And they're "yeah it does!" And it's weird, because by the time I got to the end of song, I realized that there wasn't really a chorus, there wasn't this, there wasn't that, but you don't notice that because you're just with it as it's going. It's very repetitive. It drives the same point home over and over again. Why say it once, when you can say it a hundred times, and just make it more intense? I try to find new ways to say things, but you can say "I love music" a hundred times, and it never gets any less meaningful. And that's what we're trying to do.

GG: It's important to be repetitive, I think, if you really want to change things.
A W.K.: Absolutely. It has to be beyond the shadow of a doubt. I want there to be no question.

GG: I like that you avoid irony. I think irony usually encourages people to sneer at one thing or another. It's easier to be ironic than to just face something head on.
A W.K.: It's a cheap shot. It's an easy, below-the-belt blow that doesn't take a lot of work. It can still be fun or whatever, I guess.

GG: I think people find it more important to be in on a joke than to actually give a shit, in the end. I think that, to be un-ironic, is to be non-conformist.
A W.K.: I agree. But again, I won't hold it against people. There's that line you cross where you just start worrying about every little detail, making it a pretty miserable experience. You walk away from it feeling very unhappy. I always try to allow myself to let go of those things enough to feel good about it, so it's still enjoyable. If you're always upset with how things turn out, and the process is not enjoyable… this is your *life* you're living, and time is going by so fast. You're always anticipating being happy, when you get something right. Well, I want to be happy as I'm doing it too.

GG: I guess you don't get depressed very often, then.
A W.K.: I get depressed. It doesn't last long. I won't allow that. I have bad days, like anybody else. I've got too much to do, to be really upset about something. I don't have any

real reason to be upset. Moods and chemical shifts will happen, to me and anyone else. But if I just do a quick inventory check of what my life consists of, I don't believe that I have very much to be upset about.

GG: Also, you're very young. It's coming back now, young people becoming successful as musicians. In their twenties. It seems that, for a long time, people were making it big in their thirties.
A W.K.: It *is* very youth oriented these days. I don't know if people identify with me as a young person, or if they see me as being very young. People sometimes seem surprised when I tell them how old I am. I'd like to think that it isn't an age based appreciation. I don't have any hang-ups about age, and I don't have anything against people that are older. I have nothing but respect, in fact. I just hope that it continues to stay youth *driven*, but for everybody. I hope people that are older don't feel embarrassed about liking music that's targeted towards young people. Sometimes I'll meet someone who says, "I'm the oldest person at your concert, don't think I'm weird!" I'm *honoured* that they're there. I don't think they're stupid for being there, I think it's great that they came. I wish more older people would come.

GG: John Waters is a big fan of yours.
A W.K.: Awww, I was so excited when I met him! He came to see us in Baltimore.

GG: He told me that he drives around in his car, listening to 'Party Hard', and people look at him, headbanging at a traffic light.
A W.K.: Now that's a compliment! But… yeah, John Waters. There's a guy who is just so inspiring. He's very driven, and just does what he wants. That's exciting to see. There's no one else like him, he's awesome. And so nice. He's one of those people you talk to and just seem comfortable with, right away. I made an idiot of myself, because I was nervous. I meant to say *Desperate Living*, because that was the first movie of his that I ever saw. But I think I said, *Heavenly Creatures*. I don't know what I was thinking. It was just some kind of weird mix-up in my head. I called him and left him a message, apologizing. I realized ten minutes after he left, "oh my GOD! What an idiot! Why did I say that?" What was so weird was that he didn't even correct me when I did it! He just laughed, and thought I didn't know what I was talking about. But I really did! My friends are obsessed with John Waters. So I felt very honoured to be the one meeting him. I told him, " I just want you to know, I have so many friends that just live and die by you and your movies, and it's a great honour to meet you on their behalf." I get to do so many of these things that my friends wish they could do. I always try to remember that, and do it for them, to do it the way they would do it. To never underappreciate any of these things. I have friends who play in bands, and worked just as hard as I have, for years, and haven't been able to do these things. There are people everywhere who put their soul and every bit of effort they have into doing something that just doesn't pan

out. But I will never take a second of it for granted, and I want people to know that, because it sucks if someone who is doing something you wish you were doing doesn't appreciate it. That's another reason why, when I get to do something, I want to do it all the way. Because I think that that's what that other person would do too, if they had the ability. So they know and I know that I'm not wasting it.

GG: How involved are you with your own videos?

A W.K.: I'd always had these ideas, because I had so long to dream of what music video I would do. A lot of those ideas were probably not very good. I just wanted them to be very basic.

GG: I think that 'She Is Beautiful' is the best video. It's hard to miss the self-reference there. You're basically riffing on your own life, on your hopes.

A W.K.: Yeah, that's true!

GG: What's so immensely great about 'She Is Beautiful' is that it is specifically about *a woman*. Was it written about anyone in particular?

A W.K.: All these songs I worked on for so long, and then I would get re-inspired. You know that part, [*singing*] "I ain't got nothing to lose, I'm gonna"…

GG: THAT'S IT! [*stuttering and spitting*] Wow, man… yeah, that's it! That's my favourite part! See, that's what I was talking about. Remember, when I was talking about those moments in songs? That's exactly what I meant. That's that moment, where the song just… explodes with emotion. A perfect climax! But it's not really, because the *second* time you hit that verse, that's when I just get completely high.

A W.K.: That's great. That's what I like to hear, because that really is the whole point of that. And that's a point in the song, that just couldn't have come earlier. That song was just about seeing a girl in a store, you know, she smiles at you. Or on the subway. And… not even being able to say hi. Blowing it. So… the song is basically a fantasy. I'm *saying* I'm gonna do it. I don't say I'm doing it in the song. I'm *going* to do this. But I kind of never do, really. And I rarely have.

GG: It sounds so fucking easy to do, but [*laughs*] it's not, really!

A W.K.: It's not! And that's what I was working with. "Okay, this is gonna be great. I'm gonna do a song about this."

GG: It's an amazingly powerful song and when I first heard it, it seemed like I'd been needing to hear that song all my life.

A W.K.: Thank you. People tell me that that song has made them ask out certain girls, and that that is who they're with now. That, to me, is mind-blowing!

GG: It's great you can be so optimistic, yet talk about being shy and stuff.

A W.K.: You never overcome any of those fundamental parts of your personality. You just don't give up, and try to overcome them. And in a way, you do overcome them. They can always come back, but you just choose to not

respond to them. All those things that are going to slow me down or hold me back, or keep me from doing all that I could, it just comes down to being afraid, it always does. You just say, "you know what? I'm just not going to give in." I think the most exciting thing is when you realize that.

GG: Yeah. Ask her out. But you look at it like this, right? The girl's had a really shitty day, and there you are, and she's thinking, "Oh yeah, that's all I fucking need. Christ!" [*laughs*] I don't mean to play Devil's Advocate, or to be a cynic, but there are things which must be considered.

A W.K.: I can relate to that too. Yeah, the last thing she wants is to be bothered. But… you know Eugene Levy, the comedian?

GG: Yeah.

A W.K.: He was at MTV Studios the same day I was there. I'm thinking, "oh man, I can't believe he's here, I really would love to just say hi to him." Every chance I've gotten to meet someone I really love, all I want to do is say, "what you've done is amazing, I love it." That's what would make me feel good, to just tell them. But with him, I was like, "I don't want to bug him, he doesn't know who I am!" He ended up coming up to me and saying, "I really love your music." He knew who I was! I was absolutely flabbergasted. I think it's important to remember that you never know, on one hand. Far too often, I hear from really beautiful, amazing women, that they wish guys would ask them out, and that no one ever does, because they're afraid to. It goes both ways. I think that far too often, we convince ourselves that the thing we're afraid to do is probably the wrong thing to do anyway, because of X, Y, and Z. But so what if you annoy 'em? At least you tried.

GG: My excuse now is that I shaved my head a few weeks ago, because I'd decided to become a monk. Now I go out anyway, but I'm that bald guy.

A W.K.: I used to shave my head.

GG: Yeah? Your hair is too much a part of the whole W.K. thing. You can't shave your head.

A W.K.: No, I can't, really, and I don't wanna do it. That's the thing, though! That's what I'm saying. Push it! Throw it out there! Just when you thought everything is all fine and dandy and this is who I am, and I'm speaking just for myself… I'm totally thinking do it! Make it uncomfortable, make it freaked out. Make it scary to do, because that is such a great feeling. That feeling you can get from doing stuff like that, whether it is thought based, or going and talking to a girl. The adrenaline you get from being scared? That's really empowering. You get high from it. I just think that there's a way to live that allows you to not be a complete miscreant and disregard all things that society has set up, but at the same time, to have fun with it and realize that it all really is kinda inconsequential. You can use the realization of the lack of consequence to get where you really need to be. And once you're there, you can then go back and say, "it really *does* matter, and I'm glad I did it."

GG: How often do you listen to your own stuff?

A W.K.: I guess, when we're on tour, since we're playing it every night, I don't. But every now and then, I'll put it on. You have to consider that there are literally thousands of hours spent on recording the stuff…

GG: One five second bit of your music, yeah… that amounts to so much time spent. So many track layers, one after the other…

A W.K.: This time, I hired a professional backup singer, to do these harmonies and things. I sang with him, just to get one more different voice. But the group vocals on this, I did them all myself. On some of the last songs, which were the most complex, and that's why I saved them for last, we did about 600 vocal takes. We break it down, word for word, so it's the best. Instead of singing a whole line, I'll sing half a line. Just get a few words, to make it as good as it could be. You get into a dangerous game there, because at the end, when you have a thousand tracks and a thousand things going on, you're not going to hear that level of detail, but you hear the mentality.

GG: Creating a monster.

A W.K.: That's right. And that monster, you may not see its bones, you may not see the blood running through its veins, and you might not see its guts… but you can see it exists because of what is inside. So just because you'll never hear that little vocal thing that I spent two hours on, you get a sense that it *is* there. It really does make a difference in the end! Whether you hear it or not. That's what I love about a lot of music! Especially music made for young people. The standard by which they make music for young people is so exceedingly high, and the production values are so through the roof. Yet the audience is one which would never appreciate or hear those things, or even *care*!

GG: Do you think your audience cares?

A W.K.: I really don't know! As many interviews as I do, it's rare that we talk about the music in particular. I hope people like it! I hope it doesn't become that big of an issue. I hope it sounds really easy. Look, I put all those thousands of hours of work, all those vocal takes, all the recording, and all the figuring out how the music is supposed to go… but you can listen to it, and it sounds like it was just made like *that*, BAM! It's not difficult music. It's the easiest music, as hard as it was to make.

All photos of Andrew W.K. reproduced with permission.
Copyright © 2004, R.C.U. Audio, Int'l.

Dead On Camera

- Lech Kowalski -

"I'm interested in people that have troubles, that have a hard time living. That's what I am fascinated by, people that can't fit in. Or people that are trying not *to fit in. Anyone who fits into something that is part of the major corporate reality is totally worthless to me."*
– Lech Kowalski –

"I can't even imagine a time when India could become a first-world country. I just can't imagine it, because it wouldn't be India anymore. There's a reassuring feeling about that. That certain people just are the way they are... and that's it."
– Lech Kowalski –

"What can you possibly say about sex that is of any interest whatsoever?"
– Lech Kowalski –

It is a humid, filthy night in New York's lower east side, sometime during the summer of 1998. The man to my left is tense and agitated. He runs a restless hand through his longish, greying hair and clicks incessantly on a mouse while backing up and advancing a grainy image of a guy in a candle-lit room injecting himself with heroin. Lech Kowalski is at the end of his rope; he has been in this makeshift editing room for several days without sleep.

Born in 1950s London to Polish immigrants who had fled a Russian concentration camp during World War II, Kowalski grew up in a milieu of nomadic displacement. In the early '60s his family finally settled in the post-industrial city of Utica, New York and it was there that he first came to appreciate rock'n'roll. By the age of ten, Kowalski was still struggling to become fluent in English, and having a difficult time in school. A few years later, he received a gift that would turn his world around: a used Super-8 camera.

At 14, he shot his first film, *The Danger Halls*, about high school potheads. The film marked a sinister debut for the budding auteur, soon to embark on a bleak series of film projects about misfits, outsiders, and addicts; stories and films often steeped in an all-consuming aesthetic malevolence that Kowalski could easily claim as his own style. Each film that followed *The Danger Halls* retained an ambivalent obsession, on camera and off, with both legal confrontation and narcotic abuse.

By 1971, Kowalski had fled Utica for New York City where he enrolled in the School of Visual Arts and discovered his two greatest influences, Shirley Clarke and Tom Reichman. Both were early purveyors of *cinema vérité*. Clarke was a middle-class white woman who made films about black junkies. Reichman, an impoverished genius best known for his stark 1968 film portrait of jazz legend Charles Mingus, dabbled in everything from low-rent porn to industrial gigs and sporting events. He committed suicide in 1975.

At the age of 25, Kowalski had shot and directed over a dozen porn loops. Although these Mafia-financed films did not survive the 1970s, veteran New York arts writer Mark Kramer, who was a featured 'player' in Kowalski's *Loops of Violence*, called them "Grand Guignol on a beer budget" and "a disquieting homage to anti-sex."

Ironically, it was the porn industry, although still in its leather diapers, to which sex seemed to mean the least. Unlike the punk movement, their disdain wasn't even disguised by death and gore; the lost souls of New York's burgeoning porn scene just did it – and they did it cheap. In 1977, Kowalski completed his first feature-length film, *Sex Stars*, a documentary about NYC porn actors.

Soon afterwards, the UK punk movement began to espouse a credo that went a few steps beyond the complacent hedonism of the New York scene. While the Rotten Apple's roving, Rimbaud-hip hordes of white trash transgressors boasted heroin habits, cocaine parties, and lots of hometown pride, bands such as the Sex Pistols, The Clash, and Sham 69 all despised their drab London surroundings, and were far more familiar with bathtub chloral hydrate meth-amphetamines and basic poverty than with French poetry, Peruvian marching powder, or post-beat art experiments.

Kowalski only became interested in documenting punk when a toxic double assault of heroin and commercial interest had virtually bled the movement to death – hence the title of his 1981 film, *Dead On Arrival* (a.k.a. *D.O.A.*). He used the Sex Pistols' apocalyptic tour of the American south as an allegorical stage on which to set his vision of an entire subculture's downfall. "So… if you just think about the sexual perversion, and the weirdness... spitting, green hair, safety pins, self mutilation. These were the kind of images that Americans were associating with punk. And to Americans down there, this was like the Martians coming." His unauthorized filming of the Sex Pistols mirrored the hostile climate, resulting in footage as violent and chaotic as the tour itself. *D.O.A.* was saturated in an oppressively post-mortem atmosphere enhanced by the unique sound editing of frequent Kowalski collaborator, Val Kuklowsky. Producer Tom Forcade, who funded *High Times* magazine by smuggling large quantities of grass from Central America, died of a self-inflicted gunshot wound in November of 1978, suspending *D.O.A.*'s release for over a year and leaving Kowalski to obsess over the film's structure. "It was a very difficult editing process", he told me, "because the film is not so much a story as it is a tone poem."

In 1985, he made his most shocking film to date, *Gringo* (later re-titled *Story of a Junkie* by Troma). An altogether gruelling work of cold-blooded yet oddly compassionate neutrality, the film blended fictional set pieces with authentic heroin abuse, depicting the life of a notorious New York dope fiend named John Spacely. Ann Barish, wife of blockbuster film producer and Planet Hollywood creator Keith Barish, bankrolled much of the project, and through her the film garnered heated testimonials from Stacy Keach and David Keith. Matt Dillon, who was dating an ex-girlfriend of Kowalski at the time, appeared briefly in the film's opening scene. *Gringo* premiered at Riker's Island penal colony and was also shown at the White House as an anti-drug message film. With endless scenes of bloody sinks, botched injections, and vomit-soaked overdoses, it was far too extreme for most viewers.

Over the next few years the plight of Manhattan's homeless escalated to a level no one could ignore. No stranger to poverty, Kowalski spent months in 1989 hanging out with and filming habitués of a Lower East Side soup kitchen on the verge of seizure by the New York Housing Committee. The resulting film, *Rock Soup*, was aired on public television but, as in the past, Kowalski's intensity often kept the viewing public at bay. The Sundance Film Festival invited Kowalski and *Rock Soup* to their 1989 event and then changed their mind abruptly when the director extended the invite to a fleet of homeless people who arrived by bus from Salt Lake City. In New York, a theatrical run at Film Forum was terminated when the film's subjects smashed the windows of an adjacent restaurant where a post-premiere celebration was being held.

It would be over a decade before Kowalski completed his next feature, *Born to Lose* (a.k.a. *King Outlaw*). The film proved to be his most complex and problematic venture since *D.O.A.* An early showing at the 1999 Toronto Film Festival marked the beginning of the end of a decade-long struggle to dissect a story only Kowalski could properly tell: the life of proto-punk guitarist and junkie figurehead Johnny Thunders. Thunders, whose band flyers would exclaim "See him while he's still alive!", invented the sound (with the New York Dolls) upon which later punk groundbreakers like the Ramones would base their musical style. But Thunders was no ordinary junkie; he made William Burroughs look like John the Baptist by comparison. His excess – almost pornographic in nature – was miraculously managed by the rock'n'roll Thanatos until 1991, when he was found dead in a New Orleans flophouse with ample evidence of foul play.

The film was the basis of my frenetic working relationship with Lech Kowalski. In 1999, I designed the film's original one-sheet, covered the Toronto event, and most importantly, after shattering both of my feet in a second-story plunge only hours after a New York advance screening of the film, allowed him to document my bloody hands and knees crawling to a midtown hospital. No one said working with Kowalski would be easy.

Thirty years after his emergence as the American underground's answer to Werner Herzog, Lech Kowalski has completed a dark trilogy of European projects collectively titled *The Fabulous Art of Surviving*. The first of these is 2002's *The Boot Factory*. ("Imagine if the Sex Pistols made boots instead of music," says Kowalski.) Second is *On Hitler's Highway* (an unscripted road trip on a sinister route paved by the Third Reich to facilitate the invasion of Eastern Europe). And finally, *East of Paradise*, which centres on his mother's experiences in a Soviet gulag.

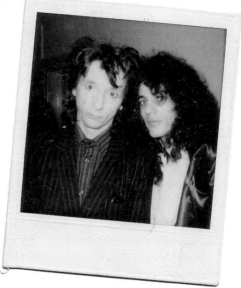

In the decade that has passed since Kowalski and I sat down for our first conversation, his Thunders film remains unreleased, as do all but one project he's helmed since (which is merely an extended out-take from *Born to Lose*).

I half-suspect that he almost likes it that way.

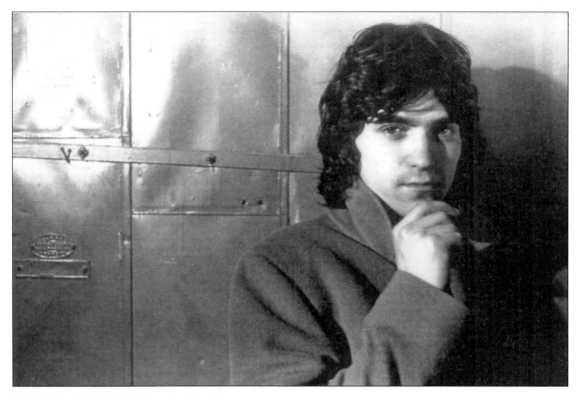

Above: Lech Kowalski, NYC, 1977. Photo courtesy of the artist.
Opposite Bottom: Johnny Thunders with Adam Bomb, 1989. Photo by Lech Kowalski.

GG: I can imagine someone walking into *Born to Lose*, not knowing about Thunders, expecting some dumb rock'n'roll film, and then watching it and feeling like they've been pistol whipped by it because it's so concentrated and potent...

LK: Yeah. The thing with this film is, I don't want to be nice with it, I just want to be effective with it. I think it delivered some things... I don't think it went all the way. But what I'm sensing is that there's an air where people want to be hit with something. It's not an intellectual idea... people are just fed up and they wanna scream and kick and if they can find a book or a film or a piece of music that would help them do that, they'll get excited by it. It's not even about quality, it's about something else. I don't want the film to be experimental in that sense, where it's like a curiosity. I want it to really have an effect on people, in some way. That has to do with pacing, and music, imagery, the way it's shot and stuff, the rawness of it. I think that there's a kind of rawness to the film that has some sort of integrity, which to me is important because it's not over-produced or anything. I mean I hate something that's shot on video for the most part. But this film... first of all, it's the only way I could really finance it, is to shoot a lot of it on video. But I shot in a certain kind of way, with certain kinds of lenses, a certain kind of video format, to give it my look. Then

translating that into a computer and re-translating that into film, I think adds this graininess that I think is pretty cool. I want to do more of that.

GG: *D.O.A.* was pretty grainy itself.

LK: Yeah, that was all shot in 16mm. It was shot with available light, with different lenses and film stock, but it was pretty grainy, yeah.

GG: Making *D.O.A.*, I was wondering about the rigors of getting in the concert halls down south with your cameras, and the trouble you got from the guards there. It was really a violent time, during that final Sex Pistols tour. When you were shooting *Born to Lose*, did you see any parallels to what happened back in '78?

LK: It's a different kind of edge, yeah. The way that I shoot this thing, is I go out and meet people who knew Johnny, and then I have to spend time with them. To interview them... try to get stuff out of them. That in itself is kind of edgy. You have to make an interesting scene, so you get people to do things, or film things in a way that it's a certain kind of emotional blackmail. You can't really tell someone what you want from them, you have to sort of manipulate them, to give you something that you want. But you don't really know what you want. You have no idea what the experience this person had with Johnny was. You're playing this game with them, and you don't want to lead them too much, but you still have to lead

them, so... it's really exhausting, I hate the whole process. To do it effectively, you have to have the right subject matter and the right characters in front of you.

GG: It has a feeling of maturity that your other films made up for in less subtle ways. They were exciting, and showed the more dangerous manoeuvres you executed to get your stuff... *D.O.A.* **and** *Gringo* **were shot in dangerous environments. But in this one, you have a more sit-down, calm approach and you're doing stuff in a studio; you're not out on some kind of** *D.O.A.***-like battlefield.**

LK: The battlefield is in the editing room. This is the first film that I edited on a computer, on the Avid. I bought this fuckin' Avid because most editors right now are not good for this type of film. Editors nowadays are for the most part doing commercials and shorts and stuff. They have no idea how to tell stories. It's like a dying art, you know? And I figured, let me learn the Avid, which I had to do and cut this thing myself. So I went through this weird learning process, and now, a year later, I'm re-editing this film... I've discovered that I've made three cuts of the film, before I got to a cut that I liked. And I realized that in the cutting, I was really influenced by MTV a great deal. Now I want longer takes, I want the camera to just sit there and observe things, and let the the viewer really see what's going on, instead of manipulating them, and cutting it up. I really hate cutaways, and I'm trying to eliminate all that stuff from the film. But I'm using the kind of equipment where it manipulates you, it lets you cut too quick, and sometimes you end up with an MTV style cut, and you've got to pull back. Somehow, this equipment is really detrimental to good storytelling. I don't know what it is man, but it's like the difference between writing with pen or pencil, and writing on a computer... that's a similar difference. And you have to control it, not let it control you. That's what I'm trying to do now; I'm going to build a pacing that gets more and more tense. The biggest part of trying to get a handle on this material is that so much of it is video. I'm trying to figure out how to pace the video so it feels like film. It's been a year of pain and torture and bullshit. Real severe letdowns in the editing room. But I'm just getting it now. This guy just asked me to edit a film that he's making about KISS, and it's a great experience because I put my own film away for a while, and I'm editing his film. So it has no emotional attachments to it, it's not my film. I think that it's gonna be a good film. At first, you might think it's a stupid idea, but I think it's a great idea. It's about stupidity, and mundane-ness, and I think it's funny because KISS were out at the same time as The [New York] Dolls. They played together, in fact. And here I am making a film about people in both worlds. As I looked at this thing... I don't know what else you can say about rock'n'roll. I don't even know what rock'n'roll means anymore. But I do know that the essence of rock'n'roll is a way of being uniquely yourself. And if you can do that, that's rock'n'roll. And there's very few people who are like that.

You don't have to be a musician to be a rock'n'roller. You could be a great chef, or run a fuckin' pizza parlour, you know? It's a certain kind of attitude, you're a rock'n'roller.

GG: Do you think you're always going to have that rock'n'roll mentality as a director, no matter what you're making?

LK: Yeah, I think so. It's too late to change that. And all my ideas are going more and more in that direction. I'm really disinterested in documentaries right now. And it's becoming more and more difficult to even finish this film, the Johnny Thunders film, because it is a documentary and it's really limiting in a certain way. It's also frightening to go into the idea of pure narrative, because you have rely on whatever talent you have to create a good story. I'm not that interested in films anymore, in terms of watching films. I'm not interested in seeing two good ideas poorly expressed. When was the last time you saw a good film?

GG: Oh, it was about three weeks ago. I told you about *No Way Home.*

LK: Oh, yeah. I really want to see that.

GG: I called Buddy [Giovinazzo] up on the phone the other night, I just had to tell him how much I loved it. When I see a good film, it just comes out of nowhere, throws me, and that's what I like. If I expect something, I may appreciate what comes, but it's not gonna have the same effect on me unless it's really, really well done, and original. I've got a pretty accurate feel for what you do – I've seen *D.O.A.* **time and time again – but I was still shocked by the Johnny Thunders stuff you showed me. It's full of surprises.**

LK: I still have some more coming. I'm looking through material that I ignored before. I came to realize that there's something buried in it. I've been shooting it on and off over the years. So if I can hold on, financially, for the next six months... if it has to be that much longer before it's ready, then I'll fuckin' do it. Because ten years from now, I don't want to sit in a theatre and cringe every fuckin' time I see it. At that point nobody's gonna care if I had financial problems or whatever, you know, you just want a good movie. So I'll wait longer and make sure it comes out properly. The drafts that you've been seeing are like sketches to me. I think I can go much further, make it much more powerful. There are more emotional parts I want to go into, more experimental parts I want to go into. So if I can take all those ideas, and channel them, really control them, it'll make a really powerful film that transcends rock'n'roll and Johnny Thunders and myself, in the material.

GG: Do you have all that footage in the can already? Because I know you have over 500 hours of footage.

LK: Yeah. It's all in this room. We're surrounded by it in here. I just got to go through it, and take out the good stuff to make it work. That's what I'm doing. Just allowing it to wash over me, without manipulating. I've been fuckin' thinkin' about this thing for so long, I know the story. I just have to find the right pieces.

GG: A lot of the power of the film is in the cutting, and then of course there's the music, which can be even more obviously effective. Do you feel your groundwork has all been laid down?

LK: Oh, absolutely. I know the beginning, and I know the end. I know some things I want to do in the middle of it. And there's a few areas that I want to go into, that are a little more brutal than what you've seen so far. They're more brutal in terms of putting people in a more devastating context. But I don't care about that anymore. I don't want this film to be some kind of emotional moralistic fuckin' thing. Like a sappy film, y'know... I wanna get away from that, make it much more real and relentless.

GG: And that would be even more hard hitting than introducing some kind of moral to the film. Then you're given a way out. I'm assuming you're going to leave it all sort of hanging in the air, nothing tied up in some neat little cop out package for those who can't swallow a hard dose of reality.

LK: No, not at all, nothing like that whatsoever. You know... Johnny's sister was at the screening in Rochester, and I was really nervous about it. So was she. To my surprise, she liked it. [*laughs*] Not really to my surprise, but just to my relief, maybe. And it's interesting, you know, when she had the time to think about it, and talk to people about it a few days later, she was really upset by some of those scenes, and one of them is the part where Johnny's son is in the film.

GG: She didn't know that?

LK: She knew that, yeah. But that's not what she was upset about. At the end of that cut, there's a scene where I filmed Johnny's son in prison, and the film ended with him, and on the soundtrack is Johnny singing a song called 'Disappointed In You'. The reason I liked it is because there's many ways to interpret that. Johnny being disappointed in [his son] Vito, even though Johnny died many years before [Vito was incarcerated]. Vito being disappointed in Johnny... Johnny being disappointed in life... Johnny being disappointed with himself... Vito being disappointed with life. I mean, these are all valid interpretations. But she didn't buy it; she just thought it was about Johnny being disappointed in his son. Because... that was her interpretation. She was imposing her emotional needs and whatever on the scene. Twenty different people have twenty different interpretations of that scene. That's the kind of scene that I like.

GG: Johnny's demise had to have been really traumatizing for those who knew him to have to witness. The relentless self destruction; no matter what anybody would say or do, Johnny was on his trip and nobody was going to get him off it.

LK: Yeah... there's no way to rationalize it or emotionalize it. He created his own life, we all do, y'know?

GG: It should be apparent that this song is ambiguous...

> "I think that it's good to try and destroy yourself because that's what life is all about... trying to destroy yourself to find out who the real person is."

LK: Yeah, that's how you interpret it, but everybody's gonna have their own reading on it. I think that a good film gets that kind of reaction, where people read things into it. If you can't read something into a film, it means it's really boring... so it has to have that kind of ambiguity. That helps make a good film.

GG: You're making *Born to Lose* to be your last statement about rock'n'roll. How does Thunders reflect your own view of the subject matter and why are you ending this part of your career with this subject?

LK: I'm not interested in rock'n'roll as a musical form, and I don't think Johnny was either. At the end, he was really tired of all the fuckin' baggage that comes with it. How many rock'n'roll songs can you write, and how many rock'n'roll stories can you tell? How many drugs can you take? How much... rock'n'roll stuff can you do? You have to sort of mature beyond that, you know? The thing I like about Johnny is that he was the extreme edge of that kind of reality. I find that commendable. I'm glad he fuckin' did that, you know, I could never do that. So I'm just jumping on his wagon and taking his ride. And that ride is allowing me to have great material to make a movie, but at the same time, for me and Johnny Thunders to criticize what's going on in society, in general. That's what I'm really interested in. Criticizing everything and... showing a mirror, you know? And Johnny is a really black fuckin' mirror. And the blacker it is, the better it is for me. I'm not looking for a white knight, I'm looking for a black knight. Which Johnny is. The darker the hole you look into, I think the more joy you can get out of life. In other words, it's like if you get so fuckin' black and depressed, it means that when you pull out of it, you'll be so much more relieved, and be happy to be alive... But you still have something that you're affected by, in a deep way. That's what I'm looking for. I'm not looking for a happy ending in any way. I'm looking for the darkest ending I can find, because we're all surrounded by darkness. I want people to deal with it, but just by seeing that somebody had the ability to live such a dark life. Because people just can't go to their own edge,

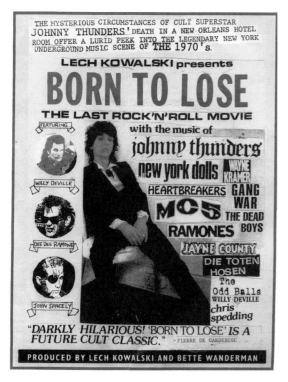

Born to Lose poster designed by Gene Gregorits, 1999.

you know? People have fuckin' boring lives. And I think most people are violent, and aggressive, and crazy, because they hate themselves for being so filled up with the inability to really live. Look at how many songs Johnny wrote, look at how many places in world he went, look at how many people he met. I mean, he wasn't meant to live for a long time. And he didn't. But you know, not everybody can live until they're 80 years old. Johnny was a black angel in that way.

GG: Your movies are full of black angels! You had Sid Vicious in *D.O.A.*, then there's [John] Spacely in *Gringo*...

LK: The homeless people in *Rock Soup*. I guess that's what I'm interested in.

GG: What do you think was killing Johnny? Besides the obvious. [*laughs*]

LK: I think lack of education. Johnny was frustrated because he was so stupid. It was a combination of intellect and an emotional thing that came together and that didn't allow him to grow. I think that he just couldn't deal with that anymore.

GG: The three main characters I mentioned before – Sid, Spacely, and Thunders – were all heroin addicts. How do you feel about heroin? What's the relevance, in the way it seems to emerge in all of your major works?

LK: It's a good question, and I've asked myself that question many times during the filming. I didn't decide at the age of 18 to make movies about heroin addicts. It

just sort of happened to me. I don't know... there's something about a certain state of inebriation, which heroin was about, which is pretty interesting to me. Because it's a way of turning your back on the status quo... I'm not sure why I'm attracted to it. I can't give you the answer, 'cause it's not clear to me. Although Spacely was one kind of character, Thunders is another kind, and Sid is another kind. And they become like, a holy trinity. And maybe I can figure out what that holy trinity is. Spacely is like...

GG: He was the living embodiment of heroin.

LK: Yeah, he's like the most disgusting one, in a way. Sid Vicious is probably the most stupid one, and Johnny is probably the most spiritual one, for lack of a better way to look at it. You know? Sid just didn't have time to evolve into anything. I'm not even sure 'stupid' is the right word to associate with him. But certainly, from what I saw of him, he was by no means the embodiment of intelligence. He wanted to have action. He's the kind of guy who would jump and do something without thinking about it. Spacely was a manipulator. And Johnny was too fearful to be that way. He was more reserved. Because he wanted to continue going on, he saw a future, I think. He wanted to get something accomplished, you know? Drugs were part of his life. But what comes first or second, I don't know... I think that we're all trying to destroy ourselves, or part of ourselves. And Johnny just found a certain way to destroy himself that was both more glamorous and yet less glamorous at the same time. So that is appealing in and of itself. But I think that it's good to try and destroy yourself because that is what life is all about... you go through the beginning of your life and your parents and society is trying to construct you in a certain way and then you spend the next part of your life trying to destroy yourself to find out who the real person is. And sometimes we succeed and sometimes we don't.

GG: But Johnny didn't want to succeed... he just wanted to destroy himself and then have nothing left. Because if he was using drugs in such volume, what could he have thought the outcome of that would be?

LK: I don't know. I think that there's a real age thing going on there... because I am of the age where I can look back at it, and I survived through all that stuff. I mean I never got into drugs like Johnny did, but I just can't imagine being *that* inebriated for *that* long... it's like, you can't win. I'm not saying that people shouldn't do it, because everyone's gonna do what they want anyway. But Johnny just never got to that stage in his life where he didn't need that kind of inebriation. I think that kind of inebriation is needed and interesting when you're going through certain stages of your life, maybe like your mid to late teens, but definitely in your twenties and thirties... because you learn things that way, you can find some of the best things in life.

GG: Do you think a lot of people understand that – your philosophy about destroying yourself to get to what's important and what's real in you?

LK: No, I think that most people are cowards. Almost everyone I know is a coward. Because they choose the easy way out. Some of them are really living the lives that they want to be living...I know people that live in SoHo and who live in California, and have made this decision to fit into society. I don't think that they have chosen an interesting thing to do in their lives. Because they've given up, and these people are probably very critical of the way I do things, but I don't care.

GG: Okay. Change of direction. What about the porno films you were making before, during, and after *Sex Stars*.

LK: Yeah. I made a few loops. Then, in the course of making *Sex Stars*, I met this guy who was the manager of the Capitol Theatre. He gave me $6,000 to make a porno for him. Which I did, and that took a while to make. It was a film called *Loops of Violence*. You know who came to the premiere of that film... Georgina Spelvin, Shirley Clarke, Gay Talese, that kind of crowd. It was the early avant garde literary crowd that Shirley Clarke was tied into. It was a very strange, weird film, a lurid experience, but I learned a lot at that point I learned how to tie in all the production and post production and final print elements of making a film, like mixing and that kind of stuff.

GG: Do you know where these films are now? Did they ever go anywhere after the '70s?

LK: I don't know where the hell they are. I'd like to get a hold of *Loops of Violence* because I think it's one of my more interesting films. It was shot on video and on film, and a lot of it was shot in this guy's apartment in the West Village. He was into blues and the entire time we were shooting, on his doorstep, he was playing Robert Johnson songs and totally oblivious to what I was doing.

GG: And you ended up taking music for the soundtrack for the film from a record you found in his apartment.

LK: Yeah. It was Indian chants. The second part of that film we shot in a loft, with Marc Stevens. In this day and age, I think it would be considered really unusual. I was not really a student of porno films, I was just doing these out of my own imagination. I think at that point I had only seen a few loops, *Deep Throat* and *The Devil in Miss Jones*. That's the only porno stuff I saw.

GG: Do you think that it helped you, the fact that you were never really into it before?

LK: Yeah. I have this distance in all my subject matter...even the punk thing, the music thing. It was like having material that I could make a collage with... so, you have the porno stuff or the punk stuff, or you have homeless material or drug material, or you have... Indians on a spiritual walk from Mexico City to Los Angeles. These are like, little groups of people who are living in their little worlds, away from the greater society. So I like to go in there and play with all the elements to make a film. The thing I like is the distance I have; I don't really get that involved other than being sympathetic to those people because of the outsider element... you know what I mean?

GG: Yeah, and it gives your films that really objective quality too. Did any of the *Loops of Violence* stuff make it into the *Sex Stars* film?

LK: No, no. It was two separate things.

GG: You didn't use any of your own films in the documentary?

LK: No. It was just a whole other reality. I was living in an apartment on East 10th street, and I rented the basement for a month. I was making loops there. It was a whole scene. This is all during the process of making this documentary. It was a pretty exciting time.

GG: How many pornos did you make in all?

LK: I made twelve loops, I made *Loops of Violence*, I made that documentary, and probably about ten or fifteen others, for different people. It was this word of mouth kind of thing... people call you… it was a really vital time in New York, because there was a lot going on. And things weren't as expensive as they are now. So you could rent a Steenbeck for $100 a month, or whatever, and edit your movies. So that's how I was learning to make movies. And at the same time, there was a rock'n'roll scene going on in New York. That was the beginnings of punk, and I

Troma Team one-sheet poster for Lech Kowalski's drug-abuse documentary **Gringo**, a.k.a. **Story of a Junkie** (1987).

was getting involved with that a little bit. I was on the scene, I was going to the clubs, and I was sort of thinking about making a movie about it. And at that time, I had this sort of fantasy to go to England to make a Super-8 movie about the Sex Pistols, and about the whole punk scene there. And what happened was I heard that the Sex Pistols were coming to the United States. I said, shit, what a great opportunity to make a movie. And I was totally naïve, I wasn't really thinking in terms of business, you know? I just said I just wanted to make a movie. So, a few weeks prior to that event, there was a party we had, and I met all these fucking people with money, you know, these models and shit. I met a guy there who said he wanted to introduce me to someone who he thought would be interested in making movies with me. So, when I decided to make this movie about the Sex Pistols, I made this list of about a dozen people I knew who had money. And I called everybody on this list to see if they wanted to put up money for this Sex Pistols movie. And nobody wanted to have anything to do with it. Except for the last guy on this list, and he was the guy who was recommended by this other friend.

GG: And this was Tom Forcade.

LK: Yeah. So I went over to his place, to his office on 27th street. And he said, I have to wait for him. So I sat in this hallway, all day, literally all day, and around five o'clock, as he was leaving he said, oh, I don't know if I want to do this. I said, man, the Sex Pistols are gonna be playing in a few days, and I said, listen, I wasted my entire day waiting here... you at least have to hear what I have to say. So, he said, okay, come with me. So we got into his car, and during this drive to his house, he had me tell him the story of what I wanted to do. I said I wanted to make this movie, and he said... well... who do you know? He said write down the people you know, in the whole punk scene, anyone you know from that whole circuit. So I wrote down some names... I didn't know people that well, but I wrote some names. When we got to his house, he said okay, he'll finance this movie. I was stunned. A few days later, we were on our way to Atlanta, which is where the Sex Pistols were opening, and Tom picked me up in his limo. In the car he didn't talk much, he was really abrasive. It was really kind of tense. So... we're late, and we get to the heliport on the east side of Manhattan. I got in the helicopter, and he gives me this fucking suitcase. And he says, "hang on to this." And you know, I had a feeling there was money in there. So we get to the airport, we run to the fuckin' plane, and I was sitting in the back in tourist class, and Tom was sitting in the front, in first class. And he said okay, I'll meet you in Atlanta. So we get off the plane, and I meet him in the airport, and he told me to go to this big hotel, in Atlanta. So...we went there, and there was a room reserved for me. And I was hanging on to this money. The suitcase. And in the middle of the night there was a knock on my door. It was Tom and these fuckin' hoods. These big fuckin' redneck types. And they

wanted the money! Tom told me right there, "listen... I'm buying a movie right now." He said, "these guys have made a movie, and I'm buying the movie, and I want you to remake the movie for me. And if you do that, I'll finance the D.O.A. movie. I said, yeah, you know... but I got to go find the Sex Pistols, my mind was on that... plus I had to get a film crew, find cameras and shit.

GG: So you didn't have a crew yet?

LK: No, I had nothing. I found my entire film crew down in Atlanta. That's where I met the soundman, the cameraman, and that's where we rented our camera equipment and stuff, because we were shooting. And the funny thing was... the big fuckin' rednecks that came in... I forget how much Tom paid, I think it was like $80,000 or something. Cash. And the name of the movie was... *The Polk County Pot Plane Bust*. [*laughs*] Which I then, eventually, remade into *The Smugglers*. The names of the two guys – who were the stars of this movie – were Oosh and Boosh. They showed me the movie, and it was really atrocious. These were not, like, moviemaking people, you know? But this was all going on at the same time that the Sex Pistols tour was going on. Tom was really into the Sex Pistols... I remember I saw Tom semi-naked, and he had two rings pierced in his nipples. I had never seen that before. Then, piercing was really unusual. And he also had two gold bullion cubes, you know? And at one point, we had an argument and he threw one at me, because he wanted me to get in the helicopter and get a tracking shot of the Sex Pistols bus. But it was really bad weather, and I didn't want to do it. He threatened to pull the film from under me.

GG: Because you were afraid of getting up in the air?

LK: Yeah. I didn't want to die, you know? [*laughs*] It was really awful weather.

GG: It was snowing through that whole tour.

LK: Yeah. So, this adventure began that way, the whole Sex Pistols/D.O.A. adventure. From the very moment that I met Tom, to the very last day – I saw him the night before he committed suicide – it was like this crazy fuckin' adventure man, you know? So the whole porno thing sort of dovetailed into this, you know? But I did take *Sex Stars* to Cannes, and I screened it there. The original title of it was *Porno Babies*. And for the title sequence I took all these little dolls... we put little penises on them and stuff. Then we poured oil, and gasoline and shit, and lit them on fire. But the name changed, I don't remember exactly why. But I took *Sex Stars* to Cannes with me, because I had met this Hungarian guy, Miles, his father was a doctor. He said he would finance my trip to Cannes if he could go with me to show this movie, but there was a big catch, because this guy was a junkie, and I didn't know about it. So, we get on a plane, and fly to Paris. And the flight was weird for me because he asked me to hold this towel up. I'm holding this towel, and I was blocking, because he was shooting up, you know? I was kind of stunned, because it was the first time I'd ever saw anybody shoot up. And here is a guy

shooting up on a fucking plane! He was a big guy, you know? And he was always sweating. He always had all this sweat pouring down his face. But he was a spoiled kid, he had a lot of money and he had some connections. So he set up a few screenings for us, in Cannes, with some pretty good distributors. And we set up the screening and in the fuckin' middle of the screening the projectionist turned off the projector... I'm sitting there, really nervous you know. And these guys are watching the film, and there was this one guy, the distributor, who was really excited by the film. And the projectionist turned off the projector because he said it was not really a proper film!

GG: So, did it have hardcore footage in it?

LK: Yeah. [*laughs*] There's a whole scene where I'm interviewing Marc Stevens and Georgina Spelvin, as they were masturbating, you know? And it's this intense fuckin' scene. It's very powerful, actually, in some weird way. And Marc comes on camera, and everyone starts clapping and stuff. So anyway... this is hardcore, you know? Because she was giving him head to get him excited and stuff. He was gay and she was gay, which is another story. So these people pulled the plug on the projector, you know? So that was the end of my screening, and Miles slipped back to LA. He just left me without any sort of money or anything, so I was stuck in Cannes. I got thrown out of the hotel... and I had my film with me. I was living in the streets there, and would go to the screenings, and there was this Belgian guy one day, who was driving around. I had my leather jacket, my jeans, and my cowboy boots. My film under one arm and my suitcase under the other. I was trying to figure out what to do. And this guy pulled over and he asked me if he could help me or whatever. So he took me to a really good restaurant. He was an older guy, he was probably in his sixties. We ate, and he said asked, "what's the matter?" So I told him my story, and he said, "don't worry, I can take care of you, you can stay at my place." So I went to his place, and in the middle of the night he tried to crawl into bed with me. He started grabbing my dick, and I said, "listen, I'm not really into this." At the same time, he had another guy staying there, whose name was Udo Kier. His best friend. You know Udo Kier, he acted in the Andy Warhol films. So I said, well... I wasn't into it... and they left me alone. But they let me stay there and hang out there, you know. And I stayed in this wonderful villa for about eight or nine days.

GG: Did you show the movie to them?

LK: Yeah, they liked it. They didn't think it was such a big deal, but they got a chuckle out of it, you know. So we were making these connections and stuff... but this guy, he was like... an older gay man, and I didn't really understand that world at all then. So he gave me like a thousand dollars and took me to the airport and put me on a plane to the States. I ended up in Luxembourg and I had to get off the plane and I missed my flight, so I ended up in Luxembourg. I couldn't make a connection back to the States. Then I met this girl at the airport, and we went to a club that night. I

John Holmstrom's **D.O.A.** street-flyer for the film's NYC premiere.

spent three or four days with her, and then I went to Iceland, spent a few days there, and managed to make it back to America. That was an adventure. I never sold the film. And I never really hooked up with these gay guys, but it did make my trip to France pretty memorable. So then I went on tour, to universities, with *Sex Stars*. I would play the film, and talk about pornography and stuff. All the kids hated the film. Very few people liked the film. Because I was around their age, they just couldn't understand why I was doing this thing, and showing this pornography. I don't know, we were very conservative, I guess. This was like Syracuse, Albany, Rochester, Buffalo, places in Pennsylvania, Canada... so I was on this talk circuit in these colleges. That was a really interesting time for me, because I realized how fucked up middle class Americans were. And it just pushed me away from that thing even more. Because these people had absolutely nothing of interest to say to me, about the film, about anything. They were just like, completely, conservatively defending their positions. And for young people to do that, to me, was kind of odd, because if anything, young people should rebel against the places where they're coming from. But they were actually defending their positions, you know, as middle class boring human beings. So that experience really taught me a lot, and I got kind of disgusted by the whole thing. And I was even more determined to get more into underground movies and stuff. So out of that came *D.O.A.*

Lech Kowalski merchandising parody designed by Gene Gregorits, 1999.

GG: *Sex Stars* **never actually did get released?**

LK: Yeah, it got released, but there was no place to play it, you know? It played in the Bleeker Street cinema, it played in a few porno houses... it was a neither here nor there kind of thing.

GG: It wasn't an art film, it wasn't a porno film...

LK: Yeah, it was like, dead. Even now, it would probably fare the same way. But the thing is, one of the problems that I had, in terms of filmmaking, was that I was kind of attached to this documentary type filmmaking where you shoot interviews and stuff – kind of like a Maysles brothers style of filmmaking, you know? And that kind of held me back, I think. It took me a long time to break through that. It's not a fun way to tell a story. But I would still try to create these events... I remember Harry Reems was one of the actors that we filmed. He never actually made it into the final cut, but he lived in Pennsylvania, and we went to film there with a porno actress, and this guy who I asked to interview him. And they were into guns, so Harry would set up this shooting range, and so [*laughs*] I was interviewing them as they were like, shooting guns, and having this male competition, you know? And then, I shot a scene where they were going down a river on two rafts. Shooting an interview that way.

And they're doing those kind of things to make this kind of interesting. And this porno actress who was there, she caused a lot of trouble because she started stripping in this bar, and a guy got beat up by one of the rednecks. So, it was just weird, man. It was out of control. I think a lot of this stuff was fuelled with drugs, too. But it was a great time. It was really great to be involved in that scene. Because it would give you a lot of ideas for when you saw people who were not normal, and those people were much more interesting than those fuckin' college students. Trying to put you down for being creative, you know?

GG: You were getting really personally involved with all these porno stars?

LK: Yeah, but I never fucked any of them. I mean, I had my girlfriends too, so I didn't really need to fuck them, but I was intrigued. I mean... I liked watching it, but I didn't really want to get involved with them, you know what I mean? And also, a lot of the gay guys were always chasing me. It was this weird tension, because I was not into the gay thing. But... [*laughs*] perhaps I should have fucked some of these girls. If I had to do it again, I would, quite honestly, because I had some really fabulous opportunities. But I kind of chickened out of it. My Catholic background, I think, sort of helped me back out of everything. Not that I was a prude, by any means, because I had some pretty wild times, but I didn't get into that kind of porno debauchery, you know what I mean?

GG: Could you describe what your everyday life was back then? Did you have a regular job then?

LK: Sometimes I had regular jobs, I'd be shooting films, and I was getting jobs from phone companies, and insurance companies, to shoot industrials. So I'd do them, and I usually got really drunk at night. I drank a lot of Wild Turkey... and I was always late to work and stuff. Life was really disorganized. I was keeping it together, but like... I didn't have a bank account, so friends of mine would have to lend me their bank accounts, or I'd give them my paychecks, and they'd give me money. I was organized but disorganized. I was very compulsive, but I had a lot of energy, so I was up a lot, I didn't sleep that much. I had to be doing something, you know?

GG: But you weren't drinking a lot because you were miserable... that's just what you liked to do?

LK: It was just to unwind, just to have a good time. I was just like, existing. Being creative without ever really self consciously thinking that I have to have a career. I was just living my life doing what I wanted to do. It was a very creative time. Not a lot of product got done, but a lot of things got done, you know what I mean? People were painting, and shooting video... it was the beginnings of colour video, portapacks... people were shooting films.

GG: So, all this time you were doing these things you drank a lot but it wasn't an unhealthy period for you.

LK: No. It was a great period.

Total Abuse

– Richard Stanley –

I saw *Hardware* about ten years ago. Its mix of sci-fi standards with genuine subversion, perversion, and putrescence left me with a raging curiosity about its director, Richard Stanley. He certainly wasn't easy to find.

Hardware is a post-apocalyptic, socio-political, and sociopathic nightmare. Its themes are dually romantic and political, a rarely successful combination of elements. The critics slagged this film off as a *Terminator* clone. The critics were numbskulled sons-of-bitches who took the film as cheap entertainment with nothing to say. The message of the film isn't even a subtext, it's a fucking plot element, so I left them to ponder the artistic significance of the latest Walter Hill blow-out and decided to watch the film again. An addiction developed. *Hardware* was getting me off like some kind of celluloid pharmaceutical.

Hardware was to British genre films what The Stone Roses were to the British music scene: a jolt of life, an unchecked egomaniacal testament to pop art at its most euphoric, matched only in its swagger by a pure focus on provocation and emotional intelligence. It's not your run of the mill ultraviolence by any means. Stanley introduces a kind of tenderness… then temporarily forgets compassion when the nails come out. It uses a sharp and focused *mise en scène* – then it obscures logic and reality. Although there is a large Argento-influence, *Hardware* does have logic. You just have to look at it sideways. You are required to squarely pit your own mind within the confines of a radioactive, real-life-banal, neo-Hitler enforced hell. If you make that jump, you are initiated into the ferocious mind of Richard Stanley.

The antagonist of *Hardware* is the result of a government-funded genocide project, a cyborg called the MARK-13. It's is named after a particularly creepy bible passage ("These are the birth pains. No flesh shall be spared.") and our boy delivers a clean, shove-shot of a lethal psychedelic drug that kills you so fine you enjoy your own death. Cancer sores cover the bodies of those dying in the street. The city is a barely inhabitable-sewage strewn battlefield. Radiation sickness is a way of life. The sun does not shine. Rain does not fall. Hardware rips off *The Terminator*? Think again. Stanley's effort has more brains, balls, and human depth than a big budget pyro like James Cameron could ever hope for. (But sparks do fly in *Hardware*, and so do several precious fluids.)

His second feature, *Dust Devil*, was an altogether terrifying, indelibly haunting travelogue of atmosphere and abuse, preoccupied with both human frailty and human savagery. Robert Burke portrays Hitch, a white trash traveller eventually revealed as a demon spirit, wandering the plains of Namibia. He preys on desperate, lonely, suicidal women. The impoverished town of Bethany is a perfect feeding ground. An adulterous white woman and her broken-hearted husband become fair game.

Both films remain sensitive to the carnage they portray. His work is anything but shock-art. In *Dust Devil*, he emphasizes spirituality. In *Hardware*, he uses psych-o-delia and a decidedly narcotic aesthetic.

Richard Stanley's third and most commercially promising feature, *The Island of Dr. Moreau* became a circumstantial tragedy. In its cast were prominently featured names such as Marlon Brando and Val Kilmer. The script was harsh. It exceeded even the confrontational realms of his previous films. Hollywood wasn't committed until Brando's interest green-lit the production. Within a week of principal location shooting, Stanley had been fired from the film.

I talked to the director for over an hour about *Hardware, Dust Devil, Dr. Moreau* and his recent independent documentary releases.

Above: Stacey Travis in Richard Stanley's **Hardware** (1990).
Opposite bottom: **Hardware**'s MARK-13 battle droid prop. Photo courtesy of Richard Stanley.

Gene Gregorits: In *Hardware* there are all these little clues and hints that you drop, as background info. The film has a lot of ambiguous elements, in terms of location, date, political climate, things like that. I know that some critics who didn't like the film said it was incomprehensible, when it fact it's very coherent if you catch all the small details and minutiae. For instance the characters will talk about going to New York, so the film obviously isn't set there. A certain portion of the cast has American accents. Did you intend for there to be a set location?

Richard Stanley: Not particularly. It could have been Detroit, Philadelphia, or somewhere in the middle of the country. It started off being England, which was a problem. A lot of the script was set on a council estate in futuristic London. Once Miramax became involved, they started casting American leads, which I didn't mind, but the problem was, under union rules in England, you can't

bring in more than two Americans onto the same project, so the whole rest of the world has to be made of local actors. You've got Jamaican security guards and an old Irish astronaut living next door, with a rather strange accent. Then there is the Chinese family downstairs.

GG: Yeah it's a very multi-cultural film.

RS: That's partially because we couldn't set it completely in America due to contractual obligations. I tried very hard to get an American to play Shades.

GG: Could you talk a little about the original script before Miramax got hold of it?

RS: The biggest change was the character of Mo. Mo in the script is basically a junkie, and he's a bit of a burnout, a mechanic who's working for the army. He lost his hand in some kind of industrial accident, and got addicted to painkillers. He's also radioactive and has cancer. [*laughs*] Also the girlfriend, in the original script, has a thing for his scars, and for his metal hand, and was busy tattooing his remaining flesh. A Miramax assistant noted that there should be no tattoos, because they'd released a movie called *Tattoo* with Bruce Dern which made no money. Terrible movie.

GG: Now, 'the hand', which isn't explained as an industrial accident or anything like that, is very much fetishised by you in the film.

RS: The hand stayed there, yeah. It was the reasons for the hand and how it fit into the relationship that were fudged. First of all, the heroin had to go, even though the droid retains the needles. And Mo dies of a lethal trip, eventually. He still O.D.'s, even though he is no longer a junkie. There was a huge fracas over the casting of his part, because I chose Stacey Travis for the lead, who was basically an unknown. They had to have their choice of a male lead. They pinned us down about two weeks before the actual start of the movie, and shoehorned us into having to go with a choice of three people, and Dylan McDermott was the best of the three. When Dylan arrived on set, he had a crew cut, and I said, "Oh god." He looked very healthy, and he's Christian. He brought his bible with him.

GG: In a way, what they forced you to cut only made the film more unsettling. You never know what happened to Mo's hand, and there's a lot of things that aren't made crystal clear but it only makes the characters more interesting. I really enjoyed that aspect.

RS: Yeah. And another macabre part of the process was that they demanded we shoot explanations of things. And they kept faxing us scenes where dialogue needed to be explained. There's a credit at the end for 'additional dialogue', by Mike Fallon. There was a whole long dinner scene that was shot just to please Miramax, between Jill and Mo. That's the reason why they suddenly have their clothes back on after they've just been making love. There was a ten minute 'alligator steak' sequence which was removed.

GG: Another great, weird detail that isn't explained, the 'alligator steaks' and 'reindeer steaks'.

RS: Not to mention the cockroach tea. With the food chain irreversibly contaminated it makes sense that the public would have to turn to alternative sources in much the same manner that ostrich burgers were briefly marketed as a low cholesterol alternative to beef during the mad cow epidemic. As the man says, "Soylent Green is people!"

GG: **Both of your feature films are dominated by female characters. They could almost be seen as feminist stories. What interests you so much about having a woman as the central character in your films?**

RS: I guess I've always been dominated by women. I was raised by a proto-feminist mother and two older sisters who believed fathers were unnecessary and that all men were basically shit, which kind of rubbed off. Of course it left me without any real defences when it came to dealing with the real thing. Perhaps the tone of the imagery was a little naïve in that encouraging women to act like men has not necessarily made the world a kinder or safer place.

GG: **The male leads in *Hardware* and *Dust Devil* come to rather unpleasant ends.**

RS: Yeah. These days I kind of regret being so tough on men. I think the next time around I'll be an equal opportunity offender. Actually I was going there at the end of *Dust Devil*, in a way that I wasn't entirely happy with. It was more ambiguous than I wanted it to be. I've always wished Chelsea [Field, Wendy in *Dust Devil*] could've looked a little scarier than she did.

> # "We had two crews working, so we were on set shooting for 24 hours a day. That way I could just go on shooting for as long as I could stay awake."

GG: ***Hardware* is really packed with technological detail, but it still manages to be about people. It's incredibly well thought out, in terms of characterization. How did you play down the tech stuff so well, yet have it so fully apparent throughout the entire film? And also, I was interested in how you made the film look like 25 million on a one million dollar budget.**

RS: They're unanswerable questions. Well, the second one's easier to answer.

GG: **Okay.**

RS: We worked very, very hard, and people were underpaid. The crew was insanely committed. We storyboarded the whole thing and shot with every available thing we had, for as long as we could. We had two crews working, so we were on set shooting for 24 hours a day. When the main unit left at six o'clock, the second unit would move in, switch the lights back on again and get going with the droid walking around, or anything that didn't involve the principal cast. Which was quite a lot, really. That way I could just go on shooting for as long as I could stay awake. I think it was just a matter of taking the time we had, and the money we had, and squeezing it for every insane detail we could get. I'd try to take cat naps, and every time I went to sleep, a few shots would go missing. We'd lose another angle.

GG: **That's pretty brutal.**

RS: Yeah. It was only six or seven weeks. I just had to grab it with both hands, and be prepared to stay awake. A long time.

GG: ***Hardware* seems to be greatly misunderstood in some circles.**

RS: In a way, the response was pretty good. It made quite a lot of money, considering. It's the most financially viable thing I've ever been involved with. And I suppose that ultimately, with the Hollywood bottom line, it's a success story. It's partially because of the way the thing was marketed, and also because of low expectations. I thought it was just going to be another direct to video *Aliens/Terminator* clone, which is kind of the expectation the backers and distributors had for it at the time. That's

pretty much what they wanted, and I figured, okay, maybe we can put a spin on the standard premise of people creeping around in a dark industrial space, being menaced by a monster who pops out once every so often, which was common for those days. Lots of bad movies like *Titan Find*.

GG: It doesn't seem that it was at all your motive to make a typical sci-fi story. *Hardware* riffs on political and ecological issues, which you rarely see taken seriously in films of that genre.

RS: I've always been very scared of the future. There are certainly plenty of things about it that bug me out. The film is so contained in one location, because of the budget. It was difficult to get into a lot of that stuff. Society hasn't broken down the way it has in the '*Max*' films. There's still a government and most of the characters are either working for it or on welfare. Unlike most dystopian futures there is no sign of a rebellion in *Hardware*. All the characters tacitly ignore or actively support the insanely draconian right wing measures espoused on the television and by Iggy Pop's character the radio DJ. The military-industrial complex are evidently the largest employers and the war in the zone is probably maintained as in Orwell's *1984* to safeguard the status quo. I wish I could've seen, in a big budget movie, a world in which the MARK-13 cyborg was successfully deployed, to see it doing what it was built for in the first place rather than a single unit running amok, I would like to have seen what would've happened if the experiment was successful.

GG: And that film would've been *Hardware 2*. How far into production did that film get?

RS: It never really got into production. The people at Palace went bankrupt. It was never made clear who actually owned the rights. The sequel was entitled *Hardware 2: Ground 0*. Sort of like a football score. It saw the cyborgs deployed across the south west and the Rio Grande as heat-seeking units policing America's borders and hunting down stray wetbacks. Each unit is slaved to its own remote operator recruited by the army from the high scores on a popular simulation game. I wanted to show that the war criminals of the future would be the liberals and computer nerds of today who are more interested in building a better mousetrap than the psychology or motivation of the mouse.

GG: You started your career making music videos. What videos have you directed?

RS: That's a long time ago now. I did one for John Lydon, and Public Image Limited. I enjoyed that. The video was called 'The Body'.

GG: That's great! I never knew you made that video. I like it a lot.

RS: That video... it starred Lydon, and that weird looking guy with the glasses is an associate of Tim Leary's. He's actually been involved in that stuff, in Operation Artichoke [CIA mind control programme] and designed waldo arms for NASA. So we threw in a cameo with him, as a mad scientist doing experiments on people. I did a bunch of

videos and some album covers for Fields of the Nephilim. Probably the ones most directly relevant to *Hardware*.

GG: I don't know their music, and never saw the videos. Are they stylistically much like *Hardware*? Carl McCoy's image is exactly that of your film.

RS: Yeah. They had a spaghetti western/post-nuke image. I'd like to imagine they were responsible for transplanting some of that iconography into the Goth scene; the long black coats and the Durango boots with those Cuban heels. The lead singer became a character called The Preacher Man, a religious zealot in a post-holocaust world. Elements of the radiation contamination, the metal hand, the thing digging itself out of the ground, all that stuff from *Hardware* appeared in the Fields of the Nephilim videos first. Carl McCoy [Nephilim lead singer] is the guy who comes out of the desert at the beginning of the film. That was their look.

GG: Where does your interest in that strange style come from?

RS: I love the spaghetti westerns. I saw *The Good, the Bad and the Ugly* when I was ten, on a big screen and it changed my life in confusing ways.

GG: *Dust Devil* is even more directly influenced by that film.

RS: Yeah. I also tried to bring it back to the place I associated it with when I was a kid, which was African exploitation movie distribution.

GG: Yeah, as a kid, you would envision the Eastwood scenarios happening in your homeland.

RS: Well, it's close. For some reason, just because of the way things were out there, they never showed arthouse or highbrow films very much. It was redneck culture. I got to see most of these things at drive-ins. Things which probably wouldn't play in the States. Bud Spencer and Terence Hill, Klaus Kinski in *Commando Leopard*, or Lee Majors in *Killer Fish*. There were things that weren't accepted in the United States, but were huge in the third world. *The Legend of the 7 Golden Vampires* and Dario Argento's *The Bird with the Crystal Plumage*, which are the films playing at the local drive-in in *Dust Devil*.

GG: What are the benefits of your background, of having a background in music videos when applied to a feature film?

RS: Well, it teaches you how to work cheaply and quickly, which is helpful. All of the videos were made very cheaply, and the cheapest one is the best one. 'Kray Twins' for Renegade Soundwave, which was made for 800 bucks.

GG: There are a lot of directors now who seem like they come from a music video background. There's Guy Ritchie, David Fincher.

RS: David Fincher I like. Guy Ritchie I don't like. There's a guy out here, Chris Cunningham, who's going to be big one day. I'm rather keen on Chris's work.

GG: David Fincher isn't quite as uncompromising nor as personal a film director as you, but his films are incredibly bleak, especially *Fight Club*.

RS: I loved *Fight Club*. From a major studio! I just thought, wow, how'd you do that?! It's a hell of a thing to get away with!

GG: I've heard about *The Secret Glory*, a film you've been working on. A documentary focused on ominous subjects such as the Third Reich, the occult, etc.

RS: Channel 4 television had a hit with a documentary show called *The Real Jurassic Park* about extracting dinosaur DNA from amber and thought they could repeat the ratings success by commissioning me to research the real *Raiders of the Lost Ark*. I set about tracking down every surviving member of the SS archaeological department and ended up focusing on one individual. A German Jewish Grail historian named Otto Rahn. Rahn did a lot of digging in the South of France before the war and met a sticky end in 1939 when he froze to death on the German/French border. I interviewed some 23 survivors including remaining members of Rahn's family and began to realise that I was really onto something. The story concerns a chalice carved from meteoric iron dubbed by Rahn "The Pyrenean Grail." The cup was believed to be made from a hyper-dense form of alien ore that never tarnished but extruded a blood-like ferrous solution. According to the 12th Century text of Wolfram von Eschenbach's *Parsifal*, whoever comes into contact with the blood "will have eternal life and will be healed." It's analogous to the philosopher's stone of the alchemists and the black stone of the Ka'ba in Mecca, the heart of Islam.

GG: That's amazing.

RS: Unfortunately Channel 4 had their heart set on the Ark of the Covenant and pulled out once they realised it was a Grail story. Most of the witnesses were on the verge of death and I realised the story would be lost unless I began to commit it to film myself.

GG: You don't have all the time in the world, these people are dying right?

RS: Well actually they are dead. Sadly only four of the participants are still with us. All of the archaeological work including the Tibet expedition and the trips to the North and South Poles were conducted before the war, usually by civilian researchers. It was pretty much the same way the military-industrial complex works now, the way dolphin research, psychobiologists and computer programmers might receive funding from the war on terror. Rahn was an isolated crank who lucked onto something big and used Nazi money to realise his dream. By the time the war started there was no money to waste on these kind of projects. Sadly uniformed units of the SS were never deployed *a la* Spielberg in this sort of wartime endeavour. The main fallacy being this notion that Adolf Hitler was really interested in that stuff. I think he was much more pragmatic than that. Basically the Third Reich purged a lot of astrologers and weirdos quite early on. If Otto Rahn isn't still alive, immortal and living under an assumed identity somewhere in South America then he was almost certainly murdered by the Nazis in 1939 and his story deliberately erased from the public record. There are still a great many loose ends that I'd love to tie up while I am still on this side of death. We know the Nazis went to the North Pole, but no one can tell me definitively what the hell they were doing there. You get every story in the world, from "hollow earth", to "radar signals", "warm water lakes", "Lovecraftian Old Ones" and "dinosaur survivals." But we've translated Otto's diary, at least the pieces that are left of it and then there's the map…

GG: I can feel pervasive rolling waves of dread already.

RS: [*laughs*] Yeah. You dig that question up and you go all over the place. Flying saucers and hollow earth. The results of ten years worth of pop cultural madness.

GG: I've heard about your un-produced film *In a Season of Soft Rains*, different things. What else have you done since *Dust Devil*?

RS: Basically writing ferociously. I've generated so many screenplays, I figure that if I ever get another one made, I'll be on a roll, with a huge supply of material. Or they'll have to auction them off posthumously the way you keep seeing Donald Cammell screenplays floating around. People are clutching "hot Donald Cammell screenplays." I keep thinking: "Christ. Poor devil shot himself. And now they're hot. Why are they hot now?" He spent years generating mounds of screenplays. Good screenplays. Some of the best work I've read.

GG: It's tragic. I guess you have a responsibility to avoid the fate of Donald Cammell.

RS: Yeah, I suppose we have had a very similar career profile. The big difference between us is I didn't get to make *Performance* and he's dead. You push the buttons on that. Like Donald I made a 'machine chases girl' movie. I made a desert-bound psycho killer movie. And I was involved with Marlon Brando in a huge and bullshit film that destroyed my life.

GG: Yeah, can we talk about it? I know many of the *Island of Dr. Moreau* stories are fictional, so what really went on down there in New Guinea?

RS: All kinds of things. Too many things to be able to put your finger on only one thing. The over-arching problem was that the politics were completely crap, from the off. Once Brando decided to take the part every other actor in Hollywood wanted to get onboard. All New Line cared about was the marquee value. They never set out to make a Richard Stanley film and I was obviously deranged to imagine that a screenplay like that could ever be made within the Hollywood system. It was a cursed shoot. We were hit by a hurricane. My girlfriend was bitten by a flesh-melting spider. We were shooting on aboriginal sacred ground. There was nuclear testing going on at Mururoa atoll a few miles away. Marlon Brando's daughter committed suicide right at the start of the shoot. The moment New Line felt Brando might pull out they closed the production down and removed me along with most of the crew and the other heads of department. Of the main shooting crew only the second assistant director was taken over onto the Frankenheimer movie. Under the circumstances I feel I came out of it lightly. Same exact thing happened on the Don Taylor movie

GG: You got the credit for screenplay, but I can't imagine that they used your original draft.

RS: Not a word. They just remade the Don Taylor version. The only difference between the two was that on the original version everyone was drunk and on the Frankenheimer version everyone was on drugs. Good book though.

GG: That's really why I haven't bothered to see the film.

RS: I saw it once. A contractual obligation screening. It did have some side effects on pop culture. As I understand, Mike Myers got his idea for "Mini Me" [in the "Austin Powers" films] from *Dr. Moreau*. There's also a genetic engineer on *South Park*, who springs from it. I was pretty faithful to Wells.

GG: With bio-genetics.

RS: Yeah. People are cloning their own dogs back to life these days. It wouldn't be a big deal to give the dog a larynx. Imagine what it would say. Imagine what wild things they would say if they could talk to us in rudimentary English. Would they curse us for teaching them to speak at all? I worked on the screenplay with Michael Herr, who wrote a book called *Dispatches*, and Walon Green who wrote *The Wild Bunch*. Best damn script that ever passed through my hands.

GG: What about the rumours of you coming back on to the set of the film, after you were fired?

RS: Oh yeah, it all happened. If there hadn't been a lady involved, I wouldn't have done it. It was a matter of the heart. Otherwise, I would've just taken the money and left. There were too many reasons why I wanted to find out what happened next, and get back there again. I wasn't entirely free to walk away at that point.

GG: Were you caught, were you actually thrown off or what?

RS: They never knew I was there. It was only afterwards. I got in with a bunch of extras, basically.

GG: Now, how did you manage to – I mean, without a mask, you would have been recognized! Was it just a lot of sneaking around in the jungle at night?

RS: Yeah, it was all the night scenes at the big house, around the plantation. Running around the funeral pyre, burning the big house, etc. The only person who had any chance of recognizing me was the second assistant director. Everyone else had been fired.

GG: Did you sabotage the product?

RS: No. Absolutely not. [*laughs*] No, I didn't have to. When I left the production, I shredded every document I had. I've heard stories over time that I'd freaked out, that I shouted at so and so, that I punched so and so. But point of fact, what I did at the time was just stay in the same chair for about two days, while continuously smoking and making telephone calls. I suppose that's bad enough. Smoking being what it is in America nowadays. Over that 48 hour period, I shredded every single goddamn document from the last two years. I made certain at that point in time, that there were no telephone numbers, timetables, rainfall charts, or any scrap of surviving research. It wasn't really sabotage, it was to leave as little trace of myself behind as possible. I hate to speak ill of the dead, but I hope Frankenheimer sucks dicks in hell. *The Manchurian Candidate* and *Seconds* were alright though. I flew down to Sydney. After a few days, I started hearing that they thought I was out in the rainforest with the ferals, planning an attack on the set. They were trying to get a court order to keep me from coming anywhere near the location and I was already on the other side of the country. Got myself a lawyer, immediately. And then, because of personal reasons, I realised I had to go back and see what was happening.

GG: That's really... one of the great film stories. Aside from Werner Herzog and his mania, I can't remember ever hearing about something like actually finding a hiding place on a film set.

RS: Yeah, that was my thinking at the time, as well. Because the situation was already so ridiculous, I thought I'd just keep pushing it further over the top, to a place I'd never been before.

GG: Where do you think genre films, or just films in general, are at today?

RS: To me it seems worse than ever. Maybe it's because I'm getting older, or maybe it's that the eye in the pyramid

is exerting further control on what makes it to the screen. It's getting intolerable, I mean, in terms of all the major studio movies which have crashed and burned, one after another. I keep thinking that if the audiences keep staying away in waves, as they seem to be, then real movies might have a chance. Certainly, at the time I was growing up, in the mid-'70s, there was some kind of halcyon period which completely misdirected me. I was growing up thinking "I'd like to be Sam Peckinpah" or one of those guys.

GG: What was it like growing up in South Africa?

RS: Pretty strange. My mother was an anthropologist, who was writing a big book at the time, which required a lot of travelling around, interviewing witch doctors, which meant there was a lot of tribal ritual going on around me when I was extremely young. At the time witchcraft and the supernatural seemed completely normal and natural to me. How the world should be. It came to me as a great shock that these things weren't meant to happen, really, or shouldn't exist in the outside world. Spirits and things. It was banged into me at an early age, before anyone told me to be frightened of them, that there's no reason to be scared. I've done a documentary on voodoo for BBC2 over the last couple of years, which gave me a chance to spend quite a bit of time in Haiti.

GG: Do you have a dream project? What would your favourite book be to adapt?

RS: Favourite book. It would probably be *The Three Stigmata of Palmer Eldritch* by Philip K. Dick. I won't say the other one, in case somebody else gets the idea. *Eldritch* gets optioned and re-optioned. I worked on a screenplay for it a few years ago, but was never able to get it off the ground. I'm very fond of the script.

GG: What are some of your favourite films?

RS: I'm always warring with myself on whether my favourite movie of all time is *The Wild Bunch*, or *Mirror* by Andrei Tarkovsky. If I could choose a comedy it would be *Duck Soup*.

GG: I know you're very fond of Tarkovsky.

RS: It depends on how I'm feeling. I used to be 100% fond of Tarkovsky, but as I have gotten older, and closer to Pike's age, *The Wild Bunch* has crept up in my list of favourites.

GG: Things are getting a little mercenary at this point, right?

RS: Yeah. It's always the one that makes me feel better. [*laughs*] I remember seeing it when I was younger. Now, it's kind of grown on me. In just the same way, I've grown away from *Pat Garrett*. [*laughs*]

GG: Your films are seen by some critics as a blend of art and splatter. One clever critic even came up with "splart" to describe your films. [*laughs*] It seems like you've really carved out a separate kind of genre. What do you think about the "art-horror" label?

RS: Of course in the '70s there were people like Alejandro Jodorowsky, who took it to the limit. It's hard to imagine these days anyone making a film like Herzog's *Heart of Glass*, Jodorowsky's *The Holy Mountain* or Deodato's *Cannibal Holocaust*.

GG: *Hardware* certainly goes way beyond genre limits. It's a really great drug movie as well.

RS: Well, I was involved with a lot of psychedelics at that time. Things in that film are drawn from personal psychedelic experiences. Bad trips, like imagining that you're cutting yourself with a knife, or that your body is rotting away, and suddenly you've got maggots on you. The party that goes wrong when somebody crashes through the window and leaves a great big hole in the wall, and somebody else says, "oh wow, man. Look at the stars." So all that stuff in the movie comes from too many late nights at one point or another.

GG: I have this feeling that I'd get extremely violent or destructive on acid, so I've never done that drug. Thanks for the surrogate experience.

RS: [*laughs*] A funny detail is I found out that when the younger triad guys rumble back in Hong Kong they hand out what they call "fighting drugs", which turned out to be a kind of low grade LSD. *Hardware* comes up like acid. You can drop a tab at the same time as Shades, and for about 30 or 40 minutes you think nothing's happening at all, then suddenly it just goes apeshit. It's good to see *Hardware* on a screen, and one thing that I regret was that we banned blue backlighting, that sort of icy '80s style lighting, because we were trying to get away from James Cameron and Ridley Scott without realising how much the warmer shades bleed on video. Every time I go back to the print, there's stuff I haven't seen in years on video, stuff I'd pretty much forgotten about. I mean, shit, it's like turning on a light bulb. It gets so dark at times, it's like twilight soup, and when you get two, three generations down, it's a real problem. The negative is still fine. *Dust Devil*, ironically, is in better shape because Channel 4 allowed me and Steve Chivers to do a proper transfer. The UK television cut is pretty much the film I intended it to be.

GG: There were those two animated films that sat on the shelf for well over a decade each, *American Pop* and *Heavy Metal*, because of music rights confusion. It seems the music part of it makes things even more tangled up.

RS: Actually... yeah. That's right. I remember how long *Heavy Metal* was missing. I liked *Heavy Metal*. I liked the original, I still like those stories. I was a little disappointed by the movie, but there's a couple of bits that still make me smile. *Hardware* will probably survive in some form. I'm fairly happy as long as it's still playing. It's playing in Germany next week. So as long as it keeps showing up in different parts of the globe, I guess that means it hasn't expended its half-life yet. I'm still trying to throw the double six, to get out of movie jail.

GG: Any *Dust Devil* anecdotes?

RS: Too many. Over 42 production vehicles written off in one company move alone. Got a splinter of glass in my left eyeball. Someone found a dead tourist zipped into a

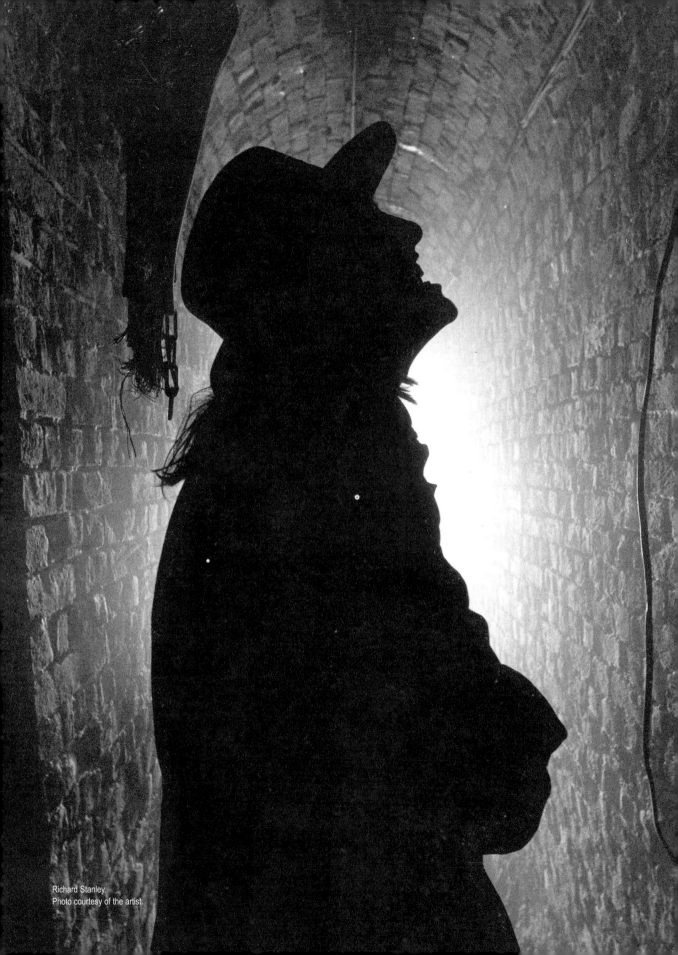

Richard Stanley.
Photo courtesy of the artist.

sleeping bag and buried in the dunes behind where the crew were staying. The clapper boy was a Nazi. The unit muralist, who contributed the rock paintings, was accidentally abandoned and left to die out there. Same thing happened to Alan, the production manager's assistant, who was left handcuffed to an overturned police car. That's Alan in the last helicopter shot doubling for Rufus Swart. Funny thing is he managed to get away and I ran into him a few years later on a trans-Atlantic flight. Someone had found him that evening and he had pretty much forgiven me for what had happened. At least he understood why I'd done it.

GG: You may not be able to answer this, but I was always under the impression that *Dust Devil* and *Hardware* never got proper releases or re-releases on video or disc, because Bob and Harvey Weinstein hated you, that there was a lot of bad blood between you and Miramax.

RS: Not really. I don't think there's as much bad blood between me and Miramax as there is with me and certain other people. Nothing that I can talk about. I know that, at the end of the day, they did not like *Hardware*. I know they hated *Dust Devil*. I'm not sure that I ever did anything personally... I think that they hallucinated, like New Line and those people often do, that I'd done things they'd like to imagine me doing. People need a boogeyman.

GG: There's another sort of dodgy thing I wanted to talk about, which I heard from Mitch Davis. He said you had a story about goats, or sheep, or something like that.

RS: Well it was a phase I was going through. After the Afghan war I channelled a lot of my tensions into pyrotechnics and took to building ever more elaborate displays for May Day and Halloween festivals, mostly for the Beltane Fire Society up in Scotland. Basically the thing Mitch is talking about is a goat skeleton that I found out in the moors when I was picking mushrooms. It had been completely sucked dry of flesh so I took it home and reconstructed its body out of fireworks, filled up its skull with a sort of toffee cooked up from potassium nitrate and household sugar. Harvey Fenton drove the thing up to Edinburgh, where we painted ourselves black and detonated it on Calton Hill at dawn on May Day. It sort of burned from the inside out. The real beauty of the thing was that it looked like an exploding effigy but as it burned it revealed the bones and gunk within. Upset a lot of people. Being an old pagan at heart it follows that I'm an animal lover and don't condone ritual sacrifice or the abuse of animals for entertainment. The goat, like the wolf, and the stag the year afterwards, was the work of our hands and a far more fitting sacrifice.

GG: However, there is real death footage in *Hardware*, subliminally almost, that they cut out. How much of that was in there originally? You do see a little bit...

RS: I always like to include a moment of real death amidst all the make-believe so the audience will see it and know it

when it comes again. The material that was cut involves the Holocaust documentary Jill was watching on the television as she sits astride the Dylan McDermott character. She was plainly more interested in the footage than making love and the tumbling bodies in the mass grave were suggestively inter-cut with the love making. In the remaining scene you still see the blue flicker of the television but every angle showing the screen has been omitted.

GG: Well, the atrocity clips you still have in there are pretty fuckin' chilling, anyway. So what's going on at the moment?

RS: I've been developing a number of things, and the one that has gained most support from the British Film Council is a piece called *Viy*.

GG: Based on... the Russian film? You didn't like the original film?

RS: The original film rocked. It's based on a Cossack fairytale. *Viy* is the earliest identifiable vampire story recorded by Gogol from an extant oral tradition. It was almost certainly a principal source for Bram Stoker's *Dracula*, yet Viy himself, the original lord of the undead, remains largely forgotten in the west. I thought he needed the press. The existing screenplay concerns a platoon of UN blue helmets who fall prey to a plague of vampirism in a remote area of Kosovo. Vlad Dracul helped the Ottoman empire bring Islam to Serbia and Moldavia and the history of vampirism is also the history of blood libel and genocide. Death and horror are our friends after all.

"FIEND WITHOUT A FACE" © 1958, 1995 GORDON FILMS, INC. USED BY PERMISSION

ART & 'TYRANT' ® © © 1995 SR BISSETTE 4/95

A Working Class Horror Is Something To Be

- Stephen R. Bissette -

Some people have too much energy, knowledge, and passion for only one craft. While best known for his comics work, particularly on the *Swamp Thing* series, Steve Bissette is also an accomplished film critic, essayist, and publisher. After nearly 30 years toiling in the dark arts, his words and pictures appearing in everything from mass-market paperbacks like *Cut!* to Chas. Balun's hard-edged splatter 'zine *Deep Red*, from *Teenage Mutant Ninja Turtles* to his own dinosaur book *Tyrant*, he can now be seen as a seminal, essential figure, one of the strongest and most recognizable champions of both the comics art form, and the frequently maligned horror genre. The artist, through his own imprint SpiderBaby Grafix, began publishing the 'X'-rated comics anthology *Taboo* in 1989. Running ten issues, and stirring up quite a response with each and every new collection, *Taboo* was an event of Bissette's and *Swamp Thing* alumni John Totleben's own making. The histories of both *Taboo* and *Swamp Thing* are almost secret ones, and more than slightly memorable in the grand scope of comic or horror culture. Steve's observations are kept current, and broad, yet his decades of labour and commitment to the arts make him nothing if not an underground historian. Little that goes on in that world, and the larger ones around it, seems to make it past him, and his views are idiosyncratic and well-considered enough to jog the thoughts of any attentive listener. And as a listener myself, glued to my phone for over five hours, I could only scratch at my reddened ear and decompress a while, worn out by so many eloquently expressed viewpoints. Few, if any, seemed arguable.

I've been a fan since childhood; it took me about 20 years to finally catch up with him. Prior to a public performance of his multi-part lecture on the history of horror comics, I had breakfast with the author in Montreal. His teenage son, wearing a Stanley Kubrick T-shirt, accompanied us. The lecture which followed was lively without being frivolous, and expansive without being exhausting. Everyone in the audience was subtly seduced by Steve's love for EC and Warren horror that day.

Since my days as a *Swamp Thing* junkie, after my own publishing struggles, and the demise of *Sex & Guts*, I've come to appreciate the Herculean efforts of a stubborn, idealistic, and multi-talented rogue like Bissette more than ever before. A member of the Comic Book Legal Defense Fund, the irrepressible Vermont native has faced more than his share of opposition and misunderstanding. He's the type to look hypocrites, sell-outs, and fakes straight in the eye, and never blink. For all his unforgettable work in comics, and consistently well-researched film writing, I think it's that quality that I appreciate most of all, if only because it is so sorely absent in the modern day.

Gene Gregorits: What's the state of the horror genre today? How can horror today compete with George Bush and terrorism and televised maggot munching and all this?

SB: [*laughing*] Well, usually during times of turmoil, which we are going through precisely now, this stuff starts… bubbling up out of the woodwork, out of the cracks in the distribution system. And that's where I go looking… where are those cracks, where are things happening? For instance, I just wrote a review of *The Jacket*. I thought it was a pretty good film. And the reason I bring it up is because it's part of this strange sub-genre that's popped up over the last three or four years. I don't think it's a coincidence that it pops up with the Bush administration… this strain of films about characters who have amnesia of some form. And the entire film is usually them trying to piece together what reality is, what's really going on. I'm thinking of films like *Memento*, *The*

Stephen R. Bissette, 2006. Photo by Joseph A. Citro.

Machinist, Session 9. They are basically manifesting, to my mind anyway, the American id right now, which is us acting like we don't live a torture state, but we do! [*laughs*] This is how I think the genre functions. Back in 1968, no Hollywood films and no mainstream horror literature was confronting the rifts that were going on in the country concerning the Vietnam war, and the counter-culture, and the generation gap, and suddenly in 1968, you have – in Pittsburgh – George Romero make *Night of the Living Dead*, which was the most confrontational film of that time about Vietnam. It basically was a metaphor for, "you want a fucking war? Here it is… it's coming through the windows of your HOME."

GG: That's what I love most about George Romero, is the bluntness of his metaphors.

SB: Well… we felt it on a gut level back then, when that film came out. Because a lot of that film involved people sitting around television sets watching oblique news stories about these atrocities going on outside. And that's exactly what we were doing! My point is, somewhere out of the woodwork will come the equivalent of a George Romero… The big budget studios have shown us, particularly with their spineless *Dawn of the Dead* and *Texas Chain Saw* remakes, all they're going to keep giving us is rich people's nightmares. And what really resonates in horror, what changes the face of the genre, are working class nightmares. What is it that we as a people are really fucking afraid of? We're really afraid of everything that's going on right now. No medical healthcare, what's gonna happen when we're old, who's gonna take care of us… we're gonna start seeing that stuff bubbling up like tar pitch coming through a foundation. How many times did I hear on the radio today a clip of Bush saying that America does not believe in torture? And yet, the news stories are full of ongoing evidence of what has been going on post Abu Ghraib… now we're shipping people out of the country to be tortured! So… we live in a torture state! Let's face it! And I don't think it's coincidence that we're seeing these medium to low budget films about people who think they're good people, discovering that they did something really fucking horrible. So horrible that they blacked it out. All these films interest me because they're all saying the same thing to us. We are blocking out something horrible that we've done. Well, DUH! [*laughter*]

GG: There is a political edge to almost everything.

SB: There is, yeah. And my belief is that horror as a genre embodies many emotions, but one of the key emotions is building right now in our national consciousness: outrage. And anger. Everything is gonna change within the next few years. The horror genre has to become the central genre of communication over the next five to six years, because we have been living in absolute fear since September 11. Ever since then this administration has come to function by keeping this population in fear… and you know how we deal with that? Through vicarious means, like horror movies.

GG: I'm talking to you now, just after the release of the film *Sin City*, which I guess you could look at as a high water mark. It's a good place to stand and re-assess where the comics industry is.

SB: *Sin City* is an amazing piece of work. The way it goes, here in America anyway, is… as soon as a comics property is put on the production block, the first thing the money people do is push the creator out of the fucking way. [*laughs*] You know? It's like, "thank you very much, here's some money, now go away!" And it's incredible that Frank Miller was able to stick to it all the way to co-directing. We've all heard the stories commending Robert Rodriguez for putting his Director Guild card on the line, insisting that Frank co-directed and that he get the credit. So this is a real turning point. Other cultures have done it for ages… When Otomo's *Akira* was going to be made into a feature length film in Japan, in the 1980s, guess who got to direct it? This is a watershed to me, it means that something significant has changed… Frank Miller is very smart, and Robert Rodriguez is very smart. All that stylized blood. There's red blood in the film, there's white blood in the film, there's yellow blood in the film… the stylization did allow them to get away with much more graphic mayhem being shown on screen than if it had looked more authentic. We wouldn't have seen Bruce Willis scoop Nick Stahl's balls out, on screen! And there it was! Because it was yellow, and it was stylized. Now… that's a game that we have played in comics for years, and Frank knows it well. When Alan Moore, Rick Veitch, John Totleben and I were doing *Swamp Thing*, we played that game all the time. We got to chop all of Swamp Thing's limbs off, because "hey! he's a plant!" Basically, what they were doing in *Sin City* was a variation on that old game. Mike Fleischer and Jim Aparo's *Spectre* comics from the late '60s really introduced that as a way around the Comics Code Authority. The way it worked in *The Spectre* was, the Spectre would punish evil people. Criminals. Very horribly. But what Fleischer figured out was that if he had the Spectre turn the criminal into something other than flesh, then he could get away with really twisting the blade. So the Spectre would turn the villain into wood, and then saw him in half! The Spectre would turn the criminal to wax, and then melt his hands. It's a game! If it's not flesh, then okay, you can draw whatever you want. So by stylizing the violence in *Sin City*, what Frank and Robert did was make it not flesh and not blood. So… you can spill GALLONS of it!

GG: Well, this interview was supposed to mainly be about *Swamp Thing*, so let's make a break for that bog. When you first read the Alan Moore scripts, what informed your sense of image, and how you were going to draw the story?

SB: My first comics publication was in 1976. And I saw my first Alan Moore script in 1983. All during that time I was struggling with, "how do I put into comics what I can feel, and what I can see in my head. And I couldn't figure

it out. I did some work that I'm still proud of it, stories like 'Cell Food,' and some of the work that Rick Veitch and I did together. But it still wasn't *there*… When I saw *Performance*, it literally blew my mind, and the only other thing that was doing that to me at the time was music… Frank Zappa, Captain Beefheart. And also, the underground comics! When I first read 'Meatball' by Robert Crumb, it just tore the top of my head off! I was drawn to anything that did that to me. It was much safer to go and do that at the movies, with a movie like *Performance*, than to take a lot of acid. It altered my perception of the world. Great films, great comics, great books, great movies, really do alter our perceptions in organic ways. *Performance* was one of those movies that changed the way I experienced my own life. It's almost like these new sensory organs had been provided to me after I saw that film. And the reason I'm going on about this, is… that's what I wanted to do in comics. When I read Alan Moore's script for *Swamp Thing* #21, it was the first pure shot of Alan Moore that I experienced. And when I read that script, the hair literally stood up on the back of my neck. I was so jazzed, when I got to the last page, I immediately got on the phone to my friend Rick Veitch, and I said, "Rick, you've got to read this script. This is the greatest comic script I've ever read in my life!" It was because Alan was doing everything I had ever wanted to see done in comics. And I got to be the guy to draw it! I just felt like I was in this magical position… I should also include Rick Veitch in this, because right from issue #21, Rick came down and helped me on some of those pages. Part of it was a deadline issue. It used to take me five weeks to draw a monthly comic. So, do the math. I was always behind the eightball. But also, Rick and I had been wanting to do comics on that level all the time that we'd known each other. And… here it was! It was right in my hands! Alan had done it. It didn't come out of nowhere. Keep in mind that John, Rick, and myself had been buying *Warrior* magazine. Right from the first issue of *Warrior*, there's *Marvel Man*, the first instalment, and even more devastating, there's *V for Vendetta*, the first instalment. By the time we got to work with Alan, we'd been reading at least two years worth of his work in *Warrior*. *V for Vendetta* was so different from *Marvel Man*, which came to be known as *Miracle Man* here in the States. There was such a difference, that by the time we got to work with Alan, I was unafraid of expressing to him what I would like to do with *Swamp Thing*. What he was able to do as a writer was to temper his orientation of the material so as not only to accommodate the artist's interests, but actually playing to the strengths of the artist that he would be working with. Alan proved that in spades, with that first issue of *Swamp Thing* that we worked on, we were firing on all six cylinders. I still think that that is one of the best pieces of work that I ever, ever had a hand in, 'The Anatomy Lesson', *Swamp Thing* #21.

"When I saw 'Performance', it literally blew my mind... Great films, great comics, great books, great movies, really do alter our perceptions in organic ways."

GG: Everything was different after that. The difference of appearance between Wrightson's version and when you started drawing him, what were your ideas regarding the new look of the creature?

SB: Well, I can't take credit for that and neither can Alan… that was John Totleben. John first came into my life while at the Kubert School. I was in the first class ever, of the Kubert School. There were 18 of us in that first class. We were the first students ever at the first American University dedicated to comic art. It was this big adventure to us. We didn't realize how unique the situation was. We just felt lucky to be there. John was in the second class that came in. He was the freshman when we were the seniors. It was a two year program so you went instantly from freshman to senior. John came in, and he could draw circles around every fucking one of us. He had gone through some sort of a high school program in Erie, Pennsylvania where he was getting college level art courses during high school. So John showed up at the Kubert School with more art chops than any of us had. And if there was any comic character that John was into, it was Swamp Thing. He did a drawing during that two year period, in school, somewhere between the fall of '77 and the fall of '79, of Swamp Thing as this sad looking, mossy creature. It wasn't the Berni Wrightson Swamp Thing. His Swamp Thing clearly was a plant creature, overgrown with all this lichen and moss. It wasn't just a matter of superficial texture; John had a vision for this character.

GG: He brought a nice healthy stink to it.

SB: Well, yeah. You put your finger on it. He had this real tactile take on Swamp Thing, where it didn't just look like this guy with mud packed all over him. He looked like this being that, if you were brave enough to stick your finger into him, it would be like putting your foot into a bog, where it would just sink all the way in. So John was the one of us who had this vision of Swamp Thing, before any of us were working on the book. John started talking about how "Swamp Thing should have all these potatoes growing off him." That he would actually grow these

tubers, or fruit on his body, and Veitch was the one who went, "yeah! And they're hallucinogenic!" [*laughing*] There were a lot of other ideas that bounced around out of those years. My point is, that aspect of the character was really all of us getting behind John's vision. Alan, coincidentally, when he was brought on the book, was thinking in the same direction! Alan, John and I were all in agreement that what we would like to do with Swamp Thing was to get rid of the concept of the poor, tortured man trapped in the monster's body shtick, and bring him into his own, as this plant being, this powerful elemental being. We were all in sync on this, and it was not a deviation from the character that Len Wein and Berni Wrightson had created. It was actually bringing their character to a whole different level.

GG: There was that whole element of sex which had suddenly become more tangible. All of a sudden… now here is a guy that's not gonna take any shit from anyone who would threaten his woman! No matter what was going on, if he was fighting someone, he only did it because he had to. You really get the sense of him being on a free love trip. He just wanted to hang out with his wife, in the swamp!

SB: [*laughing*] You got it! Exactly! A lot of specific story ideas, the design of Swamp Thing, beefing up the upper torso… a lot of the artists who have worked on the book since don't understand what we were doing. But all those narrative elements that you're mentioning, that all grew

out of the three of us. It expressed a lot of our personal philosophies. Alan's an old hippie, I'm an old hippie, and we really did want to be able to just live out in the woods with our woman and leave us the fuck alone. [*laughs*] That's where *Swamp Thing* was at. I was getting frustrated, because we have this wonderful character, Abby, and we're just *tormenting* her every issue. I said, "Alan, one of the problems with serialized horror comics is that if anything vaguely like this was happening in real life, these characters would be fucking traumatized shells." At that point, I said, "do you think you could sell our editor on the idea of 'let's do one issue of just Swamp Thing and Abby *enjoying a day in the swamp*?' Where we get to see their downtime." Alan wrote back going, "aw Steve, that's fucking brilliant!" It was Alan who turned it into 'The Rites of Spring,' that beautiful issue of them consummating their affection for each other with that trip that Abby goes on. Alan, as he always did, took it to a whole new level. I sold them all on the idea that you would physically turn the book, at the point when Abby begins to get off, in trip terms. It was, "let's find a way of, when Abby takes a bite of the tuber, she goes on a peyote trip. And let's put the reader in her mindset as best we can." That led to all those trippy visuals that carry that book. After that issue, I watched a lot of people at conventions reading that book, and it was cool, almost every time the person would turn the comic without even being conscious of it. If we could have found a way to actually inlay a hallucinogenic into the paper… [*laughs*] That wasn't gonna happen. But laying out that double page spread, where the panels gradually turn, so as you read it you would turn the book, that was the best I could come up with. That's how intensive my bond with the page was. I was trying to lead your eye on every page of *Swamp Thing*. Because Alan was writing full scripts, we weren't writing the book "Marvel method" where you'd get a plot and you'd draw it, then the writer dialogued it. DC always worked with a full script method. I was able to place all the word balloons and captions on every issue of *Swamp Thing* that I pencilled. So if you look back over my issues, you'll see that 99.9% of the time, there is only one way to read that page. I would very carefully compose not just the visual elements and the panels on the page, but the placement of balloons and captions so that your eye would be led where we wanted it to go. The culmination of that was that issue where Abby hallucinates and you are turning the book around to continue reading.

GG: The sexual intensity of that book just stands out to me. I remember panels of her trembling, with a look of unbearable ecstasy on her face, sweat pouring from her brow, I thought it was a pretty graphic orgasm!

SB: Yeah, it was! But we weren't actually showing sexual organs, and you've also got to remember, when we were doing *Swamp Thing*, the sales were so low when we started on it that nobody cared what we did, really. The issue that got us in trouble was #29. John and I just cut loose! It's

almost like Alan's script for that issue opened up the floodgates to even more that we wanted to be doing in comics. And we poured everything we could into that issue.

GG: It's a very concentrated force in that issue. Even if it was an indie comic, it would still be a total motherfucker of a story.

SB: Well, there's nothing explicit in that issue. Even at the point where you suddenly realize that there is this whole hideous incest angle, where you realize that Abby's dead husband has been possessed by her dead uncle… Alan handles all that with a single line of dialogue: "just say *uncle.*" You could take all the same material that we had in that issue, and present it in a way that would be much fouler. But by underplaying things the way we did, I think the book was a lot stronger for it.

GG: But you're not using metaphors, nothing seems very surreptitious there. Whatever subtlety that it has, it's still in your face.

SB: Well, once the Comics Code read the issue, it was in their face. It was very telling that they reacted to the visuals first, which was just the imagery of the walking dead. They thought that was too over the top. And don't forget that up until 1969 or 1970, the walking dead had been barred from comics, under the Code. Completely.

GG: I never understood who the Comics Code really was, their power and their rules.

SB: The Code was instituted in the fall of 1954. The Code seal of approval was huge in the upper right hand corner of the books. It literally shrinks over the decades. It was still visible in the early '80s, but it shrank even more afterward. When I was a kid, one of the big events of my life really was when *Creepy* #1 and *Eerie* #2 popped up on the newsstand. We were aware enough of the code that we knew that these books were something different, that these black and white newsstand horror comics were a brand new kind of comic. We'd never had real newsstand horror comics before. They'd been taken away in '54 and I was born the year after that. So the Code was a presence to myself, to Alan, and to John. Those of us doing the book were very aware of it. When we started work on *Swamp Thing*, before the skirmish over #29, I had asked my editor for a copy of the Code, wondering what are we supposed to be working under? Well, we were never given one! We never saw a copy of the Code. The only copy of the Code we ever consulted during that time was the one reprinted by Les Daniels in his hardcover book, *Comix*. He had the Code printed in full in there, and it was the early version of the Code, from 1954. We were asking during the whole flare-up, "can we see what the rules are?" We never knew. It's interesting that for you, reading *Swamp Thing* when you were younger, that the Code meant nothing to you. Is that what you're saying?

GG: Well, I don't know that I'd even taken much notice of the seal on the covers, until I found an interview with you talking about the controversy

Above: Stephen R. Bissette's original pencils for the cover of **Swamp Thing** #34, March 1985. Courtesy of the artist.
Opposite Bottom: Stephen R. Bissette's original pencils for the cover of **Swamp Thing** #42, November 1985. Courtesy of the artist.
Overleaf: Original art from **Spider Baby Comix** #1 by Stephen R. Bissette. Courtesy of the artist.

regarding #29. That's the first time I can remember having any awareness of it at all. It didn't have any presence to me.

SB: Well, it had even less presence after that, because what happened is, they put out #29 without that seal of approval, and we were casually reprimanded, "don't do that again." And guess what? Sales just went through the roof! I think it was either #30 or #31 that was the very last issue to have the Code seal. It became 'Suggested for Mature Readers'. We were the first of the DC Comics to have the 'Mature Readers' label. In a way, our losing the code on *Swamp Thing* #29 was another of the catalysts for what became the Vertigo line. The readership responded favourably to that wider freedom. That then became one of the ground rules of Vertigo. Vertigo were "direct sale" comics only, they were not sold on the newsstand. And that freed up the Vertigo artists to push the envelope even further. Now, I never got to do that. I, to this day, have never got to work on a Vertigo book.

GG: What did you think of the two really cheesy *Swamp Thing* films?

SB: The first film was made before I was involved with the book. *Swamp Thing* was deader than a doornail before that Wes Craven film. The last time that character had appeared before 1981, was in *Challengers of the Unknown*. Swamp Thing was this goofy supporting character. Completely negligible, had nothing to do with the Len Wein / Berni Wrightson Swamp Thing. Then he popped up in an issue of *World's Finest*. It was just a travesty. Then they gave up on it. What revived the comic was that film. I owe a great deal of gratitude, because without that there would never have been a *Saga of the Swamp Thing* series for me to be working on. I never would have gotten to work with Alan Moore. I've got a soft spot for the first *Swamp Thing* movie. It's a fairly effective low-budget science fiction fantasy. Craven did it straight on, he didn't do it tongue in cheek. The movie suffers somewhat because of the special effects and makeup. They were fighting some very adversarial budget and environmental and time constraints to make that film. The second Swamp Thing movie, *The Return of the Swamp Thing*, is a mess. Jim Wynorski is a filmmaker who is right up there with Fred Olen Ray for being incredibly prolific, and for completely no-nonsense schlock. He's made a couple of movies I really like, like *Dinosaur Island*. But *Return* was atrocious. Heather Locklear as Abby is just painful to watch. Much better monster effects, but the movie's a joke. I didn't sleep the night I saw that film. I just laid there thinking, "is that how what we did looked like to people?!" Because it was adapted from some of the material that we had done. There's some story elements in there, lifted out of the stories that Alan, John, Rick, and I had done. They used our covers. All our covers are there underneath the opening title credits. And the title sequence is the best thing in the film!

GG: *Swamp Thing* was beautifully white trash, whereas *Hellblazer* grew into that hipster thing, with a lot more self-familiarity. Maybe not too unlike the way that *Scream* impacted horror movies in a way, do you agree?

SB: Well, *Scream* is a lot more flippant. I want to stress that I've only read some of the Vertigo line, it's not like I saw every Vertigo comic. Out of my sampling of that line, there were only three titles that I stayed with: *The Sandman*, *Hellblazer*, and *Preacher*. Those comics had many strengths, but they also had many weaknesses. Any line of comics that becomes identifiable – and that tag, that trade marking, that name-branding, is very necessary and very important in the publishing world – but it also becomes a prison! It means that that is your name brand and you have to work within that. I don't know what went into the evolution of the Vertigo line, but I'm sure they gravitated toward the type of books they thought would sell, as well as the ones that they felt strongly were of high quality. And yeah, that did for me become a liability after a time, because what a Vertigo comic was

in my mind wasn't necessarily what I wanted to be reading. Vertigo comics were like… comfortable people's fantasies. If you're comfortable enough materially, and you're not worrying about "how am I gonna face my bills this week", then you can wrestle with theology. [*laughs*] Then you can wrestle with the essence of something like *Preacher*, that whole I've gotta go punch God in the mouth kinda thing. But that doesn't speak to everybody. There are many, many more people in this world that have been or are hungry, or have been or are really afraid, and who do not know week to week how they're going to get money, or get groceries, much less ever afford health insurance. Now, this is all blue-collar/white-collar stuff. These are class lines that we're talking about. And this is relevant to our conversation in that, when we were doing *Swamp Thing*, we were all fucking poor, we were still at the poverty level of Vermont income. And that was reflected, necessarily, because that's how those things manifest, in the stories and in the visuals of the stories. Abby dressed with what she could afford to buy: cut-off jeans, not particularly good shirts. That's how we lived, that's how our friends lived. And we thought Abby was pretty fetching in those cut-off jeans! So, with *Swamp Thing* we were kind of like the trailer park horror comic, before Vertigo came along.

GG: You have to be severely optimistic to go do what you did, to enter into a massive financial risk like your anthology series *Taboo* was. I think it's very rare for somebody to work in a given industry for a while, as a top artist, then go in the exact opposite direction halfway through their career. To decide at that point to start doing guerrilla-style work again.

SB: Well… bear in mind that for me, that was because my first love was the pushing of the envelope. And you can only do that for so long in the mainstream venues. We were lucky to get away with what we got away with, with *Swamp Thing*. As John Totleben observed at the time, as soon as the book became successful, it became harder and harder to work with the freedom that we'd had originally! As soon as you become associated with something that becomes successful, the people in charge, who have the money, steer that property into the direction where they see the greatest profit. I'm one of those stupid fuckers who keeps going, "well no, it's more interesting over *here*!" That's how *Taboo* grew out of *Swamp Thing*." It also grew out of an invitation from another crazy son of a bitch, a grand fellow named Dave Sim, the writer, artist, and publisher of *Cerebus*. While we were doing *Swamp Thing*, Dave Sim met John and I at an Ohio convention, and he extended an invite to us! He said, "listen, you guys do whatever you wanna do… I will bankroll the publishing of it." Dave was extending that invitation in many directions at that time. Anyone who was doing work that he felt was cutting edge in comics, were the people he was going to. He extended that invite to Bill Sienkiewicz, to Alan Moore… he was

hoping to convince Frank Miller to make the jump from working with mainstream publishers to doing his own work… and John and I took him up on it. That's where *Taboo* came from.

GG: You published Alan Moore and Eddie Campbell's original *From Hell* chapters in *Taboo*, which of course led to the big Hollywood film with Johnny Depp and Heather Graham. *From Hell* the film did have an unusual degree of bite to it.

SB: It did, but the problem is, they missed the point. The point of *From Hell* wasn't "who was Jack the Ripper?" What Alan and Eddie were interested in charting was, how does a series of horrific events alter lives – not only of the people it happens to, but the lives of everyone in its orbit – with the understanding that we are in its orbit as well. Really, *From Hell* is about what Jack the Ripper is to us now, in the 21st Century. In the graphic novel, from the first full chapter we already know why the prostitutes are pulled in to this circle. And we also know by the third chapter – where Alan and Eddie show us the life of William Gull from childhood – what it is that made him into this murderer. What forces shaped this human being into being not just capable of those kinds of acts, but actually indulging in those kinds of acts. As soon as you turn that into a mystery, which is what the film did, when we're not supposed to know until the last act that Ian Holm is Jack the Ripper… well, why did they buy *From Hell*? Why did they adapt it? Because they're no longer adapting *From Hell*. The big difference between *From Hell* as a film, and *Sin City* as a film, is that Rodriguez understood his source material! He also understood, "well if I don't do this with Frank Miller, there's no fucking point doing this!" Every film adaptation of one of Alan Moore's properties has disposed of – instantly – what makes Alan's material magical! And they never seem to ask Alan to get involved, or push for him to get involved… It's interesting that something which started as this cheapjack serial, that was gonna appear in this non-mainstream comic, made it into being produced as a film. But, having seen peripherally, as I did, how all that was handled, as an option and so on and so forth, it wasn't that different from what happened with *The Crow* and what happened with other Hollywood or semi-independent films that ended up manhandling the creators of the work, or forgetting about the creators of the work altogether. The best case scenario, right now, is *Sin City*. If you wanna make a film based on a graphic novel, goddammit, work with the person who lived with that piece of work for ten years!

GG: Okay, we're gonna take a shrieking hard turn into the subject of Abby, the swamp goddess, who is the love of my life.

SB: [*laughs*] Let's do it.

GG: In regards to *Swamp Thing* having a kind of social conscience, your concern for the concerns of working class people… I got stuck in this fixation,

reading the comics. She sets herself deeply in one's mind, and I'd imagine that it would be even more intense for the creator. It's intense because she's always in trouble, and it's not the trouble that your usual dame in distress finds herself in. This is a woman who is dirt poor. That has to do with her look, she is dressed in the cheap old clothes, the cut offs… when did you come up with that whole look?

SB: Abby, for me… I was at a point in my career where I was still learning how to draw, consistently, human characters. That was not a particular strength of mine. I was still trying to build up that skill, as a cartoonist. My first love in drawing, and what brought me into wanting to work in comics, was fanciful creatures. Monsters, dinosaurs, animals… creating fantastic environments. That's what really drives me as an artist. Drawing human beings, and drawing components of the real world – buildings, cars, houses – is a necessary evil.

Above: Stephen R. Bissette's original pencils for the final page of **Swamp Thing** #39, August 1985. Early John Constantine appearance. Alan Moore's concept of Swamp Thing's re-generative capability is particularly well represented here.
Overleaf: Original art from **Spider Baby Comix** #2 by Stephen R. Bissette. Both illustrations courtesy of the artist.

I don't enjoy that part of the job as much as I do the thing that really pushes me. And hearing you say what you say about Abby is very edifying because that means we fuckin' did it! We managed to create this character. When it came time to draw Abby, I chose Sigourney Weaver as the role model. This was before the era of videocassettes. There were books that came out, where they would adapt a popular film, and show it scene by scene, with frame clips, and present it in almost graphic novel form. One of these books that came out was *Alien*. So it was the perfect photo reference for Sigourney Weaver. John Totleben was the other component in this. One of his great strengths was drawing women. John draws the most ravishing women imaginable. We used to do the comic book conventions together, and John would often do sketches of Abby for people. I remember one fan asked him to do a nude of Abby. The guy was almost drooling as he was watching John draw this picture. At one point he said, "if I could do that, I would just stay at home and jerk off all day!" [*laughs*] The beauty of this was that, with my pencils, I was drawing a very angular, sort of bony, woman.

My Abby was much closer to that tough, steely look that Sigourney Weaver had in her early roles. John, with his inks, would just naturally soften that. So this real warmth was constantly coming to the character. Over three or four issues, between my approach with pencils and the magic John was working with the inks, we really arrived at our own take on Abby and who she was. At that point, I no longer needed the constant photo reference because Abby was becoming a full character in my mind. More and more, it was Abigail I was drawing, and not this woman who was *supposed* to be Abigail. To us, Abby was a woman! And when people get frightened, they get sweaty… so that's what you draw! People don't wear perfect outfits. Their hair isn't always perfect. That's part of what makes people attractive and engaging! It's the blemishes and the irregularities as much as the more cosmetically attractive aspects. And that's what we tried to bring to Abby. She was a woman who was living in the southern states, and it's very hot and sticky down there, and we made that tactile approach part and parcel of what we brought to the character. So, when she was frightened, she did not look beautiful and ravishing.

GG: There are a lot of unflattering panels of her, to be sure. That helps introduce real sex to the book, where it's not just a device or a gimmick, like in the Vertigo comics, to make the book more 'adult', it's really part of the story, an overall theme that you get.

SB: Okay, one of the key things we tried to bring into every single panel, if we could, was this fecundity of the swamp landscape, where everything is dying and living and fucking and giving birth… there's mushrooms everywhere, animals everywhere, insects everywhere. That's just an aspect of the real world, but it also brings to the forefront this tactile interaction between the reader and the comic. We tried to make it feel like it was hot and sweaty. You don't just tell the reader that, you make it feel like that. It wasn't that we wanted to make dirty comics, but we were looking to evoke this landscape where women sweat, men sweat, if you get cut you bleed. Hot, sticky. That just becomes a more sexual atmosphere. Tennessee Williams played it for all it was worth.

GG: That's the image that people have about New Orleans, very specifically. The Animals, 'House of the Rising Sun' and all that, where the brutal heat and humidity can warp you into a state of sexual panic!

SB: It's just part of the real world in general. Pulling away from the Southern Gothic aspect, that's also true of urbanity. Part of why Martin Scorsese's films were so engaging when they first appeared, *Mean Streets* and *Taxi Driver*, was because he caught that same kind of immediacy. Removing it from the southern setting of *Swamp Thing*, I think it could be applied to any location. And if you pay attention to that, it immediately lends this sexual charge or sexual potential to the material because suddenly you're in the world of flesh and blood. And that

alone is sensual. It's a sensual way of looking at the world, a sensual way of experiencing the world, a sensual way of conveying and communicating in the world. That's where we were coming from.

GG: The classic hippie viewpoint, near-Utopia. And then, even better, with rats and 'gators.

SB: Well, you've also got Swamp Thing! But Swamp Thing, John's great concept of him growing the tubers… he's such a literally rich character, in terms of soil. He's giving birth all over his body, to all this vegetation!

GG: What's the history of sex in comics, in a nutshell?

SB: There's been sex comics around as long as there's been comics. Whether you trace comics back to 19th Century England, or to the prehistoric days, as soon as people could draw, they were drawing people fucking. Sex in comics was such that when I was at Kubert, the first year, one of my classmates got an inking job for an issue of *Legion of Super-Heroes*. He received the pencils for the issue, and all the Legionnaires were engaged in some type of sexual activity with each other. [*laughs*] At that time, before computers had come into the industry, there was a process where the editors would blue-pencil the art… blue would not photograph in the process of the production of the comics. So the editor would sit down with a light blue coloured pencil, and circle or indicate in some way all the changes that had to be made. My friend, when he got the pencils which it was his job to ink, there were blue circles and blue arrows instructing the inker to, you know, separate these two. [*laughs*] We found it amusing, but at the same time it was really kinda creepy, you know? And for some of us, like Rick Veitch and myself, we were into the underground comics, and so we were like, "fuck, if you wanna draw sex, in a comic… then just draw SEX!" If you're gonna do it in this covert way, it suddenly became subliminalized, in this really disturbing way. So there's my friend, doing the inks on the issue, laughing over it, because it is funny… but at the same time, it's a sniggering adolescent view of sexuality. In that issue of *Swamp Thing*, where Abby consummates her relationship, we were rebelling against that. We were just like, "fuck! we can't have Abby and Swamp Thing fucking physically in the book, and we're not doing that kind of comic anyway. But let's make this as genuinely sexualized an experience as we can. Let's really try to communicate in visual terms the act of having sex with a creature from another species altogether, and… reach an orgasm!" That's what the book's all about!

GG: When you left *Swamp Thing*, you soon after began *Taboo*.

SB: John and I were frustrated that when we were doing *Swamp Thing*, it was the only horror comic on the newsstand. The only other horror comic on the newsstand, the year we started *Swamp Thing*, was *Night Force*. That was the very short-lived occult horror comic that DC put out. And in the direct sale market, the only thing that had popped up with any meat on its bones was Bruce Jones's *Twisted Tales*. But we were very frustrated with that too! Bruce Jones was one of the great comic writers of the '70s. His stories that appeared in *Creepy*, *Eerie*, and *Vampirella*, were some of the best horror stories ever published. He was cutting edge. What he was doing in the Warren books was these beautiful and incredibly piercing love stories, as horror stories. They were really honest, really direct, and they were using the horror aspect as a metaphor for the really horrible things that people really do to each other when they're in love. And how love twists us sometimes, and changes us. How obsessive love can become dangerous, what it can lead to… And the reason I'm bringing it up, is because John and I were saying, "this guy's better than this!" He gets the shot to start doing a great horror comic and he's just regurgitating all the old EC tropes! There were some very good stories there, but they had none of the juice and power and passion of his work with Warren Comics. They seemed watered down. What was transgressive in 1951-1954 was pretty fuckin' weak tea thirty years later. That became a real catalyst for us with *Taboo*. Horror comics have been straitjacketed by this formula that everyone ties them into. There's so much else that can be done. We wanted to put out an anthology that would once and for all smash the EC mould and push horror comics into the '90s. I literally had written up a manifesto, the *Taboo* manifesto. We sent it to all of the people who we hoped would be interested in contributing to the project. And the manifesto, in a nutshell, was "we only want stories that disturb YOU. We want you to write or draw something that really gets under your skin." That was the thrust of *Taboo*.

GG: I can see how that is truly epitomized by your story 'Cottonmouth'.

SB: Back then, this was the late '80s, there was a lot of news about toxic shock syndrome. What that was, was that some of the elements used to manufacture feminine hygiene products would actually induce the symptoms of poisoning in some of the women who used those products. It exploded into a corporate scandal at the time. To me, it was just unthinkable! Here's a whole industry that makes its profit from aiding women in dealing with menstruation, and it actually kills them! 'Cottonmouth' is a pretty old fashioned story, the dead come back to life and take their revenge. The idea was that the ghosts of these women, young and old, who had been killed by these products, were in a single evening balancing the scales by showing up in the bedrooms of the various corporate executives who had been responsible for these products, and sewing their mouths shut after their mouths had been stuffed with used tampons. [*laughs*] It's completely fucking disgusting. But at the same time, if I were doing an EC style comic today, it would all be toward this culture of rampant corporate greed, where people are dying because of products that are manufactured supposedly for their good. 'Cottonmouth' was my one stab at that. People will bring that issue of *Taboo* to

"I occasionally got stuff in the mail that would creep me out. Someone sent me the top of a woman's finger! I disposed of that. It was unsettling. "

me and I will sign it, "My Period Piece." A little pun there. I'm happy with it, but it's really an anecdote. It's not a story. It was the most superficial type of story that I would want to have in *Taboo*. I was hoping for material that would really expand the breadth and depth of the genre. I think by issue 2 or 3, we were there.

GG: I am very interested in the stuff that you rejected from *Taboo*. Did you have some real creeps coming around after a while of doing that?

SB: Not really. I occasionally got stuff in the mail that would creep me out. Someone sent me something in the mail, I opened it up, and it was in a little cardboard box. It was a vial. When I looked at the vial, I couldn't tell what was in it, there was something in it floating in liquid. And as I turned it over, the object inside flipped around, and what it was, was the top of a woman's finger! I know it was a woman's finger because there was nail polish on it still! I just went, HOLY SHIT! Someone's sending me the end of a woman's finger! I disposed of that. It was unsettling.

GG: In doing the real stuff, you always do run the risk of encountering the wrong people, who live where you are living creatively, as a constant state of being.

SB: Yeah. I have met fans who were physically threatening at conventions. But in terms of rejecting material because of it going too far, the most trouble we ever got into was over S. Clay Wilson's work, and Wilson was a sweetheart to deal with!

GG: What kind of trouble was that?

SB: Oh Christ! *Taboo #2*, we couldn't find a printer who would print it. I couldn't get the cover transparency shot, that was the cover that Totleben had painted, of this kind of piranha-headed creature, pulling her own belly open and all of this shrimp-like young coming out of her belly. I took that to a local production house, very nice people, they had shown me a gun catalogue as an example of their work. I didn't hear from them for two or three days, and then they called me one night. They were very nervous and very apologetic, and they basically said, "We are churchgoing people, and we cannot, in good conscience,

shoot the transparency of this cover." I didn't get argumentative, we settled amicably enough. I found another place to get it shot, and they were very pleasant. But I did ask them, "I need to understand something here. You're not willing to duplicate a painting that is fantastical, that no one could imitate in real life, but you are comfortable doing production on a gun catalogue." [*laughs*] As usual in that type of conversation, he just didn't get where I was going… It's okay to sell firearms, it's not okay to show piranha-headed women giving birth! Then we had trouble with one of the inside-cover paintings, a collage painting that Alan Moore had done, that tied in to *From Hell*, that showed the map of London, circa the 1880s, and how the placement of the key churches in London formed a pentagram. A production house in Vermont refused to do it, saying that this was a Satanic work! Then we finally got a printer who would print the book, but their binder would not bind the book! *Taboo 2*, because of all that interference, is now a very fragile book, with fragile binding. That was just a torturous experience. *Taboo 2* then immediately got busted in England and Canada, among other countries, because of the one-page S. Clay Wilson illustrations in there. The strongest rejections we ever got from censors were over S. Clay Wilson. It's funny, because when John and I first conceived of doing *Taboo*, we looked at each other and said, "we gotta get ahold of S. Clay." [*laughs*] We found it unbelievable that S. Clay Wilson was not being published anywhere in America at that point in time.

GG: Yeah, but he represents the limit though, doesn't he?

SB: But he's this very sweet natured guy. He was fun to work with. I found him to be a professional every step of the way. It was unfathomable to me, that what was *verboten* in the '70s, was still a problem in the '90s, and all it fucking is, is lines on paper. All S. Clay Wilson is doing is drawing!

GG: But he's the end of the line. You go past him, there's only darkness.

SB: Well, there's Mike Diana! Mike Diana is still the only artist in American history convicted of obscenity charges! The whole Mike Diana story is one of the blackest chapters of American comics history. Mike was fucking seventeen, when they were bringing charges against him. One of the results was that he couldn't spend time with anyone under eighteen! And he was a fucking teenager! And what was Mike Diana doing? Making lines on paper. That was the physical act. That is all that is entailed in drawing. And they made a martyr out of him. Mike's fanzine comic *Boiled Angel* was being sold to people through the mail to maybe 200 people at the most! And now we all know who Mike Diana is, because they fucking crucified him! [*sighs*] The Comic Book Legal Defense Fund, in his case, tried to jump right from the Florida courts to the Supreme Court. They jumped a level to try to get the case heard,

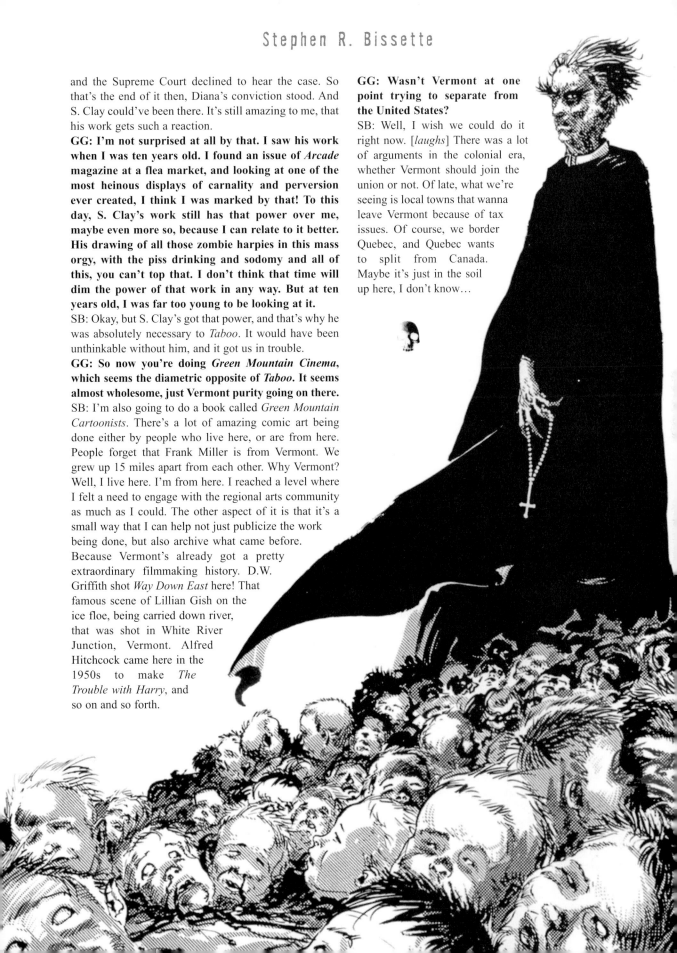

and the Supreme Court declined to hear the case. So that's the end of it then, Diana's conviction stood. And S. Clay could've been there. It's still amazing to me, that his work gets such a reaction.

GG: I'm not surprised at all by that. I saw his work when I was ten years old. I found an issue of *Arcade* magazine at a flea market, and looking at one of the most heinous displays of carnality and perversion ever created, I think I was marked by that! To this day, S. Clay's work still has that power over me, maybe even more so, because I can relate to it better. His drawing of all those zombie harpies in this mass orgy, with the piss drinking and sodomy and all of this, you can't top that. I don't think that time will dim the power of that work in any way. But at ten years old, I was far too young to be looking at it.

SB: Okay, but S. Clay's got that power, and that's why he was absolutely necessary to *Taboo*. It would have been unthinkable without him, and it got us in trouble.

GG: So now you're doing *Green Mountain Cinema*, which seems the diametric opposite of *Taboo*. It seems almost wholesome, just Vermont purity going on there.

SB: I'm also going to do a book called *Green Mountain Cartoonists*. There's a lot of amazing comic art being done either by people who live here, or are from here. People forget that Frank Miller is from Vermont. We grew up 15 miles apart from each other. Why Vermont? Well, I live here. I'm from here. I reached a level where I felt a need to engage with the regional arts community as much as I could. The other aspect of it is that it's a small way that I can help not just publicize the work being done, but also archive what came before. Because Vermont's already got a pretty extraordinary filmmaking history. D.W. Griffith shot *Way Down East* here! That famous scene of Lillian Gish on the ice floe, being carried down river, that was shot in White River Junction, Vermont. Alfred Hitchcock came here in the 1950s to make *The Trouble with Harry*, and so on and so forth.

GG: Wasn't Vermont at one point trying to separate from the United States?

SB: Well, I wish we could do it right now. [*laughs*] There was a lot of arguments in the colonial era, whether Vermont should join the union or not. Of late, what we're seeing is local towns that wanna leave Vermont because of tax issues. Of course, we border Quebec, and Quebec wants to split from Canada. Maybe it's just in the soil up here, I don't know…

Die Screaming in America

- Cynthia True -

"There are two kinds of people in this world: Johnsons, and Shits."
– William Burroughs –

"All I'm trying to do, folks, is rid the world of all these fevered egos that are tainting our collective unconscious and making us pay a higher psychic price than we can fucking imagine."
– Bill Hicks –

While one would expect a tome chronicling the philosophical, comic, and chemical excesses of the greatest humorist of the twentieth century to come from some grossly pretentious *Village Voice* scribe or the stale beer fart, under-the-couch potato chip equivalent of a male ex-comedian, this lean, mean and punishingly tragic bio was written by a young woman. And Miss True, as it turns out, couldn't have written a truer book about a truer man.

This makes such a document all the more a cause for celebration. I'm sick of middle-aged comics who make me laugh about as often as it rains in Nevada, and I'm just as fed up with stodgy, uptight biographers who rarely take chances and offer few surprises with the stories they tell. Cynthia True has balls, let me tell you.

When reading profiles and biographies, I often long for more directly relevant commentary in those places where a truly gifted biographical eye counts most. Cynthia True's book spends minimal time on peripheral data which is often confused with the flesh and blood subject him or herself. I think the most common crimes committed by 90% of all biographies have to do with too much periphery, too many extraneous topical details and never enough of the gory, down to earth ones. Psychological insight and biographical insight are not always one and the same. *American Scream* provides both. True's work is exceptionally well-paced, packed to the gills with sordid details (without becoming smarmy and sleazy) and written with a razor sharp wit. The narrative reproduces the underground glory, Christ-like desperation, and basic violence of Hicks's brutal life with a gale force intensity, yet falls just short of making a saint of the man. (We know he was, of course, but there's a lot to be said for objectivity when writing a life story, especially about someone who is no longer with us.) All in all, *American Scream* somehow finds the right formula to work both as a fascinating introduction to Bill Hicks for the unenlightened, and an emotionally draining, only slightly biased critique for the hardened disciples.

Bill Hicks was a preacher. One whose sermons, we can now truly understand, carried the raw possibility of social and political change, even if the world wasn't listening. Hicks spoke for the Johnsons just as he spoke against the Shits.

American Scream is an essential text about an essential man. And the book's author, Miss True, is a considerable talent in her own right, with brains and beauty to spare. Keep an eye on this one, her future books should be nothing less than journalistic Events.

Gene Gregorits: Do you think that anyone would have written this book, if you hadn't?
Cynthia True: Oh absolutely. I think that several other people were interested in writing books on Hicks, and I've even heard that others are involved in the process of doing so. I just feel lucky that my timing was good, and I got to it before the others.

GG: What is it about Texas that made Hicks possible?
CT: I think Bill Hicks would have been a genius whether he was born in Illinois, Massachusetts or Texas. I don't want to overplay the Texan part of it too much. I think that

Texas is certainly a republic, more than any state. It's very idiosyncratic, it's very much "Texas first, US second." Perhaps it encourages some individualism. Texas is a very conservative Bible belt state, the perfect breeding ground for voices of dissent, because when you're just hit in the face with that much big oil Republicanism in your life, plus the Christianity and all of that, someone like Hicks is going to come out of that much more extreme. In that way, growing up in the south helped shape Bill's rebellion.

GG: When you're writing a biography of someone who has died, it is, in essence, like chasing a ghost.

Cynthia True.
Photo courtesy of HarperCollins.

CT: It's always elusive. I read these biographies of Elvis that Peter Guralnick wrote, *Last Train to Memphis* and *Careless Love*. In his introduction, he writes about how you're always chasing this elusive ghost, and you're always one step behind, trying to grab on to them. I thought that was so apt. That's how I felt the whole time. You can read letters and listen to phone messages, talk to friends, watch videotapes, but you never truly understand the essence of a person unless you've met them. That was a disadvantage for me.

GG: It must have been hard being on the trail of Bill Hicks. Did it make you sad?

CT: Yes. It was very uplifting and inspiring in many ways, because his personal ethos was so original and life affirming, but it's very depressing to investigate a person who died at the age of thirty-two. I started writing the book only four years after Bill's death. I'm sitting there talking to all of these people who were still, at that point, really very grief-stricken. Of course, they loved him to pieces. You're floating in a lot of other people's grief. Plus your own, as you come to know someone in such an odd way. Not that I feel that I know Bill, but you come to a point where you know so much about them, that you start to have this huge affection for them. Bill was one of those rare people it was hard to find one truly bad thing about. I went through my own grief for his death too.

GG: Hicks's performances leave you with something really substantial. I think that there are only so many people in the world who get the big picture, and that drive towards truth versus corruption, justice versus evil and all that. He had that. Did it make you bitter, doing the book? The reason he isn't here, obviously, was pancreatic cancer. But also, it seems like he had a really hard time because he expected people to give a shit and they didn't. Did that make you bitter in any way?

CT: I don't think that has anything to do with Bill's death. I think that Bill died because he had cancer. I think that he knew that he was the shit, and as much as he was ignored, he was also beloved. A complete cult figure. He was adored. *Rolling Stone* did name him "Hot Comic of the Year." He had huge success in England. He had done two tours in two years, selling out two thousand seat theatres all over the place. What's really tragic about Bill's death is that his dreams were coming true at the same time as this horrible nightmare was unfolding. *The Nation* had just asked him to start contributing a monthly column. The New York Public Library had asked him to start touring. Things were happening for Bill. Yeah, he was ignored, but he had this very funny thing of being ignored on one hand, and on the other, being really intensely celebrated by critics and other comics. He was surrounded by people who told him, "You are really something." He certainly felt frustrated, but he was appreciated. He was excited, so when he got sick, it was just like, "Oh my god." The timing was crazy. Let's not forget, Bill was really young. For a comic to make it at forty, that's considered young. Jerry Seinfeld didn't become a household name until he was around forty years old. Bill died when he was barely thirty-two.

GG: You do make a point in the book to address the fact that Denis Leary stole lengthy bits from Bill Hicks. It was like wholesale plagiarizing. When you think about someone like Denis Leary grabbing huge lines from Hicks, and this fact: Leary is doing great, Bill is in the ground, doesn't that put a chip on your shoulder about the nature of Hollywood and show business after having spent so much time with this story?

CT: No, because I know that Bill is one hundred times the artist that Denis Leary will ever be. Denis Leary is a celebrity, Bill was an artist. Anyone who knows both of them knows the difference between them. And no matter who steals from Bill, they could never be Bill, they could never capture his essence, his rhythm, his innovation, his understanding. Leary can't touch him. So… no. It doesn't bother me. I think that Denis Leary is having exactly the career that he deserves to have.

GG: Where do you think stand-up is today? I don't know how much attention you pay to it at this point…

CT: I have to say that I don't keep up. I divorced myself from a lot of that after the book was over, because I was sick of it. And I think comedy is at a pretty stagnant place. I don't think there's anything terribly interesting happening. I think there's some really great comics out there, but I think they're the same people who have been on the scene for the last several years. They've either got TV deals, or they don't. Or they're staring at their ceiling, watching the paint peel.

GG: It took you four years to write the book?

CT: Yes. Actually, that's a slight exaggeration. About three. But by the time it came out, it was almost four years and I was doing last minute copy-reads until the very, very end.

GG: During all the research, did you discover someone you wouldn't have otherwise?

CT: Well, I knew the comedy scene fairly well before I started doing the book, because I had been covering it in New York. There's some great comics I really came to love. I'm a big fan of Dave Attell. I'm a big fan of Jon Stewart. I think he's really a deft comedian. I love Janeane Garofalo. I think Marc Maron is very political and interesting. Todd Barry is a very good comic out of New York. Patton Oswalt, out of Los Angeles, is very good. So those are a few people that I like.

GG: What are you into writing about now?

CT: You know, I always want to do reporting, because I think it's important. I'm experimenting with the possibility of writing a regular column. I really want to write about Los Angeles, actually, as a city. I know that sounds strange, but I'm very interested in the politics of this city. What's interesting to me about Los Angeles is that it is so very misunderstood. It's a great sport to hate

LA. One of the biggest shocks to me coming here was how much I really loved the city. And I love the real Los Angeles, the Los Angeles that has nothing to do with Beverly Hills, with Hollywood. The movies and all that crap. Those are very interesting parts of the city, but I love what really makes the city, which is a huge immigrant culture and amazing restaurants. There's all these fallacies about Los Angeles that I think are very interesting to try and uncover and expose. It's funny because Bill hated LA, but I think that's because he was stuck in the Hollywood version of it. He was out in West Los Angeles, but not exposed to the rest of it. I love the fact that you can eat the most incredible Persian, Japanese, Salvadorian, Ethiopian food. It can be any city that you want it to be. People bitch about how big it is, but I love it. It is fascinating to be able to be in Echo Park in the morning, then out in Malibu by the afternoon. The constant sense of dislocation is very exciting to me.

GG: Are you a big fan of James Ellroy?

CT: I am. But what I am really a fan of is *Demon Dog*, his documentary about LA.

GG: I am a huge fan of *Demon Dog*. Ellroy is the ultimate LA tour guide.

CT: I love that. And that's exactly the LA that I love. That noir-ish weirdness. So yeah, I am a fan.

GG: How did Janeane Garofalo come to write the intro for *American Scream*?

CT: I met Janeane when I was covering comedy in New York. I knew that she was a big fan of Hicks. She saw him perform in Houston. Watching him was what got her onstage. That moment got her to write the foreword. She very generously agreed to do it.

GG: Okay, his own obscurity was not directly related to his death, but could you see how perhaps, in the case of Hicks, his drug abuse and alcohol abuse could have come out of the great anger, and in that sense, must have taken its toll on his pancreas.

CT: It's really hard to say. Of course, Bill drank very, very heavily, and that's not good for your pancreas. On the other hand, Bill drank very heavily for four years. And you look around and you say, "How many alcoholics do you know who drink heavily for twenty years, and never have a problem?" For a man to get pancreatic cancer at the age of 31, no matter what he's done, it's just so bizarre. I don't know. It's really hard to say. I suppose it is a contributing factor.

GG: But he would also, at times, do almost inhuman amounts of cocaine.

CT: Right. But he was a drinker, and he's someone who did cocaine in order to keep himself drinking. It's not as though Bill was caning it every single night. He wasn't. And once Bill stopped drinking, all of that went away. I think Bill did drugs because he was twenty-one, twenty-two years old, hanging out in Comedy Clubs, and making friends with people like Sam Kinison, and getting very curious. Bill had a very curious mind. Suddenly he's

thinking to himself, "All of my favourite rock stars have done it," and Kinison says it opens up his mind about the writing thing. Bill was frustrated by the process at the time he started doing drugs. He was out here at the Comedy Store at eighteen years old, and he's doing his act, and he's already just a fantastic technician of comedy. This is very clear to everyone around him, including himself, that he's a well-oiled machine. If he wants to go to the top of the clever, observational humour, he can do that. He wasn't terribly offensive, just a mildly rebellious persona. But he got bored with all that, he didn't want to do that! I don't think that was an intellectual decision so much as it was a visceral impulse. This feeling of, "What am I doing out here? I don't want to be a monkey boy. I don't want to do the same jokes over and over! What is this really about?" I think that is just an artist coming of age, in a sense. An artist of his calibre coming of age. And again, Bill is only eighteen years old. He's a kid! He's going, "Oh! I don't want to be Jerry Seinfeld!" He's feeling very frustrated, so he goes back to Texas, and he happens to meet a large number of amazing comics, who at that time, were getting around in Texas. These guys were partying really hard. They're all quite a lot older than him. Maybe he's saying, "This can help burst the dam." You know what I mean. [*laughs*] And do things. And it did. You know how drugs are. He's smoking pot, he's doing coke, he's drinking, he's taking mushrooms. Having incredible revelations on mushrooms.

GG: All that philosophical stuff he was getting into, meditation and what not. He picked up anything and everything he could get both his hands and his mind around.

CT: Yeah! Bill said, when he stopped doing drugs, "I had a great time doing drugs, drugs helped me!" All that stuff he does about rock stars and drugs, I think that at the end of the day, it's a reflection of his personal experience. "Hey! This did unlock a lot of doors for me, creatively. Then I started abusing it and I had to quit." That's the genesis of eighty percent of us who do drugs.

GG: Absolutely. Except the quitting part.

CT: [*laughs*] We love it, it's amazing, perhaps in some instances we find ourselves smoking every morning before we get out of bed, and, "You know what? I gotta get it together." That's pretty much what happened with Bill. There was definitely a point where Bill's friends were afraid he was going to die of alcoholism. But we're talking over a four or five year period. By twenty-six, twenty-seven, he goes, "I'm done. I am living for comedy. I am living for my career. I want to do this." He cleans up. Goes back on the road. Repairs a lot of professional relationships. And that's when you see his material really fuse together. You see the anger get channelled in a much more productive way. Instead of just ranting at the audience, he begins to pull together his political beliefs and get himself educated about politics. American foreign policy. All that stuff. And he channels that rage

somewhere… and you have this incredibly intense, sophisticated comedian. He sobered up in the spring of 1988. He died February 26, 1994. He was twenty-six years old when he sobered up, and he did it pretty quickly. Bill was a Sagittarius, he was very extreme. If he was gonna drink, he was gonna drink. He'd drink a whole bottle of Jack Daniels. If he was gonna clean up, he was going to do it, cold turkey. He quit drinking, but continued to do mushrooms. Then he gave everything up, until right before his death, when he did do another mushroom trip.

GG: You're saying the violent rants just stopped?

CT: They didn't stop, they were just more focused. It wasn't him just standing up there going, "You people are shit!" In the same way that alcohol can light a fire under you, it can also blur you out.

GG: It makes you repetitive.

CT: Yeah. It submerges the real things going on. He could still get riled up, but it would have this focus so you couldn't dismiss him anymore. It wasn't "that drunk up on stage." You were going, "Wow, this guy is really saying something."

GG: You've seen the footage, I'm sure, of the Chicago show…

CT: …when he goes off on that woman?

GG: Yeah, that one.

CT: He's not drunk there. That show is from 1990.

GG: Total self-immolation. It was like he burned himself right down and took everyone with him.

CT: An amazing show. But that show got him in a lot of trouble. At the same, it made his career in Chicago. That night, when he was up there going off on that woman…

GG: "You drunk cunt! Find a fuckin' soul!"

CT: …he was actually very ashamed of that show and was very upset to find out that that tape got out and was making the rounds. He wasn't proud of going off like that. Of course, for a Hicks fan, it is a brilliant, unforgettable show. It's completely overwhelming. That's an example of Bill going nuts, but it isn't a train wreck. But there were famous stories about him losing it on stage. I don't think people were videotaping much at that point.

GG: Yeah, I never saw a tape where he actually bombed.

CT: There were many, many nights where he was totally drunk, but up there, and killing. The Chicago show… okay, half the room walked out, but the other half drew their chairs closer. Meanwhile, word is going around Chicago, while Bill Hicks is on stage, and all these other comedians from other clubs were running over there to catch the last set. It became infamous. The club owner really stuck by Bill. He was a friend. The rest of that weekend, the shows were all sold out. Word spread.

GG: They made a film out of Andy Kaufman's life. Would you be surprised by one on Bill?

CT: I don't know if they would do it based on my book or not, but I certainly think they should [make a movie], and will. First of all, Bill's life was like a perfect three-act. His story, much more so than Kaufman's, is a story about America. In terms of freedom of speech, and the shopping mall-ification of America. The death of social commentary. Bill is the emblem of the death of social commentary in our country. It seems impossible to me that someone wouldn't want to make a movie about him. There are still a lot of books to be written about Bill Hicks. I didn't have nearly enough room to do everything I wanted. I was working at Comedy Central as a writer and a researcher in the news department there, and this guy brought in tapes of Bill Hicks's first two albums, while Bill was still alive. I was completely transfixed. It changed my perception of my life, my perception of the world, in the most intense way. I would say, up to that point, he'd been the most eye-opening thing for me. I was starting to read Noam Chomsky, and hearing Bill Hicks was the same experience as reading *Manufacturing Consent*, where you just feel that someone has opened up your brain and poured information into it.

GG: I think there's a lot in common between the overall effect of hearing Bill Hicks and hearing Jello Biafra. They tap into a part of the human psyche which has been starved to death by the whole entertainment culture.

CT: Oh yeah! You just realize, "Oh right! I've been a slave." [*laughs*] And you think you're not, but you are. I think that's the real danger sometimes. Those who think of ourselves as educated, or as intellectuals, or as "hip" to mass media and everything… get over yourself. You're not, really. It's so easy to slide in and claim those things. I think that after September 11 especially. That was a time of real vulnerability, for the intellect. It was such an emotional time, and you're going, "Uh… eh… wait a minute… I don't know what to think."

GG: There was no one else spreading that word. When Bill Hicks died, there wasn't anyone waiting to step in.

CT: Of course there's people out there who are questioning the government and the world. Chomsky's book *9/11*, I would say, has been the most effecting book that I have read in the last six months.

GG: Do you have a few moments to discuss the short-changing of our generation?

CT: Sure!

GG: Bill's gone, the one real trailblazer, he's gone, he's dead. And you mentioned Kurt Cobain…

CT: Just the fact of one being a great musician, and the other being a great comedian dying within a few months of each other. Both two very smart men with a punk sensibility.

GG: Also, within that space of one year, Bukowski died.

CT: Frank Zappa died.

GG: Frank Zappa, that's right. And GG Allin.

CT: Yeah! It was a bad year for free minds.

Born Into This

- John Dullaghan -

John Dullaghan created one of the most stinging portraits of a real life creative entity over the course of seven years, financing the sprawling project out of his own pocket. He had on his side a lot of money, brilliant film editor Victor Livingston (*Crumb*), and an inexhaustible supply of loyalty to his subject, Charles 'Hank' Bukowski. The resulting film, *Bukowski: Born Into This*, was released in theatres worldwide during the year 2004.

Bukowski was the living essence of the human condition, a volatile and extreme man ravaged by the simple pains of an earthbound existence, an existence he felt to a much greater degree than most others. Bukowski is revered, I believe, more than enough for his writing and not enough for his rabid, bare-assed human soul. Bukowski was a great man even without the writing. The frequent misconceptions are, of course, a simple result of the man's own posturing. But I remain fixed in my assertion that the greatest thing Charles Bukowski ever created was Charles Bukowski.

Re-born via his father's violent beatings, and his own mad, bad-ass violence, his life's work, his perpetual self-crucifixion, Bukowski founded this Bukowski-thing on the basis of an eternal hurt, with bad booze and bad sex, and in the face of an all-consuming patriotism, careerism, macho-ism. His life was larger than his already-gargantuan literary output, and even without that work, he would remain a legend. This is why Bukowski wrote, I believe. So that the light of his star, which was something he cherished far more than words on a page – even his own – would not burn out in obscurity. Bukowski wrote from a rage, and a generosity (perhaps unintentional) that has helped, and continues to help, a huge number of people. Bukowski's rage came from his having been left no choice but to drop out of life, to drop *into* a messy, turbulent shit-storm of hunger and hatred. He remained alive, knowing that he would never find a way back into it, at least not in the same way that normalized, civilized souls are patched into life. Bukowski did at times thrive on misery and spite, but there was also joy. There is no joy brighter or greater than that which comes to a man who is in most if not all ways – apart from the physical – gone from life. To that human vessel which is in so many ways not really THERE, every meal is a symphony, every act of kindness a brand new epiphany. Bukowski's work celebrated that joy. He was known to state often, "I write selfishly, for myself." If that is true, his selfishness was a beautiful selfishness.

And in recognizing that, I believe that the man himself deserves an appraisal equal to the ideals and hopes of his work, equal to the joys and pains of his life. This is why we were so blessed five years ago to receive a fitting, fair, and truthful biography, *Locked in the Arms of a Crazy Life*.

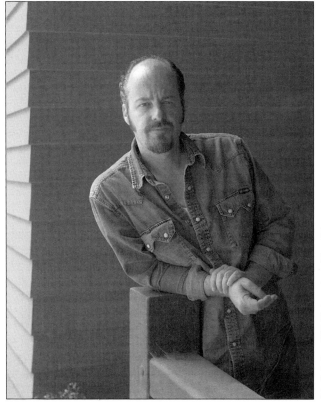

John Dullaghan, 2005. Photo courtesy of the artist.

There can be no understating his literature's importance, and by extension, his literature's effect on the literature of the world. Bukowski might have been the pre-eminent voice for the pain- and poverty-ravaged societal mutants of post-WW2 America. But in the '40s and '50s, there were few outlets for the world-weary frankness of his work. Long before his name became unavoidable, as it is in today's ineffectual small press culture of virtually talentless drug-damaged wannabes, Bukowski was already sending out dozens of typed poems a week to small magazines. Few took them. Bukowski roamed, drank, and lived an invisible life. He barely survived that lonely world.

During the Vietnam era, which was the peak of the small press phenomenon, when DIY publications actually meant something, and did indeed pose a substantial threat – at least as far as the 'Amerikan' government was concerned – Bukowski came to find himself revered a decade or so late, with an opportunity to run wild through the dense jungle of sex, to infiltrate the previously unknown women, the beautiful women. This man, whose shadow he said they spat on, was, at the age of 48, becoming an experienced lover. But that was not all. Bukowski wrote of these encounters. Bukowski revelled in the gory, spunky details.

Bukowski was not terribly moved by the superficiality of it all.
Bukowski became a cartoon; the dirty old man.
It is that dirty old man cartoon that came to tragically define him.

Throughout his post-fame years one could find, if one was so inclined, a wealth of evidence to support the oft-made claim that Bukowski was nothing more than that. And one would find, if one was not emotionally impotent and did not apply the most self-serving of human politics, that Bukowski, just in continuing to exist, cursed by God with a talent for brutal sensitivity, was capable of miracles.

Those atrocities, and those miracles, are abundant in ex-advertising writer John Dullaghan's first film. *Bukowski: Born Into This* is as intimate and profoundly powerful a cinematic document of Bukowski's 73 years on this earth as we're going to get. After three viewings of the film, I can't find much to criticize. Dullaghan got it right. Surely, I could have done with a few more women (Linda King, namely) and a few less celebrities (Sean Penn, U2 frontman Bono). But the celebrities, as in Luis Fernandez de la Reguera's film *Rockets Redglare!*, are a vastly useful element, in that their names seduce audiences who would otherwise shirk from subject matter that does not preach eternal prosperity and/or portray every bad situation as one redeemed by some last-minute reconciliation with a good-hearted fashion model... The narrative of *Born Into This* is far from experimental, yet is not pedantic either. The film thrills, moves, horrifies, and amuses.

Cherished Hollywood character actor Harry Dean Stanton reads Bukowski's work in a few scenes. Those readings elevate Bukowski's words in a fascinating manner, and fortunately, those words are everywhere in the film. It is shot through with some of his best poetry and prose. The selection is impeccable, and the usage (sometimes spoken, sometimes presented with onscreen titles, sometimes both) is a testament to Dullaghan's taste as a Bukowski-phile.

Born Into This doesn't always compliment Bukowski. For its being made by an admitted fanatic, it is admirably non-partial at times, toeing the 'fanboy' line by more than a few inches. In the opening moments, we see Bukowski shrieking at the camera: "*What do you want, mother FUCK?*" It's hardly flattering. We are given graphic recountings of Bukowski's moronic behaviour and all-too-human flaws. Yet, it's hard not to lionize the man, especially, I can imagine, from Dullaghan's perspective. I too, am a long-time reader of the Big Drunk Daddy, but I'd feel somehow slighted if the film lacked objectivity. It doesn't.

The financial success of an uncompromising documentary on an uncompromising man is not to be expected. So we must assume that this film is, in itself, an act of love. In this nightmare climate of Republican evil and rampant corruption, of greed, theft, mass murder, across-the-board conformity and outright stupidity, Bukowski's outlaw philosophy is as wildly subversive as it ever was. Maybe even more so.

Things are not going to change soon, which is why it is crucial to support such a film like this, and a man like John Dullaghan... And if you're not a Bukowski fan, see it anyway. There's much to learn. It relates to all of us. This, when all is said and done, was Bukowski's gift: he lived outside, ugly and defeated in much the same way as any man who knows that life's gauntlet is almost endless, and can be shocking and unmerciful.

Bukowski made a career out of confronting the horror, and yet, he didn't expect change. In fact, he may not have even preferred a better world at all. In his supreme and beautiful arrogance, he retreated, and enjoyed his private humour like he enjoyed his descents into booze, also private: with knowledge, with laughter... and never without a pinch of satisfaction in seeing the miserable outcome of the dark and deranged human carnival out there while his own magic, his secret music, continued to bless him.

I suspect that he is still laughing, if only in his best and most horribly informed work. And also, much to Dullaghan's credit, in this hugely important film.

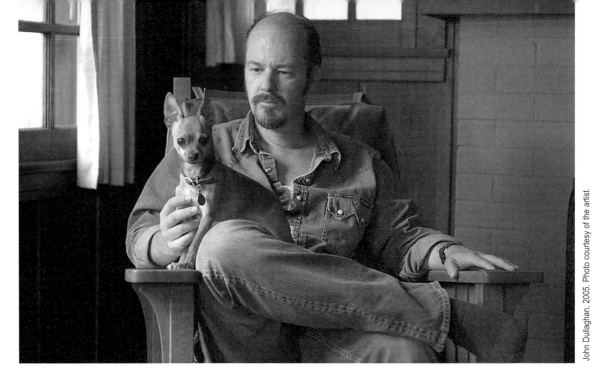

John Dullaghan, 2005. Photo courtesy of the artist.

GG: What's your background?

JD: I was an English major at Berkeley, and I wrote the advertisements for Apple computer. I had done commercials for them, also. I was familiar with the whole process of filming and editing. But *Bukowski: Born Into This*, is really my first film. I learned as I went along. Surrounded myself with the best and the brightest that I could afford to be with. Victor Livingston is the editor of this film, and he also edited *Crumb*. I learned a lot from him.

GG: What attracts you to the work of Charles Bukowski, personally?

JD: I was working at the ad agency. I don't know if you have ever worked a corporate job, but, boy if you're not corporate material, it's a horrible place to be. Especially in the ad business. It's real high pressure. You've gotta give your body and soul to your job, if you're gonna keep your job. I was working 60 hour weeks, routinely, working 3 weekends out of the month. My family never saw me. I wound up getting chest pains at age 33. They kept me on the coronary observation unit for a week. Around that time, I'd encountered *Post Office*. I saw that Bukowski was able to take that negative experience, and transform it into something that was worthwhile. Into something that helped people like me, who were in that nightmare. He inspired me. I started reading more and more of his stuff, particularly his poetry. The more I read him, the more I thought, 'this guy is hooked into the truth'. Bukowski writes about what many great artists do, and that's the human condition, boiled down to its essence. How we are torn between heaven and earth. We keep trying to do better, and be better people, and we can't stop slipping and falling on our asses. Bukowski writes about that so well. He writes about what it feels like to grow up being ugly and hated. What it's like to have your heart broken. What it's like to work a shitty job

for no pay, and get fired. Bukowski's famous phrase was, "Humanity. You never had it, from the beginning." If you read Bukowski's later writings – *The Captain Is Out to Lunch and the Sailors Have Taken Over the Ship* – it's fucking dark. But it's genius! The guy was down. But Bukowski did add a touch of humour. He has a thoughtfulness that makes the reader think on a deeper level. So… in his way, he's a very encouraging writer.

GG: Who did you get to be in the film?

JD: I interviewed between 150 and 160 people. There were people who had known Bukowski throughout his entire life. I found a woman who knew him when he was a teenager, and he was still living at home. That was a fascinating interview. Then, there was an old cat that worked with Bukowski at the post office, in the fifties. I tracked this guy down, he's great. In the later years, there were more and more people that I could talk to. Then of course, there's the celebrities. Barbet Schroeder. Taylor Hackford. Bono from U2, and Sean Penn. Dave Alvin. There are also some anchor people that I interviewed. There's Neeli Cherkovski [*friend and biographer*], John Martin [*publisher*], Linda Bukowski. They really make up the narrative of the film. They guide us through the film, as does Bukowski himself. The voiceover is often the people that knew him, telling the story.

GG: How did your film go down at Sundance?

JD: Really, really positively. People have responded incredibly to it. What I wanted to show was that he wasn't a pissing-in-your-pants wino, but rather one of the great artists of our time. I highlight that through his poetry, and through his words. And people get it. I wanted to show his sensitivity. There's one scene where he's reading a love poem about Linda King, who he'd just split up with. He starts to cry, after he reads it. And he's crying at his wedding. That's the side that he covered up, but he

couldn't have written that poetry without a really good heart, without sensitivity. The last poem in the movie, 'The Bluebird'… *"There's a bluebird in my heart, that wants to get out, but I keep him in here, I keep him down, I say, 'you're going to blow my book sales in Europe.'"* … It's the struggle you go through as a guy, in our society. You have that sensitivity, and you wanna let it out, especially if you want to make it in your relationships, but you can't, because it's a sign of weakness. What the fuck do you do? He went through that conflict his whole life.

GG: I never found his sensitivity very hard to detect.

JD: You pick it up because you read the stuff. But for most people, the first thing most of them pick up is either *Notes of a Dirty Old Man*, or the short stories. That was wild shit that he was writing. It's graphic. The underground press in the 1960s, it was 'let it all hang out', free speech. For Bukowski, that was his platform, and he went for it. So it's cruder. People start with that stuff, and oftentimes they'll stop right there. Or they just heard about this obscene, lecherous old guy…you'd be shocked if you knew how few people read his poetry! That's where you see the real guy. I wanted this film to convert people. People aren't used to reading poetry like his. They're used to reading the stuff that's crammed down your throat. And here comes Bukowski, writing in the language of our time, with the people and the places of our time. So we can instantly relate to it.

GG: Sure! It's gut level. He comes at you with a knife in one hand, and a rose in the other. Is this an upsetting film, would you say?

JD: No. I think it's inspiring, actually, that this guy went through the trials of hell and came out of it relatively intact. Certainly, he was able to transform that into art that helps people in their lives. Bukowski stood up and he told the truth. And we really admire that, particularly today.

GG: What did you find out, during the course of making the film, about what has happened to Bukowski's audience, or his myth, over the last decade?

JD: Well, I am continually surprised by the fact that all kinds of people read his stuff. The traditional audience is 18-year-old guys. But… there are people that were reading him in the '70s that are still fond of him today. He strikes a chord in people, something that stays with them. Much in the same way as John Lennon or Bob Marley or… I used to listen to The Clash. [*laughing*] It still means something to me, you know? Certain people do not get old…they always continue to stand for the same things. Bukowski was an outsider. What I find is that people who read Bukowski… their life journey mirrors his in one way or another. Whether it's not getting along with your parents, or substance abuse, or just feeling like you don't belong. Being pissed off because of that. Those are the characteristics, that I've found, anyway.

GG: Well, they are timeless problems.

JD: They are! Now, my father in law, who is a stockbroker, he really digs this film! He's not going to go buy every Bukowski book and read them all, but it's nice to see people accept and embrace Bukowski who are nothing like him. So that tells me that his message really is universal.

GG: How has this seven year production impacted your family life?

JD: It's been hard. Oftentimes, in a couple, one person will follow their dreams, and the other is left picking up after that. It happens in marriages sometimes. But my job was bringing on health problems. I don't think that I really had a choice but to make some kind of change. I decided to go for this film. It cost money, and that was a household issue. But it also took a lot of my time. I think this is the problem with a lot of directors, with artists in general. They become consumed by their work, and that person they are living with starts to feel that they are married to their novel, or their film, or whatever it is they are doing. They'll ask, 'where do I fit into that?' You have to become obsessed with something to really make it what it should be. That was difficult, but the money was hard. I quit my full time job and I freelanced in the ad business. Then, for a little over a year, I had to dedicate *all* my time to the Bukowski film. My wife took on the financial load. That's tough.

GG: But you knew it would be an ordeal.

JD: Right.

GG: You mentioned to me before that you learned a lot from the Maysles. Aside from that, what gave you the confidence to go through with this? You basically assumed the task of an artist, and I'm wondering, had you any prior experience in film that was hands on?

JD: I'd always been interested. I read everything in high school. I was an English major at Berkeley. I concentrated on 20th Century American literature. That gave me some background. I've always written. But in terms of the film, I could just see, in my head, what this was gonna be. I really studied documentary films, saw how they were made. I knew what Bukowski's story was. I could figure out how it would go. There are certain films, aside from the Maysles stuff. *Hearts of Darkness*, the *Apocalypse Now* film. That was inspiring to me. *American Movie* really inspired me. But *Gimme Shelter* got to me in a big way. I could see the film in my head.

GG: There's a freshness to this film. If you know the back story of this film – most audiences probably won't – it is exciting. It has this authentic and unpredictable energy. The structure of *Born Into This* is not the most conventional structure… The film starts off like a a short film, but then it goes into the real epic story about a half hour into it.

JD: You turn on the TV, and it's 'the life story of…' So you open up with some hook, usually an overview. You get, at the end, the grand pronouncement of what their life meant. That's a format. We wanted to make it more engaging than that. We did a deconstruction of Bukowski. We showed the myth, and then we moved backward. We began with the teen years, and you don't get into childhood until later. But it makes more sense to put the

childhood where we did. Because when you've seen his life up until that point, and then you see the childhood… 'ahhhhh!'… and then you get it. It clicks. When you see the fight scene [footage of Bukowski attacking his girlfriend and soon-to-be wife Linda Lee, culled from Barbet Schroeder's *The Charles Bukowski Tapes* -ed.] after knowing what he dealt with as a kid, you can feel sympathetic for the guy on a certain level. It's not like, on the Barbet tapes, where you cut right in. It comes out of nowhere, you don't know what the fuck is going on. We were deliberate, and we wanted to let the story out just a little bit at a time. Basically, you are revealing his sensitivity. We revealed that a piece at a time. And we showed, rather than told. Yeah, I had a lot of people talking about what kind of a person he was, and what his writing was. But the most powerful person to show that with is *him*. The editing was intense. Highly concentrated. I thought it out every second of the way. We just kept trimming and trimming and trimming it. We wanted it to pace itself so that it kept you going.

GG: How many edits did you go through?

JD: We would edit about twenty minutes at a time. We were pretty much finished with the first version of the film, and then thought, 'we need a poem at the beginning!' We were gonna save that poem about the apocalypse until the end. We had a shot of him driving through San Pedro, and we thought it would be kinda cool to have this old man in his windbreaker, and he's talking about the apocalypse. But we decided that that might be something good to put up front, because we don't want people to just see him as a scuzzbag. We want to hint at the fact that there's something more to this guy, to keep your interest. There's that part where he talks about, "if you get beaten enough you learn something, it beats all the pretence out of you. My father taught me how to write. Pain without reason." That was initially how the film opened! But it was so heavy that it cast a shadow over the rest of the film. So one of the ideas I had from the very beginning, was to make all the anecdotes from people, in the beginning, funny stories. It opens on a lighter note. Then when you reach the apocalypse poem, you don't feel like putting a gun in your mouth. That's how it worked. A lot of experimentation.

GG: It's an emotionally controlled experience, because of the tight editing. Not in the way of it being manipulative, but in your timing. The rhythm. I was most impressed by a couple of little bits. When the interviewer asked Bukowski, "what did your father teach you?", he responds "how to type." No hesitation. He's sure of that. That works perfectly within the film. And the other part was when he talked of his first experience with a woman, and how he insulted her. He talks about going to a bar to apologize to her, and the bartender says, "we can't serve you!" Then you cut to a shot of a Greyhound bus, and go into Bukowski's years on the road. It was perfect. I almost cried at that point, it was that powerful.

JD: Yeah. Victor's a great editor. But man, we spent about a year and a half cuttin' that fuckin' thing. And then we came back. There were versions. You know Gene, the reason why we all look to Bukowski, is because he is an example of what it is to not sell out. Staying true to your passion, staying true to your art, and to yourself. Editing it the way we did costs a lot more than if we had used a narrator. That's a much more cost-effective tactic, to do wall-to-wall narration. We decided that, no, we did not want to do this thing that way. We wanted it narrated in the voice of Bukowski! And we thought, well, *type* would be nice. They did that in *Hearts of Darkness*, and that worked, but to do that for a literary biography, hey! READ! [*laughs*] Y'know? It was an elegant way of doing it. My budget wasn't what it needed to be, but this is a film where I didn't want to have to make artistic compromises. If there's one thing in my life that I do that I am proud of, creatively, this is it. What I told the people who were working on the film was, 'I'm not going to be able to pay you what you're worth. But at least you can walk away from this with something creatively, that you'll have for the rest of your life'.

GG: Maybe within the realm of film studies, it will have a lasting effect. Maybe students will look at this film years from now. It's an unconventional documentary, a new way of expressing the life of a man on film. I haven't seen another film that had that approach.

JD: And the type, we had fun with! You know the typeface, the onscreen handwriting? That's Bukowski's handwriting! I bought a letter of his, it was written in block letters. We used that, and created an entirely new typeface from it. Those kinds of details helped bring about solutions that you wouldn't think of ordinarily. But yeah, we really sweated the details. My wife was telling me constantly, 'you're over-thinking things'.

GG: But your ambition obviously is a result of the fact that Bukowski was very important to you, that he was saying things you needed to hear.

JD: If you're gonna get it right, you have to go all the way. I was serious.

GG: What would you imagine, at this point in time, as being your second film?

JD: I'm not really interesting in getting a blockbuster film. If that happens, that's great. But I want to do something with my life and with my work that is positive and helpful. And that may sound corny, but the media is such an important and powerful force today… and our world needs help! In the ad world, I used the media in an irresponsible way. I don't particularly think that the ads I did for Apple computers were bad, but that's just what advertising is. It's a beast. But given the opportunity, I would now like to use the media in a constructive way. I think that it has become a cliché, it has become a bumper sticker. 'Peace in the world means peace in yourself'. But if I can bring something of that to a viewing audience, I could go to my grave thinking I'd done something worthwhile.

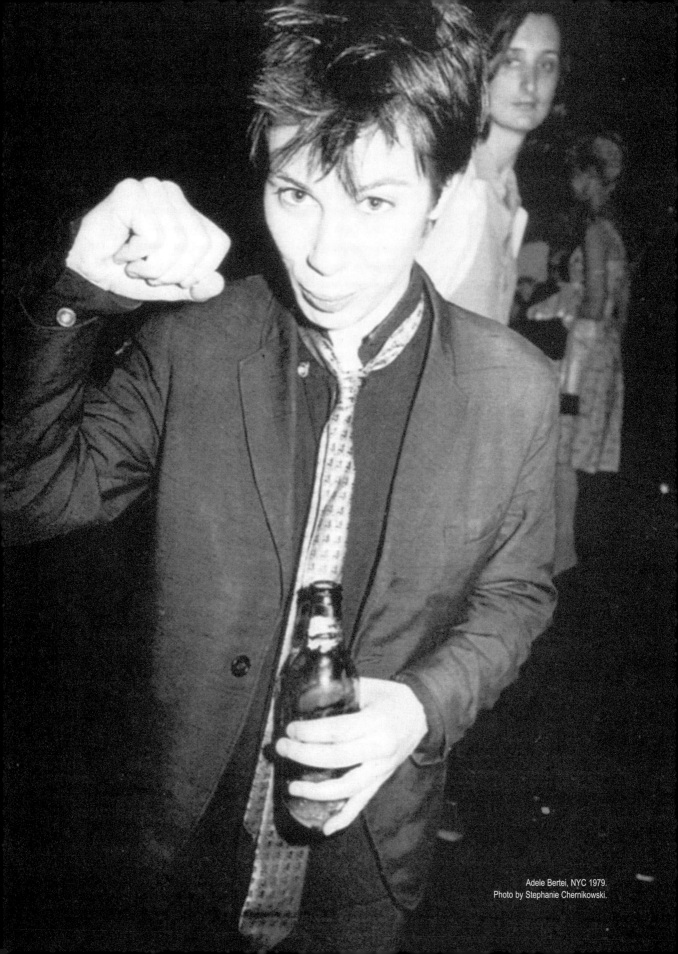

Adele Bertei, NYC 1979.
Photo by Stephanie Chernikowski.

The Long Hard Road to Everywhere

- Adele Bertei -

From gospel, soul, and blues, to punk, No Wave, disco, and top ten rock, Adele Bertei has dabbled in more genres of American pop music than anyone I've ever heard of.

Her debut solo album, *Little Lives*, was released in 1988, and while this may remain her definitive work, it was by no means the start of her career – she was at the centre of the original Cleveland punk scene as far back as 1974, and by the late '70s had already made a name for herself in New York's now legendary No Wave movement. Both street- and book-smart, simultaneously sassy and sensitive, she has a story like no other, a life history that has bestowed her with a willingness to take new turns and new risks with each consecutive accomplishment. Charting a roguish, disparate path through life in the three decades since her frenzied association with rock'n'roll casualty Peter Laughner, Bertei went on to become a contemporary of James Chance, Lydia Lunch, Beth B., and Lizzy Borden. The eighties found her touring and performing with such mainstream pop luminaries as Tears for Fears, Boy George, Jellybean Benitez, Thomas Dolby, and Sophie B. Hawkins. Turning her attention primarily towards film in the mid-'90s, she found her first substantial gig as scriptwriter and director on several episodes of the Showtime Network's *Women: Stories of Passion* series. At the time of this interview, Bertei was back at home in Los Angeles, following a gruelling month spent directing episodes of the daytime soap opera *Ocean Ave.* in Florida. Also, her documentary film on the Trinidad Carnival was undergoing a final edit, and she had a book of memoirs underway.

I suppose you can't really sum up such a bizarre résumé any more than you can fathom the true courage and tenacity required to steer oneself through the shark infested waters of reform school, '70s punk, the music industry, and daytime soaps… unless you hear the tale the way Adele herself tells it. And *that*'s what I call entertainment.

Gene Gregorits: Let's start off on when and how you hit New York, coming from Cleveland, in the '70s. Who did you know there, and how did you wind up in New York City.

Adele Bertei: Well, basically I got involved with a guy named Peter Laughner in Cleveland. He had started bands as diverse as Rocket from the Tombs, Dead Boys, Pere Ubu… and kinda got kicked out of them all, because of his rampant self-destructive streak. He was a genius. Quite honestly, I think guys like David Thomas [Crocus Behemoth], and a lot of his contemporaries in that scene really dogged him, and the reason why they treated him so badly was because his talents far outshone the rest of them. So it was a big blow to me when he died. They said that his spleen exploded, but he left a suicide tape the night before he died. And that was quite an in-depth catalogue of his most poignant, best, and brutal songs. Did you know much about that story?

GG: I don't know that story, I just know about *Take the Guitar Player for a Ride*, the CD they released of live tapes. I just love the raw sounds of that CD. It's even better that they were so *rough*. And the last song was a song he recorded alone in his bedroom the night that he died, or maybe the night before. 'Me & the Devil Blues'.

AB: The Robert Johnson song. Yes, he was very obsessed with the darkest of literary figures, songwriters, and artists of all kinds.

GG: I know that you are also very influenced by the blues. I saw you do a really great blues performance at the Knitting Factory… and you also wrote a great story about being locked up in juvenile detention centres.

AB: Well I came by the blues via gospel music, because as a kid, growing up in the white suburbs of Cleveland, I didn't have much exposure to black music besides what I heard on the radio, and at that time it was Motown, and Dionne Warwick, and people like that, that I would kinda thrill to. In terms of vocals, Aretha, you know. My family broke up when I was about ten years old. Soon thereafter, I was tossed into a bunch of foster homes that I would habitually run away from. Of course, when you're looked at as incorrigible by the state, they throw you into a reform school, they don't know what else to do with you. The reformatories I was in… because Cleveland is a pretty segregated city, and blacks were pretty oppressed when I was growing up, so the girls in the schools were from the black underclass. They were pretty tough girls. And a lot of them could sing their asses off. A tradition in black culture is, one of the ways to express pain is through singing. You know, I had a choice when I was in those

places, you could usually choose one of two different services. One of them being Catholic and the other being Baptist, and I would of course go to the Baptist service for the music because, you know, the Catholic service wasn't too funky. And I started singing with the girls there. Just as with their story, it was my way to express whatever demons and emotional confusion I had as a kid. The Gospel church, it was brilliant. It was something that was very mysterious to me, that I wouldn't quite qualify but could feel in every inch of my being. So I started singing gospel and began learning that canon in the reformatories. When I got out, around 17, I started discovering the blues. It was soon after that, that I hooked up with Peter, who was like my mentor in music.

GG: You lived with him, right?

AB: Yeah.

GG: What was it like day to day with Mr. Laughner?

AB: Oooooooh my God! JESUS! Peter, he turned me on to a whole world that was both petrifying and giddily romantic… through all of its hedonism. But it was also full of despair, too. As you know, the biggest drug highs are followed by the worst crashes. At that time he was working for *Creem* magazine as a journalist, and Lester Bangs was one of his best buddies.

GG: Peter was a great writer too.

AB: Oh, a brilliant, brilliant writer. And Peter loved *guns*. He had a whole arsenal. Between his guns and his guitars, he had collections that would rival most brilliant collectors of those two things. He was a genius at making drama, the most violent dramas, out of the most mundane things. We'd be sitting there and he'd get a call from Lester that they didn't want to print his article on Richard Hell. And he had pictures of Richard tacked up on the wall, along with Tom Verlaine, and Baudelaire. Oh, and Lou Reed. He loved Lou Reed. I remember crashing from amphetamines with him and listening to the *Berlin* album over and over again. Talk about feeling suicidal.

GG: That album is a real kick to the head.

AB: Oh my god. He'd pick up the phone, and hear some bad news, and start shooting holes through Richard Hell's temples, in the photograph. So there'd be bullets whizzing by my head, as I was imbibing huge quantities of cognac and methedrine, you know.

GG: He wrote the would-be anthem for speed.

AB: What?

GG: Lou Reed wrote 'Heroin'. Peter Laughner wrote 'Amphetamine'.

AB: Peter did heroin too, but we weren't in that together and I didn't see him do much of that. See, I never felt in fear for my own life, but his violence was exciting and dramatic to me. But when it became dangerous and suicidal, that's when I started to get very fearful. Because there'd be nights when he's be in his bathroom, I'd be in his living room, listening to music or something, and I'd hear a shot! And I knew he was crashing from crystal. It would freak me out. It would

take me like twenty minutes to get up the courage to go up into his room, to see if there were brains on the wall. Luckily, he didn't do it then, when I was with him, but…

GG: How old was he then?

AB: Early twenties.

GG: And I guess he died a few years after that.

AB: Oh yeah. He died in 1977. We had always planned to go to New York together. We'd gone on trips to New York together before, because our plan was that we were going to move there together and start a band. This was in the punk heyday. We'd stay at Lester Bangs's apartment, listen to records, go to CBGB's, wreak havoc there.

GG: What was the Cleveland scene like? Were you in bands with Peter there?

AB: I was in a band with Peter called Peter and the Wolves.

GG: Peter and the Wolves, yeah that's one of the smaller bands he was in after the other bands he had started took off and made it bigger in New York.

AB: This was during what was thought of as his demise. He had been kicked out of all the popular bands, and then he started this band with me. He was a subject of great derision to most of the bands in Cleveland at the time, because they just thought of him as a loser and a fuckup or whatever. Regardless of what they thought, he was still, to me, a musical genius. I was just learning incredible things from him. We had this little band, and bands like Devo would open for us, at the Pirates' Cove in downtown Cleveland.

GG: It really seems that, in hearing those live recordings of Peter and the Wolves, and Peter solo, one gets a very acute, almost explicit sense of the roughness of that time in his life. And the Cleveland scene at that time. It *sounds* extremely squalid. So were you harassed, playing with Peter? What was playing live music there like in the mid-'70s?

AB: Well, this was '75, '76. Punk was starting in New York at the time. And we were kind of doing the same thing in Cleveland, but it was much rougher. The Flats in Cleveland is notorious. Back then, the oil slicks on the river used to still catch on fire. It was like this industrial medieval wasteland. Very strange place to do music.

GG: Were there large audiences for music?

AB: Well the same kind of people that would pack a Patti Smith concert would come to our shows. So we had a pretty decent following. When bands like Pere Ubu, and us, and Destroy All Monsters would play, we always had pretty good turnouts. There was a pretty strong scene for that type of music, then, in Cleveland.

GG: So how did you hook up with The Contortions?

AB: After Peter died, within six months of his death, I moved to New York to fulfil our prophecy of going there together. I went without him. One of the people I had known in Cleveland, that I looked up when I got there was Bradley Field. Bradley Field was, of course playing with Teenage Jesus and the Jerks with Lydia Lunch. They were the first people I hooked up with when I got to New York.

Lydia had a loft down on the Lower East Side somewhere around Ludlow or something. I would go and hang out with her and Bradley. James Chance was playing with James Nares one day in her loft. And I thought, 'that is one of the most interesting sounds I've ever heard'. It was this kind of jagged, weird-ass funk, but really punky, like nothing I'd ever heard. A very strange cacophony, but what drew me to it were the rhythms. Pat Place was playing guitar, but she was playing it as more of a percussion instrument. So I went down and I just kept mooning around, saying, man, I wish I could be part of this. James had an Ace Tone organ set up and he goes, "Hey, you look kinda interestin'. You wanna play this?" I had never played organ before, so he basically gave me the organ and said, "Play it like you feel it." I started mimicking what I thought Pat and James Nares and other people were doing on their instruments, which was playing percussively. So I basically played keyboard like it was a conga drum. I just played these clusters, rhythmically, in between what the other people were playing, as if we had a circle of drummers. And somehow, with James screaming these insane lyrics over the top, and playing his saxophone like it's Albert Ayler being strangled or something, it just all seemed to work. It was very, very exciting. I don't think that what we were doing had ever been done before or will ever be done again, quite frankly. That's not being egotistical, it's just a fact.

GG: Right. How long were you in the band? The Contortions changed their line-up a lot…

AB: I was with The Contortions roughly for about a year. During that year, Brian Eno hit town because he was very drawn by the music scene in New York, just wanted to see what was going on. I worked with him for a while as a personal assistant, took him around to the clubs, to our concerts, to Lydia's concerts, to see a few of the other bands. He decided to put some of these bands on the compilation album, *No New York*, which was a pretty good document of the music that was going on at the time. We did some early recordings on the ZE label, with the band, and then Anya Phillips started managing James. When she took over, the less money we started making and the more money James was making. Yes, it's true that James Chance was the nova around which we all spun, but we ended up making nothing, all of a sudden. And at that time, my only sustenance was the band. So I quit.

GG: Didn't you have a story about James cutting his own face open, or his throat, to get money out of a club owner who wouldn't pay?

AB: Yeah, I think he was stabbing at his face, as opposed to cutting his throat. Yeah we played at a gay club. They weren't going to pay us. He went into hysterics and just started slicing at himself, and the guys that ran the club were so freaked out that they immediately gave him all the money he wanted. To get him out of the joint, you know? It's pretty freaky. But he had a very strong masochistic streak.

GG: Didn't he have a penchant for going out in the audience, and punching people?

AB: Oh yeah! We would be playing on stage, and this pretty anarchic sound would be happening, and he would jump out into the audience, and pick out some beautiful girl, you know. A girl who would have an extremely gorilla-like boyfriend. James would start mauling her and kissing her, which would provoke the gorilla to start kicking James's ass. And then George Scott, the bass player, and I would leap up from our instruments, into the melee, and get into this hysterical, Hemingway kind of brawl at the front of the stage. And the rest of the band would still be playing! There would be fists and blood everywhere! Then we would jump back onto the stage, and go right back into the song. I got knocked around a little bit, nothing more serious than swollen cheekbones or bruises. But at that time, I felt like my bones were made of rubber.

GG: But you never knew when he was going to do this.

AB: Oh no! It was pretty consistent. He would do it at least once a night. [*laughing*]

GG: You started off with gospel and it took you through to a lot of these other things we're talking about. But eventually you wound up in a band called The Bloods after The Contortions. How did they form?

AB: Well, I was very discouraged by a lot of the guys in the scene to not sing. People would go, "oh no! You can't sing!" They were *very* discouraging. You know, I was just like, "I'm gonna start an all-girl band then! Fuck all of you!" So I put out an ad for an all-girl band. I found a guitar player named Kathy Rey. We started the band together. We gathered some excellent female musicians and just started going out on the road. I guess it was still somewhat of a novelty to tour with a group of all-female musicians. We played Stones-ish, R&B kind of rock'n'roll, and you know, we weren't bad at it. We did get a lot of audiences and we toured around Europe quite a bit.

GG: Then you started writing songs for Jellybean Benitez.

AB: The Bloods broke up for various reasons, then after the band broke up, I got hunted down by Geffen Records. They wanted to sign me to a record deal, which was kind of startling, given the fact that I was still very much at loose ends, and still a bit of a hell-raiser. Still in my drinking and drug period. All of a sudden I was thrown into this major label world. I didn't handle it very well. It's a strange phenomenon in the world of the major record labels, because they sign you for what they hear you doing. But the very moment they get you into their clutches, they want to change everything you do. I guess they feel that because they're paying you substantial amounts of money that they have the right to do this. But it basically ruins everything, and takes the soul out of the music. Part of my doing poorly with these major record companies was my own self-destructive habits, and the other part was them just trying to manipulate everything good, out of me.

"...major record labels sign you for what they hear you doing ...but they want to change everything you do."

GG: What were some of the things that were going on around that time? Was there anything specific that happened with Geffen that hurt your reputation?

AB: Well... they shipped me off to England. First, I did a record with Thomas Dolby. I was supposed to do my whole album with him, and he got into a huge falling-out with our record company because they had taken away our masters and re-mixed them without his permission, which was really unfortunate because I loved working with him. So they ruined that relationship for me. And after I was supposed to work with a producer named Tony Mansfield. Now, all I had was a bunch of demos that I had done with various musicians. What I didn't have was a group of musicians that I had created a *sound* with. So here I was, in a bed-sit, in London, working with this guy Tony Mansfield who had a computer. And anyway, so it was me and this stupid fucking soulless computer, and he was re-doing all of my songs and making them sound like Muzak. I was MISERABLE! And drinking a lot. I would get into creative arguments with this guy, and he started treating me very oppressively, in terms of what he was doing with me musically. Just not treating me as a person. I got really furious with him one night, imbibing copious amounts of booze, and I slugged him! [*laughs*] That sealed my fate with the record company. Actually, I was quite glad to be through with it, because it was just a miserable experience all around. I got out of that and ended up getting another record deal with Chrysalis Records. You know, I was trying to be the good girl and follow the lead of what they wanted me to do. They wouldn't obviously let me do what I wanted to do. So it just didn't work out because I just wasn't what they wanted me to be. Again, I ended up leaving that label. They dropped a bunch of artists, one of them being me, when they were taken over by EMI. And yeah, I did a bunch of dance records with Jellybean Benitez.

GG: Then there was Sophie B. Hawkins, too. How did you start working with her?

AB: Well, after I did these dance records with Jellybean and Arthur Baker, I met the guys from Tears for Fears, and ended up going on tour with them as a backing singer for five months. Which was fun, because I got to do the five star hotel / making good money / rock star / see the world thing. Soon thereafter, I hooked up with Sophie and became her backing singer. That lasted for, I don't know, maybe a year or so. I toured with her when she was promoting that first album that made her a household name. But through all of that time, I had been a devout film fanatic, always reading books on film theory and watching so many films...

GG: What are some of your favourites?

AB: Oh, God. That's a tough one. *The Night of the Hunter*. I love *The Conformist*. *The Lovers on the Bridge*. Many others.

GG: You were in *The Offenders*, by Beth B., and later you were in Lizzie Borden's *Born in Flames*. How did you meet Beth B. and wind up in her film?

AB: When I was in The Contortions, New York, 1977, there was an incredibly fertile scene going on. A lot of cross-fertilization between all these young, vital artists who were doing shit like making films on their credit cards, on Super-8. Doing Agit-prop poetry, and painters, musicians. Everybody was collaborating with each other. It was just exploding with these brilliant ideas. Very anarchic, and very politically motivated. It was a movement that was very Fuck The System. We were in a period, in America, where it was very much culturally and artistically dead. No one was saying anything provocative. Everyone was just following the status quo. So this explosion happened in New York, and it was probably the most exciting moment in my life. I think for a lot of the people who were there would probably say the same thing. At that time, when I was in The Contortions, I acted in several peoples' films, and did music for films. That's where *The Offenders* came from. I met Scott and Beth B., they saw me onstage and wanted me to be in one of their films. Later the Lizzy Borden thing (*Born in Flames*) was very much a kind of feminist collective; that was a very collaborative film and a lot of fun. Actually, Becky Johnston and Kathryn Bigelow were both in that film.

GG: But where was your interest in film leading to?

AB: Well, I had some very debilitating experiences and insights around the music business when I was on tour with Sophie. It knocked the desire to continue to be in that business out of me. Because what I saw was just so horrendous that I just didn't want to be involved with that business ever again, quite frankly. Because I had always wanted to study film and take a crack at it, I just decided I was going to drop out of music and get involved with film. Learn it from the ground up. This was the early '90s. That's when I left the music business and seriously pursued film from a very grass roots, blue collar level. Get in the trenches, become a P.A., learn how a set works, and how cameras work, how a crew functions. All that good stuff. I started writing for music video directors.

GG: You've dabbled in music since then...

AB: Oh yeah, whenever I had the opportunity to score my own projects or write music... whenever there is an organic way to do it, I still do it because of course I still

love it. It's where I come from. It's the basis of everything I do in film. Music.

GG: What are some of the projects you've worked on since you stopped working with Sophie?

AB: I directed a 35mm trailer for a lesbian film that I was trying to get off the ground for quite a while, which started getting me some attention as a filmmaker. I had a lot of people at the time attached to that project. I had Angelina Jolie, when she was just getting off *Foxfire*. Amanda Plummer, Sandra Bernhard… I had Bill Pope! He signed on as a cinematographer. You know, he worked on *The Matrix*. I had a very impressive package of talent and crew. Plus a really good trailer. And I guess because it was a lesbian film and Angelina wasn't a star yet, I could not get the money to make it, which was kind of disappointing. I put that on the back burner and did some work for Showtime. They did a series called *Women: Stories of Passion*.

GG: So that was actually your directorial debut, right?

AB: No, my directorial debut was *The Ballad of Johnny-Jane*. The trailer for it. It showed at gay and lesbian film festivals all over the world. Unfortunately the film never materialized from it. Then the Showtime stuff was the first time I had actually gotten hired as a director.

GG: What kind of experiences did you have working for Showtime?

AB: It was quite confounding. Basically, it started out with such a Utopian ideal. It was supposed to be a bunch of woman writers, directors, and producers, creating a show about women's erotic fantasies. The executive producer really did have a vision of the show, but it was totally compromised by the financiers, who were very much involved with *Playboy* magazine. And here we are… the first meeting was very exciting because we had twelve female directors, writers, and producers, all in a room talking about how they would portray their erotic fantasies on film. This is taking place at the executive offices of *Playboy*. It was pretty goddamn funny. Then, as we got into it, we realized that it wasn't about our fantasies whatsoever. It was about what *Playboy* wanted to see. It was all about T&A! We weren't allowed to show male frontal nudity. They were really uptight about lesbian stuff. It ended up becoming a show for male viewers. So, it was totally compromised. I had to approach it as film school, and just get what I could out of it in terms of learning my craft more, and not just snubbing my nose because the purity of vision was compromised. I guess as I started to grow up I realized that there are things to be gleaned from every bad situation. I can not complain that much about it because it was kind of like being paid to go to film school. The same with *Playboy*. They liked my work on that show so they actually invited me to do one of their features.

GG: Hired gun work.

AB: Yeah. You shoot a feature in what, 10 to 12 days? You learn how to put a feature together on a shoestring budget.

It was just great knowledge to have under your belt. I don't regret that I worked for *Playboy* at all. It was an amazing learning experience.

GG: And then you moved on to a film which you directed last year, a documentary film about Trinidad. How did you fall into that project?

AB: The Trinidad film evolved out of a friendship I have with a Trinidadian woman who's one of my closest friends. We've been very close for about twelve years. I've been travelling to Trinidad with her, off and on, throughout these twelve years, about once a year. And I've always been really intrigued by the culture because it's a culture where every person gets to be totally hedonistic and artistic, at least once a year. And in their ability to do that expressively, in a social milieu, everyone there is so chilled out. It's a happy, loving, very artistic culture. It fascinated me. I thought we should do a documentary about the carnival, and how it impacts the society there. So when we started doing it, it became this incredible adventure where layers kept falling off, like masks, like carnival masks, to reveal this spirit underneath it. It was quite scintillating and beautiful.

GG: That footage is amazing, and quite obscene at times.

AB: [*laughs*] Yeah! Well, you know, that's nature. It's 'obscene' at it's very best!

GG: You are directing soap operas now. What was the shock of just going down there and directing your first episode like?

AB: Well, it's quite different, in terms of working with LA and NY crews. When you come down to Miami Beach, which is all about being laid back… beach culture and 'let's not work too hard'… it's a very different level of organization down here than it is in LA. It can be quite frustrating on many different levels. However I'm learning tons. I think one of the reasons, also, that I wanted to do this was because I've never been a fan of soap operas, but what I do think is interesting with soap operas is this whole culture of people that are hooked on them, and it's this idea of realism and psychological focus that soap operas provide, which drops people in on this level where they are just fascinated by these characters. And I wanted to come in from a filmmaking background to discover the whys and wherefores of that phenomenon.

GG: What are you bringing to the 'art' of soap opera that it currently lacks?

AB: Oh, I think that I'm trying to bring in a much better look, in terms of the style, and some humour, some camp, some different layers in characters that you don't normally see. I mean, that's what I'm working towards. Humour is very important too, because if you watch most soap operas, there is nothing funny at all! It's just like dead fucking weight! When you really think about it, a lot of these soap operas are quite campy without trying to be. Sooo…trying to inject some humour. Have some fun.

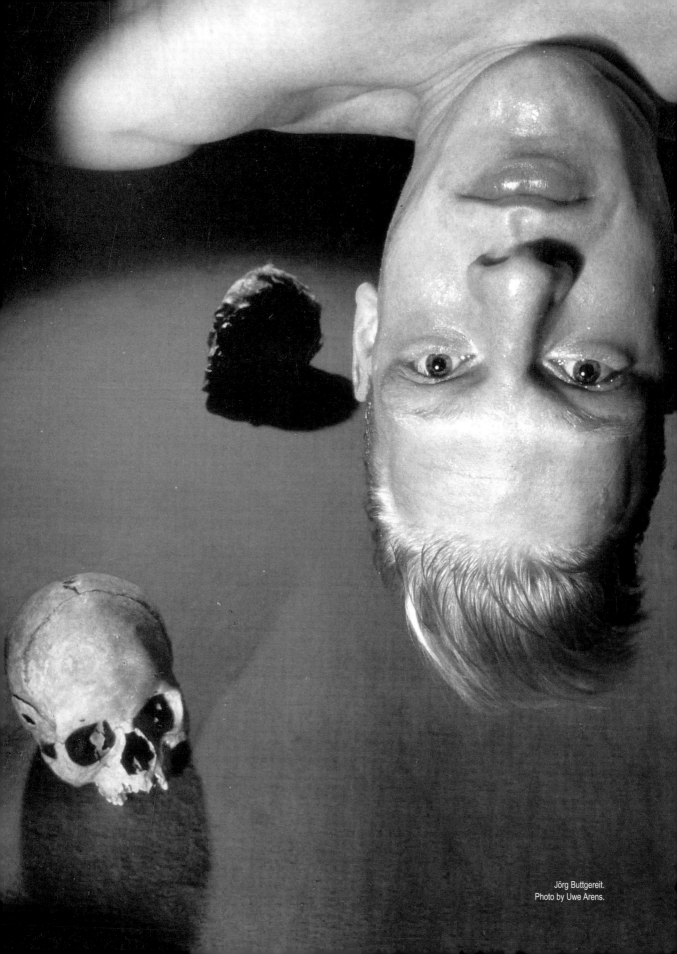

Jörg Buttgereit.
Photo by Uwe Arens.

Fear and Necrophilia in Berlin

- Jörg Buttgereit -

The first cumshot I ever saw on film wasn't, as with most 13-year-olds, in a porno movie smuggled from my parents' bedroom… it was a grainy VHS tape of a film called *Nekromantik* which arrived by US Mail. Considering the great trepidation with which I approached that package in 1989, it may as well have contained cocaine, heroin, or a very well-made blow-up sex doll. I watched it in severe physical discomfort, having worked my body into a stiff knot of fear… fear that I'd be caught by my mother, watching the film at 3a.m. I understood that *Nekromantik* was far *worse* than a porno film, it was a transmission from hell, evil incarnate, the final frontier…

NYC, Halloween 2004: Jörg Buttgereit is standing before a crowd of 50 or 60 in a theatre on the lower east side, reaching the end of his introduction to *Nekromantik*. The audience consists mainly of hardcore Goth and punk rock types. Buttgereit, an extremely tall, thin Aryan-featured fellow in his early 40s, stares out into the small theatre and says, "I will take questions when the film is over but please, do not ask me, 'why did you make this?'" Admittedly, that could be construed as a lazy thing to inquire of any artist, especially almost 20 years after the fact, but if you've spent even a few minutes with Jörg, it's hard not to wonder the same thing. After reading *Sex Murder Art*, David Kerekes's book on Buttgereit's films, the question still seems fresh somehow, and I'm tempted to ask it anyway.

The show is about to begin, and it's one nasty fucker; a deeply unpleasant, outrageously rancid German art film about a young couple who play with dead things. The notoriety of *Nekromantik* has perhaps faded over the years, but compared to the humourless hijinx of more recent entries in the 'too disturbing to watch' category, the film is almost tactful. Playing like an ungodly cross-breed of *The Texas Chain Saw Massacre*, *Pink Flamingos*, and *Last Tango in Paris*, it is not always clear how serious Buttgereit wants us to take *Nekromantik*, but there can be no doubt about its staying power as a midnight movie. The scatological realism and crude splatter effects have an unexplainable, stomach-churning charm. Buttgereit's Super-8 grunge, including that *Texas Chain Saw*-on-a-shoestring set design, and funky, pervasive pungency emanating from corpse rot and unwashed bed sheets, is impossible to duplicate now. Half of *Nekromantik*'s power lies in the diabolical manner by which it leaves your average person, within only minutes, profoundly desperate for a long, hot, and thorough shower. If ever a film needed a deodorant stick and a vomit bag in order to be safely viewed, it's *Nekromantik*.

With London's Scala Cinema still in operation, New York's Cinema of Transgression in full swing, and the punk scene a few years away from being completely co-opted by MTV, the late '80s was perhaps a more fecund era for kamikaze auteurs like Buttgereit than the early years of the 21st Century. In a quiet, post-Fassbinder Berlin art scene, with Wim Wenders as Germany's most notable film export, he unleashed *Nekromantik* on the public. Although small press fanzines and word of mouth were the only means of advertisement, its reputation quickly spread throughout Europe and across the Atlantic. People wrote of it with a sense of nausea, dread, and anger, as if it were a snuff film. They used the kind of hyperbole that no film could seem to live up to. But by the early '90s, that mysterious, sickos-only import *Nekromantik* had found its way to the centre of the black market video netherworld, and to the top of any shrewdly informed film mutant's must-see list. *Cannibal Holocaust, Ilsa She Wolf of the SS*, and *I Spit on Your Grave*, some of the most pathological, black-hearted, and downright vile works of the grindhouse era, were still recognizable as exploitation films. On first viewing, *Nekromantik* comes at you from an entirely different place… it wouldn't have been explainable in the dirty '70s, and in some ways made even less sense in the cheeseball '80s. It's exactly that rare, unclassifiable freak of nature for which the term 'midnight movie' was invented. Buttgereit's post-*Nekromantik* work, including *Der Todesking, Schramm*, and *Nekromantik 2* all prove that the rude vitality of his debut was by no means an accident.

I spoke to Buttgereit as he signed autographs for fans at the October 2004 Chiller convention in New Jersey.

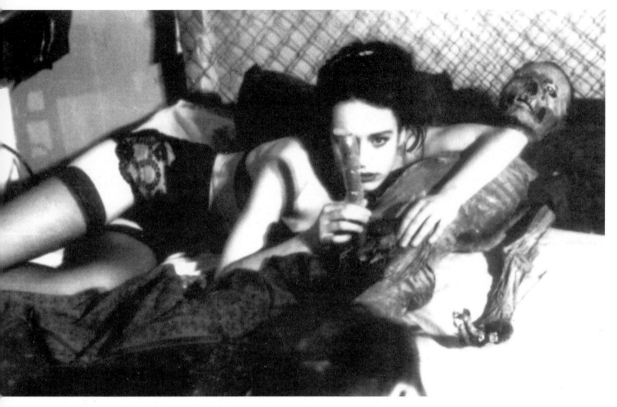

The infamous broom-handle corpse-cock, in Jörg Buttgereit's scandalous underground classic **Nekromantik** (1987).

Gene Gregorits: People are throwing money at you! Why?

Jörg Buttgereit: Because they wanted my autograph. I wouldn't charge them, so they threw money at me.

GG: So why don't you charge them?

JB: Because it feels stupid!

GG: Your passions are very innocent, compared to the things your films are about. Your films are full of necrophilia, suicide, serial murder. But in your private life, you are very much obsessed by things like Godzilla... and KISS! Someone who didn't know you would assume that you were an extremely dark person.

JB: But I'm not a dark person! Maybe I was when I made these movies, but I think I got all of that stuff out of my system. There were things that were puzzling me. I read certain articles in newspapers, and I always thought, 'if you have these things happening in real life, why should you go and look at stupid horror movies?' You might as well do something that is based in real life.

GG: But of course, the Godzilla films have grown to be extremely important to you.

JB: I got very much into it during recent years because I went to Tokyo, spent some time there, got hold of a lot of veterans from the '60s movies, and made a documentary about Godzilla, Gamera, all the Japanese monsters.

Because in Germany, those films are not very well known. If you really dig into them, and practice a little bit of Japanese, which I did, the movies become different. They're not as simple anymore. When you have learned more about the Japanese culture, you appreciate the films more. The American versions of those films were so strange... they actually made them look stupid for American release. But they are not that stupid.

GG: There are darker themes. See, even the innocent stuff has a dark streak in it...

JB: What do you mean, 'innocent'? I'm just amazed by things, attracted to certain things. Have you seen my short films?

GG: *Hot Love*...

JB: Yeah, see? That's very much influenced by all the Godzilla films. And when I had the chance to do my first feature film, which was *Nekromantik*, it just turned out a little bit more serious. But to me, it's still a very funny movie! I don't really take my films that seriously. I am amazed that other people do!

GG: So you were making fun of art films, with *Nekromantik*...

JB: Kind of, yeah... but it's also an attempt to combine art films – which can be fun – with trash films. Because often I can get more out of a trash film than I can get from an art movie, a so-called serious art movie.

GG: The Berlin film scene back in 1987, the feeling on the street, in the clubs, when you were doing *Nekromantik*, how is that different now?

JB: There is no such movement now. Back in 1987, it was leftovers from the punk rock movement, and there was something going on called industrial art. The premieres of my short films always happened in a club whose bartender was Blixa Bargeld from Einstürzende Neubauten, Nick Cave used to hang out there. It was pretty much a movement that would accept anything which was anti-establishment. And my films were that. The Super-8 movement during that time consisted of arty, experimental films. And I was so bored by that, that I went back to my roots, these monster films. I hate it when people take themselves too seriously. Again, it shocks me that my films are taken seriously. People will try to bend me to their own perceptions, because they really think it's something dangerous.

GG: Can you give me an interesting example of your work being misconstrued by a certain critic?

JB: It wasn't so much the critics, it was the censorship people. They made a statement like, "you have committed a criminal act with this movie, because you are glorifying violence." See, the glorification of violence is against the law in Germany. They banned *Nekromantik 2* and threatened to send us to jail. That could be considered a misunderstanding, I suppose. In general though, I would never say someone misunderstands my work. Because if you've done a movie, you've got to let it go, and for me it's very fascinating to see what other people see in the films.

GG: What could you possibly do to top the second *Nekromantik*, if you made a part three?

JB: *Nekromantik 2* was an anti-horror movie. It takes ages for something horrible to happen. If you cut two horror scenes out of it, it becomes more like *Love Story* 2. We were mocking the horror audience. We'd be in the back of the theatre laughing because these people have to live through endless scenes of the petting zoo, and romantic stuff. A third part would be strange. Some years ago it would have been pointless, but now it seems appealing to me because of all those big budget horror remakes of movies from the '70s, so I would think it would be nice to have a more normal attempt at dealing with the subject of necrophilia, which is something that is not being exposed in film.

GG: Was necrophilia just used as a shock device or was it something you were generally interested in at the time?

JB: For sure, it was a tool to test the limits of censorship. During that time there was a major censorship problem in Germany. Every horror movie was heavily cut. They really destroyed the whole culture for horror movies. But on the other hand, a lot of people were bored by normal horror movies. Horror movies deal with the topics of sex and death, but they never get

> "It shocks me that my films are taken seriously. People will try to bend me to their own perceptions, because they really think it's something dangerous."

it straight, in my opinion! So I was going for the real thing, for the natural thing, and leaving out all of the supernatural shit.

GG: You have the two extremes! Real life on one hand, while parodying it on the other!

JB: Maybe that's just attractive to me! Putting two extremes together. I think Björk said something about that. She said she uses a lot of electronic noise to point out that without bad things, you won't have good things. You need to figure out the extremes, I think.

GG: What would you like to do if you could get a million dollar film budget?

JB: I have a script completed which is a very strange love story between a German stage play director and a Japanese dancer. It's called *Body Play*. It has a lot of… masochism. But I cannot find anyone who will pay for that movie, in Germany! [*laughs*] It would be something nice to do in Japan, I suppose. But at the moment it is staged in Germany. Right now, it is still wishful thinking. I lecture people about trashy things. That's what I do for a living at the moment. I write about these bizarre things for these established papers, and I do nationwide radio, with my kind of stories. I also write for film magazines that are supposed to be serious. I'm trying to get my approach and my sensibility to the mainstream! Prepare the world! When people like John Waters come to Germany, I do interviews with them. Christopher Lee. I do all of that. I am kind of the 'horror guy' in Germany.

GG: It's odd that a director who was so infamous back in 1987 would be interviewing people…

JB: I don't think so. I never was very much of an established director. I was not part of any film business in Germany. I was just a guy who was doing Super-8 films with his friends, on weekends. But I got more and more famous because of other people, who liked it.

GG: How often do you meet a person who is established in the film world, and knows who you are?

JB: John Waters did. He told me I should go to the US and do a horror convention. So… that's what I'm doing now! But no, I don't approach people like that. For me,

"Most necrophiles would rather have a living person than a dead person... but they are afraid of getting rejected. So they go for the stiff!"

I don't care. I just like to meet these people. It's fun! I wouldn't have this job if I had not done my movies! Because the people in Germany, all the film editors, they know me because of my movies. A new horror movie opens in Germany, and they ask me to write about it, because I know about this stuff.

GG: Jörg, let me ask you this. You are a model kit collector. If your apartment was burning to the ground, and you only had time to grab one model, which one would you grab?

JB: The Godzilla model from the '60s.

GG: They should have a *Nekromantik* model.

JB: Actually, my friend Rainer is thinking about doing a bust of the corpse for a possible box set that we are doing. A bust of the *Nekromantik* corpse, with an attachable broom stick.

GG: It should come with a little condom then, a miniature *Nekromantik* condom, that you can put on the broom stick!

JB: No, no. That would be too hard to do. One of the first reviews I ever read of *Nekromantik* was from a gay magazine in Germany. They said, 'this might be the first movie about AIDS, because people are sleeping with death'. I'd never thought of that, but I liked it. A British publisher is putting out a book about the European underground, it's a very academic book, with essays by doctors and stuff like this. There is a very long article about how the two *Nekromantik* movies reflect the Nazi past of Germany. I never thought of this either! I was astonished. I read it, and I couldn't deny it!

GG: *Nekromantik* is a love story!

JB: I did a film called *Bloody Excess* back in 1982... they start with that. Then they go into the scene in *Nekromantik*, the scene where the apple picker is shot down from the apple tree... the gunman is a typical Nazi for this English writer. And all this kind of stuff. Like how the corpse in the film looks like a concentration camp victim.

GG: Okay Jörg, let me ask you this now... how young is too young for *Nekromantik*?

JB: When I was in school, in '73 or so, *The Exorcist* came out in Germany. And it said, '18'. Then I knew, I had to go and watch that movie. As soon as a film is there, and you know you're not supposed to see it, that's the problem.

GG: The theme is tragedy, the theme is romance! And the attitude is punk rock! Jörg, to what extent do you believe you have played a pivotal role in influencing the transgressive art films of today?

JB: I think less of my influence than you do. You keep asking me about 'how big is this' and 'how many people were influenced'... To me, it is a mystery the way these films are looked at. If I watch them, I only see flaws. And I laugh my ass off.

GG: Gaspar Noé and this other guy, Nacho Cerdà... these guys take your films seriously I think. You've talked to them, I'm sure.

JB: I talked to Nacho, a few years ago. I liked *Aftermath*. I did supplements for that DVD, because I really liked it. But they are far more serious, you are right.

GG: So you think the new transgressive art films are pretentious?

JB: Kind of, yeah! But I like the films! There's a lot of people in Germany who do straight to video horror movies. They tell me that they saw my movies and that made them do horror movies on video. But most of the time, the stuff they're doing isn't any different than American horror movies. They're just re-doing stuff... badly. They don't know their limits. That might be something I'm proud of. I did know my limits, from the beginning, and I know my limits now. When I went to Korea two months ago, I had a 700 seat cinema packed, even with my old Super-8 films. And 70% of the audience were women. Korean women! And so, I said to myself, 'how do they understand these movies?' Because they have a totally different social background. I did a question and answer session after the movie, and they were asking me religious questions. They took everything very seriously.

GG: Necrophilia is a difficult subject to get one's head around, it's a very complex reality.

JB: I see it as being based on a lack of communication. And most people who are necrophiles would rather have a living person than a dead person... but they are afraid of getting rejected. So they go for the stiff!

GG: These women in Korea sound very seduced by the concept of necrophilia.

JB: Those Korean girls, they aren't like these girls here, who get dressed up in costumes to go to a horror convention. They're just going out to see a horror movie. They come there, they sit, very civilized, they watch the movies, and they like them. That's the mystery to me.

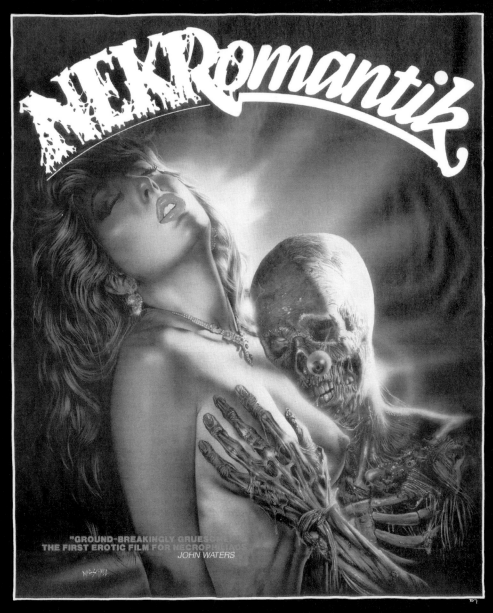

EIN FILM ÜBER DIE LIEBE ZUM MENSCHEN UND WAS VON IHM ÜBRIG BLEIBT

NEKRomantik

"GROUND-BREAKINGLY GRUESOME...
THE FIRST EROTIC FILM FOR NECROPHILIACS"
JOHN WATERS

MANFRED JELINSKI präsentiert »**NEKROMANTIK**« Ein Film von **JÖRG BUTTGEREIT**.

Mit **DAKTARI LORENZ · BEATRICE M · HARALD LUNDT · SUSA KOHLSTEDT · HEIKE S.**

Kamera **UWE BOHRER** Musik **J. B. WALTON · H. KOPP · D. LORENZ**

Buch **JÖRG BUTTGEREIT · FRANZ RODENKIRCHEN** Produktion **MANFRED O. JELINSKI**

Regie **JÖRG BUTTGEREIT**

© JELINSKI & BUTTGEREIT GBR, BARNETSTR. 17, D-1000 BERLIN 49

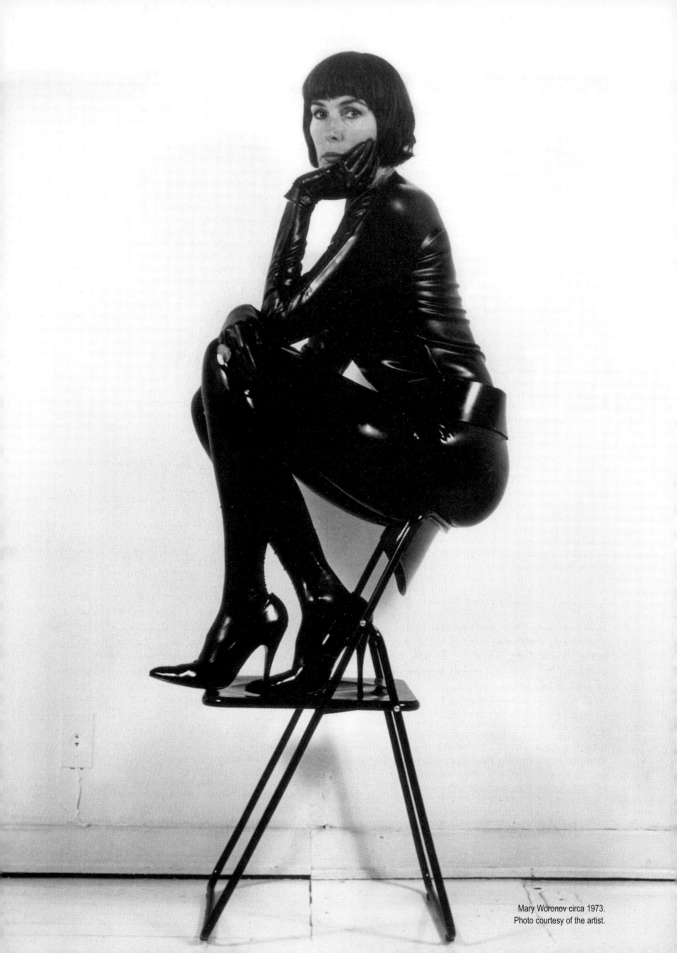

Mary Woronov circa 1973.
Photo courtesy of the artist.

Ciao on This Manhattan

- Mary Woronov -

"**M**an, I used to get a boner just looking at her," my friend Billy confided to me, when I told him of my happenstance introduction to Miss Woronov. Billy had worked on a film with the hip, coquettish actress back in the 1980s. I couldn't argue with him: extremely tall, extremely thin, and exotic as hell, Mary was a major focal point for me too, since seeing *Eating Raoul* as a wee lad.

I was in a bar on Sunset Boulevard, ogling the gorgeous barmaid, when Mary walked in. My gaze was immediately broken: "you're Mary Woronov," says I. "Yes I am," says Mary. Her smile was disarmingly humble. I told her about *Sex & Guts*, and begged for an interview. She wrote down her phone number on a napkin and that night I went home with a renewed sense of purpose.

Mary came of age as a Warhol girl in the '60s, appearing in many of the Factory shorts and features, before going on to act in a long stretch of '70s and '80s exploitation films. Many of them are now ranked among the most influential and most-cherished of the genre. Besides trash classics like *Eating Raoul* and *Death Race 2000*, she's done some mainstream Hollywood work and written three books. *Swimming Underground* is a memoir of the Warhol days, while *Snake* and *Niagara* are novels.

Gene Gregorits: So what's the new novel about?
Mary Woronov: *Niagara*? It's about this girl who thinks her past is one way but when she grows up she has to realize her past was not what she thought it was. I mean, her parents are entirely different people, her brother's a different person, and she has to either deal with it or... if she can't accept it, things just get worse and worse for her. It's also a novel about... well, her boyfriend loves her, and she actually loves her brother. And her brother loves her boyfriend – which she doesn't know. So there's that bizarre twist.

GG: One thing from your past that I remember, from your book, *Swimming Underground* was, "I hated being touched by anything in the human skin package." Now was that mainly because of the speed, or did you just not like people?
MW: No, I just really didn't like the idea of being touched. I was just not ready for any kind of sexual experience, and yet every experience to me was, like, sexual... it was bizarre. I couldn't stand it. I mean, if someone just shook my hand, eeeuuch... I felt like it was sex. And I just didn't know how to deal with it.

GG: Just like, hypersensitive?
MW: [*chuckles*] Well you know it was that I was oversexed, that's what it was. And I found an outlet for that very late in my life!

GG: Well back then everyone was doing a lot of speed.
MW: Which doesn't really help the sexual responses....

GG: No, no. How old were you at that time? I think you were only seventeen, eighteen...

MW: Eighteen, I would be getting out of school and that didn't happen until like my third year at Cornell College.

GG: Right. Well coming from the perspective of being an ex-Warhol girl, the underground must seem very dull to you, very tame. Does it?
MW: Not at all... when I became acquainted with punk rock here in Los Angeles, I thought it was just as thrilling, I really did. It was not the same, but the energy was something I related to, immediately. With Warhol, it was more gay and with the punk rock, it was more hetero. It was more music whereas with Warhol it was more art, although The Velvet Underground was there, but The Velvet Underground was very punk. I mean, in a way...

GG: I agree with that. They were sort of the first.
MW: Right, and instead of there being one little band, suddenly there was the whole community of Los Angeles doing the same thing. It was fabulous! It was connected with poetry and a new wave of literature and things. I thought it was very, very good. I loved the song lyrics, some of them were great. I'll never forget the line, "When I close my eyes, I see blood." I think that was The Germs. I've never forgotten that line, it's so neat.

GG: Who were your favourite bands from back then?
MW: From back then? Well, I really liked the Mau Maus. And you know I only saw them play once and the rest of the times they were too high to get on stage. We used to go and wait for them and they'd never show up! And I loved X. I will never forget watching X at the Starwood, every time they played the Starwood it was phenomenal. I liked The Germs, I liked Black Flag. I loved Fear.

GG: [*incredulously*] You liked Fear?

MW: I loved Fear! Fear was fucking great! I didn't care for the Suburban Lawns… the vague sort of intellectual things. I was much more thick-headed, I liked things Fear and Dead Kennedys and the bands that were really dense – it wasn't so much stupid as it was they were angry, and the anger was amazing! The anger was the same as the anger that I loved when I was with Warhol. These homosexuals were still in the closet, they weren't allowed to do anything – and they were fiercely angry! Nothing could come near the rage they felt. And this was the same thing except it was young kids – and it was so bizarre because a lot of them – they weren't really poor, some of them were kind of rich!

GG: Don't you think that was a contributing factor making the scene a lot darker out here? More violent and nasty… I mean, compared to Warhol back then, out here it was much more of an aggressively heterosexual thing, especially because of bands like Fear.

MW: Yeah, but did that make it darker? No. No, it was a different kind of darkness, they were just as dark, and just as capable of death.

GG: So, have you been out here ever since?

MW: I've been here since the late seventies.

GG: Is it your favourite place to live or are you just here because you were getting some great film roles. Are you still interested in movies? Because you were in *The New Women* recently.

MW: Yeah, I was interested in that movie and I did like it. I'm interested in these independent productions. I'm not really part of the industry, and never have been.

GG: You did land some pretty big films roles for a while. I mean, one of my favourite films that you were in was *Nomads*.

MW: It wasn't received well… but I thought *Nomads* was fantastic! Wait… you asked me something before the film thing… what was it?

GG: Is this your favourite place to live?

MW Oh, yeah! I love New York but now I've become enamoured of Los Angeles… I'm not sure why. It's a great place to write and paint in, for me, but it's a very freaky town. People out here are not really capable of emotional attachment or friendship or… I mean, they're all on the move, they're all in the business… it's very slippery here. There's no family life or community or anything. But in a way, I like that because you can be anybody you want to be… you can wake up one day and decide you're a cowboy! [*laughs*] And nobody's watching you. You can be poor one day and rich the next day. It's such a weird town. You can reinvent yourself any time you like.

GG: And in New York its such a small world…

MW: Everybody's watching you! Always. Also, this is the place of outlaws and exiles, it really is. And I think that, especially for literature, there are a million exiles here. And it's always been that way. There's a big history of that. Faulkner came out here, F. Scott Fitzgerald… There's a giant history of that.

GG: Well, it's an alienating city, which may be what makes it so good for writing.

MW: I think so, too. And it's the most comfortable city to live in for the least amount of money. And I have trees! I never saw a tree when I was in New York! It's really very beautiful. Still. So I'm in a love/hate relationship with it but I really have no intention of moving.

GG Now, Paul Bartel died recently. How do you remember him? You must have had a good relationship with him, you were in more than a few of his films…

MW: No, I had a love/hate relationship with him. He was a wonderful friend. And every time I was in a room with him I was completely in love with him. He was just a fabulous person. But as far as work goes, after *Eating Raoul*, I resented the fact that he didn't use me more. And then I really resented the fact that he would tell everybody that we were married. Because everybody believed it and I couldn't get work for a long time. And the idea of me being married to him is like, completely alien.

GG: That's like seeing *Eating Raoul* and believing it!

MW: That's what he wanted! I hated him for that.

GG: How was the experience of making *Eating Raoul*?

MW: It was a lot of fun. I mean, at the time everyone was upset, we didn't have any money. But I never felt so free on a set. It was just so easy, I never even thought about what I was doing – I just did it.

GG: My favourite movie by Paul Bartel is *Scenes from the Class Struggle in Beverly Hills*. What was it like making that?

MW: It was very hard because Paul wasn't the same person who did *Eating Raoul*. He wasn't young and fighting – he was older and tired. And I thought that Ray Sharkey's role was terribly miscast. I just didn't relate to that move at all. Now, they could have used Frank Langella , he would have been perfect. And then Jackie Bisset and I were supposed to have equal roles but most of my footage ended up on the cutting room floor. And Paul kept saying, "Well there's just no room for it, we had to cut that scene out," but he's always been like that with me. "Let's get rid of Mary."

GG: What's your favourite movie that you've been in, I mean Bartel or not, just in general?

MW: I'd have to say *Eating Raoul*. There are other films I enjoyed doing, one was *Hollywood Boulevard*. I really loved doing that. And the other one was some bizarre thing – another film with Ray Sharkey – it was called *Hellhole*. It was the most ridiculous film I ever did, I mean it was hysterical. It's the most sleazy, ridiculous film I ever did.

GG: You played a lesbian doctor, I think?

MW: [*sighs*] Something like that. It was insane. I just couldn't believe I was doing it! It's like, you know, the campy end of my career. And then, *The New Women* I really like. It was done for nothing once again and I really liked my role in it. It was kind of amazing for me.

GG: You were in a few big Hollywood films in the late '80s. You were in *Black Widow* and *Dick Tracy*... What's your take on the mega-budget film industry thing?

MW: I used to walk in and there'd be a long table and you could have an omelette with every goddamned thing in the world in it. Amazing lunches. Everybody's always asking you what you want. People are very civil. It's such a giant, big, mega fucking production, you'll never see anybody afterwards or become friends with anyone. It just doesn't rate very high in my book. It's like joining a corporation. Also, I have never worked with a really wonderful director on that level. You know, I wasn't in *Blade Runner*. I do have to say that Warren Beatty is a pretty good director. If I was a 'star' in *Blade Runner*, I'm sure I'd have a different take on it but I never got to that level.

GG: Do you mind if I talk about *Nomads*? You do this incredibly sexy bump and grind in an alleyway that is a stand out… well, to me, at least it is one of the greatest moments of your career. [*laughs*] What did you think about the fact that it was just so poorly received?

MW: I don't understand why it was poorly received. The script was wonderful, and he didn't really get the script across. I mean, I forgot the director…

GG: John McTiernan.

MW: Right, he does *Die Hard* and all of those things, but this was his first film, I believe, and he wanted to do something cutting edge. He wanted this incredible edge. You know, the "dangerous life of the punks." And you know, Adam Ant had been a punk for years, and I certainly was a punk. We just kept looking at him, going, "What?" Like, "What is wrong with you?"

GG: Right, like someone had just played him the Ramones for the first time.

MW: And he was so out of whack with us, you know, it was just amazing.

GG: What kind of films do you like to go and see?

MW: Oh, well, I'm afraid I don't watch any big budget films anymore. I don't want to see them. They're all about sensational bullshit, and special effects. They leave me cold. I've been watching a lot of older films. I like going to the museum... they had a Bresson thing, they have the Satyajit Ray festival there now. I've been going backwards, I really have, and watching a lot of older movies. Hollywood was great once, it really was. I have to say nothing will ever top *Apocalypse Now* – I love that movie. *Blade Runner*. I like those kinds of movies. But the movies I'm thrilled with now are Bresson films. I love him. And I love Tarkovsky. His film *Andrei Rublev*.

GG: What about music? What kind of music are you interested in?

MW: Well… I started with Elvis Presley. I loved The Shangri-La's and shit like that. White rock. When The Beatles came along, I tolerated them. I liked The Stones. That was it. Then I moved onto black music, like everybody. I immediately went for Otis Redding and Motown. And then by that time The Velvet Underground hit and that was it for quite a while. I didn't really pay much attention to the rest of anything until punk rock. I mean, I used to listen to stuff but I wasn't crazy about it. Then punk

Mary Woronov in Paul Bartel's **Death Race 2000** (1975).

rock came along and I was suddenly crazy about all these things. I mean, from Blondie to the New York Dolls. All of this stuff. I thought it was great. It didn't last, though, and it seemed to evaporate. And what I did was I moved straight into heavy metal. [*laughs*] I LOVE heavy metal!

GG: Wow!

MW: Fucking great stuff. Some guy handed me a tape of Metallica and I went ballistic, I had never heard them before. And then I moved right along to Nine Inch Nails, whatever… Rob Zombie… I love that voice! I went from heavy metal straight to opera. And I've been an opera nut for the last couple of years.

GG: So opera is what you throw on, around the house?

MW: Absolutely. Opera and pretty much long-haired music. I don't know, maybe it's a sign of age but it gets me going. What can I say? I'm just a Wagner nut.

GG: Do you have any plans to actively pursue any film work?

MW: I do. I have a script of *Swimming Underground*, and I really would like to direct it.

It's a brilliant script. It might just get bought from me, you know. But I would love to try and direct. But for a while I was paying the rent by directing softcore porn…

GG: You're kidding!

MW: No! I wrote and directed several episodes. One about vampires, one about showgirls and one about [*laughs*]… this red dress. Every time she puts on this red dress, people want to fuck her… it doesn't matter who it is, it could be her son, or could be her secretary, whatever. They're really good and I really loved directing, but it's very hard to get a movie on now. But that's always on the back burner, it comes and goes. The big thing is that I have two or three more books to write.

GG: I can't wait to read your new book, and I've loved your film work for many years.

MW: Thank you.

Twilight of the Id

- J.K. Potter -

Master of the phantasmagoric image, J.K. Potter has been stretching the boundaries of photo manipulation since the 1970s. What he began so long ago is now unavoidable in Hollywood filmmaking, and has since been commonly referred to as morphing. In those films, illusions exist only in a thrill-ride context. But the territory mined by Potter, through his apparently inexhaustible imagination, is much the same as that of H.P. Lovecraft's books. The specific type of spectral beauty he evokes is unequalled, pervading the soul as much as the eye. I could spend hours staring at a single piece, whether it be a painting or photo collage; each one conjures up invisible storms of wonder and expressedly Lovecraftian dread.

His apocalyptic creations are nightmares brought to life, wrenched intact from his own subconscious, starkly monstrous, spookily poignant, and always capable of a romantic suggestiveness that captures dream logic like a metaphysical Polaroid snapshot. Thousands of images like this, all of them existing as both tribute to and re-visitation of all that which lurks beyond light, in the damp chill of your own deep midnight nowhere.

This conversation is a transcript from an aborted documentary film project started in New Orleans during Mardi Gras, 2002. During my visit to Potter's home, he viciously destroyed one of his own collage masters as a means of technical explanation, demonstrated the power of his work when combined with high-intensity strobe lighting, and gave my cameraman and I a revealing tour of his studio. The energy of the man is enormously positive, and I've met few people as charming or congenial since then.

Gene Gregorits: What is relevant, in these days of digital overkill, about the fact that you still do your photo collage work by hand?

J.K. Potter: Personally, I think that the digital revolution is the greatest thing since instant water. The medium that I work in and love that is most important to me is film. Every once in a while I do work digitally, usually with a collaborator. But even if I had a huge state of the art workstation here, I would still use film… because film is what I like. It is the silver nitrate on that plastic that gives me the magic that I need to do what I do. And there are other factors as well. When I print a photograph, using the old-fashioned methods – which is just an enlarger that projects the light down – I am reaching my hands out, into the light, to block out the light in certain areas on the photographic paper. I touch nothing but the light. [J.K. begins gesturing, moving his hands as if he were creating shadow puppets.] And it's different to move a mouse on the computer or tap on the keyboards… I'm not doing anything but moving my hands in that beam of light, making my little shadow animals. When you're standing there in a three minute exposure and you're trying to do this, and you're moving your arms around… I'm actually using light as my medium as if I was using it as paint, so

J.K. Potter in New Orleans, late '90s. Photo courtesy of the artist.

it's a totally different feel to it. I like the smell of solvents and turpentine and photo-chemicals. And what will most likely be the end of me will be that lust for fumes. I hand colour my work. So I like coming out of the studio with paint on my hands. I gotta get that Lava soap out, scrub those stains right out from the wrinkles in my knuckles, and under my fingernails..

GG: Your first book came out in 1979. How did you realize you could pull these kinds of tricks with photo images, to manipulate them the way you do?

JKP: It started when I used to do very Beardsley-esque line work… I used just a brush. This work was very time consuming. It would take me a month just to finish one piece. So I became interested in photography as a short cut. I said, "I'm not going to make any money as an illustrator doing this baroque, intensive line work", so I actually started using photography to cut corners. I just fell in love with it… but I'd been photographing for a while. I had a Polaroid camera when I was 12. I was doing double exposures at a very early age with the first model of SX-70. I would have my brother sit in front of a skull on a shelf and then he would jump out of the picture after a two second or three second exposure. I have always been attracted to photography but I started out doing very complicated work. When I look back at it now I think it was a little too ornate, and a bit fruity.

GG: The trick is double and triple exposure? Is that how you get the images you get?

JKP: Well, I use many techniques but my favourite is multiple exposure. Multiple exposures are a splendid way to fuck with people's heads because they're looking at different layers of imagery and trying to organize it in their minds. I used to take double exposures with the 4x5 view camera, on a large tripod. It's the kind of camera where you put a black cloth over your head. I would make one exposure, and then make the second exposure even as late as a year and a half later. I'd make a little drawing on a sheet of tracing paper and tape it up. So I would make multiple exposures early on, I was very attracted to that. Now I've become a little bit egotistical about it. I tend to refer to myself in my private moments as the Undisputed Master of the Triple Exposure. I love triple exposure. Some of my editors don't like them because they think they're too artsy fartsy, and it confuses the mind. But you're looking at three transparent layers on top of each other, and you see, for example, someone with four arms or fingers growing out of their face. But the real romance of multiple exposure is that it's DONE. You shoot it. You print it. It's done. The other techniques I use are the collage, and multiple printing… where I print four or five different images on the same sheet of paper. Those are different methods, but I like to mix it all up!

GG: I'm sure that there are a million little things you do to make that method work so well, but it's still going to be a very mysterious thing to try to figure out from my end.

JKP: Because the camera is so widely used, people often assume that we know everything there is to know about photography. But it's such a young art form, and there's still a lot that one does not know about using a camera. The ideal way to use a camera is not as a machine but almost like a divining rod. A lot of painters who criticize photographers, they will give you the old song: if you take enough pictures, you're bound to come up with a good one sooner or later. Well, that's true! There's not a reason to deny it… but I really think that sometimes, with a camera, or with the right model, the right lighting, the right moment, you're dealing with time, you're dealing with light, you're dealing with a human being, with a certain pallete of emotions, the relationship between the artist and his subject. I think that ultimately, the camera brought me out from behind my table, where I was sitting there, the solitary artist whose brain is like a solitary ingrown toenail, staring at his work for hours on end… the camera brought me out from behind that drafting table and into the world. I'm fond of saying that I'm really only as good as my models. I do still-lifes, I photograph objects, ruined buildings, decaying statues, but I really get the most enjoyment out of photographing people. It's a collaborative thing. One could argue that even a landscape painter is collaborating with nature or god or the forces of the universe. I just like to use the camera as a tool to bring all of these disciplines together.

GG: What was your childhood like? How relevant is it to your subject matter?

JKP: It's very relevant because I had a splendid, almost Bradbury-esque childhood, with one exception, and that was that I moved frequently. I was in a military family, and so I lived all over the country. So I consider myself an absolute American. I have a feel for North, South, East, West. I was born in California, and grew up mostly in the south. But I lived in places as diverse as New Jersey, Ohio, Arkansas. But my formative years... I feel that my important development as a human being, as a personality, occurred in the South – Alabama and Louisiana. So the South has permeated my work.

GG: There is a man named Clarence Laughlin?...

JKP: Yeah. Clarence J. Laughlin. He was, along with Frederick Sommer, one of America's first surrealist photographers. He was an enormous influence on me. Clarence Laughlin was one of the first people that I truly respected as a creative force, one of the first to sit me down and say, "Look, you have something... you need to cultivate your talent." He was the perfect influence for me. Clarence John Laughlin was the kind of photographer who really condemned photographers who had young men following them like the 12 disciples. He was not that way. He had a certain distance, but at the same time, he was very free with his knowledge, and there is no substitute for what he passed on to me. He became my mentor, and there's really no substitute for the accumu-

lation of knowledge that can only be accrued with time and with extreme effort. He was an extraordinary man.

GG: Your work is very connected thematically with New Orleans. You concentrate on urban squalor, devastation... from broken down shacks, to garbage dumps... things like that...

JKP: In New Orleans, everything ages quicker. Everything looks older. The paint peels quicker. The humidity, the mould, the incredible burden. When I first stared coming here as a teenager, I loved to see the cemeteries and to see tombs split in 2 by a tree that had just grown right out of the centre of the tomb. And it sounds like cliché symbolism, life growing out of death... but I'm drawn to New Orleans because New Orleans is old-fashioned. And because one of the most pervasive aesthetics of New Orleans is that it clings to the past. To me, true New Orleanians cherish the music that was spawned here, and they still listen to it. My house is Victorian. I really think that Victorian architecture is psychologically more humanistic, more friendly to me, but beyond that, people are more friendly here than in other places that I've lived. My love of New Orleans is very complicated, and it's complicated by hatred, because I hate New Orleans almost as much as I love it. New Orleans is like an old whore that I know far too well. But still love her. It's like a poisonous hothouse flower. It's beautiful but if you shove your head into it, you're gonna come out with a nasty smell. This place is unique! I really think that this "party like there's

"I would hate to have too much of a cult following. I am actually repulsed by the whole idea of being famous."

no tomorrow" aspect of New Orleans grew out of the yellow fever epidemics. It grew out of being occupied during the civil war. And I'm drawn to this. I mean, I've left here but I always come back. And that's because this is my spiritual and creative home. There are other places that I have a strong attraction to, but this is really it. I left here and I did not return for seven years. And when I came back, I came back on the train. Carl Jung said that at least once in your life, you should take an ocean voyage. Well, plane travel is all fascinating and beautiful… especially from a visual standpoint. Staring out the window of an airplane and seeing the beauty of the clouds, of the earth from afar. But there's nothing like a train ride or a boat ride that takes time. I can remember coming down here on the Amtrak. I got here at night. I hadn't been here in seven years, and my first experience was being tired outside the Amtrak station. The cabdrivers wouldn't take me where I wanted to go. I lost my temper and I thought, "Man this place hasn't changed, this place is just as fucked up as usual." But I managed finally to get a cab, I went to a friend's house, fell asleep. Woke up the next morning, hit the street and I immediately thought, "Wow! This is what's wrong with me. I belong here." Immediately the whole vibe sunk right back into me. I'd been living in New England, and I love New England… but once I returned here I felt like an indigenous plant returned to its native soil… as corny as that sounds.

GG: Some of the earliest work I've seen by you was published by Arcane Press, in a book called *Fly in My Eye*. It was a comic anthology I got in 1989. There were also two sequels, *Saturday Mourning Fly in My Eye* and *Daughters of Fly in My Eye*. It was a lot of dark, nasty horror comic material that was coming out in the late eighties/early nineties, including work by Clive Barker, who you have done some work for, right?

JKP: Yeah.

GG: What do you think Barker's work has in common with your photographs? Or Ramsey Campbell's, for that matter, too?

JKP: Well, both of them are British. I've always felt a strong affinity for British horror writers going back to Arthur Machen and Algernon Blackwood. Scotland is

more of a motherland for me than England, but Britain is the mother country, you know? And it's also given us the finest horror writers ever. Clive has transcended the horror label and has been able to write in other genres equally well. So I'm very reluctant to just pigeonhole Clive Barker of all people as a horror writer. He's a brilliant creative talent. Ramsey Campbell on the other hand, is an extraordinarily unique human being. His style, and his warped, convoluted perceptions of the world… it's hard for me to verbally describe how Campbell's work has affected me. I pursued him early in my career. I was a fan. I wanted nothing more than to illustrate Ramsey from the time I was fifteen years old! Finally in my twenties, I realized that goal. Ramsey is stylistically unlike any other writer. I mean he's difficult for some people, especially for a lot of Americans, who find his work not to their liking, because I think it, in its own way, has a rarefied quality. But I've visited him several times. He's locked me in his basement. He's a total madman. He's hell on wheels, he cannot be stopped. He is uncontrollable. I talked to him on the phone once. We hadn't talked in a long time. I said, at the end of the conversation, "Ramsey, I know I haven't talked to you in a long time, I've been a silent Sam, but I want you to know I still have my Ramsey Campbell Shrine and the black candles are burning in front of it." And his response was something like, "Ooooooh. OOOOOH, well we have a fungus growing in the garden that we've named after you!" I can't imitate him, I can't do justice to his description… but he described this horrible bloated fungus in the garden, that he said resembled me, and that they had given my name, So, I have to love somebody like that. He's a scary guy.

GG: I know he had a scary life. There's a story about his grandmother which is also in *Fly in My Eye*… It was a really depressing story.

JKP: Well, fortunately, I had wonderful and nurturing parents, but Ramsey's upbringing was pretty horrific.

GG: So there's like a real spirituality in English horror as opposed to American horror.

JKP: Yeah, and there's a certain style. It's an English perceptivity towards the supernatural and the bizarre. It is often very dry. Ramsey practically disowns one of his early books, which was called *Demons By Daylight*… but that pretty much says it right there.

GG: You've done a lot of photos of Lydia. I suppose her work and spirituality clicks with you in a strange kind of way.

JKP: Yeah, I guess you'd say it does appeal to my spirituality, but also appeals to that distilled kernel of darkness that's either somewhere in the back of my brain or embedded in my heart. Lydia definitely has an extreme take on things. She also has an extraordinary lust for life, which is contagious. You know that. More than anyone. [*laughs*] And she's also been very helpful to me. She's a great model. You know, I hate the word "model." Nowadays it has such a horrible connotation.

GG: What about "subject," is that better for you?

JKP: Subject is almost like something on a dissection table, but I do like that. I like dissecting models. [*laughs*] That's what we want to do to them. We want to have model dissection. Lydia is more of a collaborator. She knows how to emote and project her personality through the lens and onto that landscape of chemicals embedded in the photo emulsion. I've worked with her for a long time, so I'm very appreciative. But more than that, her work has influenced me. She and I are very different types of people, but we still have a tremendous commonality. I think I'm a lot more reserved and conservative than Lydia is, but I in no way criticize her for her outgoing and often confrontational nature. I find that enriching not only to me personally but directly to my work.

GG: I know you've been doing some album covers. When did that start, and how is that different from just doing regular photos?

JKP: I just started doing album covers and I miss vinyl. I miss those great big sleeves, big artwork, especially if they're double albums, you can open them up. That shows my age. I hate the way things are shrinking. I started out doing covers for early proto-industrial bands like Hunting Lodge and Gargoyle Sox… but I also did a tremendous number of bad German heavy metal groups. So I've done album covers all along, off and on. It's just in the last five or six years that I attracted bands with a larger following and a larger pressing. But I enjoy doing CD booklets, especially the work I've done for Fishbone. And for Lydia. I've done more work for her than anyone. And Cradle of Filth's *Midian*. Designed the booklet.

GG: What about your cult following? Do you have a fan base or a fan club or anything?

JKP: I have a cult following and – oh yes I have minions [*laughs*] – but when you say "cult following," I immediately think of Charles Manson. It's the world of the nearly famous or the almost famous. Just by the advantage of being around for as long as I have, I have built up a fan base. And after my Lovecraftian sabbatical in Massachusetts for seven years, to come back here, it is startling to see that it's like a snowball rolling down a hill. It just gets bigger and bigger. It's nice. I would hate to have too much of a cult following. I am actually repulsed by the whole idea of being famous. When I was young, when I was in bands, I wrote a lot of songs. And every once in a while, I'll still write a song. The last song I wrote was out of sheer hatred for someone, and it was called 'Starstruck Motherfucker.' I've stopped watching television. There are wonderful films, there are splendid things on television, but overall the media is like a warthog from hell, and I just hate them. And I have a particular animosity toward talking heads on the television, anyone who portrays themselves as being an expert.

GG: What about Boston? How much did Lovecraft have to do with your work? Because your work is heavily drenched in a Lovecraftian vibe.

JKP: It's bizarre, because I grew out of Lovecraft. I thought Lovecraft was more of an affectation of my youth. I always really appreciated his friend Clark Ashton Smith, who was much more of a writer and a poet than Lovecraft. It was odd! One time I found myself in the Massachusetts countryside, near Cape Cod, not far from Rhode Island, and living there made me think about Lovecraft. I could not resist thinking about Lovecraft, living in New England, right in the middle of his stomping grounds. So I re-read a lot of his work. My perception of his work changed. I would be sitting out in the woods, on a stone wall reading Lovecraft for the first time in fifteen years. It did bring me back to my childhood roots. Until the day I die, I will probably return there on occasion. I love that ostentatious nature of New Orleans cemeteries, with the above ground tombs, and the statuary, but I really do prefer a New England cemetery with slate tombstones, and the rotting art of our Pilgrim forefathers. When you think about it, these Puritans were iconophobic. If you go into these cemeteries and see these slate carvings, a lot of them border on the pathological. Wings, skulls. The clusters of fruit and figs that resemble breasts and penises. It's like the true nature of the human being, even repressed, tends to bubble forth. Also, the placement of many of those cemeteries, which overlook lakes, ponds, are all situated on hills. There is a gorgeous cemetery which overlooks Plymouth Harbor which has got to be one of the most beautiful cemeteries in America.

I did an exhaustive study of the slate carvers in my general vicinity in New England, and I actually drew a lot of inspiration from that work.

GG: I can't imagine you producing the same stuff living anywhere else but here.

JKP: Well, if you're a photographer, you may as well live in a place where you can [take great pictures]. Often young people ask me, "What should I do?" I tell them, "Well, move from Bugtussle, where you're living, and move some place where there is a large gay population!" When I give this advice, it is invariably to someone who is homophobic! I say, "Move somewhere like San Francisco or New Orleans. Miami. Provincetown! Or some place where there is art." Because let's face it, where there are homosexuals, there is art. That's just one of the verities of life. I came here in search of inspiration, I was drawn here by Clarence Laughlin, by Carnival, the cemeteries, by the women. And that's something I gotta mention! That's one advantage of New Orleans over Boston, that even though it is rather cold today, it sure is very enriching to see less attire on the feminine population during most of the year. Whereas in Boston, at this time of year, people barely have their faces showing.

GG: What was your band like?

JKP: I can't call it a punk band. It was called The Wedgeheads. It was more satirical. We did really raucous and abrasive covers of songs like 'Sugar Sugar' by The Archies. We had a number of original songs, and I think if you looked back through the Shreveport Journal's archives, you could find all kinds of information on that. I learned a lot of things. I learned how to manipulate the media, when I was in bands. I learned how to give an interview. I also learned what it was like to hear a heavy beer mug whiz by my ear. I found out what it was like to get hit in the face with a cream pie, and have a quart of whipped cream pumped into my sinuses. It was in the punk era, in the middle of the bible belt. Response to the group was mixed. Some of our song titles were, 'Eat My Bazooka,' 'Shitty Shitty Hijinx,' 'It Only Hurts When It Squirts.' We were very sexist and offensive. 'Where In the Hell Is the Anti-Christ?' was one of our songs, which was not a big hit in the bible belt. 'Dry Humping in the Breeze.' Very classy stuff, right? [*laughs*] It was fun, and it helped my work. I am a lone gunman type. And being in a band was like working in a family, within the fuckin' Partridge Family. I don't want that. I hate it. To this day, I cringe at the idea of being in a band, because it is just frightening to me.

GG: What kind of music do you listen to in your spare time now? Do you play music as you work?

JKP: Yeah. More and more though I have silence or bird songs. But I listen to a lot of different things, I run the gamut. And sometimes I will get irascible and I will listen to two things at once. I'll get two tape machines going at once and have a real cacophony. It really does vary. I listen to the college station. I listen to Lydia. I listen to a lot of old punk. Still! Like a boring old fart. But I also listen to Dvoràk and Haydn. It varies, but it's amazing lately how much I have been working in silence. Not complete silence, like when these gas heaters are going. Then I have that gas chamber-effect going. That hiss.

GG: What movies have inspired you the most?

JKP: I don't go to many movies. I actually find going to the theatre overwhelming at this point. I have a wonderful friend, Roy Huston, and he had for years what he euphemistically called "The Roy Channel." I would go over to the Roy Channel and the Roy Channel would consist of a giant big screen television, stimulants, and a triple feature… which is usually some of the most extreme, obscure, and gut wrenching horror that Roy could find. And Roy would enjoy not only watching the movie, but also watching his friends squirm as he tortured them visually. So I saw thousands of films. They are all clogging my back brain, I mean, they're all there. It's not a pretty sight. But I still see films. I loved *Pi*, I thought *Pi* was great. What's that director's name?

GG: Aronofsky.

JKP: Aronofsky. I like Jodorowsky. I like Polanski's *The Tenant*. I prefer European films to American films. But I like old movies. I'm a Cary Grant fan.

All illustrations accompanying this article are by J.K. Potter, and have been reproduced by kind permission of the creator.

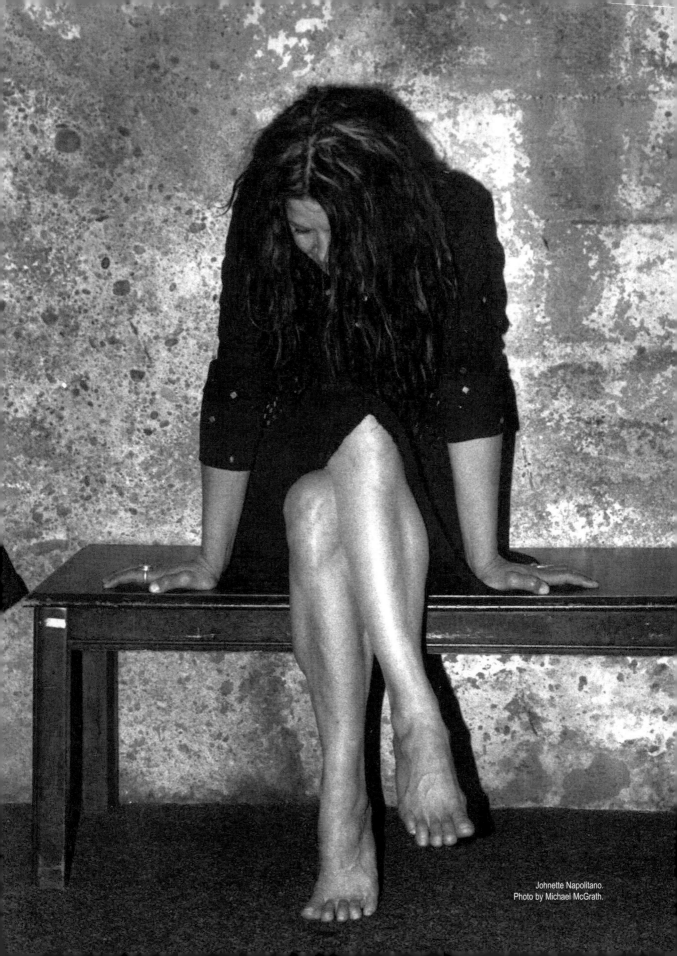

Johnette Napolitano.
Photo by Michael McGrath.

It'll Give You Lines Around Your Eyes

– Johnette Napolitano –

Like a lot of people, my first exposure to the work of Concrete Blonde was on MTV, where their breakthrough video 'Joey' aired in the late 1980s. I have remained a fan ever since, particularly of the albums *Bloodletting* and *Still in Hollywood*, a B-sides compilation. Johnette Napilotano's voice has an informed primal quality that makes you stop what you're doing, sit upright, and listen, to feel what she's feeling. It's a voice of Marlboro Red deepness, tough and sexy… that rare and precious emotional exhibitionism which gives away the soul of the artist in only a few lines, and has for many decades exemplified the greatest of female vocalists from Nina Simone to Janis Joplin. She can easily inspire anger, excitement, or bemusement, sometimes all in the same song. I get a crooked smirk or a sad stone-face off it on a regular basis.

You'll find that classic Joplin quality at the heart of her best-remembered Concrete Blonde songs, such as 'Bloodletting' or 'Tomorrow Wendy'. The latter, about a close friend on the verge of an AIDS-related death, is a remarkably potent four minutes, with a main chorus that will forever rank among modern music's truest portraits of loss, of that in-the-flesh grief which is both banal and unanswerable.

This interview, conducted in 2002, was prompted by the release of Concrete Blonde's comeback album, *Group Therapy*, a characteristically intense and personal rocker that lives up to its own dark inferences.

Gene Gregorits: I'm going to start off with a bit of an obvious one. So why eight years since the last record?

JN: Well, there was never meant to be another record. I had a conversation at the beginning of May last year and swore that it would never happen. I really don't know why but there was never meant to be another one. And I still don't know why, really, that we even did it. If we had thought about it it wouldn't have happened. It happened very quickly, without much thought, without much discussion. Unbelievably fast.

GG: Was it amicable, the break-up?

JN: Well… [*long pause*]… there were issues. I gave fair warning. Years of advance notice. "I'm not going to want to do this after five years." I can't imagine anybody being pleased with doing the same thing over and over again, for ten or fifteen years. Especially when it comes to art, you've gotta be growing. So no, it wasn't pleasant, really. The guys were pretty pissed at me actually, but I needed to do some stuff, you know? It was a lot of work [being in Concrete Blonde]. I didn't have a life, I didn't have anything!

GG: I remember when I would see your videos on MTV. You must hate what that's become.

JN: I don't have a television at all. I wouldn't know. I'm not qualified to answer the question. On the road, it is a luxury for me to have a TV, so I actually see news and things like that. But I listen to the radio a lot, to news radio and things like that. And, I'm a hip hop fan, I like to see hip hop happening. I like the women in hip hop. They're very strong, very sure of themselves. Everything that a rock 'n' roll woman is cracked up to be, I think the black women do better. So I don't mind that. I just don't have a lot of time to just sit around and watch TV. In Mexico, where I lived for a while, I didn't have a TV or a phone for a long time, and I got more writing done than I've ever done in my life! And more reading. It was just a really great thing to not have to care about all that shit.

GG: Before the band broke up, I would imagine that you were on the road constantly…

JN: Oh man, for fuckin' ten years or something. My life was stunted. My growth was stunted. Emotionally, and physically. I just was not in good shape.

GG: Touring is very physically unhealthy.

JN: It is, and it's really hard. But now we have a handle on it. We have two weeks out, two weeks off, and we enjoy every minute of it. It's just a whole new world.

GG: It isn't as glamorous as it would seem.

JN: Well… you see things you wouldn't see, wherever we go. We had a great time in New Orleans, because I have a lot of friends down there. That's a nice thing too. You get to see friends you haven't seen for years. That's wonderful. But the crew had never been there, and we got to take the swamp tour, and it was pretty cool.

GG: When you stopped doing the band to concentrate on your art, what kind of projects were you were doing?

JN: Well, painting and some assemblage, and I'm very into clay. I've been working with clay since I was twelve years old, and I studied with a potter in Mexico. I'm working with a clay piece right now, which is sitting in front of me, in a semi-state of wanting to be finished. I'm not drawing

as much as I used to. My first group show was with a couple of artists in LA… when you drive along the road in Mexico, or in some of the Southern states, you see these crosses along the side of the road where someone had an accident and died. Those have always inspired me, I always think that they're very beautiful, and should be there. I did some mysterious mosaic tile work behind all that. I did seven of them for that group show, and for my solo show I did a series of turntables. I did one for Steve Wynn's album cover, for his last album…

GG: Those are so great.

JN: Oh thank you! I might show them again in Ohio next year. I would like to do it in LA, I just don't know where, exactly. But I really liked that show. It was at a university up north, and everybody, from the oldest faculty member to the youngest kid, could relate to the music. And then it got a following with the DJs up there, because the turntable to them is like a vintage car to somebody else.

GG: Well, the way I took your turntables is, "that's how all music should be." It should have heart. It should be guts and raw emotion on vinyl. And I rarely hear that. You're certainly one of the few songwriters who's really captured a real, deep level of that in recent years, on the new… well, CD.

JN: Thank you.

GG: I liked all of your collaborations with Steve Wynn, especially 'The Ship Song' and 'I Have Faith' on the final Dream Syndicate record. And he just toured with you. Do you think you'll do an album together?

JN: I don't know if we could do that. We value our friendship tremendously. We've worked together long enough to know that we see the recording process in two completely different ways. So, I value our friendship more than an album together. We had a blast… I don't know if you saw it on his website, the hotel room session in Austin?

GG: No, not yet…

JN: Well, I have this portable rig now, that I can just take around like a stewardess carry-on, and record anywhere I go. I plugged it in, in Austin. Jim Mankey, Steve, and I did 'Long Black Veil'. It was really great! Jim played wine bottle percussion, and Steve played a bag of pretzels for percussion, got salt all over my fuckin' new keyboard, and it was brilliant. It was great just to be able to edit the sucker, mix it down, send it to an MP3, and now it's on Steve's website. It was a lot of fun. But we approach things differently. If we had a clear concept of what it was and what we were doing… and did it as a one-off thing… but it would have to be something that was conceptual. Like a Leon Russell/Willie Nelson kind of a thing, where there's common ground. I'm not the kind of writer that sits and writes a song on the spot. I need to think about it, reflect on it. I can work fast, but I also need time to get into it. I have to think about what it is. I don't necessarily trust anything that is that fast off the cuff. I don't do that. Steve is the king of that. We're both such strong writers… and we have strong egos too. That's why we did 'Long Black Veil',

because it's traditional. It's like, "Okay, this is traditional. This is neutral ground. Let's get this together and do this."

GG: Was Concrete Blonde's reunion in the works before September 11th? And if so, did that change the creation of the record?

JN: Yes! We got together in the last days of May, and we were in the rehearsal studio June 1st. Jammed for the first time in years. Had to get used to that. In July we made seventeen cassettes of just jamming. We listened to them, picked out what was the best, and by July we had refined what stood out. We recorded 10 days in August. Then that was it. When the shit hit the fan on September 11th, I felt, "God, I've got to be somewhere I know, and do something I know. I've gotta make a record. Immediately." And that was the fastest way to do it, really. It was the weirdest feeling beyond anything I could explain to you.

GG: You mean that pervasive zeitgeist ominousness?

JN: Yeah! Scary.

GG: One of my favourite songs on the new release is 'Violent'. Was it meant to be taken ambiguously? Is it pro-hedonism?

JN: I was really scared. I remember driving to rehearsal every day. I would see people sitting in their cars, just screaming at each other, honking their horns, all pissed off. And I'm thinking, wow. You have the fancy car. And you're probably going to lunch at a great place, and you've got a well paying job, and you're still screaming at each other. And then, I see a guy sitting at a bus stop talking to himself and laughing. And everybody's looking at him like he's crazy. I thought he was right on. And I was scared. People are nuts out there.

GG: Is there any part of the song that referred to what might be good violence?

JN: No. There is no good violence.

GG: I meant as in a creative violence.

JN: Well, alright. Björk had a great title: 'Violently Happy.' Which was brilliant, like everything she fucking does. Violence, I believe, is a physical act. And the physical act of happiness is wonderful. It could be dancing, painting, anything. The physical act of violence could be creating something. The turntables I did were extremely violent. But hostile violence I think is very destructive. True alchemy is turning the hostile violence into creativity. That's what being civilized is.

GG: Why was there only one LP as Dream 6?

JN: Well, we were going to stay Dream 6. We signed to I.R.S. Miles [Copeland III] suggested we change our name. I didn't mind doing that, because he didn't change our music. He was the one guy that came along and didn't change our music.

GG: It was you and the same two guys?

JN: Well, Michael Murphy left to be a part of a band called Lions & Ghosts, on Capitol.

GG: Were they good?

JN: Yeah. They were neo-romantic and spacey, and all the kind of things that were cool at the time. If you listen

to the record, it's probably really great. They were just a little bit more fashionable than we were. We were always geeks, and not really sociable. So I don't blame him, and I love Michael. He later did *Deconstruction* with Dave Navarro, an amazing record!

GG: It is?

JN: Oh fuck, it'll blow your mind. So Michael, he did just fine. We had another drummer after that. He didn't want to do anything but major label shit. And we were like, "We're not doing that. They don't want us. We've got this label who does want us. And that's what we're gonna do." So he quit. It's a crack-up, because he later tried to sue us… for money we didn't have. He thought we were famous, but fame does not equal money. When we got Harry Rushakoff, he had been in a band with Al Jourgensen and Frankie Nardiello from the Thrill Kill Kult, called Special Affect, and you can see on the website, all the old pictures of them looking like Ultravox and shit, back in the day. He has a lot of sensibilities that are very cool. He's into straight rock and roll, seventies glam and rock star shit. He's also into the art aspects.

GG: Did you see any impact on civil rights for Mexican citizens after the release of the *Los Illegals* album?

JN: Oh, they don't need any help from me. Actually I consider it the other way around. I've been enriched much more by the exposure to that culture. The Chicano culture that I've always grown up with led me to Mexican culture. And probably the biggest disappointment is that I found out that Mexicans and Chicanos don't get along.

That became a huge disillusionment. But people who are actually activists, people who work 24/7, have had a much bigger impact than I can. I like the fact that I got mail from people that had Chicano friends and Mexican friends. The only common ground they found was rock and roll, which I thought was very interesting. It brought up a whole series of questions, and issues. People have a fear of losing their own culture, and when it comes down to it, can you really be at peace with one another and find these touchstones, or, in the end, just hate each other.

GG: Did your fans disregard it because of the use of Spanish lyrics?

JN: Well, some of them really liked it, because some of them are Latino. We had people say, "They speak Spanish like they're from the fuckin' Valley," or whatever. Well, they're from East LA, they're Chicanos, they're not Mexicans. We got blasted from all sides, and we got support from all sides. I think it was a pioneering record; I'm very proud of it. I commend Miles Copeland for putting it out.

GG: What is your affinity to Mexico, its causes, politics, and imagery?

JN: I'm not necessarily drawn to all of the politics, although I would like to point out that they were able to oust a corrupt party after seventy-three years by direct election. So that's a kind of politics I personally agree with! [*laughs*] We would have had a whole different ball game if we had done that in the last election. Culturally, I grew up in LA. It's just always been here. It's part of my home. There's nothing that's drawn me to it, it's where I was born.

Johnette Napolitano in the UK. Photo courtesy of Sultan.

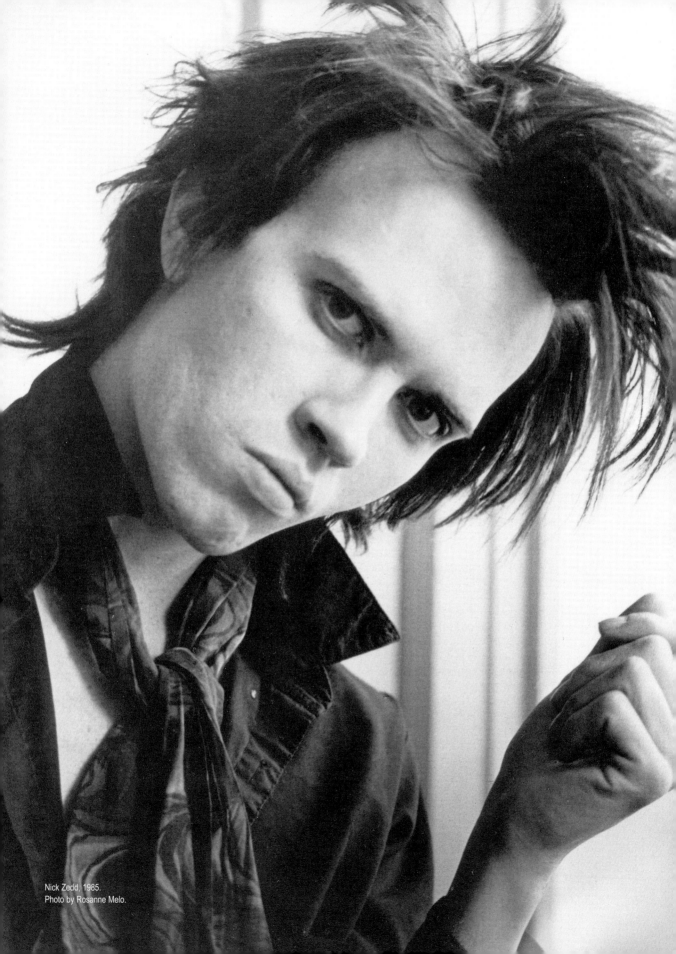

Nick Zedd, 1985.
Photo by Rosanne Melo.

Master of Transgression

- Nick Zedd -

In the late '80s, *Film Threat* magazine ran a fake obituary for infamous provocateur / filmmaker Nick Zedd. Politically, he is an anarchist, and as with a lot of gifted social revolutionaries, could be said to exhibit a combination of intense bad vibes and unchecked self-deification. It's a personality type that often instigates such malicious acts. However, bogus death reports can backfire, infamising the victim. They often make for great publicity, especially if the victim has Zedd's high cheekbones, Satanic one-yard stare, and fuck you where you breathe sneer to burn into the mind of all dupes everywhere.

But how much of the Zedd mystique is based in reality? Could the demonic reputation and comic book anti-hero image be the result of yet another Xerox media prank, or an insider fabrication?

Unfortunately, most of it proved to be genuine. I wound up living a block away from Zedd between 1997 and 2000, and one constant factor during that time was the disembodied voice (horrendous agitation, vague fury, weirdo staccato, sarcastic monotone) of The Master on my answering machine:

"Gene…I need…to use…your computer."

"Gene…why are you never…at home?"

"Gene…why are you…shunning me?"

The Master and I got drunk in bars, and being a young lad of 20, I suppose I learnt a few tricks from him. Although I have vague memories of my nights out with The Master, a pile of ratty old tape recordings confirm my suspicions that few intelligent or even coherent things escaped my lips back then. The Master always seemed acutely annoyed by me, but no matter, I was introduced to his fellow hedonists and proceeded to indulge in a seemingly endless variety of crude public behaviours, illicit substances, and sexual fiendishness. Those frenzied, narcissistic Manhattan nights, filled with reprobates from the 1970s who had used up all of the dirty NYC fun for themselves… I still remember a few. But feeling under-whelmed by the 1997 leftovers, I became determined to create new and better scenarios, as often and as filthily as possible. The Master became my partner in social terrorism on more than a few occasions. It was easy to get away with the psycho idiot boy routine back then… my dark cluelessness appealed to women, particularly upper middle class artists and journalists who would always pay for a cab back to their loft in Brooklyn or SoHo or wherever. In the morning, I'd find that I'd gotten sweet on the hipster lass, and attempt cuddling or some other such post-coital gesture. Invariably, I'd be kicked out of bed and sent stumbling on my way. I shared tales of my frequent romantic misadventures with The Master, who would confide in me also. I was standing drunk in my roach-infested kitchenette one morning when out in the stairwell there arose a great clatter… so I went to see what was the matter… and through a grease-mottled peephole, in the yellow light of toxic Brooklyn dawn, what to my wondering eyes should appear… but a dishevelled figure in a flowing black trench coat, dragging a young woman with translucent skin up tenement steps by her long black hair! Spreading across his face was the grin of a satiated hellhound. I knew in a moment, it must be St. Nick.

I was by no means innocent of such things! My anti-social aggression offended even The Master, who had once tossed a steel garbage can through the front window of a club… on many an occasion meanwhile his frequent put-downs began to offend me. Eventually, in a bilious torrent of pent up ill will, our friendship ended. Of course, this in no way means that I have lost respect for The Master. He's inarguably one of the most intriguing self-made myths of the New York underground, and played a crucial role in the only meaningful lower east side film movement of the 1980s.

I was nine years old when I first read about him in *Fangoria* magazine. It must have been the colour photo of the Ed French-designed monster in that single page report on *Geek Maggot Bingo*, Zedd's 1983 attempt at schlock horror, that made the name stick out sharply in my own memory. About seven years later, after countless inquiries to pen pals, found mentions and photos in various fanzines, I tracked down a bootleg copy of a ten-minute film called *Thrust in Me*, which familiarized me with, among other things, a piece of Nick Zedd's history. Directed by Zedd and Richard Kern, the former plays both a man and a woman, who kills herself in a grimy bathtub as he stomps home, pouting, kicking things, pushing his way through a quarrelling couple who block the sidewalk. After taking a shit and wiping with a faded picture of Christ, he discovers her still warm corpse, taking a sarcastic look at it. Then, with the technical aid of trick photography and a stunt cock, we witness Zedd express his grief by administering himself a post-mortem oral jack-off.

In slow motion, he spews an impressive load of spunk over her dead face, to the rhythm of a great Dream Syndicate track from their gloomy second album, *Medicine Show*. *Thrust in Me* is obnoxious, immature, and hilarious. I consider it to be one of the most striking films, underground or otherwise, to emerge from New York since its release in 1984. It clearly demonstrates not only the potential of no-budget filmmaking, but also how Kern's technical attributes complimented and polished Zedd's own crude personal visions. One can only imagine how some of Kern's later work may have been improved by Zedd's input, and vice versa. They never again directed another film together, although Zedd appeared in several of Kern's shorts, including *King of Sex* (1986).

Around this time, Zedd was publishing a fanzine called *The Underground Film Bulletin*, which documented with a corrosive wit the NY film scene. In addition to his own clandestine celluloid, the *UFB* covered the work of Kern, Tommy Turner, Lydia Lunch, Casandra Stark, Tessa Hughes-Freeland, Manuel DeLanda, Lech Kowalski, and many others. Zedd paid tribute to his own heroes such as Ed Wood, Jack Smith, John Waters, the Kuchars, and Kenneth Anger with profiles and interviews. Its look was bare bones cut and paste, reflecting his own poverty at the time, but illustrated in grungy, grainy, Xeroxed black and white was the message that this "Cinema of Transgression" wasn't a concept or a movement that aspired to look pretty or please anyone. It was about breaking rules, sidestepping imposed limits (as publicly as possible), sexual experimentation, unleashing chaos, and exposing the smug cowardice of the upper class. The Cinema of Transgression was guerrilla war on the New York avant-garde, and a street based, full frontal assault on publications like *The Village Voice*, who ignored Zedd and his co-conspirators. While he hypocritically established a few rules of his own in the *UFB* manifestos, he was also responsible for generating a sense of importance, for keeping track of the films, filmmakers, events, and the growing public awareness. He'd kick-started the movement, named it, organized it, and became its unofficial historian. Ultimately, Nick Zedd was the movement's Face.

When it faded back into the sidewalks of Avenue A, Zedd remained one of the few who hadn't let the mass ignorance of their audiences destroy all the chaotic ideals behind these films, such as *Ism Ism*, *Nigger Night*, and *Submit to Me*.

The *UFB* folded and the late '80s saw the completion of Zedd's *Police State*, a highly accessible and darkly comic work about humiliation and murder at the hands of an NYPD officer played by Rockets Redglare. During a stay in Sweden, he fathered a son, Kajtek, and was subjected to the violence of European cops. Back in New York he drove a cab, lived at Hotel 17, and met a beautiful stripper named Susan Manson, who appeared with Nick in a psychedelic porno short called *Whoregasm*. That film has a destructive effect on one's sex drive. In the '90s, Nick Zedd made several films, including *Smiling Faces Tell Lies*, *War Is Menstrual Envy*, and *Why Do You Exist?*, the latter being his most rewarding effort to date.

Darinka and many of the other Lower East Side clubs where the films were originally shown are now closed, and gentrification has made living anywhere in New York impossible. In terms of a unified movement, The Cinema of Transgression exists now only as a bit of film history, that ended before it ever really began. The foundations were laid, a tone was set, a direction was acknowledged, but Zedd's predictions of "blood, pain, shame, and ecstasy" were never fully played out or lived up to before the dissipation of his various associates. Zedd has expressed an unabashed bitterness towards old friends, evidence that no small amount of bickering and animosity led to the movement's inevitable disappearance.

Gene Gregorits: So, tell me about this new book, that was called "evil" by Henry Rollins.

Nick Zedd: I don't want to be difficult, but I don't respond to questions where the person begins a sentence with "tell me." It means you're dictating to me. Like you're giving me an order, or something.

GG: Could you please tell me about *From Entropy to Ecstasy*?

NZ: It's a historical novel. Actually, if you were really interested in it, you would've read it. But you haven't.

GG: [*nervous laugh*] So what I was getting at was, what's in the book that has caused it to be, as you told me, rejected all over town. What's so evil about it?

NZ: Probably the violence, there's a lot of sex and violence in it, and then there's politics in it and blasphemy. All the usual ingredients that seem to scare people away. Which, I do not think should.

GG: Were you intentionally striving to get a shocking reaction?

NZ: Yeah. It's always better to shock people.

GG: You don't think that detracts from a story?

NZ: No, it adds to it. It makes it more exciting.

GG: How do you feel about the finished book?

NZ: I think it's great. It's one of the best things I've done. It's funny and entertaining. But for some reason it's a hard sell because publishers are more interested in memoirs.

GG: I've seen *Totem of the Depraved* on the shelves of people who aren't that perceptive of anything that could be called 'underground'. So the book has a wide-reaching attraction. What is the attraction to people who aren't already familiar with your name?

NZ: Maybe the pictures... it's got lots of good photos.

GG: Do you have a larger following overall in Europe than you have here?

Willoughby Sharp and Nick Zedd (*right*) in **Police State** (1987).

NZ: Well... it's hard to tell because it all depends on how well an event is promoted. I could get a huge crowd here if it's advertised and promoted right. But most of the time, in Europe they'll do it, because they had to pay your airfare to get you there so they want to make the money back. So they'll make sure to publicize it. But the same thing can happen here you know. It's all about promotion and advertising to get people to show up.

GG: Are you having a hard time doing your own advertising now that Giuliani's graffiti pigs are at work? I know you were arrested a while ago for putting up posters.

NZ: Yeah, it's getting hard to promote your own shows on an underground level.

GG: So I guess back in the mid '80s it was a lot easier to promote your work, and to produce it as well. What do you miss most now about the era of your heyday?

NZ: The lower rent.

GG: Have you become disillusioned with New York?

NZ: I guess. But I can't think of any place better to make movies, unless you have money.

GG: Have you ever thought you might get more financial support if you were based in Europe?

NZ: They keep claiming that that would happen, whenever I go there people talk about getting financing, and ideas to make movies, and about what great

architecture there is there, environments to shoot and people to work with, and it never happens. So I think they're all apathetic over there. They just talk and they don't do anything. They should put their money where their mouth is. You know? But nobody'll do that in America either. For me.

GG: When did you first start writing novels? Is this recent, or is there material from when you were making the early films?

NZ: No, that was recent. I had this idea of writing a novel about a serial killer. When I was living in this basement on 17th street I really wanted to kill the super, and I started writing about that. I thought it would be interesting to make a story about killing your super, or your landlord. But then, when Sue [Manson] left, I started writing about a real person, and it came out even better when I was not making it up, so then after I went to Europe I started writing more. And I thought, I could probably fill up a book with these stories.

GG: How far did you get with the serial killer story?

NZ: It was just a part of that chapter about being in the 17th street basement. I wrote one chapter, and then I changed my mind and decided, "I'm not gonna write this." It's better to just write about the truth. But in the back of my mind, I thought I'd still like to do a novel about a serial killer. And this was before all those books came out that

Above: Nick Zedd (*left*) and Gene Gregorits, 1997.
Opposite: Annabelle LeFleuer Pinion and Squeaky in Nick Zedd's **War Is Menstrual Envy** (1990).

made it so trendy. Now, I'm less interested in it. After the first book got published I thought as an experiment I'd write a novel. A fiction book, making everything up, and that was more like the original idea, except that I decided to make it in Albania. In this exotic country that's far removed from my own life, mainly because the first book was all about my life in the Lower East Side, and also about going to Europe and travelling, and I wanted to do something that was totally the opposite.

GG: Your third book is also autobiographical. Is it a continuation of what you began with *Totem of the Depraved*?

NZ: It's really like diary entries.

GG: Does it differ from the *Totem* narrative?

NZ: Yeah, because it's more day to day events and I might edit a lot of it out. And also I think I've found more humour in everyday life. I've changed as a person, my life has changed. I've found a way to derive humour from misery. Even from the mundane stuff, I think that I'm good at observing, and remembering, even little absurd things. The way people act you know... in the past I was ignoring it more. I mostly focus on the people that I know. When anything unusual happens I write it down.

GG: Does writing come easier to you than making movies?

NZ: They're both difficult. It's never easy... it's not fun or easy to create something valuable. It takes hard work and discipline. I mean, once I start writing, the ideas come out and it starts to flow you know? It's not at all collaborative. It's isolated. And I don't have to rely on anyone but myself and in that way it's easier. At the same time the hard part is getting people to even read what you've written, and getting it published is really hard. It's less motivated by audience response or getting attention. I am hoping that in the future, I get attention, once it's published.

GG: But you've said that you don't care what the audience thinks, feels, or says about what you do. So when you do get a good reaction, are you encouraged, or as apathetic as you'd be towards a negative response?

NZ: Yeah, I appreciate a positive response because I figure that means more money coming in when people start buying it. With the writing, it seems there isn't ever a negative response. It's usually overwhelming acclaim and massive indifference. Indifference mainly from the book reviewers and the people stocking the bookstores. I feel that the people that should be doing their job, as usual, are not doing it. So the writing isn't reaching enough people. Same thing with the movies. The movies are more like a performance. I like doing both, I'd like to make more movies but it costs so much money and that's a problem.

GG: Like I said, I've been seeing *Totem of the Depraved* being read by people who just picked the book up randomly. So there must be something attracting an audience to the work of an underground filmmaker who a lot of people are not familiar with.

NZ: That's good, I want to reach a wider audience. I don't like being underground.

GG: How do you feel about the way that word is used now?

NZ: It's been overused and perverted. It's become a cliché.

GG: Do you see your book as a final statement on what you've done? Or do you intend to keep going?

NZ: I want to keep making movies. Yeah, I think it does sum up the first part of my life. So I'm going into the next phase. With the next book, chronicling my existence.

GG: You've said that you don't acknowledge the word "morals" or the place of morals in your life.

NZ: Morality is a human invention. It's arbitrary. The term is useful to priests and to religious authorities. I have a sense of ethics, and that's something different. I have my own feelings about what's right and wrong. I don't believe that a lot the things that are identified as immoral are. For instance, I don't believe there is anything inherently wrong or evil about anything that people do with each other sexually, as long as there is mutual consent. If someone wants to be beaten, or cut up, or if they want to eat shit, that's fine. It's not moral *or* immoral. There's all kinds of things you can do, and it's beyond good and evil.

GG: Do you appreciate anybody who creates a mass disruption? Someone in the entertainment industry, like Howard Stern, who enrages huge numbers of people every morning he's on the radio. Do you have an appreciation for his manner of troublemaking?

NZ: He can be amusing, but he's also mostly boring. He's really naive politically, and usually he sides with the powers that be. He appeals to the prejudices of his listeners. He's reinforcing their prejudices. The thing I like about Howard Stern is he's a Dadaist I think, in a way. I always like people who have this attitude that nothing's sacred.

GG: What you've sometimes showed interest in, during your career, is causing a scene in everyday life, like the way you used to show movies on a wall in public, outside of a club. Does that have anything to do with Guy Debord, and Situationism?

NZ: I think that kind of comparison is a shortcut to real thought. What I did maybe has parallels to what the Situationists were doing, with writing slogans on walls and I suppose it is a Situationist strategy to affect people who didn't pay to see what you've done, or even shown any interest in it. That's something I'm interested in.

GG: The media projection of yourself that you helped to create with your *Underground Film Bulletin* manifestos was influenced by something right?

NZ: I wasn't influenced by anyone. I just wanted to subvert the censorship of omission. It's really arbitrary who gets our attention, through the media. It's sort of decided, in advance. Usually the people who are reported on are already wealthy. No one makes the cover of *Time* magazine unless they're a millionaire. We're all supposed to think that these famous people are worthy of our attention based on the amount of money they've made. And that's why the media doesn't pay much attention to people like Marcos, of the Zapatistas in Mexico, or Abimael Guzman, the leader of the Shining Path in Peru, because they don't want to give legitimacy to real revolutionaries until after they're dead and the money can be made on them. Same thing with Jack Smith. Now, all these books and films are coming out. Historians and academics like being there at the funeral, they don't like being there when things are really happening. This I resent. And I've tried to subvert that. And at the same time I get criticized for self-promotion. How else am I gonna get any attention for what I have done? Or what other filmmakers who I've been associated with have done? I think it is possible to promote yourself, if no one else is doing it, and get the attention. But the way I did it was to put up posters and publish a magazine.

GG: Do you think the *Underground Film Bulletin* was successful in presenting the public image you wanted?

NZ: It was very successful... the book *Deathtripping* that Jack Sargeant put out, most of the material was inspired or paraphrased from the magazine. But it's less about image and more to do with the content of resisting and subverting the dominant culture or consensus reality. I mean, it was helpful having Richard Kern there to take the photographs, you know because he's a good photographer so then we get a bunch of good photos of all the people involved. Casandra Stark took some good photos too, but I don't think it's any different than what politicians and movie stars will do, where they'll have the photographer that follows them around and then they'll pick out the ones they like, you know. Those people are actually more at the mercy of the mass media, because every time they show up in public they're being photographed by somebody. Whereas that doesn't happen too much with me because I'm not that famous.

GG: Have you thought about ever collaborating with Kern again on a new project? Do you think he's got a quality of being more conducive to your images than your own camera?

NZ: No. It's easy enough to hire a good cameraman. That's what I did with *War Is Menstrual Envy* and *Police State*. The most important person is me, you know, I'm the director. I'm the author and I hire people. Theo Stefano, he was good. He was the camera guy on *War Is Menstrual Envy*, along with Mark Brady. I could not work with Kern as a cameraman because he's also a director and we would have ego conflicts. Plus, he's not making movies anymore. He's taking photographs. Standard commercial photography. It has nothing to do with what I'm doing.

GG: How did you personally benefit from his directorial collaboration on *Thrust in Me*?

NZ: [The success of the film] was due just as much to his willingness to go along with my ideas, since I thought up the whole thing. And when the right people collaborate it comes out good. When I collaborated with Annie Sprinkle [on *War Is Menstrual Envy*] I produced something really significant. Also with Susan Manson when I made *Whoregasm*. When Paul Holahan filmed that, it resulted in a really beautiful, exciting colour movie. Each one is like a stepping stone.

GG: You were teaching a film class in a New York college recently. Did you see any potential in the kids there?

NZ: Sure, everyone has potential. Do you act on it, or are you just bullshitting? That's the question.

GG: Is that what you see in the new trend of low budget filmmaking? Bullshit?

NZ: A lot of so called "underground" is bullshit, and that's always been the case. I mean, there's all these catchphrases that people hide behind to get people's attention, and it doesn't mean that the work lives up to it. I have an open mind, and I don't feel that every film has to be subversive. I like films that are more challenging, but I also can enjoy something that just makes me laugh. Or is nice to look at. But I like it when someone examines themselves in an honest way, and challenges their own perceptions. One of the students made a documentary about being gay and black, and encountering resistance from his family. Having a hard time being accepted and finding a lover. I thought that was pretty honest. That class was really only for a couple months. I wasn't even really teaching anything. Well, I guess maybe I was... anytime you expose someone to something they haven't seen, with movies, or writing I guess you're teaching them. If they pay attention.

GG: Do you see any long-lasting benefit to the use of different forms of exploitation in the making of a film?

NZ: Well, I love exploitation films you know. They are the most entertaining.

GG: Would you call any of your own films exploitative in any way?

NZ: What is exploitation? How would you define that?

GG: I'd define it as personal gain on someone else's misfortune or pain. In your book you have a lot of good horror stories that are very entertaining but are any of those people unhappy with your depiction of them?

NZ: Lung Leg. I've never exploited anyone else's pain or misfortune. If I encounter someone in the real world, and they're promoting themselves openly, as a living, breathing manifestation of schizophrenic angst, and insisting that I read their diary entries and listen to their orations about their hallucinations… This person is obviously really interested in getting attention. So when I pay attention I am giving that person precisely what they deserve. I'm giving them actually more than they deserve, which is a spotlight on their individuality. For this, she should be grateful, as well as anyone who is mentioned in my writings. No matter how so called "negative" the portrayal, since I do tell the truth. And if they disagree, they can write their own book. If they aren't too lazy.

GG: So anything that's happened to other people, without exception, can be used in your writing to further its own entertainment value.

NZ: Well, it depends. Like if it's someone I'm close to and it involves things that have happened with me, if the person asks me not to write about them I might change their name but I'm still gonna write about them. If I think it's interesting. If I think it would be amusing. But this is the risk you take by living in the real world. I mean, usually people that resent the spotlight of attention have something to hide. They're dishonest, and they want to be perceived one way while doing something else. They're hypocrites. Especially politicians are like this. Always the most reactionary politicians resent the attention of journalists. People who really resent me writing about them are just pint sized reactionaries or politicians. All literature is gossip, and I'm creating something lasting from the experiences I've had with these people and they should be really honoured and grateful. If someone tells me a story, the story is lost unless I document it, unless that person intends to write it down themselves and that's something different.

GG: What if you were told something in confidence?

NZ: Then they shouldn't have told me! [*laughs*]

GG: Do you ever feel like you've been in competition with your own public image? You're someone who to a great extent works in a public environment, showing movies, doing book readings… so, have you ever felt that a reputation that formed and took off from your work has at times been uncomfortable to you?

NZ: I can't control how people react to a photograph, or something I've written, or something someone's written about me. It's really a collaboration any time I make something and I expose it to the general public. The work isn't finished until it's seen by other people, then they complete the work with their perceptions of it. I don't think that I can compete with my public image because I'll always lose if I try to. Because you continue to age, and

Donna Death in Nick Zedd's schlock flick **They Eat Scum** (1979).

you can never live up to what you looked like... even two years before. The older you get, the less good you look. So people see photographs of me from ten years ago and they think I'm that person. And if they see me in person they're going to be disappointed maybe. If people are that superficial, that they're going to judge you by the way you look, then they're probably not worth anything anyway. So, that's what image is. The surface. What's beneath the surface is what's really interesting. You find out in my writing, and my movies. To some degree, it's a result of what I've created. Because a lot of journalists are so lazy they just paraphrase what they've read about me, which originated in the magazine that I put out. So in that way I determined how I would be perceived. I've hoped that somebody, once in a while, would come up with their own analysis of what I've done. I've been getting that in some of the book reviews, so that was an improvement; some of the book reviews were more penetrating.

GG: A lot of other people who were making films with you kind of disappeared. You told me they're making films but they don't show them around too much. Have you ever detected any jealousy from them? Because you were like, the most successful in building a lot of this stuff up into the history it is now, and getting the notoriety that came with it. While their films collect dust.

NZ: They fell by the wayside. I don't even understand it. Some people are just comfortable with obscurity. And they like also, feeling sorry for themselves. I've stopped concerning myself with these people. They can continue squabbling amongst themselves and barking at my heels.

149

Dan Fante.
Photo courtesy of the artist.

Benderstruck

- Dan Fante -

A southern California native with the somewhat dubious privilege of being the son of a famous writer, Dan Fante's own novels take a sledgehammer to the myth of romantic alcoholism. In his graphic, sweltering tales of a life spent either inebriated or hanging on the razor-sharp edge of relapse, boozy grandeur is quite absent. Humour, fortunately, is not.

Between Fante the son and Fante the father, as family, lies a world of anger and malfunction. As writers, one inextricable link is an unrepentant carouser and poet named Charles Bukowski. Bukowski's sudden fame in the 1970s led to re-issues of *Ask the Dust*, *Wait Until Spring Bandini*, *The Wine of Youth*, and other John Fante titles which had been out of print for decades.

Dan's hyper-confessional first novel *Chump Change*, published in 1996, has got the cum, shit, grease, and mustard stains of the most desperate kind of whiskey binge, the stains of the soul which do not wash out. The book is noxiously funny though, infused with a crippling ache for enlightenment, the kind you're not going to find in Fante's milieu of motel parking lots, telemarketer boiler rooms, and strange beds. *Chump Change* cleverly combines the joyless lucidity of Alcoholics Anonymous with unrestrained vulgarity, never masking the natural assertion that people simply are the way they are, and that as long as you can say you've hit bottom, you probably haven't yet. And Fante, an artist every bit as fractured and maligned as your average man or woman in recovery – probably much more so in fact – lost everything and more during his decade-spanning relationship with liquor. He went from an upper-class adolescence to an epic-length sewer crawl and one hellish shit-job after another.

He returns in his novels, not always gracefully, as the always-broke user and abuser Bruno Dante, bringing with him a story of slow death and furious abandon. The real life Fante is inarguably an immensely brave writer, sharing absolutely everything of his past including the horror stories your average, self-respecting citizen would sacrifice a limb to keep buried.

Dan Fante's 'Bruno Trilogy', which consists of *Chump Change*, *Mooch*, and *Spitting Off Tall Buildings*, is available in the UK from Rebel Inc., who have also published several of his father's books.

Gene Gregorits: Your book *Chump Change* has the feeling of being very recent. When reading it, I think a lot of people would get the impression that the squalor described in the book was still very fresh in the author's past. Was it?

Dan Fante: Oh yeah! Sure. That's intended. It was intended that the immediacy of the novel not be dated. It's very important to me, to be urgent and in the moment with that kind of stuff. That's why it took a couple of revisions to get the tone right on the book.

GG: There are certain writers who write a lot about alcoholism, drugging and drinking, leading that kind of life. But a lot of them don't get down into the meat and the marrow of it like you do. Waking up bloody. Sucking dicks. Junk food. Stinking. Living in this horrible car, with a horrible dog. I mean, that's honest! It's not a good time! It's a horrible time! It wasn't a pleasant reading experience. Bukowski, for example...

DF: ...He romanticized it! I'm a big fan of Bukowski, as a poet. I am not a big fan of Bukowski's novels. I find them not particularly well thought out. They ramble on. But his poetry is a motherfucker! I have to amend that by saying that I like *Post Office* and I like *Factotum*, to a degree. Bukowski was a wonderful poet, and an important short story writer, just not much of a novelist. I mean, the poetry book that I just put out was much better received and more highly regarded than I would have thought. I owe that to my relationship with Bukowski. I knew him casually. I'm talking about my literary relationship, because without Bukowski, this shit wouldn't have gotten done.

GG: Despite the comparison I made, there's a big difference. Bukowski loved LA, though his romance of LA is bittersweet. What separates your work from his, I think, is that I didn't notice a single ounce of affection for LA in your book *Chump Change*. I get the feeling that LA makes you completely miserable!

DF: The reason that I bash LA a bit is because of what it's become, and the aura of Los Angeles. In fact, for a guy like me, a writer, I have a great place to live in one sense – in only one sense – and that is the freedom, the mobility, being able to move. For a writer and an artist, LA really allows you to move around, unrestricted. But it's an enormously grating fuckin' town. It's so pretentious, and silly. But I feel very comfortable. You can be anonymous here, and get away with it.

GG: Yeah. And also, you have phoniness completely shoved down your fuckin' throat out there. You have to be a good person in some way, to just be able to fight against the wall of bullshit. I don't think that most human beings are prepared to wage that war, and a town like LA really raises the stakes. You have to be really strong to go against it. I think the ones that do have been, are, or are becoming, great writers.

DF: Or great convicts.

GG: [laughs] LA does have the best convicts. Like Manson. Being a California native at the time of 'Helter Skelter,' what's your take on Charles Manson?

DF: I grew up on the west side of LA, and I actually know a guy who was part of that group. I won't mention his name. He wasn't part of the violence, but he was in that group at one time. I think that Manson is the kind of aberration that – less so now – but in the '60s and '70s, that appeared very easily in Los Angeles. Weird cults, and all that stuff. It's so easy to be anonymous and underground here, but Manson's an LA aberration. He's a bull's-eye for the kind of consciousness that has germinated in southern California. He was a fascinating sociopath. He had the ability to persuade people. If he couldn't get them to do what he wanted one way, he'd get them to do it in another way. He was completely amoral. He's the kind of guy that really *should* be in prison, and be treated like a lab animal. The cocksucker was a psycho killer! He ordered peoples' deaths. But for his own bizarre aims. Those fantasies about the government, and McCartney's record playing backwards. And all that shit! When you do too much angel dust, and too much pot, and too much acid, you begin to relate to things on that level. I don't talk about him anymore. He's just a sad aberration of California.

GG: But what he wanted to do was change things. I'm assuming that you don't really care about changing things. You just want to document your life.

DF: No! I care intensely about changing things! But nothing that Manson could purport would sway me, in the face of who he is! What is it that Emerson said? "Who you are speaks so loudly, that what you say is silent!" He's a motherfucker and a whacko! And whatever he wanted to change is invalidated by who the man is! He made the choices that he made because of his own needs. This is a man who was compelled and driven to control and keep more power. He's like fucking Hitler.

GG: But what about the circumstances of Manson's upbringing? Henry Lee Lucas was the same way.

There are a lot of sociopaths who have murdered people. I don't condone murder in any way. But I also look at the brutal lives they've often been forced to endure. You've had a pretty brutal life. So do you have any compassion for the fact that these guys have been pretty much fucked by their own lives?

DF: In truth, everyone at a certain point becomes an adult and is thereby responsible for the choices they make. My parents were not good parents, but they did the best they could. I've got death and all kinds of strange psychological aberrations in my family. But at a certain point, I am responsible for my own validity as a human being. For my own destiny. There's no condoning aberrant behaviour. We all eventually become responsible, or we pay the price.

GG: I know that Bukowski was dramatically influenced by your father. But your writing seems a little more similar to Bukowski's.

DF: I like *Factotum* best, simply because it's episodic. Bukowski rambles if he stays on one subject. *Factotum* just went from situation to situation. It's very important, to a writer… the consciousness of the people who are going to read my stuff… I owe them, as an artist and as a writer, I have an obligation to the people who read my shit.

GG: Do you find Bukowski's work funny?

DF: Yeah. But again, it's the poetry that does it for me. He had a way of synthesizing stuff, and a way of making deliberate poetic statements that had humour, philosophy, and horror in them, all in one stanza. That's pretty good stuff. I mean, Bukowski has my admiration!

GG: After having read so much Bukowski when I was younger, I was left, after reading *Chump Change*, with what felt like a slap-in-the-face rejection of what Bukowski wrote about… in terms of your view of both the city and excessive drinking. *Chump Change* wasn't pretty, or even funny in an appealing way, it was just sad and nauseating and very real.

DF: But the horror of it – that stuff with the dog, and all of that, it's all high humour. I've had friends of mine who are drunks read it and just laugh their ass off! It's psycho! Bruno's very marginal. That is a voice that is not represented in literature. And that's why I wrote the book. I have known many, many alcoholics. And I know what it is like to wake up in a pool of shit. I know what it's like to be on a bus, and to shit in your pants. I know what it's like to be puked on. I know what it's like to wake up in bed and you can't fuckin' believe it. I know what it's like when you become psychotic from days and days and days of drinking, and you can't retrieve yourself, and your demons want you to kill yourself. All of which Bukowski happens to gloss over!

GG: How much of the book is true?

DF: It is based on fifteen years of my life condensed into three weeks. It's truth and fiction. It's autobiographical fiction.

GG: So most everything did happen. The car, the dog, the shitty chocolate bars, the young girl?

DF: Some of the stuff, yeah! The death happened. The relationship with the girl, Amy, that happened. The dating service salesman happened.

GG: What was it like having John Fante for a dad?

DF: My father was an artist. He was a very difficult man. He was so internal, and filled with intensity. The most intense person I ever met. He really had a problem being on the planet with other human beings. If they got in his way, he let them know it. He did his best. My dad did the best he could.

GG: What would you fault him with?

DF: He was not a kind man! He was abusive to people. He was combative. He considered his sons threats, so he inculcated us with negativity. He put us down. I got a brother who's dead from alcoholism. He just was never able to transcend his rearing. But my dad was an artist, he was not a celebrity. People forget that. He was not famous during my formative years.

GG: He's really not that famous, even now.

DF: No. He was a screenwriter. But after Bukowski guided people toward my dad, then he became received. And now he's published in, I don't know, 25 countries, he's regarded as one of the best writers of the twentieth century. As a kid, growing up, my dad was just a screen hack. That's all he did. We lived in Malibu, he drove on Sunset Boulevard, and he hated it. He hated the studios and he hated actors and he hated agents. He was not shy about telling people their flaws. He was not shy about reminding people of their character.

GG: I remember one story he wrote about having a dog who was gay. An akita. Is that true?

DF: 'My Dog Stupid'. No. No, he made it up. But he did have an Akita, who was a marvellous dog. My father and I are very similar in that way. We take the truth, and extrapolate with it. Everything that happened in *Chump Change*… for instance, I was at my father's deathbed, but I didn't have a dog with me. You take a scene, and you embellish it. That's why it's autobiographical fiction. When I was a kid, my father was a wonderful raconteur and could keep a roomful of people spellbound, for half an hour, telling stories. But every time he would tell a story, it would have more dimension. There was more colour. Characters were added. Teeth were now blackened. There were hookers. He just kept adding. And that's what a good writer does!

GG: Do you feel pressured, writing under the legacy of another great writer?

DF: To me, his work is more personal and more vital and more inspirational to me than almost anybody. I think he was a better writer than Hemingway. My father could be enormously descriptive, and cynical, and sad… all in the same paragraph.

GG: Your father was more vulnerable than Hemingway. I think that being a good writer, an important writer, requires the writer to be vulnerable, naked to the world. I don't like cold writing.

Classic Bruno: Dan Fante in Los Angeles. Photo courtesy of the artist.

DF: It depends on what your purpose is. You have to look at modern fiction. You have to look at the time of Steinbeck, Hemingway, Saroyan and my dad. Fitzgerald. In the '30s, western writers had a literary ethic. It had to be redeemable fiction. Certain canons had to be observed. But my father just blew the socks off everybody else. Because he was really honest! People are so moved by his literature because he's poignant! He really gets into you! Hemingway was about macho and bravado.

GG: Whereas your father was just a human being, telling the truth.

DF: Yeah! Very different! My dad was a good example. My dad did not inspire me to be a writer, but my relationship with him inspired me in a literary sense, because his work habit, and his structure of sentences, and his appreciation of literature, was monumental for me. It was a gift to have a father like that. That's being said in the same conversation where I said he was a prick. Do you understand what I mean?

GG: Yeah, I do. I think it's too easy to just blame parents for everything.

DF: You have to be able, at a certain point, to forgive people for their shortcomings. He was from a time and a generation when the intellect was everything, and intelligence was everything. Very different from now.

GG: Well, those were better times, in many ways. What do you think about where everything's at now?

DF: I'll answer that by giving you a statistic. 80% of all people in the United States get all of their information from a rectangular box. People don't read. It's a great crime. When you go to Europe, you see people on buses

and on subways, and they're reading. Books are vital. In America, we're looking for the next Stephen King book. We just wanna be titillated and shocked, all that shit. It's all TV! The media has had an enormous downsizing effect on the American consciousness.

GG: Where do you think it's all going, eventually?

DF: Fascism.

GG: A lot of people see it that way, and live here only because they can't afford to move to Europe. If you could afford to, would you move to Europe?

DF: Oh yeah. There are certain places over there where I'd love to live. The coast of the Adriatic in Italy, I love. France and Spain.

GG: You're very popular in France, I've been told.

DF: My books sell over there, sure. And they sell really well in Italy. Really well in England. Not enough for me to make a living. But I'm well-regarded, and well-publicized.

GG: What are some of your favourite books?

DF: One of them, for sure, is *Last Exit to Brooklyn*.

GG: I haven't read that, because I'm scared of it. *Requiem for a Dream* gave me nightmares.

DF: It's very different. I know Selby, and I'm very fond of him. He's evolved as a writer. It's a very fifties style. There is no punctuation, no capitals. There is enormous truth and power and honesty in it. That is probably my favourite book. *Ask the Dust* is one of my favourite books. *The Pawnbroker* by Edward Lewis Wallant.

GG: What did you think of the movie?

DF: I don't think of the movie. Doesn't even compare to where Wallant was going. Kafka said, "a novel should have the same effect as a blow to the head." I try to write books like that.

GG: Shouldn't all art have that impact? Movies, records, everything?

DF: Hopefully, yeah! I don't think that movies are art. I think they are an amalgam of people with talent. But I don't think they're art.

GG: They can be very artful, though, don't you think? What about *Taxi Driver*?

DF: I think Scorsese is an artist, but I don't think movies are art. Although from time to time, they have the same impact as art. But I just don't think, when things are an amalgam of talent, that they can be art.

GG: So you think that the presence of a committee, or the involvement of a committee, corrupts art?

DF: Sure. If you are an artist, create something. Do it yourself. Write your script, direct your script. But even then, there are all these forces that come into to play, and… no, I don't think films are art. No. Sorry.

GG: That's a harsh statement! Movies shaped my life!

DF: I love movies! My father wrote movies for forty years!

GG: Having the opinion about films that you do, about their overall lack of validity in terms of art, what movies do you like?

DF: *Taxi Driver* is one of my favourites. *Raging Bull*.

GG: What are you working on now?

DF: A collection of short stories.

GG: 'Princess' is a great story. What I like about it is that it shows your affection for animals. But you show that in a story about animals dying…

DF: I'm the type of writer who likes to see just how far I can push. And 'Princess' is one of those stories. It happens to be a true story. See, some people do feed kittens to horrible fucking beasts. That's the way it goes.

GG: Whatever happened to that guy? He's a lowlife motherfucker, he should be put in jail.

DF: [*laughing*] He's around. But you've gotta understand, he wouldn't do that today. But when a person is shooting junk, and drinking all day long, and all that is important is to sustain that world… Tennessee Williams said, "there are no lies, but the lies that are stuffed in the mouths by the hard knuckle hand of need. The cold iron fist of necessity." When people are that compulsive, and when they're that directed, there's no romance or art or creativity in them. They're just machines, to get what they need.

GG: Is there such a thing as a good alcoholic? Don't certain people have a motive to do that?

DF: Alcoholism is just a low-level search for God.

GG: Yes! If you're smart. Some people just do it because they enjoy being obnoxious though.

DF: No. Anybody who changes their consciousness, repeatedly, intentionally, is looking for something. And what they're looking for is… well, it's no accident that it says 'spirits' on the label. It is a search for something else. What is ultimately revolutionary, the new frontier, is spiritual self-discovery. You have to make peace with yourself at one point. It's very western to take shit from outside oneself to enhance one's consciousness.

GG: That's why pop culture exists to such an extent.

DF: Sure. It's about consumption. Gimme, gimme, gimme. When you've had enough, if you're like me, if you're lucky… when you've passed through as much alcohol and as many drugs as you can, and you've managed to keep your liver and your sanity… it leads you to yourself, ultimately. If you don't die, you get yourself.

GG: So, would you say that you have more respect for survivors, in general, than for people who have not made that breakthrough?

DF: That is not a distinction that is important. What is important, is this: I have met many recovering alcoholics, who have had to search and find who they are, essentially as people, to stay alive. You're talkin' to one of 'em. That's the distinction. I'd be dead otherwise. I have known many people who are at peace. I just happen to have been very crazy and very out of control a lot. Then managed to get through it with my life, and into another level of consciousness. That's the reason I write the stuff I write, so that people will understand alienation and self-destruction.

Fishing Nasty

- Joseph De Leo -

Joseph De Leo still works a full time job and devotes his every discretionary hour to the making of films. *Fish'n Chicks*, his debut, is worth seeing. It is the summer of 2003 and I have just watched that film, which lies somewhere in between *Clerks* and *Your Friends & Neighbors*. It shows more than enough promise to put the director's name on the map. *Fish and Chicks* is stand-the-fuck-back raunchy.

Arnold (Mark Tyler) and George (Mike Dufays) are old chums spinning yarns about their sexual exploits while fishing from a small boat with a case of beer. Their conversation runs the entire gamut: pick-up lines, dating philosophies, friends who might be gay, threesomes, blowjobs, broken hearts, jealousy, heterosexual scum-politics in general. The entire fishing/dating analogy works well without calling too much attention to itself, and flashback scenes are both sexy and laugh-out-loud funny.

Fish'n Chicks is, above all, a memorably honest meditation on that never-ending spectacle of confusion and diseased pathology called the war of the sexes. It has a sense of humour filthy enough to rival Richard Pryor, with lots of oversexed women, an obnoxious script, and one genuinely sick finale.

De Leo wrapped his second film, *Pilgarlic*, in mid-2004.

Gene Gregorits: I get the impression that making *Fish'n Chicks* was a complete nightmare. But every independent film is a nightmare. What sets your nightmare apart from what you know of the average independent film nightmare?

JDL: I have no idea. Because I just did this one. I've been doing little things since high school. They're all badly written and shitty. But this one was just brutal. The whole thing I was trying to do was to at least make it look like a film. That was the objective to begin with. I wound up acting for a while. It got to a point where I realized that there were too many actors in Toronto. I said 'fuck this', and I tried writing. I wound up learning the structure and started writing. Anyway, with this film, for the first time I didn't use friends. I went out in Toronto and checked out a theatre district office, which was a lot of sub actors who were looking for work. None of them were paid. It took me half a year to write *Fish'n Chicks*. I was writing it in my then-fiancée's basement.

GG: So you *did* marry the girl?

JDL: Yeah, we're married now.

GG: There's a lot of turmoil and rage in your film, directed against the female. Why would you write a film like that when things were going pretty well for you, when you had a girl?

JDL: I don't know.

Joseph De Leo. Photo courtesy of the artist.

GG: It would make a lot more sense for you to have written *Fish'n Chicks* when you were with a person who you despised, hated, and loathed.

JDL: No, it wasn't like that. That's the funny thing. She knew from the beginning that I was creatively inclined. As a matter of fact, to get her on a date, she had to read something I wrote. That's a feature which has been sitting on a shelf for years now. That's called *Crooked Eight Ball*, and it's about a struggling screenwriter. The clichéd thing of the screenwriter who is down to his last five minutes to produce a premise to salvage his career. Somewhere in the script, he ends up getting abducted in a cab by a prostitute, only to discover that the cab driver is a terrorist hiding out. This was way before 9/11. I've always written dark stuff anyway. It has nothing to do with my life.

GG: Why write dark stuff?

JDL: I just like it. To me, there should be something psychotic in it, that's what people really want to express. My objective with *Fish'n Chicks* was to create a character who is not likable and make him likable. I like dark comedy especially, just because it's real. If you're laughing at that, you're laughing at something that's actually happening. I didn't want to make something fake. If it's gonna be real, and still be funny and have all the other elements, I figured, why not give it the extra edge? And that's what, to me, made it dark.

GG: What about the misogynistic element of it? Do you think there is a certain risk you are facing of people reacting to the film as something that is misogynistic?

JDL: Yes. On many levels. But I can't think about that. All in all, when I really look at it, I don't pay attention to that. And I never will. I was told by an old professor, after he read *Crooked Eight Ball*, in class, he turned to me and asked me, "how are you going to explain this stuff to your critics?" There was a lot of shit in *Crooked Eight Ball* that was kind of risqué. Not PC in other words. I told him that I didn't care what they thought. I told him that I thought, in the end it's press anyway so they'll want to see it regardless.

GG: You had no one looking over your shoulder on *Fish'n Chicks*?

JDL: No. Everybody around me who went through the process of creating it did not once ever pick at any of those elements unless I brought it up.

GG: The dialogue is just so explicit and rude. Enough to make women cringe!

JDL: Yeah, that just gives it intrigue. Are they going to talk about it afterwards? Sure. That's the beautiful part.

GG: I look at your film kind of like what Kevin Smith should be, but isn't.

JDL: Oh man, you gave me such a fat head! Listen to this. I'm a working stiff... When I first saw *Clerks* I didn't think anything of it. It was before I really started paying attention to films at all. I started writing around the age of 19. It was an obsession to direct though. I thought that the only way I could do something decent, that I would actually approve of, that was actually good, was if I wrote it myself.

GG: What was *Fish'n Chicks* shot on?

JDL: Mini-DV.

GG: It has the appearance of a typical video film at first, in my opinion, but then the performances take it over, beyond that. You had really good actors. Were they previously trained, and if not, how did you coach them?

JDL: I think that all of them were. The funny thing is... the two guys in the boat... one guy is better than the other. Dufays, yeah. Dufays is fucking amazing! I'd never met these guys. I got them through the Theatre Ontario thing. I had a big audition at a university. The only thing I had in common with these guys, and the reason I think we worked so well together, was we all took the same acting class, by this guy named Tony Pearce. I would like to say that I had more of a hand in moulding them, but I didn't really. I'm the type of guy that, when I write it on the page, that is the way it is. I'm gonna have you take after take after take, but I'm never going to tell you if you're doing good or bad.

GG: You just wait until you get what you want.

JDL: It drives 'em nuts, but it works! It works, all the time. You yell 'cut' and there's always one actor who looks at you with a really goofy look on their face, looking for approval with a smile.

GG: Hitchcock said all actors were sheep.

JDL: I went by that long before I made this film. I thought about that. But then I started to think, 'maybe I shouldn't think that way'. He was saying sheep, I said puppets.

GG: Getting back to the hardcore male point of view of the film... what inspired you to write that story?

JDL: It wasn't coming from me. It came from a group of people that I know. Fishing was a big thing for me at the time. I was obsessed with it. Lord knows why. Filmmaker/fisherman? Forget it. But I did that for a year. The two guys I was hanging out with at the time... the persona that they had, and the way that they treated their ladies – who were mutual friends of my wife – it was pretty close to what you're seeing in my film.

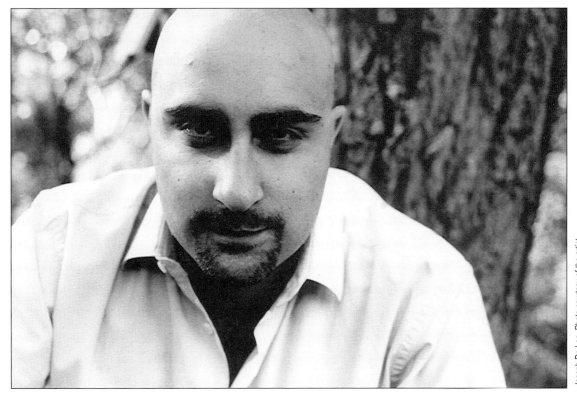

Joseph De Leo. Photo courtesy of the artist.

Except I took it a step further and made them completely sick, to the point where people are really going to hate them. And yeah, I did worry about how women would feel about it. I assumed that any woman who is head of a festival, who sees this movie, is going to hate me, and just not pick it. It made sense that any homosexual who saw this film would want to kill me. Definitely hate it. I am not trying to shit on anybody, and I'm not trying to insult anyone with it. I just wrote a story about a group of people. And they just happen to be this way. That's how they were.

GG: What's your next project?

JDL: I am bouncing between two right now. The next one is a ten minute short, probably the only thing I can afford. Because my wife said so.

GG: [*laughing*] That last statement would contradict everything anyone who saw *Fish'n Chicks* would assume about you.

JDL: I am the complete opposite of what I wrote. The attitude of it though? Being mean? That's a part of me, sure. That's there. At the right time. This new idea is interesting. It's a ten minute short called *Shotgun*. The story revolves around a guy who is sitting in a Cadillac, with a henchman looking over him, making sure he gets to his destination. On the way there, he is reflecting back upon all of his past actions, which got him there, into that car, and where he is going. The overlaying story is that he, as a gangster perhaps, has murdered somebody, and now he has to go see the boss. When you get to the ending, it's

actually something else. He's being driven to a church because he knocked up some guy's girl.

GG: Another riff on a similar theme. Women. Playing on the war of the sexes again. Everyone falls into that trap. Especially guys. But they never actually try to figure it out. They keep getting duped. You go through years of that, and there you are one day, sitting in a boat, talking about sex and drinking cheap beer.

JDL: Yeah. And the only reason for that is because they never figure it out. The comparisons between behaviours, and whatever.

GG: It takes a lot of courage to even think about it though. A lot of guys prefer not to think about it, because it is something much bigger than them. And it'll always win... I think your film is far more honest and real than anything Kevin Smith has done. So, I'm a big fan.

JDL: I tried my best. I didn't think that was going to be the selling point.

GG: Your film is cool, and you're creating art. That takes more visceral energy than sitting here doing interviews.

JDL: Hey, you want a laugh? How much do you think it cost me to make this movie?

GG: How the fuck could I have missed that? Okay. Right. How much did it cost you to make *Fish'n Chicks*?

JDL: Five thousand. It would have cost four, but my dog knocked over my friend's camera, and it had to be fixed.

GG: [*laughs*]

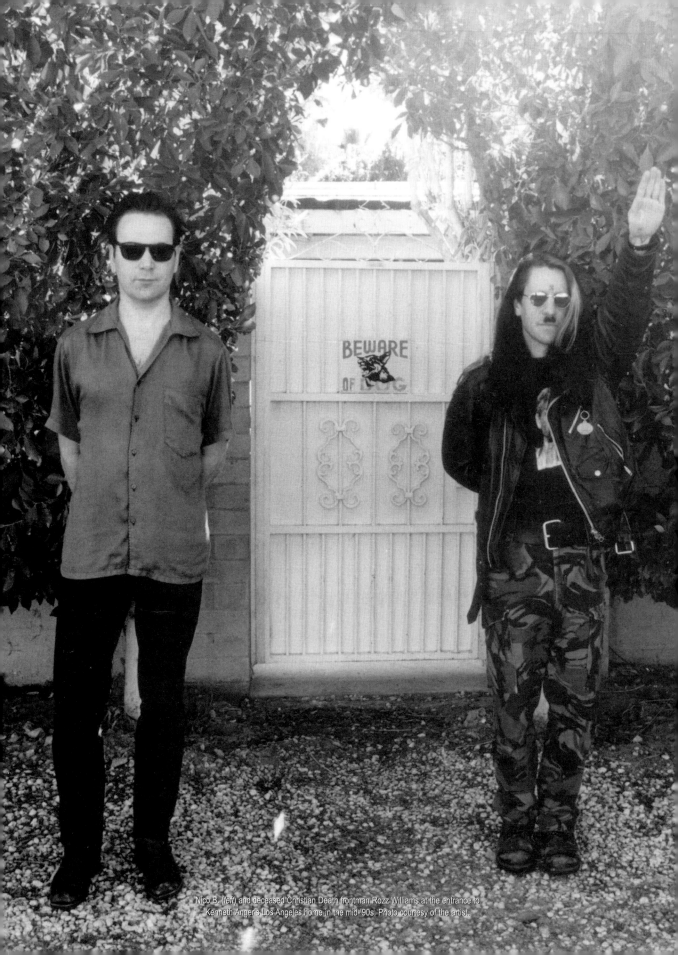

Nico B. *(left)* and deceased Christian Death frontman Rozz Williams at the entrance to Kenneth Anger's Los Angeles home in the mid-'90s. Photo courtesy of the artist.

Sex/Art/Pig

- Nico B -

A man came to visit me in Detroit last year, a friend of mine I hadn't seen in a long time. The man wore shiny black leather dress shoes, smart black slacks, an expensive black topcoat. His coal black hair was slicked tightly back and away from his pale, angular face, on which he displayed a perpetually arrogant smirk. This man got drunk on wine and engaged my girlfriend in a discussion about foot-long penises. Before that evening ended, he had pissed on my boots, slapped my face, and called me a faggot. Had I not been suffering from malnutrition, and had I not so desperately needed the $300 he was paying me for a screenplay treatment, I would have been obliged to mash his face in.

I have a cloudy memory of meeting this Dutch enfant terrible, a film licenser and director named Nico Bruinsma, while working in a Greenwich Village video emporium in 1998. He was in town from Los Angeles for only a few days, and left me a copy of his recently completed collaboration with Christian Death frontman Rozz Williams for me to review. This film, *Pig*, was a sleazy and malevolent 30-minute study of sexual torture taking place in an abandoned Death Valley shack. Bruinsma told me that he was the owner of Cult Epics, a company which had released the film *Cannibal Holocaust* on laserdisc in 1997.

I next caught up with the swarthy gentleman in 2000, at his Los Angeles home. By that time, he'd released a number of DVDs, among them *Henry: Portrait of a Serial Killer*, Walerian Borowczyk's infamous *The Beast*, and a collection of 1930s porno. Nico's commitment to the preservation of obscure and perverse art/exploitation films is substantial, and besides all that, he's a blast to hang out with (if you're the forgiving type).

In the years since this interview, Nico has directed a film about Betty Page, *Dark Angel*, and complimented his ever-growing Cult Epics catalogue with releases including *In a Glass Cage*, a two-disc *Driller Killer* set, and surrealist Fernando Arrabal's violent 1971 classic *Viva la muerte*.

Gene Gregorits: How did you find the house in *Pig*? It's really creepy.

Nico B: We didn't find it. The inside shots were actually Rozz's apartment. In the basement, where he used to live. Just the outside shots are of the house in the desert. There was a laundry room in the basement [of Rozz's apartment building]. So the whole time we're doing this, people had to do their laundry. We had to stop the takes all the time. Or stop the shoot. It was horrible. HORRIBLE!

GG: The victim in the film… is he really being cut?

NB: [*sarcastically*] I believe so. The actor freaked out, because he didn't know how deep Rozz would cut. It was very difficult. You should know. If you cut too deep, you get a vein or something, you're fucked.

GG: If you're doing it yourself, you can control it.

NB: You can control it better. The same thing, in the shots with needles. I have outtakes. Rozz sticks him, right next to the vein, misses the vein and really, really hurts him. You see in the outtakes, he jumps up, "Fuck! What's happening?" [*laughs*] In the end he said, "That's it!

NO MORE TORTURE!" We'd been shooting a couple days, and he'd had enough. Any junkie knows how to get his own vein, but to get someone else's is a difficult thing. I showed this to Abel [Ferrara]… and he thought this was dark. [*laughs*] He didn't want to see it. I remember, I showed it to somebody at this party once, and he said, "I can't watch this." It was too real for him.

GG: What can you tell me about the soundtrack to *Pig*.

NB: I had to find this twelve year old kid, who Rozz had met and liked. He wanted him to record these dialogues in Russian, this poetry. The little boy translated it, but he never recorded it for the film. Finally, after months, I found him and was able to record the dialogues. He never saw the film and I always wanted to give him a copy.

GG: Where did you find those creepy surgical instruments?

NB: Some of them belonged to Rozz, and the others belonged to the guy who plays the victim. Ironically, that actor was a special effects guy in real life. Yet we did everything for real. Kenneth Anger said, "This is the most

convincing dead body in a movie of all time." [*We are watching* **Pig** *as the tape rolls.*] There's the skeleton, see? That's it. Very quick, subliminal. Not to give this away, but early on there's a shot, driving though the desert, and you see the skeleton hanging on a Joshua tree. Just for two seconds. If you catch it.

GG: Tell me about your first meeting with Rozz Williams.

NB: I was hanging out with this woman called Gitane Demone. She was the female singer and keyboard player for Christian Death. '84 was the first year I saw Rozz live on stage, in Holland. He had re-formed Christian Death with this guy called Valor Kand, and Gitane. I was a kid. Same age as Rozz actually. Twenty-one. Five years later, I met her again. She had left Christian Death and she had started her solo career. We fell in love and I lived with her for about seven years. The second year we were together, in the early nineties, we went backstage at a Rozz Williams concert. That's how I met him. A year later, we went on tour together. We became friends.

GG: Was he very self-destructive?

NB: No! He was actually the most funny and happy person in those times. He was very emotional. I can't say he was self-destructive. He had his problems, yes. Deep problems. But he could lay off things pretty easy, I think. He had a good sense of humour. And he liked a lot of things.

GG: So you wouldn't describe him as morbid or nihilistic.

NB: No. That may be the side he portrayed on stage. But personally, being with him was a lot of fun.

GG: I've never heard Christian Death before.

NB: Shame on you. The first album is a classic rock record. The first Christian Death record struck me when I was young. The things he talked about, like religion. We have to deal with the religion parents bring into our life that we didn't ask for.

GG: So Rozz grew up with Christian parents?

NB: Yeah. Baptist.

GG: When did *Pig* start, or the idea of making the film?

NB: It was Rozz's idea. I was working on my own script at the time. I knew that would take more time to work on. Rozz was telling me about this Super-8 short film that he shot with this guy named Iggy. He was frustrated because he really wanted to make a ten- or twenty-minute film. I said, "Alright. We'll work on it." It was the end of 1996. Towards the end of December, we sat in a bar every day, and wrote it in one month. Straight through, you know. Then a month later, we started shooting. The film was really Rozz's film.

GG: The credits say a film by Nico B and Rozz Williams…

NB: Co-director. It says right there, co-directed. That means a lot of scenes came from him. But I had written the script. See, he was a musician, he knew about music and stuff. He knew something about film, I knew a bit more. He would tell me his ideas and I would work them out in the script. Come back the next time, and on and on, until we finished the script. Slowly, it became a vision. We shot part at his apartment, and there were other parts in the desert. We probably only shot about 7 days, throughout a period of three months. Mostly on the weekends. We had jobs.

GG: So again, how did you find the house?

NB: Well, we were just driving around in the desert and we noticed it. That was it. It was abandoned.

GG: All the graffiti and occult messages on the wall, that was authentic, the way you found it?

NB: Oh yeah, the whole film is real. There's no special effects, no re-creation of things. Even all the artwork you see is from things he already did. Nothing was done for the film. That's his art. It was a weird house, with those things written on the wall. It was one sick motherfucker who wrote those things. You can see it a little bit in the outtakes, we didn't use it because it was too unclear, but one of the messages read, "Only boys of nine to twelve are invited into this house." And "Suck my dick," etc. But Rozz liked that.

GG: What did Rozz have to do with post-production?

NB: He wasn't involved at all, really. I did the camera, the lights, etc. And I just edited it. But I came up with the idea of using his art in the film. I thought it would work as an editing tool for me. Much better than just cutting scenes together of somebody being fucked. Well, not fucked, but you know, brutalized. With the editing – to finish that up – I needed a studio because I bought the rights to these Betty Page films from this guy, and these people I met, they had editing facilities, so I made a deal with the guy. I said, "If I give you this money, can I also edit my film? This is how long it's going to take me." So I started editing in this place, with this weird guy. He was a real freak. But he edited my film, and did the time codes, and by the time we did seven edits, I liked it. And I showed it to Rozz. He liked it. The problem was, the guy lost it on Avid, before we could make the final cut on 16mm. To do that you need the timecodes. All the information was lost. So we had to re-edit it, laying all the layers on top of each other. So the final film is not exactly as it was, it's a few frames off. But the week after I finished that edit, Rozz killed himself.

GG: What was in your mind when you were editing the film? I mean, it's really ugly, the attention to detail is great.

NB: This film was just an experiment. It was a whole experiment for me. It was my first film on 16mm, after doing a documentary, and for me it was just experimenting. I didn't think about releasing it. We thought about showing it in clubs, when Rozz would play the soundtrack live. That was the whole idea for it. I didn't know we were shooting what it would become. It evolved through editing.

A scene from the film **Pig**, by Nico B.

GG: Were you influenced by Kenneth Anger?

NB: No. The only scene, which is a kind of a tribute, and it was unconscious at the time, is the scene with the eye... when the gauze is being taken off, and the eye is revealed. This was actually just a moment of inspiration. Rozz never wanted me to tell this, because he wanted it to be a guy-guy film. But actually, the person whose eye is being revealed is my girlfriend, and she just had this eye operation. I thought it looked so amazing.

GG: That eye is completely red.

NB: They actually took her eye out and put it back in. It was red. Of course, she had to heal a couple of days, she couldn't even get out of bed. And I asked her, "Would you let me use your eye?" [*laughing*] So we shot the scene with her and I thought it was a really nice image. In a way, it is a tribute to *Un chien andalou*, by Luis Buñuel. That film had an eye scene too, but in a different way. Maybe, unconsciously, afterwards... I didn't think about it at the time. Because I didn't want to imitate, or portray something from another mood.

GG: When you first saw it finished, what kind of potential did you think it had?

NB: Well, it has no potential. I mean, the way I think about filmmaking is not to think about selling it. I've been selling films through my company, but that's not the way I think of filmmaking. That's another side of me.

GG: Let's talk about your past in Holland.

NB: After leaving school, I got a job at Honeywell, which left me with about two hours a day sitting in the archives. So for two hours, I would do nothing but masturbate. And write poetry. And this poetry turned into lyrics. Then I started working in the music business. I started out being the editor of a music magazine in Holland that eventually failed. And then I was distributing these records for companies in England and France, bands that were people I worked with, people I knew. Setting tours up and things like that. I was friends with the guys from Gallon Drunk. Von Magnet, which was a Spanish electronic flamingo group, it was like La Fura dels Baus, but mixed with electronic music, performance art. And they're actually still going. I became friends with them because the record company was releasing their first record. I met Gitane around the same time, and began representing her on my own label, called Cult Music at the time. It started because I was more interested in film, as a creative artist myself. I attended the film academy in The Hague, my teacher was Babeth, who's a good friend of mine now...

GG: She directed Kiss Napoleon Goodbye.

NB: Yeah, yeah. I wandered into the school. She noticed me, and we talked. She took me to school every day, because we both lived in Amsterdam. After one month, she said, "Okay, I like what you're doing but the films you

want to make are not going to make any money." Or, "No one's going to invest money in these films." I thought, Well, I'll make money first, and then I'll do films. She gave me the best advice of my life. Then I got the idea of starting a mail-order company for films I liked. Because it was the only way for me to see films I liked, on video. Video was new. For the first time, you could buy a video in a store. Before it was only rental. Sell-through didn't exist yet. I knew all these great films, and I found all these distributors with these rare videotapes. They would sell them to me for a regular price and I would re-sell them. So it started as mail-order. And soon, all over Europe, I was selling these tapes, through all these stores. After a while, I thought, I could make more money selling these at my own store in Amsterdam. Then it became renting. Soon, I had a store, two stores, three stores. I franchised. The name is Cult Videotheque. It's still in existence ten years later. Someone else just took it over last year. But... but the thing is... in the store, there were all these people that would come in. 'Do you have this? Do you have that?' You know, like in *Clerks*. So I started my own label because of that, just out of necessity. And the big request then was Betty Page. Everybody has seen her photograph, but they didn't know these movies. I was curious, because I was a big fan of Betty Page in the eighties. By the early nineties I had a collection of her stuff. The films were

really rare. So I thought, I'd heard about a company that released them, Movie Star News of New York. So I just grabbed a phone book, called Movie Star News, and said, "Hey, what about these films?" And they had them. I couldn't believe it. And I bought the rights. Over the years, I bought many films from them. That was the first video I released. *The Exotic Dances of Betty Page*. After that, I released at least 40 films in Europe, and I had a partner who I started another label with.

GG: What other films did you release?

NB: I released like seven films on video with Betty Page. I did the Ed Wood collection. I had a lot of avant-garde, including *Tokyo Decadence*. *All Ladies Do It* by Tinto Brass. *Thundercrack!* We're talking more than ten years ago, about 1991, until the end of the nineties. Then I moved to LA, because my girlfriend wanted to live here. We broke up one month after. After seven years. We were supposed to get married. But for me it was an opportunity, because I am doing exactly the same thing now that I did then. Only now I sell ten times more than in Holland.

GG: How did your laserdisc release of *Cannibal Holocaust* happen?

NB: That's one of the movies I bought too. I bought *Henry: Portrait of a Serial Killer* for Europe, and *Cannibal Holocaust*... I love that movie. It's great. I put that out on laserdisc. *The Betty Page Collection* was my first laserdisc. The next was a documentary I directed myself. *100 Girls By Bunny Yeager*. She was the photographer. I did some art shows in Europe with her and her Betty Page photography. In galleries. I mean, Betty Page is art. It's not just trash, or sex, or whatever. I fell in love with her image. Same thing as Blondie. When I saw Blondie for the first time, it was actually non-sexual. It was like something you admire, but you couldn't think of having sex with a person like that. I don't know if you understand that.

GG: Yeah, of course. Especially Blondie. [*laughs*]

NB: They are like icons. Too perfect to fuck.

GG: So why does the world need Cult Epics?

NB: Nobody needs Cult Epics. Some people are interested in certain things. And there's not many companies who want to release these things. Listen, I can't even find a distributor over here who is interested in distributing my films. Even Fox Lorber, or Winstar, they think commercial. They either are unwilling to take the risk, or they just don't think the film will make enough. So they don't buy the rights, so they don't want to deal with me... I would be happy to find a partner in distribution who could make these films available to a larger audience, because I think they deserve a place.

GG: What are your personal favourite movies and what movies do you want to release with Cult Epics?

NB: My favourite movies I will never be able to release. My favourite movies are things like *Videodrome*, or even *Wuthering Heights*. Alfred Hitchcock's *Vertigo* – a perfect movie. There's other people doing that kind of business.

Nico B. with Dutch filmmaker Babeth, late 1980s. Photo courtesy of the artist.

All the films I hope to release I did release. And there are things in progress which I hope will come true.

GG: What about *In a Glass Cage*? Can you talk about that or is it still a sensitive area?

NB: *In a Glass Cage* is a wonderful film. It is a film which has a larger appeal, I think, than some other Cult Epics releases. It's in the same vein as a film such as Pasolini's *Salò*.

GG: You've been working with Abel Ferrara. Could you describe what that's been like? There's a guy with a lot of serious fucking demons.

NB: The only person I met was Abel the Nice Man.

GG: Bullshit! You never saw The Demon?

NB: Not really. I guess I know how to basically deal with artists. And I think the main thing is to respect someone. And I've been dealing with quite a few directors during the years. Of course you can't be an idiot, you can't be ignorant about their work… but basically what counts is, I think, respect. When I met Arrabal, I remember he didn't even know what a DVD was! He's sixty, seventy years old. I was in Paris, with Jodorowsky, and we were talking. There was this film I saw through this dear friend of mine. One day, my friend brought from Spain to Holland a film called *Viva la muerte*. I loved this movie. It was in Spanish, and I didn't understand one word of the dialogue except for the film language. I never thought of buying the rights. Anyway, maybe seven years later, I happened to be at this place in Paris, with Jodorowsky, and we're talking to him about Arrabal. He says, "Oh yeah, I see him, I hang out with him." … "Ahhhh, can you give me his phone number?" So I called him that same night, and Arrabal said, "I will have my daughter translate you. Let's meet on Tuesday. This time." I said, "I'm sorry, I'm leaving tomorrow." And he said, "Oh really? Okay. Well, let's meet at ten o'clock in the morning." I'm thinking, "Oh Christ, ten in the morning!" We drank Arrabal's wine, and we had a great time. I fell in love with this man, he was wonderful. And we talked about the movies, the rights… he personally owns the rights… He was born in Spain, but he is exiled, I guess. He lives in Paris. *Viva la muerte* was actually shot in Tunisia. But it is about Spain.

GG: Yeah, I thought so… I only saw ten minutes, but it was unbelievably beautiful.

NB: It's very emotional and beautiful.

GG: Yeah. So let's go back to Abel Ferrara.

NB: Yeah… I bought the rights from this man who used to be a friend of Abel. I suggested to Abel to do the commentary for *The Driller Killer*. And we did it. It was insane.

GG: You recorded the commentary for Driller Killer in the Chelsea Hotel, what was that like?

NB: It was wonderful. It went like this… Abel said, "Bring the money. There's this guy you will meet. It's for paying the rent at the Chelsea Hotel. In return, he will record the commentary with us. In his home studio in the Chelsea Hotel." This guy who told me he had a home studio… his main occupation was drug dealer. I

A still from **Vintage Erotica Anno 1930**, one of a series of stag reel compilations released by Nico B's Cult Epics DVD company.

can say that now, because he's already in jail. It took two nights to do the commentary. It took Abel two sessions to do the commentary, and he was great. But he's not like anybody else. He would have to be inspired. Whatever it took to inspire him.

GG: What did it take to inspire Abel Ferrara?

NB: Anything to stay awake. [*laughs*] But I respect Abel. Abel is a unique person. One of a kind. The films he did, and does, are one of a kind. I think that in every director's first film, you can already see the mark of the rest of their career. It doesn't have to be perfect. People try to perfect themselves through their work. That's a human thing. In his early films, and even in his student films, it's still a film by Abel Ferrara. I'm very happy that I have obtained the rights from him.

GG: What do you see that indicates later work in these early films?

NB: Well, there are certain shots that always come back in his later films… and also the dialogue. The dialogue is great in his early films. I think they are very personal films, also. They are films he made with other people around him. And they are still made that way. He works with people around him for a reason. He doesn't just get a crew together and shoot a film. It's always the people he feels close with. But Abel is the best to answer that.

GG: You know, DVD is the only place for the films you're interested in now as there aren't many arthouses left in America.

NB: That's true. I got this beautiful print made for *The Beast, La bête*, in French with English subtitles. I showed it at the American Cinematheque and there were 300 people. They did no advertising. That means there is an audience for these films. But I can't get any theatre to play it. Anyway, it costs lots of money to make a print, and even more to get a new transfer from the negative. See, I don't care. As long as I break even. If I get ten screenings, I might break even. The point is, you must always do what you believe in. Otherwise, don't do it. Like Sinatra, you know, 'My Way.'

Ben Meade, Kansas City 2000.
Photo courtesy of the artist.

Kansas City Cringe Factor

- Ben Meade -

*"I keep telling my students that it won't hurt your movie-going if you **think** while you're watching the movie. They find this very hard to believe!"*
– Stan Brakhage in Ben Meade's *Vakvagany* –

If even three percent of the underground movies being made today were as nutty and entertaining as Ben Meade's, your average DIY film festival would not be so overwhelmingly insufferable. Maybe it's his defiantly un-hip location that keeps him so energetic, that provides his films with a sense of awe that you won't find in most of the work by struggling *artistes* half his age from New York and Los Angeles. To the vast majority of freakozoid art scholars, Kansas is probably notable for very little beyond its having served as the last home of William S. Burroughs, but Meade insists, in his last two films, that the region is a fascinating place, teeming with grotesque and sub-normal elements.

His debut feature *Vakvagany*, which was the focus of this 2001 discussion, probes the dark history of a WW2-era Hungarian family fraught with alcoholism and general dysfunction. The film begins with the discovery of a stack of film cans in a vacant house, which contain home movie footage of the nuclear Locsei clan from 1948. This footage is miraculously intact, which at first recalls another mythological *Blair Witch*-style premise. By the halfway point, *Vakvagany* emanates an eerie intensity; the Locsei footage is too idiosyncratic – too fucking weird – to be anything but 100% real.

After having these cryptic images analyzed by experimental film granddaddy Stan Brakhage, tough-talking crime novelist James Ellroy, and a psychologist, Meade travelled to Hungary in search of the surviving Locseis, and to possibly lay a few of the more unsavoury suspicions raised by the family's home movies to rest.

As a basic documentary, *Vakvagany* inhabits a sub-category of its own, but the film is also an experiment in celluloid language, the free-associative properties of decontextualised images.

Either way, *Vakvagany* is a remarkable film, and not only by the lowered standards of "experimental" or "underground" movies… no grading curve is needed to praise Meade; his compulsive urgency shines through and moves you based on any standard of film viewing. *Vakvagany* flaunts both the raw objectivity of a sociological portrait and the emotional sting of a gritty melodrama. There is absolutely no overweening preciousness. *Vakvagany* doesn't strive to be crass or unsentimental, nor can it be accused of politeness overall. Its interests are many, and as far as I can gauge anyway, Meade succeeded wonderfully on all levels.

2003 saw the completion of *Das Bus*, an unadvisedly slapstick look at the Kansas City public transit system told with fictional setpieces. It came nowhere close to casting the same spell as *Vakvagany*, but that can hardly be regarded as a surprise; most filmmakers will never even have the opportunity those battered film cans afforded Meade, let alone the chance to repeat it.

His next effort *Bazaar Bizarre* is indeed among the most deranged low-budget films to emerge during the last decade. Its subject, a real-life homosexual serial killer named Bob Berdella, is handled by Meade with both mirth and menace. The film fully exploits the revolting particulars of the murder case (injections of household cleaners, anal rape, car battery torture), immersing you in them to an extent that would preclude any possibility of humour. But somehow, no matter how tasteless it may seem, Meade's unconventional dramatic approach (including music segments by the cheesiest bar band this side of the Mississippi, whose set consists exclusively of songs about Berdella) does manage more than a few successful comedic moments. This is all the more bewildering when one considers that the crimes of Berdella are not only explained through authentic-looking re-creations, but also his own nearly unviewable Polaroid photos which document the victims' pornographic physical ordeals. Common sense would suggest that you can't tell a story like Berdella's faithfully without risking the loss of all but the most hopelessly necrophiliac audience members… but Ben Meade draws us in and gives us something more like a dangerous, 'X'-rated funhouse ride than another pointless visit to the morgue.

Gene Gregorits: How did you actually come into contact with the *Vakvagany* footage?

Ben Meade: András Surányi, who was my assistant director, called me about it. I teach in Hungary every March. In March of 2001, he said "Hey, I got this friend of mine who has some home movies. They belong to a family. He just took them." I said, "You're stealing." He said, "Well, I guess. But I think you should see these things. You might like them." So we just watched a few of these fifty foot reels. I asked the guy, "How much do you want for them?" We settled on $250. I took the whole bag of them. Flew back to the States. And I just started watching them.

GG: There are a few moments in the film where you put it into the context of it being something ominous or sinister. Did that all hit you immediately when you first watched this footage?

BM: No. I couldn't understand what the father was doing. From the get-go, I knew that somebody experienced shot these films. Everything you see in that film was edited in-camera. My first reaction was, "Oh come on. These aren't home movies!" I spent some time with a professor from Budapest, a retired guy living in Canada. I said, "Tell me what you think of this stuff." He said, "Where did you get these?" I told him, "Well…" he said, "Okay whatever. But this doesn't make any sense. There's no military police." He was telling me about what he did in the past, and said that none of this footage made any sense. I asked him if he would help me with the film and he said, "NO. This is dangerous stuff." He was very paranoid. We got four

Hungarian draft students who watched it one night, and they gave me some insights, but they wouldn't appear in *Vakvagany*. I was trying to get historical context. I gave up and said, "There's no way to do a documentary because there's no way I can find this out." That's when I decided to go back. I returned and said, "Okay, I'm gonna find out what happened to this kid, and I'm gonna find out what the fuck this is all about."

GG: What was the total budget?

BM: There wasn't a budget. I just sort of paid as I went. I figure I blew about $26,000 on it.

GG: You shot mostly on digital video?

BM: I shot the interviews on digital video. The rest of it is all shot on Pro 8mm, a really fascinating tool. Jim Jarmusch uses that now. There's a company in LA called Super 8 Sound/Pro 8mm. What they do is they take 35mm negative film, and they repackage it. They re-perforate and slice it and put it in Super 8 cartridges. So you're shooting 35 negative in a Super 8 format. So you get a really cool film but it's gonna be a little grainy. I wanted something that, even though you could tell it was current, it kind of matched the aesthetic of the old film. I shot the whole film not knowing what the hell anybody was saying. That's a real act of faith.

GG: The film is nearly impossible to articulate after you've seen it. It has a very singular effect. I have to confess, when I read the story, I was thinking, "Hoax! It's a goddamn hoax!"

BM: [*laughs*] What I've noticed with this film is that it speaks to each person differently based on what each person's experiences have actually been. Hell, I premiered this in Budapest and the people there just wanted to lynch me. Because someone said it means this, and someone else said, "No, it means this," and no one could agree on what it actually meant. On the language end of it, it is speaking to us, but it is almost Nimrod and the Tower of Babel. [*laughs*] I think that an independent filmmaker who wants to do a narrative film, they're out of their mind. They're trying to go into the hardest type of filmmaking there is. Hollywood does that best. They've got the stories. They've got the talent. They've got the rights to stories they want to regurgitate over and over and over again. You're never gonna top 'em. That's one thing that film can do. It can entertain and it can tell stories. But I've always said that film can do a lot of other things. It can provoke, it can upset, it can disgust. Just like any other art form. I studied under a guy named Stan Brakhage, who I put in *Vakvagany*. He let me understand more about how I could bring my own experiences to the table.

GG: It is a pretty linear concept, plot-wise. It's about tracing a family and chronicling the survivors in this dysfunctional lineage of Hungarians. Could you give me an example of something you did differently with that idea?

BM: I don't have any actors, no one with any artistic training in acting… so that's a big part of it. The whole

film was an experiment… if you look at the opening scene, I go into that sequence which I call the "Budapest chase," and it looks like the film is set up, when the guy is hurtling through the city. That's really not what's going on. When I shot it, I was shooting two frames per second. So what happens is you have missing information. All you have are hundreds and hundreds…

GG: Of cuts.

BM: Well, they're actually photographs! They're just going so fast. And what the viewer has to do, in their mind – and they don't know they're doing this – is they have to put that together piece by piece. Part of the language is that your mind has an element of closure to it, when you have these gaping holes, whether it's in the narrative or, as in this case, in the film itself, you're gonna fill them in. My film is more visual than anything else.

GG: You get a much clearer, more accurate sense of real life. Because most people seeing it don't know Hungary.

BM: Aside from a bit of historical context, it doesn't have a damn thing to do with Hungary. It has to do with the family. This could have happened anyplace.

GG: It's definitely a film that leaves itself open to interpretation. I'd imagine that you're very happy with the way it turned out.

BM: Oh yeah. I have a Q&A when it is shown in a theatre, and ninety percent of the folks stay. I like that a lot. There were parts of it when I wanted to quit! I wanted to just say, "Fuck it," and quit. I was just tired of it.

GG: Guerrilla filmmaking is an emotionally draining, if not devastating experience. In your case, dealing with exceptionally tragic characters, who have basically been broken and made dysfunctional by a number of things… how was Erno to spend time with?

BM: He was great! Upbeat! Everything we asked him to do, he did. He was nuts. Anybody that says, "Don't drink beer or vodka, you should drink cognac because it has caffeine in it." What is that about? I did a lot of work with the camera, laying on the floor, like his father did when he was a baby, shooting from crotch level and all that. When I was filming him from that angle, on the floor, I thought a few times that he was just going to put his foot right in my face. I was with him for about two and a half weeks, and… he was predictable. You knew how much he was going to drink, you knew what he was going to do, you knew how many hours a day you would get out of him.

GG: What was he like when he got really drunk?

BM: Very harmless. Just slurring, finally he'd slump over and pass out. The guy is gigantic. Huge. And you think that when he gets drunk he'd be mean, but no, he's really a child.

GG: Ellroy says something which basically implies that he is mentally retarded. I didn't get that impression. In my opinion, he was slow, and he was damaged, but at the same time, there was something wise about him.

Above: Ben Meade and James Ellroy: Kansas City, MO. **Vakvagany** premiere, 2001. Photo courtesy of the artist.
Opposite top and bottom: Typically perverse moments from the found home-movie footage in Ben Meade's **Vakvagany**.

BM: Sure. He drank to the point where he became a big oaf. But on the other hand, he wasn't that dumb. I mean, he read the paper. He read magazines. He wasn't retarded. If I ever met Erno again, I'd say, "Now let me tell you what you did for my life." And it doesn't have anything to do with money. When we were done with the shoot, I said to Nora Gogl, "Just find out what he really wants." And you know what he said? "I'd really like to have my own radio."

GG: That's it? A radio?

BM: A radio. So I bought him a boombox, with all the bullshit on it. Nora wrapped it up, she put on a dress. I got dressed up. He came home from work one day and we were waiting for him in that stinkhole apartment. He opens this thing up, and he said, "Oh it's a Sony." He had tears in his eyes. He just said, "Thank you." I don't know if he's still got it, if he's still alive, if someone stole it. But for that one minute, there was this connection. We'd spent these two weeks together. He knew what I was doing but he kind of didn't know. At one point he said to his sister, which really shocked me: "I don't even know who these people are! They just showed up at my work one day!"

GG: When that moment happened, I thought, "That doesn't make sense." Because at that point, you've been documenting him for two weeks, and I was thinking, "Ouch, that must have hurt Ben's feelings!"

BM: Well, it did, but at the time, of course he's speaking Hungarian, so I didn't know what he was saying. I was like, "What's that about?"

GG: Yeah, it didn't seem that there was any lack of trust between you guys.

BM: Oh no. He drank, he passed out in front of me, he peed in front of me, he'd do anything.

GG: Do you drink?

BM: Oh yeah.

GG: So you and Erno, you guys were getting hammered together, huh?

BM: Oh, no. No! See, I would sit and have a beer with him after the shoot. I never drank when I was working. We'd get done, and he had this bar. A tiny little place but very cool. I'd get a beer, and he'd start with a twenty ounce glass filled with wine. I was sitting there with him and Nora one night, and she says, "He's a lot better than he used to be. I think he's doing okay."

GG: He's a very life-affirming character in a strange way. He's sweet, modest, and humble. That's rare. In any culture, it seems only one in a thousand has avoided the fate of complete cynicism or ego. James Ellroy seems like a very odd choice to be included in your film as a commentator. You don't think of him as a guy that watches art films.

BM: I just know him. We were talking one day and he just says, "let me look at it." He doesn't watch TV. He doesn't understand films. I asked him, "okay, watch this, and tell me what you see." I'm saying, "you can see this and you can see that." He said, I see… none of that! But here's what I DO see."

GG: How much of that do you think is an act?

BM: What?

GG: His profanity and crudeness.

BM: None of it. We had a screening here, and he got up for a Q&A, and I said, "James, is there anything you'd like to say?" He stood up and said, "Ronald Reagan was right! Communism eats shit." That was his comment.

GG: He's a grandstander.

BM: He loves to rile people up. He doesn't give a shit! Here's a guy who has all the money in the world, and he came from a life where he had nothing. So he doesn't give a damn. "What? Fuck it! I don't care what you do with it! Put my name all over it! I don't care!" Imagine most people: "oh, you must talk to my agent." I introduced him to a professor. I said, "James, this is my friend, she teaches college students how to write." He looked right at her and said, "Can't be done. You are wasting your time." That's all he said to her. It was great.

GG: Your film doesn't have any art film snobbery about it. It's real and close to the earth. How is that?

BM: When I was over there, Gene, I was scared. I wasn't a tough guy. I was living in a little apartment and hanging around with two or three people who spoke no English. I didn't even know what the hell anybody was saying. Here I am, a 49 year old man, but yeah I was fucking scared, man. Situations were becoming hostile. Some days, I would come home and think, "What the hell am I doing here?" And then I came back with all this material. I did my interviews with the three guys, Stan Brakhage, James Ellroy, the psychiatrist, and then the artistic process comes in. For me, it is like being in a tiny boat, in a great big hurricane… I have a nice studio facility in my house, and at six o'clock in the morning I go down there, and won't come out for as many as eighteen or nineteen hours. It's like being in solitary confinement. They shove your food through the door.

GG: You're feeding on direct, raw passion. And if that's what keeps you going, it could be that you're afraid of the passion running out. That's my thing. I'm afraid of losing it, because then… what the fuck do you do?

BM: Yeah! And then it would stop, you know, and the thing was, in my heart, in my stomach, man…I was just hurting. I don't know how else to say it. I hurt.

GG: What about your concept of inventing a new film language, a new way of telling stories. How does that relate to the subject matter?

BM: The gist of what I do is all about film language. I think that a lot of academics argue for this, but they don't make movies. I like to use film as a non-linguistic language. To go beyond the actual word. More symbiotic, symbols that mean things. You see the golden arches, you know what that means. You see the Nike swish, you know what it means. There are certain things, in this particular film, which pose my question: "what do the old movie images actually tell you?" All you got is that. I didn't go back and dig for facts or clues or who was really who, or who was screwing who, or who was killing who. It was, "Here is what we have." What I was trying to do was illustrate the language of the visual to each of us.

GG: Are you comfortable with *Vakvagany* being considered a documentary?

BM: No, because it's really not. There's not enough information there. The one assistant I decided to use out of ten I interviewed worked with his dad. Most of them wouldn't even look at the camera, they have that Cold War, East European paranoia. This guy… I never knew his name! I didn't even give him a credit! He's called "the colleague." I mean, what does that mean? And "the guardian." What I'm trying to do, again, is not to force the viewer into a box, but force the viewer out of a certain comfort zone. If a person is used to watching narrative film, then this film is going to drive them up a wall.

GG: Well, I found nothing distracting about the film. It moved along very naturally to me.

BM: Yeah, I think you're pretty tuned into this. But a lot of people who came to the premiere were cool, but afterwards said, "It was interesting but I just don't get it."

GG: I think it has a lot to do with what Hollywood does and what they deem entertaining and valid in our culture.

BM: Right. You come out of *Vakvagany* with what you bring to it. Most people have things moving and breathing inside their own minds that they've never even come to terms with. This film opens doors, like a Pandora's Box.

GG: I love secret histories. And that notion that everyone has a story, everybody has a secret.

BM: We'll be screening this for the third time here in Kansas City, and every time so far, I actually hear people crying in the audience. Beside themselves. I'm thinking, "My GOD!" One woman, who teaches here at the University where I teach, said, "What did your film DO to me? I'm just torn apart. I was sitting there with my husband and he was embarrassed. I couldn't stop crying!"

GG: Erno is definitely one of the most tragic characters I've seen. Most of the films I write about are bleak films about people coming apart or just not getting along. Not happy stuff. I always have to justify why I have this interest in the darkness. I don't understand why people can't just accept certain things in life. What's their fucking problem?

BM: If you go back eighty years, the one purpose of film was to entertain. Sure, you can look at what Luis Buñuel and Salvador Dali did with *Un chien andalou*. Or what Oskar Fischinger did with animation. People call them 'avant garde'. But the point was that they were artists using film instead of a canvas. They were painting on film.

But you don't go to an art museum to be entertained. I go to an art museum because I want to think, and feel. I think that art, and especially the art of the films that I do, is really one of the last places that is a public display of a private person. A lot of people don't like that. "God damn, I don't want to watch that! That's going to make me FEEL something." It's the same way, if you look at the history of film, when Dali did *Un chien andalou*, people were outraged! They said, "What's this about?" Well, it could be about a lot of things. It was to make you think. Ideas. They're fine, but I like film to provoke, like I said. Sometimes, ideas just aren't enough. You say, "Okay, that's fascinating, now let's argue this back and forth." Then, you take the idea one step further, and someone gets angry, someone cries, someone laughs, then you've got more power. Overall, I think the biggest impact lies in the fact that I crossed a lot of boundaries. But I think people are glad that I crossed them. People have said, "You pushed it, but I'm glad that you did. I think a film like this will have impact in the long run to get people to make a difference. Let's go back to Brakhage's closing comment: "If we can get rid of the professionals altogether, and someone can just show true love in a film," because that's something Hollywood can rarely do.

Ben Meade in the editing studio, Kansas City, 2004. Photo courtesy of the artist.

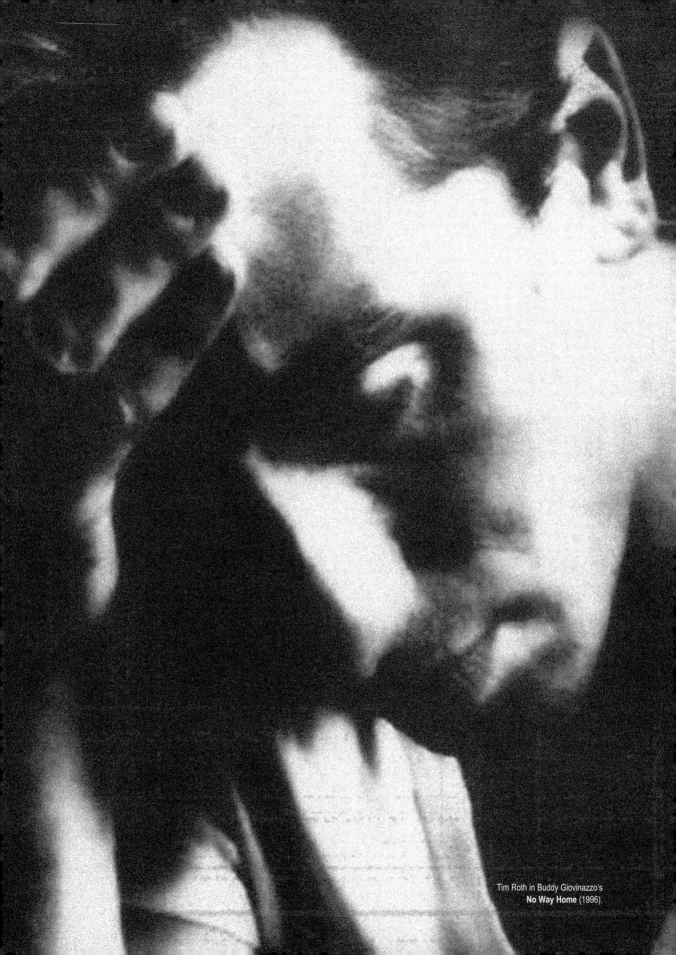

Tim Roth in Buddy Giovinazzo's
No Way Home (1996).

Blood on the Floor

- Buddy Giovinazzo -

The films of Buddy Giovinazzo, a born-and-bred New Yorker, represent a netherworld of poverty and rage. You get through his eyes a pinpoint-accurate sense of menial dead-end existence so raw, even a seasoned horror film audience is bound to be set reeling in their chairs. It's not what *any* audience is accustomed to seeing. At least, not in the movies.

American Nightmares, Giovinazzo's debut, was shot guerrilla-style with a meagre budget and bare-bones crew in 1984. His brother Ricky played the lead, and the credits revealed further substantial family involvement. A few years later, Troma Films acquired the rights to *American Nightmares*, re-christened it *Combat Shock*, and marketed the film as a *Rambo* knock-off with spliced-in stock footage.

A deliberate, suicidal plunge of a movie, *American Nightmares* is as comfortable a viewing experience as a 100-minute skid-row stakeout session. The post-mortem pacing, droning music, surreal visuals, and hardcore depictions of drug abuse seem unrepentantly driven to induce a near-comatose state of depression. The film's anti-hero, Frankie Dunlan, is a psychologically unstable Vietnam vet with a heinous secret, a deformed child, a shrieking wife, and holes in his sneakers. He and his family are starving; Frankie is unemployable. The film is shot as a day in the life, seeming plotless much of its running time, and by the midway point, things have gotten as ugly as any sane man could imagine. In the end, they get uglier.

Today, *American Nightmares* – as *Combat Shock* – is regarded as an underground classic.

It would be over a decade before Buddy Giovinazzo was able to make another feature. *Gasoline Alley*'s story was not dissimilar to that of *American Nightmares*, but it was a better story; finely-honed and crafted over the years by the writer, without much hope of a production deal. *Gasoline Alley* finally did enter production status however, albeit many years after it was first conceived. The title was initially changed to *Life Sentences*, before Giovinazzo agreed with his producer on *No Way Home*. The film was released in 1996.

No Way Home opens with Joey Larabito (Tim Roth) emerging from Sing Sing prison and finding his way back to the neighbourhood where he grew up with his older brother Tommy (James Russo). We are slowly introduced to these two twisted personages, starting with a biting montage of prison flashbacks, during which Joey is glimpsed in a shower room being forced down and mutilated. Released back into the world after six years, with only forty dollars and the clothes on his back to call his own, Joey shows up at his old house, only to find that his key no longer fits the lock. He owns nothing, and believes he knows nothing. With his re-entry into the outside world, things are about to take a violent, and possibly enlightening, turn for him.

In the shadow of a modern cinematic establishment bankrupt in every sense except the financial, I guess it's become easy for mainstream cinephiles to forget what kind of impact Scorsese's *Taxi Driver* must have had back in 1976. In those days, NO movie cost 100 million to make, and an aggressive mainstream opponent like Paul Schrader had a chance. Scorsese was not yet a legend and Hollywood – although morally corrupt since its very birth – still remained open to new ideas, once in a while. If you can take a step back far enough to see how the lease once given to savage, bold films has now elapsed to be replaced by an all-encompassing anti-blue-collar prejudice, it might be obvious why another film that operates with intentions similar to *Taxi Driver*'s would have no chance today. These intentions are to question, examine, and plead for an end to the darkness that working people face, every day. Hollywood doesn't know that darkness. And when they try to pretend, what results is always a horrible insult.

This talk of darkness and angst isn't an attempt to say that the *mise en scène* of Giovinazzo's *No Way Home* is existentially motivated. Far from it. The characters in this picture are too hungry and too broke to care about the meaning of life. *No Way Home* is a film that knows desperation like few others. Love him or loathe him, Giovinazzo is the genuine article, and he has achieved a blunt celluloid realization of himself in spite of a climate of artistic fascism. His work is part of a very small group of similar unlikely film breakthroughs and it's something to be celebrated. *No Way Home* brings with it a distinct, unflinching hyper-*vérité* quality of unmerciful torment, of life without poetry or magic. And of the sort of redemption that feels like any other moment, because it is. The film

doesn't glorify anything; certainly the plight of the urban starving class it portrays is spot-on. The landscape is painted in shades of grey and sepia. Black and white, in colour. Producer Bob Nickson jokingly remarked at a New York screening of *No Way Home*, that the film's last 15 minutes, especially in the unrated print, "make it quite obvious why film noir pictures were shot in black and white."

The film's climax, astonishingly visceral, explicit, and drenched in all the right details, transpires so rapidly you've barely caught your breath before you realize what has happened. In *No Way Home*, reality is merciless, true to Giovinazzo's intentions. It's New York hardship as expressed by someone who really knows, who has accepted that surviving is not necessarily any victory at all. Not for everyone.

Buddy directed a third film in 1999 called *Everybody Dies*, later retitled as *The Unscarred*. He has written four novels to date, two of which (*Life Is Hot in Cracktown* and *Poetry and Purgatory*) were published in the United States. His latest book, *Potsdamer Platz*, was released in Germany and England. Don't read any of them if you can't take the hard stuff. Buddy is the closest thing we have to Hubert Selby right now.

Gene Gregorits: When you came to make *No Way Home*, how did you feel about working with name actors, after only having previously worked with unknowns?

Buddy Giovinazzo: Very natural. I'm an actor's director. Even in *Combat Shock*, not all the acting is really good, but the people that had talent, I think I got a really good performance out of them.

GG: Ricky was great in that.

BG: Yeah, my brother never acted before. He wasn't an actor, in *Combat Shock*, and I think that he just makes the film. You know, I'm really very caring with the actors. I try and bring as much as I can to the table, as far as making it comfortable, and making sure they understand what's up. And you know, casting is probably more than half of it, although the casting job is much easier.

GG: What happened between *Combat Shock* and *No Way Home*? You were teaching at SVA weren't you?

BG: Yeah, I taught at SVA [School of Visual Arts, NYC college –ed.], and I also taught at the college of Staten Island. That's how I was paying my rent and surviving, but I was trying to make a film; I actually came so close to many films...

GG: I've never been to Staten Island, but is it really as depressing as it's depicted in your movies?

BG: Worse. [*laughs*] Well, for the exteriors, we didn't have to do anything. We didn't have to dress anything down. I grew up in Staten Island, on the streets, and it was bustling... before there were malls... everybody shopped out in the street, just the one main street, in *No Way Home*. It was packed with people. So what happened is, during the decline of the '80s, or in the '70s I guess, it became a shit-hole.

GG: Well, I'm reading your book *Poetry and Purgatory* right now, and there is a mention from a
character in the book, Uncle Ted, that the construction of the bridge somehow led to the decline and fall of Staten Island prosperity.

BG: Yeah. That's exactly right. When I was a kid, people would ride horses along the street, and there was a lot of wildlife, and then once the bridge came up, they just over-built everything, and all the woods and swamps that we used to play in as kids were gone, for these big apartment buildings. And they weren't prepared for that type of growth. They never built up the streets. All they ever did was... they'd knock down one house, and put up ten houses, where there used to be one. So, it really just added up to overcrowding, and economic decline, and... actually... the Staten Island chamber of commerce is not happy at all with my two films.

GG: They've commented on them?

BG: They've commented on *Combat Shock*. I had a screening, on the Island, and they really did not like the film at all, and felt that I was doing an injustice. And I said to them pretty much what I said to you: "I didn't touch a thing. That's how it is." I found those places, you know. They weren't hard to find, they're right out in the street.

GG: Do you see yourself as a spokesman for Staten Island, in a kind of way that John Waters stays in Baltimore, or George Romero in Pittsburgh, that type of 'dedicated to your hometown' thing?

BG: No, not at all. You know, it's just where I grew up, and obviously the sense of home and the sense of place, are a strong pull for me, but let's face it, they're not very pleasant places – in either film – to live. But you know what? Staten Island is for me, indicative of a lot of places in America, of decline, where instead of it getting better, it's getting worse. And your sense of security is no longer there; you don't have a home there anymore. The whole thing of 'home' ...no way home. There is no home, you can't go back.

GG: So you're not thinking of making another film in Staten Island then? Have you had your say on the place?

BG: From a production standpoint, I love shooting in Staten Island. Nobody bothers you, nobody fucks with you. You basically go in, take over the neighbourhood, and become part of the neighbourhood. And people are really great there. Plus, being that I'm from there, it's almost like, 'this kid's coming home to shoot a movie'. The next film I'm doing takes place in East Berlin, so it's a far cry from Staten Island. I might come back, I can't say I never will.

GG: Well, *Combat Shock* and *No Way Home*, they're both totally 100% Staten Island.

BG: Yeah, maybe, but in both films, there's really nothing that says it's Staten Island. Although in *Combat Shock*, at the end of the film, there's a chase sequence, and you can see this sign, it says 'The Refugee Church of Staten Island'. But it's more about the films' characters, than where they are. I mean, these guys would be the same, whether they lived in Pittsburgh, or Florida. Actually, people who don't know Staten Island have asked me if it is Pittsburgh. [*laughs*] Seriously, I have a feeling it looks a lot like Pittsburgh. And parts of Detroit also. I've had a couple people ask me if it was Detroit. See, I know Staten Island, I go there to shoot. But I have a feeling that Staten Island is indicative of a lot of places in America.

GG: How did you get the deal for *No Way Home*? I mean, it took so long... I know that *Combat Shock* was recognized by some people [Steve Bissette, for example, in *Deep Red*] as an important, brilliant film, but they didn't seem to be the types of people that might grant you access to James Russo and Deborah Unger and Tim Roth.

BG: To tell you the truth, anyone who thought *Combat Shock* was a brilliant film... I haven't met them yet. I'm in Los Angeles now, and... *Combat Shock* does not exist. I can't go to anybody out here, with *Combat Shock*. They never heard of it, they don't want to know about it, they don't even want to see it.

GG: So how then did you get financing, cooperation, production, etc., for *No Way Home*?

BG: I tried to make *No Way Home* for about four and a half years, with different people attached... you know, I wrote it to do it like *Combat Shock*, for like $40,000. That's why it pretty much takes place in the house. And believe it or not, I couldn't raise $40,000. It's really hard. In some ways it's harder to raise forty thousand than it is to raise three million. Finally, after four years, Tim Roth read the script, and just loved it. And on the basis of Tim's interest, I was able to raise the money.

GG: You seem to be really attracted to people in tough situations, and you have a knack for detailing and following, step by step, what happens to them along the way to the final collapse. What is valid, to you, about such bleak stories?

BG: I'm much more interested in that part of life than happy, rich people that have everything. That's boring to me. I don't know, maybe just trying to understand why people do the things they do. I really don't know. Believe me, it's destroyed my career. When I would try to get work off *Combat Shock*... I tried to get work even on bad horror films, you know, horror films that nobody wanted to direct, and those I would lose out on because of *Combat Shock*. Producers would see it, and they would just say, you know, 'We don't want this! God forbid this guy does it again! We don't want to do this type of film!'

GG: The predicaments you create are scary as hell. This guy has no money, people are coming to kill him, so he's got to cut the drugs he's selling with oregano. The character Ricky played in *Combat Shock* was in a similar trap. They're both in hell, more or less. Did you grow up as poor as you depict them? Did you have any traumatic childhood experiences that left you pre-disposed to some things?

BG: I think everyone has traumatic childhood experiences. I mean, I could say I went to the circus when I was four and my balloon broke. You know, that's life. I can't say I was dirt poor, but I certainly wasn't wealthy. When I was growing up, me and my brothers were probably lower-middle class. So, I'm much more attuned to the idea of not having money, and that pressure. People that have money, they don't understand what it's like to not have money. To wake up every day and realize, 'What am I gonna do today?' Especially in Los Angeles. Out here, people just don't have any conception of what it is to not have money. To be poor. I find that interesting. To be poor in Los Angeles is different than being poor in New York. Being poor in Los Angeles means you only have $30,000 in the bank because you drive a BMW. Being poor in New York means, 'Can I afford a slice of pizza for lunch?' I think people in New York have more empathy for the downtrodden, for the down-and-out. Out here, you can be broke, but you can't tell people you're broke. Out here, you have to pretend like you're doing great. Everything's great. Your project's great, your film's great, it's happening, everything's great. You don't need a thing. And that was different to me, after living my whole life in New York. New York is very real to me. In New York, you know who your enemies are, and who your friends are. And out here, you tend not to know the difference. Everybody's friendly. They're smiling as they're screwing you out of a deal. And it's only business, you don't take it personally. In New York, you take it personally. If you're fucking me on a deal, I take that personally.

GG: I think when people see your films, it's obvious that you're catching every single blow that someone's going to get. Like, in *Combat Shock*, when Ricky pulls his sneakers on, his shoelace snaps. It's these assaults of disappointment you deal out to characters, that makes me wonder what you've been through, to allow you to convey this attack from reality so clearly.

Scenes from Buddy Giovinazzo's **No Way Home** (1996).

BG: I don't think that's so horrible, that's just how life is. You know, your sock has a hole in it, and your shoelace does break. You find something and you think it's gonna give you some kind of reward, and you get fucked. That's nothing. I think that's life, how I see life as being.

GG: But shit, I mean you can so get fucking close to the edge. You'll have a dead dog lying in the street, a junkie convulsing, and hookers flashing knives, and this is all in the same scene, sometimes.

BG: Well, that's more real to me. Times Square really was like that at one time. Times Square was the biggest sewer... transvestites, drug dealers, criminals, murderers, dogs, I mean... garbage, porn, everything. It was nothing like it is now. And there was something real about that. That's the other side of life that you can't just try and clean away. I'm really curious as hell to know where everything went in Times Square. I mean, those places don't just disappear and don't exist anymore. They're somewhere, where did they go?

GG: *Poetry and Purgatory* is so sad, reading it is completely like drowning, just drowning in it.

BG: *Life Is Hot in Cracktown* is even worse. It's probably the most harrowing thing I've ever done. See, *Poetry and Purgatory*, to me, is a love story. *Life Is Hot in Cracktown* is really just a relentlessly depressing book. I'm trying to make *Cracktown* into a film. I adapted it into a screenplay, and I've been shopping it around, but it's just so dark that I can't get it made.

GG: Well, if you got a distributor who was willing to take a chance on what you'd done, help it find a wider audience, do you think you can count on people to have a stomach for this hard material, to not be scared away by it's honesty?

BG: Yeah, yeah I really do. I think that the same audience who likes David Lynch and David Cronenberg, and even Wes Craven, to a degree, respond to my work. Not that I compare myself to them, but I touch on themes and images that they do. Like when I go to see their films, I realize that the people that are in this theatre are the people that would probably respond to my work, if they were exposed to it.

GS: The song that plays at the end of *No Way Home* works really well. Who did that?

BG: That was done by a brilliant songwriter named Gerard McMahan. That guy saved the ending of my film. The producers felt the ending of my film was too dark. They didn't want to do it that way, they wanted to cut out the ending. I really fought for the ending, and tried to explain to them that it was the right ending... then Gerard McMahan wrote this beautiful song. Once they heard the song, they said okay, we get it now. So I tell Gerard every time I see him, 'You saved the ending to my film'.

GG: I thought the ending was as hard as the rest of the movie, but there was some vague lightness about it. I mean, in one shot, literally, you see light coming in over Tim's face. He lived through the ordeal.

BG: Well, yeah, but the joke of it is, people have said he's escaping, he's moving on, he's growing, and my joke to them is... well, look where he's going. Bayonne, New Jersey, for God's sakes. [*laughs*] My God, who wants to live in Bayonne?

GG: I saw it as being like... a Buddy Giovinazzo happy ending. Like Buddy's most heartfelt attempt at a happy ending, which would amount to what you saw, and is still pretty bleak. [*laughs*]

BG: Well, you know, I agree with you. That is my idea.

GG: How much hope do you have for more people to see *No Way Home*?

BG: I don't even think about. I'm going to move on, and do another film. And you know, probably just like with *Combat Shock*, years from now someone will just find it, discover it, and just say, 'hey, this is a cool film'. *Combat Shock* was dead to me for three years. It didn't even exist in my life, for three years. And then I got a call from a guy named Steve Bissette, and he wanted to do this big article for *Deep Red*... and then I just started getting these calls from people all over the world that were just screening the film. I think that's what's going to happen with *No Way Home*.

GG: Have you had any experiences with people in New York that you drew on for character details in your book? Junkies and prostitutes, lowlife types?

BG: Absolutely, completely. Everybody in *Poetry and Purgatory* is somebody that I know. They're composites. I can't say that they're direct, specific people... but just that shit that takes place on the street, the stuff that he's seen, I've seen.

GG: What is your take on New York now? Because your books, and *Combat Shock*, were written and produced in a different era, when New York was still crime-infested, when it was a lot dirtier. Now that it's become sterilized almost, how do you feel about it taking the appearance it has?

BG: Well, you know, for me, Times Square is that way, and the East Village is getting to be that way. I still have an apartment on East 4th Street and First Avenue that I am subletting. So, I will always be a New Yorker. I'm coming back. I think that they might be able to clean up the surface, but there is still always going to be the mental degradation, and there's still going to be the poverty. But I am not worried about it. It's cyclical... You know, they're having a good time right now, there's money all around. But the next time a recession hits, everybody's going to be starving. Everybody that has those expensive apartments in the East Village is going to be evicted.

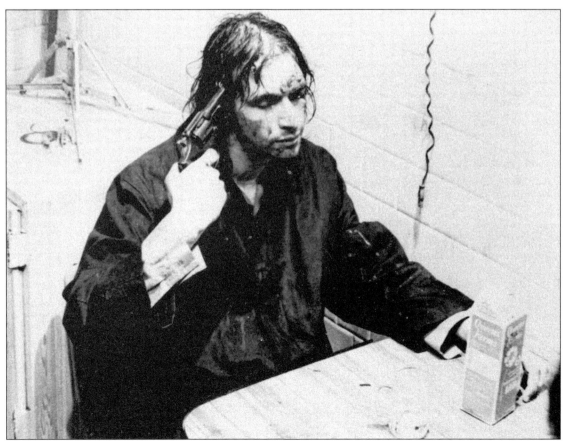

Buddy Giovinazzo's brother Ricky in **Combat Shock**.

New American Folk Nightmares

- Rennie Sparks -

"Sometimes I flap my arms like a hummingbird
Just to remind myself I'll never fly.
Sometimes I burn my arms with cigarettes,
Just to pretend I won't scream when I die."

'Drunk By Noon'
- from The Handsome Family album *Milk and Scissors* -

Brett and Rennie Sparks, with a building cult reputation, are better acknowledged than ever, and since 1994's *Odessa* have proven, with greater certainty each time, that as The Handsome Family they are among the only artists out there who may, by sheer originality and mad passion, pull us disheartened music lovers out of the tar pits and back into the light of work we can be proud to obsess upon. But they are still underground, and that must change.

The Handsome Family's work is perhaps best described as a screaming mad Brundle-fly morphing of early Peter Laughner era-Pere Ubu with Johnny Cash or Kris Kristofferson. Add a side of Springsteen's *Nebraska*. Then you might get the picture. The songs vary wildly between loud and threatening guitar damage to soft, despondent melodies, by turns sarcastic and sentimental. *Odessa* changed lanes with virtually each successive track. On 'Pony', Brett Sparks screams an increasingly weird mantra, and the more convincing and literal it seems the more uneasy I tend to become. Announcing himself as "a man, who dreams of baby beavers", a man who "wants a pony, a big fat pony", Sparks achieves maximum unsavoury weirdness here. After you soak up your pool of befuddlement and worry for the overall mental health of the songwriter (probably Rennie), you might understand just what the fuck's going on here. And if you do, you may have to watch a few *Seinfeld* repeats just to wipe that grin off your face. Or, you may just hit repeat. That's what I do. A combination of wit and insanity can be just as catchy as good old fashioned pop, and as it turns out, is much better for you.

The next song is also sung by Brett, with a resignation rarely heard outside of the classic country genre, asking "How can you say there's only one way up, when you know there's a million ways down?" This is not music to pull you out of any state of ennui or a serious suicide kick, but it can drag you sideways, to the outskirts, and as I said, with their strange effect, and even stranger sense of humour, you'll find yourself laughing. If you listen closely.

Towards the end of *Odessa* is what I consider to be that first record's shining moment: 'Moving Furniture Around.' A cheery little ditty about re-decoration as psychotherapy, it opens abruptly with a beautifully played whiskey and cigarette melody. "Took a walk down the alley today, I'm getting used to the smells and the sounds. Don't look outta my windows no more, what's the point, everything's brown."

Personally, I feel that combining contemplative thought and depression is like mixing fire and gasoline. Laughter and good storytelling are solid cures.

When I'm feeling down, I throw on The Handsome Family. I melt into a song like 'Passenger Pigeons', about a man letting himself freeze to death in a park, lamenting the loss of his love, via the death of a species. "Once there were a million, passenger pigeons. So many flew by, they blackened the sky. But they were clubbed and shot, netted gassed and burned. Until there was nothing left, but miles of empty nests. I can't believe, how easily, a million birds, can disappear." More often than not, the horror and the truth and the laughter and the genuine weirdness of Brett and Rennie Sparks throws me back on my feet quicker than black coffee, meaner than amphetamine, livelier than lightning. It's above all of those things. The dark energy on these records is entirely human.

God bless 'em both. I mean it. The Sparks are mutually possessed with true blue genius. And a sadness that makes me weep. For you, me, everything. Without hesitation, I can say that The Handsome Family is one of the most phenomenal discoveries I've made in years. Missing out on what they have done, and are doing, is almost as tragic as a million dead birds.

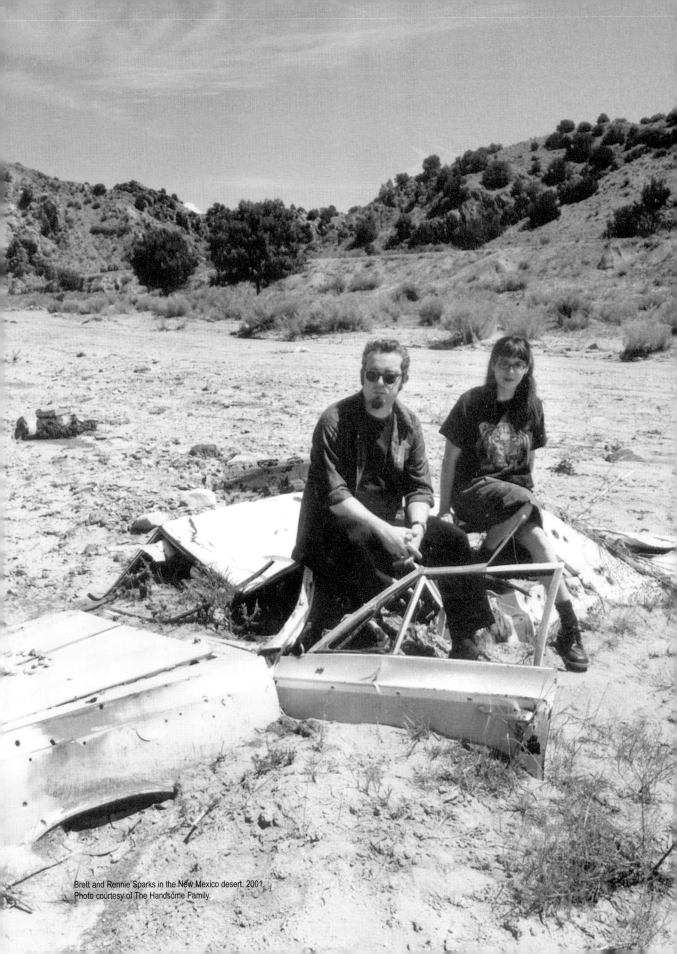

Brett and Rennie Sparks in the New Mexico desert, 2001.
Photo courtesy of The Handsome Family.

Gene Gregorits: Do you remember the first time you read Flannery O'Connor?

Rennie Sparks: Hmmm. A long time ago. I was probably nine or ten.

GG: Were you writing songs?

RS: No. I wasn't writing anything. I liked to read, though. I liked to go for the books on the top shelf, the ones that were put up high so no one would read them. Usually, there wasn't anything very good, except for *The Exorcist*, there was a lot of good parts in that. I remember reading Flannery O'Connor and not understanding why she was being so mean to everyone. I still feel that way. I think she's a great writer, but she wasn't a lover of human beings, that's for sure. No compassion for people at all. Maybe that's just from being Catholic. There's a right and a wrong from her point of view.

GG: I haven't read her. I am such a moron for not reading her, I guess… but now's probably a bad time, since she's on the Oprah Book of the Month Club.

RS: Is she?!… Weird. And inappropriate. Because she's not kind. She's not living in an Oprah-style world. She's ruthless. She takes these characters and just pokes at them until they are just covered with little bruises everywhere, screaming "stop it!" It's a real ugly world that she painted. She had a really strange life. She was sick, and she was isolated. So maybe that's the way it was for her. People always mention her to me like I'm supposed to have some kind of affinity with her, but I don't. I'd say if was gonna pick a Southern writer that I had an affinity with it would be Faulkner, by far.

GG: At the point that you first wrote songs, who was it that inspired you most?

RS: I think it was probably Vic Chestnutt. He's another songwriter, he's in a wheelchair. I had his first record, *Little*. I don't know if you know Lambchop, you know, Kurt Wagner…

GG: I know who he is, yeah.

RS: I'm not the only one who's said this, other people I listen to I've read in interviews have cited this one record *Little* and how it changed their lives. Well, it did change my life in a way, because Vic Chestnutt was drowning in depression, as I was… because he'd been driving drunk and smashed into a tree. He was smashed into a wheelchair. I think that he was thinking, "I'll write some songs and then kill myself." These songs have that feeling, like… so long, farewell. They are so beautiful, and so vivid, and so full of empathy for the suffering of every little creature in the world. You can tell, that just being sad was a gift, because it gave him some way to connect with the rest of the world.

GG: Didn't you always have that hardship, of being too empathetic, being overwhelmed by all the suffering of the creatures you can't save?

RS: When I was hearing voices, I would go to my psychiatrist and he would tell me that I was acting like I was the sole survivor of a giant shipwreck. And I do feel like that, yeah. How could I possibly have a moment of pleasure when all around me, there is suffering. But I realized that in the end, my own self-torture does nothing to alleviate the suffering. So… you think about how you have to make the world a little bit better… that's tough! I'm still working on that one.

GG: Me, I've thought of trying out veterinary science if I ever run out of words.

RS: [*laughs*] I love my vet! She's a nice lady. They seem like good people.

GG: How often do you write new songs?

RS: I'm trying, all the time. It just takes me a long time to finish them. I was telling Brett the other day, that even though we've written six records, I've gotten no better at it. It's just as hard as the first time, which is a little frustrating!

GG: I read your book *Evil*, and it seems like it's largely autobiographical.

RS: Well, everything is, to a certain extent, and it's all a lie too. It's always a mix. That's what writing is. You take your experience and manipulate it into something which expresses what you're trying to say.

GG: Didn't you grow up in Chicago?

RS: I grew up in Long Island and New York. But I lived in Chicago for 12 years. A lot of the stories in *Evil* take place there, but some of them take place in suburban Long Island, which is a pretty hellish place. In a lot of respects, it was a lot more hellish than Chicago. At least Chicago was a dirty ugly place full of poor people and abandoned factories, so there was a reason why people were cruel to each other. But suburban Long Island is full of people who are cruel for no reason. They just couldn't stop being cruel. I think it was engrained. There were a lot of different immigrant groups who had been fighting for crumbs of bread for hundreds of years. Eventually, they get their big suburban house and they're still assholes.

GG: I could imagine the Chicago writer Nelson Algren, if he were alive today, really relating to your songs, and the imagery.

RS: Well, you read him so you know what I'm talking about. He didn't hate the people he wrote about, he loved them I think. They were all fucked up, but that wasn't the point. He didn't write to make fun of people.

GG: And you don't either. But what really defines The Handsome Family, what you've done with your songs, is blend the sad and the tragic with the totally absurd. Nelson Algren did that in his writing. And I would imagine that confuses people as to whether they're supposed to laugh or get morose.

RS: Yeah. People do ask me that. "Is that a sad song or a happy song?" And I always say, "why do I have to choose?" Because life isn't really one or the other, ever, for more than a few fleeting moments. So I think it's pretty childish to demand that a song be either one or the other. But a lot of people really want childish songs. My next door neighbour, who's really depressed right now, because

her husband left her… every morning for the last week she's been going outside on her front porch and listening to this collection of Disney songs. They're all really happy. Nathan Lane singing along with all the little animals, "don't worry! don't worry! don't worry!" It seems to be helping her, so who am I to go over there and say, "stop listening to that crap."

GG: Well, what about when a fan comes up to you and says, "that is the most morbid song!" when maybe, to you, it's uplifting somehow…

RS: Yeah, that happens. But hey, that's just the way it is with everything. Those Disney songs weren't designed to upset people, but they sure upset me! [*laughs*] It's all very subjective, but I certainly don't want to make anyone's life any worse than it is. Our record *Twilight*… a lot of people wrote all these things about how dark, dark, dark it was. But then I get this letter from this woman who said that she's just given birth with a midwife in her house, and all she played, over and over again, for the hours that she was in labour, was *Twilight*, because she found it so comforting. And now she puts her kid to bed with it, because the child really seems to like it.

GG: *Twilight* has what is my favourite of your songs, 'Passenger Pigeons'.

RS: Oh, I like that one! But you wouldn't think you'd want to listen to that when you're giving birth, would you? Well… it's subjective. I was happy that it worked for her.

GG: Do most critics get your stuff?

RS: Most people when they write reviews, they write them quickly, because they're not getting paid any money. They just churn them out. Yeah, I think that some people will call us crypt-keepers, and "oh how scary and awful they are. They must have bodies in their basement… these are nice songs but I certainly wouldn't want to go over to their house!" Ohhh! Or they'll just say that we're making fun of something, that it's all laughing at misery. Like 'Passenger Pigeons' for example. I just basically described what happened to the passenger pigeons, but a lot of people laugh hysterically when that song plays. They think it's just a big joke. And then the next song there'll be somebody crying. So I don't know…

GG: When I first heard your stuff, I have to admit being a bit baffled. I reached a point where I felt like I just wasn't getting it. I thought, "these are really depressing songs!" But I like that.

RS: Yeah, but why can't you laugh? I laughed a lot when I was really depressed. Things aren't as clear cut as we might like them to be. Happiness and sadness are very close. And crying and laughing are almost identical. My friend was saying the other day that sometimes when she laughs too hard it does become painful after a while. It can turn to crying.

GG: What are you reading right now?

RS: I'm reading *The Journals of Lewis and Clark*. It's a really heartbreaking book to read, because you just see how gorgeous this country was at one time. They'd be

"People ask, "Is that a sad song or a happy song?" Why do I have to choose? Life isn't really one or the other, ever, for more than a few fleeting moments."

going down the river just seeing herds of buffalo, antelope, hundreds of grizzly bears everywhere, and now… now it's just another world entirely.

GG: It gets weirder and uglier all the time, yeah. I just got back from the Michael Moore film *Fahrenheit 9/11*.

RS: How was that?

GG: It was stomach churning and frightening, of course! It was intense.

RS: I can just see people who love Bush not wanting to believe any of it.

GG: Well, yeah, and they're just not going to go. They're afraid of that evil warlock Michael Moore, afraid of being convinced. I mean, they don't even want to consider the possibility that Bush and his team are criminals.

RS: But I'm thinking that some people who already hate Bush but weren't planning on voting, maybe they'll be so terrified of Bush that maybe at least they'll vote. I don't know who I'm going to vote for.

GG: So you do follow politics?

RS: Not really. But right now, you have to because everything's such a mess right now. Travelling in Europe, I am constantly reminded of what an evil empire I come from. And when you come home, you really feel the weight of the police state that is here. And the absolute lack of real news, the lack of facts. Everything's great! Go on about your business, the police are taking care of it!

GG: Yeah, it's impossible not to have an outsider's perspective on your own country when you're in Europe, touring. In Europe, people get your stuff better, and they appreciate you more. That holds true for pretty much any artist I talk to. Europe is always the place to go.

RS: Well, you actually get adults who come to see music there. Here, it's mostly just kids, and they come because the shows are late night. Music here is only really marketed to children anyway. Like *Spin*? If you're over 13, it's pretty hard to read that magazine, I think. And music that you hear on the radio, that's mostly geared towards kids! So people who get past 25 tend not to listen to much music anymore here. But in Europe, that's not the

Brett and Rennie Sparks, Albuquerque, New Mexico.
Photo courtesy of The Handsome Family.

case at all. There are great music magazines over there, great music channels, great radio shows that play lots of good music. There's a lot of crap too, of course, but you have much easier access to music.

GG: So now you're living out in the desert...

RS: We left Chicago because we couldn't afford to live there anymore. It was the same shit-hole that it had always been, but now it was double the price. The only reason I lived there to begin with was it was very, very cheap! It was like the epitome of the rust belt abandoned city in 1990. All the cities were like that. Cleveland was fucking horrifying, Columbus was fucked, Detroit is still fucked! All those Midwestern cities were like that. You'd go into these neighbourhoods that had just been trashed and abandoned. You could find a cheap place to live, you could start a theatre, you could open up your own club, you could make as much noise as you wanted to. It was a great place to just do your art, but to pay $2,000 for that same factory is pretty silly, when you used to pay $300. Also, Brett is from New Mexico, his family is out here. I like it here, it's different. It's got the same crap as the rest of America, but it's got some other things too. There's a lot of Native American and Spanish culture here. It's not too white. It's only 40% white in New Mexico, which I think is a healthy thing.

GG: Have you ever thought about fleeing to Europe?

RS: I've thought about that, yeah. But we're needed here! They don't need us over there! [*laughs*] They have lots of people over there doing things. People like us should be here, speaking our minds and being assholes, I think. That's all we can really do.

GG: Would you ever consider doing another punk record like your first album *Odessa*?

RS: I don't know... I don't listen to that kind of music much anymore. I think my nerves are shot. [*laughs*] I used to find loud, angry music very comforting, but I don't anymore. Right now, I listen to Italian opera, and really schmaltzy country-politan music like Eddie Arnold and

Ray Price. Jim Reeves. I'm not really moving in the punk direction! It's certainly a valid kind of music. It just doesn't pull my heart strings, or make me wanna cry, it doesn't make me feel the way I used to feel. I have a certain nostalgia for it, I like going back to a certain time. Yeah, that's great! It fills me with old memories.

GG: On your latest record *Singing Bones*, there's two songs about the apocalypse, that are like two parts of the same song. 'If the World Should End in Fire' and 'If the World Should End in Ice.' This is the first record you put out since 9/11, which must have had some impact on your songs...

RS: Those two songs weren't in any way connected to 9/11. I've been waiting for the end of the world long before 9/11. That didn't change my worldview at all. 9/11 just made me say, "I told you so." Maybe some people experienced some kind of before and after thing with 9/11, but I'm surprised that things like that don't happen every day. I think it's a miracle. I think we're a lot safer and a lot less hated than we may believe, because otherwise we'd have shopping malls blowing up here every five minutes, and we don't. I mean my God, they already tried to blow up the World Trade Center once before 9/11... if you had any real thought in your head, you'd say, "you know, maybe this isn't the best place to work..." I don't mean to belittle anyone who died there... Even after 9/11, I have a lot of friends who refused to leave New York. Not because they had some nobility about fighting terrorism, they just had really good jobs! And they don't wanna give 'em up! We all do that to a certain extent. [*laughs*] Death is gonna find us wherever we are.

GG: Do you have any notable neuroses right now?

RS: I have a huge fear of insects, which is bad in this area because there's some big ones. I'm paralyzed by them. Terrified.

GG: Aren't there tarantulas out there in New Mexico?

RS: Yes. I haven't seen any of those, but I saw a lot of other spiders. I hate them to death but I also feel a maternal longing, to make them safe. It's really not good, while landscaping, to be worrying about all of that, but I do. I'm worried about a lot of things.

GG: Are you afraid of flying?

RS: Oh, flying's horrible. It's so unnatural. You get up there and you just feel like, "this is wrong!"

GG: What I really hate about flying is that if the plane goes down, you end up dying at the exact same time and in the exact same way as 200 or 300 other retards.

RS: There are people who find that comforting. I think that's why there have been so many doomsday cults, because people can't stand the idea of dying by themselves. But yeah... that's my attitude. Death is my time to shine! I don't want to share it with all you people! [*laughs*]

GG: What's the creepiest American city you've been to?

RS: Detroit, for sure. Detroit's bad! It just breaks my heart. Everyone I meet who is from Detroit, I say "really?! Where do you live?" And then they name some

suburb. They've got themselves brainwashed into thinking that Detroit is okay. But… it's not okay. And it hasn't been for a long time.

GG: It's very strange for me to observe the basic acceptance, and even pride people have, you know, as an outsider. I just wonder what that is, or where it comes from. How that kind of delusion can be sustained… about Detroit.

RS: Well, it's easy if you don't go downtown, I guess… if you just stay in your little suburban dream. But there's a lot of forgotten people in Detroit. It's inexcusable, and it's racism, really. It'll take another hundred years until anything changes, until we care about everybody equally. It's very easy for us to abandon people, especially black people, in a city like Detroit, where everyone's afraid of black people which makes it easy to just turn the other way.

GG: You were writing stories before songs, before The Handsome Family, and your book _Evil_ has some of that early work…

RS: Some of that book was written before The Handsome Family, some was written after. I'm always writing other things while I'm writing songs, because otherwise I'd go crazy. Song writing is so slow, and it's like picking little needles out of your hand… that's what I've been doing all morning before this, because I touched a cactus. I have all these little microscopic thorns that I've been trying to pull out with my teeth or with tweezers. it's going to take me all day, and into tomorrow, to get my hand clean! So, that's what song writing's like. Fiction writing, you can just sit and type for an hour or two, then have a look at what you've written. It's much more relaxed, I think. I'm working on a novel right now.

GG: That's the hardest thing there is, I think, writing a novel.

RS: Well, trying to envision the whole thing at once, is what's hard about it. You can envision a short story or a song. So you have to let go of control a little bit with a novel. Because you really can't know how the ending's gonna be until you really get close to it.

GG: How did you break into writing songs?

RS: I did a lot of copy writing. I think that's how I learned how to write songs. Doing advertising, where you'd have two inches square, to say enough about this great suitcase to sell it. Yeah, I think I learned a lot. It's a good job for writers, really. You learn how to edit, because you're forced to. Because you have to get all of the wonderful details about how great the suitcase is, and you only have a little bit of space.

GG: When _Odessa_ came out… well, there hasn't been another Handsome Family record like that since. The records have gradually gone towards country, or folk. _Odessa_ though, was totally psychotic. Frighteningly so.

RS: [_laughs_] Yeah, we were at the time. That's our pre-medicated record. Maybe that's what you're you're noticing. The effect of our medication on our creative

output. If we went off our pills, we'd be right back to _Odessa_ in a day. I think… that I'm happier this way…

GG: When did you first feel that the band was hitting it's full stride?

RS: Right around the second album was when we were really unstable, and having some major mental problems. I think we actually started to write songs that might make us feel a little better. I'm not sure what we were trying to do with _Odessa_. We were trying to comfort ourselves, but in a slapping each other across the face kind of way. We'd taken it down a notch by the time of _Milk and Scissors_, the second album. We were starting to limp around. That was a tough one. But people seem to like that one, so it probably helped us get from point A to point B. It also made our drummer want to quit because he thought the songs were too boring and too depressing. He was out of there after that one.

GG: Who drums for you now?

RS: Well, sometimes Brett's brother does, and we also have a computer.

GG: Yeah, I can see how _Milk and Scissors_ kind of bridged the gap between the violence of _Odessa_ and the comparative gentleness of the third and fourth records.

RS: Yeah. That was when Brett was not supposed to drink at all. So he started using these sports bottles, you know those things with the tubes sticking out? He was drinking beer in them. He had the look of a guy who was trying to get into shape, but he was actually drinking beer in those things, because nobody wanted him to drink. He had just gotten out of the hospital. I think that it was in the middle of that recording that he realized he was drinking a lot!

GG: 'Amelia Earhart Vs. the Dancing Bear' is on that second album, and it's one of your weirdest songs ever. Where did that come from?

RS: I've always liked Amelia Earhart. And I've always been fascinated by why people enjoy seeing a bear dancing. It's gone out of favour now, but up until 1950 or so, it was still a viable form of entertainment. I remember looking through one of Brett's family albums, and there was a picture of one of his uncles coming back on a ship from World War 2, and part of their celebration was, they had a dancing bear, on the ship! [_pauses_] He didn't look very happy. [_laughs_] I was also reading a lot of that Hindu cosmology about the universe, you know, and the big dance. So that was covered.

GG: You record at home. Most bands go to a studio… what are the benefits of home recording?

RS: You can be a little more leisurely this way. We can take our time, which is good for us, because we're slow. We can pick something up and put it down for a while without thinking about the clock ticking away. It enables us to stay on a small label. Our label wouldn't be able to support us, couldn't afford the money to pay for a studio to record the stuff. It's a good way to survive and a good way to learn. Everyone should at least try to record at home. You learn a lot more about song writing that way.

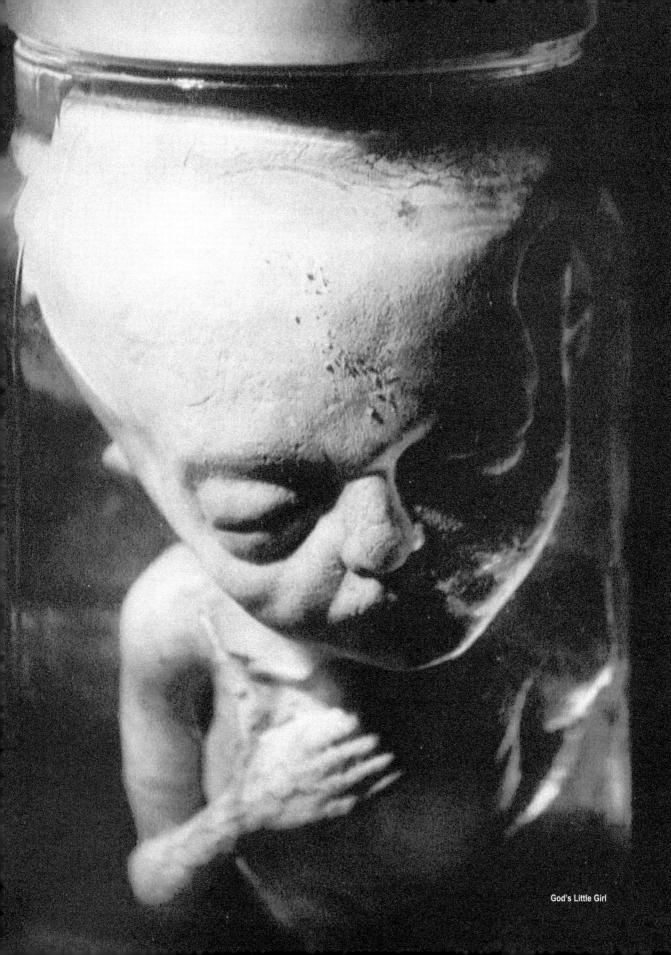

God's Little Girl

The Flicker Man

- Mitch Davis -

Here are the general stats: Mitch Davis is the director of two bold short horror films, *Divided Into Zero* and *God's Little Girl*, which probe deeply into the damaged minds of their respective protagonists. Back in 1998, I said of *Zero*: "Its final judgement seems to defy every self-help book ever written." Both films have stimulated audiences worldwide, the award-winning *Zero* in particular having gathered outrage and acclaim over the last several years. He's also been impressively active as a producer, having served in that capacity on Karim Hussain's transgressive clusterfuck of an art film, *Subconscious Cruelty*, as well as Rick Trembles's fiercely scatological cartoon short *Goopy Spasms*. Mitch's writing credits include such genre journals as *Rue Morgue*, *Flesh & Blood*, *Post Script*, and *Eyeball*. Since 1997, he has been the Director of International Programming for Montreal's prestigious Fantasia film festival, and recently celebrated the tenth anniversary of that event by working with Synapse Films to produce *Small Gauge Trauma*, a DVD collection of some of the strongest and most eccentric shorts that have screened over the festival's history. From September 1999 to February 2006, he did some amazing work for Montreal's Cinéma du Parc, programming rarely-screened cult films on a monthly basis.

The dark truth: this demon dog called Mitch Davis inspires a certain passion and sensory alertness when you're in his company, because he LIVES for this stuff. He's a one-man film preservation society, tireless romancer of world cinema, a walking, talking database of celluloid memory, felonious fetishist, transgressive freakozoid, scholar of the moving image, a Zen monster in an otherwise empty movie house. It has been said that Mitch can have the same effect on one's neurological state as a six-pack of Red Bull, under the influence of which he himself might become dangerous.

We need more like this mutant Mitch Davis. His spectral presence looms large over the city of Montreal.

Gene Gregorits: First of all, how did a fine young Canadian lad wind up behind some of the most offensive films ever made?
Mitch Davis: I guess by going to Disneyland. I'm actually not kidding. When I was very, very young my parents took me to Disneyland, which is probably the single worst thing they could have ever done, and I love them for it. If it wasn't for Disneyland, I'd probably be a tax accountant right now. But what happened was, I got to see two clips from *Fantasia*, the film. They kept showing 'Sorcerer's Apprentice', with 'Night on Bald Mountain'. You know, with the really Satanic Lugosi imagery. That really impressed me. Then, what really, really did it was, they took me to the haunted house. I had the intuition to want to go there. I practically forced them to take me to the haunted house. They wanted me to ride the tea kettles, or whatever it was. I don't know if you have ever seen the Orlando, Florida Disneyland's haunted house? It's probably not the same now. Now you've probably got a bunch of holograms, or something like this. This was in the '70s. Besides the witchcraft, it was also full of hanging bodies. You're in this elevator, going down, and the walls

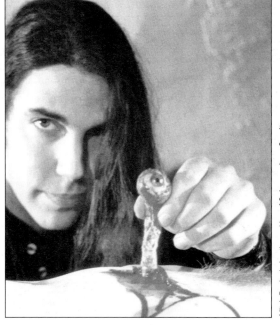

Mitch Davis during the making of **Subconscious Cruelty**.

would stretch and there would be a body hanging above you. The legs descended through shadows. I'd never expected to see anything like that and I couldn't believe the gamut of emotions that it provoked in me. When I got back to Montreal, I drove everyone crazy, describing everything I saw in the haunted house. From that point on, I was just doing everything I could do to get that rush back. I started to look for horror comics. I found good old Forry's *Famous Monsters* magazine. Of course, that lead me to the other Warren magazines, *Creepy*, *Eerie*, *Vampirella*. I started to buy them religiously. If I was ever given junk food with my packed lunch, I would sell it off at school to buy these magazines. My parents were very disapproving of this stuff when they saw what it was.

GG: I was hugely impacted by the Warren stuff, probably in the most negative way. *Eerie* and *Creepy*, especially, were really sick comics. They took the EC formula to a much darker and more explicit level. It was like *Tales from the Crypt*-meets-*Taxi Driver*.

MD: Completely. But you've got to give props to EC – they are so subversive and so truly scary, and they never condescended to their readership. I mean, stories about killer cops, racism, rapists, junkies, child-killers, wife-beaters, kids killing their parents so that they won't have to be like them, crimes in the military – and this was aimed directly at kids. In the FIFTIES! Kids who were probably just at the point of realizing how unfair the world can be. EC told them to question everything, and to never unconditionally trust anything.

GG: That is very subversive, but after Vietnam those comics turned much uglier. That's when the rapists in the black vans, and the necrophiles, and all the hardcore stuff started appearing in horror comics.

MD: You had some of that in EC too, but yeah, you're right. Warren became the EC of the seventies, which means a lot more of everything. So definitely, it was very extreme stuff. I mean, *Vampirella* completely defined female sexuality to me. Years before I realized that women could make me cum, I knew that they could bite me and force me to be their slave. All I wanted to do was be bitten by a cute girl, and to this day, I'm attracted to strong women. I think the world might be a better place if more men had *Vampirella* at the dawn of their sexual awakening. We're way off topic now. The *Famous Monsters* mags, in particular, were a huge inspiration for me. I would sit there and fantasize about these incredible images that I was seeing completely out of context. About what kind of plot developments could have possibly led to these images. I would think up these great back stories. Then I'd finally see the films, and almost always be disappointed because they'd never be as crazy or interesting as what I'd been hoping for. But these images were all pure catalysts for creativity. Once I developed a film vocabulary, once I learned the names and memorized the titles of these movies, I'd look through the *TV Guide* every morning and look through every movie listing, praying that any of these

things would be on TV. In Quebec, we speak a lot of French. At the time I had no French friends, and I probably learned more French in my hunt for fleeting glimpses at horror than I ever could have in school. French is very similar to English in some ways, so if I saw a title that was kind of like something I read about in *Famous Monsters*, I'd be like, "OH MY GOD!" I'd circle it, or I'd tear the page out and put it on my wall. I'd have to be sure that I would be home when that thing was going to air. And half the time, it wouldn't be the same film! About a year or so later, my grandfather decided that the best way to have someone get over an obsession is to let them indulge themselves in it until they got bored. Never happened! He bought me this tiny self-threading Super-8 projector with a couple of 200 ft horror film condensations that ran roughly 8 minutes each. I'd project this stuff on every wall in my apartment until my parents were ready to kill him for doing that. I even brought it to school for Show And Tell. I projected an 8-minute cut of Whale's *Frankenstein* and everyone freaked. I was forced to stop it pretty quick, but it's probably where I got my first taste of film exhibition. I loved showing films to groups of people. I'd just stand there and watch them react.

GG: I got heavily into underground comics as a kid. S. Clay Wilson fucked me up. Contrary to unpopular opinion, there are limits on some things. Wilson for a ten year old? I'm not so sure. *Caligula*? That's okay.

MD: I saw it when I was 12 and it didn't affect me at all. I found it really funny. Also very boring, believe it or not.

GG: Well, it is boring but you also have blowjobs being shown onscreen.

MD: You do, yeah. You even have hermaphrodites. Just the same, it was a pretty negative experience, I guess. After all the hype and infamy, I was expecting Hell on Earth with that movie and I didn't get it there.

GG: Well, also, you had no direct sexual experience, so there wasn't as explicit a context for you. There's no frame of reference, when it comes to a blowjob. You were twelve!

MD: Yes, but just knowing that women could do that made me very happy. [*laughing*] I'll tell you, I've always been a huge oral fetishist. The first thing I notice when I meet women is their mouths. Mouths and eyes.

GG: Mitch, how can you say that? There's an unspoken oral oath to consider here. People are going to be reading this Mitch!

MD: It's funny, because it is such an inversion. Guys typically love legs and asses and sure, so do I, but it's first about lips, tongues, eyes and teeth. Thankfully, a woman will never get angry with you for that. "Hey, you're looking at my eye!" [*laughs*] "Stop looking at my lips!" That just never happens.

GG: Your cover is totally blown. Now, they will always know what you are thinking.

MD: Anyone who has seen my photography knows. [*laughs*] My cover is already blown in that department.

INFLICTION FILMS PRESENTS

A Mitch Davis Production A Film By Karim Hussain

SUBCONSCIOUS CRUELTY

www.inflictionfilms.com

GG: With so many responsibilities, you must feel like you're going crazy sometimes. It can be hard to reach you.

MD: No, not really. Only if I'm behind on a writing thing or if it's like, the last week of hell before the new Parc program hits print, when we're finalizing all the bookings and playtimes. [Since the time of this interview, Davis resigned from the Parc in protest after the theater's owner laid off head programmer Don Lobel. –ed.] The odd freelance projects come and go as well, and sometimes they can be gruelling, but I'm definitely not complaining. I've been fortunate enough to be able to avoid a formal day job so get enough downtime to stay sane. And during the build-up to Fantasia, yes. Because everything moves very slow at the beginning, for months on end, distributors not calling back, nobody giving any real commitments... then we have a five-week scramble where everything happens. Films that had been confirmed for months cancel on us without warning, others that initially turned us down end up coming through for one reason or another, guests change travel dates. It's pure chaos, but the best kind.

GG: And you were just thrown into this, with almost no experience.

MD: Yeah, but '97, the first year Karim and I were on, was a great one for us to bust our cherries with. We didn't have to concern ourselves with the hottest new films because there was so much amazing stuff from the last bunch of years that had never gotten to Montreal. It's like we went through our favourite bootlegs and wrote up a dream list of titles. And we actually got a lot of them to the screen. We dealt with very few major distributors that first year, so it was a good way to start. It was more about tracking down Richard Stanley's number to get his cut of *Dust Devil*, or Mariano Baino for *Dark Waters*. Chas. Balun put us in touch with Jim Van Bebber so that we could screen his workprint of *Charlie's Family*. It was a fucking incredible time. When you deal directly with the filmmakers themselves, programming is the best. It's when you're forced to work with ambivalent or nervous

sales agents that the ulcers begin to burn. We just couldn't believe that we were actually in a position to help get these films seen. Pierre [Corbeil, Fantasia founder and president] gave us permission to invite guests, so we brought in Baino, Jim, Rich, Chas., Sergio Stivaletti, Lloyd Kaufman, Nacho Cerdà, Todd Morris, Deborah Twiss and a bunch of others. Chas. was calling it the Woodstock of horror. It was so unreal.

GG: Why was *Subconscious Cruelty* made? Where did it come from?

MD: It only got out in 2000 but *Subconscious* really is a product of the early 1990s. It came together in a climate when the genre was losing its edge. We were so angered by reading about our favourite films being recut or sometimes pitched direct-to-video after test screenings. Everything seemed to be about 'considering the audience', to such an extreme that it seemed as if there was no longer going to be any room for anything that was truly individualistic. Like, if it wasn't easy to classify, it wasn't going to get out. The films that made it to cinemas seemed less experimental than ever and the average horror film release was *Dr. Giggles*, you know, apolitical, impersonal, safe, sanitized for the widest possible audience appeal. It got to the point that when we were finally going to make a feature film together, we're all like, 'Consider the audience? We will consider the audience. We'll throw a fucking hand grenade in their faces! WE'LL DESTROY THE AUDIENCE!' So many films were out there, selling themselves on sex and violence and delivering something that was so perversely clean and digestible. We decided to make a film that would sell itself on its sex and violence, and then deliver in larger degrees than anyone ever could have wanted to see. Much more than anyone could possibly enjoy. There would be no 'crescendo points' geared for rapturous audience applause. We wanted to do everything possible to bring an element of real danger back to the genre. By the time the film had its World Premiere screening at Sitges in October 2000, so much had changed in mainstream film, much for the better, I'd say. It's still not

Subconscious Cruelty

the '70s, but it's so much better than the early '90s – a time when something radical like *Fight Club* never would have gotten made on such a large scale. Today, we all agree the film goes further than it needed to go, but that was part of the point. I'll always defend the choices that Karim made, because I can tell you that there isn't one image in the film that didn't come directly from his dreams or hang-ups, and in that sense it's a very honest piece of work. Almost every image is metaphorical. It was very deeply thought-out and he's got the grey hairs today to prove it. I realize that a lot of the more poetic symbolism sometimes gets lost to audiences who are repelled or even captivated by the torrents of gore. It isn't the sort of picture that Karim would make today but he's still very proud of it. Wait until you see his new material. He's just finished his third feature film, *La belle bête* [following 2002's *Ascension* –ed.] and co-wrote Nacho Cerdà's first feature *The Abandoned*. I think the next few years are going to show the world what a major talent he really is.

GG: What was it like being on that set, in chaos, surrounded by pools of blood and lots of beautiful, naked women?

MD: Well, there was an interesting harmony. People mostly had a good time, even though the hours were insane and the pay was a joke. I think it's safe to say that anyone who lived with us during that month in the warehouse wasn't doing it for the money, and atmosphere-wise, that's always where you'll find the best film sets. Some of the actors had extensive stage or film experience and others were ambitious non-union newcomers, performance artists, models or dancers. Eric Pettigrew, our Christ figure, had just come off a string of beer ads. Most of the actors and crew were charged on doing something totally new. They were very brave people and they were absolutely willing to go all the way. We did lose one actress – she got scared off by her very unimpressed boyfriend, before she even got to the set – but only one.

GG: Was any of the sex real?

MD: No! But some of the shots of Christ being pissed on... the first shot of Martine Viale pissing was real. Eric actually requested it. He said he didn't mind since he was wearing an appliance against most of his chest, but we had our suspicions. Hey, good for him. We couldn't go any further than that one shot though. With pissing, you get one take, unless you want to wait another 4 hours for someone's bladder to fill up again. It was tubing or nothing. Ironically, the tubing actually looked a lot more convincing in the rushes than the real thing.

GG: It's always that way. The effects seem more real than reality.

MD: Oh yeah. When you think about gunshots... you've probably seen the Budd Dwyer suicide, right? [Budd Dwyer was the Treasurer of Pennsylvania, in my hometown of Harrisburg, PA –GG] I was a teenager when I got that tape. We were all stunned, that he would bleed that much. If we would have seen that in a film, we would have been cracking up, saying, 'that's just so over the top'. But yet, that's exactly how it looks. I guess pissing is up there with gunshots on the imagined-reality scale.

Divided Into Zero

GG: We've since seen death in a visually bloodless but much more resonant and profound manner. Planes flying into the World Trade Center. That hits harder than a thousand Budd Dwyers. Where do you see there being a cultural space, post-WTC, for films like Nacho Cerdà's *Aftermath* or the other ultra-shock films?

MD: Well, it depends on what that content is. On a philosophical level, people will always have the capacity to be shocked. *In a Glass Cage* will shock people until the end of time. But it's not a particularly graphic movie. It is though, one of the most disturbing films I've ever seen. *Combat Shock* is another one, that doesn't wallow in blood and guts, but it's ten times more upsetting than a gorefest like *The Prowler* is. I think that there will always be ways to get under people's skin. Sheer unadulterated honesty, for one. As long as people have any capacity for emotion, they're going to feel something. I hope. I would like to think that people read books and go to films and do everything else they do in hopes of feeling something, in the search for feeling, or maybe a new perspective. Just some kind of visceral experience, if nothing else.

GG: In the context though, of today, when shock TV and reality TV have become so successful… is going further, in terms of graphic depictions of sexual and psychological excess, still a valid transgression?

MD: Again, it depends on how it's done, what the mind frame is. Michael Haneke's *The Piano Teacher* was as rough as they come, and its power was earth-shattering. It's a perfect example of explicit shock content being used in an honest and effective way. But please, don't think I'm

on some sort of raunch soapbox here. I'm just saying that this kind of content is one of many elements in an arsenal of tools that can, in the best cases, be validly used to affect people. But as I just said, the films that have bothered me the most have not always been the ones that roared the loudest. For shock content to be truly relevant, it has to be confrontational. It has to make you ask yourself questions that you never wanted to consider. I mean, Atom Egoyan really shocked me with *The Sweet Hereafter*. That film really disturbed me. Or Romero's *Martin* – it's easily his best film – I mean, it cuts so much deeper than his zombie movies ever could. I'm sure that films, literature, music, photography, shocking content in any expressive art will always have power as long as it has a philosophy or at least, a genuine intent. As to whether shock-for-shock's sake still has a deeper purpose, I'd say that nine times out of ten, the answer is no. Most of the sacred cows have already been sodomized ten times over. That doesn't make those films worthless, but in a sense they're no different than your average sitcom, soap opera, pop song or Saturday morning cartoon. They're there to deliver superficial kicks without peeling the surface. I can still get down and enjoy it sometimes if the film is audacious or clever enough but, you know, *Guinea Pig* ain't no *Salò*.

GG: There's a lot of gore and bodily fluids in most of the Infliction films.

MD: Ha! I'm not going to talk for Karim or Rick, but as far as *Zero* is concerned, the fluids are there as ultimate truths. Also, their nature is perfect for the metaphors of the film. Fluids seep across surfaces, get absorbed so

This page and opposite: Confrontation and conflict in **Divided Into Zero**.

endless obsessions. They keep coming back to him no matter where he is in life. No matter how cleansed he thinks he is, the cycles are always there, slowly chipping him away. It might take him seventy-odd years to give in, but the urges are so constant, so relentless, that they finally break him down. And this is why he's incontinent as an old man. He's completely lost control, been conquered by the cycle. Man, I know how pretentious it probably sounds, but this is where the film is at. I really wanted to take the fluid elements all the way. That's why the character's first introduced when he's naked in a bath. Why there's constant pouring rain. Why the girl's abducted after she pours a glass of lemonade for her killer. Before I really knew why, I knew that water imagery was going to be the code of the film. Everything I wrote for it ended up going back to running water, blood, tears, urine.

GG: How closely do you relate to the main character of *Zero*?

MD: At the time I wrote the piece, I would say that I related very strongly to about 80% of who he is. Not in any literal sense – God, no – but everything the character feels, his absolute weakness, how he's this pathetic victim to the mousetraps of his mind. I started writing the film at the beginning of 1995, at the tail-end of this insane drug-spattered depression that lasted for several years. I'm talking about waking up every morning wanting to burn my eyes out with a Bic lighter. A really bad time. Man, this is going to be VERY weird for me to recap for you,

easily into almost anything, break down most solid matter, turn earth into mud. Fluids are also about intimacy. Okay, I'll go down the *Zero* fluid chart for you. Blood is who we are. Its person-to-person characteristics can't be changed and it's as much about the past as it is the future. The character is a cutter who needs to see his own blood more so than anyone else's, just to keep him grounded, to help him understand himself. Tears are the ultimate physical expression of emotion. Urine is cyclical – a constantly repeating pattern, like the character's

because it's so not who I am today, but I guess I have to. Okay. We shot the first weekend of material in September 1996, just to show you how excruciatingly slow the process can sometimes be. *Subconscious* was still mostly on hold while we were trying to get more money together, and we shot the first weekend of *Zero* on something like $600, because by that point, I had to start my own film or I was going to go crazy. The complete budget, all said, was in the neighbourhood of $8000 Canadian, which is really, really low for a 34-minute short shot on film with so many locations, actors and special effects. It's not really the kind of film that I could have made before the time I did it. I guess I have to go through the history a bit. The fun began in 1993, a few months before we started pre-production on *Subconscious*. I was a crazy party guy for a good deal of my teens, smoked lots of dope, loved dropping acid and 'shrooms, whatever. By '93, a good bunch of us were doing pretty much anything we could get our hands on. All kinds of crazy shit. Thank fuck I grew up with a diabetic mother and was always disgusted by needles. I never touched one. Several of the people I grew up with became addicts, and I was one too for a while. I watched my friends change into thieving, lying, manipulative sacks of weakness. These were people of such strong character, man. Really good people I would have trusted with my life at one time. A few of them kept their cool and didn't rip anyone off. Fuck, I never ripped anyone off. Better to be sick and still be able to live with yourself. Anyway, during this period, there were really only three sober people in my immediate life – Karim, Pat Tremblay [A.D. on *Subconscious*, *Key grip / FX assistant on Zero* and *God's Little Girl*] and my then-girlfriend. I'd been dating this girl for about three years then, the most intense relationship I'd ever had, and by the end of 1993, she was so sick of me wandering around in stupors and ignoring her that she finally dumped me. I loved her more than anything in the world and that just did me in. I couldn't believe how I'd allowed myself to take her for granted for so long. It's incredible how disgusting we can get when we're secure in a relationship. The timing couldn't have been worse, because by this time I was barely able to trust most of my friends, who were totally dope-fucked. Everything in my life fucking disappeared. She wanted to stay in touch but I told her not to call me until I let her know that I was able to handle it. She told me that if I hurt myself she would kill herself. She probably saved my life, because I spent the next two years wanting to get hit by a bus. I tried to overdose once, puked and fell asleep. There you go. I was blasted to the point of toxicity around the clock for almost a year. Karim did everything he could to help, but nobody could. He'd take me aside and say, "you are going to die." By then, I'd shot a few shorts on video and was planning on shooting my first on film, but after this happened, I was barely even able to talk to people and definitely didn't feel up to trying to direct anything. I'd always loved Karim's

"The only thing I was concerned about with 'Zero' was raw expression... after enough time, it felt unreal to even imagine a human audience ever watching it."

Subconscious script, which in its current version was about a year old at the time, and I decided to put whatever energy I had left into producing it. That was also when I launched Infliction. It took me about another year to finally hit the breaking point on the chemical front. I went nuts and forced myself to quit everything. EVERYTHING. I even quit smoking, and I was a fucking chain-smoker. It was not a pleasant time. Once I sobered up, I had absolutely no energy, a foggy memory, no drive to do things, and I was still as broken-down and miserable as before, only it was even worse because it was totally unfiltered and I felt like an alien. I had to break away from all my dope friends, and even though most of them weren't the same people anymore, it killed me to do it. I was so uncomfortable around people by then, I didn't trust anyone, I never wanted to go out. At one point, I joined this telepersonals group – you know, those phone lines where you leave messages for strangers and I guess somehow expect to get a date? Thing is, I didn't want to meet anyone, it was like, this anthropological experiment. I was so unsure of my ability to read people by then, I just wanted to talk to all sorts of strangers to try to understand them, you know? It was so funny, Karim was living with me at the time and he was going nuts because I had like, ten women calling me and we'd discuss all kinds of things

"I've seen every kind of reaction... some people have cried at screenings... several recovered addicts said they got chills from it."

for hours on end. I told each of them that I didn't really want to meet them in person, but I don't think any believed it. They believed it soon enough! So there was this arsenal of strange girls that I'd talk to day and night. I gave in and met one of them and regretted it instantly. I consulted all sorts of naturopaths, trying to build myself back out of this dulled funk, and that really helped. Vitamins, herbs and diet are the way to go when you're recovering, believe me. Some people suggested I go on antidepressants but I refused to even consider it. I was afraid that I'd totally burnt myself out because I felt like the oldest man on the face of the earth and for a long time I couldn't enjoy doing anything. It was terrifying. What's weird is that now, I think I have more energy than I did when I was fifteen! I mean, I really love everything that's going on, and the people in my life. I honestly never thought I'd feel any of that again. I've got the tolerance levels of a twelve year old too – like, two beers get me hammered. The only real habit I've got left is coffee, and it's a motherfucker supersonic habit as far as rituals go, but I can live with that. I can even smoke for a day or two when I feel like it, and then just stop without really Jonesing. By the end of 1996, when Pierre brought me on to Fantasia, I was already getting a lot better, but I was still very uncomfortable around people and had a lot of strange hang-ups that I don't think he really knew about. It was strange, because I got to make *Zero* through this almost re-birthing period, when I had a much clearer perspective on things. It still had to be true to what it was, so I constantly had to work myself backwards to get back in the proper mindset for little bursts of time. Anyway, when I began writing *Zero* in '95, I was already more or less out of the void, but it was very important for me to document that period as honestly as I could, and the only way to do it was through abstractions, so that there would be powerful emotions that people could feel whether or not they really understood the issues of the character. I always tell people that *Zero* is a junkie film without smack. The way I saw it, the best films about addiction had already been made. Between *Christiane F*, *Dead Ringers* and *Bad Lieutenant*, and now in a lesser sense *Requiem for a Dream* and *Blood*, there's really not much to add that wouldn't be totally redundant. I made the

character a child-molester because it was important for him to be something that virtually every rational person, no matter how tolerant they might think they are, would find contemptible. It had to be something so terrible that even the person with those urges would be revolted by them, at least on some level, I presume. I mean, there are almost no absolute rights or wrongs in life, but I can't imagine that someone who hurts children could possibly think that there's nothing wrong with that. Anyway, with the character being a child-killer, it left the door open for me to fuse the cycles of addiction with self-revulsion, self-destruction, guilt, loss and the indescribable horror of realizing that you're no longer in control of yourself. That you've become something that goes against every ideal you've ever had. The film is about a man who loses his entire lifespan to a cycle that he is totally aware of – he understands everything about it, but can't use any of that enlightenment to do anything. No matter where he is in life – at age 7, 30 or 70, he's in the exact same state, dwelling on the same things, with no hope of moving on. I can tell you that every line of voice-over, with the exception of that stuff about his youth, every line is directly autobiographical to what I was feeling when I began writing it. You'll notice that he never once talks about hurting kids, or anyone for that matter. The imagery goes everywhere but I kept the voice-over pure to its foundation. There's also a good deal of iconography that hints towards the real subject, at least symbolically, in the ways they reappear. I wanted to keep the film ambiguous to a certain extent. I paid close attention to certain images without spelling out their significance, because it leaves the film open to playing like a Rorschach pattern for the audience, to be filtered through each person's backlog of emotional luggage. I've always found the films that did that to be some of the most intimate experiences for me as an audience member. Everything felt so much more personal, and I felt it was important to use that here.

GG: What about the problem of alienating audiences who are incapable of empathizing with such an extreme case study as the subject of *Zero*?

MD: It doesn't matter. The only thing I was concerned about with *Zero* was raw expression. I'd shoot a weekend every fifth month and after enough time, it felt unreal to even imagine a human audience ever watching it. I'd never do that if I was shooting something with someone else's money but in this case, the only responsibility I felt was towards myself. And you know, I'd say that more people are turned off by the film's structure and aesthetics than any of the more graphic content. It bears mentioning that we were always very protective of the child actors during the shoot. Their parents were on set at all times and we jumped through hoops to keep the atmosphere light whenever kids were around. The heaviest moments in the film, with the exception of the crucifixion, are all conveyed through editing and surreal abstractions, and we were careful to never jeopardize the children's emotional well-being.

GG: Describe some of the more extreme instances of audience discomfort or outrage. How do audiences react in general?

MD: With *Zero*? The craziest would have to have been at L'Étrange Festival in Paris. It had three screenings there, and after the first night, the festival got a call from the police. It seems that an audience member was so satisfied with their viewing experience that they called the cops! Two days later, I was hanging out at the Festival office when these four classical European anti-smut cops came in. I mean, middle-aged, dressed in yellow, brown and grey, the whole deal. They grilled one of the organizers for a pretty long time, asking him all about me, whether the film had screened elsewhere, etc. To make matters worse, when they came in, I was with this girl Ingrid – this totally amazing person that I met after the first screening – she was twenty but she probably could have passed for 16, and there I was sitting with her, having barely slept, with greasy hair, rings under my eyes and dressed completely in black. A bad first impression under the circumstances. Anyway, they finally saw the film and told the festival they had nothing to worry about, apparently shaking their heads in disbelief that they'd even been sent down. I'd already taken off to shit bricks and get a drink down the road! That was definitely the heaviest one. It ran into a lot of problems at the Brandon Film Festival too, but nothing as extreme. The local censor board tried to force the festival to pull the screenings but they agreed to a compromise, where the door was restricted to people over the age of 18 and organizers were instructed to warn the audience on a mic before the screenings started. How could a film do anything but disappoint after that? I've seen every kind of reaction, from anger to boredom. Some people have actually cried at screenings. I know that several recovered addicts said they got chills from it. The trouble is, it's been grouped into that list of extreme transgressive filmmaking, and I think a lot of people hunt it down looking for an ultra-violent horror film and end up just being bored to shit by it. It's really not that graphic a film, save for two very punishing setpieces. It's the subject and tone that gives the film whatever power it has. I screened it at Fantasia and I don't think it was all that liked there. It was the first public screening and I don't know what people were expecting, but this probably wasn't it. A few weeks later it won the jury prize at the Chicago Underground Film Festival and I began to feel a lot better about it. At one point I wasn't sure if I even wanted it to be shown. Years later, it's still getting booked at festivals, which totally amazes me. Films have strange lives.

GG: When will the films be commercially released?

MD: In North America? Probably a few days before the end of the world. An amazing two-disc set came out last year in Austria, Germany, Switzerland and Holland, released by Sazuma, and these guys went absolutely bonkers on the presentation. It features pristine, uncut transfers of *Subconscious* and *Zero*, as well as extensive

Divided Into Zero

making-of's for both, there are interviews with both Karim and myself, a 10-minute unreleased track from David Kristian, Karim's short *La dernière voix*, even clips from my early video shorts. These guys were crazy into the films and wanted to do something that was absolutely definitive for them. I still can't believe it. Both films also came out in Portugal through Cinema Novo, and there's a DVD of *Subconscious* available in Japan. It's got some optical fogging over some of the more radical genital shots, but most of it got through. They're really weird in how they choose what to fog these days. The entire menstruation fantasy was left alone, and you've got genitalia galore there! The shots of the fishhooks peeling the businessman's penis? Fogged to hell and back. We think it's an unspoken rule about passive genitalia being permissible. A company in Sweden was going to release the two films together but *Subconscious* didn't pass classification. It's now officially on the banned list out there, so that ended that deal. I get all these e-mails asking about the films and I hate telling people that there's no video release in this part of the world. It's very tough to get these sorts of films out in North America, though certainly less so today. We knew it would be like that when we made them. So far, the only way to see them out here has been on the festival and alternative cinema circuits.

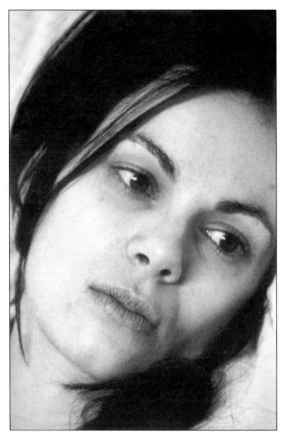

Emma Sara as Cynthia, **God's Little Girl**.

GG: How did *God's Little Girl* come about?

MD: A lot of people close to me brought up the very good point that if I ever wanted to raise outside money for a feature or even a bigger-budget short, I should make a film that can be shown to an audience without getting the cops called! Of course, that wasn't the key drive behind this one, but the thought did remain in my head as I went through my various ideas to choose one that was less graphic, though philosophically, the film is in many ways much harsher than the last one. *God's Little Girl* is a very compact sixteen-minute, 16mm film about a woman coping with the spontaneous death of her baby. She can't begin to fathom how God could allow something like that to happen to someone who was pure on every level, and convinces herself that there are so few truly 'good' souls in the world that when God was faced with her daughter's full and complete Goodness, he / she / it lost patience and took her to heaven right away. She then begins to question whether the fact that she had always lived her life by strict moral codes could inadvertently be paving the way for an early grave of her own. In a state of panic, she embarks on a quiet mission to undo some of the good of her past. It's my version of a comedy, I guess! The film is visually pretty experimental, and very much informed by the aesthetics of still photography. The actors only move in slow, subtle movements, really, almost all movements are very slight within the frame and usually the most substantial movements in a shot are a focus rack, a dolly or a slow zoom, not the actual material being photographed. It's all about physicality, frame composition, lighting, cutting and sound. I'm very happy with how it's turned out. It was the first time that I got to shoot everything in one tight production period and not an endless series of weekends. Post-production was eternal though, and marred with more strangeness than I can even try to get into here. Its World Premiere is coming up in the fall at L'Étrange Festival, followed by Austin Fantastic, Sitges and the Lausanne Underground Film Festival. So, it begins life in Paris, Texas, Spain and Switzerland. Note the distinct absence of Canada! I have no idea how people are going to respond to it. If they hate it, I can't pull the pretentious artist line of accusing anyone of not 'getting' it, because if they really hate it, chances are it will be because they DID get it!

GG: Have you got any plans to make features?

It's funny, people always ask me when I'm going to make a feature, and I'm not really in that big a rush. The more I see what friends are going through on their bigger films, these crazy power struggles with egomaniacs who want to test you every step of the way, investors who can't get their story straight on the sort of film they expect to see delivered, producers who abandon every promise they made, actors who try to sabotage the shoot, it makes me question how far into that world I really want to go. I love shooting films with small crews and dedicated actors, where the atmosphere is communal and positive and nobody feels that they're above anyone else on the set. If I end up dealing with the sorts of situations that I see on some other peoples' shoots, I'm worried that I might end up losing my love for all of this, and I don't want to become a bitter film guy, because the world already has more than enough of those. I've got two feature film scripts I've been toying with, but I definitely don't feel like it's the right time to start serious work on getting either into production. I'm perfectly happy with making a short film every few years and not getting eaten alive in the piranha race of Industry. With shorts, I don't have to worry about making an audience happy. I can just go forward on my own time and make the purest work I can, both in terms of aesthetics and content. If people like it, great, if they hate everything about it, that's cool too. Films find their audiences over time. I have zero interest in making a normal film that everyone will enjoy and then forget about ten minutes after watching it. I'd rather be the crazy guy shouting from rooftops about neglected films from other filmmakers who nobody is fighting for. You know, "Look at this! How can you not be paying attention to this?! LOOK AT THIS!"

100 Questions

- Dave Schramm -

The plaintive, sinister sweetness of the Schramms is a welcome diversion from the over-compensatory penile yowlings of so many licentious, leatherdecked pussyhounds who dominate rock'n'roll. It also provides ample relief from the sissified whine of Pop-Tart chowing, soy milk sipping indie rockers. Like an aspirin for a hangover, the quashed hope in Dave Schramm's lyrics and voice knocks out some of the more manic energy built up over a week's worth of social bullshit… it cures the head static, while suggesting a multitude of little wars raging on just beyond that thin veil of tranquility which can't last longer than a few hours. The Schramms haunt the gravesites of Emily Dickinson and Nelson Algren in their music, bringing their hard innocence from verse to song. Few bands have managed such an ideal, and The Schramms, as a collective entity, thrill and pacify in equal measure. They are all but unknown in America and, as with so many other original artists covered in *Midnight Mavericks*, enjoy a large cult following in Europe. Disarmingly confident and deceptively melodic, their 1990 debut long player *Walk to Delphi* opened the door to a series of excellent records released throughout that decade, all characterized by the frontman's gloomy and bizarre lyrics, and twangy guitar style.

Prior to forming the eponymous folk/pop outfit in 1987, Dave Schramm was a guitarist in the celebrated '80s indie-rock group Yo La Tengo, to whom he returned one last time for their 1990 album *Fakebook*. Over the years, he has guested on records by many other important artists, ranging from The Replacements and Soul Asylum to cultish folk rockers Richard Buckner and Freedy Johnson.

Underrated as The Schramms may be, Dave remains a potent force, ever the more sympathetic, complimenting an area of music which would be even more lacking without his own gift of dignity in the face of hard rock macho-strut, glam-rock tack, Satanic power-thrust, Conor Oberst-style infantilism, or the generalized smartass cool which pervades almost everything.

Their most recent release, *2000 Weiss Beers from Home*, is a warm, lo-fi live album featuring an outrageously adrenalized cover of The Saints classic 'In the Mirror'. The last studio album, *100 Questions*, is a strange, sombre and decidedly damage-themed collection of laments with the odd rocker thrown in that I can not recommend highly enough.

In 2003, Mr. Schramm graciously accepted an invite to appear on the bill for a *Sex & Guts* release party at CBGBs, performing a brilliant free-form stretch of instrumentation accompanied by eerily effective spoken word. He plays the New York / New Jersey region on a semi-regular basis.

the schramms

dizzy spell

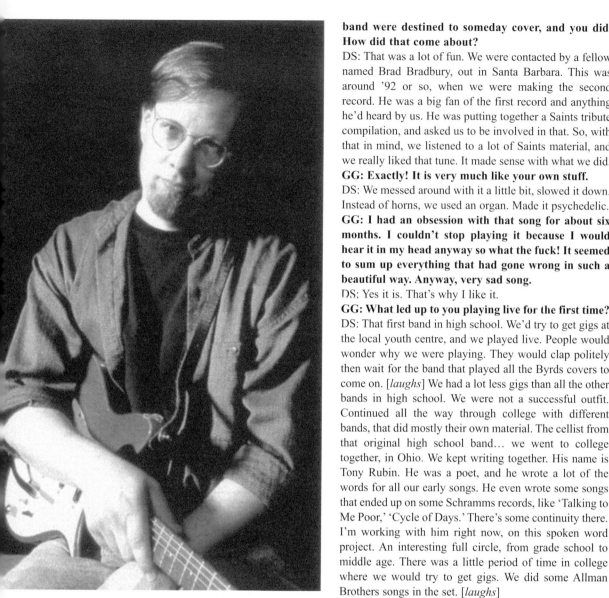

Dave Schramm around the time of his solo album **Hammer and Nails**. Photo courtesy of the artist.

Gene Gregorits: When did you start playing music?
Dave Schramm: I started playing clarinet when I was really young, in grade school. My grandfather was a clarinettist. He had a polka band. He was Eastern European. I started playing guitar very young, around 12. My first band was an all-original band at a time when that wasn't really the thing to do. All the other bands in high school were playing Jethro Tull and Led Zeppelin songs. We decided to write our own songs. We had a cellist in the band. It was pretty whacky.
GG: The Schramms covered a song originally by The Saints. 'In the Mirror'. It's an incredibly haunting piece of work. It seems like the song you and the

band were destined to someday cover, and you did. How did that come about?
DS: That was a lot of fun. We were contacted by a fellow named Brad Bradbury, out in Santa Barbara. This was around '92 or so, when we were making the second record. He was a big fan of the first record and anything he'd heard by us. He was putting together a Saints tribute compilation, and asked us to be involved in that. So, with that in mind, we listened to a lot of Saints material, and we really liked that tune. It made sense with what we did.
GG: Exactly! It is very much like your own stuff.
DS: We messed around with it a little bit, slowed it down. Instead of horns, we used an organ. Made it psychedelic.
GG: I had an obsession with that song for about six months. I couldn't stop playing it because I would hear it in my head anyway so what the fuck! It seemed to sum up everything that had gone wrong in such a beautiful way. Anyway, very sad song.
DS: Yes it is. That's why I like it.
GG: What led up to you playing live for the first time?
DS: That first band in high school. We'd try to get gigs at the local youth centre, and we played live. People would wonder why we were playing. They would clap politely then wait for the band that played all the Byrds covers to come on. [*laughs*] We had a lot less gigs than all the other bands in high school. We were not a successful outfit. Continued all the way through college with different bands, that did mostly their own material. The cellist from that original high school band… we went to college together, in Ohio. We kept writing together. His name is Tony Rubin. He was a poet, and he wrote a lot of the words for all our early songs. He even wrote some songs that ended up on some Schramms records, like 'Talking to Me Poor,' 'Cycle of Days.' There's some continuity there. I'm working with him right now, on this spoken word project. An interesting full circle, from grade school to middle age. There was a little period of time in college where we would try to get gigs. We did some Allman Brothers songs in the set. [*laughs*]
GG: Was that the first band you made money with?
DS: The first real band I played paying gigs with, that meant anything… there were some strange bands, like the Kinetics. Some stuff I did in Columbus, Ohio, when I lived there. Jon Klages used to be in a band called The Individuals. Glenn Morrow was in that band; he runs Bar/None Records now. Ira Kaplan and Georgia Hubley from Yo La Tengo were also in Jon Klages's band. We played some gigs. That's how I met Ira and Georgia. When Jon's band broke up, we got together, and started playing together. And they were the first band I went out on tour with. That was around 1986.
GG: How major was your creative role in that band?
DS: I had two songs on the first Yo La Tengo record. They wanted me to do more, but at that point I had already decided that I was going to start my own outfit. It ended amicably.

GG: Your first Schramms record, *Walk to Delphi*, is a really great record. And you've maintained that purity throughout the other Schramms records. It seems like you came into your own element pretty quickly. You haven't gone in too many different directions with the band, almost as if you knew who The Schramms were meant to be from the first album.

DS: Yeah. I guess it was fully formed… But I had to write a lot all my life, so it wasn't like it was a new thing for me.

GG: What are some of your favourite writers?

DS: I guess I'm a big Thomas Mann fan, he wrote *The Magic Mountain* and others. The song 'The Way Some People Die' comes from a Ross Macdonald detective novel.

GG: Do you usually write the music first, or the words?

DS: Sometimes it's the music first. And the words fall in where the melody goes. But there are plenty of occasions where I had a piece of semi-poetry. The things that come to mind are the song 'Dizzy Spell.' That was a poem before it was a song. The first song on our last record, '300 Answers'… that was a poem. There's a few. Mostly music first though.

GG: There's a lot of dark humour in your music. The joke of '300 Answers' being the first song on *100 Questions*, for example. Sad but really funny.

DS: Yeah, I guess I'm a cynic. But I have a positive outlook, I think.

GG: There's a link to an Emily Dickinson site on your website.

DS: Oh, I'm a big Emily Dickinson fan I guess. I wrote a lot of songs with her poems. I used her poetry.

GG: 'Let Them Lie Down,' for example.

DS: Well, in that one I just took a line from one of her poems and ran with it. But songs like 'Number Nineteen,' 'A Woman's Name' and 'Funeral Song' are all based on Emily Dickinson material. Nice, uplifting stuff.

GG: Who would you say your core audience is?

DS: It seems like it's an older crowd. But then again, when we play shows, there is a whole range of people there. That's just my perception though. Guys with pocket protectors and funny glasses make up a lot of our demographic. In Europe, it's much different. We've done pretty well over there, better than we have in the States.

GG: It's strange that you'd define a lot of your audience as these nerdy guys with pocket protectors when you're writing about harsh subject matter quite often.

DS: Yeah. And somebody once said that our songs felt very schizophrenic… these cheery melodies about the apocalypse.

GG: Your last album is very loose, almost ready to fall apart at times. But it never does. Is this something you intentionally go for in your music?

DS: My main focus with this last record was to try and distil everything, because the record that came before it I

" ...somebody once said that our songs felt very schizophrenic... these cheery melodies about the apocalypse."

thought was a little overblown. It was long. That was called *Dizzy Spell*. I'm really happy with the songs on there but I think that maybe there's too many of them. I could have stripped them down and made more sense of them. In doing that, I think it kind of freed up the feel of the songs. It wasn't weighed down by so much structure. The other aspect of that is that, the first time the band heard the songs we were in the studio with everything miked and ready to roll tape. So we worked it out as we went along. That was a very liberating type of thing, not to have everything written in stone before you even step foot into the studio. I like to record that way.

GG: Between *Dizzy Spell* and *100 Questions*, you did a solo record. What compelled you to release that?

DS: Because I wanted to record a certain way, and it didn't make sense with The Schramms. Sometimes it seems a little too precious at times, to me. It's a gentle record.

GG: You seem very comfortable with The Schramms. Are you going to be recording with them soon?

DS: Well, I don't have any great plan, or any great ambition for the group. We just do what we do, and we're able to still make records. We have our own studio so we can make the recordings we want… as long as we can still find outlets for them. Not to be selfish about it, but the main thing is the making of the record. We're playing for ourselves, to make ourselves happy.

GG: What can you tell me about an instrumental track you did called 'Duck Hunting in Hell?'

DS: I think I was just being belligerent about the title at that point. [*laughs*] It's a kind of sappy, Beach Boys-type instrumental. We had all these sappy names for it, and I didn't want to make it more sappy than it already was, so I just said, "Let's give it a title that makes no sense at all, and call it 'Duck Hunting in Hell'… and let people wonder." There was nothing more to that. The title has nothing to do with the music, other than to be contrary.

GG: You told me you were a cynic. What is it about you personally, do you think, that gives you the kind of worldview that you have?

DS: I think I'm more a realist than a cynic, but on the other hand, I'm an optimist. I don't think everything sucks. But I think that a lot of things that people think are great, SUCK. That's the way I would characterize it.

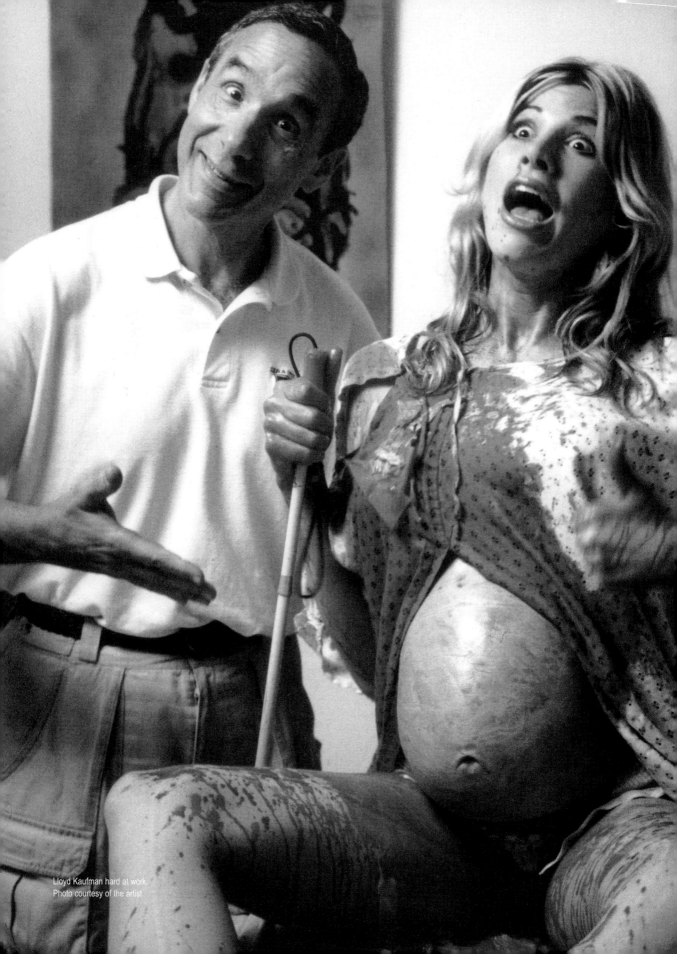

Lloyd Kaufman hard at work.
Photo courtesy of the artist.

Crapmaster

- Lloyd Kaufman -

Who among us has yet to see a Troma film? *The Toxic Avenger* and *Class of Nuke 'em High* are now '80s relics, serving as noxious nostalgia for horror and schlock film audiences worldwide. Those two films in particular unquestionably delivered more cut-rate, brain-damaged titillation than anything else on the market at that time, but they're only the tip of the iceberg. Over the last thirty-odd years, Troma has released well over a hundred similarly repellent films, scouring the globe for grade Z muck most sane distributors would walk out of before the opening credits finished rolling. With every new 90-minute orgy of scat humour, deviant sex, and ultraviolence, which they hastily serve up like a goopy, half-rancid triple cheeseburger, Troma is reminding us that regardless of severe ups and downs in the exploitation film industry, through it all, they will be there. Even in times of desperation and strife, behind dense clouds of flatulence, neck deep in pools of vomit, Lloyd Kaufman will remain undaunted.

He is the irrepressible co-founder of America's longest running independent film studio, and director of many in-house Troma productions. Lloyd, in this day and age, can be said to be damn near as persistent a face in film culture as Roger Ebert or Martin Scorsese. Lloyd himself is actually more entertaining than a lot of Troma's titles, and likely to end up as the subject of a Hollywood bio-pic one of these days.

He routinely flies into rants about the film industry, with a sustained political rage which exceeds even that of his old friend Oliver Stone; he could hardly be accused of mellowing with age. It finally emerges, especially during this particular chat, that as combination skid-row carney barker and anti-authoritarian idealist, Kaufman is without equal. Nor are you likely to find a man who can utilize the special talent of self-deprecation with more sincerity or sweetness.

I'd rather not comment on the watchability or integrity of the bulk of the Troma catalogue; to be perfectly honest, schlock films rarely find their way onto my screen. But I have never failed to enjoy an interview with Lloyd Kaufman, and I have very fond memories of the few times I've had the chance to meet him. His books, *All I Need to Know About Filmmaking I Learned from the Toxic Avenger* and *Make Your Own Damn Movie!* are both enlightening and brilliantly tasteless.

Gene Gregorits: What's the film you're currently directing?
Lloyd Kaufman: Well, I'm not directing it. It's a troubled film. We had to remove the people involved. We had to take over. It's called *Tales from the Crapper*. It's our first in-house digital feature. They didn't do a good job. We're trying to save it.
GG: What's the film about?
LK: It's two vampire stories.
GG: That take place in a bathroom?
LK: Ah, well no. See, the Crapmaster... I'm the Crapmaster!
GG: That's great. Sounds fantastic.
LK: It's really good! It's the first Dogpile film. Are you familiar with the Dogpile 95 doctrine of filmmaking?
GG: So it's a take-off on Dogme?

LK: Yes! Dogpile 95 is our credo for filmmaking. It's been published on the Troma website. Go to the Troma website, you will read the credo. *Tales from the Crapper* is the first. We've done some feature-length documentaries. We are premiering a documentary at Cannes film festival next week. It's called *All the Love You Cannes*. It is a documentary about the Cannes Film Festival, and how Troma operates there and how we do it on pennies a day while big companies are spending millions...
GG: Do you often run into trouble at festivals? At the TromaDance festival in Park City Utah, a few of your guys got arrested.
LK: That was because we believe in the First Amendment, so two of our volunteers were put in jail. All we're trying to do is get the message out, that the

Lloyd Kaufman in the editing room during the 1980s heyday of Troma Films. Photo courtesy of the artist.

world of art is being run as a private preserve for a handful of devil worshipping international conglomerates. They don't want that word to come out. We have a fan site in France, a French website by the French fans. There are lots of fan sites for Troma but this is the official one. They are organizing a march at Cannes. We formed a political party. Partie Tromatique Francais. They've been working for weeks on this. They've been making picket signs. On the 21st of May, we're going to have a big march down the main strip at Cannes, and throw blood at the palace. The theme is "GIVE ART BACK TO THE PEOPLE."

GG: That can't be said enough. That's my agenda too. No more Indiewood!

LK: Perfect.

GG: Troma is the scapegoat of the film industry. What else can be done? You're fighting, but do you foresee a breakthrough?

LK: Well… I think the hymen of the establishment is pretty impenetrable… you know Troma is the oldest independent movie studio in the history of cinema. We are one of the few. Certainly, in the history of cinema, we are aberrant. But every time we have penetrated the

hymen of the establishment, we have been the ones to get fucked. And I think it's worse for small companies.

GG: It is. I know you have to pinch pennies just to keep the office running.

LK: Well, that's why we started the TromaDance film festival. Sundance charges filmmakers money to enter their films. And you know how difficult it is to make a movie. It's very expensive. It's very expensive to make a movie. In fact, you have to donate a kidney to get a movie made. Why should these film festivals, why should these bureaucrats be eating at fancy restaurants – owned by Robert Redford, by the way – and taking business-class airplanes, while we artists are eating dog food and travelling coach with stopovers? I'm the president of Troma and I'm going to Cannes on an airplane that stops in Munich! Right? To save money!

GG: Right. Sometimes you have been rumoured to "shoot yourself in the foot," and I say that in quotes, regarding the way certain business is done, the way films are handled. Is it part of the Troma ethic to make a mess of things? Is it a Gonzo tactic or do things just get so pressured and hectic that they slip out of control?

LK: We don't have the ability, as I said, to penetrate. Every time we penetrate the hymen of the establishment, we get fucked. Meanwhile we're still here after 30 years, thanks to our fans. We're blacklisted economically. There's economic blacklisting going on, and pretty much every independent studio gets killed, or eaten, one or the other. They do not last. We have lasted, because, when you're economically blacklisted, you've got nothing to lose. You can do anything you want. You can make a movie like *Citizen Toxie* where we have abortion. Where we have Columbine killing. Old women getting their heads crushed under the wheels of an automobile. Shitting. Black people being dragged by pickup trucks… There's economic blacklisting, so what the hell.

GG: We are entering an age in which we are seeing the pornification of America. Peter and Bobby Farrelly are making films that are basically doing things that you pioneered many years ago.

LK: Sure, and *There's Something About Mary*… how many critics have written that without us, there would be no *Something About Mary*. It has all those jism jokes too. And when we did that, we were castigated.

GG: Where is there a space for Troma in this age, where *South Park* and the Farrelly movies and things like that have become the new status quo?

LK: *South Park* is great. It's wonderful satire. Trey Parker is writing the forward to my next book.

GG: You invited me to a book signing. What are you promoting there?

LK: Trey wrote the introduction to my new book. It's called *Make Your Own Damn Movie!* You know, Trey did *Cannibal! The Musical*, a Troma movie. James Gunn wrote *Tromeo and Juliet* with me, and he then wrote the *Scooby-Doo* movie and the re-make of *Dawn of the Dead*.

GG: Who co-wrote the new book with you?

LK: Adam Jahnke and Trent Haaga. Jahnke works out in our LA office, and Trent as you know is the star of *Terror Firmer*, and he's got a commentary track on *Citizen Toxie*. He's the main writer of the film.

GG: He told me he had created a Columbine subplot involving the "Adult Diaper Mafia."

LK: That's right! The adult diaper mafia! We re-created that scene based on Columbine. We re-created it at Cannes Film Festival last year, in the lobby of the Carlton Hotel. We had all these people running around in diapers. As a joke.

GG: Did you have any permission or licenses? Or did you just go for a "happening" type thing, a spectacle?

LK: A happening, yeah. Well, E! Entertainment wanted us, E! and there was some other TV cameras, but E! asked us to do that. Of course, we complied. You can see what we did in *All the Love You Cannes*. Some of that's in the documentary.

GG: What is the general attitude towards Troma at Cannes?

"Every time we have penetrated the hymen of the establishment, we get fucked. Meanwhile we're still here after 30 years, thanks to our fans."

LK: Well, the fans love Troma! The film people love Troma. We have a lot of fans in France. But the Carlton… see, we used to have our offices in the Hotel. We had them there for pretty much the whole history of this company. This year, however, the Carlton gave us the heave-ho. Warner Brothers was across the hall at Cannes, and they were constantly sending the security people into our offices. It's a festival. We were actually being festive. I guess you're not supposed to be festive at a festival. You're supposed to be Warner Brothers.

GG: One thing I always love about Troma is that there's always a spectacle. You love what you do and people in your ranks have a great time at these things. What's the worst example of Troma publicly getting on someone's nerves that you can remember?

LK: Doug Sakmann was strangled. He wasn't killed, but he was strangled rather severely by security people at the Carlton hotel last year. That's about the worst. Film fans like Troma. The critics, for the most part, like us. In fact, last year at Cannes I met the head of the Cinémathèque Française who invited me to come there to show *Terror Firmer*. I was introduced by the head programmer of the Cinémathèque and he said that I was an influence on Peter Jackson, Quentin Tarantino, Alex de la Iglesia… This is on the record, this is public. He said he had spoken with these people. He went through a litany of these major directors that have been influenced by my stuff. That's very cool. Now we have a storefront and two offices in Cannes. We have a storefront for our political party, behind the Carlton, and then the sales office which is in the Palace. Le Grand Palais.

GG: I have always loathed the Dogme films, except for *The Celebration* [*Festen*], which I liked. In general, they are uptight and annoying, ultimately. Is your parody of that coming from hatred?

LK: Well, first of all, as always, we don't get any credit. We've been making movies with bad lighting, crappy sound, amateur actors, for thirty years! Nobody remembers. I would add that our movies aren't as boring as the Dogme movies. We've spent hours, and we've

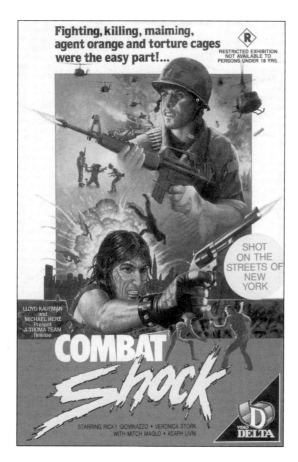

Fighting, killing, maiming, agent orange and torture cages were the easy part!...

RESTRICTED EXHIBITION NOT AVAILABLE TO PERSONS UNDER 18 YRS.

SHOT ON THE STREETS OF NEW YORK

LLOYD KAUFMAN and MICHAEL HERZ Present A TROMA TEAM Release

COMBAT Shock

STARRING RICKY GIOVINAZZO • VERONICA STORK WITH MITCH MAGLO • ASAPH LIVNI

VIDEO DELTA

wasted much time idealistically devising the Dogpile 95 doctrine. Oh, and the other thing is, Dogme 95 charges you! You gotta pay to get the Dogme 95 certification!

GG: It all works out rather nicely. You give them your budget, and then you don't have money for lighting anyway.

LK: Right!

GG: Will Troma ever make a serious art film?

LK: We have the Bow Wow Vow of Chastity. A contract undersigned by the filmmaker for their eternal soul to the dark lord Satan, to make sure their cinematic vision remains pure and true. Well again, we are involved with serious movies. *Combat Shock* – it doesn't get more serious than that. We had nothing to do with directing it, but we put money out for it. We put up more money than anybody did for that one.

GG: I didn't know you produced that.

LK: We were executive producers!

GG: *Story of a Junkie* and *Combat Shock* are two of the most grim films ever made. Had it not been for Troma, those films might have never been released by anyone.

LK: *Story of a Junkie* would have been made, because we didn't put up any money for it, but *Combat Shock* would have sat in a can. The shooting never would have been finished.

GG: Right. That's why the date on the film is 1984/1986. So you came in midway and finished it.

LK: Exactly correct. It was originally titled *American Nightmares*, and it was just sitting there. The opening hadn't been done. And when it was released, nobody got it. But now, the DVD of *Combat Shock* is very popular! In Europe. Not here so much. It's still becoming better known and people understand that it is a serious film. It's the best handling of post-Vietnam stress of any movie.

GG: It definitely stands apart, along with *Story of a Junkie*, from everything else in the Troma catalogue. Troma Films have been called "dumb films for smart people." There is still a place for Troma, even though there are cultural gimmicks like The Farrelly Brothers, but that means you'll have to keep going further and further.

LK: No, that's not true. We've never had more of a place. We get millions of people on the website. The problem is the consolidation of the industry. The laws have gotten re-written to favour the ownership of theatres by the major studios. The laws have been re-written to give Rupert Murdoch the right to own more than one TV station in every market. The laws have been re-written to prevent competition! The point is, the independent movie is totally marginalized.

GG: Right. The entire media is owned by three or four companies. I thought that monopolies were illegal.

LK: It's a disgrace. It's all over the world, because one is a French company, one is Australian, one is American, one is Japanese, it's not just limited to America. There is a club. As I say to you, the world of ART – it's not just the media, it's the world of art entirely – is run as a private preserve by the small number of elites. Including the Guggenheim museum, which is used to promote Armani suits... mediocrity... collections that are owned by billionaires. It's used to promote Harley Davidson motorcycles. All of which, one can argue, are art, but I would argue that there are some much more deserving artists whose work is much more important. Who are eating dog food. If van Gogh were alive today, he would not be shown at the Guggenheim museum. I guarantee you. He would have blown his brains out not at the age of 37, but at the age of 22.

GG: You mentioned motorcycles. When was that, the late '40s or early '50s, when an entire gang of cyclists took over an entire town? Anyway, they've commodified rebellion. That's another problem.

LK: Well, there's two ways of looking at motorcycles. Harley Davidson is the Armani of motorcycles. So, "let's publicize them." Why do they need publicity? Why do they need to be shown at the Guggenheim museum? There is an excuse, I mean you can write an article about why they should be. Definitely, they are part of Americana, and blah blah blah. But also, the

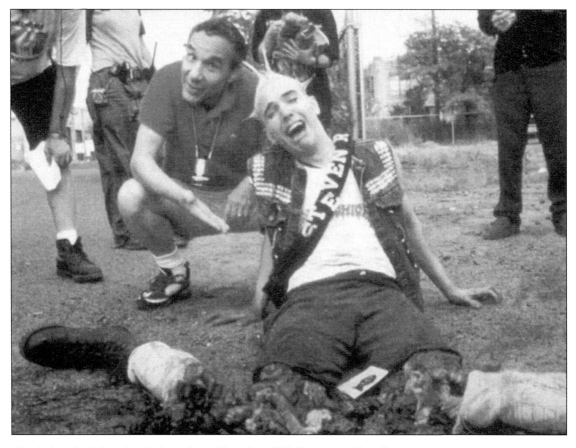

Above: Punk cut off at the knees. Lloyd Kaufman on the set of **Terror Firmer** (1999). Photo courtesy of Troma Films.
Opposite: Poster for Buddy Giovinazzo's melodrama **American Nightmares**. Typically exploitative Troma marketing, with misleading artwork and a loud new title.

right-wing people who used to go around beating up fags and communists in the '50s, rode Harley Davidson motorcycles during the blacklisting period!

GG: It's very ironic that in the beginning, the Hells Angels were used as one of these bogus government threats to terrify the public, before Charlie Manson.

LK: Yeah, that's true. It's kind of like the punk thing. Did you see *Terror Firmer*?

GG: Sure did.

LK: You know then, that the punk character in *Terror Firmer* gets his legs cut off at the knees! That was not accidental! The guy was a punk and that's what happened to the punk movement. The punk movement was the greatest revolution in America, other than the women's liberation movement. And it was totally cut off at the knees, due to MTV, due to a lot of things. And MTV is part of Viacom. It was destroyed by the major media.

GG: Yeah, I think the music industry bled punk to death a long time ago.

LK: Point is, they cut off its legs. That's what that was all about in *Terror Firmer*.

GG: What were you doing when punk happened?

LK: I was hanging around with the Warhol gang.

GG: Also, you're good friends with Oliver Stone, which is kind of interesting.

LK: We grew up together! All the way back as kids, little kiddies. We lived close to one another. Our parents were very good buddies. He used to beat me up as a kid. His films are great. They're terrific. He's a psycho but he's really spectacular. If you go to see one of his movies, you will find something interesting. At the very least. At best, you will find an amazingly artistic personal statement. He is one of the very few who has been able to make movies that are totally his own, that he controls 100%, and he's been doing it for a long time! You have to hand it to him, that's terrific.

GG: Oh, and he also manages to make the establishment scared of him. He's a threat in broad daylight, to right-wing politics in the industry.

LK: He was very right-wing when he was young. He switched around after Vietnam. There are very few of us who have control over the movies we make.

GG: Is Troma doing as well business wise as you were 10 years ago?

LK: Well, we're bigger than we ever were, but it's harder than it ever was. There's so many countries in the

world, the world is a big place. And we have a library of over 900 movies. We own about 900 movies. We're useful to certain companies. When a country is liberated and they get free TV back, they can't afford to program *Lethal Weapon 4*. What they can afford is *Tromeo and Juliet*. There is a need for us.

GG: You mentioned the punk movement, and some affinity with that...

LK: I can't say consciously I have felt any affinity. I don't know anything about punk. I'm ignorant about music. You know what I mean? I'm totally ignorant when it comes to music. I hate that MTV shit they shove down our fucking throats. Well, Weezer's alright! The Strokes are good. I like Fiona Apple a lot. I dedicated my book to her. A great girl.

GG: But your favourite movies, I learned reading your first book, are not typical at all of the stuff you produce. You seem to like mainly classic films. Stuff nothing like Troma...

LK: Ehhh, well... if Preston Sturges were alive today, he'd be making *Citizen Toxie*. You think if Chaplin were alive now, you think if Chaplin was 25, he'd be doing black and white silent movies with blind girls?

GG: Of course he wouldn't!

LK: He would be doing *The Last Temptation of Toxie*! Right?

GG: Times do change. Sure they do!

LK: Right! The violence in Chaplin's films, in their day, was just as entertaining and shocking and funny as the Adult Diaper Mafia in *Citizen Toxie* today! They wouldn't be doing what they did, they'd be far more extreme! I really feel sad when I see what Hollywood has done with Jane Austen! It's such a shame that *Sense and Sensibility* is such a banal piece of shit. When she wrote it, that was hot stuff! Right?

GG: Right.

LK: *Pride and Prejudice* was a revolutionary book when it came out! Riots broke out! When Marcel Duchamp put a urinal on the wall of the exhibit in Paris, in 1907, fistfights broke out. He wouldn't be doing that today. Today he'd be doing something equally as interesting... but of the day! That urinal, by the way, just sold for $350,000 at that sleazy Sotheby's or Christie's. One of those obscene auctions. It just goes to show that real art will survive. Stan Brakhage's movies will be around long after Penny Marshall's movies are dust! Long after Steven Spielberg's *A.I.* is returned to the soil, when it's mulch. The people will be taking the silver out of the prints of *Star Wars* and Stan Brakhage's movies will be shown in every museum in the world.

GG: I agree with you about *Sense and Sensibility*.

LK: Well, yes. And those are the people and those are the movies that people want you to believe are Sundance Independent movies. Safe, non-controversial stuff.

GG: Independent, as a word, as applied to films, has been a lie for at least ten years.

Above: One-sheet poster design for **Tromeo and Juliet** (1996).
Opposite: Romance, Troma style, in **Tromeo and Juliet**. Photo courtesy of Troma Films.

LK: They've stolen the word independent! Give art back to the people!

GG: Thanks for doing Shakespeare the way it always should have been done, with *Tromeo and Juliet*. It's really the greatest adaptation of his work ever, I mean that. And it's the best film you've directed. You made a film called *The Battle of Love's Return*. An unforgettably awful title, and a great title. Has that been released?

LK: It's on video. It was my first feature length colour film, and my first synch-sound feature.

GG: What was your first film?

LK: *The Girl Who Returned*. I don't think you can get that.

GG: Right. What are your favourite films from the Troma catalogue?

LK: I don't have a favourite, but certainly, *Def By Temptation* is a great film. *Combat Shock*. I think *Citizen Toxie* is pretty amazing. *Troma's War*. *Tromeo and Juliet*. I'll tell you, they just did a Troma retrospective in Pittsburgh. I wrote in my book that *Sgt. Kabukiman, N.Y.P.D.* was very unsatisfying because of compromising and what have you. But I watched it in Pittsburgh. I had not seen the film for ten years. But I looked at it in Pittsburgh and it's actually a very delightful movie. It's not graphic and has no extreme

"Citizen Toxie opened in New York on November 2nd [2001]. The very first shot in the movie is the World Trade Center. People applauded. People got it."

elements in it. It's very funny. The audience cheered it, it was a packed house, everyone loved it. I was pleasantly surprised.

GG: I was wondering if you, as someone at great odds with the system, liked the movie *Fight Club* and if you had high hopes for it to change anything in movies.

LK: I loved it. I thought *Fight Club* was one of the greatest big-budget films ever made. A little known fact is that in *Citizen Toxie*, we used a line that the studios forced Fincher to remove from *Fight Club*. That line that had to be cut was, "I want to have your abortion." But isn't it a great film?

GG: My third favourite of all time! But it's a thorn in a studio's side. It's a deliberate "fuck you" to all the bullshit in the world.

LK: Well, bravo to all the actors involved. Meat Loaf, Brad Pitt, the chick. It was terrific! They all deserve a lot of credit for doing that.

GG: Sixty million dollars.

LK: Yeaaaah! They got away with it! That's the thing! Fincher seems to be able to get what he wants to do for us, and get all the money he needs. There aren't many of those guys. Hopefully he'll be around for a while. Oliver Stone's been doing it for a loooong fuckin' time. Woody Allen's been doing it for a loooooong fuckin' time. I've been doing it for a loooong fuckin' time. The dean of the American Film Institute wrote me up as being one of the few original American auteur directors. I hadn't thought of myself that way, but he's correct. Auteur means you have total control over your material. I'm one of the select few, I just don't have any money.

GG: New York is becoming a police state with more cameras than ever before. Had you seen any of this advancement of fascistic policy and sort of Fourth Reich lawmaking as being a threat to Troma and yourself? Have you considered your being silenced a possibility?

LK: Only the blacklisting which is going on.

GG: What about all the technology being installed in the airports?

LK: Oh that, that's just a distraction. No, the big thing is, the powers that be, the brotherhood of the elites, they're trying to figure out a way to put roadblocks up on the internet. Then they will. Then that will be the end of it. Right now, the internet is the only democratic media. People living in Utah cannot get Troma movies no matter how good they are. But with the internet, at least they can buy them on the website. We're selling them like crazy off our website store. If the bad guys can figure out how to use Nazi tactics on the internet, and make the internet the way your TV is now, where everything you look at on television is controlled by five or six people… you may have 150 stations but you're getting content from only five sources. And then, we're fucked.

GG: How did the attack on the World Trade Center impact your day to day business?

LK: The attack? We saw it immediately! We saw the media, and Rupert Murdoch give it a name, gave it a title. "America Fights Back." They had a theme song. And they played it as they showed human beings jumping out of the 107th floor of the World Trade Center. We certainly got a lesson in how quick the mainstream media is to profit from other people's misery. Three days later, NBC is trying to erase shots of the World Trade Center from the TV show *Friends*. They're cancelling Arnold Schwarzenegger's movie and removing shots of the WTC in *Spider-Man*. Meanwhile, *Citizen Toxie* opened in New York on November 2nd. The very first shot in the movie is the World Trade Center. People applauded. In other words, what 9-11 showed is that the major media has lost its moral compass. Rupert Murdoch had front page photographs of people leaping. All over the world. People leaping from windows in the WTC. They even had one picture showing a point of view of a man leaping. So you could see what it looks like as you're jumping from the 107th floor. There was an inset photo of what it looks like if you were there and were forced to jump because of the flames. How the ground would look to you as you faced your death. This is how sick they are. I think that's the biggest lesson that comes out of Revolution Number 9-11.

GG: So you had no plans changed or plans to do anything differently?

LK: Why should plans change? What would be different? Other than the tragedy of it… you're never going to forget. But like I said, six weeks later, we premiered *Citizen Toxie* and the World Trade Center is the first thing you see. People got it. The mainstream media has no sense of ethics so they don't know what to do. We knew what to do. We knew that people would applaud. What's the big mystery?

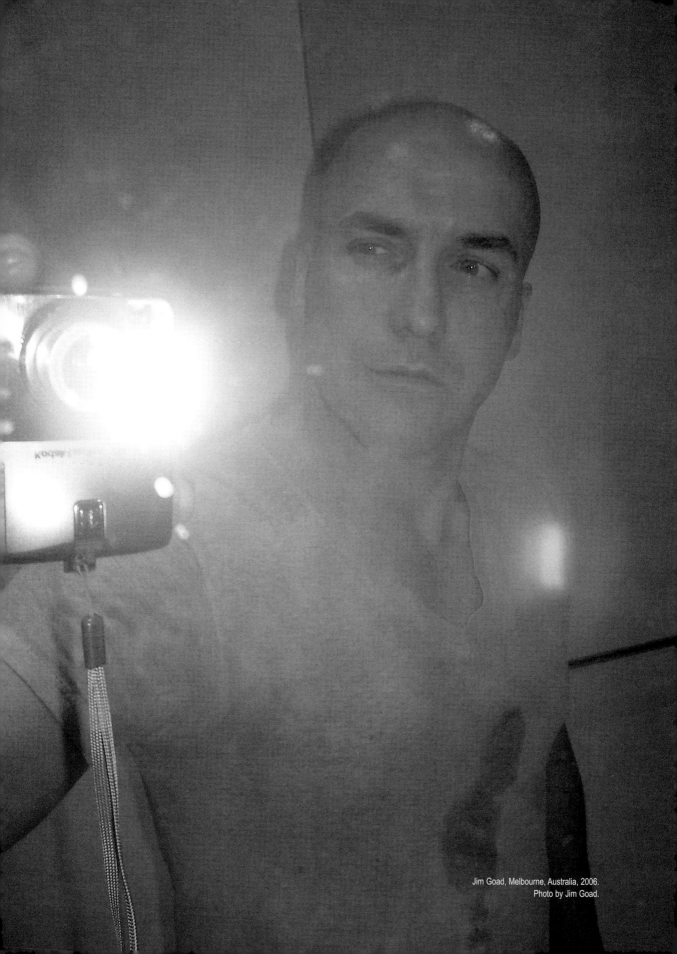

Jim Goad, Melbourne, Australia, 2006.
Photo by Jim Goad.

The Truth Is a Virus

- Jim Goad -

Jim Goad rolled into underground superstardom on a wave of his own bile, when the small-press magazine he and wife Debbie published, *ANSWER Me!*, became an international sensation in the early 1990s. Jim and Debbie drove their message into as many hearts as possible, stretching to the breaking point what would have been in the hands of anyone else nothing more than a instantly regressive mantra: '*we hate everyone*'. The magazine has been linked to an assault on the White House by a lone gunman, a suicide pact in England, and an obscenity trial in Bellingham, Washington.

During *ANSWER Me!*'s reign of reader abuse, the Bonnie and Clyde of fanzine culture were based in Hollywood, and it was the pop nether-regions of that town, along with suicide, homicide, and the human condition in general, that the publication largely obsessed upon. Goad's first book, the polemic *The Redneck Manifesto*, is a true aberration of historical sociology, just as his second, a confessional memoir and sustained novel-length rant called *Shit Magnet*, went far further into social commentary than most anything else you're likely to find in the personal non-fiction genre. Anger is what defines Goad, and justifying that anger is what he has chosen as his foremost function on this planet. Tragedy has in no way served to deter him from the warpath of unyielding provocation, of obtaining and maintaining a clear vision of the world at any cost.

These days, he is as notorious for the circumstances which led to his 2 1/2 year incarceration as for his merciless skewerings of race, class, and sex relations. One of the few writers whose work has been used against him in a court of law, Goad continually sneers in the face of the powers that be. Since *Shit Magnet*, Goad exists in the public eye mainly via his website, where he uses the 'blog' format to take his pathological exhibitionism to the next level. What separates Goad from your average confessionist or blog-jockey is that he more often than not finds some worldly relevance in his self-obsession. The turbulent electrical storm in him rages on unabated, tearing through the ravaged gulfs and gulleys of his grey matter, resulting in a stream of words that assail the reader like radioactively charged microbes. Goad can be exasperatingly self-aggrandizing, or a King Daddy Mr. Bad Vibes, but he's never dull.

I once found myself in Goad's hometown of Portland, Oregon. After being forcibly removed from the house of the woman who I was staying with, bereft of phone numbers or cash, I had no one to turn to for help but Jim Goad. He surrendered his computer for a bit, introduced me to his beloved pug Cookie, and placed my beer-sick ass in a sleazy motel across the street. For all his hyper-aggressive button-pushing and racist humour, which I believe is partially a test of the reader, Goad is by most accounts a loyal and generous friend. Like many provocateurs, he asks, even begs you to write him off, to be offended, and to hate his guts. This process of social filtering is useful to him, as he pries only the most staunch of self-actualized individuals out of the morass of conformist ninnies. In his case, opinions are formed from facts, self-consciously lacking in sentimentality. He wields the awful truth like a scythe. And when you outright reject his point of view, or disagree with his dire denouements, you are nonetheless left thinking hard about the most unsolvable human problems, things you'd already given up on, all the scabs you may have taught yourself to stop picking.

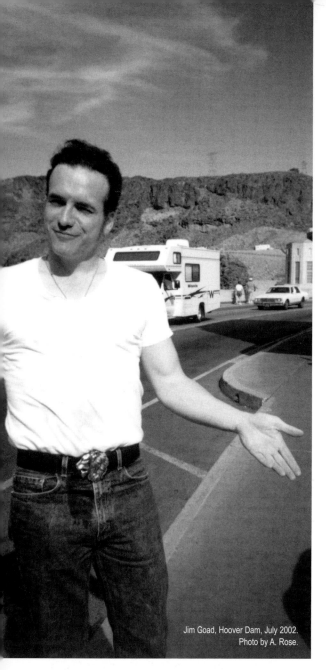

Jim Goad, Hoover Dam, July 2002.
Photo by A. Rose.

people...in the name of anti-fascism. And it's so... fucking absurd, and as always they never see it. I covered the same thing in *Trucker Fags in Denial*, these homosexual [*laughs*] yet homophobic, homely truckers who have homosexual sex and then *kill* homosexuals. That's the theme I keep getting stuck on – guilt-projection, the wrong person getting blamed, the bad guy never being who it seems.

GG: Well, you're on the warpath... it seems like if you could ever reach the end of a given obsession, you could just say that your work is done, and then you'd move on to the next. Has that happened with anything so far, where you felt you'd had a final say? Have you ever gotten anything out of your system where it was really over for you?

JG: Maybe on a particular topic, but not that general theme. I'm not dumb enough to think that my writing is really going to change human nature. There may be a couple of people who see I'm right. I may be able to chip away at it a little bit, but in general it's ingrained. It's evolutionary. And it would be foolish to think that I could really have any effect on anything. People are going to remain stupid and commit atrocities in the name of good. That's the way it's always been. Name one major cataclysm or atrocity that *wasn't* committed in the name of good. Name one person who ever came out and said, "I'm doing this for evil, people." It's always in the name of purification, of "exterminating the scum." I'm not saying I'm righteous. To me, it just makes for black comedy. I've never claimed to be a righteous person. It's just always galling that people miss the big picture. When I wrote *The Redneck Manifesto*, people were screaming about hate speech, and yet they're spewing hate speech against poor whites. These are people who would break out in a rash if you said "spic" or "nigger" or "cunt"... these are the *same* people saying "redneck," "cracker," "toothless inbred hillbilly mama-fuckin' lowlife piece of SHIT!" And, well, don't you see a little bit of a contradiction there? "No." You could fucking spell it out for them, and they wouldn't see it. And in *Shit Magnet*, there's a woman threatening my life, physically attacking me, and the minute I hit her back, BOOM! Cognitive dissonance drops like a curtain, and nobody can see that as a complex situation. Nobody can see that she was malicious or violent or any of those things that a man always gets tagged with. *Trucker Fags in Denial*, same thing. These guys are out killing fags while engaging in fag sex. My skinhead article: These guys are out harassing people for what they wear, seeking to exterminate The Scum, which is exactly how a Nazi thinks. To me, it's that 800-pound gorilla, the giant monster sitting there in the room, and nobody sees it. That's what is fuelling me at this point. It's blackly comic that these people are so stuck in a binary way of thinking that they can't see it's the same principle running through all of these things.

Gene Gregorits: You've been dealing with some intense obsessions since *ANSWER Me!* In that magazine, there was a finger pointed at subculture, and you were pretty fixated on death, and since then you've gone on to cover class and race. In there now anything new to add to the list?

Jim Goad: I think the big themes, post-*ANSWER Me!*, are guilt-projection and scapegoating – poor whites, definitely, in *The Redneck Manifesto*, and males in general in *Shit Magnet*. I guess the only thing that's cropped up recently to evince those things is that article I wrote recently for VICE magazine about my encounters with the anti-racist skinheads here in Portland, who are going around *acting* like Nazis, shaking people down, and physically attacking

GG: You come from a working class background...

JG: ...but I never claimed to be entirely that. I'm really a weirdo straddling two worlds.

GG: But you are enough *of* that world to be in a better position, morally, to speak about it and to defend it. Why do you think there haven't been more people, of that class, making the same arguments that you're making?

JG: There could be all sorts of reasons. Maybe there's nobody who's a hybrid weirdo, like I am. The ones that are from that class, maybe they're too busy going to NASCAR races. Too busy working! That was a big thing that fuelled *The Redneck Manifesto*: I realized that the creative class was the upper class. They're people who had time to create. And invariably all their creations reflected a protected upper-class existence. So why don't they? I don't know. Maybe I already summed it up, but nobody can argue with it. [*laughs*] And another thing I hit on in the book... people will say, "Well, rednecks don't read that shit!" Well, you know... some ghetto hood rat doesn't read Maya Angelou, either! But you never get *that* fuckin' criticism!

GG: [*laughs*] One point you have proven is that it is possible for one to prove one's point too well.

JG: [*laughs*] I think my biggest creative frustration is that people just take shots and run. No one ever wants to argue with me. Or they'll say, "Don't even give a subhuman like that a forum." Well, if I am so subhuman, and I'm such a fool, then fuckin' argue with me, and clown me, because it shouldn't be that hard. So I have to wonder if they actually believe I'm a subhuman, or if they're just intimidated by me.

GG: Let's get on sex for a bit, since sex is what your upcoming book deals with. How's your love life these days?

JG: Ehhhh... complicated as always. I've reached my three-dozenth vagina since paroling, which is...

GG: [*laughing*]

JG: ...easily three times as many vaginas as I encountered before going to prison.

GG: You didn't even talk about sex very much before prison.

JG: Hey! You beat a woman, then go to prison for that, and they all wanna hang on it! I'm not really glad that that's the way the world works, but again... is that proof of female masochism, or that they like real bad boys... maybe they like a guy who actually put his money where his mouth was. I have a fuckin' appeal like I never had before.

GG: Did you have the idea to do a book on sex before the prison term?

JG: No. When I got out, I got a job for a porn magazine, so I just tailored it around that.

GG: What's this book have, aside from the subject matter itself, that your other books didn't?

JG: I think there's more straight satirical stuff like 'Adult Films Made By Children'. 'Virgin Mary's Face Appears in Wet Spot'. 'Penis Sizes of World Religious Figures'. 'In Search of the Prostate Gland'. More satirical.

GG: *Shit Magnet* was optioned for a film. I'm assuming that's going to be some type of documentary, right?

JG: No, they want to make it into a fictionalized movie that they consider a love story. They bought the option a year ago, and now they have about three more months to turn it into something before it runs out. They don't seem very close to getting it made.

GG: If they get this off the ground, will you have to be closely involved in it?

JG: Yeah, of course. I'm a total control freak over that stuff, because people always get it wrong. The only thing that I didn't have control over on *The Redneck Manifesto*, at least on the hardcover, was the subtitle. They chose this appallingly stupid subtitle: 'America's Scapegoats: How We Got That Way and Why We're Not Going to Take It Anymore'. The very minute somebody starts interpreting you, there's gonna be problems if you're halfway intelligent and actually care about how you're going to be presented.

GG: Simon and Schuster didn't do anything to promote your book – out of fear, I assume. Did you manage to make any high-profile connections over the years, despite the book's marginalization?

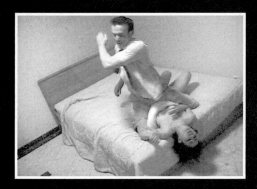

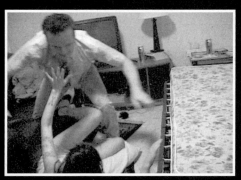

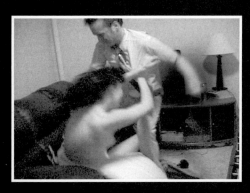

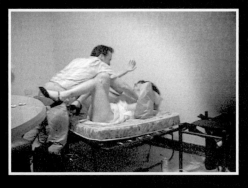

JG: I still think that anyone who knows me, knows me from *ANSWER Me!*

GG: You're talking about American society in a way no other book has, and it seems like the book should have prompted a bigger controversy. Are there any political writers who take you seriously?

JG: [*laughing*] I don't know! Look, if you beat a woman, you're a pariah. That automatically makes you *not* credible. Alright, so what did my crime have to do with honesty? What I did was *intensely* honest. I felt like beating her up, and I did. She fuckin' bloodied my nose. That's what always irks me. "Oh, he's lying about this." I suffer for being honest, at least people should cut me that much slack.

GG: Have you ever considered holing up in a compound somewhere? Is it really worth it? Because you just wrote, last week I think, on your website, that, "the world is upside down, and the reason I write is to turn it right side up. I'm having trouble lifting it all by myself." Do you ever feel like it's just not worth the effort?

JG: I am told, "what you're doing is shock value, you're trying to offend." What offends me is this: I'm not writing for anyone but myself. I happen to get paid for what I write, and I would probably slit my wrists if I had to go to a normal job now, after everything, but again, I don't suffer the delusion that I'm going to change anything. I think that maybe there are some benefits to getting my opinions out there, but they're *my* opinions, and I'd feel this way whether or not I wrote about them. But yeah, way too much has already gone into making human nature what it is. I can't change that. But I'm ultimately compelled by the idea than I'm right! [*laughs*] And they're wrong. And I won't fuckin' shut up, until one of us cries uncle. If I wanted to do 'shock value' it'd be a hell of a lot easier and a lot less risky. People do freak out, and some of them are upset that maybe I *am* right, and all their most cherished beliefs just dissolve under my scrutiny. [*laughs*]

GG: A lot of people are hated more for their political affiliation, or their philosophy, their agenda... but you are not merely stating your case, you are tearing your enemies into little pieces, and laughing at them. They hate you not only for your beliefs, but the fact that you're laughing at them.

JG: Because they've made my life so fucking inconvenient! It goes back to the *ANSWER Me!* obscenity trial. People on my side were saying, "Oh, these fuckin' redneck Republicans!" It's not the redneck Republicans who started that shit against me! It's these screaming protected liberals! They fucked my life up then, their philosophy about gender relations, certainly, is what landed me in prison for two and a half years... not because this woman suffered so much, or because she wasn't a predator or violent. *These are the people who fucked my life up!* And they're WRONG at the same

time! So of course I'm going to be outraged and write about it. To me, that makes perfect sense!

GG: I can think of other non-fiction writers who are despised and vilified, like Michael Moore or Al Franken, two guys criticizing current politics and the Bush administration. I don't see any of that in your stuff. You're aiming at the very subculture, more often than not, which you also happen to exist within. I'd be nervous if I were you, because you're outnumbered. Doesn't this make your life dangerous, in a highly cultural town like Portland?

JG: Yeah, of course. But again, why should I shut up? About three years ago, I broke up with this girl who was threatening to have me sent back to prison if I kept the dog that was given to me as a gift for my 40th birthday. She called some greaser, ex-Nazi guy to beat my ass, and… this one guy was like 6'5", former Army Ranger, could have easily torn my head off. He said, "Hey, I need to talk to you outside." So I went outside. He said, "What happened with you and her?" I told him, and he asked me a couple more questions. He said, "Okay. I'm going to take you inside and buy you a drink." He said, "You know what? Everybody in this town poses like they're a real badass, but you're the only motherfucker in this town who actually went outside and talked to me." I said, "Hey, you could rip my head off, that's not going to make me wrong, and I'm not going to shut up if I'm right." Because I didn't do anything wrong to this girl until I tried to leave her, and then she pulled all kinds of shysty shit. Why give up if you're not wrong?

GG: Maybe that's something to envy. Some people have to respect the threat of danger when they have nowhere to fall. For me, pride is less important, at this point in my life anyway, than remaining physically intact. One thing that prevents a lot of people from proving their case, or justifying themselves, is fear. Or poverty. They can't afford the hospital bills or the legal bills.

JG: I can theorize the same thing about crooks. I always wondered, while I was in prison, about this bloodlust to just *smash* criminal testicles. The warden at Oregon State Penitentiary was a woman whose husband had been killed by a drunk driver. Apparently, she wanted every fuckin' criminal to suffer for time immemorial. Hey, my brother was murdered in Paris, in 1969, stabbed 40 times and strangled with his own belt, YET… *miraculously*, I don't want to kill every criminal. I don't have this hard-on to seek blood vengeance against people who never committed anything against me, or my brother, personally. So it can't be just that they were transgressed upon. Most people wanna do things that criminals do. And they resent criminals because criminals actually had to be shackled and beaten down to stop them. These normals are people who have been beaten down without anyone even lifting a finger. They are scared, so of course

Above: Jim Goad, Portland, 2004. Photo by Jesse Watson.
Opposite: Jim Goad in **The Suzy Evans Story**, a film by Dave Taylor.
Photos courtesy of Jim Goad.

they're going to resent the criminal – the criminal's got balls. That's why they hate them… not because of anything they actually did. And I don't understand getting upset about a crime that didn't happen to you. Maybe that's solipsistic or sociopathic. But as long as the thing hasn't been done to an animal, I don't care! Because of the fact that humans… well, they're guilty! [*laughs*] If they didn't do what they're being blamed for… well, they did *something*.

GG: Which brings me back to sex. When I was in Portland, I had ample opportunity. What is it about Portland that keeps the meat rack so well-stocked, and in steady rotation?

JG: Well, as far as the sex industry… apparently they have a certain kind of obscenity law where if *one* person in the community finds value in it, then it's not obscene. So with that, you wind up with more strip clubs per capita than anywhere else on Earth. So yeah, I've gotten a lot of action but again, I was here for three or four years before going to prison and it wasn't the same as when I got out. When I got out, it was like Gene Simmons on tour.

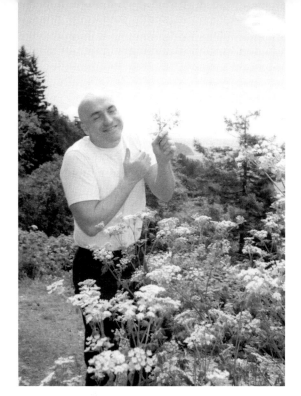

Jim Goad, Northern California, 2005. Photo by Jen Osborne.

GG: There's this whole twisted idea of what a sociopath is supposed to be, but you don't think you're one yourself, do you?

JG: I might have sociopathic traits, but I don't think I am a sociopath, no. As self-serving and ridiculous as it sounds, I think I'm over-compassionate in some ways. I have compassion for groups that most people feel need to be exterminated. Who really cares about poor white trash? Who has any sense of empathy for what males go through? All it takes – and a lot of guys who are going to be reading this know *exactly* what I'm talking about – all it takes is to just be accused of something, to have your fucking life *ruined*. There is a type of woman out there who knows that. And they get away with it. You take a lot of shit for even bringing that subject up. Me, especially. When I say that, I look like an abuser in denial. I've been accused of felonies twice in my life. Each time I'd done something wrong. And each time, the accuser embellished and lied. Unless you've fuckin' been on that side of it, you really don't know how that feels. Actually, I think that one of the lines in *The Redneck Manifesto* was, "I'm not here to deny any of the guilt that you know about… I'm here to infer that there's a lot more guilt than you might have suspected." So if anything, I might just be the opposite of a sociopath. I might be just a little more hypersensitive.

GG: The thing that might lead someone to suspect the sociopath would be your lack of fear.

JG: I have that because I'm really not impressed by mob mentality! I'm not swayed by what the current sentiments are! That's what always blew my mind: this thing that people don't see. "What a coincidence! Everybody in Iran is a Muslim! What a co-incidence, everyone in Portland is a P.C. freak!" People just *go with the herd*! And I never did. Maybe that makes me a sociopath. One-on-one I can get along with almost anyone! Was it Nietzsche who said, "Madness is rare in the individual, but the rule in society"? It's true! Societies do much more horrible things than any individual serial killer has ever been able to accomplish. And wasn't that the premise of *The White Negro* by Norman Mailer? That in the face of the Holocaust, the atom bomb, communist atrocities… that the only noble thing to do would be to pick up a knife yourself. And start killing.

GG: There is a re-issue of *ANSWER Me!* coming out, in collected form within the next year. It will be entering a much different world now than when those magazines were first published. Do you think it's going to find a new legion of readers?

JG: Yeah, maybe. I think that more than anything, that was the one that just slammed people upside the head. A lot of people, the first time they see it they're gonna go nuts. But legions… [*laughs*]… I don't know.

GG: Okay, that's a little corny maybe. But who *are* your fans?

JG: I don't even talk about that. I hate getting blamed for certain fans. People do things in your name that are kind of retarded.

GG: You almost tried to *lose* your readership, with *ANSWER Me!* #4, the 'Rape Issue'. But the people that stuck with you through that…

JG: …well, those are people who actually understand what I'm trying to say about human nature and hypocrisy… especially people who can discern that there is some effort and thought in there, that I actually try to turn a decent phrase here and there. I think it was H.L. Mencken who was commenting on somebody and said, "This person does not have the honour to realize that maybe his enemies have noble intentions." That's the most frustrating thing I encounter with my harshest critics, is these people who can't even see that "maybe this guy IS trying, he's thinking. Maybe I don't agree with him, or ever get past what the politics are to acknowledge there's effort there." That yeah, I can choose a good word here and there.

GG: There's that joke of the writer suing himself for libel… of everything you've written, does anything stand out to you as something you regret? Do you have regrets about anything you've said?

JG: [*laughs*] No. Why? Even if I don't like it now, it's what I felt at the time. I think the only stuff I regret is the pre-*ANSWER Me!* stuff, where unconsciously or otherwise, I curtailed what I was saying because then I really was conscious of the editors… and the audience. That was the magic of *ANSWER Me!* I just threw all of that out the window. Whether the reader wanted to come in or not is optional. But we were saying what we felt… and that made it [*laughs*]… unique.

GG: Well, you mentioned H.L. Mencken, who definitely pissed off a lot of people in his day.

JG: He pisses more people off now than he did then. He was pretty popular in his day, actually.

GG: I don't know where I was going with the Mencken thing now, I've sidetracked myself. But maybe you are a modern equivalent. I know you really like Dickens… and you don't comment on music much, but you loved the early Clash records. Isn't there a connecting thread of social justice there that interests you? And who is there from the last, say, twenty years who has fought for that, who interests you?

JG: Well once again, I don't really see much good coming from fighting for social justice. You have to take a shine to society to want that, and I really don't like society very much. But what has impressed me over the last twenty years? Well… the *Unabomber Manifesto*. Yikes. Little things here and there, people that have a unique, weird take on things. I keep going back to this guy The J Man. He's a really good writer who filters everything through Christianity. He annoys the hell out of people. That term 'social justice' leaves a bad taste in my mouth, even saying it. It's like ordering the Rooty Tooty Fresh 'n' Fruity Special, just having those words come out of my mouth.

GG: Yes, I know it is very unpleasant for you, but…

JG: …what I liked about The Clash is just that they were powerful. It had nothing to do with social justice. The first time I saw them, they were just unbelievably loud. Forceful. And Dickens? He was funny and drew really colourful characters. *Hard Times* was I guess his most socially conscious work, and it's probably his worst. I'm not sure that a fight for social justice is really what appeals to me in any of these people.

GG: I see that *The Redneck Manifesto* was powered primarily by the theme of guilt projection or scapegoating, but do you see where someone who feels a socialist thrust when reading that book might be coming from?

JG: Yeah. [*laughs*] I mean, I think I lay enough traps in that book where they really *shouldn't* get that impression. Social critics are usually the most socially maladjusted people, and the last people to look to, for social criticism. That's one of the great ironies.

GG: Well, a lot of times people like that seem to be maladjusted because they are viewing the world from the furthermost possible outpost, where maybe things can be seen objectively.

JG: Apparently, I don't know. I really want to see this movie *Michael Moore and Me*, from a disgruntled former employee of Michael Moore. Have you heard about that?

GG: No. And your thoughts on Mr. Moore?

JG: He's a self-righteous turd! Okay, great… he comes up with some good factoids. But *would he be a better president*? I don't think so. It's so easy for all of these people with horrible personal lives to criticize people in power, who are there for a reason. This is really

"Social critics are usually the most socially maladjusted people. That's one of the great ironies."

unpleasant for most people to ponder, but they're probably there because they can do a better job than the critics. That may be reactionary, but it's true. It's much easier to criticize! People understand that principle with music or with writing, but not with politics. Janeane Garofalo would be a good president? Al Franken? Gimme a break! He's a comedy writer! Where do these people get off thinking that they know how the world runs? They don't! That's why they're in the creative arts! Because they're spacey! [*laughs*] It's so obvious! It's like George Bush reviewing 'zines or something… he wouldn't know what the fuck he was talking about!

GG: But would the world be a better place without the efforts of Michael Moore and Al Franken? I mean, you have to be outraged by what's going on, with the Bush administration. It's impossible not to be!

JG: I'm not outraged. [*laughs*] I disagree that it's impossible not to be outraged. They have power, they operate like any power mechanism does. I saw the Cheney/Edwards debate, and I was blown away by how brilliant Dick Cheney is! That guy is Dr. Strangelove! And it's obvious why he's in power, because his IQ is probably 220 or something. Edwards is this legendary trial lawyer and he looked like a little baby. And Cheney's answer, every time, was "Oh, you don't know what you're talking about." He just swept him off of the podium. It's amazing! Outraged? By what specifically?

GG: By their arrogant dismissal of NATO and the UN. Their constant misinformation. And the unemployment rate has skyrocketed under Bush. I depend on dog labour to survive, and I can't even get a job washing dishes.

JG: Was it better under Clinton or is that just a trend that's been ongoing for decades? Workers get fucked! I'm always amazed by these people who think there's a significant difference between Republican and Democrat. I remember seeing this one study about Republican warmongering… it showed that Democrats have started and escalated more wars than Republicans! Another thing I like to throw in people's faces is, what party do you think Abraham Lincoln belonged to? What party did most of the black senators and congressman in the

Jim Goad, Portland, 2002. Photo by A. Ivancie.

Reconstruction South belong to? They were all Republicans! The Democrats were the party of the KKK and lynch-mob justice! And that blows most people's minds! I'm always chagrined when I see these people who really should know better and be a little more complicated fall prey to these simple, binary us versus them, good versus evil scenarios. There are much larger mechanisms at work, Republicans and Democrats are two arms of the same monster. The Federal Reserve is what people need to attack. *That*'s where the power is. It's a fact that this entity called the Federal Reserve is *not* federal, it's not part of the government, they will tell you as much… it's a fact that this association of private bankers who print worthless paper money then charge us taxes on it, is what's causing inflation and joblessness… you get rid of the Federal Reserve and let the government start printing money again, like they did before 1913, you could house *everyone*. Every fucking social problem, at least the ones that are financial in nature, would be erased. Where do you see any of these Bush attackers even talking about the Federal Reserve? They don't even *know* about it! [*laughs*] This whole thing of there being this weird right-wing conspiracy…it's bullshit! Look at it. You print out a thousand dollars, lend it out, then expect eleven hundred dollars back… you're gonna have to keep printing money to perpetuate that system. That's where most of the financial problems in this system come from.

GG: Well, I don't know anything about the Federal Reserve, but there is plenty of evidence out there that the 2000 presidential election was stolen. There's been a multitude of books and films released since then to unequivocally prove that.

JG: I don't *care*! I just don't care. I don't see how either one of them isn't a highway robber. You're voting for who's gonna steal 40% of your income. There's no consent in that. Whoever you vote for, they're going to take your fucking money and do things with it that you don't sanction. It's a shell game between Republicans and Democrats. Either way, they're going to rob you. And that's what I find hilarious but tragic. People miss that. People whine about social programs. Most of the money doesn't go to social programs, it goes to paying off these fucking bankers. And then of course, you get, "What are you, an anti-Semite?" And it's like, "No. *You're* the one who brought up Jews! What, are *you* saying that all the bankers are Jews? I'm not, I'm just saying they're bad!" [*laughs*] How do you argue with that? It's extortion! It's paying the school bully to take care of you, either way… and again, the bigger picture…

GG: Let's switch to a topic that I am slightly more qualified, or prepared at least, to discuss.

JG: [*laughs*]

GG: Publicly exposed genitalia. Please tell me about this recent incident of penile exhibitionism on your website. What prompted you to flash your readers?

JG: A long time ago, Debbie took a picture of me at Mardis Gras. I don't know if the angle was bad? But I'm like, "I'm never showing anyone my dick, EVER!" Then about a year ago, I had a girlfriend who insisted on taking pictures, and she showed me the Polaroid. I said, "Yeah! Alright." Then, I just got into the habit of taking pictures with my cell phone… and started sending them out to girls. It took off from there. If a girl did that, "Oh, she's empowered… she's sexually positive." A guy? Well, then it's just tacky. Tacky or not… it gets me action.

GG: Did Hunter Thompson's suicide upset you?

JG: I was a little surprised that he killed himself; beyond that, not much feeling either way. The only celebrity death that I felt sad about recently was Waylon Jennings. Waylon… maybe this sounds gay, but he was the perfect man. You listen to his voice, he's got the machismo of Johnny Cash, but there's this tortured, anguished element to it. I'm not a big fan of the stuff he did with Willie Nelson, and I'm not a fan of the '70s bearded hippie stuff, but when he was a greaser in the '60s… a lot of people don't know that he was Buddy Holly's last bass player, and that he was almost on that plane that crashed. His music in the 60s was timeless. And everything that I would hope to be as a man. Strong, but also emotive. He was perfect. I was very sad when he died.

Beautiful Fibber

- Carla Bozulich -

*"A fool I have lived, and a fool I will die
But you'll go to the devil, for making me cry."*
– The Geraldine Fibbers, 'House Is Falling' –

Carla Bozulich, with The Geraldine Fibbers, birthed some of the most piercingly, explicitly evocative meditations on the nasty side of love in all of modern music. Mournful, multi-dimensional country ballads ridden with track-marks and tears, ripped clean open by punk fury. Carla's dusky, desperate, and sometimes deranged voice is a revelation, her words stretching the possibilities of how far an artist can seduce their audience. I delight in playing The Geraldine Fibbers for my most fucked-up friends, because I know it won't be lost on them. I've loaned those CDs out countless times, occasionally having to buy them again. More than once, people have thanked me in a most tender manner for having turning them on to this music.

Imbued with a vivid sense of horrible heartache and long-term sex and drug damage, the Fibbers' *Lost Somewhere Between the Earth and My Home* and *Butch* are both unique examples of aggressive country and rock fusion, timeless albums deserving of a much broader audience. The former, in particular, showcases a level of hurt that is the very essence of confessional songwriting. And for all the brash surrealism, unrelenting torpor, and frantic violence of The Fibbers, there is a deep and very powerful beauty at the core of their music. The sentimental stranglehold of drug dream imagery and dingy apartment flashbacks that drives a song like 'Marmalade' or 'Richard' only points back to Bozulich's source; the culmination of her time served in ugly places. This music is as purely human as anything I've heard by Waylon Jennings or Dolly Parton.

Carla's discography stretches back to 1982; she spent several years thrashing through the underground in a series of obscure punk bands. After an extended absence, Carla re-appeared – minus a few dangerous habits – as vocalist for Ethyl Meatplow, a short-lived art-performance band who revelled in public indecency; stylistically unclassi-fiable troublemakers perhaps remembered more for their stage antics than their music. The Fibbers, formed by Bozulich in 1993, signed to Virgin two years later. Their first and second albums with the label garnered the adulation of critics everywhere, from *Spin* to *Rolling Stone*, but sold poorly. They did not record a third. *Lost Somewhere Between the Earth and My Home* is far too beautiful a record to miss. Everyone should hear it.

Since then, Carla has continued to be active in music, playing often with Wilco guitarist and ex-Fibber Nels Cline in a series of collaborations and side projects. 2003 saw the completion and release of her dream project, a track-for-track interpretation of Willie Nelson's 1975 concept album *Red Headed Stranger*. Nelson himself sang on three songs. Carla's solo debut *I'm Gonna Stop Killing* was released in April 2004, and her latest at the time of writing, *Evangelista*, was released in May 2006. More information about Carla and her music can be found are at her website: www.carlabozulich.com.

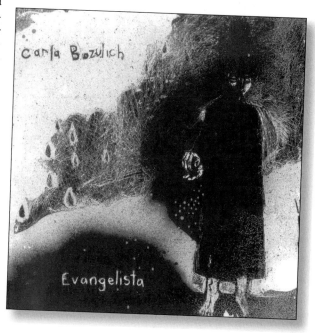

Carla Bozulich, 'Red Headed Stranger', 2003. Photo courtesy of the artist.

Gene Gregorits: In your darker days, you saw the worst of this city in the worst possible ways. What are your feelings about LA now? Does it haunt you?

Carla Bozulich: When I drive around, I find places where I have never been. I get lost on purpose. I do that very impulsively all the time. I do it so much that it makes me late for things. I like to see things and find pockets of things I had never pictured before. I also like to try and sense geographically where I am, then find my way out. I think I just enjoy the process of it. I really do get lost, and generally it takes me a long time to figure it out. I

take a lot of wrong turns but I get to see all kinds of stuff. I like gardens. A lot. And I like architecture a lot, so sometimes I'm just looking at that stuff. Sometimes I'm just trying to see where a certain place fits into the perspective of the city in general. I just love Los Angeles so much.

GG: Did you grow up here?

CB: Yeah, I grew up in San Pedro, which is about thirty miles south of downtown LA. A harbour town. It's the harbour of Los Angeles. It's incredibly beautiful and diverse, and hilly. It's very much like San Francisco in a

lot of ways. It's a throwback town, very steeped in tradition. It has a lot to do with very hard work and old country values. There's a lot of dangerous, dark, masculine energy.

GG: What is your heritage?

CB: I am one quarter Armenian. I'm German. I'm Romanian Jew. Also, Scottish. I was actually born in New York City, and I lived there for the first couple years of my life. The interesting thing there is that I always disagreed with this New York arrogance, and judgemental-ness, and ridiculous self-image of being a New Yorker, and total self-importance.

GG: New York is great, but it isn't all. I don't see a complete justification for that extreme arrogance.

CB: The funny thing is that even having only lived there for two years of my life, I don't know if it's the influence of my folks, who lived there a lot longer. The fact that my dad stayed on there, and I had this mythical idea of him as this super progressive, musical, political, gentle, non-violent, civil rights activist, smartypants, college guy… gone wrong! But I always possessed that same arrogance that I hate in others, to some degree. I would be in San Pedro, or I would be in LA, and I would always feel that same weird pride of the whole New York East Coast thing. Even though I was only two when we left! It's crazy! But I still feel it now. Even though it's a total contradiction to what I just said. I guess the two sides have made peace inside of me. [*laughs*] Added to all of that, I know for a fact that in many ways, Los Angeles is a place I need. I could never, ever have the things I enjoy about my life anywhere else. I like to drive up into the mountains, and it takes me only an hour till I am at the top of the mountain. I'm in this beautiful forest. It's so interesting, because at the bottom of the mountain, it's desert. You start ascending and it becomes forest. If you go to the east, there's Joshua Tree, Death Valley, the whole Mojave Desert. If you go south, you hit San Pedro, which is incredible, and it's this part of the coast that people who carry these stereotypes about LA have no idea even exists. There is a very small beach and then the harbour. Aside from that, it's all cliffs and it is the most insanely beautiful place in the world! Tide pools! You go there and you could be down there for hours and hours, negotiating with the tide. The tide comes in, and, 'Uh oh, we're fucked!'

GG: Okay, I was living in Brooklyn, getting ready to move out here. I had been to LA briefly, for a few days, the same month. I returned to New York with total fear. You know? I had been dreading it for some reason. Also, I had never been on an airplane before. When I came back, the fear was justified. I was ten times more afraid. I was playing that record. A lot.

CB: What record are you talking about?

GG: *Lost Somewhere Between the Earth and My Home*. What I am trying to say is, that… I sensed something…it got me ready to come out here. I had to

get used to the fear, and accept it. The album seemed to say that LA is where anybody who is weak gets their ass kicked in a very ugly way. That this is where love got the shit beaten out of it and thrown out to dry. Do you feel it is a malevolent record?

CB: Yes, of COURSE! [*laughs*]

GG: Is the death in the record stronger than the romance of it? Is there light at the end of the tunnel?

CB: Oh yeah. There's a few times where, as a game with myself, I tried to force myself to write something that wasn't darkly tragic in terms of romance. Love. And it was really like fuckin' pulling teeth. It was an exercise that I did. 'House Is Falling' is an example of that. If you really listen to the words, I couldn't quite get through it without putting in the ugly part too.

GG: What about 'Richard'? That is one of the most terribly ugly and depressing songs on that record!

CB: That song, to me, is hilarious! That, to me, is strictly entertainment, it's comedy. It's directly inspired by a book called *The Master and Margarita* by this guy named Bulgakov. It's not really based on the story, it's inspired by it in humour and style. You probably shouldn't read it in your current state, let's just put it that way.

GG: Too late! It's very scary to be reminded of the fact that even in hell, you're being laughed at!

CB: Well, what do you think? What do you expect the devil to say?

GG: [*laughs*] That's cool. Just nip that in the bud. One song on *Butch*, you talk about a man on a morphine drip.

CB: 'Trashman in Furs'.

GG: That's the one. There's a lot of drug-related romanticism in your songs.

CB: No. You're missing the point on that song. I use a lot of symbolism and a lot of metaphor. That song is definitely not romanticsing drugs. It's not about voluntary drug use. It's about medicinal drug use, when you're dying. They have to use a morphine drip when you are a terminal patient, to make your last days more bearable. That song is about a friend of mine that died from AIDS. That's what he was experiencing. The reason I used that imagery is because people that have been around terminally ill people… they know exactly, they know instantaneously what you're talking about. Even if it is somebody that is a drug addict, which this person wasn't, necessarily.

GG: There's a certain type of romance which does have a narcotic affiliation. Even if it isn't a song about drug abuse, just having known the hell of drugs… doesn't it give someone a certain urgency, in the way they look at things? You have to say that drugs do reshape one's aesthetic view of the world. Doesn't that have a lot to do with the way your songwriting has really matured over the last, say, ten years?

CB: It's definitely a part. I'm the type of writer that – this will come back to bite me on the ass – but I write from

"I work hard so that I don't have to have a structured life... I work hard to protect my good fortune of not having to live that way."

my own experience. I usually always deny that. [*laughs*] I just write from what I happen to have a stockpile of. Whatever it is. For me, at that time, I was still very traumatized by my experiences on the street. At this time in my life, I am so NOT traumatized by that. At all. It really depends on what is coming through. I do stream of consciousness writing, and then I go back and I edit. Most everything I do, I edit. Maybe ten percent of things will come out pretty much perfect. I like to work on things, like they're a puzzle. A lot of times I don't know what they mean, so while I am working on them I figure it out. It is very hard because you have to be very careful not to figure it out on purpose. If you figure it out on purpose, you mess it up in the editing process. If I am being intentional like that, I'll always be mistaken about what it means.

GG: Isn't a lot of what's great about writing, or about being a songwriter especially, is having the happy accident? Being surprised by what you do?

CB: That... what you're talking about... is my basic reason for being alive. That's why I have stayed alive, all these years. Because of that. That's all I care about in life.

GG: Happy accidents!

CB: That's all my days are. A series of accidents. They're not all happy, and they don't have to be. To me, the reason why it is so important in art is that it's just fuckin' boring, otherwise. Real boring. And I'm generalizing that, and there are exceptions. I work really hard so that I don't have to have a structured life, because I don't care to have one. I mean, if I had to, and there were other reasons for me to be around, I guess I could do it. But I work hard to protect my good fortune of not having to live that way.

GG: Your second Geraldine Fibbers record was *Butch*. Nels joined the band for *Butch*. What kind of a difference do you see between those two records?

CB: It's weird, because I don't know if it feels that different to me. They feel like part of the same piece. As far as bringing Nels into it, what was happening was I was getting much more interested in improvised sound, and in stretching. I wanted to stretch out artistically, and I wanted to explore a lot more instrumental music. Nels unfortunately didn't come into the picture until the album

was already written. And so I really hoped that we could have made an album after that because I was always dying to hear what would happen if Nels was part of the writing, from the beginning. We wrote two songs together, on the album, after he joined. Obviously, his influence on recording was very positive. His whole influence on the group was so big. Aside from the fact that he's gotta be one of the best musicians living, and creative thinkers, let's put all that aside. Nels has a demeanour that is so inviting and inclusive and warm and supportive. There's no babysitting Nels. There's no trying to figure out ways to say something that's not going to send him off on a tirade. He loved the band so much, that he was peeing himself that he was getting to play with us, which I am embarrassed about. But I know he would tell you the same thing. It was almost shocking to me, because I am so used to people conveying a sense of entitlement. And to people making me fly through hoops so I can have the honour of their presence. We were totally seeing eye to eye musician-wise. We were inspiring each other and challenging each other. It's not other people's fault that I get drained like that. It's totally my fault. I just have a personality that you can do that with. You can put your suckers on and just suck. I don't even know I'm doing it, until I'm really, really tired, and I'm having a hard time getting my job done. The experience of making that album with Nels, and having it be so exciting... we got to invent things every day. We were lucky to have a great studio, and a great producer and engineer. I would be watching Nels do a take on a song. I remember sitting there watching. I'm thinking, 'It's just me and these two other guys! We're the only two people that saw that!' I think you know what I mean. I'm watching Nels overdubbing guitar on 'Yoo Doo Right', and I'm thinking, it's just me! I remember looking around, like, 'WHERE ARE YOU GUYS?' [*laughs*] It was like that every day. I had never seen anything like it. The thing about him that is so special is... yes, he can play anything he wants. I don't know if there is anyone in the world that could get sounds out of a guitar the way he can, but that's not what makes him good. What it is, you can hear his own insanity and private depth shooting straight out of him.

GG: Will there ever be another Geraldine Fibbers record?

CB: I hope so. I always wanted there to be one. I never said the band was broken up. You've probably heard that we were, but it was never from my mouth. It's a project. And the thing about it is, when we stopped playing, I had another album in the works, in my head. There were a couple of things that happened that made me not go for it right then and there. But I still have the ideas in my head.

GG: After *Butch*, you did the *Scarnella* album.

CB: Most of the members of the Geraldine Fibbers didn't want to talk to each other any more. I just wanted to do something, if any big records company listened to it, they

Carla Bozulich, songwriter, late '90s, Los Angeles.
Photo courtesy of the artist.

would say, 'This is hopeless'. That album, *Scarnella*, was made in a very selfish manner. I needed some healing, I felt so dirty and sick at that stage in my life. Nels took a lot of time out of his life to try to help me get back on my feet. *Scarnella* came out of that. It got me back into improvising.

GG: What came after *Scarnella*? You're always working, you never stop working. Whether you're touring or not...

CB: Right. I was working on these drawings of horses. That was something I could do without moving too much. [*laughter*] That went on for a while.

GG: And you have painted cats.

CB: Oh that's right. The cats! I just simplified my life, a lot. I started getting into rocks. I started getting into gardening. Cactus. Rocks. Old pieces of wood. That's another thing that helped me to get stronger, is just playing in the dirt. A lot. I'm one of those people. I'll say I'm going out in the yard, and you'll come out there in a few hours, and I'll be covered head to foot in dirt. I have this friend who is a geologist. He spends a lot of time in Utah, and a lot of time in Arizona, and different parts of California. He always brings back boulders for me from these incredible places. I have green rocks, and clear rocks, and rusted ore. Lava. All these things that I don't know the names of. I go up into the LA forest a lot and I get rocks from up there. Some of them are so cool. There's this one outcropping that is mostly grey granite; ink stripes run through it; they're diagonal. If you're

lucky, there'll be some big boulders that just fell off, and you can get them, hopefully, if you're strong enough. Anyway, what I had done was, I had made this edging around my whole yard... with rocks... I was obsessed with that 'no mortar' kind of thing. I was fitting all the rocks together, so that they fit exactly. I was chiselling at them, with a hammer, so that they would fit. I made these walls, all around my yard, with these incredible rocks and stones, all different colours. Since I'm a heavily compulsive person, I'd be out in the yard from seven in the morning until two or three a.m., doing this under the streetlights. I would have to slow down on my work because once I got back inside my hands would be bleeding. I would be hunched over, I'd have to put ice all over my body. The next day, of course, I'd just get right back out there, you know? Anyway, I've had to slow down a little. I try to come in when it gets dark now.

GG: I saw you performing the Willy Nelson tribute show.

CB: No, it was not a tribute. It was us performing the entire Willie Nelson album *Red Headed Stranger*. I think it's one of the best things I've ever done. It's also the most likeable thing that I've ever done, in terms of a broader audience. Seems like all kinds of different people like it, that don't have anything to do with each other's taste.

GG: What about the bug movie?

CB: I did a song for a movie called *They Nest*! I did a song called 'Crushed'. It's a country and western song. And the movie... it's about cockroaches. And how they attack a town! The song is about a cockroach falling in love with a lady in the bathtub, who is about to step on him and kill him!

GG: Aw. That's really sick. What will you be doing in the near future, do you think?

CB: I have to start dealing with the fact that nobody's calling me back about this *Red Headed Stranger* album. All that requires is me calling them, and going, 'What's your problem?' Beyond that, I can put it out on a fantastic label that I love and would be very happy with.

GG: What is the name of the label?

CB: 'Kill Rock Stars'. I love them! I want to say one more thing about Kill Rock Stars. I think we're far enough away from it now that you can really look back at a time where the music scene became more inclusive of women and girls, in a very dramatic way... to the whole Kill Rock Stars thing in the early nineties. That's big!

GG: But they put out men, too. Let's not forget about the boys.

CB: They like girls.

GG: Yes, they do like girls. Yeah.

CB: I like girls.

GG: Me too! But wait... you should have the last word.

CB: I did.

Carla Bozulich and Jim Reva during the Ethyl Meatplow days. Reva is the inspiration for 'Trashman in Furs'. Photo courtesy of the artist.

Kicking the Pricks

- Chas. Balun -

You can blame Chas. Balun for *Midnight Mavericks.* That's right, because if it weren't for him, many of the artists covered in these pages could very well be unknown to me today. And that tragic ignorance, dear reader, may have been a contributing factor to the worst death of all: a normal career. Imagine, if you will, The True Horror: a parallel dimension in which your sub-normal scribe, rather than marinating his cerebral cortex in uncompromised anti-intellectual depravity on a nightly basis, floundered in an air-conditioned office forty hours a week, sexually harassing a curvaceous co-ed bimbo at the front desk, and pulling in big bucks souring the already bankrupt fabric of this nation's heart with demonic television commercials or soulless music videos. *(Coulda happened. Sure.)* Anyway, I think you get the point here.

Jack Ketchum called him the Lester Bangs of film critics, and justifiably so. A rip-snorting, seriously pissed-off junkyard dog of a film maven, Balun has been setting the record straight about the horror genre since the early '80s when he self-published *Deep Red*, a small press, but slickly laid-out title which never failed to shock, amuse, and inspire. *Deep Red* didn't hint at its subjectivity, nor its anger, nor its incredible LIFE: Balun slammed it down your throat like a bloody set of scraped knuckles. His writing is a glaring testament to personal expression determined to rival the glaring emptiness of mainstream media. We who read Balun read him for honesty, first, and then humour. But it's the first that counts most, because it's the most scarce. And we want him *pure*.

The guttersniping punk in Balun is important too, for in moments where I don't agree with Balun, his sense of humour keeps me from losing any faith. He's a witty son of a bitch, downright viciously funny. Sharp and succinct, even artful criticism of one film will be followed by a vulgarian crucifixion of another, fraught with every four- and twelve-letter word he can muster. He's especially fond of nasty, spittle-flecked flames which involve descriptions of the post-mortem maggot expulsions of road kill. And that, too, is something to behold. Because more often than not, the films have it coming, they really do.

Balun's indelible mark was left on the mind of many a young horror creep, and I stand proud as one of them. Like Bangs, it makes sense to say that Balun imparted a certain vitriolic freedom to journalistic writing, and if you were hooked on hardcore horror back in the '80s, it's safe to assume that *Deep Red* was your bible. And if so, a certain 1989 info- and yanked-out-intestine-tract-packed tome known as *The Deep Red Horror Handbook* was the fucking Dead Sea Scrolls.

All those long years ago, I opened the first issue of *Sex & Guts* with a dedication to Chas. Balun. Unfortunately, I couldn't reach him at the time. Here, finally, the man speaks.

Gene Gregorits: What are your first memories of watching horror films?
Chas. Balun: I would say a great drive-in, double-bill feature of *Jailhouse Rock* and *20 Million Miles to Earth*. I was 9 or 10, and I got to see the first film rated 'objectionable for all' by the Catholic Legion of Decency, which was *Jailhouse Rock*. And I saw Ray Harryhausen's monster from Venus in *20 Million Miles to Earth*. I thought, "wow, I'm on to something here. Rock'n'roll shit, and monsters from outer space. I think this can work!" And Elvis kills a guy in a bar fight, but was the hero of the movie. The Legion of Decency just hated that kind of thing. It kind of started from there, and forty-plus years later, it still seems to work.

GG: You don't write a lot about rock'n'roll, but you're a big music fan. Weren't you in a band at a certain point?
CB: Weren't all beer-guzzling, pot-smoking hippies in a band at one time or another? I mean, 48-minute jam versions of 'The Pusher' or 'In-A-Gada-Da-Vida'. [*laughs*] Sure. Playing guitar. And that's probably why I can't hear very well out of my left ear anymore, because that must have been how I was facing the amplifier. It's never been enough to just watch, and be a spectator and listen. With writing, and watching horror films, or watching rock'n'roll, or whatever… I wanted to *do it*, even if I did it pretty shitty, at least I was a participant and not just a spectator.

GG: I know you're very much into Blue Cheer and you love garage rock. Isn't Blue Cheer your favourite?

CB: Ah my favourite, well… they're all 'B's'. The Beatles, Badfinger, and Blue Cheer. And sure, when I first heard Blue Cheer coming out of the AM radio speakers in '66, even then I said, "fuck, those guys are playin' really *loud*!" Even though little AM radios only went up to 3 in the volume scheme, they sounded really loud and bad. And, "hmmm, they play about as well as I do and they're on the radio!" I liked this combination too.

GG: I guess you had an easy time seeing films as a kid.

CB: Yeah. Regular tradition in the Balun household, at least as far as I was concerned, involved going into the Fox Anaheim theatre every Saturday. A matinee was 35 cents in those days. I'd go see a double-bill and almost all of them were grungy horror and exploitation films. And in really weird bills too, like Walt Disney's *The Shaggy Dog* and then *House on Haunted Hill*. They'd throw these weird mixes of shit. And that was a tradition for years and years and years. Of course, being a good Catholic boy, finishing the monster movies then having to go to confession and say, "I'm sorry Father, for having wasted so many hours of my life watching exploitation films to expand my status in the spiritual world." So it was a good conflict.

GG: You wrote an article called 'I Spit in Your Face: Films That Bite'. And you were one of the first writers to write seriously about sick, morbid films like *Nekromantik* and *Cannibal Holocaust*. What's the first movie that really disturbed you?

The 15th Anniversary Special edition of Chas. Balun's **Deep Red** is, to date, the last issue to go to print.

CB: *Night of the Living Dead*. That was cutting edge at the time. I will always remember the little girl using the trowel to finish off her mother in the basement. At the time, you're going, "this really hasn't been done before!" The kind of nudity they were hinting at, and noshing down on the guts and everything. That was shocking, and it had that *cinema vérité* feel to it, where you felt a part of it. It was unlike any other film out at that time.

GG: What you've done over the years is work as a graphic artist. You've done covers for rock'n'roll albums, and stuff like that. Do you still do graphic design work?

CB: Oh, hell yeah! That's what I do. I've been a painter and an illustrator and a graphic artist… who wrote. It wasn't the other way around. Every few years the emphasis was shifted from one axis to another, but it never really changed the core of the matter. I was always a painter, illustrator, cartoonist, graphic artist, who could write. To me, it's way easier to write than it is to draw and paint well. I've always had an attitude, I was always a smartass, I was always good in college, I was always good in English, traditional reading, writing, arithmetic stuff, I mean, fuck, people paid me to write their term papers when I was in college. Even though I didn't know shit about something, I was still glib and self-confident and focused enough to put together a decent paper. Which is not to say that I am a great writer or tremendous wit or anything, but I can do it better than most people.

GG: That's an under-statement, man! Now, one area people may not know a lot about is your oil painting. Your inks are featured all throughout the pages of *Deep Red*, your artwork is in there, but your paintings haven't been. I wasn't aware of this work until I went to your website.

CB: I know, isn't it weird? I get that same reaction when people just go, "Hmmm….wait a minute. This must be a different Chas. Balun than *that Chas. Balun that we know*."

GG: It's so wildly diverse. Your subjects range from bluesmen and classic Americana to still-life's and nature portraits.

CB: I think I probably would have been a wildlife painter, in another life. That's a consistent theme in a lot of my stuff. I kind of respond to the natural world more than the mechanized or artificially constructed one. When you get to the heart of things, that's gotta be part of my old hippie/back to nature vibe. There's a lot of truth in the natural, real world around you, that's remained unchanged for millions of years, and a lot of trends come and go and some things remain constant. We should pay more attention to that. Give those things their due.

GG: I wanted to ask you about Jim Van Bebber… you had a project going with him called *Chunkblower*. What happened to that?

CB: It became one of the most expensive independent trailers of all time. I think he ended up spending 20 or 25 grand to make the trailer. They shot it on 35mm and they

had Steadicam, they had explosions, they had a soundtrack by Skinny Puppy. They wanted to film that for between $850,000 and one million dollars. This was ten years ago. They wanted to market an unrated, one million dollar film called *Chunkblower* with a cast of unknowns! Right away I said, "wait a minute, what's wrong with this picture? What are you guys thinking?" Look, whenever I'm in a conversation with people and *I'm* the voice of reason, then I really get worried. That was my first experience with the film process. I'm going, "okay, I'm a writer, I'm a painter. And I'm sitting in here with these guys who are *film people*." They're different from you and me. Film people are different. Waaaaaay different. I was sitting in this motel room on Sunset Blvd., listening to the producer and the director arguing, "I've got to shoot this in 35mm" and "I've got to have this kind of a budget." I just sat there and thought, "Jesus, you want to spend 35 grand on the fucking trailer?" Why don't you just make the movie for that, and shoot it in 16mm? You own the equipment for that. You could do that."

GG: You did art design for Fred Olen Ray's T&A comedy, *Evil Toons*. What was that like?

CB: That was fun. How hard is it for me to draw cartoon shit? That's easy. I like Fred. I met him, did an interview with him. This guy's like a fucking super-fan, and he's making movies the best he can with thirty-thousand bucks and an eight day shooting schedule. People have done worse than this! Every once in a while he put together a highly entertaining little package. So he knew me from those days, and he said, "hey I'm doing this kind of *Roger Rabbit*-with-tits kinda movie. Do ya want to design the characters?" … "Oh yeah, suuuure." I don't know what the budget was for creature design, but it's a Fred Olen Ray movie so it was probably 250 or 300 bucks. So I said, "Yeah, I'll draw a cartoon." So I did and they shipped it off to China or Korea or Taiwan, wherever they animated. Then I watched it and said, "Gee, the cartoon guy doesn't look a whole lot like the one I designed! And he's only in it for 22 seconds!" But hey, that's showbiz. But the movie has a great credit, still. When I show it to people, that's where I stop the movie. I say, "Look at these credits! 'Creature design by Chas. Balun'!" That's great! It looks terrific. Now the movie is just a Fred Olen Ray kind of thing. Tits, ass, and here's the creature for 22 seconds! But I did get a cool autographed photo from Dick Miller and David Carradine, who are in it. It was shot on film!

GG: Any other film industry minglings?

CB: Not really. People wanted to film *Ninth & Hell Street* and *Director's Cut*. They just yak, that's film people. They like talking. They don't *do* a whole lot but they *talk*. They return phone calls and send faxes and send e-mails. That's the thing I like about doing the artwork that I do. I can sit in my office, by myself. I don't have to communicate with people. I don't have to send faxes, I don't take conference calls with people. I can create something on my own without all of this input and without a huge budget. I like

Above: Chas. Balun today. Photo courtesy of the artist.

the control and power in that. And there's just so much less bullshit involved in it. I'm not a team player, I do not work and play well with others. I never have. So for me to be involved in a film project, when whatever you have to say is so diluted by the time it comes out the chute, out the other end… you know, do I really need that? I can do this other form of visual communication and being unedited and uncensored and present *the director's cut*. What's wrong with that?

GG: Absolutely nothing!

CB: Movies are so expensive now, and so expensive to market, they're not going to just say, "Here's 15 million, here's 25 million dollars, you're an artist, I trust you, I trust your vision, make the film you've always wanted to make." C'mon! They're not doing that! They're fucking loan sharks, man! "Here's the money, and we want a return on this, and we want a big fucking return the first weekend! Our attention span is not such that we are going to promote this for several weeks. You better open BIG."

GG: Yeah, that era of loose cannon directors is over. Moving on though, now, in the wake of films like *Deadbeat at Dawn* and *Nekromantik*, films which showcased extreme violence, extreme depravity, or both, we've been seeing a sort of pissing contest masquerading as art, or as horror, in underground, fringe horror movies which I'm fucking sick of, and you don't seem to care for very much either. You have called it 'gorenography.'

"...it's easy to shock and repulse people. It's much harder to tell a linear, cogent story that really has some kind of payoff."

CB: Well, we've got to separate Van Bebber and *Deadbeat at Dawn* from these kinds of efforts, because it's easy to shock and repulse people. It's much harder to tell a linear, cogent story that really has some kind of payoff. When I saw stuff like *Aftermath*, or *Guinea Pig*, it just seems kind of like film school brats who are pushing all these buttons to get a reaction, but they don't have anything to say except, "we are so punk rock, that we can make you squirm in your seat. Oh look, I'm going to show a guy jacking off when he's fondling a corpse. Aren't I just so *bad*?" That gets tiresome right away, if that's all there is to it. Because it's easy to make a twenty- or thirty-minute display of, "how many people can I offend with the most obnoxious behaviour that I can come up with?" I like Nacho Cerdà as a person and a director. I mean, he's obviously a really talented individual. It's just that I feel he wastes his talent, with *Aftermath*. God, given that kind of a talent, and that vision… if he would say something, it would have been pretty stunning. Instead, he just decides to shoot the fish in a barrel. And then when it ends, where the guy brings this girl's heart home, that her parents are grieving about, just not sure what's happening here, and he puts the heart into a blender, feeds it to his dog, reads the obituaries… what does that *say*? Is that just saying, "fuck everything?" Is that what it is? Is that the message of the whole film? How hard is that to do? If you're going to be revolutionary like that, why not just sit at your kitchen table, with a revolver, and play Russian Roulette, and BLOW YOUR BRAINS OUT ON FILM. Be *real* punk rock.

GG: Between that and Wes Craven's *Scream*, I don't see how anything is left. How has this apparent lack of a future for horror films affected your outlook? Has it make you have second thoughts about horror?

CB: Yeah, but the trouble is, they've been sucking for a long time now. The era of the post-modern horror film ended in '85 or '86. That summer, we got *Day of the Dead*, we got *Re-Animator*, we got *The Return of the Living Dead*. Back then, you went, "Jesus Christ, these movies all opened within the same month. They're theatrical releases. And they all ROCK!" You just saw this whole future opening up. And the doors closed right after that. They slammed shut, and someone LOCKED them. Because it just started nose-diving after that. And you have all these self-referential films like the *Scream* things and the ones that didn't know whether to make fun of the genre or just go balls-out in the gore assault. And they just got confused. Once formula started cropping up, whether it's *Halloween*, whether it's *Nightmare on Elm Street*, the *Scream*-kind of franchise things, that sunk everything. But they got the big distribution. They were in 25,000 theatres on opening day, rather than being platformed out at three or four theatres across the nation, working its way out to the west coast… and it's disheartening. But it's always been a cyclical thing. The new hit will come out of left field, totally unexpected, you never heard of this person, wonder why they did what they did. That'll happen again just like it did with *Night of the Living Dead*, or *Chain Saw Massacre*, or Peter Jackson's *Braindead*, or a *Hellraiser* or an *Evil Dead*. It's always, "whoa, where did THAT come from? How did they do that"? Worse case scenario, regardless of what horror films are due in the next few years, it's got a rich history. C'mon, Thomas Edison began motion pictures a hundred years ago with a little short on Frankenstein. No matter how they fuck it up now, they're never going to blow the thrill of *Frankenstein*, *The Wolf Man*, *The Creature from the Black Lagoon*, all that. So they can't kill it. Just like they can't kill rock'n'roll. No matter what kind of hip hop posers come out now and do this stuff that Otis Redding and The Impressions, and Smokey Robinson were doing so dead-on, so long ago, they can't destroy the early magic of those early tunes. If you have to look at the big picture, you can say, "Yeah, horror has had its ups and downs, sure, but look at the *great* shit, just like rock'n'roll. Yeah, that's had its ups and downs, it's had its boy bands, and The Archies, and The Monkees, and so many permutations of the original but the pure heart and spirit is still there. Go back and listen to those Chess recordings! Muddy Waters, Willie Dixon. Listen to B.B. King and Albert King, listen to Albert Perkins, Johnny Cash. Listen to those people. No matter how the fakes do it, they can't fuck that memory up. They can't fuck up the essence of things.

GG: But in the next ten years, do you foresee a revival?
CB: I don't hold out any great hopes for anything anytime soon. It's too much of a business now and the money angle is so engrained in it that making a five hundred thousand dollar or million dollar movie, carefully nurturing it, advertising it, and then turning a nice profit of 7 or 8 million dollars… that doesn't matter anymore. They want a film that costs a hundred million dollars to open at fifty or sixty million, to bring in a billion dollars worldwide, right before it hits video and DVD and Pay-Per-View and cable. If some producer recorded an Elvis Presley or a Jerry Lee Lewis song in two or three takes, it would get lost no matter how great it was today. The world is bigger than that now. The United States, the multimedia empire is so huge now, you can't capture that two or three minutes of pure rock'n'roll gold. Today, fifteen or twenty million is the fucking catering bill for *Pearl Harbor*.

GG: Do you plan to do another issue of *Deep Red*? What's the status of the magazine?

CB: We're on hiatus until there's something to write about. [*laughs*] I'm a graphic designer, putting together a magazine is no problem. I could put out a magazine and yak and shoot the shit, but I cannot write a fucking editorial, or do a serious issue, excuse me, about Japanese and Korean and Hong Kong recycled zombie and gross-out films. It doesn't connect with me. I mean, fuck, I'm a fifty-three year old white kid. I was born in Compton, California and migrated out here to Huntington Beach, California surf city. I can't relate to the cultural context of Japanese and Hong Kong gore films.

GG: You were a pig-hating, rock-throwing Yippie in the sixties. Doesn't seem like you've mellowed out very much.

CB: [*riotous laughter*] Oh no. I'm an angry old man now. Well, I grew up when there was a lot of really pissed-off people. And a lot of them were really smart people and they had a lot of reasons to be pissed-off. Whether it was the racism, the war in Vietnam, the drug laws, or just having presidents like Richard Nixon to toil under. The trouble is now, there just aren't enough pissed-off people. All the hippies and radicals and Students for a Democratic Society members… I guess they decided that once they got the degree, became lawyers or accountants, that, "gee, it wasn't such a bad place after all." Then there were the believers who saw things for what they were. "Fuck! Let's bring down pig nation! The world is ready for a revolution." I'm not an ex-pig-hater. I'm STILL a pig hater. Nah, we never got along. They used to pick me up for hitchhiking. Being six-five and two-fifty, and their little macho ass struttin', with their little handcuffs and stick... they didn't like my attitude. And they did something about it several times, too.

GG: Do you want to go into that? Sounds good!

CB: Every hippie in the sixties got busted several times. I got busted on Christmas Day, hitchhiking out to Laguna Beach where they were having a pop festival. I had a red joint, and a green joint my roommates had given me as a Christmas thing, a stocking stuffer. I got busted, put in jail. You know, they spray that bug spray up your ass and do all that strip search shit. And fuck, it's Christmas Day and I got busted for a felony. And that kind of changed things. My attitude didn't help any. I spent several hours spelling out "PIGS EAT SHIT" in toilet paper, woven into the bars. And spelling it *backwards*, man… that takes talent!

GG: That was also the time of *Spaz. The Life of Mr. Hostile*. The underground comix of Chas. Balun. Care to elaborate?

CB: Yeah. Some of my friends named this incarnation of me, Mr. Hostile. Oh sure, I did underground comix back then, in the late '60s, early '70s. I knew the guys from *Zap Comix*, I used to party with them, at the San Diego Freak Convention. We did our own comics and published them, got them distributed. One of our biggest distributors on the

west coast was George DiCaprio, who I knew from waaaaaay back in the hippie era. He got *Spaz Comix* and *Mighty High* out to all the west coast stores. Then I kind of put two and two together, and it hit me. "Oh fuck! He's Leonardo DiCaprio's old man! No wonder he's not selling dirty comic books out of the back of his beat up '63 Pontiac anymore!" He was one of my early supporters.

GG: You were just at a Fangoria Weekend of Horrors in Pasadena. Did you talk to any of the big names? John Carpenter, Tobe Hooper, and all those guys showed up.

CB: The rooms are pretty crowded at that time, and usually the friends that I'm with… they hate it when I ask questions. Because with Tobe and John, I say things like, "Really, after all this fawning and adulation, and the sycophantic attention, how does it feel to have really peaked 25 years ago, when you didn't even know what you were doing? Then, scrambling for the rest of your life to regain what you had then so effortlessly? I mean, it must be horrifying. Every day, don't you want to kill yourself?" Heh heh heh! They hate that shit. They don't have the relevance that they had at one time.

GG: What *did* happen to Tobe Hooper? Like you said, every film sucks, it's either bad or… worse. [*laughs*]

CB: Yeah. Well I think those first few efforts are the most un-self-conscious things he put together, in which he's

really not aware of himself 'as a director'…that, "this is a genre *product*, that is addressing a certain *audience*." Back then they were flying by the fucking seat of their pants. I mean, a lot of times, they don't know what they're doing. And they don't have enough money to ponder it for too long. They gotta shoot this film and they gotta get the equipment back in so many days, you don't have time to be angst ridden and too self-consciously probing one's Freudian sub-text. And I think that helps out a whole lot, like Allen Ginsberg when he was counselling Jack Kerouac: "First thought, best thought." A lot of the beat writers didn't edit themselves. They got into that free-flowing prose. And once you started realizing that, "oh, I'm a serious writer, people are paying attention to what I'm doing", I think you put yourself in a totally different arena.

GG: Another topic I wanted to run by you is *The Blair Witch Project*. I enjoyed that film, but you had a different take on it. You weren't quite so complimentary.

CB: What the fuck is "not quite so complimentary?" That's the difference between a jaywalking ticket and a lethal injection. There's quite a broad band there. Oh no, I HATED it, right from the get-go. After five minutes, I hated it. I knew where they were going with this. I said, "man, they better have just some HUGE payoff at the end of this", which of course they didn't. That whole found footage thing, and the jittery camera stuff? Hell-oooo? I mean, c'mon, Ruggero Deodato and *Cannibal Holocaust* did that same routine, and put a spin on it, that they couldn't even *hope* to come close to. That whole disingenuous approach with their website, trumpeting this as something that was really happening…I don't think that works. I think that's going to blow up in your face. A horror film can be very, very effective, but can be completely fictional. It doesn't have to draw you in to the real life aspect of it, because if it did, then fucking *Faces of Death* would be the ultimate horror experience. But how can they do it so well with *The Exorcist*, when you knew that this girl was not really possessed by the devil, that this guy didn't really die, she didn't levitate, but what a powerful story!

GG: Shock reality is where we're headed, for better or for worse.

CB: That's because there are no good storytellers anymore! Everybody's recycling the same horseshit again and again. Sad to say, but all the high rating TV shows are just unscripted material. "Let's turn a camera on, and let people make asses of themselves. We don't have to pay a writer. And we don't have to pay an actor. And we don't have to have any production value. And there's no special effects." This, for them, is a dream come true.

GG: For a while, with that writer's strike, they were almost being *forced* to move into reality television. But you like *Cannibal Holocaust*, which is full of geek show elements. You're an animal lover, they're murdering harmless jungle wildlife.

CB: I'm an animal lover. I've always had dogs and cats. I'm a wildlife painter, and a member of the San Diego Zoological Society. *But*, I'm not a vegetarian. So I start tip-toeing onto the thin ice of hypocrisy if I'm eating a hamburger or a steak, and then I'm condemning somebody else who's killing an animal, much like I endorse killing an animal for my hamburger. But they did it *on film*. Is that death better or worse? That's tough moral territory. If I was a vegetarian I would have more of an issue about it, and it would sound genuine. Because I'm not, I've got to be careful. Of course I abhor seeing the death of a creature used as a dramatic device. It's just not necessary. On the other hand, how can I condemn someone for what I'm approving of every day by eating meat? It's a tough call.

GG: One last thing: the re-make of *Dawn of the Dead*.

CB: I don't think we should be so shocked and bewildered by a ploy like that because let's face it, they've remade everything else. Isn't that the answer to the poverty of good scripts and good stories? There's stuff like *Car 54 Where Are You?*, and *The Beverly Hillbillies*. Do those need to be remade? It goes on and on and on. Now *The Time Machine*'s coming out. Now it's *Planet of the Apes*. Now it's *King Kong*. I can't think that all of a sudden there's going to be some kind of morality and ethics involved. "These projects were all so good the first time out, it would just be a crime against humanity to re-do them?" [*laughs*] Come on! USA? United States of Advertising. That's what that stands for.

No Rest in the Middle of the Night

- Chris D. -

One of those seminal figures whose life story is at least as compelling as his work, Chris Desjardins has remained a vital force in the LA scene since his 1976 emergence. With so many years to cover, I did my best to take the trip with him as chronologically as possible. It's a vivid, richly evocative portal to a squalid and dangerous time, before MTV or the Internet, when hedonism was still very much affirmed – if not outright demanded – in those Southern California sub-stratas of track-marked teenage death trippers and smut-strutting strip-mall theme-park Caucasoids. The life of Chris D., if translated to film, would make for an authentic LA hell-ride; he has worked closely, as either musician or producer, with a plethora of groups central to that pop cultural history: The Dream Syndicate, The Gun Club, X, The Blasters, Green on Red, Los Lobos, and many, many others.

Shortening his surname to its first letter for the Flesh Eaters' 1980 debut *No Questions Asked*, Desjardins kicked off a rock music career that has to date begat more than 15 records. With his vocal posturing, a Flesh Eaters record gives an uninformed listener the impression that the singer would likely resemble Max Schreck's Nosferatu channelling the Dead Boys' Stiv Bators. The altogether unnerving collision of petulant punk shrieking with obsessive Gothic lyrics has served Desjardins well. In between Flesh Eaters records, Desjardins formed Goth-country group Divine Horsemen, with then-girlfriend Julie Christensen. The first of these collaborations, *Time Stands Still*, appeared in 1984. Until 1989 he recorded exclusively under the Horsemen name, but as before, with an inconsistent line-up. The best work from that period, *Devil's River*, is a classic piece of warped Americana, rife with an unremitting sense of tragedy bolstered by strong musical and vocal performances (all duets with Christensen, an incredible singer whose sweetly youthful yet spiritually ailing voice is in top form here). He's a romantic, in the truest sense; the songs on *Devil's River* are characteristically derived from Desjardins's fathomless fascination with cinema; the themes of the record are a distinctive hybrid of western, noir, and horror film elements. It's my personal favourite of all his work, a comparatively soothing and poignant record which is literally crying out for a re-release on CD.

The Flesh Eaters name was resurrected in 1991 and used for all future releases to date, excepting a solo debut released in 1995, *Love Cannot Die*. Desjardins still plays and records with The Flesh Eaters, but has devoted much of the last three years exclusively to film-related work, as director of 2003's *I Pass for Human*, and author of a massive volume on Japanese Yakuza films. His full time gig with the Hollywood repertory company American Cinematheque affords him the unique privilege of programming into their monthly schedule some of the films to which he, as Flesh Eater and Divine Horseman, owes specific personal debts. The Cinematheque has a long-term residence at the beautifully renovated Egyptian Theatre on Hollywood Boulevard, only several blocks from the apartment where this interview took place in early 2002.

GG: What separates your band The Flesh Eaters from a lot of other music is that you can't throw a simple tag on it. It's not exactly punk, it's not exactly Goth. Would you say that that's because it's inspired by films, especially horror films, as opposed to other music?

CD: Yeah. I've always been inspired by film. Hammer horror films and sixties and seventies Hollywood movies wreaked considerable damage. Originally, what I wanted to do with my life was make films. I made a lot of Super-8 films in High School, which I have no idea how to find now. I wanted to go to film school at UCLA and I didn't get in, even though my dad was a professor at UC Riverside at the time. I ended up going to Loyola Marymount in 1970. By the time I got out, I'd made three 16mm student films. By that time, I was so disillusioned with everyone I'd met in Hollywood that I could never see myself operating as a cog in the entertainment machine. I was also much more of a prima donna back then. I didn't know how to function in terms of commerce or economics. Didn't know how to market myself or hustle money to make movies. I didn't have a lot of confidence in regards to that. I'm glad I went to film school, but in a practical sense, my disappointment was as much my fault as it was the school's. And then it was mid-'76 and the whole punk rock thing was starting. I was still married to Bonnie, my first wife. We had done a poetry anthology together that had some of our own poetry and other people's too. Local LA people. I got permission from Patti

Smith to reprint some of her stuff. The collection was called *Bongo Chalice*, which is long gone and forgotten. But I would go hang out at the Venice poetry workshop all the time. I was writing for *Slash* magazine. I'd sent them some poetry. I don't know what I was thinking, sending poetry to *Slash*. Although my poetry is poisonous and vitriolic. They wrote me back and asked me if I wanted to do some record reviews. I said I did. The first record I reviewed was Iggy & The Stooges' 'I Got a Right'. I was going to punk shows all the time with my wife Bonnie. Then, she and I split up. I moved to Hollywood, and just got really into the punk scene.

GG: Were your record reviews vitriolic?

CD: A bit... I could be brutal. I hadn't really performed or recorded much yet. I think the most savage critics are inspired people who very much want to create in the same way that the people they're writing about create but have been frustrated or haven't had the opportunity, talent or confidence to go out there and do it. They have no idea how fucking hard it is. Especially trying to stay true to your vision. Unfortunately most stuff out there – and this holds true today – is just plain crap. I was actually very lucky with critics over the years. About eighty to ninety percent of the write-ups I've gotten have been at least positive or actual raves. A lot of good it's done as far as sales, though...

Chris D., 2002. Photo by Lydia Lunch.

GG: So you were writing and hanging out. But when and how did you actually form The Flesh Eaters?

CD: I'd had a band in high school, for an absurdly short period of time, and nobody really liked my style of singing, which was kind of a combination of Mick Jagger, Iggy Pop, John Kay, Jim Morrison, Captain Beefheart, Howlin' Wolf and Rod Stewart, when he was with Jeff Beck, before he got bad. So that was the stuff that really influenced me and that was the way that I liked to sing. Of course it didn't come out that way at the time.

GG: I always thought that you sounded like a shrieking vampire in an old horror film.

CD: Yeah. I wasn't really trying to calculate it, but that's what came out. It came out as a manifestation of all the sickness within. [*laughs*] A lot of my singing from that band is hard for me to listen to now. The first album, the *No Questions Asked* record... It just seemed to me that everybody I knew in Hollywood was in bands, and all my new friends were in the music scene. I didn't need someone else to validate it, to say, 'This is okay'. I just saw all these people who didn't give a fuck, who were going to do it whether anyone liked it or not, and I told myself I could do it. It didn't seem like you could do that sort of thing with film at the time. I wasn't in the climate or in the circle of people where a film could be done with a punk ethic. If I had been in the same circle Andy Milligan was in, or Martin Scorsese, to name two very different kinds of directors, and if I'd had the contacts, and if I knew how to get into a film scene, I would have gone into film. But I never found those people. The people I found who thought like me were all musicians in the punk scene.

GG: What happened to your 16mm films?

CD: I have prints of all three. The first one, *Le ciel du sang* [*The Sky of Blood*], was very good. It was a vampire film set in 17th Century France. It actually looks like a period piece. It's only three minutes long. We showed it at the Cinematheque a couple years ago as a short with a lesbian vampire double feature. [*laughs*] The next film I did was an experimental film called *Rocket Day Johnny*, which was really incoherent and pretentious. There's some cool imagery in it. The way I was editing then was not on a Moviola. I was editing on a table, so I didn't know exactly how a lot of this stuff was coming together. The editing wasn't snappy at all, and it takes too long between transitions. I didn't get to see the rhythm of the movie as it was taking shape. That was my own fault because I was too lazy to just get in there and do it right. I could have commandeered a Moviola somehow, down at the school. It was also too ambitious, because it was like seventeen minutes long. The last movie I directed was a film noir called *Night Spur*, done with synch sound. That actually came out a little better. When I got out of school, it seemed that to raise money to do a feature motion picture, it would be in the tens of thousands of dollars. At the very least. We're talking low-budget, between fifty and a hundred thousand bucks. Of course, it could be done for less than

that, but I just didn't predict being able to raise the money. To make music, which was my second love, it would take, at the time, a couple grand to do an album. Economically, it seemed like the thing to do, and I was more excited about it at the time. But I continued to see movies. It was a really great time for films in the early to late seventies, because a lot of the cool theatres were still open on Hollywood Boulevard. Theatres would show double and triple features until three in the morning. You could still see all the exploitation and grindhouse stuff. Italian horror movies were regularly playing. Biker movies. Exploitation. All kinds of great trash, which I would go to see all the time. I was in Hollywood a lot, even when I wasn't living there. Right before I moved to Hollywood, end of '77, I taught English at a private high school for about six months.

GG: How did you feel about teaching high school students?

CD: It was unlike anything I've ever done before. I taught English and literature. The couple who ran the school, they were really obese. Absurdly, hideously huge fat people. The guy who hired me, the principal, had a stroke shortly before he hired me. He was totally paralyzed on one side. He could hardly get around. He would strike terror into the hearts of the bad kids. When I had problems with a kid and would have to send him to the principal's office, they would come back perfectly behaved. I don't know what he did in there. But then, after I had been there about two months, he died. And his wife took over. She let the kids do whatever they wanted. The kids were breaking into her house, and she wasn't doing anything about it. There were a couple of gangster-type kids who were incorrigible. I met one guy's mother on parents' night. She was obviously a junkie, and that was depressing and unfortunate. This guy was scary, always on angel dust, I could tell. I failed some kids, and they threatened me physically. I never knew if they'd try to follow through. Then I left, because I was perceived as not being able to control my class. But it was basically because I would get no reinforcement from this woman principal, like I did from her husband. Kids were rolling joints in class. I don't think that when you're that young you should be doing drugs. It was none of my business what they did outside of class, but I wasn't going to let them roll joints in class. Whatever I did at the time, smoking pot or drinking, I didn't do it at school, and I wasn't going to let these kids roll joints in class. The tenth grade class was where I found a lot of the kids with drug problems. That was horrible, it was a nightmare. After that I worked at CBS Records for about a year, a temp job in the tape library. I hated working there.

GG: Were there any perks?

CD: No. I would occasionally get promo records and stuff I could trade in, but everything they were putting out at the time was shit. And all the A&R guys sucked. This was late 1978. I'd just made a single, and I remember giving it to one of the girls in the A&R department. She was a nice girl but I knew she was not going to get into The Flesh Eaters.

No fucking way. The A&R guys there were such pompous dickheads. You could just tell they looked down at anybody that wasn't on their level, in their department. They sneered at a lot of new music. But they were putting out Toto and crap like that.

GG: What was your first record called?

CD: I can't remember if it was 33 rpm or 45 rpm, but it had two songs on each side: 'Radio Dies Screaming', 'Disintegration Nation', 'Twisted Road' and 'Agony Shorthand'. That led to the next thing I did with Judith Bell: *Tooth & Nail*, the first LA punk music compilation record. It had The Flesh Eaters, The Germs, U.X.A., Controllers, Negative Trend, Middle Class. X was originally supposed to be on there, and then Billy Zoom kyboshed the idea. He wanted to hold out for a major label. Of course, shortly thereafter, they did the Dangerhouse compilation and single.

GG: I always think of Slash when I think about LA punk music, and forget about Dangerhouse, even though a lot of great records came out on that label. Were you ever on there?

CD: No, but we knew all those guys. Everybody there… they were all brilliant, but they were all nuts. They had a real bunker mentality, and they would get that way with bands on their label. They would have adversarial relationships with a lot of people. A lot of bands had unrealistic expectations. Little independent labels are not going to be raking in the dough. Then I worked at Slash Records, which grew out of working for *Slash* magazine.

GG: You've had some notable people on various albums with you, like John Doe and DJ Bonebrake from X. Dave Alvin.

CD: Those guys were on the second album, and that's probably when the albums started to sound good. We were working with Pat Burnette, who really was integral in the quality of those early Slash records. He was the engineer. He was from the Burnette family. His father was Dorsey Burnette, the country-western guy. His uncle was Johnny Burnette, the really famous rockabilly guy, his brother was Billy Burnette who had a couple of regional hits, and his cousin was Rocky Burnette who had a one hit wonder. Pat was great. He engineered The Germs album for Slash. He engineered my records *A Minute to Pray, A Second to Die* and *Forever Came Today*. He engineered *Fire of Love* for The Gun Club, *The Days of Wine and Roses* by The Dream Syndicate…

GG: Which is a masterpiece, one of my favourite albums. And you produced it. When you did that, what was in your mind?

CD: I just wanted to try and capture them the way I heard them live. To me, when you hear a band live, if they're really good and they're operating on all cylinders, if they've got soul and passion, there's a lot of factors involved with playing live, that are going to be sabotaging a band every step of the way. Sound, PA, and various other distractions that happen. With Dream Syndicate, I felt that a giant, Phil Spector-ish production job was not

the way to go. I just wanted to try and enable them to get across their own sound without distractions and technical problems. To make it as live as possible, in the studio. The only things we overdubbed were the guitar solos and the vocals. Everything else was pretty much played live. It was fully recorded and mixed within a week. Which is how things usually worked back then. I did the Green on Red record too, *Gravity Talks*.

GG: Green on Red was brilliant, but people say that Dan Stuart was a total psychopath! What did you face working with them?

CD: They were so talented, those guys. I loved their stuff. Danny Stuart… he was drinking really heavily at the time, even heavier than me, and I was a serious drinker at the time. Actually, it worked out well, because you could tell he was loose enough to do his work, and it came out good. He and Steve Wynn from The Dream Syndicate were very close friends.

GG: The Green on Red shows were rumoured to be totally over the edge, intense, and drunken.

CD: Right.

GG: You played on the same bill with them occasionally.

CD: Oh yeah. But everybody played together in all kinds of different combinations. I was a big fan of Tex and the Horseheads. We played a lot with them. That was originally a side project of Jeffrey Lee Pierce, outside of The Gun Club. He was just playing guitar, not singing. He was going out with the singer, Texacala Jones. She was a wild woman. Very funny character. Great songwriter. They put out one or two records on Enigma. The first one was excellent. You can really see her songwriting abilities on that record. She would sometimes tend to scream more than sing. I liked her singing… I wish she'd done more of it. I have a cassette recording of her, in the stairwell at Slash, singing with an acoustic guitar and it's just amazing shit. Haunting, bizarre, southern folk songs. Her singing was very haunting and very individualistic. With the Divine Horsemen, I did one of her songs on the *Devil's River* album, 'He Rode Right Out', which came out great.

GG: Why did you do Divine Horsemen?

CD: In '83, The Flesh Eaters had gotten to a point where I was getting along with everybody individually, but we'd all get together, get really stoned on pot, and the band would get in each other's faces. It got to be so acrimonious. One of the guys got us this speed from some biker friends of his. This weird purple looking crystal stuff, bathtub methedrine. It was horrible, would burn the hell out of you. And we'd all be drinking incessantly too. We'd do it at rehearsals sometimes and I don't know why I ever did it, because I didn't enjoy it. But we weren't doing it enough to be going into any kind of psychosis, like some people you hear about. We would just do it enough. But it's not a good drug to get along with people on. If you have a short temper in the first place, it's a bad idea. I got really frustrated with it, and I didn't really ever have a major falling-out with anyone. I just said, 'You know

what? I can't do this anymore'. And I didn't want to play loud music, music that is over the top. I went the other direction. I wanted to do country, and folk, but from a warped standpoint. That kind of very warped, murder ballad-type folk music that I liked. That first record, *Time Stands Still*, which came out on Enigma, took shape out of those intentions. With the Divine Horsemen, we were playing semi-acoustic electric-type gigs, and it gradually evolved into a real band. It pretty much became an electric band again and went back towards rock'n'roll. It was also a band through which I met Julie, who wound up being my second wife. We had a kind of collaboration together that I've never had before – or since – with anybody, as far as music goes. That was really one of the high points in my career. Actually, The Flesh Eaters record I'm doing right now, called *Miss Muerte*, sounds like the Divine Horsemen crossed with The Flesh Eaters.

GG: There's a power in your singing with Julie that is unique. Are you going to be working with her again?

CD: Yeah. And we have worked, periodically. She's all over this latest record. We broke up in '88, mainly because of too much alcohol and drugs. She cleaned up her act, but I just couldn't do it. It was beyond me at the time. It really fucked everything up. It fucked me up pretty bad. Financially, I didn't lose anything. I didn't lose my place or go out on the streets. But it fucked our relationship up, and broke the band up and everything. It took a long time for me to get clean. When I finally did, about six years ago, it had at that point been something I'd been trying to do for several years. It took that long where I was motivated enough to get off and stay off everything. It took me a long time to understand why I did it and that I did have truly addictive behaviour. It comes with becoming really lazy in regards to your ability to care about other people. The more selfish you become, the easier it is to become addicted. When I broke up with my first wife, I immediately began to drink very heavily. I was fucking around on her all the time, and that definitely increased my drinking. When I split up with her, the girl I hooked up with was really into drinking, and she introduced me to hard drugs. Which I thought I never would do! I was… totally shocked! And thinking to myself, 'how could you do that?' And then, a few months later, 'is there some more?' But for five or six years I was doing it like once or twice a month and it was no big deal. But you know, it became one of those things where you realize there are some things that you can't do recreationally. It gets to a certain point where it stops working… but you're still doing it anyway. And you can't stop. That's when the real life horror started. I know so many people that have gone through it. But I can't imagine having done things any other way. I'm glad, because it's been a real odyssey. I don't mean to sound too pretentious, but I went through a spiritual progression. When you do stuff, especially drugs, when you do any kind of opiate, it can be a real spiritual and visionary thing. Sure, it was wanting to feel good. But it was also all the

French poets from the late 19th Century who would smoke opium and drink absinthe. I had romanticized all of that. Like a lot of my old rock star idols, from Jim Morrison to Iggy to Keith Richards. Jeffrey Lee Pierce was another one. Jeffrey went beyond the pale with all that stuff. Which is… why he's no longer around.

GG: Were you friends with him though any of his darkest periods, especially towards the end?

CD: No. I really grew apart from him. Not so much because of a falling out, but he was just never in town. Divine Horsemen actually played with him a couple of times. But I saw him maybe twice at the most those last couple of years.

GG: You co-produced the *Fire of Love* record, which is thought by a lot of people to be The Gun Club's best album. Was working with him in the studio difficult?

CD: No. He was very easy to work with. He and I had pretty much the same idea of what we were going to do. That was recorded very quickly. Especially the sessions I did. The stuff that he had done with Tito Larriva as producer, I don't know how long that took. They were using an engineer who had worked with Tom Petty, and that stuff just did not sound sonically quite as clean. So we – Tito, me, and Jeffrey – remixed all that stuff. That's why the record does sound kind of 'as a piece', even though there were two different producers. It really came out good. It could use a little more bottom in the bass department, that's one thing I don't think it had enough of, but it really does sound good, that record.

GG: What else have you produced?

CD: Well, there's that one, The Flesh Eaters, Divine Horsemen, The Dream Syndicate, Green on Red, The Gun Club. I took Glenn Danzig in and we re-mixed the Misfits' *Walk Among Us*. We wanted to put that out. But Bob Allecca didn't want to spring for the money to re-record it, and we thought that the multi-tracks they already had were probably good enough to re-mix, and do it that way. The multi-tracks they had they recorded in New Jersey, but the mix they had was horrible. Their singles sounded really raw, and you couldn't hear the drums a lot of the time on their singles, but they still had a power. We got Glenn out here. Glenn and I went in with Pat Burnette and we remixed it in one night. We re-mixed the whole album in 12 hours. That was a total nightmare; we were totally burnt by the time we got done. It could have probably sounded even better if we could have spent a little more money and time in there. But it came out sounding fairly good. I produced The Lazy Cowgirls first album, in an 8-track studio we had just started going to called Control Center. Lazy Cowgirls was the first release on Restless Records, which was an offshoot of Enigma. Restless is still around. The next time I did a project at that studio was with the Divine Horsemen, and by that time they had a 24-track studio. So we started going there all the time, to that studio. It was more affordable.

GG: What made you want to go into record production in the first place?

> "I started work on this book on Japanese Yakuza movies in 1990. I didn't realize how much I was undertaking, and it's still not quite done…"

CD: With producing a record, I just had an idea of how I wanted it to sound, which comes more out of the mix than any ability to know what I was doing in the studio. I've always relied on a good engineer. And I had a very definite idea about how I thought music should sound. I have lost that, periodically, being able to tell. I've lost my perspective. That is really frustrating. That last Flesh Eaters record from '99, *Ashes of Time*, has very good songs on it, but I'm not entirely happy with the way it sounds. The album I'm doing now, *Miss Muerte*, I'm pretty happy with. But I'm digressing.

GG: I like that…

CD: I've been a movie fanatic for such a long time. I started work on this book on Japanese gangster films and Yakuza movies in 1990. The late fifties through the late seventies. It's an encyclopaedia. When I started work on it, I didn't realize how much I was undertaking, and it's still not quite done. It's about 95% done, and I've been working on it since 1990.

GG: What led you to these Yakuza films?

CD: I had gone to some Japanese video stores down in Little Tokyo in '89 and '90, looking for the Lone Wolf and Cub movies. I was also looking for some Japanese ghost stories, which are called 'kaidan'. That means supernatural period piece. *Kwaidan*, for example, is one of those movies. There are others that are kind of famous, on a cult level, like *100 Monsters*, which most people here haven't seen. I found only one or two samurai movies, but… I found all these Yakuza movies! I didn't know anything about them. The video box covers were just so amazing. They were reproductions of the posters, which were incredible. I got sucked in. Even though they didn't have subtitles, I was hooked. I just started renting those movies wherever I could find them.

GG: How did you know what to get? I used to drop by a lot of Japanese and Hong Kong places when I was a kid, Korean grocery stores, and these places always had massive video collections, but it was mostly bootlegged material and they didn't have covers.

CD: I know which ones you're talking about. The stores you're talking about are the ones that have only stuff taped

Chris D., 2002. Photo by Lydia Lunch.

from TV. I have found videos that way. But nearly everything in the places I went had a cover. In the last five or six years, I've become friends with a guy from Japan named Yoshiki, who's been an enormous help to me. He records stuff every month off Japanese cable for me. He sends me a list, with the titles of what's going to be on the Japanese cable stations, stuff he knows I'm interested in, and I'll e-mail him what I want. Then I pay him twelve bucks a tape or something. I've gotten hundreds of tapes from him that way since 1998. I actually went to Japan for two months, in 1997, because I'd gotten a grant from the Japan Foundation. I lived there for two months, did interviews with some directors, and a few actors such as Sonny Chiba from the *Street Fighter* movies. Chiba is always described as Japan's answer to Bruce Lee. He'd been working in Yakuza and samurai and science-fiction films since the early sixties with this company Toei. He was always into martial arts and karate, but not to the degree he was in the seventies. I don't know if he came up with the idea himself or if it was Toei, but they attempted an answer to Bruce Lee, which is how the *Street Fighter* movies happened.

GG: Those films are so incredibly violent, bloodier than most of the martial arts films of that time.

CD: Oh yeah. And Chiba's a great guy. Quentin Tarantino is a big champion of his. Sonny is in *Kill Bill*. He also did lots of martial arts training of other actors for that movie. I also interviewed Meiko Kaji who was in the *Female Convict Scorpion* movies, and the *Lady Snowblood* swordfight movies. She's incredible. I interviewed directors like Kinji Fukasaku, Seijun Suzuki, Teruo Ishii… several others. One of the reasons I went to

Japan was to collect imagery for the book. To buy up some of those posters. It was hard finding stills from the movies, but I did find posters. I've got hundreds of posters now. I used a lot of my grant money to buy those posters. I've gone back there twice, just to buy more posters. I know all the places to go, and my friend Yoshiki will take me. I'm a movie poster nut. Euro stuff, from the sixties and seventies, especially Italian horror and spaghetti westerns, Belgian horror. The Japanese Yakuza, horror, sexploitation and Samurai posters from the sixties. They are some of the most beautiful movie posters on Earth. One thing I've always wanted to do is exhibit them all somewhere. At some gallery.

GG: Are there different kinds of Yakuza films?

CD: Yeah. There's the more traditional Yakuza movies which are usually set between 1890 and 1930, where they have the sword fighting. They're period pieces, basically. Those are known as the 'chivalrous' Yakuza films, where a chivalrous outlaw goes up against other unethical outlaws. Then there's the more authentic, 'true story' or Jitsuroku films from the late sixties and seventies that were set in a contemporary time period, films with basically no heroes, only marginal villains caught up in conflicting loyalty in horrible gang wars.

GG: Is there always a line between Samurai films and Yakuza films, or do they merge?

CD: There are Samurai movies that are also Yakuza movies. There are wandering Samurai gambler movies that are definitely Yakuza movies, set in the 1800s. The Zatoichi blind swordsman movies are Yakuza films as well as samurai stories.

GG: Aren't there four or five of those?

CD: No, there's actually 26 movies in that series alone! His name's Shintaro Katsu. He's amazing. It went to television for over 100 episodes. He was actually the brother of the guy who was in the Lone Wolf and Cub movies, Tomisaburo Wakayama. Katsu became so successful from the blind swordsman movies that he formed his own production company. He produced the Lone Wolf and Cub movies, and starred his brother in them. There are so many great Japanese horror movies too, and there's been a real resurgence in the last ten years. *Ring, Pulse, Cure, Evil Dead Trap, Suicide Club, Uzumaki*, the *Tomie* films. It's great to see. It can never approach the kind of volume of the fifties, sixties, and early seventies because they don't have the studios that were churning these out. People were going to the movies in much larger numbers. Then in the mid-seventies the bottom really dropped out. TV didn't become a common Japanese household possession until the late sixties. So as soon as everyone had TVs in Japan, the movie industry crumbled.

GG: That happened in Italy too.

CD: It happened in a lot of places. It's really unfortunate. There's a lot of movies shot on film that are then released straight to video over there now. Yakuza movies. Some of Takashi Miike's films were originally shot just for video, but they got released for a week or two in a movie theatre and they took off. Like *Dead Or Alive*, one of the most amazing Yakuza movies from the nineties. And his movie *Audition* is really incredible. We're releasing that through the American Cinematheque video label.

GG: How did you begin programming films at the Cinematheque?

CD: I met Dennis Bartok, the main programmer, in 1994. We were talking about putting together a retrospective of this director Hideo Gosha who did *Three Outlaw Samurai, The Wolves, Hunter in the Dark, Hitokiri*. We were both big fans of his. We put that retrospective together in 1996, and that was the first thing I co-programmed. And I wasn't on the staff yet, I was just working as a volunteer. The next series we did was Japanese Outlaw Masters, which has stuff by Kinji Fukasaku, who did *Battle Royale*. This was the first time these movies had been shown in the US since the 1970s. We showed a couple of Koji Wakamatsu's pictures, a notorious underground director from the sixties and seventies. I programmed other things too, like the spaghetti western series they did. I co-programmed that with Dennis and another guy, Bill Connelly. The Jess Franco/Lucio Fulci thing we did.

GG: Are you a fan of Fulci's stuff?

CD: Lucio Fulci's early giallo stuff I really love, like *Lizard in a Woman's Skin, One on Top of the Other*. His gory films I am not as big a fan of. *The Beyond* is really good, but the rest seem a bit lazy. There are other Italian directors, like Mario Bava, who were doing horror so much better. Anyway, I eventually joined the Cinematheque staff on salary in '99. That was when the Egyptian Theatre became the venue.

GG: What are some of your favourite movies?

CD: Fukasaku's *Graveyard of Honor and Humanity*. Hideo Gosha's *The Wolves*. The Lone Wolf and Cub movies. The Zatoichi movies. Seijun Suzuki's *Branded to Kill* and *Gate of Flesh*.

GG: Do you like the *Shogun Assassin* film, the Americanized version of *Lone Wolf and Cub*?

CD: I don't like the American version. I hate the music. I hate the kid's narration. In the original movies, the music is so much better. I also love Italian Gothic horror and *giallo* movies, Italian crime movies. I'm hugely influenced by American Film Noir. American fifties science fiction. Also, Fritz Lang, Luis Buñuel, Douglas Sirk, Sam Fuller. All the British 'angry young man' movies. *Saturday Night Sunday Morning, Look Back in Anger*. I love a lot of French crime films from the fifties and sixties, like Jean Pierre Melville, he was brilliant, especially *Second Breath* and *The Red Circle*. Jacques Becker's *Casque d'or*. John Woo. Mario Bava, especially his *The Whip and the Body, Kill, Baby... Kill!* and *Blood and Black Lace*. Sergio Corbucci's spaghetti westerns, especially *The Great Silence*. There's just too many good movies.

GG: Okay, but what are some of your favourite American films?

CD: *Out of the Past*, with Robert Mitchum. I love Nicholas Ray, all his stuff. *Rebel Without a Cause, Johnny Guitar. The Lady Eve* by Preston Sturges. Almost anything by Anthony Mann, especially his film noir, *Raw Deal* and his epic, *El Cid*. Budd Boetticher's Randolph Scott westerns. *The Fugitive Kind* with Brando and Anna Magnani. I love *Mean Streets. The Panic in Needle Park. Pretty Poison*. Gosh, I'm trying to think of some other movies that really destroy me when I watch them... I love *On the Waterfront*. I'm going to continue to discover more stuff, I'm sure. And you know, it's really heartening to see someone like Buddy Giovinazzo getting films out. Even though they don't get the best distribution. Like that film *No Way Home*. What a great movie! Juanita Myers, who sings back up with me and is on the cover of my latest CD *Ashes of Time*, borrowed it and now she's just crazy about it. She's watched it several times. It's not a big pyrotechnic movie, but it's just so real, in terms of being about real people, in a tough situation like that. Tim Roth and James Russo are outstanding in it.

GG: How much more work needs to be done on the film book?

CD: I have fifteen or twenty more movies without subtitles that I need to watch. The book is so complete in its listing of these movies, from 1956-1980. There's going to be a special section for each of the Japanese studios that produced these movies. Each studio will have its own section, with the movies listed. There are two or three thousand movies in the book. About a third of them have reviews, probably between 500 and 700.

GG: Why not wait until you have all three thousand covered individually?

CD: Because I'll be dead by then.

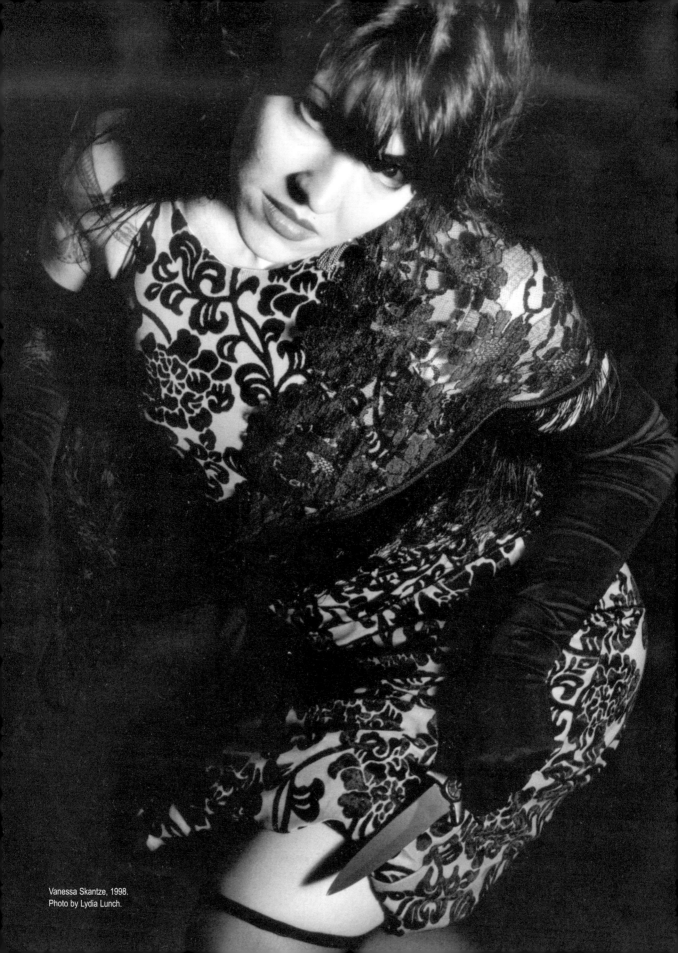

Vanessa Skantze, 1998.
Photo by Lydia Lunch.

A Goddess in Exile

- Vanessa Skantze -

Because there isn't much sincerity to be found in performance art, spoken word, or just about any other bastion of self-indulgence/anti-expression (fill in the blank with whatever you please), it was inevitable that my defences would be down for the next encounter with a blood-stained demon-rant like this. I gently placed my copy in the CD tray, and waited to be provoked. *Pariah*, the debut CD by Vanessa Skantze, does not stop at provocation.

An hour later I am silent and motionless, in a stupor of delirium and muted admiration. Ultra-explicit, ultra-intimate, the delivery of Skantze's fury defies the inexpressibility of a total and utter perception of powerlessness, of repulsion, of the dread a poet or a painter feels when driving by a football rally, or seeing *American Idol* for the first time.

Pariah has a phenomenal primal intensity. To absorb this spoken dirge of great beauty and inverted hope is to infect yourself with the psychic cancer of outsiders, that cancer borne of enduring true American ugliness for too many years, that human plague of desensitized meat puppets who carve their strength out of what simply amounts to avarice, ego, and exploitation, who succeed via sugar titty and robotic ambition, by force, by number, by manner of which the precious few are left only the piss and shit of their own delusional existence so as to be further estranged from self, and only steps away from never gaining the truth. The confessions of Vanessa Skantze resonate with the intimacy of a long, slow sadness, like a slender dagger that works from the inside out and leaves no trace but the exhaustion, in a real-time torrent of emotional fecundity, and raw intelligence. *Pariah* sinks in as a revolt against the concept of original sin, as a pervasive reminder that in your efforts to traverse the outer boundaries of all regrets and all loss you have found only another diseased strata of opposition, a malevolent and ever escalating impossibility among the millions who do not understand/just couldn't give a fuck what is driving you downward, inward, away... or in a greater sense, what is wrong with the landscape which, in their pettiness, they overpopulate solely to dominate.

To see another's true face, bared in a time of limitless unwinding, is worthy of notice and praise. Skantze is a most delicate and tender breed of warrior/heretic, one who made this very journey and leapt back into life, out of the void, illuminating an implosion of awareness that reaches the darkest corner of psychosis and hunger, accusing heaven, hell, and the purgatory of time itself for their great failures... because these failures are also blessings if you observe them in the proper context of the absolute, the infinite, the beyond.

In effect, her own blessing of violent curiosity and intoxicating, explorative language is anything but disguised and should linger throughout many an introspective night, when no amount of rock and roll or pornography will steal your attention from the bigger picture. *Pariah* will indeed haunt. In the course of Skantze damning damnation and betraying all conventions of conduct in her yearning, frenzied imagery, something indelible is left behind.

The value of this is yours to ponder. Unquestionable, however, is an emergent voice of poetic self-dissection, in whose suffering we are disavowed of anything less than fiercely engaged, hyper-stimulated emotion. Once again, she offers no answer. For, as with the mystery of God, an answer may well be necessary and miserably worshipped, wildly evoked, blindly romanticized, but truly does not exist. A higher power, she states, is only to be found within certain kindred spirits and above all, within ourselves... whom we have chosen to assault and even murder, one promise, one betrayal, and one wasted revenge at a time.

Such is the sentence of the highly evolved, yet godless martyr. Those who crumble in the sensitivity and severity of this raped angel, this whirlwind of voice named Vanessa Skantze, who, in the fevered, burning hour of *Pariah*, may find themselves re-visiting a few of their own deepest scars; closer, perhaps, to realizing the truth of that sullied, once redemptive illusion which originally perpetrated them.

Vanessa Skantze, 2006. Courtesy of Lisa Seminoff.

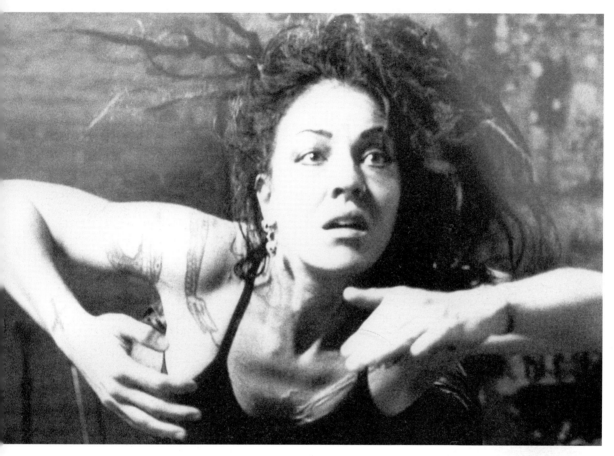

Above: Vanessa Skantze, circa 2000. Photo courtesy of the artist.

Opposite: Vanessa Skantze, 2006. Photo courtesy of Lisa Seminoff.

Gene Gregorits: You grew up on military bases. Could you describe your childhood, in that kind of environment?

Vanessa Skantze: There was always a feeling of transience and I think one of the deep feelings I carry from growing up that way was not having a home. Not having a home town, never knowing what that meant. When people ask the simple question "Where are you from?" I'm always like, "Do you mean where did I live last, or where was I born?" I'm not from anywhere. So there's just a sense of homelessness, which I'm really grateful for, because to me it's more real than this absurd sense of being bound to some place. And they're very rigid, they're very codified, military bases. You show an I.D. to get on base, you show an I.D. to go shop in the store.

GG: Did you consciously realize any specific thing, at a young age, that would later perhaps form the view of the world you have today, in a way that relates directly to your work?

VS: I think the overwhelming thing I realized at the time was always being watched. Feeling like there's always someone watching. And I was raised Catholic too, and

there's that whole thing of someone watching. The place you live, there's guards, patrols, they have guns. And there's just always this sense of not being free, so I think what I felt overwhelmingly was wanting to be away from that, and wanting to find some other place where I could break out of that.

GG: And Catholicism shaped your literary progression.

VS: Absolutely. And strangely enough, more so now than ever. I rebelled more directly against it when I was younger. I just completely kicked over the traces of any of it. I didn't want anything to do with it. But at the same time, it held an incredible power, and still does. The imagery, the iconography, the sense of suffering really does hold an incredible power, and I'll say it, beauty for me. There's a real beauty locked in the horror of that religion that I can never tear myself away from. It's something I continue to wrestle with.

GG: What books did you read at that time?

VS: When I was very small, I read a lot of fantasy type books. I was really into *The Chronicles of Narnia* when I was a little kid. I mean, again, the idea of getting away. When I was really little, about six or thereabouts, I

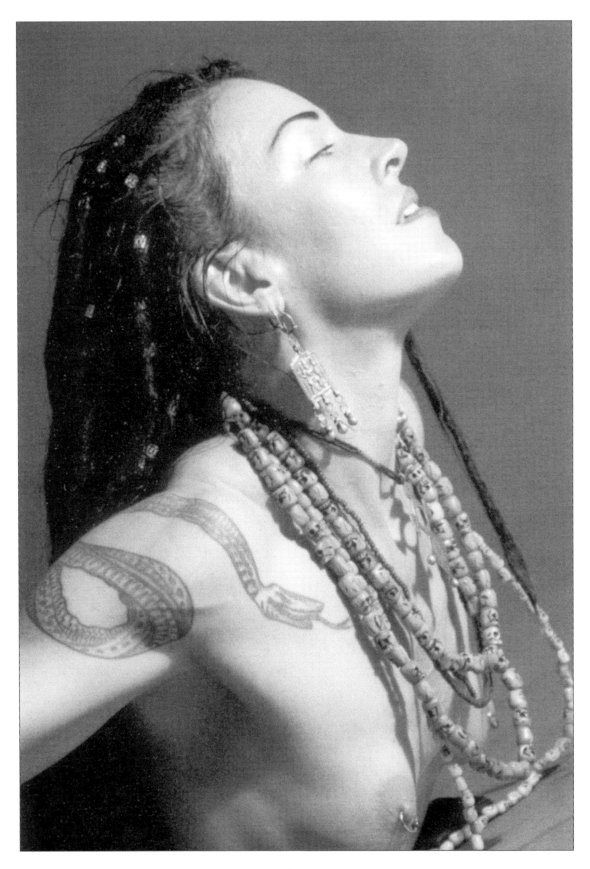

actually used to go around the house and open the closet doors, and hope that I would walk through into Narnia. And then, books like *A Wrinkle in Time*. It's funny because they were written by Christians, which I didn't even realize. They're very much about going on a quest, this sort of journey and self-searching, and fighting all these battles that are on behalf of something, that these kids who are the protagonists go through. And I think that's what I really identified with. That they had this task they had to fulfil. That's something I took with me from reading those books very young, that you have a task to fulfil and you have to fulfil it with as much honour and integrity as you can bring to it. And even though I didn't think of it consciously, it sustained me through my adolescence when everything around me was so wretched I would have ended it but for, in part, that conviction.

GG: What was school like?

VS: I had problems with other kids. I was very much a classic misfit from the word go. Ostracized to a greater or lesser degree... I went to several schools because we moved around... some places being worse than others and as I got older, it was less that I was ostracized but I was apart and I was a freak and that was that. At a point, you get stronger and you just stay with that. You get more of an attitude. And so after a while you just get fatalistic, and that in a way makes you stronger.

GG: What would you say to someone who accused your work of being fatalistic, or called your ideas bleak?

VS: I would tell them they're not listening, because there is bleakness and there is fatalism but I feel that in all of that work there is the thread of light and strength that keeps me going. If it were totally bleak, I would have killed myself at 13. And to me, at the end of every piece I write I feel like there is the way onward. This feeling that everything you go through is a part of you, it does teach you, it's the fabric of your being... and by accepting that, and taking that with you, it becomes something else. It becomes something that doesn't just make you stronger but makes you more. It makes you clearer. And then you can turn from that and bring something forth that is different, that is a work of art. To me, there's always the paradox within it, and not just the one wallowing in the mire.

GG: Are such face value type reactions to your material extremely frustrating?

VS: Yeah, I think that it may be a little bit frustrating at times. And I find that the people who are less receptive and open are the 'avant garde' people a lot of the time. Often, the sort of average people who find their way to one of my shows, sometimes they understand it better than the people who consider themselves on the fringe. Because it's a human experience... anyone who's lived

Vanessa Skantze, Seattle street fair, 2005. Photo courtesy of the artist.

through any part of their life in which they felt alien and wrong and confused, there's a part of this that's gonna speak to them. And I feel that if people can't be open to that, then they can't be open to something in themselves, that's their deal. I can't do that. I can only present what I have.

GG: Has *Pariah* gotten any great reviews yet?

VS: Well, I haven't really gotten it out too much, because I'm distributing it myself. Or giving it out. It's funny, I've given it to a lot of people and for the most part, they don't say anything. [*laughs*] So I don't know what that means. Maybe they don't know what to say. And they're my friends, they're not bad people, but I don't know what they think. That's why I was so appreciative of your response, because it was much more open than what I've gotten from anyone I know. And it may just be that people don't know what to say. I find that in performances. People don't know what to say.

GG: What was initially responsible for the introduction of dance in your show?

VS: Well, even in *Pariah*, there's a lot of reference to feeling trapped. I was slowly drawn back into studying dance. I'd studied some when I was young, I'd done a little theatre. I loved it when I was small, and then I tried it in college, and hated it. I hated theatre people, I hated the whole fakeness of it. But I did have that way back there. And I think incorporating dance made the metaphors real for me. And brought the worst fear more out into the arena. Suddenly, I'm the matador and the bull, instead of just the matador. I'm showing all of it. It was the hardest thing I could ask myself to do, on many levels, which is why I do it. That drew me to want to keep searching for that freedom. And it allows for multiple levels of expression, and that's what I'm trying to study more now, even with things like how I use my voice. Vocally, in performance. How many layers can I put into this so I'm not just addressing on a direct verbal understanding but that there's different levels at which not only someone's mind and heart and spirit, but someone's body and physicality can actually perceive me, because one body can talk to another and completely bypass the mind. I've seen that with yoga. And so it's a richer, for me, possibility of communication.

GG: Would you like to talk about scarification? Does it have a role in the performance?

VS: I've used it twice, in actual performances where I've cut myself, and for me it was a very concentrated version of what it means to me to use the body in performance. So for me, to cut myself on stage was a literal opening of myself, a literal offering. And a baptism at the same time. I have a scarification design on my chest that I had done recently. What I love about it, especially, contrasting a little bit with tattoos, is that you're actually working with the body's capacity to heal and become something new. You're having this experience of wounding and releasing and opening, and

> "I was very much a misfit from the word go. I was a freak. At a point, you get more of an attitude. And so after a while you just get fatalistic, and that in a way makes you stronger."

it's such an incredible feeling. It's a very different feeling to do it and then to have someone do it. And have that sense of warmth that comes over. The healing process of it is so fascinating because suddenly, it's like you've just shape shifted. You're something new. I mean, you've got these marks, and they're not made with ink, they're made with your flesh becoming something else. To me, that's just absolutely beautiful. That's such a fascinating process.

GG: The design on your chest is a heart with thorns around it?

VS: Yeah. It's like a sacred heart, and then there's these rays that are nails at the same time. And they incorporate two scars that I had done in a performance.

GG: Isn't that Catholic iconography? There's even a cross at the top.

VS: There is. I took it from a tombstone that I found in Mexico when I was travelling there. It's a figure of a woman, Mary, but the head's been removed and there's this great crescent moon behind her and she's got her hands around it. It was an amazing image, because it was a Catholic image yet at the same time, it had a goddess quality to it as well. I am trying, within myself, to bridge that violent Catholicism that is so much a part of me, and particularly that sense of suffering. The beauty of suffering. And this more... earth cradled female wisdom. I want to find a way that those intensities can co-exist. I don't want to give up one, completely.

GG: One of my favourite lines from *Pariah* is, "I cannot fall, I can only burn." When did you start performing the kind of material that's on *Pariah*?

VS: Theatre was what I went to school for, and I got disgusted with that and everything, and went on quite a spiral for a while, where I didn't do a lot besides try to destroy myself. I crawled out through the words. I met Lydia [Lunch] and we became friends. I started writing press releases for her, and she thought the press releases were wonderful and she wanted to see some other

Midnight Mavericks

> "You have this natural sadness... if you're human, and sensitive... I get so tired of people wanting me to feel better so that they're more comfortable."

writing, so I read her some journals. She was like, "Get something together, do a reading." And that got me going with the spoken word. That was ten years ago, maybe.

GG: How would you describe the manuscript you're working on?

VS: Journals. There's so much I've never published. I've got a stack of things I need to publish at some point, when I edit it. That was how I got through, that's been my catharsis. And I never even really thought it was much of anything.

GG: Have you ever considered a novel, short stories? Has there been any work in those forms?

VS: No. I've never been drawn to do fiction. I mean, some of my favourite writing – like Kafka and Dostoevsky – is fiction. I can't imagine at this point doing something like that. That might change. I've always written in the way that *Pariah* is done, that more direct prose/poetry style.

GG: What makes New Orleans such an ideal place for you to work and experiment.

VS: What's made it ideal for me is that I had wonderful teachers. I found my yoga teacher who's been amazing and is my mentor. She, like Lydia, has helped me so much through her faith and encouragement for my words. I have an insane Russian ballet teacher who's ruthless and fantastic. I have an excellent voice teacher. In terms of the community here being supportive and accepting of alternative work? No. My shows don't do very well here. In New Orleans they live up to their reputation, they like to have a good time. And a lot of the more popular, I hesitate to say, performance art, and a lot of the things that go on here, are campy, are funny, are kitschy, are all those things I absolutely hate. I've done group events here, and my turn comes up, and it's like, death comes to dinner, and everybody is suddenly silent, because I'm not making them laugh. [*laughs*] They're actually having to think, and it's this sort of rupture in the night of entertainment. That's a problem but at the same time it does excite your rebellion, to continually put it in their face. They should have to think on occasion.

GG: There is also, though, the voodoo, and the dark spiritual quality of the city.

VS: It's physically very beautiful. The old buildings. I really have a love/hate relationship with it. The places I've been in the world where I feel much more... not exactly at home, but where I feel I belong more, tend to be more rugged, and mountainous. There's something about this swamp that's very draining. I feel more and more, that the earth here wants something back. I don't know if it has something to do with the bloody history... I'm sure it's a lot to do with that history, but also with the earth itself. The Mississippi River is kept on its course by the army corps of engineers. Technically, the river wants to move. And a ton of money is spent to keep it where it is, because if the river did what it wanted to do, New Orleans would be gone. So you live here for a while and you feel those things. You feel how we've fucked with the land, and you feel the land's anger. That becomes part of what you have to live with. There's this combination of anger and that something's being asked of you that you can't quite give. I hate Mardi Gras. One of the reasons I'm doing these shows in Washington D.C. now is because I can leave and be away for Mardi Gras. But at the same time, it's a culture with a love of music, a love of something more than just money, and there is definitely more of a vibrancy here, more than anywhere else I can think of in the States... Eventually, I'll leave it.

GG: Where might you go?

VS: I don't know. I'm drawn to go to a Spanish speaking country. I'm studying Spanish. I've spent some time in Spain and Mexico, and in both those countries, for very different reasons I felt that one of the things that really stole my heart was... here is a place where you can be sad. Both places are very tragic, but it's a very passionate and open tragedy. One of the things that makes me so tired about this country... if you're sad, that's not good and you need to get better, and you need to take the right amount of Prozac or whatever. You have this natural sadness that, how could you not feel if you're human, and sensitive, and you're being told that there's something wrong with that very human sensitivity that's part of everything that makes you who you are and I get so tired of that. Even from people that I care about, I get so tired of people wanting me to feel better so that they're more comfortable. And I don't know, it may just be a myth in my head, but when I'm in these other places you're just allowed to express that, and that's a part of life. That you feel these feelings of darkness and sadness and anguish and anger. There's more of a sense of that freedom. But I don't want to stay in this country. When I've gone back to New York, I've just been horrified. Especially having lived there before Giuliani came in with the Disney squad.

240

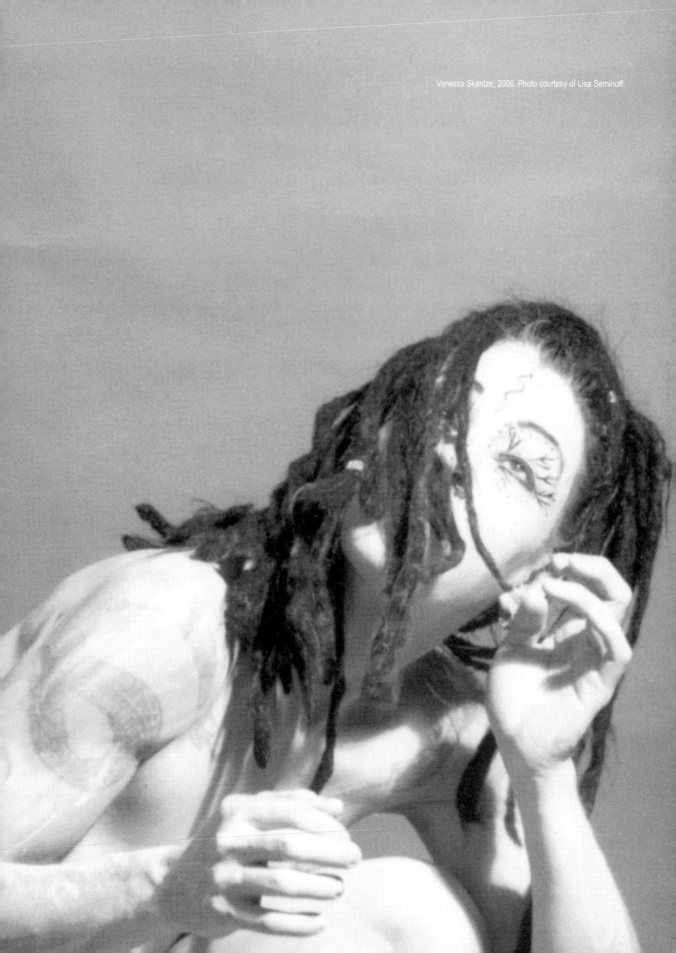

Vanessa Skantze, 2006. Photo courtesy of Lisa Seminoff.

In Love, Morphine, and Memory

- Rockets Redglare -

I hung out with Rockets a half dozen or so times. He had one place in a basement: his shrill holler would come up from under my feet on 6th Street, literally underneath the street... from a storm grate through which all the airborne scuzz of Manhattan would filter and then perhaps settle upon his threadbare sheets as he slept: "Gene, I'm down here!"

I saw him a few times on Sheridan Square. He'd ring me up some days and ask, very politely, often apologetically, if I would bring him booze. I always stopped whatever it was that I was doing, and went to him with his precious Kettle One vodka. I always took his money for the stuff when I arrived. Now, I wish I'd refused it.

The first time, his girlfriend's dog bit the hell out of my hand, and I offered him the vodka with the other. He slugged the half pint down inside of five minutes. Rockets was kind, hopelessly fucked up, and brilliantly funny. He acted in movies by Steve Buscemi, Oliver Stone, Penny Marshall, and Jim Jarmusch. Rockets was in *Desperately Seeking Susan* and some people believe that in 1978, he murdered the girlfriend of Sid Vicious.

I understand he ripped a lot of people off.

I'm aware that a lot of people scoff at good memories of Rockets.

Yet, a lot more people have them. I do.

We didn't know each other that well. But it always made my day to see Rockets. Rockets was in bad, bad shape the last five years of his life. As with Johnny Thunders, the only shock about his death was that it hadn't occurred a long time ago. And for someone so physically and chemically stigmatized, the guy had enough life in him for a whole fucking block party.

Rockets was a great liar. He spread rumours of his own death for a cheap kick.

I thought he was extremely fucking cool. A true tough guy with brains. A dying breed. I looked up to him like a father.

He bought me drinks. I bought him drinks.

We were supposed to go to Tower Records on Lafayette Street and buy ourselves each a complete set of the works of Bill Hicks. Rockets loved Bill fucking Hicks. That day never happened.

A briefcase containing an address book with Rockets's many phone numbers (you never knew where he'd be) was mysteriously stolen from an empty Bleecker Street bar one night. It's safe to say that the last time I spoke to him was some two weeks before that night, during God knows what month of 1999. Soon after, I left New York. I caught a one-way a flight to California. I gave most of my stuff away, and that was that. Rockets was in Jamaica at the time, and if he wasn't, I told myself he was because I was afraid to see anyone, even Rockets. It made it easier. New York had finally gotten to me.

A year later, an NYC 'zine publisher named Bob Bert told me Rockets was gone. During the course of that year, I'd often think, or say, "I've really gotta find someone who can give me Rockets's number." I knew, and would also often say, that Rockets might not live out the year. I think one of the reasons I didn't try too hard to reach him was fear of finding out he'd already died. I worried about him often. That trek to Tower would have been an entire afternoon, even if we were just a few blocks away. He could barely walk. To cross a street with him was a test of will. And friendship. There were scars covering his arms. I never asked how he got them.

It was an e-mail that told me Rockets died. I immediately wished someone had called me instead. But it was just an e-mail read over scrambled eggs. Like nothing. "Oh, look. Rockets died." But I didn't take it that way, at all. It was the way they say it happens, like someone just kicked you in the balls. My jaw dropped, the blood left my face. I was sad as hell.

Later that morning, I returned to sleep. In my dream I was walking down 6th Street, searching for the source of this bizarre, shrill holler that kept screaming at me like the invisible man. With some degree of alarm, I noted that the sound was coming from beneath the concrete, through a thick horizontal shelf of sidewalk. Through a storm drain, I saw a familiar face. He was smiling, he was alive.

"Gene! I'm down here!"

Rockets Redglare in **Stars and Bars** (1988).

Rockets Redglare: Lemme tell ya... for a fact... I know that Sid did not kill Nancy. That I can completely ascertain... I'm positive, basically, she was killed by a drug dealer who worked at Max's Kansas City. The big problem for Sid was, it took him so long to report the crime... when he did report it, he had the blood all over him. And people had seen him walking him around with the blood all over him as if he was in a daze. Well, he was in a stupor, because I was there the night that Nancy died.

Gene Gregorits: Right before Steve C walked in...

RR: Yeah, that's the guy. I saw Steve when I left there. I was there just before Steve. Then the next time I saw Steve, was not that night. But I saw Steve coming down the stairs giving titbits to all these reporters about how Sid abused Nancy and the story of him beating her up with his guitar, and hanging her out the window by her legs and all that. So that made me a little suspicious and then I realized what was going on, that he had said to me that he had all these Tuinals [barbiturates –ed.]. He wanted to sell them to them, and what happened was Sid and Nancy took a bunch of them. Sid, being the drug hound he was, he was completely out of it. He was unconscious, fucked up. And the reason that he didn't report the murder in the morning right away was that Nancy was dead. He knew

that he was gonna at least be detained, and he was on the methadone program. So he wanted to get his methadone. Plus, he was still in the half-life of barbiturates. Like the next day, you're not thinking totally clear, so that's why... that spacey look, and him stumbling, and having the blood all over him... it wasn't like some kind of blood simple stupor he was in, you know how they talk about how after someone commits murder sometimes, especially a gruesome murder, they get into this head where everything is surreal and they don't know where they are… you know, that whole shock thing.

GG: Was Steve C ever called in for questioning after that?

RR: No. They didn't think he was anything. He just provided background. He provided the kind of stuff they wanted to hear. Sid was a perfect fucking scapegoat. If Nancy hadn't happened, something else would have happened. Yeah, you've gotta realize... this guy was influencing youth. And everything he was about was so negative. Heroin addiction, stupid violence, and while John Lydon sang about it, Sid was pretty much the embodiment of that kind of thing. Now, you can look at it and say how stupid it was, but at the time it was easy to get caught up in that. It was like anti-glamour. Anyone

Sex Pistols bassist Sid Vicious two months before the stabbing death of girlfriend Nancy Spungen, 1978.

could be a star. All of a sudden, regular people were giving themselves rock star names. It was street culture, criminal culture... I guess the closest thing we have now is hip-hop. The whole violent aspect of that, the whole street thing you know, guys who are making two million dollars on an album going around cutting each other, shooting each other with guns in alleys.

GG: The cops had something against punk?

RR: Oh, absolutely! I think it was even deeper than just the cops. The government does not let somebody who has that kind of a forum just spew endless shit. C'mon, there was Hollywood and that whole blackballing thing. You don't even have to be a celebrity. It's just having access to the printed word. And now, I'm sure they're having a ball with this Internet stuff. I'm sure they have whole buildings full of people that do nothing but hit websites to see what's going on.

GG: Do you think that the establishment really took punk and the Pistols that seriously?

RR: Yeah. Let me put it this way. I think they realized the potential was there. I mean, take a Malcolm McLaren, who was interested more in power than in money. If someone who was that Machiavellian had stepped in and used Sid, and people of that ilk, we could've seen a whole different mindset among youth. It was definitely diffused with that Sid thing. There he was, his first love, his first

girlfriend, he's a rock star, he's a junkie, he's the most libertine character that's been around for quite a while, that has had that much attention, and then all of a sudden, he goes to the complete fucking other end of the spectrum. He's in jail, with a murder charge. He's locked in an American prison, which for a guy like him, who was known as Sid Vicious, who was weak, he's skinny and can't fight worth shit, but who has a big mouth. He'd have been killed within the first six months. He never woulda went to trial. He woulda got killed in Rikers.

GG: In the period that he did spend in Rikers, did he ever get raped or beaten up?

RR: He got beat up a couple times. He wasn't the kind of person who bull faggots in jail would have seen as attractive. He was too funky. You know, I mean he was dirty, he smelled bad. I loved him, I thought he was a great guy. Because he was an innocent, in his own sad way, he was an innocent.

GG: Aside from the drug connection, did you have a pretty strong friendship with them?

RR: Well, I couldn't stand Nancy. The only other thing I'll tell you is... uh... [*long pause*]. I know, whenever I mention this, it's like, "oh God, fringe lunatic!", but Maury Terry wrote a whole book about it, *The Ultimate Evil*. And, well, there are definitely reasons that I have to believe that Nancy's murder was videotaped. It's the same kind of thing... they videotaped the Son Of Sam murders, and there is enough evidence there that Terry is not the only one to believe that.

GG: So in twenty years, what do you think has kept that videotape from being discovered?

RR: It was never easy to see, you know. You probably had to put up quite a bit of bread to see it, to have a screening. Listen, the place where Lucky Chang's is, the basement over there? Thirty years ago, they had live – just like how they did it in 'Nam – they called it "telephone." Matter of fact, telephone shows came over from 'Nam.

GG: What were telephone shows?

RR: A girl would sit on a chair, and be abused by a guy, suck his cock, get smacked around, and then... sometimes they would say "telephone for you!"... then take a gun out, put it to the girl's ear. And pull the trigger. Shit like that. I know one person who's very wealthy, and a real sick individual, almost like a connoisseur of very decadent sexual books and paraphernalia. I know this all sounds like all that trite shit you hear, but... it's true. My friend who had seen the Sid and Nancy tape told me that there was a German film that was made by these artists. This was a recreation of the Sid and Nancy tape. And they used kids. So it was almost like a joke. There's the Sid character, kid, laying on the couch nodding, and the door opens and this other guy comes in with another little kid, with a video camera, videotaping the third boy... stabbing Nancy. This was done by a German artist who had seen the tape and tried to recreate it almost like a goof, like an inside-inside-inside joke.

GG: Did Sid Vicious know that he was being taped?

RR: No, he was out of it. That's why I say, Sid couldn't have killed Nancy.

GG: Well, either Sid or Nancy had contacted you earlier that evening about Tuinal...

RR: Yeah, they wanted more Tuinal. And they wanted dope. But I said to them, "I don't want to get you dope because the dope out there is shit. I'll get you Dilaudid," which is pharmaceutical, and just as good for their purposes. I had gotten them some before and they were happy to get that. But the point was that Nancy had showed me like $1,400 and she said, "get Dilaudid. I got the money."

GG: But the Tuinal they did was what Steve brought over before you talked to them.

RR: Yeah. The Dilaudid was what I was gonna get them. My point being that Nancy showed me all this money and the next day, Sid had like nine dollars and change on him. And that was all the money that was in the apartment. They didn't give me the money upfront, because the thing was I was gonna get it and bring it back to them. When I came back to the hotel the following morning, I saw that something was up.

GG: But you didn't actually go into the room.

RR: You couldn't get into the room!

GG: The last time you were there was 4:30a.m.

RR: Yeah, I had been there early, and I must have came back like 11-ish because Sid had already been taken away, or was being interrogated in the room.

GG: Do you know what Sid did when he woke up?

RR: Yeah, he went to the methadone program. We talked about it afterwards, when he got out. Now the first time Sid got out, he started hanging out and trying to behave, not get in trouble. But he was hanging out in clubs and stuff. And basically doing dope here and there but not really being outrageous. Because he knew he could get put back in like that. You're on bail, you know, you gotta be careful. Which is when he said to me, "you really gotta stay with me, you know the city a lot better than me." Because he really was lost in New York. He said, " you know what is gonna bring trouble on and what won't, better than I do." So I said... "all right." So what happened was one night, we were hanging out at Max's, and this guy Peter Kodiak – he's a photographer – showed up with a limo, invitations to Hurrah's and a stack of drink tickets... I mean, a ridiculous handful of drink tickets. Fifty drinks. So we're drinkin', and Skafish was on, and Patti Smith's brother and his girlfriend were in front of us. And Sid was dancing around, playing around, and [long pause]… he fucked up. I think he did something to Patti Smith's brother's girlfriend... and they got into words. Sid hit him [Todd Smith] with a beer mug, fucked him up pretty good. It broke on impact, all the bouncers came running over, and I was dragging my girlfriend and basically carried Sid out, all 6'4" of him. I managed to get us out. So I got Sid out and I took him to The Nursery, an after hours club. His

"My mother was a heroin addict, my father was a mafia guy, so basically... there was always a scene."

hand was cut open, so I took him into the ladies room, and I got a needle and thread from this girl, and just kind of closed it up enough so that it wasn't dripping and shit. Wrapped it up.

GG: How the hell did you manage to do that!?! You were really drunk at that point!

RR: Oh yeah, well, it was like, that whole Sid Vicious thing. What, he's gonna say, "no, don't do that"? Of course he was gonna let me do it. He just saw it as more of his myth being invented. Anyway, strangely enough, it was like four days later before he got arrested.

GG: How old were you when you first got involved with a scene?

RR: My mother was a heroin addict, my father was a mafia guy, so basically... there was always a scene. I was running around with the gangs from Little Italy and even the kids in Chinatown... you wouldn't think so, but kids from Little Italy and the kids from Chinatown didn't really fight each other because they were right up each other's asses. It was much more about keeping the bridge and tunnel at bay. That's who everyone hated. Like, Abel Ferrara... I liked a lot of his work, but he missed the mark with *China Girl*, because basically, it wasn't about the Italians vs. the Chinese. It was about Jersey guys, and Brooklyn guys... everyone hated Brooklyn people because there was like these weekenders who would come in and fuckin' hit on our girls, and get drunk and throw beer bottles in our parks.

GG: When was the first time you were aware of some kind of underground scene, a drug culture...

RR: Like I said, I always had illegal activity in my home. I was five years old. My uncle Eddie tied me up with his raincoat when the FBI kicked down my parents' door for robbing the Minneola post office. Shot an FBI agent right in front of me. He carried me down the fire escape and drove me to Long Island, gave me to my aunt and said, "Fay, Michael's going with you for the next six months; otherwise they're gonna try to take him away from Dominic and Agnes."

GG: What name were you born with?

RR: Morra. Michael Morra.

GG: So when did you come up with the name Rockets Redglare?

RR: Well, I had a band at the end of glam, beginning of punk. The name of the band was Rockets Redglare and

Above and Opposite:
Rockets Redglare, photographed by Luis Fernandez de la Reguera.

The Bombs. People started calling me that, which was actually kind of my plan anyhow. Because I always knew I was gonna go into show business, one way or another. And I figured, "if you go into show biz, Americanize your name." And, well, how American can ya get?... Rockets Redglare. I didn't write the music. We were ripping off anything that we liked. Just kind of rearranging it.

GG: What did you like?

RR: Bowie. We were a beefed up, incredible string band. We got some gigs here and there. A lot of loft parties. We were hanging around SoHo a lot, the West Village, East Village...

GG: Who were some of the first people that you remember meeting, who were of some social stature in the area?

RR: Actually, Todd Rundgren. I used to always hang out with Nils Lofgren when he was in New York. Then later I was hanging out with John Cale, and his guitar player Sturgis [Nikides], porno stars, Sharon Mitchell... I played the judge in a [porno] film that Sharon Mitchell directed, which was funny. They sprayed my hair silver, and this is when my hair was black and stuff. Almost all the musicians had girlfriends that worked as strippers or porno actresses. A lot of the girls did that to pursue their careers. [*laughs*] There was this guy, at the beginning of my film career, Lance, that had a loft on 30th Street and 6th Avenue. His loft was like the playground for adults. He was a heroin dealer and a coke dealer. He had fashion models over there and celebrities. He took this incredible liking to me, and he really seduced me into hanging out there, because he liked to pick my brain. He had almost every film I could imagine on laserdisc, Beta, or VHS. He had all this great pussy around all the time. He used to hold kangaroo court, and shave a model's head after he had chained her to a radiator for a day or so. There's a girl that's gotta be in London in two days, and he shaved her head! There was one that he did it to and she went to the job anyhow... and it was a big deal, it went over really big.

GG: Do you have any good stories about the porno era, about hanging out with the people, seeing what kind of lives they led, that kind of stuff?

RR: There was a lot of dysfunction and weirdness. Just imagine the frustration of some guy that has access to 10, 15 good-looking girls that would just rim their asshole at the drop of a hat. And because of all the coke, and just being so fuckin' jaded, they just cannot get it up. If you were there, believe me, you woulda had tears in your eyes. I laughed so hard. This guy Jerry... his father's this mafia guy from Vegas. And the father has sent Jerry to New York to oversee his porno empire. Jerry has gotten so caught up in these chicks and in all the bullshit that he's totally coked out, all the time, and he's got these twins that go with him everywhere. A couple of times I had been with Jerry and the twins hanging out, doing blow, and smoking cocaine. The twins would be eatin' each other out for like two hours. And Jerry'd be kind of like languishing around. But I figured, he can have it anytime he wants. He's probably just more interested in getting high or something. I've seen a lot of that. That was one of the things that bothered me... there was this girl that totally fit one of my all time fantasies. She looked like a little librarian. She had glasses and milky white skin, and used to wear these cotton sundresses. One night, we're watching this movie and she starts crawling around on the floor on all fours. She pulls off her panties, and just starts backing up to where I'm just laying on the bed watching this movie. And I had the coke pipe there. And I realized, holy shit, I'd rather watch the movie and suck on the pipe, and give this girl Lisa the boot. So that was one of things that made me realize, that made me get my priorities straight. [*laughs*] Anyway, so Jerry... couple times we were hanging out and I'd see similar things like that go down. I just figured Jerry can do this any time. But sex is one of those things, I guess, you can only do so much. But there are all these drugs you can do until you drop dead. So I was seeing this girl Gloria who was a dominatrix, who I met through Sharon Mitchell. Now Gloria is no babe in the woods. She's been around the block a bunch of times. Jerry comes over to Gloria's apartment with the twins and a third girl, who was a knockout, and a bunch of coke and shit. He starts cooking the coke, and says to Gloria, "do you mind if I get comfortable?" Gloria says, "no problem, get comfortable." Well, in Jerry's twisted concept of what comfortable meant, it was his cue to completely take his clothes off, lay

down on Gloria's bed, and start whippin' this flaccid fuckin' dick of his all over the place. It was embarrassing and pathetic. This thing is so dead... And I happened to look over at the twins and the blonde girl, all simultaneously rolling their eyes in their heads. And he did that for about four hours. Nothing happened. But that's how burned out some of them can get. But I'll tell ya one thing... a lot of those guys wind up with greased up, big black dildos under their bed because their dick just stops working. They're in so much need for some kind of stimulation that I guess they decide to get on a real positive frame of reference with their prostate. I'll tell you the story of the Danish girl. Actually, I started going out with her after Gloria. I didn't know [she was a porno actress] when I first met her. I thought she was just a thrill-crazed émigré. She never talked about any of that. One night we're over at my apartment and I show her some scenes from my movies. She goes, "you know, I've been in movies, too." I said, "really?" And she says, "Yes. You must see some of the films that I acted in sometime. I will make you dinner tomorrow night, come over." Now, this is really funny, because this girl, I could not picture her being anything but one of the sweetest little girls in the world. Anyway, she makes me this dinner, which was really fuckin' atrocious. I don't know what the fuck it was. Cod, with some kind of herring sauce! [*laughs*] I don't know, but it was about the fishiest thing that I had ever tasted. It tasted like you were biting into some kind of fish's bladder. Like fish piss, melting in your mouth. Anyway, she goes, "after dinner, we'll see some of my films." I go "all right." Well, the first one was a Danish film. She puts on the videotape and it's in Danish, but it opens up and it's beautiful! It's this young girl, and she's running through the park with her dog, and you see her playing with the dog, and jumping and stuff, and she gets to the barn of her farm. She's got her horse there. So now, she starts grooming the horse. But it's really cute and it was her dressed as a little girl, dressed in a little short pinafore... I'm saying, "that's a little weird", you know. So she rides the horse all the way out from the barn, gets off the fucking horse, starts rolling around on the grass with the dog [*laughs*], and starts to blow the dog! And get this. After a while she gets up, leaves the dog there and she walks over to the horse and starts playing with the horse's cock. Then she starts blowing the horse! [*laughs*] Then there's a screen title, and I guess it was [*laughs*] ten years later, and it shows her driving a Saab to the farm... she gets out, and the dog comes running out, and she scruffles the dog's head... gets on the horse again... now she's dressed as a business woman, right? She gets on the horse, hikes her skirt up, rides the horse, and does the same thing as a grown woman, right? Then, of course, the guy across the way sees her, the young buck farmhand. He sees her doing this, and then they get started. After that it just degenerated into a typical porno flick. But I was just so flabbergasted! Here I am, an inch away from saying to myself, "ah, the mother of my children!"...

Rockets Redglare, Film Actor and Comedian, Dies at 52
(*The New York Times, 6 June 2001*)
Rockets Redglare, a comedian, actor and long-time fixture on the Lower East Side of Manhattan who played characters not unlike himself in many movies, died on May 28 in Manhattan. He was 52. The cause was complications of kidney failure, liver failure, cirrhosis and hepatitis C, said his cousin, Madeline Schuster. Rockets Redglare's rugged good looks and rollicking nature made him a recognized figure on the Lower East Side, where he hung out and often lived. In the early 1980s he began performing as a comedian in neighbourhood clubs like the Pyramid and Club 57, where for a few years he staged a string of performances called the Taxi Cabaret. In the mid-'80s he began acting in films, appearing in nearly two dozen over a 15-year period. He played a sushi-hating cabby in *Desperately Seeking Susan* and a poker player in Jim Jarmusch's *Stranger Than Paradise* and appeared as himself in *Basquiat*. Although his parts were often small, his colourful presence impressed viewers. "When Rockets was on screen, you couldn't take your eyes off him," said the actor Steve Buscemi, who met him on the downtown comedy club circuit in the '80s, appeared in 1992 with him in *In the Soup*, then directed him in 1996 in *Trees Lounge* and last year in *Animal Factory*. Born Michael Morra, Rockets Redglare grew up in Sheepshead Bay, Brooklyn, and in Lindenhurst, on Long Island, sometimes living with Ms. Schuster's family. No immediate family members survive him. While growing up on Long Island, he worked as a roadie for a band called The Hassles, which included Billy Joel. It was his first brush with the life of show business. In the late '70s he worked for a time as a bodyguard for the Sex Pistols and later for Sid Vicious, that group's bass player, who split with the band.

Luis Fernandez de la Reguera during the Tribeca Film Festival, May 2003.
Photo by Dominic Thackray.

Rumble Tumble

- Luis Fernandez de la Reguera -

The Strange and Terrible Saga of
Rockets Redglare!

Rockets Redglare! showed up in my mailbox on a bright, balmy Friday afternoon. As I trudged back into the house, sifting through bills, club invites, pizza menus, and other assorted tripe, I heard the mailman yelling, "whoah, hold it there!", sprinting back up towards my porch. He'd forgotten a couple of things.

"Two packages!", he wheezed. "They were in the truck!"

I tightened the belt on my disintegrating bathrobe, and with outstretched arms, accepted the rest of my mail. The first envelope held a newly purchased copy of *Huckleberry Finn*. No return address. The second was a videocassette labelled *Rockets Redglare!* I became anxious and actually got a little dizzy, immediately jumping in the shower. I combed my hair, made sure my socks matched, that I had enough to drink, and plenty of privacy. Pulled the shades. Popped in the cassette. I'd been awaiting this moment for months.

Around November of 2001 I began to occasionally check in with Mr. Reguera regarding his work-in-progress film about the hellishly turbulent life of hustler/character actor/downtown scene fixture Rockets Redglare. A happenstance discovery of Reguera's then ongoing project while browsing the internet had renewed my deep obsession with the late Redglare, and I was thirsting for a taste of what he'd documented. A 10 minute teaser on Undergroundfilm.com revealed that Reguera had gained access to several well-known actors who knew Rockets, such as Matt Dillon, Steve Buscemi, and Willem Dafoe. It was then that I began to realize what a lovingly ambitious attempt had been made to tell his story, warts and all, undiluted, unrestrained.

So I was only ten minutes into the fucking thing when I had to slide off the couch and pace back and forth for a few minutes in the kitchen, trying to shake away the concentrated dark energy of what I'd already seen and heard. I was uncomfortable looking at these images of Rockets, having been friends with the big guy towards the end of his life, but left with no choice but to plant myself back down and finish it. Yeah, *Rockets Redglare!* is THAT intense.

Not only does Reguera's film capture Rockets's obnoxiously brilliant humour, it bares his soul. It explores his wounds with a bravery and a sincerity matched only in a small handful of other documentaries.

A man of Rockets's charm and endurance is someone you may encounter only but a few times in this world. His laughter was richly inspiring. But to laugh with him is to suffer, too. Perhaps the most memorable aspect of *Rockets Redglare!* is the manner in which Reguera skilfully articulates the horrible fact that in his most unbearable midnights, laughter was his greatest weapon, his best defence. To the bitter end, he retained a sense of humour. Any bar in NYC was considerably livened by Rockets, and his jokes and stories would have inspired a lot of people in the aftermath of 9/11, had he lived that long.

As a film, I wouldn't hesitate in calling *Rockets Redglare!* a masterpiece, and what I find most valuable about the overall work is its bizarre mass-appeal. One need not have any appetite for human horror stories or harrowing subject matter to appreciate *Rockets Redglare!* It extends to any attentive audience an uncompromised reminder of the great beauty inherent in simply surviving the perpetual defilement and abuse of human existence. It demands a simple respect for self-education and learned resilience in an age when men are castigated if not outright castrated for acting like men; in a culture where the life of the outlaw is taught by professors and paid for by rich parents.

The undeniable magic and loss of this film spring to life before you like the saddest sad song and the dirtiest dirty joke you ever heard, simultaneously, in real time. This is the man Rockets Redglare was, and for me, Luis Fernandez de la Reguera's hugely powerful debut remains the most important film of 2002.

"I had met Rockets in the mid-eighties. Our relationship was good. It was sometimes adversarial because I didn't like to watch him kill himself with booze."

Gene Gregorits: When did you first meet Rockets and when did you decide to shoot a documentary on him?
Luis Fernandez de la Reguera: Well, I had met Rockets in the mid-eighties. We had actually dated the same girl at one time or another. [laughs] Rockets had infringed upon my meal ticket and I was very pissed off about it. We became re-acquainted when I was working in a bar in the East Village that he used to come into. Our relationship was good. It was sometimes adversarial because I didn't like to watch him kill himself with booze. It was always like the game of him bitching that I'm not putting enough booze in his drink, and me coming back with some smartass comment. It was a battle of wits, and he was quite sharp. Even when he was toasted, he was sharp. So one night, we were at each other, but in some weird way. It was getting old. He was drinking pint-glass-sized drinks. He didn't drink regular drinks. He took it in a pint. A pint of vodka. And he would bitch if it wasn't at least half full of booze. And at the end of the night, he was still there so it was just me and him. I said to him, "What is it? What makes you want to do this?" And he's like, "Ehhhhh, I don't want to talk about this shit." Then we just started talking. I started drinking, and we hung out. Then, he told me that story about his mom being murdered. Then her decomposing while the guy was over there shooting-up. It was devastating. And I could tell... he's a man that was known to be a con-artist, but when it came down to the real deal, he wasn't pulling any punches with that. And... he started crying. It's the same story that he tells in the movie. And we were vibing on the first time he had told it to me, and he started crying. Those are real tears. People can say what they want about him; he did a lot of hustling, and he did a lot of conning to support his habit and survive and get what he needed. People can ask, "What killed him?" I think that killed him. I mean, in a larger sense. Yeah, the booze killed him and the dope killed him, and the hard living killed him. The methadone killed him. But that pain that he carried with him, underneath it all, that killed him. And I got to see parts of him that a lot of people didn't, in the movie, his

friends, intimate stories that they weren't even aware of. I heard that story and it really changed my perspective. I mean, I've heard stories of him on the move with chicks, and yeah, you know, that was one side of him. But that other side of him I don't think he was so free with. And I think he knew that I cared enough about him to confront him on some issues, that some people wouldn't bother about. I mean, who gives a damn, with alcohol, everybody drinks at a bar. You see somebody like that, however, and you say, "What is UP with you, man? What's going on here?" So I decided somebody's gotta do this documentary. He told me more and more stories that night, he just kept hitting me with them. I had him tell me the same stories maybe 15 times during the making of the film. He's a very good storyteller, he was very consistent with his stories too. So I knew it had to be done. Just the story of his childhood alone. Even if he wasn't in films and stuff like that. I mean, I wanted to focus on his life, and not just the film thing.

GG: Did you encounter people who would just flat out refuse to talk about Rockets, who'd be like, 'what are you, CRAZY? I'm not going to...' Y'know, that kind of thing?
LF: I encountered one fella, who Rockets was in movies with – I'm not going to name him – who was like, "No. Why the fuck do you want me to talk about Rockets? He was a scumbag." ... "Well, you know I didn't want you to say anything nice, I just asked you to talk about him," that was my response. I mean, fuck! No one's under obligation to say he was a saint. When people like Jarmusch or whoever say things like, "he needs one thing or another to support various things," they're his friends and they don't want to go into details. See, all these guys were interviewed while he was still alive. And they're looking at the film project like I was looking at it, being that it was a vehicle to get him together. And to get his career on track. That was the whole idea. To get these very successful people, or people who had any reason to want to be in the movie, and say, "Yeah, he's really talented." To show what he was, and what he did with his talent, and to help him get it together, so that he could have a career. I mean, nobody expected him to live forever. But we were all hoping for at least another couple of movies. Steve Buscemi had offered to produce a one man show of his, if he would get it together. So... we all had plans for Rockets! [laughs]

GG: What about the toll I know it had to have taken on you emotionally, there's no way around that... it took three years, right?
LF: Yeah, two and a half. Yeah. I mean... jeez. You're watching someone sink. Slowly. At one point I was so devastated I had to leave town for two months. I went to San Francisco and just stared at the wall. I had a friend out there I stayed with. She was cool and she knew I needed a break. And Rockets, he said to me, "Look, I know I am a bit much. I'm a handful." I mean, he didn't

250

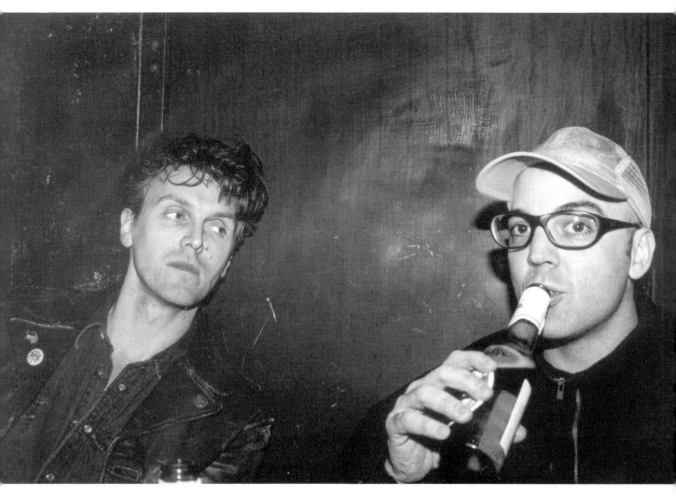

Luis Fernandez de la Reguera (*right*) with his friend Robert Burke Warren (*left*). Photo by Dominic Thackray, who recalls: "I first met Luis in May 2003 during the Tribeca Film Festival to interview him for the *Raindance* magazine. I don't remember much about the interview except that at the end I had to take some photos of Luis. I asked him if he had a favourite side. He said, 'Yeah. Between my balls and my asshole', and I fell into the street."

begrudge me that. I'm glad I didn't stay any longer. When I came back, I started shooting and shooting, and everything wrapped up the way it did, unfortunately… Look, I have answering machine messages from him that I wouldn't use in the movie because it just wasn't appropriate. And he also didn't know they were being recorded. But I took them anyway, and had to work that out later. He would call me, and shit, he would be crying, "I'm sorry!" He would always be like, "I'm letting you down, Luis." And I would always say, "Rockets, it's not about me, it's about you and yourself." He would always be worried. "Luis, call me, please." We were tight. It got to the point where I had to be a relative to get into the hospital to see him, so he had to be my 'Uncle Mike'. That was kinda sweet. Jeez… yeah… There were times I found myself in bed, in a foetal position and just crying. Because I just couldn't take it anymore. I had started the movie, and I was unemployed when I started it. And I intentionally applied for like ten credit cards!

GG: Excellent! Wise move!

LF: I just said, "Fuck it! All these dot-com kids, everybody's running into debt. But I'm going to make something with this." I got all these credit cards and I went for it. I took him to Puerto Rico, and I wanted to make a movie. Number one, I wanted to make him feel like it was serious. That I was serious, that it was a 'real movie.'

GG: That footage is great.

LF: He felt like he was appreciated. He knew that I was willing to put myself out financially. It was really hard being there, though, because that's when I realized – in Puerto Rico – how bad of a drinking problem he had. There was one point when we're driving, looking for a liquor store, on the way to the methadone clinic, so we were late getting him his methadone... and he was out of booze. I thought he was going to die. I mean, he was shaking. I got back to New York and I convinced him that he really needed to go into rehab. And he went for two months! He was clean! Then he came out and he was

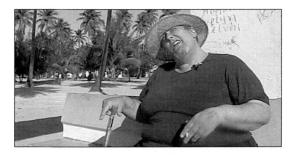

Rockets Redglare, photographed by Luis Fernandez de la Reguera.

fucking really trying. And I remember, I picked him up, and went with him, to AA meetings every day. For thirty days. Just to make sure he got there. And Steve Buscemi helped him get a room, because he was in a really weird living situation that wasn't really so positive, to say the least.

GG: He was living in a basement at one point.

LF: Yeah, he was. So Steve said, "Yeah, I'll get him a place, but will you go with him to meetings? I'll pay for his room, but I don't wanna pay for his vodka!" So, we did that, and then he slipped. This is when he got off methadone, he was off methadone for like three weeks. He came over and he could barely walk to my house. He had gotten in a cab, which was like thirty bucks because the guy was trying to drop him all over the place, and Rockets didn't [*starts laughing*] know where he was! The guy was freakin' out! He could barely walk. And then, true to Rockets's form… through the tears, he had to make a joke. That's the way he was. He really knew how to fuckin' stick you and make you uncomfortable.

GG: He said to me once, "Come on in! What? You think I'm gonna make ya bite the pillow or somethin'?" I was just standing there like, frozen. [*laughs*] Now, what's your background in film? Isn't this your first movie?

LF: Yeah. Actually I did one short before this, a short I actually wrote for Rockets. I made it just to show around, to eventually do it as a feature. Of course, the documentary took precedence over everything when I started it. I had dinner with Steve, who tried to talk me out of it actually. I was like, "No, Steve… I'm the man, I can do it!" He was telling me how insane and difficult it was going to be. And it was like forty times MORE insane and difficult than he told me it would be. But he liked it. He said I didn't miss a thing, so that felt good. He's telling me, "You gotta go for the top, go for Sundance." I don't know. I don't know the business, Gene. I played music until I started this. I did this because someone had to do it. I don't have a film school background. I mean [*starts laughing*], I didn't even finish high school!

GG: Well, what kind of musical background? What kind of music did you play?

LF: I played in a power trio, sang and played guitar in a band called Orgy of One. But I don't like the music business. I don't want to do that, really. I enjoyed this. I'm bitten now. Now I know I like documentaries. I mean, I don't know if I'll ever do anything this good again. I don't think I'll do anything quite like this ever again because this is such a one time thing. It was all about access… see, I had to max out the credit cards and go for it, or Rockets woulda been gone. It was just one of those things where everyone tells you, "Oh nooooo, you're going to blow your credit!" Okay, look. I didn't come to the East Village when I was 18 so that I would be able to buy a house when I was 40. You know, and I had to recall that, to recall my punk rock origins to be able to say, "Fuck man, this is what you do. You go for it." Fuck Visa. Fuck MasterCard, you know? Well, who cares if I owe them money. I don't consider fucking them over like fucking over a friend. You know? [*laughs*] And people get so weird when you tell them that you owe 35 grand on your credit cards. They look at me and I'm like, "Well, I wasn't smoking crack! I made a film!" And they go, "Oooooooh, you'll never again." See your credit rating is like your permanent record, that they threaten you with in high school.

GG: So are you going to look for another project to direct?

LF: Yeah, I would like to do another film. First of all, I hope this film gets Rockets, as a person, the recognition that he deserves, and not just for his talent, but for surviving and for managing to give what he gave… it's incredible. To grow up like that. And even though he's a seminal character in a lot of ways, he still did a lot. I mean, when you look at that film, *Stranger Than Paradise*, Rockets is ruling that camera. And he just had 'it'. And the conventional aesthetics that people have: 'What does talent look like?'… 'What does beauty look like?' … 'What is love?' I mean, I loved that guy more than I love my own family. It really taught me a lot about what love is, and how far you can go out for a friend. For someone you care about it. It changed me as a person. I have a lot less tolerance for assholes and idiots, that's for sure. Because life became so precious to me then. I find myself snapping at people more these days. "SHUT UP, you don't know what you're talking about." When before, I was a lot more of a peacemaker!

GG: So what is your best memory of Rockets? Is there anything that comes to mind?

LF: Well, one that I can relate to, with the movie, was the day when he is flopping around on that bed in the hospital, and he was just cuttin' up a storm. He was just so on fire that day. There's another shot in that movie where Jim Jarmusch is talking about him, and Rockets is in the bed, and he glances at the camera, it's a cutaway, and it's all in that same day. When Rockets was funny, when he was on, he had the entire hospital on its ear at points! There was one day when I came in and he had one of these gummy candies he liked, and he had sucked on it, part of it was red

and… anyway, he had stuck it in his eye socket, and he had taken his own blood out of his fuckin' IV and squirted it on his face, so the blood was coming down his face. So I come in to the hospital, I walk in and look. He says, "Luis, I think I did something to my cornea." I go, "HOLY SHIT!" I go runnin' down the hall and I yell, "I NEED A FUCKIN DOCTOR HERE!" I'm grabbing this young resident by the neck and dragging him into the room, and when I'm leaving Rockets is going, "No! No, Luis, no!" … "FUCK YOU MAN, YOU NEED A DOCTOR!" So I get in there and the doctor's like, "What, what?" And Rockets goes, "Oh it's nothing, I was just foolin' around!" And I'm like, "You motherfucker!" It was a testament to him, he would always, when he was just hours away from going into his final coma, he said, "I get scrambled eggs for breakfast, and I'm never going to walk again." I mean, it's… it's just not funny, but he's trying to use humour as his ultimate survival tool. Which it was. I mean, he was always so full of hell… there will never be another person like that.

GG: So great. Anyway, what thoughts do you have for future projects? I know *Rockets Redglare!* is done, but I guess you're still consumed with it.

LF: I'm still consumed with this one, but if this enables me to have the opportunity for another film, a fictional feature… I like the word fiction… look, you can be very honest and it can be fiction. Documentaries can be a lie. I've learned that. You really have to work hard to maintain some authenticity in a documentary. You can completely lie. Just because it's a doc doesn't mean it's true. But I struggled to have a sense of truth and morality with this. And morality, I don't mean that in a Christian sense, but morality as being honest to who Rockets really was. I want to do something that will require me to work in Spanish. It's a story in Mexico about the Chiapas Indians, and how they fought against the slave labour camps that were there, in the mahogany forest, a few hundred years ago. It's a story about these people. Basically a small revolt, about people who would rather die on their feet than live on their knees. This whole globalization thing that's going on now… young people are not going to understand that we didn't start at a starting line, and they fired a gun. And, 'These people are rich because they worked harder'. And, 'These people are poor because they're lazy'. It's not about that! So this story is the story of cultural dissemination, exploitation. But… see, the Rockets film could have been a lot less entertaining and completely impossible to watch, yet with lots more stories in it. It could have been three hours long. But the idea is that you have to entertain. It's a balance. Nobody wants to be preached at. Sometimes you just want to rock and roll, and you don't want to hear preaching. I think you can get a message across, and entertain people at the same time, which is what I tried to do with Rockets. Because he was so entertaining. He was so funny, and so sad too.

On 14 August 2006, Luis G. Fernandez de la Reguera suffered a motorcycle accident in upstate New York. His injuries were severe, and emergency surgery was not successful. Only two days before, I'd been in touch with the director in regards to photos of himself and Rockets which were needed for this book. He was on a road trip; long periods of roaming were essential to his general well-being, and he'd just purchased a new Toyota camper. We'd spoken of meeting somewhere on the east coast, where I'd planned to return in September. Clichéd as it sounds, I honestly couldn't believe the news to be true. Luis was one of the most hard working, independent thinking, and big hearted human beings I've ever known: a true outsider, a guy who simply got it, no explanation necessary. At a devastating personal cost, Luis made a tragic and unforgettable film about a notorious hustler, as a sincere promise to that notorious hustler. Luis was the kind of guy who kept his promises, who tried to be decent to people he felt powerful hatred for (that list would include politicans, hipsters, and definitely soccer moms). Luis was far too good to be as broke as he often was. Too good to tolerate pricks and parasites and shit-headed critics as he often did. And certainly too good to no longer be with us. In the years since the release of his debut film, Luis traveled extensively; by 2003 he had settled in a Mexican village, doing finishing work on a remote beach house and researching another feature. Sadly, his new passion, a film about the Chiapas Indians, was never realized – due in no small part to the cold-blooded betrayal perpetrated by Small Planet Pictures, the US distributor of *Rockets Redglare!* At the time of his death, he and executive producer Steve Buscemi were embroiled in a $1.75 million breach of contract suit against the company's president. In his last e-mail to me, Luis wrote: "the scumbag didn't show up for his day in court and I will soon get a federal court judgement against him which will make his life hell if he ever wants to get a job or have a bank account or do anything… but it is a hollow victory." A memorial service for Luis Fernandez de la Reguera was held on 20 October, 2006, the director's 40th birthday.

These Endless Fucking End Days

- David Peace -

David Peace's *Nineteen Seventy Seven* is the single most unbearably and inconsolably dark work of art in any medium that I've ever encountered – easily my favourite book of all time. His esoteric manner of defying all the great traditions of literature, and a strange commitment made by him to deliberately lose himself in the ugly moment, is something that has been rivalled by few. Only Nelson Algren comes to mind.

Certainly, no one with enough intellect and courage to fully absorb a David Peace novel could ever attest to being unchanged by it. Peace makes almost any other fiction writer look like a bourgeois phoney, posturing softie, or subcultural gimmick. He writes books that I occasionally get goosebumps of anxiety just thinking about; I consciously avoid thinking about these books, they bring on dread like a particularly blunt gust of freezing rain. They exist in a dark, brutal universe which is, unfortunately, based largely on fact and his own personal memories of Northern England. One could label the guy as a punk successor to James Ellroy, but that implies a dip on the morality scale. With Peace, that's hardly the case. His writing is intensely moralistic, but it does not yield to genre boundaries, nor to conventional plot structure. He does not always make the reader's job easy, but offers the persistent and patient reader the greatest of rewards: unvarnished truth. The musical equivalent of a Peace novel would be a recording in which every single instrument can be heard stuck in the red zone, animal noise and crying symphony at once, like an ungodly overlap of Throbbing Gristle and the Kronos Quartet. A perceptive reader might also "hear" transmogrified trace elements of The The or Iggy Pop's Stooges. Music is important to Peace, probably in much the same way it was to Hunter Thompson, and any other writer who does not view the process as a calm or therapeutic one. Peace's violent literary psychosis plays on both your heart and your last nerve, with a battering, clanging, and naggingly desperate narrative that throws more sparks than a cattle car careening down rusty tracks at 100 miles an hour. The overall emotional and atmospheric density of his work is central to its spooky, psychotic appeal. Just an excerpted slice can slam into you, hard, but the entirety of a novel, like a large death toll, is difficult to fully condense into a single logical response. At a certain point, it seems necessary to let this material numb you a little; there is no other conceivable way to make it through. But no matter how necessary, the strength and size of Peace's heart does not allow you any numbness. When a character is beaten, you're taking that beating with him. Every word David Peace writes is imbued with such enormous regret and compassion and devastation that he himself seems to be driven to temporary insanity by it… because he is so intimidatingly deft with poetry, it only seems natural that he would use that to throw you into the same void. And his navigation of the void is performed with the cunning of an old pro, yet it feels like a man martyring himself for all the evil in the world. He operates in this fashion to such a degree that anyone who actually *enjoys* the horror of his work may well be perfectly capable of it… and that could truly be the most disturbing aspect of these books. Collectively, they are one enormous teardrop.

Nineteen Seventy Four, Peace's debut, was the first time I'd found another writer who'd mastered a specific style of writing that I'd already conceived, and for years had been attempting to crack on my own, that I thought needed to be done by someone. It was like seeing a terrible truth proven, by force, to those millions who would rather use the written word for attention-getting purposes, or financial ones. (And also to myself… after reading Peace, my own fiction work read like hyperactively scribbled pornography.) Here is a man who writes only to communicate damnation, as a means of confronting evil, and no other type of writer could possibly be more relevant to this exact moment in time, when we are damned to a future of rigged elections and frat boy leaders, of conformist bigotry, pre-fabricated rebellion, and youth subcultures so wilfully impotent that they may as well not exist at all.

Peace translates evil in a manner few others have barely even considered, and as such remains hands down the most exciting and important thing happening in literature today. He may indeed write, as one critic has said, "like a man with one hand down his pants and the other on a shotgun" and this is both accurate and a damn fine use of hyperbole (it seems impossible to write about him without it), but Peace is in no way limited to crime fiction. At this time, I am not sure that there is a genre tag that applies comfortably to Peace's work. In England, they call it "Yorkshire Noir"… but I think that's selling him far, far short.

Peace's career-making four part series, *The Red Riding Quartet*, is based on the murders committed by Peter Sutcliffe, the Yorkshire Ripper. Although excessive in literary terms, the Quartet is basically a high-volume prayer to God. The books are fundamentally about the absence of God, in Yorkshire or any other land, a conceptual literary baseline which only serves to increase the resonance of Peace's unspeakably horrific vision of twisted and tormented human souls who haunted, and were haunted by, the crimes of the Yorkshire Ripper. His 2004 book discussed in the following interview, *GB84*, is a sweeping, multi-faceted, and ragingly violent saga of the UK coal miners' strike. The book is an unadulterated and unapologetic blood-portrait of Great Britain in 1984.

David Peace. Photo courtesy of Serpent's Tail.

Gene Gregorits: Tell me about your first novel, the one that never got published…

David Peace: I worked on this book from the age of 18 until 25. Then I sent it out and it just got completely [*laughs*] fucking rejected! It was massive! If the leg fell off your bed, you'd be able to use it for that. Now, I am kind of disciplined about my work. But at that stage I was about as undisciplined as you could be. I don't think I was the greatest editor of my own work. The trouble with that is, it is bound to be uneven.

GG: What about being disciplined as a novel writer?

DP: When I sat down to write *Nineteen Seventy Four*, I was about 30. But even that seven-year book… it wasn't something where I would just get up in the morning and do it. I didn't do it like I do now. I was working jobs, too. One thing that I think helped me, in the end, was moving away from something so overtly personal. The time you spend writing is never a waste of time, because you learn, don't you? When I did *Nineteen Seventy Four*, it was fortunate that I was in Tokyo, where I met my wife... we had a schedule where she left the house really early, and my job didn't start until later on. So with her out of the house, I could do some work. I'd been hitting upon the idea of *Nineteen Seventy Four* at that time… there's always an element of luck when one of these things comes together.

GG: Yeah, but I hate that feeling that you have to get lucky with the writing itself. I don't like it when it feels like a gamble. I think a lot of writers drink because it can force luck out of the equation at times, and just barrel straight through the stiffness.

DP: That was a problem with me, too. To be honest, drinking has become a bigger part of my life again… it breaks things up, dunnit?

GG: You get a surge of energy but then you never get the chance to use it entirely because you keep getting drunker. It's a hard thing to put the brakes on.

DP: It's a cycle, yeah. It had a lot to do with why my book didn't get published, really. It took so long to write because of drinking. I don't think I was ever able to get a proper perspective on it. My present wife doesn't drink, so there's that. Previously, I've always been able to find women who drank. That never helped, either. One of the other good things for me was that my wife wasn't actually that interested in my writing. That may sound weird, but the relationships I've had before were always with people who had some artistic bent. They were interested. So you spent a lot of time analyzing and talking. I think that can lead to a case of too much time talking about it and not enough time doing it, yeah?

GG: Music can work both ways too. Just listening to music, and getting the feel. When I've got five or six beers in me, blasting a certain song, I know what I have to do even better than when I first started, but I get lost in all that energy. Time goes out the window.

DP: I'm the same. Even now, with the wife and kids, when they go to bed, it's back downstairs to the stereo. You do get the ideas, but yeah… it doesn't work. When I look back on it, some of the things I've written… it's almost like I can't remember how that happened. I have these blanks, yeah? Particularly *Nineteen Seventy Seven*, which is my favourite book, because of my father-in-law dying, my son being born… always being in the hospital. I was writing these things down in the hospital ward, or by his bed, and then coming back and listening to the music that went into the book. It's one of these books where I just can't believe I ever wrote it. I was working full time as well, so I don't know how I did it. Then, with *Nineteen Eighty*… Those transmission bits. See, we move to a different house with the publication of almost every book, and so I can picture the room of the old house, and I can almost see myself there doing it. But you go to these places and they're difficult to get back to. When I read those transmission pieces, when I'm done reading, that's when the emotion comes back, when it hits me. When I read it out loud. [*Note: these are page-long interludes stuck between the book's chapters, flow*

'A writer of immense talent and power'
The Times

of consciousness passages which combine and overlap
the voices of victim and killer, as psychological radio
transmissions, seemingly from both the killer's subcon-
scious and the afterlife.]

**GG: The last passage in *Nineteen Seventy Seven* is the
most overwhelming writing I've ever read. I can just
read that endlessly. It really fucked me up.**

DP: That was just written straight, in one go. I think that
in the original draft, I can remember when I was writing
it, I was listening to *Horses* by Patti Smith, and there
were little bits of Patti Smith lyrics in there that I took
out. It had just been going on in the room when I was
writing the book. Everything else is straight, as it came
out. But thank you for your words about the books. *GB84*
is a book that might be difficult for people that didn't live
through it. And you didn't live through it. It's obviously
a very peculiarly British kind of political event…

**GG: The only roadblock for me was the abbreviations
for the coal industry and the union party sub-
committees. But I had the Internet to use for that,
those things were easily solved.**

DP: Well, I appreciate you helping yourself out with that,
yeah? To be honest, that book was even more draining
for me than writing the Quartet. Since it's been finished,
it's hard to get back into writing again.

**GG: You say *GB84* is a fiction based on a fact. How
much of it is truth? Percentage-wise?**

DP: I've said to someone before that it is 90% truth and
10% fiction. But really, it's 90% truth *as I perceive it*.
This whole fiction and fact thing, which, obviously, has
gone through all my work, can be a burden, always
watching carefully the extent to which you can twist the
factual events. It's something that I'm not good at articu-
lating outside of the actual writing.

**GG: But there is the notion of something being truer
than real life. Either by injecting a higher sense of
moral justice into the work, or just coming from a
moral perspective and using that to exaggerate
certain things.**

DP: I think that fiction can illuminate fact. If someone
was going to write a factual account of that year, of the
miners' strike, or say, the factual account of 9/11, they
are still bringing the editorial process into it. They're
going to start here, and finish there. And they're gonna
choose to mention this, choose not to mention that. Even
a historical account of any non-fictional event, there's a
great degree of subjectivity involved. You read some
kind of fictionalized historical account, say *All the
President's Men* or something like that… they've made
choices there about what to include. It's all subjective. So
when you say, "fuck the non-fiction, I'm gonna write it
as a fiction", then you're at that point immediately being
a bit more honest, in a perverse way, do you know what
I mean? And with the book, I wanted to do that. I wanted
to go top to bottom, and left to right, and get it in all in
there. That's why it's got multiple narratives. Some
journalists who have interviewed me have said that the
criminal element of the book is kind of weird, and it
doesn't fit well in the book. [*Note: there are intermittent
breaks in the story involving "The Mechanic"'s grocery
store hold-ups, and his abduction by a crooked cop on
Thatcher's secret payroll.*] But that was the atmosphere
of the times. I mean, these kinds of things were
happening. And it does seem a little bit odd in amongst
the daily lives of the strikers, who are just simple
working people being shit on, but I wanted to show the
whole of the time. To me, it would have been dishonest
to have only one of those narrative strands. You have to
have them all going on in there.

**GG: It's not as if it's not relevant. The stuff with The
Mechanic further illustrates the lengths to which the
Thatcher government went to sabotage everything.**

DP: Yeah. So I think it works quite well. But it's the same
people who don't like the character of Malcolm, and the
more occult elements. What a lot of people don't pick up
on is that Malcolm, in part four of the book… he's a
ghost! Some people are like, "you can't do that kind of
thing in a political book!" But I don't want to read
something that's just a wordy political tract. I wanted to
have the full atmosphere. The occult side as well as the
real side of it.

GG: It's very easy with a book as big and as complex as *GB84* to miss something here or there. The thing with your work though, is that I do remember your stuff a lot better after the fact, than I remember the work of other writers. Because it's written in such a way as to imprint itself upon your psyche.

DP: Well, I appreciate that. I would hope that they are the kind of books that you can go back to, and pick at them a little bit. What I would hope is that people would go back and look at stuff again, if they miss something.

GG: You could, by default I guess, call *GB84* a political thriller. The research that you did on the sabotage of the strike, and the corruption existing on all sides... how much fact did you rely on for that specifically?

DP: I did a full year of no writing, just research. That's scary. Because you're thinking, "I'm spending all this time on the research but why, if I can't deliver..." That's a kind of pressure in itself. I did a lot of research into Northern Ireland, into the things the British government and the British army did. Methods used in the kidnapping and torture of IRA suspects. I transferred a lot of those methods in *GB84*. Because it was the same people who were then involved with the miners' strike. A few people pointed out to me recently that a lot of these techniques have come back in the Iraq war. Everyone thinks it's a joke, but I tend to believe it. I think these things went on. From what people told me personally... you kind of piece it together. And that's the kind of world I think it was.

GG: Well, the miners obviously knew the truth, since they were the ones getting their heads bashed in, but was the public generally aware of it at the time?

DP: There's one major battle that took place. The battle of Orgreave. This was the turning point. What happened was, the police charged the miners. And then the miners retaliated by throwing bricks. They were still completely beaten, beaten badly. When it was shown on the evening news, the BBC and ITV deliberately edited the footage so that when you watched it at home, the miners charged first, and then the police responded. They just switched it around. But I have to say, there were some completely horrific photos shown in the newspapers. Even then, despite the news being doctored, there was some sympathy. Later on, there was a judicial investigation. The news editors admitted that they had edited the tape to show the opposite of what happened. It depended where you were. In the north, where we were, obviously there was an inherent, almost innate sympathy for the miners. It kind of went away a little bit, as it dragged on. And I think that comes across in the book... that it dragged everyone down. But in the south, I think people just believed what they saw on TV and what they read in the newspapers. That all the miners were violent. But I don't think it could happen at all now, because it is so much harder to control the media. And amazingly, you

couldn't witness these things, because they wouldn't let you drive near them. This is one of the things that was good about *GB84*, was that it did bring this back to people's attention, that the police would say that you couldn't drive out of London north, or you weren't allowed to drive south... there were roadblocks. It really was a kind of civil war, in that the police state was mobilized against the working population.

GG: Is *GB84* the first dramatized history of the strike?

DP: I believe so, yeah. There was a movie about a boy who wants to be a ballet dancer called *Billy Elliot*. That was set during the strike, and the strike forms a backdrop to it. It's a sentimental film, but at least it brought people's attentions to that time. I don't think it's a great film. But aside from that, there's never been a novel about the strike, no.

GG: The riot scenes are extremely tough going. The clashes with the police. It's punches, kicks, things like that. In a certain way, that's even more gruelling to read than anything involving a gunshot wound, because it's easier to imagine someone smashing your face in than blowing it off. Describe if you can the experience of writing that stuff, and how you put yourself in the middle of it all enough to be able to write it so vividly.

DP: I've read as many accounts as I can... and they're not riots, really. It's picket line violence. I spoke to people who had been there. I got a sense of it that way. When I was about 17, there was a lot of political activism against Thatcher. And I went on political demonstrations, which were broken up quite physically by police. Also, I have been in football crowds that the police have charged. I am familiar with their tactics. It's just a question of putting yourself there, trying to get myself into the feel of it, and just a very real fear of being attacked by the police.

GG: And that's a pretty terrible fear. A fear that is far removed from the false violence of films.

DP: There would be accounts of things happening like people having chunks of hair pulled out. If you can imagine just how fucking painful that is... these are real injuries that real people had.

GG: In *GB84*, you have the character of The Jew. You call him "The Jew" repeatedly, but his name is Stephen Sweet. That didn't bother me, but I can see how it might bother other people...

DP: Yeah, and it's caused a great deal of trouble. Some people have said that was put in there simply to be controversial, which it wasn't! See, Stephen Sweet is only referred to as "The Jew" in Neal Fontaine's narrative. While it is a third person narrative, it is a subjective third person narrative. Neal is a product of the Army and the security services... what I wanted to do was to show that even when Thatcher's right wing started, even they themselves were fractured. One of the

interesting things about Thatcher herself was, she was propelled to power by these kind of shadowy, far-right ex-intelligence people. This is quite common knowledge. But she herself, when she was in power, surrounded herself with lots of people of Jewish background, because she really admired the self-help ethic of, as she saw it, Jewish culture. The fact that people would bring themselves up, work hard, own property, start businesses, from quite humble beginnings. That was her myth of Jewish culture, which obviously has some truth. But I always thought, with Thatcher, that there was this really odd alliance between this far-right group, who are anti-Semitic, and racist, and quite horrible upper-class English, security service elite… with these self-made Jewish businessmen. Yet, they're all working to defeat the miners. I felt that one of the points of the book is how weirdly ironic that is, and to show how very divided the country was at that time. Even the miners themselves are fighting with each other, getting divorced. And I think the thing about "The Jew"… "Jew" as a word, number one, is exactly what someone like Neil would have called someone like Stephen Sweet. Two, it constantly kind of bucks you, every time you come across it, it just makes you feel uncomfortable as you read it. My publisher really worried about that. They suggested that I call him "The Yid" or "The Kike"… which are more explicitly racist terms. They thought that was better because it obviously then showed Neil off to be racist. But I like the ambiguity. I'm not going to define someone by their ethnicity or their religion, yeah? I felt that with, "The Jew", is Neil using this in a racist way, or is it just a mistaken adjective? It allowed then, for me to build their relationship. I think one of the interesting things of the book is how do you feel about this guy? He's calling him "The Jew", but he's picking him up and washing him after he's been drinking, dressing him and stuff.

GG: What about writing the book in Tokyo… I might have asked you this before, about the Quartet, I can't remember… would there have been any advantages to writing it in Yorkshire?

DP: No. With all the books, I need the distance. There's still a research element, but distance is important. Again, I was researching intensely, for one year, the years 1984 and 1985… as usual I just listened to the music of that time. I was able to shut myself off from the present and re-create the time, just sitting in that little room, I could re-create it in my mind. I listen to a lot of music when I'm writing. When I'm not writing, I like to listen to extreme music. I don't agree with these bands politically, but the Norwegian black metal groups. This band Darkthrone. It's dark and extreme, and that's the kind of music I like.

GG: Did you listen to any Satanic death metal while writing GB84?

DP: No, it's black metal that I listen to.

GG: What's the difference, really?

DP: Death metal is associated with scenes in Sweden and Florida. Bands like Cannibal Corpse. In Norway, there are groups that don't play quite as fast. Black metal is not as fast, and they will use synthesizers whereas death metal is guitar based. A lot of people find the distinction to be academic, but there is a big difference. Don't get me wrong, I like death metal as well… but it's a certain kind of early '90s Norwegian black metal that I like.

GG: Your disclaimer at the beginning of the book refers to the book as an "occult history"… your use of the word of "occult" is not in the context of Satanism, or black magic… you basically just mean it in terms of secret history or hidden history in general. But you also have the Satanic element.

DP: I just love that word. Yeah, I do mean "hidden", but you still get the connotation of something, as you say, more Satanic.

GG: I wanted to ask you about the experimental narratives of your books. First off, you get compared to James Ellroy a lot. Do you get sick of that?

DP: To be honest, that's just an easy comparison, and I can see why people think that. He was a big influence at one time, particularly when I started writing. But it's been a long time since I read any Ellroy.

GG: The literary comparison might work, but there's not much of an emotional comparison to be made. There's so much more testosterone in his writing than there is in yours. You seem to be more sympathetic.

DP: Well, people have said that GB84 is like American Tabloid, and I didn't see that at all, to be honest. There's possibly some similarity, in the tendency to focus on the men behind the scenes, as opposed to the more famous people. We choose similar narrative perspectives. I think there's a slightly cartoonish element to what he does, which I think works, but I would say that my writing is more grounded in reality than his. But White Jazz, that's the one that made the biggest impact on me. I read that when I was really drinking a lot, having bad relationships and things. It just seemed to channel how I was feeling at that time. I like the fractured narrative, and I like the one word sentences. He really hit something there. I don't like the way he seems to have pulled away from that.

GG: Your own Nineteen Seventy Seven was exactly that kind of book for me! Did you listen to a lot of Sex Pistols and Clash, during the writing of Nineteen Seventy Seven?

DP: Yeah. Seventy Four was Bowie's Diamond Dogs and also, particularly, Raw Power by Iggy and The Stooges. Seventy Seven was mainly the Pistols and The Clash, and a reggae group of the time called Culture, an album they did called Two Sevens Clash. I used the punk song titles as the chapter headings. 'What's My Name?', and 'God Save the Queen', and what have you. Within the actual body of the text, there's no real mention of it because it wasn't noticeable at the time. A little bit later, it became more prevalent. Particularly in the north of England.

But in 1977, it was more of a London-based phenomenon. The music that was in Chapeltown and Leeds at the time was reggae. People like Bob Marley had more of a cultural influence up there during '77. In Rastafarian culture, there was a feeling that '77 was the year that the apocalypse would come. That's why I riffed on that.

GG: You say frequently in that book, "the two sevens are clashing again."

DP: Yeah. If you're listening to that album, the reggae groups and the dub music of that time are very full of biblical imagery, to produce this extremely apocalyptic feel. The Clash were the first band to really pick up on that. It uses a lot of the early Clash stuff as well, because they got their name from that Culture record. And then, with *Eighty*, it was Joy Division and Throbbing Gristle. *Eighty Three* was a bit more difficult, because it fragments, time-wise.

GG: I'd imagine that it was the most difficult book to write, out of all four.

DP: By far, yeah. Musically, things had gotten a bit twee, with stuff like Echo and the Bunnymen. At that time, I was into people like Swans and The Birthday Party. But that was very underground at the time.

GG: Now, one reviewer who loved your Quartet, was nevertheless extremely sceptical of the books' morality, or of the morality of you re-creating such hideous crimes in such an overtly bleak and psychologically aggressive way when these crimes are still fresh in people's minds, in the minds of the victims' families. How would you respond to that?

DP: Well, that's a tough one, yeah. I hate to be over-dramatic, but the big baffle within me is that I have been writing these books for so long. I grew up during the era of the Yorkshire Ripper. It had a personal effect on me and my family. Obviously, my mother was not killed in a Ripper attack. Fortunately, I am one step removed. That is where and when I grew up, and that is how I remember it. Nothing that I have researched has caused me to doubt my recollections. Even reading about the people involved who were trying to protect the public and solve the crimes, has actually hardened my resolve about the failure and deep corruption of the police department. But… see, some people have asked me about why, in real life the Yorkshire Ripper was Peter Sutcliffe, but in the book he is referred to as Peter Williams. It might be a little cosmetic, but I did change all the victims names.

GG: You changed their dates of death too, I noticed.

DP: I choose to write these books. I choose to have them published and earn money out of it. That's the moral dilemma I have about it. But I wanted to change the names and dates because it *is* a fiction, yeah? That's one of the reasons why, for example, in the third book and the last book, I'm dealing more with the fictional crimes. It's another reason why I used a sort of fairy tale motif. There is a big difference between the fiction and the reality.

GG: Well, "fairy tale" is a good word to describe the first book in a sense, too. The surrealism of the first book. There are certain things which go so far, like George Marsh who has this underground bunker. That's almost going into a David Lynchian reality, but the hardness of the books keeps the reader from getting swept up in too much surrealism. I mean, it may be outrageous, but it's very believable at the same time.

DP: I'm not going to deny that Lynch is an influence to some extent. There *was* a guy named Donald Neilson. This was prior to the Yorkshire Ripper. He was known as the Black Panther. He was, at that time, Yorkshire's most famous criminal. And he *did* kidnap a woman, but for money. No sexual motivation, but for money. And he kept her in an underground bunker-type place. And also, the murders of the children, in *Seventy Four* and *Eight Three*, are based very closely on the murders of four girls in Japan, that I researched. That was a guy who kidnapped a four-year-old girl, brutally murdered her, and then, six months later, he sent a box containing the bones, ashes, and some photographs of the girl, to the parents. I mean, horrific crime… Yeah, there are things that seem far-fetched in the books, but I did, as much as possible, base it all on reality.

GG: When you were a kid, did you have a palpable sense of there being such a rottenness in Yorkshire?

DP: Very much so. My parents were schoolteachers. They didn't divorce or anything when I was a kid. They're still together. We had a family unit. Me, my sister, my mom, and my dad. A nice little house, and a garden. I think it was a very secure world, yeah? We lived in a suburb of Leeds. The minute you went into the centre of town, it was a dark and dangerous and threatening place. It's in the very architecture and landscape of the place. This is at the arse end of industrialization. There was massive recession. It was a very bleak, ailing place. And then you had the contrast, as you went further north, and got out of the city, and then it got very very bleak. That's the scene of the Moors murders. Everything seemed to be charged with some element of threat or danger. And these crimes, the crimes of the Yorkshire Ripper, they began in 1975. But it wasn't until 1977 that he murdered his first known non-prostitute victim.

GG: You have the facts and dates worked out so well, on such a grand scope, I would imagine you have your own little personal crime lab set up. Did you ever feel like you were almost becoming a detective, writing these books?

DP: I have a study. There's actually a UK TV company coming to make a film about where I work, and the fact that I live in Tokyo but write about Yorkshire. About the way I reconstructed this history and these crimes.

GG: I try to imagine you as a child, playing happily in a mud puddle or something, around the time when these things were happening, and being shielded from that in a way. What age were you when you first became intimately familiar with the kind of lives that you wrote about, the life that made Yorkshire a hell on earth for the characters of your Quartet? What prepared you to get inside those minds?

DP: When he murdered Jayne MacDonald, in 1977, this is at the time of the Silver Jubilee. She was a 16-year-old shop assistant who lived in Chapeltown, which is the area where most of the prostitutes had lived. Her family was a large Catholic family living there, very working class. She was walking home from work. She'd had a date in town and missed the last bus home. She said goodbye to her boyfriend and was shortly thereafter murdered by the Yorkshire Ripper. This is when it crossed over. People knew about those murdered prostitutes, but they weren't panicked about them. I can remember that quite vividly. I was only ten when that happened. I was ten and she was sixteen. We lived about five miles apart. As a ten-year-old kid, I was reading Marvel Comics, and Sherlock Holmes. Believe it or not, I wanted to be a cop! That's what I wanted to be. Me and my brother, he's a bit younger than me... my parents had this garage and a little place behind the garage where they kept tools and stuff. It was like a little office, yeah? We were gonna solve the cases of, like... missing pets, and that kind of crap. Then the Yorkshire Ripper started, and we took all the press clippings, put them on the wall. [*laughs*]

GG: There's one or maybe two characters in the Quartet who have these backyard sheds, like little think tanks, where they work on their own case theories.

DP: And that's exactly where that comes from, right. Peter Hunter... But the crimes just kept on happening. It built up and up. At this stage, this is when it got weird. When you got to school, you'd hear things. The famous line was, "he's somebody's husband, he's somebody's son." I'm not saying I thought my father was the Ripper, that sounds a bit hysterical, but if you talk to any kid who grew up at that time, they were all unsure of, if not their own father, then somebody else's father. The old guy who lived on his own. *Everybody* was suspected of being the Yorkshire Ripper. The thing that happened recently, that really brought it back to me, the fear and paranoia, was that Maryland sniper thing. Where people were not going to the shops, and things like that. The media fuelling the fear, the fear fuelling the media. The thing that really moved the Ripper case up a notch, and really changed things, which was possibly more like the Son of Sam murders, was when the tapes came to the police. It turned out to be a hoax. But in June '79, they got this tape, with this very strong, north-eastern English accent. England is very small, but the difference between accents is very marked. Yorkshire has the accent that I'm speaking in now, yeah? The accent on the tape is northeast, which is only 60 to 70 miles north, but there is a marked difference. They played the tape, which was taunting, and kind of goading the police. Threatening to kill again. I remember, people just went nuts. It was horrendous. I've got a friend now, didn't know him at the time, who had the same accent as the Ripper. But he was living in Yorkshire. And he was picked up by the police routinely. After every murder, the police would swoop down on his house. This is what they were doing to people! Then it turned out to be a hoax! And the other thing about it is... people might wonder about the morality of going back to it or whatever... but they've never answered the kind of questions about the case that people wanted to know. It's been left open in every kind of way, because people talk about it still!

GG: I've read quite a lot of books that got under my skin and hung around for some time, but I have to say that, bar none, *Nineteen Seventy Seven* is the most horrific and upsetting thing I have ever read in my life.

DP: That was born out of... my father-in-law was dying of cancer, while that book was being written. That book was written in hospital wards and during the last six months of his life. My son was born during that period. It was a raw time. And it remains my favourite of the four books. It's kind of a forgotten one. *Nineteen Seventy Four* and *Nineteen Eighty* got a lot of attention. I got this Young British Novelist award, yeah? And got a lot of attention. But people overlook *Nineteen Seventy Seven*.

GG: I really don't understand why. It's the scariest one. You met your wife during the writing of *Seventy Seven*, yet that book is ten times tougher than the one you wrote when you were single, and seemingly very lonely.

DP: I don't know. I look back on it, and to be honest with you, I can't remember how I wrote *Seventy Seven*. That whole period is a blur of hospitals, of my son being born, and my father-in-law dying. It was such a protracted illness. My sister back in the UK, she had a baby and then a post-natal breakdown. So many bad things happened during that book, and it was horrendous. I think that I used the book just to escape from the reality of the emotional intensity we were going through domestically.

GG: The entire book, things are going very wrong. But then it all zooms straight down. There's no relief, and it seems as though you were angry. Not just having a tough time, emotionally, but that there was a rage you felt, that you took out on the characters, to keep driving them further down.

DP: Yeah, I think that's very true. At the end of *Nineteen Eighty Three*, I see there being a kind of redemption, but unfortunately [*laughs*] no one else who reads that book will think so. The end of *Eighty Three*, I worried that I was making it just a little too light.

GG: Oh come on! It's a fucking nightmare!

DP: I got to thinking that I've been doing this too long. [*laughs*] But at the end of the day, this is the thing that pisses me off about 99% of crime fiction, or films, or whatever. The endings. The honesty of the situation is, anyone who has suffered from a crime, and the loss of a friend or loved one, for whatever reason, they know that it doesn't ever go away. It's bogus to paint some kind of happy ending and tie up all the loops. In Britain, some of the reviewers said they wanted things more neatly done and dusted and tied up... but I'm not going to do that. because it just isn't the reality of the situation.

GG: The way your particular style of writing flows, is kind of like a boxing pattern: bobbing, weaving, twisting around. It's almost as if you're waging some kind of battle with not only the reader's mind, but with your own mind as well. You've mastered some kind of literary assimilation of culture and climate, environment, and how that relates to the mental state of a book's characters. You could almost call it the art of psychosis. When did you start writing like that, doing this snaky, internal mind-fuck kind of prose?

DP: I could just say, "idiot savant." But yeah, it is what it is. I do the research in a very methodical way, yeah? I go back, go day by day through every paper. I try to assimilate and put myself back in that time, as much as I can. I don't know. I think that then, everything just takes over.

GG: It's a natural instinct for you.

DP: Yeah.

Yorkshire Dread: David Peace, circa 1999. Photo courtesy of Serpent's Tail.

GG: Has your own work ever made you cry?

DP: It has, yeah. I know it sounds dramatic, but... in *Nineteen Eighty*, the "transmission" pieces, those were tough. I wrote them all in a 72-hour detailing of the actual crimes, and the photographs. That was the most emotionally tough for me. I mean, I've just took my kids to school, yeah? Then I'm coming back to write these things about the murder of children. It is very, very draining. And I know that I have to be extremely careful. In my family, we've been through some patches. The books caused me a lot of problems in my family life, because it's difficult to switch back from one to the other.

GG: Reading *Nineteen Seventy Seven*, I mean, it wasn't a very appropriate time for me to be reading a book like that. I was getting over a three year relationship at the time. What makes the book such a ghoulish experience, and the thing that fucked me up so much, is the looming presence of the Reverend

"People have told me that the books have had a tremendous emotional effect on them, but I do not want to give people a bad feeling."

Martin Laws. It's hard to comprehend a man like that actually existing. I mean, he's a great character, but he's just *so* evil. I would like to think that a man like him is too demonic to even be real. Is he at all based in fact?

DP: Well, yeah he is! Back in 1974, in Ossett – this is a small town where we were growing up – there was a case involving this bizarre evangelical Christian sect. And this guy Michael Taylor was a member of this sect. It was still attached to a regular kind of church. He became convinced that he was possessed by the devil, and the priest from the church – and his wife – decided that they were going to exorcise him. They took him to the church, and they kept him there overnight, trying to expel all these demons. This is recounted in my book. They expelled all kinds of demons from him. They tied him down, on the altar of the church, yeah? Man, this is a regular fucking priest who is doing thi*s*. They tied him down on the altar, threw holy water on him, said prayers, and cast out the demons. And the demons *did go*. I can't remember, there was like 49 or 52 demons? *Except* the demon of murder, right? They're all exhausted at this point. They send him back to the house. And on the fucking front lawn of his house, he killed his wife. He took her eyes out with his bare hands. In the book, he is called Michael Williams.

GG: And in the book, he is the next husband of Carol, after she divorces Jack Whitehead.

DP: That's the fiction, yeah. That's a kind of fictional take on it. And then, this guy, who is naked, except for a pair of socks and wearing his wife's blood, runs naked down the streets of my hometown. That obviously affected my family! Because his kids went to my dad's school. This really, really upset my family.

GG: She died from having her eyes pulled out?!

DP: I think he might have stabbed her as well.

GG: But he used his bare fucking hands?

DP: He took her eyes out with his fingers, yeah! Well… then, you see, the bishop got involved, and the whole fucking thing went to court. The guy is still in a secured mental hospital. He's still alive. And the priest was defrocked. There was lots of criticism of the priest and the bishop. It always led me to wonder, what happened to this

priest? Whatever became of him? And that is where the Reverend Martin Laws came from. It's not a very well documented case. I came across a book in a rare book shop called *The Possessed*, which is a history of exorcisms. There is a chapter on him in there. And that is the only thing I've ever read in print about him. So I don't know. Maybe the priest spent his life doing charity work or something. Well… the other part to that story is, about ten years later, when I was sixteen or seventeen, I went to a party. And one of the boys… the son, of this murderer, yeah? The son was at the party. We were all punks at the time. And we were tripping. Someone brought out a Ouija board. Everyone was drunk, stoned, whatever. And suddenly, this guy, who was the son of this murderer, he started talking to his murdered mother with the Ouija board. The mother tells the guy that he must continue his father's good work, and he goes into the kitchen and grabs this knife. Man, we fucking got up… I knew who it was! It was horrific. I remembered all the awful details of that case, but me and my friends, when the obvious thing would have been to just leave the fucking building… we hid in a wardrobe, yeah? And he's going around with this fucking knife, out of his head and talking to his dead mother, saying that he was going to continue his father's work. It was fucking frightening, until he just passed out.

GG: There are books that are sad, and there are books that put you through a wringer. But what you do is on a whole other level. Do you ever wonder about the impact your books might have on someone?

DP: Again, because I am in Japan, I'm distanced. I've been writing these books, putting them in the post… and yeah, I get e-mails, I'll have telephone interviews like this one, but it's a quite detached process. I do wanna go back to the UK, I wanna do a couple of readings there. But, it's a detached process. It sounds terribly selfish, but I write the books as I want them to be. This is what I think, this is what I believe, this is what I feel. People have told me that the books have had a tremendous emotional effect on them, but no, I do *not* want to give people a bad feeling.

GG: You're not looking to truly fuck up someone's head?

DP: No! But it causes me to have a very weird feeling. Because I am *ejecting* this stuff, and other people are *injecting* it. There's a strong element of catharsis for me, having written it.

GG: But then it becomes a kind of debt that the reader has to settle with themselves, when the book is finished.

DP: I guess. And I think that, to some extent, once it's finished, I just move to the next thing. But, really, I have to get this out of my system, yeah? But obviously, I want books that are powerful, and I do want people to read them. Otherwise I would just keep them for myself. It's a difficult question.

Bohemophilia

- Larry Fessenden -

My first exposure to the work of Larry Fessenden was in 1998, when his vampire melodrama *Habit* premiered in New York City. The director attended, and was immediately recognizable to all and sundry after the film, since he played the ill-fated male lead. Larry and most of the audience spilled into an upstairs 13th Street club for a celebration after the film. I waited an hour or so for my moment, then introduced myself to him as he made his way to the toilets, mentioning that I was interested in doing a piece on him. I told him *Habit* was the kind of vampire film I liked, that I enjoyed it more than any other since George Romero's *Martin*. I remember that night particularly well, because I'd only been in New York for a few months and there were many boxes left unpacked at my Brooklyn apartment, something which later had to be explained to the beautiful blonde whose acquaintance I'd made at the party.

Boho life in New York City, in the feeding frenzy of the cold Gotham grid. The biological risk involved with sex, the mental risk of love, in an overcrowded city full of overworked people permanently fixated on financial, social, or sexual gain. Losing yourself in New York is a notoriously easy thing to do. You must consciously ward off the psychic pollution found in streets and bars, especially when a relationship is going bad, when the frantic pace breeds an accentuated paranoia, when the roving throngs of strange faces conceal other faces, when the experience of observing 10, 15, 20 strangers per sidewalk second becomes an accepted ritual on the way to the store, to work, or back home. A thousand eyes lock into yours on a daily basis, and any one of those glances could suggest attraction, contempt, or cold indifference. It's better to avoid glances. Repeated eye contact in such a butcher shop of hyper-social reality is unhealthy, more for some than others. Everyone is either a potential user or a potential victim.

I was coming to understand this in my own experiences when I saw *Habit*. There was a girl who would drift in and out of my life, an aloof and relentlessly manipulative girl who was not very unlike Anna, the siren of Larry's film.

In retrospect, I have to appreciate *Habit* on a nostalgic level, as well as an aesthetic one. It was shot just prior to Manhattan's heartbreaking Disneyfication, which was carried out via sanctimonious raids and vicious harassment by NY's most nauseating mayor ever, the lisping fascist Rudolph Giuliani. *Habit* recalls not only better times for the downtowners it depicts, but a certain type of raw, intimate filmmaking you don't see happening there very often nowadays. The side of New York which justifies the film's horror genre elements is as perilously real as ever, and *Habit*'s gaze into it is still one of the most lucid on record.

A veteran of the NY art scene, Fessenden operates under his umbrella imprint Glass Eye Pix, a company which has, in addition to his own large body of work, produced films for several other NY-based directors. Since 1998, he has acted in films by Steve Buscemi, Martin Scorsese, and Brad Anderson. In 2000, he directed *Wendigo*, a supernatural lost-in-the-woods story about a Native American demon spirit which was released the following year. At the time of writing Larry is preparing his latest project, *The Last Winter*, for release.

Larry Fessenden, as seen in **Habit** (1997).

we live as we dream alone

the best lack all conviction

all love ends in sadness

Gene Gregorits: A lot of people might say that the vampire genre is one that has been well worked over. *Habit* is not your average bloodsucker horror flick. In what ways do you think it sets itself apart?

Larry Fessenden: Well, I think the primary thing is that I wanted to tell it from the point of view of the victim. And keep it very ambiguous as to whether it was really happening, so that it becomes a metaphor for other possible addictions and afflictions. I conceived of it in 1980, and I made a video version of the movie, and that was before even *The Hunger* and that sort of thing revived interest in vampire movies. But at the time, I really wanted to bring a sense of reality into the classic myth. And you know, over the next 15 years, I never really saw it done in that way, so it still seemed like a fresh idea... to just play out all the everyday experience, and have this sense of the potential for this guy to be victimized by this vampire.

GG: Is that video ever going to be available?

LF: You can get it through my website. It's not really a full work, I mean it's 70 minutes, it plays as a feature, but it's very pared down and spare. But I did play the character, and the same elements are in the movie, but they're just not fleshed out the way they are in the current feature.

GG: Was the title something other than 'Habit'?

LF: No, *Habit* was the title. I spent a lot of time working on the title back in '80, and actually came up with 'The Hunger', and 'The Addiction', but I wanted, actually, my title to be something more mundane, something that we all kind of take for granted. So I called it *Habit*. That's not as compelling a title...

GG: What were you drawing on for influence and direction back in 1980?

LF: I was very turned on by Polanski's work, and I still think of him as one of my major influences. The way he blends real attention to detail, and realism, with a sense of the supernatural and what have you. Obviously, *Rosemary's Baby*, but also *The Tenant*, which is one of my favourite movies, has that very 'day in the life' type quality. Even though there's something going wrong with the guy. So, I wanted to make a psychological story, and leave it to the audience to fill in... the overall concept of *Habit* is to suggest the mythic vampire story in a very everyday setting. And to sort of show how we all want that kind of narrative cohesion, which is to say, 'Oh, she's a vampire'... and to play off those expectations, almost those desires of a movie to have that narrative through-line. But in fact, speaking of denial, it's really about how we always come up with excuses for what's going wrong. I mean, the guy's basically an alcoholic, and yet he seizes on this idea that she's a vampire, and it's kind of a metaphor for how we all come up with scapegoats and other things, rather than face our own demons.

GG: Well, that carried over from the original to your own remake, but was there anything else, at all, that changed in the script, in the course of the 15 years?

264

LF: Actually, no. Obviously, it's all in the casting and the subtleties of things, and as I said I fleshed out a lot of characters that are only mentioned briefly. But the centrepiece of both movies is the conversation he has with his friend, which is really about how, even with your drinking buddies, it's hard to punch through to the other side, and really ask for help, so it's also about our inability to communicate with each other. That is very central to the original, and it carries over. It's this very long, 10-minute scene. It offers up the opportunity for comedy because it's sort of absurd, what he's proposing, which is: his girlfriend's a vampire. So in that way, it's about things that are very hard to discuss with your comrades and kind of the eternal loneliness of life, which is maybe the ultimate theme of the movie. Where it's in your own world, with your own demons, and it's very hard to reach out and get people to see your point of view, which is maybe the human condition.

GG: I remember, that was one of the funniest scenes in the movie. You show off some nasty scars in _Habit_... they're real, aren't they?

LF: Uh, yeah, they are real. I was one of these guys who cut my arms as... some form of self-expression, I suppose. I don't really know the ultimate reason one gets into that, but to me it was a way to shake-up a party. I've always been obsessed with the presence of horror in the everyday, which is maybe what my film's about.

GG: Did your experience with bloodletting in the past motivate you in any way to write a script that focuses on you being bled by a woman?

LF: Well, yeah, I think I was just interested in a character that was already pre-disposed to the macabre point of view. In the way that this guy was doing himself in one way or the other, and the woman just became a vehicle for that. She became a centrepiece for his own self-destructive qualities. That was the idea: 'what kind of person would get involved with a vampire?' Somebody who was already open to the 'dark arts', so to speak. And without him being a Goth or something, I just wanted to suggest that in this sort of bohemian lifestyle of his, this vampire could slip in and become part of his lifestyle very easily.

GG: How about the re-write? How long did it take, and was there much added?

LF: Well, it was a nice experience because, you know, I'd been sitting with the story for 15 years. Obviously I'd learned a lot, made a lot of films, so doing a re-write was very intuitive because I had this background story in my mind, I knew the characters, and it was just a matter of fleshing them out. As for the script, in the film, it is as scripted, it's not a lot of improv. or anything.

GG: What elements attract you to other movies?

LF: I think the shock of reality... I sort of have two criteria. One is realism, and naturalism, and those things, which is what I like about Polanski. I also

Above: Larry Fessenden played the lead role in his horror-noir, **Habit** (1997).
Opposite and below: Promotional trading cards for **Habit**.

respond to artistry in cinema. I'm very into Kubrick right now, and there's an example of somebody whose every frame, and every shot, is carefully crafted. So it's that blend of those two things that informs my own movies. Even _Habit_, the whole construct of it is this naturalistic portrait of a guy, with some things sort of narrative – even Hollywood – in terms of story, or a setup, in this case a vampire story. I like to infuse reality into clichés that we're all familiar with, and to set up that tension between the stories that we live with – the narrative structure that we live with and that we respond to – with mythical storylines. And then to infuse that with more naturalism to suggest how those myths do inform our everyday experience. I'm among many who are very influenced by Scorsese. He's also I think an example of intense realism/naturalism, and yet in his filmmaking there is an artifice which becomes a commentary where the director is showing you how to see these scenes. I think that's what I respond to in other people's movies. And also, I like riffing on clichés, riffing on expectations, and then suggesting that in life, those expectations don't always come through. But they

careful what you wish for

"I wanted to paint a picture of bohemia as I knew it, in the early '80s, in New York. There's so much mystery here, so many different types of people who have all come to New York to express their darker side."

sort of inform how we perceive reality, or perceive the world. There's always that tension that I'm looking for between the real and the imagined. And obviously, that's the setup of *Habit*.

GG: What about screenings, publicity?

LF: We played well in Germany, it was well liked there, in various festivals. But every film has it's own course... we didn't get into a festival circuit that you'd hope for, which is to say that Sundance begets Berlin which begets... you know, the real circle of major festivals. Unfortunately, we didn't have that opportunity, but eventually I got this award, which brought attention to the film, the 'Someone to Watch' award, and that gave the film a second chance; critics watched it with a little more seriousness. I think at first it was at a time when they'd just come out with *Nadja* and *The Addiction*, which are two other Lower East Side vampire movies with their own riffs on the myth. So my film seemed a little tired when it came out. It took me some time to re-establish that it was a unique film, and it had its own reason to be... well, after the award, we decided to put it out ourselves. All the distribution companies that I can think of had passed on it for one reason or another. But I felt that the movie was strong enough that we should try it on our own. So I put it out with my friend Michael Ellenbogen and we opened it in Chicago and got good reviews from Roger Ebert. That gave it some legitimacy.

GG: It was shot back in 1996?

LF: Actually, we shot it in 1994, so the whole thing is a lesson is patience, and sticking to it, and believing in your film, which isn't easy in this environment where everything's about overnight successes and real commercial impact. I think that's the problem with the independent scene. You really need to break through all the way in order to get noticed, like a *Good Will Hunting* or something. And as a result, your story needs to be fairly mainstream to catch the real flame. It's important for a movie like *Habit*, which is a sort of off-kilter movie, be given a chance. And that's the big challenge, finding a distribution landscape where that's possible.

GG: How do you think *Habit* might have played differently if it was shot in a different area, a different city, different part of the country? Are there a lot of important elements to your story that rise out of New York?

LF: It's totally a New York story. I mean, it'd be fun to make a movie about a guy who meets a vampire in Wisconsin, that would be a whole other story, sure. I think a lot of the themes would be the same, feeling like an outsider, secret love, and all of that. It would be a fun thing to consider. But certainly for *Habit*, the landscape of New York is so much part of it. And the street living, the bar culture... these are things that I also wanted to capture. 'Cause I think they're sort of under siege as everything becomes more conformist. I also just wanted to paint a picture of bohemia as I knew it, in the early '80s, growing up in New York. I wanted to show the Lower East Side in all of its grungy vitality. It's where you really can blur the line between the femme fatale who's drinking your blood, and the chick that you meet in the bar. You know, there's so much mystery here, so many different types of people who have all come to New York to perhaps express their darker side. And so I think that's where this story could flourish.

GG: How do you feel about your film being described as Bukowski-esque? Are you a fan of Bukowski?

LF: It's a great honour. I'm a fan of Bukowski. And the reason I particularly like that is because it does suggest the dipsomania which is a whole other reading of the movie. If you really aren't drawn to the vampire element of my story, or if that isn't your issue, I think *Habit* still offers a portrait of an alcoholic, and all of the confounding puzzles of addiction and denial. I even was considering that as a title for a while – 'Denial' – because it's really about this guy who believes this woman is a vampire and yet there's so many other things going on in his life that he would need to face, in order to pull out, and instead he focuses on this imaginary possibility. In that way I'm making a comment on how we all come up with excuses and reasons on why things aren't going our way whereas it is in our power to make the change. And that's why it is an alcoholic story, and it is a Bukowski tale in a way.

GG: Were you ever involved with a woman who was into bleeding? A sexy 'lacerationist' perhaps?

LF: Actually, not really. I did know this French girl, and she did have that quality of aloofness, and I was obsessed, and it was a very potent thing in my life. But

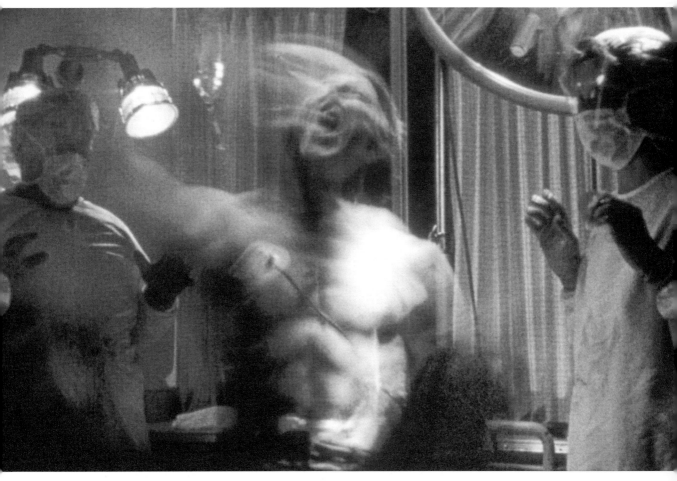

Larry Fessenden's next feature film as director after making **Habit** was **Wendigo** (2001), a much more literal horror feature, based on native American folk-lore.

you know, there was no kinky bloodletting and so on. Maybe a little sex in the streets... in fact the bloodletting is something I brought from my own immediate history, and also a love of old horror films. And maybe my macabre nature or something. That's where the fusion came in, as opposed to any direct experience I had.

GG: Is there anything else you wanted to say about the movie?

LF: I guess my hope is that it would stand among other remarkable spins on the vampire story. You know, a movie I like is *Martin*, it's a movie that has an offbeat, you know, it's a movie that belongs in the horror books but it's something different. And I would hope that *Habit* would join the ranks there. Another film is *Vampire's Kiss*. I mean, these aren't my favourite movies but I think they are remarkable because they take the vampire genre and do a spin on it, and they become very personalized by each director. That's what I wanted to offer, my own take on it. And make no mistake, I am a fan of Coppola's *Dracula* – I thought it was a fabulous effort – but it's more a pageant, it's more in the old tradition of the

grandiose vampire tale, and I have a very soft spot for that. But my own approach, with re-visiting these great old stories, would be to place them in a reality that we all know. And then, I think that re-invigorates the themes that are there, and are somewhat timeless. I'd love to make a Frankenstein story that was similarly more grounded so that you could see the themes clearly again. And I think that's my agenda, at least when I approach horror films, which is definitely a genre that I like and am familiar with. To just bring new life to it. I think a lot of movies nowadays have so much artifice that there's very little shock of recognition, which is what interests me in films.

GG: In today's Hollywood landscape it is unique simply to be realistic.

LF: Yeah, exactly, I really believe that. I think movies have become so artificial. Obviously in special effects and so on, and in how far that can be taken. But even in performances very often, it's just cliché upon cliché, and there is no distance from the cliché of the film. And everybody's just sort of making films based on other films, and so on.

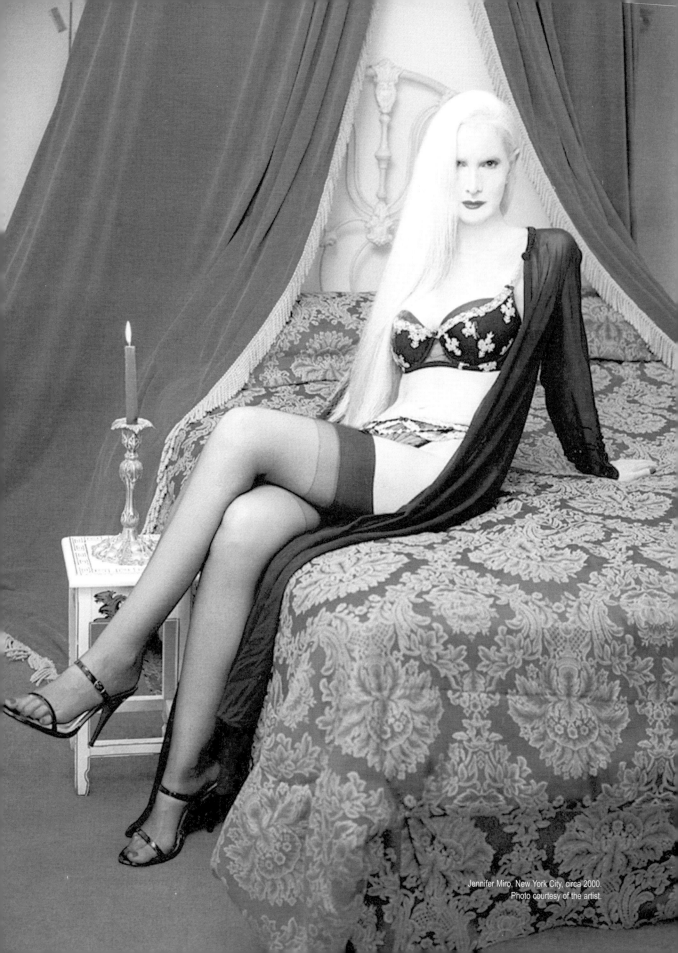

Jennifer Miro, New York City, circa 2000.
Photo courtesy of the artist.

Kitten with a Whip

- Jennifer Miro -

Her career as singer for The Nuns spans from the embryonic days of San Francisco's punk scene to the glam/Goth underground of present-day New York. Jennifer Miro survived the decadence in which she was so immersed with her femme-fatale beauty and enormous love of performance both intact. It is true that she has aged tremendously well; her physical resilience supports her current 'NY Vampire' role to a degree that is both shocking and thematically appropriate. Anyone who has seen one of her S/M fashion performances certainly remembers it.

I would not venture above 14th Street in 1999, but after speaking with Miss Miro at New York's Continental Club, she agreed to meet me the following week at the Metropolitan Museum of Art for an interview. ("I like to go there, to listen to the orchestra and drink wine.")

I realized I'd have to make an exception.

Out I went, getting off the train at 86th Street, and gingerly making my way four blocks south, up the marble steps and through the museum entrance. When I reached the balcony, I scanned the small tables for her. There, around the corner by a massive pillar, overlooking the orchestra, was Miss Miro.

Six hours later, I was stuffed with exorbitantly-priced shrimp and pasta, and at least three bottles of fine wine. As I had drank rapidly, in an attempt to pacify a bad case of nerves, I was sloshy before the second course arrived, speechless, incapable of everything save for facial spasms. I found it difficult to justify my presence in this ritzy Italian bistro, with Jennifer Miro, who was paying for everything. It was twice as difficult for me to exit the dining room without knocking over tables.

Much to my befuddlement, she did not until the very end of the night appear to be noticeably affected by all this wine. I don't know that I've witnessed a woman drink such an amount with the same astonishing sublimity ever since. That particular kind of class is woefully rare these days, and the experience of this put a spell on me, wherein I hallucinated a horse and buggy ride through Central Park.

We finished the interview at her Upper East Side apartment where, while lighting a cigarette from one of her many candelabras, I managed to set my hair on fire. A sulphuric stench exploded through the entire room, but I was looking quite dapper that evening, and after extinguishing the blaze with a richly exaggerated Fonzie Fonzarelli hair-swipe, Jennifer was amused enough to forgive my idiocy.

Gene Gregorits: Let's start at the beginning. How old were you when you first got into music?
Jennifer Miro: I was very young. I started in high school. Early in high school. A lot of bands, just the worst bands in the world. That's how I met Jeff Olener from The Nuns.
GG: Jeff has been in The Nuns since the very beginning.
JM: It was 1975. I was in a band in Terra Linda, which is sort of like the Valley, if you've ever been to LA. A suburb. There was this really strange band playing down the hall. They were doing these weird songs. I said, "oh let's go meet them! Let's go!" So we went down. We went in, and Jeff was there. So was Alejandro Escovedo, who is now doing country music.
GG: Right. I'm a big fan of his. He was in Rank and File way back when.

JM: Yeah! So him and Jeff were there, and this feminine-looking bass player, who is now a girl. At that time he was still a guy. He was wearing purple lamé leggings and purple platform shoes. And this is the middle of nowhere, okay? In the middle of suburban America. Just out of the blue. They sang a song, using a terrible drummer who had a terrible drum kit. They couldn't play, but they played 'Suicide Child' and 'Decadent Jew'. I thought, "god, this is the worst thing I have ever seen. It's so bad it's good." I thought to myself, "this is just like what's happening in New York. Lou Reed and punk and all that stuff. I thought that this could be really good. They called me up and they said, "do you want to join the band?" I was kind of shocked because I didn't really know how I would fit in. I was just a girl from California.
GG: But you were playing music on your own.

JM: Oh, yeah. I played piano. I'd studied classical piano since I was five years old. This band wanted me to play keyboards. I started to rehearse with them, arranging songs. I had a few songs I'd written. Punk songs. I was already into punk. I was with the wild crowd of girls in high school. When I was very young I dated 35-year-old coke dealers. They'd pick me up in high school, pulling up in their Jaguars. So I grew up really fast, I was a real bad girl. We'd all sneak out at night and go to nightclubs. I was very tall, and about 28 years old when I was 13. We were all into that music scene, going to nightclubs. They wouldn't let us in, because we were underage, so we'd just go to the backdoor, and stand there until someone could sneak us in. We'd hitchhike into the city, in our little outfits and our platform shoes. I don't know why I'm not dead. The things that I used to do, I can't believe. My mother never knew. "I think I'm going to do my homework" and "I'm going to bed now, don't disturb me." Then I was out the window and on my way to the city. Stay all night. I grew up in Mill Valley, which is out near the wine country, Sausalito. Across the Golden Gate Bridge. Very pretty and very wealthy yuppies. Marin County is full of yuppies, and they're very conservative people. I just did everything I could to annoy them. I'd come to school wearing black fur coats and eye liner. All the kids just hated me. So I tried to make them hate me even more. [laughs] I wouldn't even talk to any of the guys. I was a nightmare, an absolute nightmare.

GG: So Jeff Olener is still in the band now.

JM: He's still in the band, yes. They chose the name. I didn't like the name at first, but we couldn't think of anything else. These guys were making some film about a rock star that lived in a refrigerator. In the refrigerator, he was reading some book called The Nuns. And then we couldn't find anywhere to play! This is before punk rock happened, there were no punk rock clubs, not even in LA. There were just a few hippie places. So we'd play the hippie places, and start dancing with the hippie dancers. They didn't get it. Then, we finally found a place called Mabuhay Gardens, which became the big punk club, where all the big punk stars used to go and play. The Ramones, Blondie, and the rest of them. Iggy and Bowie used to hang out there. We rented it out. It was just a club that had female impersonators and Elvis impersonators. A really schlocky restaurant which we rented out. There were a few people interested in punk, so a lot of people just showed up at our first show. It just started to happen. When national TV did their big story on the Sex Pistols and Johnny Rotten, then BANG, it was immediate. Everyone was in that club! Everybody was dying their hair green. Everybody was wearing safety pins. The media jumped on it. And [laughs] we were the first ones! We came before LA! There was no punk scene in LA either!

GG: Is this in 1976?

JM: Our first show was in January 1976.

GG: That's really early.

JM: I know! We really did start it… which is an odd thing to say, but… we created this scene that was so much fun, for a while. All the great bands played there! We used to have these parties, in San Francisco, and everyone would show up. It was a fun place. It was a bit out of the way, and you wouldn't think of it as the jet set kind of place, but for a brief moment, it was really great, it was magic. We actually opened for the Sex Pistols. We played a show in LA, and there were no punk rock clubs. There was no punk rock scene. It was just glitter rock, heavy metal, and hippies. We played a show, and it was just… nothing. Of course, a year later, it was mobbed. We'd play with The Dictators, and the Ramones. But LA felt like competition to us, because we were ahead. But still, I thought it was fun until it got to be really super-hardcore, because then all the girls were pushed out, and all the creativity was gone. It just had to be hardened guys…

GG: Violent.

JM: Violent. A lot of people I know got their faces cut up. Really, very intensely violent.

GG: You're talking about the scene The Germs came up in.

JM: Yeah. When the Dead Kennedys came out, that's when it was over for me.

GG: Kind of ironic, because they were so politically concerned and peace-minded.

JM: That's what I mean. We were creative, and we were artistic. The Dead Kennedys had an entirely different viewpoint. We were just exploring a different art form. Creating something new. I'd go on stage and sing some lazy, weird cabaret piece. We'd do really odd things. In it's prime, The Nuns, and the scene we played a big part in starting, it really was a magical time. It wasn't about money, and it wasn't about corporate stardom. There were really imaginative bands, people doing something new. A nice creative time. Then it all became... part of the business. The music business is a very strange thing. The tides come in, and you can't fight it, it just happens. All of a sudden everything turned hardcore, and the band got really fucked up on drugs. We had drug dealer managers who used to give the band heroin. Personally, I've never done heroin. In fact, I've never taken drugs. I was a young teenage girl. It scared me. But it fascinated me at the same time. It still does, sort of. All that decadence stuff fascinates me and repulses me at the same time. I don't want to see people destroy themselves, but at the same time there is something morbidly fascinating about that dark side of life. Maybe I'm making it worse by paying attention to it. But I saw the whole band destroy itself in front of me. I didn't know what to do because I was really young. I didn't have any power, and they all hated me because I wouldn't do drugs with them. They thought that I was an outsider, and that I was snubbing them. Of course, the drug dealer management hated me, because they had no power over me. Some of these guys need that

power, that's why they become drug dealers. Everyone's ego blew up. Alejandro's ego got so bad that no one could talk to him. So the whole thing self-destructed, which was too bad. We toured, we played New York. We were staying at the Chelsea Hotel, with Sid and Nancy. The band actually copped heroin for Sid and Nancy. They used to do dope with them.

GG: I guess this must have been after Winterland, because before the Sex Pistols' final show, Sid and Nancy hadn't lived together in New York.

JM: Right. This was after we played with the Sex Pistols. Sid Vicious OD'd at our party. That's why he missed his plane, and that has something to do with why the Sex Pistols broke up! [*laughs*] It's all our fault!

GG: Did any members of The Nuns ever go on to anything else?

JM: Well, Alejandro did Rank and File, but he never really achieved stardom. He's still struggling with his country music. He's still doing records. One of the guitar players, who played with The Nuns, is now playing with Keanu Reeves's band Dogstar. In Keanu Reeves's press release, it says that this guy played with The Nuns, as if The Nuns are some kind of cool status symbol for Keanu Reeves.

GG: "For those in the know…"

JM: Yeah! It's funny. Bret Domrose is a really good guitar player and he worked hard with us. It's hard, because everyone wants to be a big rock star all the time. I don't know how to make people rock stars. People want me to make that happen for them, and they always expect me to succeed. Then they get mad at me when I can't make that happen. People want to be rock stars more than anything in the world. I think it is the strongest human drive there is.

GG: Well, sure. Even Hollywood actors wanna be rock stars. Look at Keanu Reeves, for example.

JM: I know! It's scary though. I've dated a lot of people in the music business and it never works out, because everyone is so jealous, and competitive. All they care about is success. I'm not a big superstar! But for some reason, they're always intimidated by me and by what I do! They always try to tell me not to do the band. I tell them, "okay, I won't do the band!" Then, I do it anyway. [*laughs*]

GG: What do they want you to do?

JM: Well, one of them, a very famous rock star, one of the most famous rock stars in the world, told me I should either be a stripper or a prostitute. I thought, "yeah, I think that's a really good idea. Yeah, I think I'll really do that!" [*laughs*] Guys in bands… they like strippers, and big breasts, and all that. Which is nice, there's nothing wrong with that. But I'd rather just do what I wanna do. In a way, it's flattering to me that for years, this rock star has told me to give it up. So there must be something about me that intimidates them, because why would anyone want, so bad, for me to stop doing my thing? Why would it bother him so much that I'm doing it?

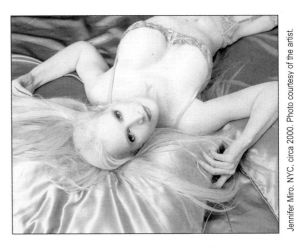

Jennifer Miro, NYC, circa 2000. Photo courtesy of the artist.

GG: They want you to do something that has nothing whatsoever to do with creativity. He doesn't want you to be you.

JM: Yeah! They don't want me competing in their field. They want you to be the little blonde bimbo.

GG: You don't wanna mention his name?

JM: I better not. I better not, because I almost got sued once by another rock star.

GG: C'mon, it's a great story!

JM: I do have really great stories, and I would get sued if I told them. One thing that I have learned over the years is that really famous people do not like you to use their name. Even if you think that it's nothing damaging, they still don't like it. No matter what you do, and they will sue you. Even if it's the truth, they'll either sue you or try to sue you. But I can tell the story without saying the name.

GG: You mentioned hating the music business. Have you ever considered giving up the business, and just doing the band for yourself?

JM: That's impossible! The music business is everywhere! You really can't escape it. I've tried to give up and just lead a normal life. I really thought it was all over for me. I've been doing this for so long. I said to myself, "Jennifer, this is it. Just get married, lead a normal life. Go to New York, just be happy and don't worry about anything." So I came to New York. What happens? I start buying little rubber outfits, I start dancing in bars. [*laughs*] Next thing you know, I'm doing The Nuns again. It's an addiction.

GG: So there was a long gap between when The Nuns ended and when they began again.

JM: Not really. It's just that no one knew that we were trying to do it. We had a lot of sad times. The Nuns have been through every known scandal on earth. We've been through sex changes, drug dealer managers, fleeing America to avoid the IRS. We've been through murders and overdoses, we've had people try to sue us. One of my guitar players tried to strangle me. That's why I moved to New York, because he was madly in love with me, he was

"I can't turn my back on the dark side of life. Instead of living it, I write about it, and try to make it beautiful."

obsessed with me. We got into a big fight. We'd started doing S/M kind of stuff, and it went a little too far. He'd never done it before, it was new to him, and he went a little too far with it. Tried to kill me. I realized that the only way to get away from him was to get on a plane and go to New York. I was just gonna come here, just lead a different life. Pursue something else. Then, I met Michael, he's the guy I whip onstage. I met him, and we clicked, we started to hang out.

GG: He doesn't actually play an instrument.

JM: No, but he sings, and we do all this bondage stuff on stage. That's a lot of fun. We do the weirdest things! We do modelling, and fashion shows. I'm able to incorporate the band into the fashion shows. The last fashion show we did at Limelight included a bondage act. It was was really super intense bondage. We videotaped it, and they're going to make a video out of it because it was so good! For some reason, it just came out well, so… we're using it. It's funny because I couldn't get a modelling job in California to save my life. Then I come here, and I'm modelling all the time! I'm modelling more than I do anything else! I'm doing fashion shows. It's a really fun thing to do!

GG: Does it pay better to do modelling?

JM: It doesn't pay anything. I'm not doing anything but playing around. I have an inheritance. There's no other way I could do this. I wouldn't live here if I didn't have money. I could never survive.

GG: Do you do magazines?

JM: Mostly just runway and fashion shows. In clubs like the Limelight. Medieval Goth gowns and things. Bondage clothes. Modelling is just like anything else. You have your clothes, and the clubs like you, but… also, it's very expensive to have a band in Manhattan. You don't make any money. Lately, it's been really great. We've been recording with some amazing session people. All the musicians in New York are just terrible, they're so bad! So what I've done is started recording with session people. We got Billy Idol's drummer. The bass player from a few L7 records. It came out great! This guy is the best drummer I've ever heard! That's what I've been

doing, just making great sounding recordings. And also doing these weird performance art shows, which are easier to do than perform with a band. And people seem to like it. It's very creative.

GG: So you want to bring those two things together for shows?

JM: Yeah! The thing is, I can't afford to get a really, really good band. I would like to get excellent musicians, but you have to pay them a lot. The only ones you're going to get for free are the ones that can't play at all. Like I said, we've been doing bondage/fashion pieces…

GG: Not to take attention away from the music, but to make it more interesting.

JM: Well, yeah! It's so much easier than trying to rehearse with a bunch of musicians who can't play. The last guys I had in New York, I would literally have to yell the chorus during shows! I'm just presenting this band as if it's a new band. A lot of people haven't heard of us, but that's good! We could just be a new band as far as they know. In a way, it's better, because if they know you've been around a while, that's very negative sometimes. People are… are so cynical! They're tired of things that happened fifteen seconds ago, let alone 15 years. It happens so quick. So, that's what I'm trying to do. I'm trying to present it as a new band, it's a whole different thing. It's all new stuff. We're working on a new style of music. Let's face it, punk rock will never be new. The only old song we still do is 'Suicide Child', which goes along with the new stuff, because I'm still the keyboard player. Those keyboards meld the whole thing together.

GG: And you have these solo pieces, like 'Lazy', which is one of my favourite songs that you do. You do that solo, with a keyboard. It's great.

JM: Oh, thank you! Like I said, I opened the Sex Pistols' final concert [14 January 1978 –GG] doing 'Lazy', and that was terrifying.

GG: You had a huge crowd that night!

JM: Eight thousand people. And you have to remember the backdrop…there was still no punk rock. They were watching, just to see, "what is this new thing? What are we about to see?" A bunch of hippies, just checking it out. So I was the first one to come out, under the spotlight, wearing this green taffeta Vampira-like dress, and black vinyl stiletto boots. I came out, the light hit me. I just stood there. And everyone cheered. It was the best!

GG: At that point, when the Pistols came to America… they opened in Atlanta. They played a week, on tour, before they got to Winterland. So, that blew the whole punk thing wide open. American strip-mall culture saw it for the first time. But still it was only a little over a week between when they got here and when they played San Francisco. The media picked up on things so amazingly quickly. Punk rock wasn't developed and pasteurized the way it is now. So you had people that would come to the shows, who were really weird people. Genuine misfits.

JM: It was so much fun. You're right!

GG: How would you describe the audience?

JM: They were just a bunch of individuals, like you say. Back then, everybody knew each other, we all had parties together. It was a really – dare I say it – an innocent time. Nobody did anything too terrible, except do a lot of drugs. I never did. That's why I've survived all this. But after a while, I became afraid to go to Mabuhay Gardens. It had become dangerous. Some nights, there would just be a wall of people in front of the stage, and if something violent broke out, there was nothing anyone could do about it. And to this day, I don't understand why they all hated me so much.

GG: The band or audience?

JM: The band!

GG: Well, if you're drunk or high, you can't maintain any real communication with someone who's not.

JM: And there was nothing I could say! You could see that they were stoned. Jeff's voice would go out at shows. Jeff has a really self-destructive, evil, demonic side to him. He's a damaged person, let's face it. I guess we're all a little damaged. I've had a very sad life, so I can't turn my back on the dark side of life. Instead of living it, I write about it, and try to make it beautiful in a way. I don't want people to be self-destructive. I just think that you have to accept that there is a dark side in life. Most of my life has been pretty sad. When I got here, I became so happy though. I love it here. I said to myself, "I'll move to New York, and never be unhappy again." And it's true. I just put all that behind me. I just love New York. I love the pace, and I love the energy.

GG: The dirt and the winters don't get to you?

JM: No. San Francisco is cold all the time! In a way, it's colder than New York, because it's always damp and windy and cold. They don't heat the buildings in San Francisco. It's never quite cold enough. So you're always chilly and always getting sick. I hate it there! Such a horrible place.

GG: What about the band Crime, who were also from the Bay Area. Did they come before The Nuns, or after?

JM: Right about the same time, or maybe just a little bit after.

GG: So you guys were the first!

JM: *I KNOW!...* When we played New York, Andy Warhol came to our shows. All the New York stars were there. Lou Reed, all of the Dolls. We were playing with Blondie, but we got kicked off their show.

GG: Why?

JM: Because our drummer threw food at Debbie Harry.

GG: [*laughs*] While she was onstage?

JM: Yeah! Then backstage, Clem Burke just jumped over a table and beat up our drummer.

GG: What kind of food was it?

JM: Egg salad.

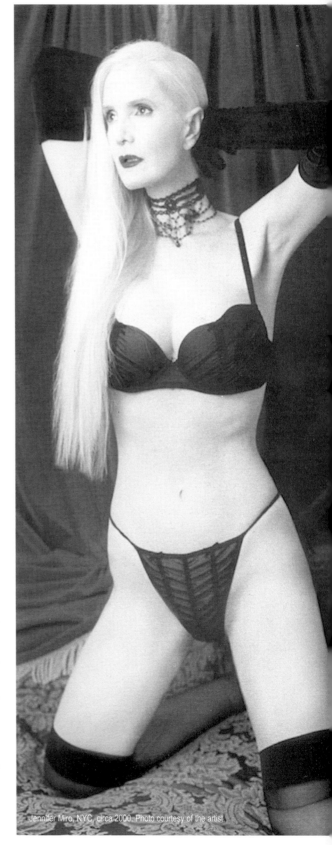

Jennifer Miro, NYC, circa 2000. Photo courtesy of the artist.

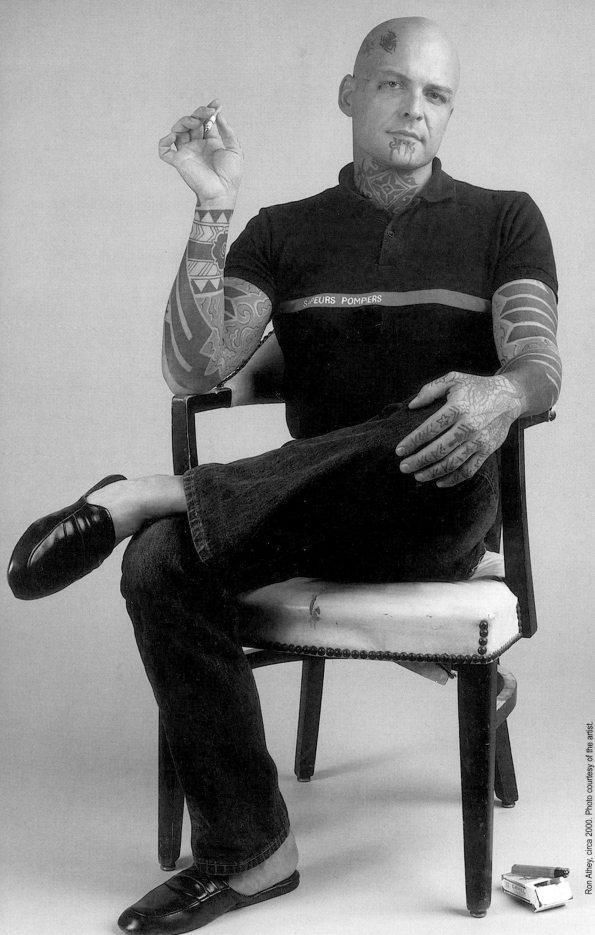

Ron Athey, circa 2000. Photo courtesy of the artist.

Violent Disbelief

- Ron Athey -

An incendiary furore rose up in the wake of Ron Athey's 1994 performance of *Four Scenes in a Harsh Life* in Minneapolis. For years, rumours persisted that the HIV-positive artist had threatened the audience with his spilled blood and like so many others, I believed the hype.

Athey was introduced to me by Lydia Lunch over breakfast in Los Angeles, several months before we got together for a *Sex & Guts* sit-down. Sometime in between, around August 2001, I was offered a role in a short film he was directing. When told what the role actually involved, I balked. I was only a year into the healthiest relationship of my life, and although that's not saying much at all, I was still doing my best to keep a host of personal demons under lock and key. This 15-minute short, shot on video, was to portray the notorious fringe culture/body modification icon Athey in his early 20s, when he was prone to drugged-out fits of self-mutilation and other suicidal nastiness. I guess I was the obvious choice. After a few days consideration, I began to see it as a challenge, so simply out of sportsmanship and good old-fashioned exhibitionism I finally agreed to appear as 'Young Ron Athey' in the film *Ronnie Lee*.

The resulting footage, when shown as part of his multi-media performance *Joyce*, pushed several nauseous and horrified audience members to the point of vomiting. While my role and its requirements were hardly pleasant, I couldn't have imagined its effect when projected onto a large screen with the soundtrack fiendishly modified to accentuate the "*SHIK*" sound of the serrated edge, eight inch steel blade ripping through my thick Hungarian epidermis.

As I sprawled out nude on a toilet in the bathroom of frequent Athey collaborator Vaginal Crème Davis's Los Angeles apartment, I recall feeling a powerful sense of disappointment: none of the wounds had been of significant width, length, or depth, nor had I brought on any immediate blood flow. These freaks who stood around me, with cameras, boom mikes, and megawatt lamps, were all part of the pervo elite, knowers of repulsive physical agony... if I didn't end this session with a first class, Vietnam-calibre gash, I'd be a gutless poseur. For all intents and purposes, this had to be the cumshot. I pressed the blade so tightly into the skin of my upper arm that it nearly split from the pressure alone, then cranked the handle like it was attached to a stubborn lawnmower chain. The movement created an expanse of white subcutaneous fat, which quickly turned red. I threw the blade into the bathtub where it made a clanging sound reminiscent of the slamming red door which concludes Leatherface's first hammer attack in *The Texas Chain Saw Massacre*. That was the final straw for the cameraman. His face went white as he struggled to remain afoot. As soon as everyone had cleared out of the bathroom, the beleaguered lensman lost his lunch, and we drove back to Ron's place where he sutured the arm with a staple gun that hurt like a motherfucker. In the end, I received a hundred bucks and a handshake of solid respect from the torture terrorist himself.

That film shoot familiarised me with the relationship between the mean streets of LA's skid row and Hollywood's film studios. On that day I came to know first-hand the chasm in which the S/M scene, the porno industry, and the drug trade bloom like mutant dandelions. Here was a purified example of subterranean show-biz, fuelled by deviant lust and transgressive philosophy, here on the outskirts of unmitigated indulgence, a spectacle of defiance, a mockery of death, the furthest reaching point before the drop zone of snuff films, where Grand Guignol and the Inquisition merge with the Marquis de Sade and Hubert Selby Jr., in short: the pitch black, irreconcilably redemptive world of Ron Athey.

Lydia Lunch: *Joyce.*
Ron Athey: I've been writing notes on *Joyce* for five years. It's about not only my schizophrenic mother Joyce, but also three schizophrenic women and how it becomes one shared disease in a small house. I don't think you can really portray what I was trying to get out of the piece, visually, without using mixed media. That's

where I got the idea to start using the films. I thought, one wasn't enough. So it is a synchronized movie shown on three screens. The screens are about twice as big as the characters.
LL: So you walk into the theatre and what do you see? This emotional retribution against the schizophrenic women that basically ruined your childhood?

RA: It's very formal. I prefer a venue with curtains, where you sit down as if you were going to the theatre. Then the curtains open and the screens are already on. The word 'Joyce' is showing. There's an intro where it's like a triptych between the three screens. My head, the middle of my body, my feet. I got huge needles in my head, like an EKG. All the wires are attached to the hand of the psychic woman doing automatic writing on the screen. It's this kind of shabby shamanism. All the characters are standing on the stage.

LL: Which characters?

RA: The live characters, which are the three women and myself. Everyone has their own room. It's the screens and then the stage on top.

LL: A stage on top of the screens?

RA: Yeah. Each character has their own room, divided equally. It's me at a podium with a sling, and then Joyce, played by Hannah, inside a white tower that goes above everyone. Just a little tiny window. Then Vena, who is played by Patty Powers, inside a boudoir with transparent curtains. Then there's Annie Lou, the grandmother, played by Rosina Kuhn, who is doing an Aktion painting, with angel sleeves that go to the ground.

LL: The screens start with the shamanistic writing. Then they progress into the characters in flashback.

RA: Right, so you get a four minute establishing scene, where the characters just stand there glaring, and then [*laughs*] they go into action. You start with the grandmother, who's just having a sweaty dream vision. She gets up and starts automatic writing. Then she breathes out an angel, that tells her that her flesh will become fresher than ever, out of a child. I had to use animation and special effects to get this idea across. This idea was influenced by ectoplasm. I like sort of hokey things that were trends at a certain time. During the Victorian times, ectoplasm was a big thing.

LL: So we got grandma, going through her schizophrenia, religious hallucinations.

RA: Yeah. On stage, she is a lot colder than she is on video. On stage she takes a different colour for each character, and paints a different pattern on her entire back wall, which is three metres by two and a half metres tall. She's painting these colours, she paints yellow for herself. Then we switch to Joyce, who on the video is just skitzing out in a room about her clothes. Lint picking. Constantly smoothing.

LL: Squirming.

RA: Yeah, as if her skin was crawling.

LL: Which is the way that women who have been traumatized, who are hyper-sexualized, act. That kind of seething, fidgeting, can't sit still…

RA: …where the hair needs to be a mess. That goes into an endless loop. Then she's straightening out the lining of her pantyhose along her toes. That goes into a loop on another screen, and that's to drill in the neurotic straightening and writhing.

LL: Fetishised compulsion.

RA: Yeah. Smoking and bugging out. Then you go to aunt, who is played by Patty. This is another repressed, sexualized thing, where she is showering, and then her mother comes in and cunt-fists her. [*long pause*] Sometimes the truth is harder to show. You couldn't write that, in this religious, schizophrenic household, that there was sexuality revolving around red-hot Betadine douches and creams, and… five long fingernails up the cunt.

LL: When this was going on, when you were a child, did you hear it going on, or did you see it? Were you in the room when these things were going on?

RA: They happened in the bathroom. It happened at least once a week, during my whole life when I lived at home.

GG: What is the genesis of the Betadine douche? How does someone get an idea like that?

RA: This is the idea that 'you're filthy'. And you probably are, after a while, because you don't have any natural enzymes left. [*laughs*] So you rinse it out, scrub it, have your mother help you until you come, and then feel ashamed. I've talked to other people who have similar backgrounds. It's this idea that we're filthy inside, and putting lots of cleaning products up inside there. When in reality, the filth is coming from the victimizer, who then drains you of your natural defence against bacteria.

GG: This isn't symbology, then? Joyce was actually doing these douches?

RA: Oh yeah. You can actually go to the store and get a pre-mixed Betadine douche. Of course, some fanatic like that, at home, would be mixing a much higher ratio, with water that is far too hot.

LL: On the fourth screen?

RA: On the fourth screen is my character, with Gene playing the self-destructive part of me. I also have footage of me at 18, jacking off in a shower.

LL: That's the self-loving part of yourself.

RA: And that's just intercut with other footage of me, the psychic surgery scene. Pulling the needles out of my head, and I'm bleeding in the bath, laughing in the bath smoking a cigarette. Then it cuts to real life, real acts, with funny moments. The text I recite over this is based on a vaguely poetic narration of all the characters. Then, the third part being what it feels like to disassociate and have audio hallucinations, which was what I suffered from a lot as a child, and occasionally still have.

LL: Did the audio hallucinations come before your evangelical preaching stint as a young boy?

RA: No.

LL: You preached first, then the hallucinations came.

RA: Yeah. [*laughs*] I think the hallucinations came with facing reality. You can be told anything as a child, and you'll believe it to some extent. But then, having to go to school, and having some contact with reality, there was always some kind of doubt. As nutty fundamentalist prophets will do, they said things like, "On this day, Elvis is going to come to the house."

GG: At what point in the performance do people start to leave the room?

RA: Only during the self-mutilation part. Gene's scene, or right after that, his scene goes into an American Indian dance from an illustrated sermon, where we mimicked the dance. The evangelist, she has on an Indian headdress and a red sequin gown. She has a gun in her right hand and she's doing a Pow Wow dance. [*laughs*]

LL: So there's live preaching?

RA: Yeah.

LL: Beautiful. So how old were you when the spirit moved you to start preaching?

RA: Out of the four kids that were raised in our house, I was the only one that was interested in religion. My family didn't like churches because they were too boring. At least they were right about something. We only liked revival meetings, so we were like church junkies in a way, going from revival tent to revival tent. Anywhere from the middle of the Mojave Desert, to Rosemead, to downtown LA. We were always on a journey, to see someone with stigmata, or healing, or someone who specialized in exorcisms. It's not as if evangelists could last for a few months in one city. There was one church we went to, and that's when I started feeling like I could receive the gifts of the spirit… which is speaking in tongues, and spirit dancing. I just caught on the vibe. And I was nine! The minister's wife, she figured out I was catching the vibe, and suddenly I had twenty people who were pouring oil on their hands and just shaking me. And finally, it busted out of me.

GG: What busted out of you?

RA: Glossolalia [*laughs*] My own demons. I thought I was filled was something from outside of me. Something took over. I left my body. It was like being high. I was having an epileptic seizure while screaming at the top of my lungs.

LL: And you were being filled. That's the point of fevered religion. So, how long did your glossolalia last?

RA: I still have it. I believed in it for about six years. I was just a little over-emotional, tender creature and I remember being in this church. I started crying. So the minister took his white shirt off and tore it into squares, and put a tear on each square. And everyone lined up for one of my tears. So talk about grandiosity and self-importance; people were lining up for one of my tears. Meanwhile I was going to an all-black school, in the poorest fucking neighbourhood. My mother was in a mental institution and if I ever did anything wrong I was threatened to be put in a foster room. So it's like, "You're special, we love you!" And then, "You're about to LEAVE."

LL: No special treatment at home for the little saint.

RA: Maybe compared to my brothers and sisters. My sisters had it worse. That's why, in *Joyce*, I wanted to show how, when women create a power structure, how sick it can be. When they would bring my mother home, she would hear my sisters talking about her in the middle of the night, and pull them out of bed by their hair. And I'm

talking out of bunk beds. CLUNK! On the concrete floor. My older sister was kind of good-looking, but she looked like someone threw her teeth at her from across the room. Really fucked-up teeth. My grandmother would hold her by the chin and just start slapping her face, just for being ugly, until they both fell down on the other side of the room. Really twisted shit. Instead of that sister being fucked-up about her face, my younger sister went and had her entire face sawed apart then put back together. She had a half inch of skull sawed out, because you could see her gums when she smiled. She had a rib removed, and her lower jaw extended.

GG: Your first performance, when you got to Hollywood, was with Rozz Williams of Christian Death, right?

RA: I worked at a restaurant in Claremont. So I had a job, slept in a friend's car. I was eighteen and Rozz was sixteen. I started going out with Rozz, started doing performances.

GG: So what did these performances consist of?

RA: It was an explosion, I guess. We were little suburban punks. Probably had seen photographs of the Viennese Aktionists...

GG: You were aware of that stuff all the way back then?

RA: I wasn't really aware of it. I remember seeing the photos. There'd be someone with guts all over them. I absorbed the aesthetic, without knowing what they were saying. I guess I did understand what they were saying on a certain level.

GG: I still don't know what they were saying.

RA: He was re-aestheticising Catholicism, with all this goriness. But gory on a formal, ritualistic level, as opposed to a shock film level. I could tell the difference. We took this idea of all these projects we were into, like SPK and Throbbing Gristle. The noise thing was really happening right around then.

GG: Yeah, in some ways they were the punk era's practitioners of the Otto Muehl aesthetic.

RA: I didn't have any awareness of art history. I was, and probably still am, mostly influenced by what I read as far as subject matter is concerned. It was physical, and in a lot of ways embodied the physicality of punk rock, that I liked, which was the disregard of your body. Making an art out of destroying yourself.

GG: What were your favourite punk bands?

RA: I was more adjacent to Orange County than Los Angeles, so I was more into the Cuckoo's Nest, where I had my earliest gigs. I was into hardcore, like Black Flag, Circle Jerks. Dead Kennedys, of course.

GG: You mentioned reading. I've seen your library, you have a really great library. What kind of stuff do you read now?

RA: I love reading biographies and non-fiction. I just read *Prepare for Saints*, which is about the making of Virgil Thomson and Gertrude Stein's *Four Saints in Three Acts*. An opera they did in 1934, using an all-black cast.

It wasn't really religious, but dozens of people played saints. There were lit up cellophane sets, if you can imagine that in the thirties. It was supposedly the only American opera that ever existed. It was about the process and the determination, and also about the study of a scene. I just read *England's Dreaming*, not so much because I am Sex Pistols crazy, but for the analysis of how an authentic scene starts, and how it runs its course. And also, what ruins it. Media always seems to ruin it. If it is based on something crusty and underground, media ruins it immediately. If it is based on high art, media doesn't ruin it, but it plays out in a different way.

GG: In that book, they traced the origin back to the Situationists, Guy Debord, etc. Do you take that stuff seriously as performance? What about that element of social, public pranksterism?

RA: I think if everyone had been aware of Situationists, if punk rock had been that savvy or intellectual, it wouldn't have been the same thing. That's a reverse analysis. I think that the bulk of those people didn't know or give a fuck what any of that shit was. What it was, was a real scene, where everything exploded at once. Everyone turned on everything conventional and traditional. In the opposite way that the hippies did. Once that was over, that's why it was so tired and boring. You still see these ageing punk rockers, who don't seem to have ever changed. 'Fuck you!' I think that the real ones died, if they really meant that.

GG: Absolutely. What's your opinion of Darby Crash, the one from the early LA scene who did seem to understand himself as an animal much more so than as a human being?

RA: I think he had charisma, but he was really full of himself. I don't think he really believed that. I think he was a poseur! Because punk was a real scene, it was the first scene that I got into after religion. I know punk was really important for a lot of people, in forming them, if you were a certain age, at that time. But I had left a belief system and was empty. And this was a lot of the reason I was destroying myself. I didn't know who I was. On a deeper level, deeper than the punk level, I really didn't know how to live. I had come out of this conditional love and had never been touched, and never had a role model of how to develop a life. You couple that with this destructive scene, and after slam-dancing for a year, I felt like, 'How fuckin' lame.'

GG: You could go far beyond slam-dancing.

RA: Right. I've always read, since I was a tiny child, night and day. Suddenly finding the right books…

GG: What was the first 'right' book you found, that you can remember?

RA: I ate up Jean Genet and William Burroughs. I read Patti Smith's *Babel*. Probably among the first books I read when I was young. And you know how one book leads you to another. Smith mentions Rimbaud… and you go in these circles, through all the French existentialists and so

on. Literature saved me because I thought I was the first atheist. When I still lived at home, no one had ever come to the conclusion that there was no God. In the Latino and black neighbourhoods, even people fucked up on PCP still go to church. They still have a strong family belief system. I didn't know any white people and I didn't know anyone who went to college. When I started reading *Last Exit to Brooklyn*, it was important because I realized that there's been fucking freaks and perverts and people bucking the system forever. You know, you're given this thing that, 'Oh, people in the fifties were all prim and twee and *Leave It to Beaver*'. But there were all kinds of people. We were around back then! And something about that made it okay for me to exist. I had to find a reason to exist.

LL: So these books came pretty late…

RA: Around when I was eighteen. I'm definitely a late bloomer. I was a born again Christian at fifteen, and then I became a late night disco queen during that period. At seventeen, punk led me to literature. If I would have had those books at home, I would have been crucified right in the house.

GG: You had said that you found the punk rock scene to be rather weak. At that point, you already knew that you were far more frustrated than even that. Did you ever blow up in public?

RA: That's when I started doing *Premature Ejaculation* with Rozz. I thought, 'I don't wanna be in a fuckin' PUNK band! I can't play anything, I don't wanna scream and roar in an ugly voice'. I enjoyed it at the time. To me, it was complicated. It was very clique-ish, and being a punk in Pomona, we either did Hollywood or Orange County. That's where punk rock went military, in Orange County.

LL: Were you self-mutilating before you turned body-manipulation into an art form?

RA: I started self-mutilating at fifteen, when I couldn't understand the concept of Jesus anymore. You're crying, and there's no one to pray to. I stuck tweezers in a light socket. That's when I started going on and on with trying to wake my body up. I did cuttings, with razor blades. Fingers, hands, arms. I would slam my head into concrete walls and floors. I felt like a numb piece of meat. That's when my head started ringing. I felt like I was just going to float away.

GG: Being so alive that you have to make yourself a piece of meat is a rebellion against the deadness of people around you, not so much deadness inside. You were dead inside then, but you're very alive now, and you still attack your own flesh.

RA: Well, my reality was so limited then. I didn't understand how I fit into the world. I was still trapped in this house, and I enlightened myself beyond that and there was no one to turn to. I didn't have any mentors, I didn't even have those books yet. It was almost just to get through the minute. Once I injured myself, I would flatline a little bit so that I could go on with the next day.

LL: When did you ritualize the endorphin high and release of self-abuse? To express in that way your outsider status which you now wear as a badge of honour?

RA: I think it's because I caught the exact right age to go to S/M bars, before the whole seventies thing was over. The One Way was still open on Hoover, and it still looked good. It wasn't a lot of fifty-nine year old men in chaps. You'd go in and there'd be all these guys under the bar, just drinking piss. Somebody in chaps is getting fucked in the ass. Someone with a hard on is getting strung up on a chain link fence. I felt, 'Okay, this is what I need. It is structured'. I never wanted to belong. I was never a 'boy' in that scene. I never joined it. But I would go there and get drunk and leave with someone or a couple of people, get tied up and be set on fire. We would run the whole gamut. I'd get shot up with homemade crank, feel like I had a stroke, then shit in some old man's mouth, on a toilet seat on stilts. There was no limit.

LL: When you first got into that scene, even before you could comprehend that this was reclaiming your trauma, ritualizing it, to get over it basically... did you feel good after you did these things? Did the transgression suit you, or did you have guilt over it, for coming out of what you came out of previously?

RA: I had no guilt whatsoever. I wanted someone to fuckin' kill me. And it felt good. I mean, I would go off with anyone, and go anywhere. And then, later on, in the early eighties, I had got rid of my really freaky look. After I broke up with Rozz, I got into this Nazi youth look. The skinhead look. I remember going to one of those bars, and realizing that I had a different kind of power. Instead of someone sleeping with this weird boy, all of a sudden I was the top, and someone was giving me a hundred bucks to kick him in the head, with boots. [*laughs*]

GG: Would you define everything you were doing then as hedonism, or just what you had to do. I think there's a difference, somehow.

RA: I think it's like... why I took LSD. I was experimenting and wide open to feeling everything. Somehow I had no taboos at all. I wasn't afraid of blood. I wasn't afraid of shit. I wasn't afraid of piss. I just walked into everything like a child, without any hang-ups. I have more hang-ups now than I had then.

GG: You don't do drugs anymore. When did you stop?

RA: By the time I was twenty-five, I was dying. By then, it was heroin and methadone... and Valium again. My first addiction. I was a trash bucket and I did so much LSD and crystal meth and speed when I was younger that I actually couldn't take any stimulant. If I did coke, I'd be climbing the walls. Heroin was the end of the road for me. My nervous system was shot. Every time I'd do speed, I'd start hyperventilating the minute it hit my blood. forty-eight hours later, I'd have to be telling myself, "Okay. You have to breathe in, you have to breathe out." Then, there was nothing left but heroin. And how boring is that?

Waking up sick, and I could never seem to wake up. Because I was a pig, I'd get up at three in the morning and shoot up my wake up, so I could wake up at nine in the morning sick as a dog. Then I'd get up, get on the bus, go downtown, get my heroin, shoot it up in the bathroom. Come home and be kind of half-ass well, and figure out how to make it. You get high when you get enough, but it just doesn't last long enough. And then you start getting to where you wake up with a bump on your head, because you did so much you passed out. But you don't even remember that. You just want more.

LL: You still didn't answer how you went from sticking tweezers into electrical sockets, shitting in people's mouths, to body modification as a mark of identity, and performance.

RA: It started before, in scenes I related to. Savouring that really nutty punk rock period, where people had a cheap safety pin stabbed in their cheek, and it was infected... man, I thought that was fuckin' funnier than fuck. Or the statement of 'fuck you' carved in your chest. I actually did get that, in a tongue-in-cheek way. That, and a lot of these leather bars had piercing salons inside of them. The Gauntlet had opened here in the mid-seventies. Genital piercing in the back. I started seeing this layer of expressing your freakishness through mutilation, or adornment. Cutting. When I was on acid, I would just take some broken glass or tear a can open and cut myself up. I just wanted to feel blood pouring on me. And I would just start cutting other people without asking.

GG: One of the most notorious moments of your career was at the Walker Arts Center in Minneapolis, the HIV controversy. And that is what, I suppose, in the history books a hundred years from now, might stand out.

RA: Yeah, and how fuckin' lame. I guess I didn't get it before then. I was just doing my thing, however I could do it. I started out in these shitty underground galleries, nightclubs, and places like that. I started in the early eighties, then started up again in 1990. I got on this tour circuit. I did New York and Chicago. I felt that, with my work, the timing was right. In between this new consciousness and resurgence of body art was happening, but not done in an eight-hour durational, boring performance setting. But actually done with some sense of presentation. It just clicked at that time. And the politics clicked. The people I was using. It just all added up to something at that time. I felt what happened in Minneapolis is that it was the presenter's fault. He became nervous after he booked it. He pre-sold all the tickets to a specialized crowd, to try and make it safe by attracting only gay leather men and ACT UP people. But of course somebody else got in, who was a curmudgeon.

GG: Could you just go into what actually happened, because people reading this might not know the details of that controversy.

RA: This was one of those shows that you don't want to do, because it's not well produced enough. People are

saying, 'Yeah but this is the Walker Arts Center, we can bring you back on full budget if you just do one scaled-down version'. So instead of using a cast of twelve, I used a cast of four. I did a sort of gallery version, of what was supposed to be a huge theatrical presentation, *Four Scenes in a Harsh Life*. I do this African pattern cutting on Darryl's ['Divinity Fudge'] back, and make imprints of it, and run it out on lines. I've done it at the LA Theatre Center where it goes 150 feet in three directions.

GG: But there's no dripping, right?

RA: No, it's impression. And the first one is very wet, but not dripping. These are white paper towels. In a really clever way, the press had, instead of falsely reporting it, they falsely attributed quotes to different people, without saying their names. It shows you how cheesy the media is. It was on the front page of the *Star Tribune*. It went over the AP wire and wound up in 200 newspapers. And then… you can still read it on the Internet as if it really happened that way. That I was throwing blood at people. That people were falling over their chairs to get out. But people liked it, and it took three weeks for that story to hit. The person who wrote it, and the person who complained, they both really had to pump it up to get the placement that they did. I was just used as a political tool. Suddenly they found a good weapon with me.

LL: Infected blood.

RA: They used me to dismantle the NEA [National Endowment for the Arts], they used me to attack the contemporary art movement.

LL: But I would consider dismantling the NEA a highlight, if that had happened with my career, because I think that too many people have applied for grants, and gotten them erroneously, when artists for centuries before had to fucking make it on their own. I think that galleries or theatre spaces… they should be funded. But individual artists? I think spaces should be funded, and that is the whole twist to that controversy. They used it to paint everything.

RA: That was phase two. Individual artists had already been cut at that point. And they used me to end Walker's funding, and suddenly every small venue and museum that wasn't just showing paintings. And then they went so far as to even shut down museums.

GG: They were trying to get the general public to turn their back on performance art, through intentionally false reportage.

RA: The media is sleazy! There's that, which is predictable. And then there's the counterside, which is that I was in *Details*, and I did a shoot for *Vanity Fair*, and all of it was this same stupid profile. 'This is Ron Athey! He is a nice guy!' And suddenly it became the whole point to everything about me in the media, for years: 'humanizing the monster'. So I got mileage out of it. But it didn't get me any fucking shows…

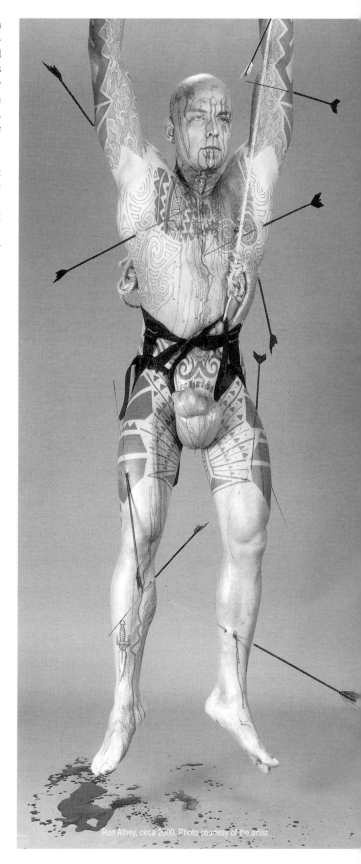

Ron Athey, circa 2000. Photo courtesy of the artist.

Charlie vs. Jesus

– Jim Van Bebber –

Jim Van Bebber is a snarling, mercurial, alpha male cult legend; American martyr for underground exploitation cinema; the gossip-generating director of *Deadbeat at Dawn* and *The Manson Family*. He has claimed to see in Popeye the Sailor Man what others see in Christ, Buddha, or Allah. He unhesitantly faces bodily harm in the name of art. A man so brazenly self-assured you'd need an M 16 to sway him from his path. A suffering, confrontational, excessive man who delights in testing the cringe-factor and waxes barroom eloquent on life, love, and the arts. Sometimes, when angered, he will bellow like a wounded animal, or tear your heart out with a single well-aimed insult.

Bellow and insult he did, for hours, as I sat in his Hollywood apartment baiting him with beery invasiveness. He was well-cut, slurring… a sparkle in his eyes one gets from consuming a case of German brew. It was a brilliant and inimitable night of supercharged banter that I will never forget. A few weeks prior, I'd recognized him among a crowd of people standing in front of the Vine Theatre, on Hollywood Boulevard. There was a triple bill of splatter movies showing there that night, and the first feature had just ended. "You're Jim fuckin' Van Bebber!," I said, too loudly. "Yes I fuckin' am!" he replied, louder still. I got his number and split. The resulting interview became something of a classic. It remained among the most-read features of Sex & Guts Online until the website's demise.

I first became aware of Jim's work in the early '90s, when his sadistically violent kung fu/street gang opus *Deadbeat at Dawn* began to achieve popularity in horror magazines and black market video trading circuits. Today, the film still works for me, and I have remained in awe of its ambition, ingenuity, and overall style. *Deadbeat at Dawn* carries a considerable wallop and is most certainly the *Citizen Kane* of DIY action flicks. Shot mostly in and around Dayton Ohio, it is simultaneously exciting and repellent, drowning you in blood and small town scuzz while completely succeeding as a hardcore martial arts exploitationer.

Van Bebber's other films include the creepy and repulsive serial killer short *Roadkill: The Last Days of John Martin*; *Doper*, a day-in-the-life portrait of a Dayton factory worker; *My Sweet Satan*, which is a condensing of the Ricky Kasso murder case; and *The Manson Family*, a film he began in 1988, but which was not seen in its finished form until 2003. *The Manson Family* does not by any means romanticize its subject, nor is it a film which is meant to be enjoyed in any traditional sense. In what might be considered a gesture of twisted compassion, Van Bebber asks you only to endure the horror of it all.

My second in-person interview with the director occurred in October 2004, when Jim was in Detroit as part of a promotion tour for his then just released Manson docudrama.

Jim Van Bebber, Montreal, Canada, 1997. Photo courtesy of Ashley Fester.

Gene Gregorits: What was the experience of seeing the film with a brand new sound design for the first time like?

Jim Van Bebber: I was confident then that I had something which worked. The sound mix took two weeks, we did it at Chace sound studios in Burbank, and every day was a battle to get as much done as we could. We wouldn't even go back and watch what we had mixed, we just kept going all the way to the end. On the last day we had scheduled there, we finished it. We watched the whole film mixed, and felt like all those months of me making these sound logs and picking out this and that, all that sound editing… we looked at it and said, "okay, here's the baby. It's got five fingers on both hands, and it's okay!"

GG: Were there any weird procedures you tried to get certain sound effects? Natural stuff?

JVB: I foley'd quite a bit of it myself, personally. Bryan Rosenthal is credited as our foley artist, but it was basically me with him helping. [*pauses*] I guess I shouldn't start taking credit away from people. [*laughs*]

GG: Is it surprising to you now that it's playing art houses, as opposed to just film festivals, or midnight shows at regular theatres?

JVB: I don't know that it's a surprise, it's just like, "oh, thank god!" When we started shooting it, and we went for the NC-17 approach right off the bat, people who I was trying to convince to invest in it, they'd ask me, "where do you think this thing's gonna end up? It's got way too much sex, and way too much violence." I said, "well, the best case scenario I can ask for is that it gets an art-house release like *Henry: Portrait of a Serial Killer* or *Bad Lieutenant*. So that was always my goal. After not having success with a lot of my other projects, I didn't know if that was gonna happen or not. It's happening, it's the fulfilment of the dream that we had when we went into it. I'm very happy.

GG: When I interviewed you last, you gave me some extremely outrageous anecdotes about the making of *Deadbeat at Dawn*. Like, for example, you didn't have squibs, so you exploded the blood bags by having baseballs hurled at the cast. You followed *Deadbeat* with *The Manson Family*, rather quickly. Any aberrant techniques worth mentioning that you employed in the making of this film?

JVB: I think we tried to get more sophisticated. For the gunshots, we actually did use squibs for the first time. Otherwise, with the makeup effects, I just tried to keep a low-tech approach to it. I can tell you it was no walk in the park for any of those actors, having the young actors playing the murderers, coming at them with these retractable knives. Going full bore. They didn't like that at all. But I begged and pleaded and cajoled them, to play it real. This isn't some church play we're doing. We're trying to represent the pain that these people suffered. The fear, the horrible invasion of their lives.

GG: It was emotionally battering for them.

JVB: Yeah! Probably the one that had the worst time with it was Dawn Edmunds, who played Abigail Folger. That scene in the kitchen where she gets chased in by Patty Krenwinkel, and she's fighting with the knife… she almost quit the film over that scene.

GG: That's the most shocking thing in the whole film, the saddest, I think. Watching her death is the toughest, because it's so protracted. Yeah. Right. Nudity. Did that become a problem for anyone?

JVB: I made it apparent when we were casting that this is going to happen in the film. It's in the script. Everybody knew it was coming. They all reacted in various ways when they had to strip down. I tried to make it as easy on the actors as possible, directing all the scenes in which they were naked, naked myself. Well, the hardest thing for an actor who's on the set and is nude, supposed to be doing a private scene, and there, just on the other side of the camera, there's 15 guys, who are all dressed, who are running up to their butts with tape measures and shit, and they really feel vulnerable. They are more at ease and more able to concentrate on their craft, if they have an ally, in the nudity. Then, they can look over there behind the camera, and there I am wandering around buck naked, talking to all the crew. They stopped being so self-conscious. I did that just because of the nervousness factor, and I had learned in film school that Haskell Wexler did that during the sex scenes in *Medium Cool*. So, I said "hey man, that sounds like a good directing technique. I'm gonna cop it."

GG: Just the raw experience and the reality of being out, at one with nature, naked and all, for long periods of time, when you were making the film… I'm sure no one forgot that a film was being made, obviously, but did you ever find yourself becoming immersed in the lifestyle?

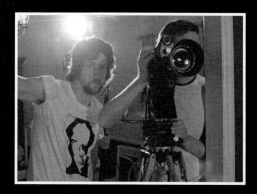

JVB: I did everything I could to re-create that reality. When we were doing those scenes, like the orgy scene, I tried to isolate everyone, and do it in a more remote location, so we forgot where our apartments were, and what have you. I had a portable speaker prior to shooting, and I played tapes of *The White Album*, and I'd have the cast get up and body-roll with each other, just try and get comfortable with each other... grounded in a make-believe reality that we could just run with for the duration of shooting.

GG: Did it ever get to a point where it became almost too real for you or anybody else?

JVB: Oh, I don't know. It never bothered me. During the crucifixion/dog blood/orgy sequence, we lit that with two big 10 Ks. It was basically two huge circles of red light, and the cast, depending who was in the shot, would wander off just out of the light, and you would hear sex going on. So... they ran with it, a lot of them did.

GG: So there was sex on the set. Was everything off camera?

JVB: Yeah. Nothing happened for real on camera.

GG: What about drugs?

JVB: Well, you know... we smoked some weed now and then. But everyone who had to be involved in playing like they were on LSD had had some familiarity at some point in their life with real LSD. And, I just said..."use your *sense memory*."

GG: Why do you think the film hadn't been made before, that someone else didn't do it before you did?

JVB: Well, lots of people did.

GG: Not like this though. Not as much from the cult's perspective.

JVB: I don't know. Especially during the '70s, when people were willing to explore more alternative universes besides their own, and a more liberal viewpoint. I'm not sure why somebody didn't take this approach before. I gotta tell you, I was scared to death the day that CBS ran their re-make of *Helter Skelter* this past May. I was scared, you know, that it was gonna be better!

GG: How was it?

JVB: It was very well done for a TV movie. It's got a lot to like. At the same time, it screwed up incredibly on minor details. It just goes to show that even if you've got millions of dollars, if you're not almost obsessional about it, which I became, you're not gonna get it right. There's plenty of examples. Probably the most glaring one is what Tex, Patty, and Linda wore during the killings. In the CBS remake, they had them wearing their hippie clothes. In reality, they were wearing all black! They were wearing their creepy-crawl clothes! And to miss details like that... besides that fact, they're all LA actors. Even though they're trying to look like hippies, it's obviously wigs. And they got greasepaint on their faces, it's supposed to be dirt. And they're all kinda buff. I loved the fact that, in using Ohio unknowns, we had

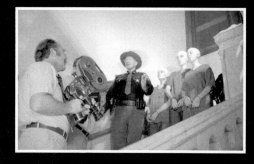

Left: Behind the scenes during the making of **The Manson Family**.

sixties bodies, nobody's buff! The pubic hair is there, there's no tanning strips or any of the kind of crap that's going on now.

GG: At what age did you start obsessing over the case?

JVB: I didn't start obsessing over it until we started making the film. But the interest probably surfaced in 1977 when the first TV movie was aired with Steve Railsback. Because my parents wouldn't let me watch it. There was a taboo element about it. I had to go on the playground the next morning and ask everybody what the hell this movie was about! And why is it so taboo? So, a couple years later I got to see it. It's a fascinating case! I pretty much forgot about it until Mike King, the producer, said "let's make a movie about Charles Manson." And the reason he said that is because me and him had seen Geraldo Rivera's interview.

GG: I've seen that a hundred times, that's great.

JVB: We were flabbergasted! Geraldo is such a showman anyway, but just his brazen ratings grab, by having Manson on. And the way he used that as a hook to make you watch the entire two-hour special. He doled out the interview in little segments. We were just amazed at how well Manson really did come off, and how revealing it was to show Geraldo for what he is.

GG: What about that though, how Charlie really is one of the most brilliant entertainers [*chuckles*] that I can think of.

JVB: Mmm hmmm. Without a doubt!

GG: What are your feelings on his politics, and his morality. Hypocritical as it may be, he's been ranting and raving about the environment for years now...

JVB: This'll sound really wrongheaded, but the guy has an incredible amount of integrity. He's unrepentant. He decided that he was gonna project this image of himself, as the boogie man for America, and God if he hasn't stuck by that, and built upon it year after year. So he's created his own little image. And everybody else, with the exception of Bobby Beausoleil, has become incredibly sorry for their actions. That's still not gonna help their chances of ever getting out, I don't think.

GG: When Manson talks, I listen. He does the whole self-pity thing in a very crafty way, because he actually has an entire lifetime of abuse to back it up.

JVB: Well, I think Manson's rhetoric... when he starts talking about the human condition, I think he is about 80% fucking spot-on. He's so brilliantly right. When he cops heavily from the rhetoric of progressive people in the late '60s, which he does often, it's spot-on. But he inevitably throws a homicidal monkey wrench into it, ruining everything he said.

GG: Do you think that's maybe because he wants to be in jail?

JVB: Well, I don't think wants *out*... I'll tell ya that! When he was set free from Terminal Island, he begged them to let him stay in. He didn't know any other life! And then he got out, and it was the summer of love, he was suddenly welcomed because of his musical skills and his willingness to be anti-authority. He fit right in!

GG: Watching him can be so enormously frustrating, because, as you said, he always ruins his own positive statements. But you don't have to be an actual glorifier of Manson, which I'm not, and you're not, to rally behind him on certain levels. Then you have Bugliosi, who almost makes you *want* to romanticize Manson as a knee-jerk reaction, because he's just so fucking self-righteous, and bourgeois.

JVB: Absolutely. The defender of the conservative values. Communal living, and small cults were not unknown, especially in California, during the late '60s. It was a grand social experiment. The Manson Family, unfortunately, became the poster child for that, and the message there is, "SEE what happens?" It just totally blew apart the progress that was being made. Those murders took us all right back to conservative values, and the element of fear.

GG: Do you think those conservative values contributed in a direct way to the murders themselves?

JVB: Probably. Because when it came down to strait-laced Vincent Bugliosi throwing out the Beatles' *White*

Above: Jim Van Bebber with Richard Stanley, Montreal, Canada, 1997. Photo courtesy of Ashley Fester.
Opposite: Jim Van Bebber's restaging of Abigail Folger's brutal stabbing death: **The Manson Family**.

Album to the public, all the parents are going, "SEE? LSD? Marijuana? Free sex? See what happens?" That was just what all the scared parents throughout America were waiting to hear! They needed someone like Manson to justify their own paranoias.

GG: John Waters's feelings on Manson have changed drastically over the years. I don't think he's quite as frivolous about it as he used to be. His film *A Dirty Shame* deals with a sexual utopia, where you can go out and fuck whoever you want. And your film deals with that too. Do you think that kind of Dionysian reality could ever happen again, in this or any culture?
JVB: Oh boy! Yeah, I do! I think once science perfects a cure or something to prevent AIDS, I sure hope people get free all over again. It's a personal dream for me, I would love to see that happen in this lifetime.
GG: But when you take it to that level, like Manson and his people did, where you don't work a job…
JVB: Well, that's a whole different thing. When you totally reject the conventions of our society, where you don't participate in the economy, or have any basic acceptance of law, you're asking for it. Sooner or later, it's gonna blow up in your face, just because you're outnumbered.

GG: If you ever had the opportunity to speak to Manson face to face, what would you want to talk to him about?
JVB: His ideas on music, and the healing powers of music. I think that's the most interesting thing I could glean from him. I feel sorry for him in a lot of ways, because he's a product of the American correctional institutions. He was locked up in reform school at age nine, and between nine and thirty-three, he had maybe six to eight months of freedom, before he broke parole and got put back in again. He's really a product of American prisons. He never had a fair shake growing up. In some ways, I'm surprised that he didn't turn out worse.
GG: Like Henry Lee Lucas, for example.
JVB: Right. His musical aspirations, if that had gone well at all, I don't think any of this would have happened.
GG: Are there any other true crime cases that you're interested in as film subjects?

285

Production still taken during the making of **The Manson Family**. Van Bebber far right, as Bobby Beausoleil.

JVB: I'm really interested in the story of Al Capone, done without the bullshit, only the truth. That's something that I'm beating around in treatment form at this point. You know, there's a lot of fascinating cases, but after doing *The Manson Family*, it's like... I almost want to steer away from that for a while. Really, if there was any justice in the world, I would be funded to make the Ken Kesey movie, or the Timothy Leary movie. There are people from the late '60s who I consider to be far more important, and need their stories told to actually *help* society. To progress society. This film depicts the antithesis of that. But there is no justice in the world, so I probably won't be able to get money for a Ken Kesey film.

GG: You're a populist.

JVB: Oh absolutely! I want people to *like* my work!

GG: The murder of Sharon Tate has got to be a major point of concern, or worry, for people who haven't seen the film. That's what they're going to think about first, is "are they gonna show it? And how are they gonna show it... and if they do... why?" But in the film, her death is polite, compared to the other ones. A long time ago, you said you were actually gonna show that whole thing. But in that specific murder, a bit of respect is shown.

JVB: At that point, it's basically overkill. You don't need to see any more to grasp how heinous and how horrible this was. Not only that, but I've got too much respect for Roman Polanski, and all the tragedy that he's encountered in his life. Also, everybody makes such a big deal out of Sharon Tate, and that's pretty much the big reason that everybody got interested in this case, because it was a Hollywood starlet married to a famous director... where's the humanity there? Isn't Gary Hinman just as important, as a human being?

GG: But with Sharon Tate, it was actually two people.

JVB: Pardon?

GG: Her and her baby. Doesn't that make it worse?

JVB: Well I guess... A human life is a human life, whether you're carrying another one inside you or not. Most people, when they address the case, they just gloss over the shooting of Lotsa Poppa Crowe, or Hinman. And the murder of Ronald Hughes, the defence attorney.

Or Shorty Shea, the ranch hand. They're all human beings. Just because one of them happened to be in *Valley of the Dolls* doesn't make her any more important. Because somebody in Hollywood was killed, now all of a sudden we should be concerned?!... I think you should be concerned once anyone gets killed. When there's that kind of overt violence, it's time for concern. When it's all because a celebrity has been murdered, that only shows how celebrity-conscious we are in this country. And how short-sighted that is.

GG: So Manson was never part of your pantheon of subcultural icons?

JVB: No. Not in any way, shape, or form. I was very ignorant about the case until we started the film. I then became super-scholar. Here we are now, with the release of the film, and I probably know more about the case than most people in this country. Unfortunately. But I am ready to move on, man. He is off my radar. There is just so much more to me as a filmmaker, and the stuff I want to touch upon at this point has absolutely nothing to do with true crime or Charles Manson. I do not want to be pigeonholed as this fanboy of Manson or some shit.

GG: So what is your bottom-line agenda as an artist?

JVB: To explore my own backyard, in my brain. The stuff that I want to put on film, the genres that I like. Things that I don't think have been done right on film. I've got a lot to say. This film has stymied me for a long time, kept me from moving forward, because I won't start another film until I finish this one. That's because of my uncompromising attitude, demanding my cut, demanding that it does not simply get dumped to home video... that's why it took *forever*. It was stalled until I found the right people, David Gregory and Carl Daft, who came to my rescue like the dynamic duo. They took a risk, a huge one. I'm very proud of them.

GG: You really are the epitome of the stubborn auteur.

JVB: With this film, I had to be. It's based on a real case, real people, and I thought it was irresponsible to cut it down to an 'R' rating. It had to be this way. It had to be shocking. I'm sure my level of compromise will be a lot higher on other projects. This one, I felt like I really had to have my way no matter what. But I don't want to be branded as someone who is inflexible. The stance on *The Manson Family* was one I chose and stood by.

GG: Can you count on this to open doors, when it does go so far, and push the limits of watchability at certain points? I haven't seen anything this gruelling since *The Passion of the Christ*.

JVB: The mania of the director. He demanded his way. I really liked *The Passion*. I did! I admire Mel's mania!

GG: So do I! But haven't we seen enough, throughout the years, of the bloodshed provoked by religion? The wars and mass casualties, the devastation wrought upon countless human lives? I guess it comes down to the audience really, deciding

"I think you should suffer with those people inside the Tate house every bit as much as I think you should suffer watching the scourging of Jesus Christ."

whether or not they are willing to think about Manson. There are enough people willing to think about Christ, and in the case of *The Passion*, it's their duty, isn't it? To go and see Christ whipped 10,000 times. [*laughs*] But just on a basic human level, to sit and watch one guy's death for two hours... it's a fucking nightmare. In your film, in terms of getting people to look at crime done in the most horrific way, true to the acts themselves... people don't wanna think about Charles Manson, do they? Or Tate's nine-month-pregnant belly getting stabbed!

JVB: Well, I think that it's entirely justifiable that it's the audience's decision every time, so they will do what they feel is necessary in terms of an endurance test that they have to take. On a personal level, I think you should suffer with those people inside the Tate house every bit as much as I think you should suffer watching the scourging of Jesus Christ. What makes one human life, even if he *is* the SON OF GOD, more important than ours? If any one of us was the victim of a home invasion and got killed, it's just as horrible as what happened to Gary Hinman, as happened to Sharon Tate, as happened to Jesus Christ!

GG: This is a very important point to make... you are not seeing, in *The Passion*, the death, and scourging of a man who *thinks* he is the son of God, but of the man who *is* the son of God. That's the problem with *The Passion*.

JVB: That's Mel's mania. And you know that right from the first ten minutes, when he puts a Roman guard's ear back on his head! You know he's got supernatural powers.

GG: But you wouldn't have made that film that way.

JVB: No.

GG: You would have left it open for...

JVB: Interpretation, of course.

GG: For your normal, intelligent person to think about on their own time.

JVB: Totally.

Hangman of Horror Fiction

- Jack Ketchum -

Dallas Mayr is a laid-back, charming, and dare I say, compassionate guy. Except when he's Jack Ketchum. If you've read *Off Season*, his grim, ferocious tale of cave-dwelling cannibals on the rampage one dark night in rural Maine, this description may not exactly gel with your image of the man, and if so, all the better. Ketchum/Mayr, since that book marked his debut back in 1980, has carved a torturous, twisted, and wildly unpredictable path of human atrocity in his work, which runs the gamut from misogynistic lust in *Broken on the Wheel of Sex* to a random thrill kill in his 2004 novel, *The Lost*. He's even given the old dark house formula one hell of a treatment (*Hide and Seek*) and written a devastating study of the loss of a pet (*Red*). What hits hardest in all of his work is its blatant lack of tidy resolution. Those who read Ketchum don't go there for knee-jerk moralizing, nor for run-of-the-mill escapism. God help anyone who does. The great question is posed about as frequently as rainfall in Death Valley, leaving the savagery of his damned and demented characters to speak for itself. The worst kinds of headlines burn in these novels, the ones you repeat endlessly in conversation because the details are just too virulent to keep bottled up once they've penetrated your mind.

In other words, check your grin and your gag reflex at the door. You may want to grab a twelve pack and a box of Kleenex, too. Trust me, in this blood-soaked wasteland, you'll need 'em. After all, Jack Ketchum is one of the few in his field with the balls to tell it like it is, and it's good to come prepared.

In the minutes preceding this interview, I flashed back to my initial discovery of Ketchum: *Off Season*. It shook me up, but I absorbed it on rational, controlled grounds, as an extreme horror novel that delivered. I got what I paid for a hundred times over. A rare occurrence by all means, but the book didn't ruin my week, nor did it light my brain on fire. *Off Season* served as boot camp for the one I read next, a book that would in fact cause a long-lasting literary hangover, and quite frankly, serious regret.

Now… run down your list of all those ill-tempered male writers. The ones that write about hell. The crime fiction demon dogs. The literary sadists. The sociopathic philosophers grinding axes with the abyss, or failing that, with themselves. There's a lot of them, wielding that axe like the last hope of all things to come, when hatred becomes logic.

None of these guys prepare you for the heart stopping tragedy and pared down, blunt force abuse of Jack Ketchum's *The Girl Next Door*. No amount of hyperbole will cut it here. The book is a motherfucker, and yet so full of feeling and heart that you barely recognize your own when the author has ripped it straight out of your chest like a rabid pit bull… and shown it to you.

I was only 15 when I read the book. I haven't looked at the world in quite the same way since. Yeah, I regretted *The Girl Next Door*, and can say the same of no other book. But I kept it, nonetheless.

I began reading Jack Ketchum in 1991, well before the advent of the Internet. Back then, if you weren't willing to stake out used bookstores, this book, like the others, was out of print and damn near impossible to come by. But today, after Chas. Balun's mad dog appreciations in *Deep Red* magazine, and the recent Overlook Press reprintings of *Off Season* (the unexpurgated edition – for those who found the original a bit tame), *The Girl Next Door*, and the release of two short story collections, *Broken on the Wheel of Sex* and *The Exit at Toledo Blade Boulevard*, a Ketchum revival is well in effect. *The Lost* is available everywhere as a mass market trade paperback, and in a signed hardback edition for the discerning collector.

Gene Gregorits: I know you started out as a music critic, and I heard you were an agent for Henry Miller.
Jack Ketchum: They weren't at the same time. I'd been acting, and writing ad copy and stuff, it was real hand to mouth, so I came back to New York from New Hampshire and decided "to hell with this." I was gonna basically try to get a regular job. So I found an ad in *The New York* *Times*. The Scott Meredith agency was looking for a reader at the time. When Jack Scovil, who eventually became my boss, explained the reader's job, I said I didn't want it. He said, "well, you're kind of in luck, because we also fired an agent today." And he explained that job to me and I said, "Yes I do." I worked there for three years, learned a lot. It was a hellish experience, because Scott

Opposite: Jack Ketchum. Photo by Douglas E. Winter.

Meredith had a fee service, so we were dealing with people who really couldn't write, ripping them off really, as much as we were dealing with clients like Norman Mailer and Arthur C. Clarke, and people like that. And eventually, Miller's letter, asking for representation, came across my desk, and I had been reading Henry since I was a kid, since I stole *Tropic of Cancer*, or *Tropic of Capricorn*, and hid it back by the brook…

GG: [laughs] Just like the *Playboy*s hidden by the main character of *Girl Next Door*!

JK: Absolutely! And I loved Miller's stuff; I'd read pretty much everything he'd written. Coincidentally, once when I was living in New Hampshire, I heard he was dying. I wrote him a letter saying, "don't." [*laughs*]. "You're a national treasure!" He sent me back a postcard saying, "No, I'm fine!" It was funny; we had tripped over one another on a couple of different occasions. Anyway, to make a long story short, I begged Scott to let me have him, and Scott said, "he's an old man, he's cranky, he'll run up our phone bills!" I said, "look… it's Henry Miller, you can't turn him down. If the phone bills get high, I'll call him from home. I just want him." He said, "alright." So I had him on my desk for the year before I quit. I'd been reading enough of other people's stuff, and knew enough markets, and editors of those markets from men's magazines, rock'n'roll magazines I had represented, and people in those areas, to figure I could probably sell myself, if I can sell some of the junk I'm selling. So I took a chance and decided to quit, but before I did… I knew I wanted to go meet Henry. I'd only talked to him on the phone, and answered letters. I flew out to California, and met him at his house, and had a marvellous, exciting day with a brilliant, blessed man… and then went back and quit. [*Laughs*] I came back, and stared writing. The first time I wrote full time was '77, and that was largely men's magazines, and rock'n'roll magazines. The rock magazine work was mostly in *Creem*, out of Detroit. The men's mags… I did one thing for *Penthouse*, but mostly it was low-level things like *Swank* and *Cavalier* and *Genesis* and things like that. But I got a lot of work. As I said I knew a lot of the editors by then so it was easy to ask the editors what they wanted. Instead of having to write query letters, I could just call up the guy and say, "look, how about this idea or that idea."

GG: Jerzy Livingston was one of the names you wrote under…

JK: I was writing under all kinds of names. There was one magazine. I don't recall which one it was; it was a men's mag. I had four different pieces in it. So I used three different pseudonyms and my own name. Livingston was the one that I used most often. Especially for the short stories. That was a play on words. I grew up in Livingston, New Jersey, so there was that, and I spelled [Jersey] with a "z", in a sort of homage to Jerzy Kosinski, who was a favourite writer of mine at the time.

GG: You wrote for the men's mags and *Creem* simultaneously?

JK: Yeah. I was writing for everybody! I wrote for *Classic Decorating and Home Crafts*. I wrote for *Miniature Collector*…

GG: So it was a pretty busy time.

JK: Yeah it was. It was crazy. And finally it got so busy that I decided, "this is a little too hand to mouth," and I was starting to feel a bit of burnout. I said, "Why don't I try doing a book. I can support doing the book by doing magazine work." I thought that might get me out of that hand to mouth thing. And it's nice, with a novel, to know what you're gonna get up to every morning. Which is a luxury I didn't have.

GG: Were you a friend of Lester Bangs while working at *Creem*?

JK: Oh yeah! I can't say we were best friends or anything, but we hung out at the Belles of Hell together. The one who introduced me to him was Nick Tosches. I was Nick's agent; I sold his first two books, and sold his first piece to *Penthouse* for him. And that began a long association with *Penthouse* for him. Nick and I were real good buddies. Our favourite place, after work, was the Belles of Hell, which was pretty close to where he lived. So I'd subway down there, almost every afternoon or evening, and Lester was there all the time. I saw Lester perform a couple of times, with his band. Yeah, he was a good guy. He was a lotta fun. Very smart, and very funny. And a mess. [*laughs*]

GG: Jerzy Livingston is some of the angriest sex writing I've ever read. Do you feel like you would have written that material even without the skin magazines to publish it for you? Did you need to write the "Broken" stories?

JK: Well, I had been reading a lot of Charles Bukowski, and they don't get any angrier than Charles Bukowski. A lot of the stories are clearly influenced very highly by Bukowski. It was a point of view that I liked, because I could get out whatever vitriol I had in me. It was a good comic stance. They were all dark comedies. See, sex didn't interest me all that much. What interested me was the darker side, even then. So I invented this guy Stroup, among other characters, who is just a total misogynist. He hates homosexuals, he hates women. He hates himself. And he's out there trying to get dates all the time! I don't think that was ever really part of me. I mean, some of those experiences, in those stories, did actually happen or they're based on incidents that happened, but I've never been that angry, not since I was a young boy.

GG: So he wasn't a kind of fictional co-conspirator. Or a scapegoat.

JK: I suppose. I remember Ben Pesta, I think he was at *Swank* magazine, when I sent him the final Stroup story, or what came to be the final Stroup story, he said, "Look. Unless Stroup is a necessary thing you must rid yourself of, could we go on to something a little different?" [*laughs*] And that was funny, because the story I had sent him was the only story where Stroup is kind of sweet!

Maybe that was the problem, I don't know! Now about Stroup... I invented that name as a kind of in-joke. It's Proust phonetically backwards.

GG: Tyler Durden comes to mind...

JK: No, no. I wouldn't say that. But you know, you saw a lot of angry guys around in those days. The title *Broken on the Wheel of Sex* doesn't come out of nowhere. That's also Nick Tosches's title, of an article he wrote once. I asked him for permission to use it. But yeah, you saw a lot of angry guys because the promise of free sex was everywhere, and it simply wasn't free. You always paid for romance in one way or another. I think I said in the introduction to the book, you went from free love to free sex, and free sex had its come-uppance, sooner or later. Sooner or later you met the wrong woman, or you met the wrong man, and you met them all the time.

GG: The fun in sex itself was on it's way out it seems, when those stories were being written, just before AIDS hit. You say in the intro, "whistling in a graveyard."

JK: Yeah.

GG: I have this book of historic slang, and I just flipped open to "Jack Ketch", the executioner's title. I assumed that name must have been the source.

JK: No, it wasn't. Things happen subconsciously, often. I chose Jack Ketchum because I like his story. I was reading the story about the Hole-in-the-Wall Gang in *Bloodletters and Badmen*, and I read some very funny things about him. And also, it had a very nice sound to it. I like threes, you know. Three syllables, bam, bam, bam.

GG: Jack Ketch was a real person?

JK: He was. Here's how it worked out. I had also been Marion Zimmer Bradley's agent at one point. I sent her a copy of *Off Season* when it was published. And she said, "hmmm, interesting book! And very interesting pseudonym. You know Jack Ketch is English slang for hangman, don't you?" I said, "I did, but it certainly hadn't occurred to me when I decided to use that name." It was some subconscious clue, perhaps. It was in there, and I had certainly read many times that Jack Ketch was the original English hangman. But... totally subconscious.

GG: What authors do you find yourself reading?

JK: God, I read a lot of different kinds of people. I'm sort of forced to read a lot in-genre now. See who's doing what. But I like a lot of people. I recently read the newest Harry Potter book. I'm reading Larry Brown's *Fay* and just started reading some Annie Dillard again. *Pilgrim at Tinker Creek*. Jim Harrison, I read, whenever he's got something out. Cormac McCarthy, a lot of guys.

GG: You've only written one book that was overtly driven by supernatural plot elements, and many of your books are more comparable to hardcore crime fiction or suspense than traditional horror. What is it about the human condition that so obsesses you?

JK: The first time I can remember being afraid... really afraid... was not of the spooks under my bed. Or what was in the closet. Now, I may have been, but I couldn't have been all that afraid because it doesn't linger in memory. My first memory of fear is of the kid up the block, who walked down the street with a snake in his teeth, and wanted to beat the shit out of me! Just because I was a fat kid. People scare me. And what they do to one another, just for fun sometimes, is appalling. There was a guy not too long ago, a guy and a woman, whose dog wouldn't obey. So they tied him behind the car, and dragged him at thirty miles an hour until the dog was a bloody mess. So that's scary to me. There are people, plenty of people, who do the supernatural better than I do. I dip into it in stories now and then. But the only reason I did *She Wakes*, and the only reason I tried a supernatural book at all I think, was because Greece is a place that has always really spoken to me in a spiritual way. I find it very big. Very spooky, in a good way. Very few other places have done that. There have been a few others in my life, but if I ever write another supernatural novel, it'll probably be a ghost story of some sort. Because I don't feel comfortable writing about demons and gods, and certainly not about vampires. I wrote one vampire story, and that was about four pages long. That's all I have to say about vampires. I'm attracted to writing about real people and the extremes that they go to, in either defending themselves from evil, or becoming it.

GG: I was wondering where some of your specific story ideas come from. Do you watch much TV news?

JK: I don't think I watch TV more than anybody else does. And certainly not the news. There are long stretches of time where I don't look at a newspaper or turn on the news. It's sporadic. People send me a lot of stuff. The beginning of *The Lost*, for instance... the opening sequence in the woods was based on a clipping that Chris Golden sent to me, and said, "I think this is a Jack Ketchum story." That happens. I've got a cousin in Florida who sifts through newspapers and clips out weird Floridian crime and sends me that, you know. So I get the ideas from all over. Some of the best ones I've gotten in my local bar. *The Box* was written down on a cocktail napkin, in a different form, by a friend of mine, Neal McPheeters, who does a lot of my cover art. He handed it to me and said, "I think you should write this."

GG: Greece is important to you, but except for *She Wakes* it doesn't feature in your writing. It's not the place where your writing comes from.

JK: Well, there are a handful of short stories from when I first went there, back in '77. Those appeared in the men's magazines. *The Liar*, which was incorporated into *She Wakes*. *Old Men Dancing*, and I think there's one or two others. But that's true, it's not someplace I go to write. To me, Greece is depression-proof. If there's any place in the world that is depression-proof, that place is Greece. For me, anyway. That's because of this strange mix of spirituality, and the physical. The spiritual and the physical coming together so hard, for me... on one hand, you've

got beaches, warm sunny days, balmy nights, lots to drink, lots of people to drink with, nude beaches, great food. That's all on the physical side. Then you've got ancient Greece. The grandeur of ancient Greece, I don't think has ever been surpassed. It really touches me when I go to a place like Mykonos. The last time I went back to the Acropolis, the first day I was there, I looked up at this wonderful structure, the Parthenon, against the bright blue sky, and I started to weep, just because it was so beautiful, and so grand, and so human. And I guess tourists walked around saying, "who the hell is that?" [*laughs*] "Crazy bastard!" I find it very moving. And a place where I can be calm and rational. And New York is not a place where you can always be calm and rational, you know? Quite often it's the opposite.

GG: Well, New York really isn't your writing either. Your writing seems to come more out of middle America, and suburbia.

JK: Because it's where I grew up and it's imprinted deep.

GG: When you spend so much time with these stories, all the time that it takes to write a book, have you ever noticed an effect taking place under the weight of it all? Does the pressure of writing these books bleed out in relationships?

JK: No. The opposite. The relationships bleed into the work. It's more a case of people who I know, and who I care about, informing the work. I'm not like your basic actor who is wandering around angry because his character is angry. Or walking around in tears because his character is in tears. My job, as a writer, is to move myself. To scare myself. To make myself cry. That's my basic job. And to do that, I have to touch bases with people I care about, or people I'm afraid of. Or both.

GG: Do you have nightmares often?

JK: Naaaah. I sleep pretty well. I enjoy my dreams. I've often said, "you know, if something ever happens to me, and I'm on some sort of a life support system, don't cut me off if I'm dreaming." [*laughs*] I might be having a really good time!

GG: Ever had a story concept too grisly for even you?

JK: No, I don't think so. There are things that I don't feel comfortable doing, but they're mostly things that I don't feel comfortable doing because they've been done. A serial killer book. A *Silence of the Lambs*-kind of thing. I don't know if I would want to do that, not because the subject matters are repellent, certainly, but just because it's been done awfully well.

GG: *Off Season* provoked a great deal of extreme controversy.

JK: I've had some fun things happen as a result of that book. I recall going out to my neighbourhood watering hole, handing it to my favourite bartender, and coming back the next day. He said he had read it in one night, and he was "fucking ashamed" of me. [*laughs*] And he meant it. He was quite pissy about it. It was the end of our relationship. Another time, I walked into another bar, and

a friend of mine was chatting up this woman, sort of using me a little bit to chat her up. And he said, "He's a novelist, he just published his first novel." She said, "Oh really? What is it?" And I said, "Well, I write under the name Jack Ketchum. The book is called *Off Season*." She said, "you son of a bitch" and walked out. I caught a little heat!

GG: The original cover had a severed arm on it.

JK: Yeah, it was a very lovely severed arm. The guy had patterned it after Adam's hand in the Sistine Chapel, except it was female, and it had bracelets on, and rings, and it was cut off at the elbow. But it was very well done. They botched it twice, really. They botched it once by not using the actual drawing; they used a photo instead which wasn't as good. And then they decided to get rid of it all together, and go with a single drop of blood. Boring.

GG: So in the end, the publishers just wanted to wash their hands of the entire book.

JK: Yeah, and they really wanted to wash their hands of me. They didn't want to publish *Ladies Night,* after having given it the go-ahead on the basis of a very long outline and a couple of chapters. Very detailed outline. I'll never do one of those again. They balked at that, after having paid me half the advance. They didn't want to pay the other half. And finally I said, "Alright, I'll write one more book for you." They sweetened the pot by ten grand and I wrote *Hide and Seek* instead. They dumped that out on the market in 40,000 copies. Presumably, I had at least 250,000 or 300,000 readers by then. But they didn't consider that at all. I think they just wanted out.

GG: I think that's one of your best. I really like *Hide and Seek* a lot.

JK: Thank you. It's funny what favourites people have. It almost says more about the person than it does about me, because my books are kind of all over the place. No two are really very alike, except for *Off Season* and [its 1991 sequel] *Offspring*.

GG: *The Girl Next Door* is your most psychologically confrontational, intense book in your career. I wanted to know what it was like writing it.

JK: It was difficult to write, because I knew I was skating on very thin ice. If I hadn't written *Cover* first, and felt like I had, with that book, grown a lot as a writer, I don't think that I would have dared to do *The Girl Next Door*. Because I was very aware that if I took one wrong step, I was straight into child pornography. And there were many, many times where I had to think very hard about how I was going to play this. And one of the decisions I came up with early on was that, even though the boy is next door, he doesn't have to be in on everything. He can just see the results of things. That was a way to soften the blow, for the reader. But he keeps coming back, even as it gets worse and worse. He keeps coming back. And so do you, as reader, if you continue reading the book. What I want you to do is identify with this boy, and by doing so, in the same way he is complicit in the crime, so are you. You're reading the book.

GG: **Maybe there have been other books that have done that, but I can't think of any other one that used the same tactic as destructively, where you become… implicated, at the same time.**

JK: [*laughs*] Thank you.

GG: **The book has so many personal, intimate touches. Like *The Lost*, *The Girl Next Door* is set in suburban New Jersey where you grew up. Do you recall, as a youngster, hearing about anything which stuck in your mind, which gave you the idea of "the basement", specifically?**

JK: Well, that house is my house. What I did was, I put my hero next door to my own house. The house that Ruth lives in, the kids live in, and the girls live in, is my own house, in Livingston, New Jersey. And we had such a basement. We did not have a bomb shelter in it, but it was capacious. It was capacious enough to have held one, if it wanted to. That was my hideout when I was a kid. Sort of hideout-cum-clubhouse. If it was not a nice day, couldn't go outdoors, couldn't go down to the brook or play in the woods, I'd go down there. That way, I could get away from my parents, I could do whatever I wanted to do, in some kind of privacy. My house had the bedrooms all on the same floor as the living room and the kitchen. Then there was the downstairs, the basement. The basement was the only thing I could call my own. My mother would walk in on me in my bedroom. She'd just appear. You know, sweet woman, but she didn't believe in privacy all that much. When she died, at first I really didn't want to do much of anything. I was involved in a traumatic affair, and with her death. We were very close. With her death I was pretty depressed. So I revised *She Wakes*, dabbled with that a little bit. And then, I'd been wanting to write Gertrude Baniszewski's story a long, long time, and it just occurred to me – bang! – I could put it right here. And since I am a writer, I have more flexibility than most people do, if they hold a 9 to 5 job, so I took my time selling the house, giving the stuff within the house away to friends and relatives and charity, and in the course of doing that, I went through everything, I went through all my mom's stuff in the attic. The last scene in the book, where…

GG: **…he finds the newspaper clipping.**

JK: Yeah. Well, there were plenty of newspaper clippings up there. And that was part of what gave me the idea for that. An event like that, the death of a parent… your boyhood comes back to you very, very easily. That house was still my real home. I hadn't really adopted my apartment until I sold it. Because it was still my base.

GG: **It really comes through in the book. It's not really so much a book about a crime, as it is about youth and adolescence…**

JK: …and memory. You know, this poor kid's memory is haunting him. And since I was being haunted by all those good memories, and bad ones… it was very easy to incorporate everything.

GG: **You had mentioned attempting to soften the book. I think by adding a sentimental touch, the subject matter is validated, but at the same time it multiplies the trauma and impact considerably. It just made it a much more horrific book.**

JK: Well, I want my books, and my stories, all to have heart. I want to move you to fear something, but I also want to move you care about and love something, hold something tender. And there's some tenderness in that book. And you're right, I think one augments the other. But that's the way with life, isn't it? I mean, no dark, no light.

GG: **I agree, yeah. Without the tenderness, it might be an easier book to forget. As you wrote it, you can't forget anything. It's a dangerous book, in that respect.**

JK: Yeah, I wanted it to be subversive.

GG: **Your books are notorious for their excesses. Your readers, I can imagine, are often outraged by what they encounter. Has that ever crossed over into your reality, I mean, have you dealt with a reader's devastation first hand?**

JK: I haven't so far. There was one incident with a friend of mine who read *The Girl Next Door* who said, "Dallas, you've gone too far on this one. You've crossed the line." But I understood that I was going to get that response from people. And I was not bothered by it at all. But for the most part, I don't hear from people unless they like the stuff! Long may that continue… Horror fans in general, I find, are very smart most of the time. They get it. They don't mind the fact that I'm doing *Off Season* one day, and then something as tender as *Red* the next. They get it. And so I have a lot more room, doing what I do, than if I were working say, in a strictly supernatural vein, or if I was writing mysteries, or romances, or whatever, because I've got a real smart audience. And a sensitive audience.

GG: **If you make your readers trauma victims, is a Jack Ketchum fan a glutton for literary punishment?**

JK: Well, I want to put a reader through a certain kind of wringer. In all the books, I do. In *Red*, I do. But I want him to come out the other side, with also a sense of what the good stuff is, in the human experience. And there is not a lot of that in my first book. I mean, those poor people were really put through hell. Really, all they do is try to survive it. But that's something too. You know, Marjorie, the main character there, is at first very weak, and you figure it's her sister who's going to be the strong one. But Marjorie finds her strength. Well, that's something I think we all have to do, and it's something I want my readers to do, and something I want myself to do. I don't see that I have ever painted a picture of a totally black, bleak world. I wouldn't know what to do with it.

GG: **Well, *Off Season* was coming in at the tail of a very mean streak of writing for you. Maybe it was just Stroup, getting his last say.**

JK: [*laughs*] Yeah, could have been. Could have been.

Dirty Movie Blues

- Sturgis Nikides -

Unless you're a big fan of John Cale's solo work, you're probably unfamiliar with Sturgis Nikides. As Cale's guitar player throughout the 1980s, in an ignited haze of NYC debauchery, Nikides fulfilled his lifelong ambition of becoming a professional musician. His first full length solo album stretches his talents to the limit, allowing him to reveal much more than knockout playing.

Nikides's *Man of Steel* goes beyond your average blues rock, evoking the indigent American toughness of both Robert Johnson and John Huston. This is blues the way it was originally meant to be heard, and to be honest, I think it gives Ry Cooder a run for his money.

Nikides plays in a way that doesn't ask of the listener anything more than their ears and their time. It is not necessary to be an expert on the blues, or even a fan, to appreciate the full range of what's going on here. This music grabs the listener with an instrumental articulation of melancholy that transcends the blues genre while remaining essentially true to it… it is classic yet contemporary, and technologically bolstered without sounding too clean. It seems, like all the greatest guitar playing, at once effortless and impossible.

For those who know Nikides's instrumental style first-hand, the above praise is to be expected. A revelation to us all, however, is the confident voice and richly visual lyrics on *Man of Steel*. 'She Got a Gun' and 'Room 204', the album's best tracks, shimmer with emotional truth of the highest order, that which comes from real bruises and hard-earned street experience. The guy pours his damn heart out with fearless intimacy. The album is brought down by a tired old Rolling Stones cover, but despite it being unnecessary, Nikides's earnest handling makes it sound fresher than it should.

Man of Steel is more than a blues record, it's a vivid blend of elements all finely honed by the artist throughout his life, and as such, remains one of the true standout efforts of recent years. This is the kind of music you hear as if it were part of a film you can't quite remember seeing, assuming a widescreen scope in certain spots, and the claustro-phobia of personal obsession in others. *Man of Steel*'s vision is that of the man lost in a burning field or somewhere down the dirty boulevard, but it retains a sense of redemption. Nikides has been around the block enough times to claim the life expertise music of this genre is founded on. Bubblegum blues this ain't, allowing you to tap into the real stuff, a main circuit of hard life, of roads that don't seem to end. It's an astonishingly ambitious one-man show that, much like the following yak-fest, proves that he is no mere axeman.

Gene Gregorits: You told me that George Scott dying worked to your advantage. Could you explain that?
Sturgis Nikides: George Scott played in 8-Eyed Spy with Lydia Lunch. Prior to that he was in James White and the Blacks. Or James Chance, whatever you prefer to call him. George Scott was the bass player in that band, and he was also the bass player in 8-Eyed Spy, which was Lydia's band. Somehow he ended up playing with John Cale, in the 1978 version of John Cale's group, which was known as the Sabotage Live Ensemble. This is when John Cale started playing at CBGB. This was right after he produced Patti Smith's album, *Horses*. He, for whatever reason, decided to put a New York band together. Prior to that, it was all English musicians. Chris Spedding. Phil Manzanera from Roxy Music, and people like that. Eno. All of a sudden John was getting this reputation of being the Godfather of punk rock…which he rues to this day, I'm sure. That particular honorary, you know, "Godfather of punk rock", is applied to a few different people. John gets it. Iggy is called that from time to time. There's a few people who get that and I don't think it's such an honorary thing. It would be more of a pain in the ass, I think. Anyway, George Scott was in that version of John's live band. That album was recorded at CBGB, over a five night period. They toured for about a year, to support that album. They went on hiatus, and George Scott overdosed. At that point – and I don't know if John decided to purge the band of its drug element,

because I never asked him. I am not intimate with the details – but because of George's death, the guitar player left the band, and the drummer left the band, which opened up the spot for me. And that was in 1979.

GG: You were high school sweethearts with Sharon Mitchell the porn star.

SN: That's right. Well, junior high.

GG: Where were you born?

SN: I was born in Brooklyn. My family moved to New Jersey when I was 8 years old.

GG: How did you get into music?

SN: My uncle took me to see The Beatles at Shea Stadium when I was five. And I knew, right at that very moment, what I wanted to do. I know how that sounds, like "how would a five-year-old know?" But it's the same as any other five-year-old saying that they want to be a policeman or a fireman. I wanted to be a guitar player, from that moment.

GG: When did you pick up the guitar?

SN: I picked up the guitar at seven years old, and I've been playing ever since. It took me a very short amount of time to learn. I took lessons at the age of ten or eleven. Formal lessons for a couple of years… and that's it. Otherwise I am self-taught. I can read music to a degree, but mostly I work with what are called "head arrangements." My composing is done that way as well, I don't write it down. I just play it and record it.

GG: What were some of the early records you bought, that you could say shaped the way you play the guitar?

SN: Johnny Winter. I was big time into that. And Jimi Hendrix.

GG: So what was your childhood like, in terms of playing music, or hanging out with people?

SN: Well, that's all I did! Other people played sports, had social lives. I played in bands. This is from the age of 12, I started playing in bands. I started earning a living as a musician by the age of 14. We had moved to Staten Island, because I got in trouble. Drug possession at the age of 13. So, we moved to avoid my being sent to reform school. It's not like I was a drug dealer or anything. You have to remember that this was 1972. And all across America, the backlash of the '60s was happening. Drugs, which started to become popular during the '60s, pot and acid, was pretty much adult entertainment. But by the early '70s, it had filtered into the schools. So schools, all across America, went crazy. They were bringing in police, police dogs, searching lockers, what have you. And anyone who was even in the most infinitesimal way involved with drugs, was cast under suspicion. And you knew who it was, because the school was divided into the jocks, and the freaks. And I'm telling you, this was every school in America. JOCKS. FREAKS. So… you knew who they were. You could tell just by looking. The jocks all had crew cuts, and they played on the football team, and the freaks were the rest of us. The grungy longhairs… that was the crew that I fell in with, so when the authorities decided

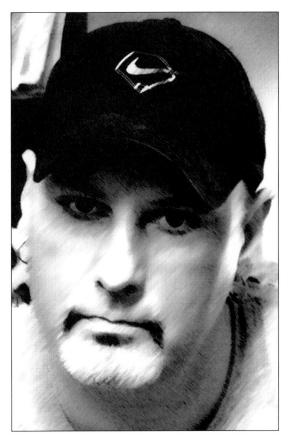

Sturgis Nikides, 2002. Photo courtesy of the artist.

that they were gonna clean the drugs out of the school, everyone would be suspect. My mother allowed the police into the house, and into my room, while I was in school. And they found a roach clip in my room. That was enough to arrest me, at the time. You could be arrested for residue! It was enough to have me dragged into court, and all of the shit that happens… so we had to move.

GG: The New York Dolls had started playing at that time. You were only 14 then… were you going out to see them?

SN: Yes. I left home at 15. I would directly credit the New York Dolls for the complete destruction of my family. [*laughs*] New York Dolls, at the Mercer Arts Center. I was just barely 15 years old. Max's Kansas City. This was 1973 and 1974.

GG: Did you meet any of the guys back then?

SN: Oh yeah. But I got to know members of the band much later, on a more professional level. I was just a kid then, so I was heavily influenced by what was going on down there in Lower Manhattan – as any wannabe rock star at a very impressionable age was. The New York scene was so cool. I can't even describe it. The drugs. The sex. The whole thing was just fantastic, it really was. Just amazing. I knew what I wanted to do and I had not been

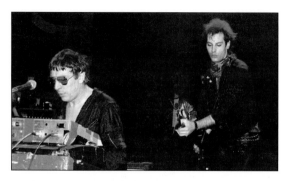

John Cale and Sturgis Nikides (*right*), New York City, 1979.
Photo courtesy of Sturgis Nikides.

getting along with my folks. Home life was really shitty, so one day I just up and left. I moved to Manhattan. And no one ever came looking for me. Strangely enough. That was that. I had started playing gigs, in the Village. I shouldn't call them gigs… but I would do folk night, or what they called 'Hoot Night', at Gerde's Folk City, where Bob Dylan got his start, in the '60s. Hoot Night was basically like open mic. I was playing blues. I was in a blues duo, me and this guy named Nick Burns. He played harmonica and was about five years older than me. He was 19, I was 14. We were good! His brother lived in the Village and his brother is the one that found me a place to crash. Nick Burns helped me escape from my home. I got started with a place to crash, and I joined a band very quickly. I was already in bands in Staten Island, but Manhattan was a very different scene.

GG: Staten Island, 1974. Now there's some secret history. What the hell was happening there?

SN: Well… that's a whole other thing. There were these great, great bars. At that time, the drinking age was still 18, so if you were 14, 15, you could get fake I.D. and kind of pass, as far as hanging out in a nightclub went. Whereas now, with the drinking age of 21, there's no way you can get away with that. Back then, it was do-able. And I looked a little older. There was a fantastic band called The Rats. The bass player and the lead singer was Kasim Sulton, who has been a member of Todd Rundgren's Utopia all these years. He also plays with Meat Loaf. The guitar player was a guy named Johnny Rao, who went on to become David Johansen's guitar player. The drummer was a guy named Frankie LaRocka who is now the president of A&R for Atlantic Records. All these guys were very influential, and they were cover bands in Staten Island. Mott the Hoople, David Bowie, English glitter music, you know. But I didn't want to play cover music, I wanted to play original music. That was the attraction of hanging out in the city. There were no cover bands in the city, there were only bands who played original music.

GG: Now the Village is infested with cover bands.

SN: Well, real music is what I wanted to do. I ended up in a band, in 1974, with Neon Leon.

GG: I have heard wild stories about this guy.

SN: You've heard of Neon Leon?!

GG: Of course! [*laughs*]

SN: Oh alright, alright.

GG: He made some claim about being given all of Sid Vicious's possessions the night Spungen died.

SN: Bullshit, bullshit, bullshit. Leon is the king of shameless self-promotion.

GG: Someone told me he was 'hiding out' in Sweden.

SN: If he's alive, I guess that's where he is. He's a survivor, so he's probably still alive. He is responsible for my getting back together with Sharon. I hadn't seen Sharon in a couple of years. Sharon and I went steady in junior high school, when I was still in junior high. When my family left New Jersey, that was it! I didn't see her again, until I hit Manhattan. I was playing with Leon. She was involved with him as a backup singer. He would promote these porno chicks to be part of his stage show. It helped draw people to the gigs! It was good for his image! We're at rehearsal one night, and he says, "you know, there's this girl Sharon that says she knows you!" I had no idea who he was talking about, of course, but I found out shortly thereafter. I moved in with her, I think, that day! [*laughs*] Anyway, I played with Leon for about two years.

GG: What kind of crowd was the band involved with? What people were hanging around?

SN: Leon lived in the Chelsea Hotel. These were the Max's days. It's not a matter of who surrounded him. He was part of the scene. Leon was famous in his own right. But he fell just short of the mark. He didn't get onto the Max's compilation record. He was too much involved with doing his own thing. There was no way he was going to allow them to have any right to his material, which was very stupid on his part. He should have been a little more generous with his talent, which he wasn't, which was what left to my leaving and forming my own band. The first band I started when I left Leon was a band called Man Ray. In that band were two members of Pure Hell. It was two black guys and two white guys. I can't claim that it was one of the first integrated punk rock bands, because Neon Leon was the first integrated punk rock band. Leon is black. And all the band members were white, for the most part. Different people passed through, so there may have been one or two other people. I know that Spider, who was the drummer from Pure Hell, played with Neon Leon at one point. That's how I met Pure Hell, through Leon. [Sid Vicious was slated to play a Philadelphia gig with Pure Hell – who were the inspiration for DC hardcore legends Bad Brains. Sid Vicious died before the Philly concert date. –GG]

GG: Was there any concept behind Man Ray?

SN: It was just original music. No concept. I've never been into those kind of image-bands.

GG: Me neither. But Man Ray, taking the name from the artist, who was a conceptual weirdo…

SN: Oh c'mon… this was New York! Max's, Andy Warhol, Velvet Underground… it was just a name.

GG: So Man Ray was just straight rock'n'roll.

SN: Yeah, pretty much. Actually, there was more of a porno connection. I was living with Sharon, and the lead singer, this guy Conrad… his old lady was also a porno actress. She was very sweet. Spider, from Pure Hell, had aspirations of being a porno star himself. Later on, he lived in a tree house in Sharon Mitchell's backyard, in Los Angeles. When Leon hooked me back up with Sharon, she was already at the age of 17 a massively popular porn star.

GG: How did you deal with that?

SN: I didn't. It was traditionally done. Come on. That didn't stop until the Traci Lords exposé. That is what ended the reign of the teenage porn queen. Although, for all we know, they are right back at it. But it was not uncommon, I mean, get serious here. Don't even go there.

GG: Did you know Rockets at this time?

SN: Yes. I met Rockets through Leon, and just by living at the Chelsea Hotel. Sharon and I lived at the Chelsea shortly, but Leon lived there permanently. We were in between apartments so we lived there for a while. I met Rockets around 1975. The way I met him was… he was a hairdresser! He cut my hair! Rockets had a barber's license. He would cut everybody's hair! That's how he met Sid Vicious! He wasn't Sid's bodyguard, he was his hairdresser!

GG: [laughs]

SN: It's true! You can laugh if you want, but it's true. All these people now have a much different perception of Rockets. Movie actor, and all around *artiste*. But… he wielded a mean pair of scissors!

GG: Anybody who was friends with Rockets has a great Rockets story. Rockets had the best stories. He was always out of control.

SN: Yeah but everybody I knew was out of control, including myself. He wasn't any more out of control than anyone else who was in that crew. You have to understand that my relationship with him is not even remotely the same as his relationship with the people that knew him around the time of his death. One thing about living downtown in those days… I don't know what it's like now… but you never stayed at home at night. Ever. You were out every night. Wherever the scene was happening. You'd make the rounds and be at an after-hours bar until dawn. There wasn't a night when we ever stayed home. What could you possibly do at home? There were no drugs there! There was no booze there! There was no pussy there! You have to go out for these things. You went out and you stayed out! So I saw Rockets every night! Seven nights a week! For years! And we spent every night together, along with around twenty or so other people, who all knew each other intimately. When the night ended, as the sun came up… at nine or ten o'clock, when we got thrown out of the after-hours bar, we'd all end up

> # "The New York scene was so cool. I can't even describe it. The drugs. The sex. The whole thing was just fantastic."

together at somebody's apartment, doing drugs for the rest of the day. Laying around on the floor, doing more drugs, watching TV, zoning out. That's what we did!

GG: Coke and heroin?

SN: Coke and dope, yeah. And pills! The pills kinda gave out towards the end, when we were more hardcore. But in the beginning, a lot of Quaaludes, Tuinals, Seconals, Valiums. [laughs] All taken… at the same time!

GG: There was such a huge porno element…you must have been on the sets a lot, on porno shoots.

SN: Yeah. Constantly.

GG: What about that? What…uh …what stands out in memory?

SN: Okay, I'm just gonna pull one outta my hat. Just for novelty's sake. Here was a threesome. It was me, Sharon, and Long Jean Silver… who could do more with her STUMP than I could with my dick. I'm being serious. Long Jeanne Silver only had one leg. She was the one-legged porn star. She didn't lose the leg, she was just born with this deformity, so her stump, which ended a few inches below the knee, sort of tapered into a very… pleasing shape that would fit into certain bodily orifices. [laughing] You never heard of her?!

GG: No.

SN: Oh maaaan! You've gotta see some of her movies! Oh, she did all this girl/girl stuff, because they used the stump! Long Jeanne Silver. She was beautiful. Super sweet, super nice. I even knew her mom, okay?

GG: That never occurred to me. I guess a stump would be a highly beneficial asset in a lesbian relationship.

SN: HOT! I'm tellin' ya. And it wasn't even a sicko, freak type of thing. It wasn't like, "oooog, I'm getting off on your STUMP, baby!" No, it's not like that at all. This was an extremely sexy woman. What a great memory that is. My God, you have to see her movies. What a weird sub-cult that is, right?

GG: Damn straight. Hard to visualize but maybe you'll send me a video.

SN: Believe me, it is head and shoulders above www.ratemypoo.com. Which is all I'm left with. It's the best I can do these days.

Boiled Angel

- Mike Diana -

South Florida: muggy, rain-ravaged home to countless trailer parks, swamps, Satan teens, serial killers, and a criminalized comic artist named Mike Diana. His case, publicized so widely since his arrest and imprisonment in the 1990s, has become one of America's most notorious violations of the First Amendment. Given Florida's pivotal role in the outcome of the undemocratic presidential election of 2000, what happened to Mike is perhaps less surprising in hindsight.

Outrage over his comics is certainly to be expected; the title which got him busted, *Boiled Angel*, was rife with child rape, incest, murder, and cannibalism. The artist's *modus operandi* is nothing if not base-level assault, but in the death-metal culture of its origin such heathen artwork could hardly be thought to be out of place. A Largo, Florida judge ruled in favour of the prosecution, deeming *Boiled Angel* obscene and Diana a threat to his community.

I was actively involved in the small press when Mike's story first began to circulate through it, and recall how omnipresent it became over the next few years. For me personally, the crudeness of the *Boiled Angel* comics defused any of the visceral power they were said to have. Still, I can't deny enjoying the occasional Mike Diana strip, and when I found out he was living in Brooklyn, only a few minutes away from my front door, I had to meet him. (He was at that time working as a dancer in a lower east side club called Don Hill's.)

In person, Mike surprised me: his appearance and personality were at odds with the themes of his work. In aesthetic terms, however, the link was reflected quite obviously. Mike had a childlike quality, long bleached hair, and a surfer's build. When we met at a diner one night after this conversation, I offered him Xeroxes of the transcription, already laid-out in cut-and-paste galleys, with samples of Mike's artwork. He began reading, and stopped suddenly, turned one of the pages around to face me. Mike snapped his fingers against one of his own comic panels, in which a child was being sexually assaulted, and said, almost to himself: "boink!" An impish grin crossed his face. Later, he tried to eat all the free breath mints by the diner's pay counter.

Since then, he has continued his work, unmolested by any law enforcement agency. His *Sourball Prodigy* was reprinted in 2000, and more recently he contributed art to a September 11th-themed collection published by Dark Horse Comics, and a tribute to the late Will Eisner. Mike Diana's work appears regularly in countless fanzines and comics anthologies worldwide.

Gene Gregorits: What's going on with *Boiled Angel* right now?
Mike Diana: Well the last issue was number eight... and I was charged with numbers seven and eight being obscene... I haven't done anything with it since then. It was 1991 when the last issue came out. I have to wait until I'm off probation and everything to see if I still want to do number nine, if possible. I'll have to do a special anti-Florida issue maybe.
GG: And then for a while you had something called *Superfly*...
MD: It turned out the court prosecutor got a hold of *Superfly #1* and brought it to the court to show the judge, trying to get me in more trouble. It certainly caused a lot of problems for me that I didn't need. But I'm lucky they didn't throw me back in jail.
GG: When did you start drawing comics?
MD: I started drawing comics back when I was real young, I remember I used to read the newspaper comics when I was eight years old, and draw my own little comics and they'd always be kind of weird, like people's faces would melt, and an alien comes and abducts Charlie Brown or something.
GG: [*laughs*] How old were you when you started reading underground comics, or anything harsh, adult...

"Some people looked at my drawings and felt that I had crossed over a certain boundary, that I should've known when to stop. I don't agree with that at all."

MD: I started reading comic books a lot when I was 12 or 13 years old. They didn't have any good titles, any adult ones, in this neighbourhood, so I started going to flea markets. There was one that had a drive-in theatre that I could walk to from my house. And people would sell underground comics, old issues for a dollar each. Like old issues of *Heavy Metal* magazine and other adult-oriented comic books. I always enjoyed them. I liked them more than the superhero comics I was seeing at the comic book stores.

GG: That's strange. You know, I first got into underground comics at a flea market that was located in the parking lot of a drive-in.

MD: Wow. [*laughs*]

GG: I found a 1975 Robert Crumb book for a quarter when I was nine. That was my first exposure. So, of everything that the Pensacola County cops did to you in Florida, what still bothers you the most today?

MD: I guess... the fact that they wanted to put me in jail, just for drawing. They wanted to give me three years in jail! And then when the judge told me I wasn't allowed to draw, it was very disturbing to me that they would have so much power over the constitution and my First Amendment rights. To tell me I'm not allowed to create any drawings. The whole thing was really horrible to have to go through, from the very beginning.

GG: The support that the small press community extended to you... How many people came down to help? Any prominent figures?

MD: Peter Cooper was there, talking about art. Trying to convince the jury that comic books were considered art, and Seth Friedman [*Factsheet 5*] was there. Also, Chuck Shepherd, he does *News of the Weird*. I met him before my trial. He had interest in it and he wrote an article for *Playboy* about the case. He was there through the whole trial. There was a few people from my community that showed up, who just heard about the case through the newspaper. Some of them were there in my support, watching the trial. And some were there giving me dirty looks through the whole thing. There

were religious groups that wanted to see me convicted and thrown in jail for what I had drawn.

GG: Didn't you go to the Comic Defense Fund? Is that what it's called?

MD: Yeah. Someone gave me their 1-800 number so I called them right away. They decided to defend me after they saw the comics. They knew my rights were being violated. I had heard rumours that they almost weren't going to accept my case just because of the graphicness of the material. But luckily they did and they were able to help me. They spent a lot of money defending me.

GG: Did you find that other people were reluctant to help, who might have helped another comic artist, but held back because of the content of your book?

MD: I'm sure it scared some people away, even some people that say they're into freedom of speech. I think that some people looked at my drawings and felt that I had crossed over a certain boundary, that I should've known when to stop or something. I don't agree with that at all. But it got some shows scared away. I was going to be on *A Current Affair*, and then once they saw the comics they decided not to have me on the show. A couple things like that. Most of the people though, I think were supportive of it. Even if they didn't like the comics that much.

GG: Well, when you were doing the comics, and you'd come up with a horrifying idea and were reaching obvious moral boundary, did you ever stop and consider the possibility of police involvement?

MD: No, I didn't think they would actually go that far. Even though I knew the police and the law in my community was really bad. I had been arrested once. I was driving my brother and his friend home and they wanted to stop into this 24-hour laundromat – it was like two in the morning – to get a soda out of the soda machine. They put their quarters in, and the pop wouldn't come out, so they start kicking the machine and stuff. And I was just there, waiting in my car. I was getting out, to walk in the laundromat and say, "C'mon, let's go," you know, "let's forget about it." And a cop jumps in the doorway with his gun drawn. He made us lie on our stomachs and arrested us for breaking and entering into the soda machine, even though we really didn't break into it. Because we were kicking it, they said we were breaking into it. They impounded my car, saying it was for use in a robbery or whatever... Eventually I had to pay bail to get out of jail, but then they decided not to press charges, 'cause they probably realized I didn't do anything wrong. I was just waiting for the kids. But being harassed constantly, for years, made me think that they might try and do something. My father was always telling me I'd be arrested for pornography someday, for my drawings. He didn't try to stop me. He just told me I shouldn't be doing it. And I didn't listen to him.

GG: Did you ever reach a point where you wished you had?

MD: Not really. No. I thought it would be worth it anyway, even if I actually got in trouble. I just felt like I had to do what I was doing. And I was being so suppressed in the area I was living, in Florida, in those surroundings, where everybody's kinda like... really fake, ignoring things that are happening. I felt that being in that environment is what made me draw the things that I did. So I felt it was something I had to do, really.

GG: I guess it's inevitable that you see Florida as a police state. Is all of Florida that bad?

MD: Yeah, I think so. Most of the areas.

GG: What is the main reason for the abuse of power there? Religion?

MD: Sure, that has something to do with it. I think a lot of the police are just assholes. They go after a certain type of people, who have long hair, drive a certain type of car. And they go after the blacks, the minorities constantly. In my neighbourhood, all the white trash I was living with... I consider myself white trash [*laughs*] because I was living in a trailer for free, without electricity or anything. I'd run an extension cord to it and live there for a while. But at my dad's convenience store, where I worked, the customers would always come in to buy beer and someone would come in with their wrist broken in a cast and say the police beat them up. They arrested one of the customers for having his barbeque grill going. Just really crazy nitpicking type things that the police do there and I've been harassed several times for just... doing nothing at all. Like walking from the store after work, to my house which was right across the parking lot, and more than one time the police would pull in the parking lot almost running me over, you know. And they're like, "What are you so nervous about?" and I'd say, "Well you almost ran me over! Of course I'm nervous!" [*laughs*] "You got any drugs on you?", you know.

GG: So when you left, were you expecting any problems here in New York?

MD: The only problems I think I'll have are the ones I have now with my probation, still being harassed by the state of Florida. I have to take a journalism ethics course, so I can become a serious journalist. Like the judge said, here in New York. And I have to pay my three thousand dollar fine. Also money towards probation fees, forty dollars per month. I have to do eight hours a week community service work for a non-profit organization. And I was also ordered not to draw anything 'obscene', so... it's still like I'm being punished, even though I'm not in Florida.

GG: Have you made any effort to comply with that? I mean the drawing stuff...

MD: I'm just saving a lot of my more explicit drawings till after probation's over. I have enough regular type drawings I do for New York press. You know, they

don't accept any really graphic stuff in there... so I think they [the State of Florida] would be okay with a lot of the things I'm drawing anyway. I'm sure there's things I'm drawing now that they would consider obscene just because they're so crazy down there. Anything to them it could be a phallic symbol, or... something wrong, you know.

GG: The publicity that the whole mess in Florida generated got your name pretty well recognized all over the world, at least in some of the small press circles. How has all the free press benefited you?

MD: I've gotten a few donations, I'll get twenty dollars here and there, to help me pay off some of my fines, and pay off the legal bills. I also go to some of the small press conventions. In Washington D.C. I did a speech about my case.

GG: In terms of over-the-top disgust, is there anything you've seen that outdoes *Boiled Angel*?

MD: I haven't seen anything yet that I would say was worse. I've seen some Japanese comics that are really graphic. And that is sort of the influence of my comic.

But I haven't seen very many comics out there, with like, babies being fucked and... you know, torture. I'm sure there's some. But I think that's what really offended the jury, and the prosecutor, maybe why he wanted to prosecute is because you're not supposed to draw... like, babies you know....

GG: Well, how do you defend drawings of a baby being raped?

MD: I think it's just like any kind of drawing, of anything really. At the time, it's just what was on my mind I guess. I thought, what can I draw that would really be shocking... I did not want to... not do it, you know. Censor myself.

GG: Do you know much about Randall Phillip? And his nutcase/gross-out 'zine *FUCK*?

MD: Yeah. I started writing to Randall, it was probably back in 1989. And we would trade videos. He told me once that *Boiled Angel* was one of his inspirations to start his own 'zine. And I remember the first issue of *FUCK* he sent me, how I thought it was really good, with all the gross pictures, the deformed babies, just a lot of weird things. We just traded 'zines for years. Then I finally got the chance to meet him, and he's a really nice person. I went with him to a museum in Philadelphia where they had deformed babies in jars, preserved. Collections of bones, and unusual medical things.

GG: Do you see your work as being analogous to his in any way?

MD: I think in certain ways it is. He has a lot of gross-out images, and especially in the *Boiled Angel* books,

that's what I was trying to do. Shock people, and have something that people would enjoy, or not be able to forget. That's the same feeling I get when I look at the *FUCK* 'zines.

GG: I'd like to hear more about this serial killer in Florida who you were suspected of actually being. Danny Rolling?

MD: Yeah. It was 1990, and I was working at the Pinellas County School Board, and... three students were found dead. I remember the news reports, everybody at work, the secretaries I worked with, were talking about the murders, and what kind of sicko might've done it and whatever. And the next day I went into work and I heard on the news on the way over that they found two more bodies, making the total five. So I was the one who had to tell all the secretaries about it. I was like, "Oh! They found two more!" and I saw the fear people had, even though it was in Gainesville, which is so far away. There was hysteria about serial killers. Even though most murders, I don't think, are committed by real serial murderers, you don't have to worry about serial killers really, in reality. But everybody's really afraid of them. And this was around the time I was putting together issue 6 of *Boiled Angel*, and they finally had a suspect, I forget his name but he lived in Gainesville, he had a big scar on his face and people said that he would crawl around in the woods behind his house practicing army manoeuvres, you know, when you crawl through the leaves and stuff. He was arrested for hitting his grandmother. They suspected that he committed the murders. It turned out that the grandmother said that he did not strike her, but they charged him anyway, kept him in jail. Then I was Christmas shopping with my mom, getting a present for my grandmother, and we returned to my mom's house. There were two detectives there, a man and a woman. They were talking to my step-brother – my mom got remarried and the person she married had two young children – so they were out there talking to the two young kids showing them *Boiled Angel*, asking them, 'Have you ever seen your brother's drawings before?', you know. I'd just returned home and they approached me and pulled a copy of *Boiled Angel #6* out of a briefcase. I had only sent out about ten copies of that issue so far, and they told me that I was a suspect in the murders, because of the artwork and they wanted me to take a blood test. My mom walked up with me and talked to the officers. She got very upset, they scared her... showed her issue 6, which I had purposely tried to keep her from seeing, 'cause I knew it would upset her.

GG: But she'd seen number 5, and the ones before?

MD: She had seen just like, very small bits and pieces of my artwork. She hadn't really seen a whole issue I don't think. And they wanted me to take a blood test to clear my name. Finally they left, and that was where most of the problems started, that's how they knew about me. I found out years later, I got the paperwork...

my lawyers got all the files on me, and I found out it was someone in California that had sent that issue of number 6 to the police in Florida. And they wrote a note saying maybe I am the Gainesville murderer. So it's their fault. But I just kept doing my 'zine anyway, and my mom was embarrassed because rumours went around at the office that I was the murderer. Then finally they caught Danny Rolling and charged him with the murders, let the other guy go.

GG: When you were working for the school board, before you were arrested, were you working around children?

MD: No. My mom was a secretary in the same building where I worked. I was a secretary's helper. I used to do janitor work at the school board at night, for years, and eventually I went daytime. Used to change light bulbs, and do little maintenance things. But there were no children around.

GG: What kind of people read your comics? Are you aware of a certain type that composes a large majority of your audience?

MD: I've met a lot of people I've been sending my artwork to for years through the mail. Most of the people I've met seem to be very nice and they just like that type of extreme material. I've sent issues to other countries, Germany and Australia... one person ordered it in Africa. One person in the Soviet Union, and Egypt, lots of exotic places. It was fun to be able to say that I had a fan there. A lot of people would order *Boiled Angel* and I'd never hear back from them. So I assumed they didn't like it, maybe threw it away, it scared them, and I had a lot of prisoners who were *Boiled Angel* readers. I'd send them free issues. I'd correspond with them.

GG: What would their opinions be?

MD: They liked the artwork, they'd say it was the only good reading they could get...

GG: Were any of these people sex offenders?

MD: I'm sure there was a couple that were sex offenders. You know, one I'd mail it to was a paedophile, another guy was in there for killing his wife. Different murders and drug offences.

GG: Did you ever worry about these types of people reading your comics and getting some new ideas, that it might be a counter to any type of therapy they were receiving?

MD: Not really, I don't think the prisoners were receiving therapy. It's like, they just throw people in prison, make you live there. There's probably so many bad things in some prisons that it does you more damage than it would do you good. Some of them are in there for life. But I don't think it would set anyone off or make people actually harm someone as a result of seeing these drawings and comics. Most people understand that it's just entertainment, it's something they should just try and have fun with.

GG: How can you be so sure that a convicted rapist or child killer would see the 'fun' in *Boiled Angel*?

MD: Well, I think that if someone looks at it and it causes them to want to rape even more, then it must be something wrong with them. I don't think that people should blame material, like written material or movies or anything, and say that that's responsible for someone's actions. I've always had fantasies, and thought it would be nice if they found *Boiled Angel* copies in the residence of a major serial killer or something, for the publicity, but that hasn't happened yet. I think some of the drawings are just too weird, like gross, the way they're drawn. There are things that you can't actually do, just because they're so far-fetched maybe. I've seen like, S&M drawings, and... they call them snuff drawings, people killing, torturing people, that are drawn much more realistically, nice drawings of people rather than absurd characters like my comics are.

GG: Okay, well let's say you got your wish. A guy comes along who makes Ted Bundy look like Mary Poppins... they find a whole box of *Boiled Angel* comics in his basement soaked in someone's blood. You'd be more famous than you'd ever been, but wouldn't that land you right back in court? In jail even?

MD: I don't think so... I probably wouldn't be surprised but supposedly, when I get through with my probation,

Above: Mike Diana. This photo and all Mike Diana artwork reproduced in these pages courtesy of Mike Diana.

and I've done everything, then Florida can never re-try me on any charges like that again. And I would think, or hope anyway, that I wouldn't be charged with anything. I try to think that I'll never have any problems again, because otherwise I get too nervous and stressed-out thinking that my problems haven't even begun yet. The federal court I don't think would prosecute me. I think they understand a little better about freedom of speech, and would see that there's nothing wrong with the drawings.

GG: I don't know if there's ever been anything so confrontational with the First Amendment. Your comics really challenge that, test it, stretch it... Do you ever stop and consider leaving yourself some space away from the furthest extreme... Or is there no further to go?

MD: I guess I can always go further. I would consider doing things that are even worse than what I've drawn so far. I wouldn't let the fact that I got in trouble stop me from drawing anything I wanted to. And I wouldn't censor myself. I guess I just have to see what happens. I don't know myself 100% what makes me want to

draw certain things, and at a certain time. But I don't think I'd hold back anything.

GG: How has your artwork changed since you moved here? The new people, the new environment, how has this all affected your artwork?

MD: I've been doing paintings lately, more than comics, so I can get some art shows, sell some paintings. It takes a long time to do comics and I haven't had enough time to do them like I should... And I've been doing comic strips also that are like especially about New York. Like *Honcho* magazine, I've done a couple of comics for them. And they're about specific things for the magazine. I've been doing drawings to accompany certain articles they assign me. So there's a lot more drawings like that I'm doing, illustration type jobs that I wasn't doing before. Since I got to New York, there's been lots of inspiration, seeing the homeless people and seeing a dead body in the street, the needles laying around. There's always new ideas wherever I go. Even if I went out and lived in the country I could probably find new inspirations, even if it's just new 'zines I discover, or new comics. I was

thinking of doing the illustrations for a children's book my father wants to write. I talked to him last week and he wants me to do some illustrations for him. It's about this baby cub, in Yellowstone National Park. It would be good, just to show the judge, 'oh yes judge, this is what I draw now'. Little cute cubs and bears and stuff. [*laughs*]

GG: When you open a newspaper, and you read a story about a child being raped and murdered, or they find a murdered three-year-old in an alleyway under a heap of trash... when you read this, do you ever feel a twinge of conscience?

MD: I think it always bothers me, in a certain way. But the comics are like a reflection of those things. I've been hearing and seeing that since I was young, on the news, knowing it happens in almost every town in the United States and in other countries. So many horrible things, injustice towards children... and the different people who should be held responsible in a community that doesn't do anything. All kinds of feelings like that, and knowing that I can't really do much, so I do comics... I don't know the extent of how it bothers me really. I try not to think about it too much. I just know that's reality, that's the way the world is.

GG: Do you like kids?

MD: I like 'em when they're not around me, screaming or something. I guess overall I like kids. I'll probably have one of my own kids someday, see what happens. I've never had any problems, never abused children...

GG: Was it suggested in court that you have paedophiliac tendencies?

MD: Yeah, they bashed my name every way they could. The psychiatrist for the prosecution was saying that my drawings are exactly what turns people into paedophiles when they read it, turns people into serial killers, and part of my probation was that I am not supposed to have contact with anyone under eighteen. Supposed to stay at least ten feet away from kids. And that was on the news. I visited my sister a couple times at the day care centre she worked at, and her bosses told her, you know, 'Don't have your brother come over here anymore'. There's just a lot of painful things, being treated that way by the law, them talking about it on the news.

GG: Well, I don't agree with a statement like *Boiled Angel* can turn someone into a killer, I know that's absurd, but at the same time, people who are convicted felons for those crimes... you said that to them it's entertainment. Well, what really intrigues me, is how can something be exploitative comedy and serious social commentary at the same time? You know, when it's still the same subject matter. And it's still Mike Diana doing it.

MD: It's dark humour. Things that really happen, made into humour, into something you can laugh at. Which lots of people do. Like Jeffrey Dahmer jokes... a lot of

the things that tabloids show are just exploiting and not really putting a message out. Not trying to be preventative in any way. Just exploiting. And I think I was doing even less than that.

GG: Not doing any great service either.

MD: Well, everything had to be funny because I didn't want to do a book explaining what people should do or something. I don't know what can be done really...

GG: I think its entertainment value lies in its subject matter. As raunchy and depraved as it gets, well, that's when it's most entertaining. But can *Boiled Angel* be taken ambiguously?

MD: Yeah, I think it's taken a lot of different ways. I've seen people that totally don't like it at all, actually get angry when they see the comics. It scares them. Maybe makes them think about something that they didn't know was there, or see a part of themselves in the work maybe. It's definitely gotten a lot of different reactions.

GG: So your stuff was confiscated, you've been through all the legal ordeals. What have you learned in the process that you could offer as advice to someone else in the same predicament?

MD: I would say that people should just stand up for their rights, even if they think they might lose, it's better to fight the system, than to try to just get off with it or something. I don't think that artists should hold back what they wanna draw out of fear of being prosecuted.

GG: Do you also believe that an artist is automatically taking responsibility for themselves and their work when they go directly to the main nerve of the judicial system, with material that is extreme? That doesn't push so much as directly tests laws and limits. Is it a willing choice on the part of the creator?

MD: They shouldn't have to worry about being prosecuted in any way. And since it's something that happens, they should just be aware that it could happen.

GG: Your story is definitely one of the great American censorship cases. Are you planning to write a book about it?

MD: I'll someday write a book, or maybe a comic novel about the trial, the conviction, talk about different influences, upbringing, what might have led me to where I ended up, in trouble and everything. I'm working on a documentary, should be done soon. Mark Hejnar in Chicago is doing it.

GG: I saw his film with you in it, there's some amazing stuff. What was that called?

MD: *Affliction*.

GG: Yeah. There was one scene where a guy slices open an artery on his dick with a razor while masturbating. Was that real?

MD: Oh yeah. Yeah, everything's real in the video.

GG: Did you inspire that act of brilliance? [*laughs*]

MD: [*laughs*] It's possible.

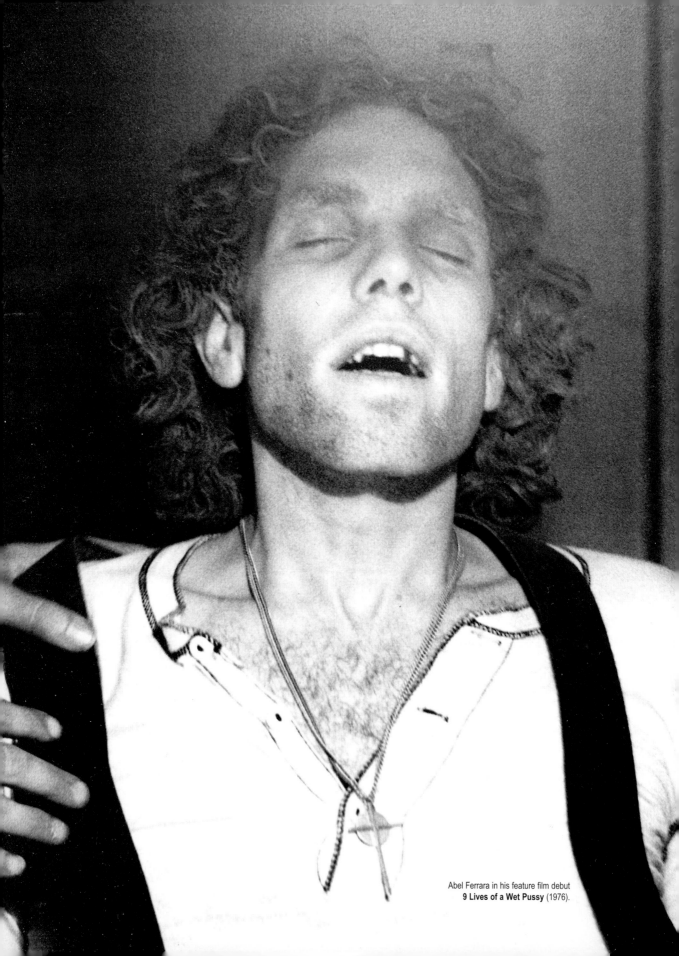

Abel Ferrara in his feature film debut
9 Lives of a Wet Pussy (1976).

Guilty As Sin

- Abel Ferrara -

For reasons that are only somewhat clear to me, America doesn't seem capable of producing artists like Abel Ferrara anymore. In an era whose studio films are as much the work of industry players and schmooze-artists as writers or directors, unrestrained outbursts of pure cinema like *Bad Lieutenant*, *China Girl*, and *Ms.45* are a preciously rare element. While regarded by many films snobs as a druggy lowlife, a practitioner of sleazy psychodrama, others seek deeper truths in Ferrara's films, many of which could be described as Charles Bukowski filtered through the French New Wave, or vice versa. He is the most tempestuous and hyper-accentuated of New York cinema's Dantean rovers.

No matter which camp you fall into, his body of work must be seen as one which forms a singular netherworld category all its own, which merges exploitation with art… a high-speed collision of the basest elements with higher spirituality. If you collect the rumours and anecdotes, all those horrific scattered fragments that substantiate his legacy of mad living, and examine them with generic textbook psychology, you'll find it quite easy to understand why he makes the films he does. He has an inexorable need to express these feelings; they are about the twisted human game as he sees it and lives it. One might assume of the man a tightly-held faith in the maxim that a life without extremes is one hardly worth living. But how many great artists, either by personal philosophy or hardwired basic nature, are able to enjoy any sort of traditional methodology in their personal or professional lives? Abel is one of those so consumed by his passion that the line between the two is often blurred. He has pulled off scenes and dialogue that would endanger the career of a less obsessive and insistent filmmaker. He creates crises to play out before and during the terminal stages, to examine both how and why. It is ultimately Ferrara's heaviness, the aggressive tone and solid granite conviction, that affords some the ability to assess the films seriously, and strains that ability for others. The cynic might wonder whether or not Ferrara is having a nasty chuckle in a particularly gratuitous moment, but I don't think he makes films for cynics.

Is he a man of conscience? Definitely. Does karma apply to this berserk bastard? Of course. Of all the questions raised by he and screenwriter Nicholas St. John, many – even most – are theological. In the end, I think Abel Ferrara demands a clarified divide between the hopeful and the hopeless… true sociopaths just don't give a fuck. But even the most morally obliterated of Ferrara's lead characters are holding out, if only in a hidden part of themselves, for a chance to repent their sins.

There is a demon in all of us. That demon provokes contradiction, innumerable ambiguities, and he greets some of us on the occasional holiday or anniversary. Others, such as Abel Ferrara, apparently wake up in bed with the demon every morning. And the audience's reaction to Ferrara, his energy, and his work, is based largely on their own spiritual ideals, their religious politics, and their familiarity with demons. He asks you to dig deep, to approach the abyss without irony.

Of course, that was just my own take; I could have been laughably off-base with it. And so, not being one to trust my own assumptions, and having read very little about him, I travelled to New York in 2003 to hear it straight, in real time, from Abel himself. If only for my own sake. But in my determinedly undiluted state, I lost track of my agenda, lost myself entirely in Ferrara's scabrous charisma.

Underneath his wiseass shtick, I believe, is a tender soul very much impacted by the urban paranoia and desperation he studies in his work. There's also a deeply-engrained rebelliousness which sets him apart from any other filmmaker in New York, if not America. His penchant for chaos, in both fictional documentation, and real life, serves only to enhance a creative presence that he has sought to establish since the 1960s. He's among the funniest men you'll ever meet, but there's the inevitable flipside, the side that suggests tragedy, a broken heart. The man's maniacal reputation is probably well-deserved, but art is a fire that burns both ways, something which requires the

soul of an underdog. With each passing year, that soul becomes more scarce. But Ferrara carries the torch, brazenly. He lives for art, for searching, for extreme possibilities, for acceleration. He recalls the hell-bent passion of Rainer Werner Fassbinder and Pier Paolo Pasolini. Ferrara lives out his dreams of a better time, of an open society, of unbridled hedonism, and he does so against the odds, against the rules, and against the clock. Like I said, they just don't make 'em like Abel anymore. He knows what freedom is, and he also seems to believe that most if not all the wars fought for it are lost, over. But he rushes forward like a bloodthirsty zealot, into the next euphoric realization of a better NOW.

My mission was to further explore Abel Ferrara's heart of darkness. Clearly, my mission failed. But I came up with something that is perhaps far more immediate and incontrovertible. And if not, well… at least I got to drink his beer, eat his food, and laugh at his jokes. I think I caught the laughter intact… but the Budweiser and baked ziti are long gone.

Abel Ferrara interviewed by
Gene Gregorits with Lainie Speiser

Gene Gregorits: What kind of jobs did you have, before you went to film school, and made your first film?
Abel Ferrara: I worked for my father, worked for my uncles. Driving garbage trucks… I don't know, typical shit. Worked in a factory. My uncles and my father owned scrap metal yards. That was their business. Driving trucks. Washing dishes in a fuckin' old age home, anything I could get. Any job at that age is good.
GG: How do your remember yourself as a kid in school?
AF: [*long pause*] It was so different from grade to grade. Some grades you were like The Man, and you were in control, and you were like, in a good place in terms of where you were at. Different school, it would be a different situation. I guess it was tough, I don't know. We were like… evil bored. You know what I mean? This was a town that my writer Nicky [St. John] came from, and Mel Gibson came from. Tommy Boyle, the writer. You know the fuckin' guy. He just had a book out about a commune in California that moved to Alaska. You should look this guy up. He's like the great American writer. T. Coraghessan Boyle. Imagine, coming from the same town as the great American writer.
GG: What were your aspirations, and what were you interested in as a teenager. Who was Abel Ferrara at the age of 14?
AF: Well, I come from the Bronx. My mother was very into instant breakfast, the latest this and the latest that. TV dinners. Being in a modern suburban world. But my father was from an old Italian family in the Bronx. Steeped in tradition. Very much an outsider in a white world, you know what I'm sayin'.
GG: When you flash forward in your career, and look at the fact that many of your films end in either suicide or mass murder [*laughs*]… I mean, these films are about extremely self-destructive people. Does that tie into anything you experienced as a kid? Where do you think you acquired such a dark

sensibility? **There has to be a reason why you tell those stories as opposed to other stories.**
AF: Well… we were watching a lot of films. We saw *Hour of the Wolf*. We saw *Teorema*, you know? Back then, those were some hardcore films. *Fat City*. There's a certain time when you're really into watching movies. Now, I am not big on movies. But then… you saw everything for a certain period. '71,'72, '73… that was the golden age of movies, for me. *The Devils. The Servant. Alphaville. Performance.* And *Mean Streets.*
GG: When you had your first idea to do a film – coming from your background, what you'd lived and seen – what was your idea of a movie that you would make?
AF: We were making movies based on the equipment we had. We were making four and five minute silent movies that were much more metaphorical and pseudo-intellectual. We couldn't get sync sound. We couldn't get dialogue, which really bummed us out. But in fact, it helped us in that it taught us how to work without sound.
GG: Your first feature, *The Driller Killer*…
AF: We were making films for ten years before we made *The Driller Killer*. Our first films were 2 or 3 minutes. But we made a porno film before *The Driller Killer*.
GG: *9 Lives of a Wet Pussy.*
AF: Yeah, right. And look man, I've got kids, so I'm not about to broadcast the fact that we were doing hardcore films, but it's also the fact that they weren't that good to begin with. We were still learning to make movies. The few good things we did manage to finish don't exist anymore.
GG: What about *The Driller Killer*? I'm very interested in the origins of the script, where the idea came from. How you developed it.
AF: We went to Stan Brakhage and guys like that, as much as we did other films. Short 16mm films, spaced-out stuff at the time. We were trying to do that and going nowhere. Totally out there, without a net. Nothing happening. Nothing looked like it was gonna happen.
GG: How would you describe what New York was to you at that time?

Matthew Modine taking direction from Abel Ferrara on the set of **The Blackout** (1997).

AF: Violent and broke. It was *Fear City*. *Taxi Driver* gets it. That's what it was about.

GG: It seems as if *Taxi Driver* played a vital role in the inception of *The Driller Killer*.

AF: Well, that was The Movie! That's what we were working off of! And Dee Dee Ramone. That was New York. 1978. The music started getting a lot better. We were making films. Rock'n'roll really helped the whole film situation.

GG: That was when you did *The Driller Killer*. The punk scene was exploding at that time. Were you aware, at the time, that you were making a film that would be marketed as an exploitation film?

AF: We raised the money that way! We went around with *Texas Chain Saw*, saying basically, 'I think we could do this'. We've been making films for ten years, right? That's one of my favourite films too, for some reason. They made a lot of money with *Texas Chain Saw*. So, we used that to try and sell *The Driller Killer*.

GG: Another household, industrial instrument used as a murder weapon.

AF: Exactly. It worked! *The Driller Killer* did really well. It's actually one of our best releases.

GG: What kind of attention did it get? What were the reviews like?

AF: The reviews were horrible, but we had never been reviewed before. So we thought it was great, just to see our names in the paper. We didn't give a fuck what they said.

GG: What were your ambitions? Where did you want to go from there?

AF: Our only ambition, with *The Driller Killer*, was to make a movie for a hundred grand. We swore we'd do it, and we did.

GG: What kinds of movies did you want to make after that?

AF: The kind of movies we were making! You never know what kind of movie you're gonna make. We worked from original material, so you don't question your muse. Whatever you come up with, that's what you gotta use.

GG: Your muse is a pretty dark one. Again, these are stories about people who are fucked! Doomed people.

Victor Argo and Christopher Walken in Abel Ferrara's **King of New York** (1990).

AF: I don't know about that. Which ones in particular?

GG: Well, especially *Bad Lieutenant*.

AF: I don't know man. He solved the case… whad'ya want? He got the reward money, you know? He was actually on the road to recovery. [*sarcastic laugher*]

GG: What is the impulse that drives you, though? To make disturbing films?

AF: Which ones?

GG: *King of New York*.

AF: *King of New York* was a dream.

GG: *Ms.45*.

AF: *Ms.45*… she was too young to overcome the tragedy of being attacked twice in the same day. That was a tough girl. That was a tough life.

GG: Why tell that particularly story? It's a very nasty movie.

AF: Well, because! These are interesting stories! What else are you gonna talk about? Films are bigger than life, and are meant to be… well, take Hitchcock's quote. He said, "my films are not a slice of life. They're a slice of cake."

GG: But your films *are* slices of life!

AF: Yeah, *sure* they are! How many people you know get raped twice in the same day, then use the murder weapon to go off on a man-killing rampage? Look, women are brought up in a male dominated society. You're being raped every day, one way or another. That is the metaphor of the film. It would be more violent if we did documentaries on gun-running or some bullshit like that.

GG: There is no fake Hollywood moralising in your films. It's up to the audience to decide what's right and what's wrong.

AF: Who cares about the audience? Those people up there on the screen, they're making their own judgements. If you're waiting for the answer to come from someone else, listen, that just ain't the world that I'm coming from. I'm not saying there's not a time in your life to be a follower. There's a lot to learn by being a member of some group, or subscribing to some ideal, or philosophy. There's a time to be taught. But then there's a time to be.

GG: That's a much more streetwise sentiment than you usually deal with in the average Hollywood film. This is not the thought or the attitude of the middle class.

AF: *The Addiction*. That character, Lili Taylor, she was an upper class intellectual in that film. Graduate of philosophy. That's an upper class character.

GG: I think she's one of the least believable characters, of all your films.

AF: Well, she's a vampire!

GG: [*laughs*]

AF: What? You don't believe in vampires?

GG: I believe in psychic vampires and emotional vampires. This city is full of them.

AF: But you don't believe in real vampires?

GG: I don't *not* believe in them.

AF: That's how I feel, actually. I don't *not* believe in them. But how can you explain that in every culture, in every civilization, since the dawn of man, that character has been either scratched on a cave wall, or told through a song, or passed down somehow. Everywhere, in the entire globe. All that whacky shit, the blood. Eternal life, sleeping in the dirt. You know? All that fuckin' vampire bullshit… it doesn't come from *Nosferatu*. That was *there*, you know what I'm sayin'?

GG: That whole concept of human morality, and human guilt…being betrayed by selfish, parasitic people. Those are the real vampires! Maybe they used to drink your blood, and now they just drink your confidence.

AF: Hey man, I'm with ya. The metaphor. We can talk about that too. But I'm talking about the reality of it, just for a second. That thing, it comes from Aborigines, down under. Or it comes from Eskimos, up north. From 5,000 B.C., every culture talks about that monster.

GG: Nearly all species of mankind have practiced or resorted to cannibalism at one point or another. That's human nature. Survival. Vampires, even 'real ones', isn't that just bottom-rung existence? I don't see much of a difference between the junkies of *Bad Lieutenant* and *The Addiction*, which is the most explicit handling of that theme, of all your films… but I prefer *Bad Lieutenant*, because it goes about the whole existential crisis thing in a much more profound way. Here's this guy that's been pushed to the brink, in this horrible job. He has to hang out at murder scenes. Being a cop is hard. Who wants to see someone's brains splattered all over a windshield every day? And this guy, you almost can't blame him for having some of the problems that he does. He becomes a vampire. Stealing coke from a crime scene, shit like that.

AF: It's metaphorical vampirism, absolutely. But vampires are cannibals that don't die. That's a scary thought.

GG: *Bad Lieutenant* is your most extreme film. Did you realize at the time how far you were going?

AF: No. Chris Walken was gonna play that part, originally. It was a different role. We did rehearsals, we rehearsed that for two or three weeks. What made it so extreme was the point that Harvey was at in his life. He was at that point as a performer, you know?

GG: What made Harvey so inclined to do that part at that point in his life?

AF: He'd just broken up with his old lady.

GG: Lorraine Bracco?

AF: Yeah. I had just met him at that time.

"People basically need that icon. The mad director. They need to know there's somebody getting away with something."

GG: I'd like to talk about Asia Argento. What do you like about working with Asia?

AF: I don't know… I loved her in *New Rose Hotel*. I thought she was tremendous.

GG: That was your first film with her. How did you get involved with her in the first place?

AF: We were looking for girls that age. Twenty or so. A girl young enough to play the Mata-Hari role without giving it away. Because in a story like that, it's basically a cliché that the chick is a double-crosser. We were looking for someone young enough. We looked at Jovovich. A couple chicks. I've told this story three hundred times. She just got on a plane. Everybody else is worried about their *per diem*, and if their mother can come. Asia just hopped on a plane and showed up. She moved in with me. That's a cardinal sin. The cardinal sin is living with your actress.

GG: She seems like a very complicated person.

AF: Yeah, too complicated. She was just playing with me. She had me and [Willem] Dafoe going. But it was a film about that. We basically all played out our roles, to make the film better. Did you like *New Rose Hotel*?

GG: That's the only movie of yours that I have not seen.

AF: You're kidding. Unbelievable. [*pause*] You'll enjoy it, you'll dig it! You like Asia, right?

GG: Yeah, very much. So anyway… what about you being a crazy film director?

AF: That's a stupid question. How could I respond to that? People aren't even on the sets! The sets are closed. And in the film business, it's really bad protocol to talk about what goes on. That's like the locker room in football.

GG: Yeah but you must know about being regarded as a tempestuous artist.

AF: Yeah because people basically need that icon. The mad director. Whether it exists or not. Sam Peckinpah or Pasolini. Oliver Stone. People just need that. They don't wanna hear about Brian De Palma, someone who is a hard working, calm guy. They wanna know about me. I hear, 'hey man, you moved in with Asia Argento'. I mean, Asia wouldn't have moved in with me… well,

"That looks like real shit." Zöe Lund and Harvey Keitel get high in Abel Ferrara's **Bad Lieutenant** (1992).

maybe if I fixed her car, I mighta got something. [*laughs*] But you know what I'm sayin'. Everybody wants that reputation. They need it. They need to know there's somebody getting away with something.

GG: What about you as a person, and the rumours, being fused with and interpreted as part of the subject matter of your own films.

AF: [*laughs*]

GG: But you're not the Bad Lieutenant, and you're not Frank White from *King of New York*.

AF: I'm not even the *energy* of that. Everybody brings their energy to the plate…

GG: Let's talk about Zöe.

AF: Zöe. We just did this show last Sunday. They advertised it in the papers. It was like 'An Evening with Abel'. We were out of town, we were in Paris. So we just came back, and on Sunday, they had this show at Arlene's Grocery. There was an ad in the paper. Make a long story short, ten times more people showed up – for us onstage bullshitting – than when *'R Xmas* opened. And really, that's gotta piss you off, at a certain level. But there's people that expect something, not to just show movies. We brought some friends of ours, they were reading pieces. It turned out to be a good evening. Now, Zöe's husband…

GG: Robert Lund.

AF: …He's exiled. And they can keep him exiled. There he is, right in front of me. And he's scary enough looking, with that hole in his head. Zöe, the chick he loved so desperately, who left him for another guy, a year before her death. She sets *him* up to get cracked in the skull, because *she* ripped somebody off. And he's still like, 'that's my girl'. I mean, Zöe? Zöe is Zöe. She was *Ms.45*, she ripped us off, yeah, she basically ripped us off, after *Ms.45*. So we didn't work with her for long time.

GG: She wrote a lot. She did a lot of writing in her lifetime.

AF: Yeah, she was good. After *Ms.45*, she weaselled her way back in. It was very hard for her to say, 'I'm sorry'. Then, we did *Bad Lieutenant* together, which she wrote, and acted in. That was her flick.

GG: There's a scene with Zöe and Harvey Keitel in her kitchen, and she's fixing some drugs up for him. That shit looked like… real shit.

AF: Well to even answer that yes or no, that's such a… thing is, a magician is not going to tell you how he got the rabbit. David Blaine ain't gonna tell you how he's levitating. You're saying they have to be, right? So why should I ruin that for you?

GG: [*laughs*] I know they were!

"'Bad Lieutenant' was not made to be controversial. Publicity created that. Harvey was in a disturbed and upset place in his life. He was in agony..."

AF: Good! You know they were. That's alright. Because Harvey's got you like a three card monte player! [*laughs*] And Harvey's playing that like the audience is a bunch of fuckin' suckers anyway. Because he doesn't even watch movies. Wouldn't waste his time.

GG: To get Harvey to do the things you got him to do in that film…

AF: Hey, I didn't get him to do anything.

GG: That nude scene, and the one where he masturbates… it's tough to imagine an actor being that intimate, working with a director for the very first time.

AF: We had no idea what he was gonna do. I didn't do it. This was his performance. Zöe didn't write that. It wasn't improvised. It was just part of the process of making that film. That scene was worked on. We worked with Madonna on *Dangerous Game*. Now, Madonna thought she had a week of rehearsals. That we were gonna keep doing it over and over again. No. In actor's studies, that's like a joke. You never say a line you're gonna say, ever, until the moment comes. But, there's no improvisation, either… in the rehearsals. In a situation like that, yeah, we became close quick. His work is director-proof. It's every man for himself, and that is a direct quote from him.

GG: What was the atmosphere like on the set of that film?

AF: It was a disaster. I was so far beyond whatever you might have heard, the reputation, what this guy said, this, that, the other thing. Baby, I made the bad lieutenant look like fuckin' Pinocchio. I remember the life I was living at the time. It's a wonder we even survived.

GG: What role did you have to play in the script, with Zöe?

AF: It was my idea. Nicky didn't want to do it. So Zöe came in, and she wrote it.

GG: Why didn't Nicky want to do it?

AF: Because he thought it was ridiculous. See, he's a believer. The film was about a search for Jesus. He's a Christian. He's a believer. *Bad Lieutenant* is the work of a conflicted person. So Zöe, myself, and Harvey maybe, but… Nicky don't have those questions. He believes in the word of Christ, he does not question the word of Christ.

GG: What attracted him to working with you?

AF: Even back to *The Driller Killer*… those were all his ideas. *The Addiction* was his idea. They're dark, but they're him, as much as me. Just because he's a Christian… I'm not saying he's some goody-two shoes. You're watching his work from the time he was 25…

GG: *Bad Lieutenant* was very controversial when it came out.

AF: *Bad Lieutenant* was not made to be controversial. Publicity created that. But hey, I grew up with *Salò* and *Performance*, and hardcore pornography. So *Bad Lieutenant* never seemed that dark. Harvey was in a disturbed and upset place in his life. He was in agony… You ever see *Dangerous Game*?

GG: That's one of my favourite films of yours. That's an amazing fucking movie. Everybody in that movie is great. I've seen it several times. I like how you used your own name on the clapboard in that one scene. Completely audacious.

AF: Nancy played Harvey Keitel's wife in that one. [*laughs*] Can you imagine that? Pimpin' out my own wife!

GG: [*laughs*] Back to *Bad Lieutenant*, you said you became close with Harvey Keitel after that.

AF: Yeah, we have a really good working relationship. We did those two films.

GG: Is he playing you, in a sense, in *Dangerous Game*?

AF: No, he wouldn't play anybody. His ego… he's not playing anybody.

GG: He plays himself.

AF: Right.

Lainie Speiser: What about Madonna, do you think she's a good actor?

AF: Well, she played an actress who was so bad that the director committed suicide. [*laughs*] So yeah, I thought she was a perfect choice. No. C'mon. She can't act her way out of a paper bag. She hated the film.

GG: I know, she must have hated the film, because you put her in situations that were pretty ugly.

AF: What, do you mean 'bad situations'? She was treated like a fuckin' queen.

GG: She was upset with you about the film.

AF: She expected to be on equal ground with Harvey and Jimmy [Russo]. You know… you're not on equal ground! Harvey is on a different plane. She coulda learned a lot, but… she didn't. She was just in the wrong place. She accused us of sucking Harvey's dick, of being afraid of him, or intimidated. But we just learned from him, and respected him, in a certain way.

LS: Do you think she has any potential?

AF: Absolutely not. Not one molecule… Well, I think – in the film – she was good. In spite of herself. I don't know. Acting is about confidence. At this point, she has been so trashed and so destroyed… *nobody* gets reviewed like that!

Madonna and Harvey Keitel in Abel Ferrara's **Dangerous Game** (1993).

LS: But she keeps making movies.

AF: You gotta be so fuckin' masochistic. To be on the front cover of a magazine, with people saying things that are so vile… how could she fuckin' keep going on, no matter what? There's no ego big enough to overcome being trashed like that! And you can see it!

GG: In a way, *Dangerous Game* almost becomes a film about *Dangerous Game*.

AF: We don't make films that have two characters. Harvey does, okay? Even in *Who's Afraid of Virginia Woolf?*, the neighbours show up at some point. And you never think, at any time, that that might approach boredom. Harvey was just going at it. But he was genuinely disappointed in the performances. He was trying to get something, but he lost direction. And Madonna didn't know we were filming her. We were filming during rehearsals, a month before we started shooting. She had no idea we were gonna use it in the film.

GG: Weren't you worried about being sued?

AF: By the person we paid four million dollars? No! She was being paid to act in a movie! Everything she did was mine. She felt betrayed, yeah… and she used that as an excuse. What the fuck does she care? The thing is, man… these questions are boring me. I've answered these a million times already. And you keep asking me about *Bad Lieutenant*. Obviously, something keeps bringing you back to *Bad Lieutenant*. I know you're a big fan, but you haven't even asked me about *China Girl*!

GG: *China Girl*'s a great film! I'm just interested in your relationship with the bad lieutenant.

AF: No, it's YOUR relationship with the bad lieutenant! Which is fine! Anyway, he was stealing drugs and selling them… he gave the kids a box of money. He solved the case… Okay, fine. Let's talk about *Bad Lieutenant*. Let's just do the whole nine yards.

GG: What was the atmosphere like on the set?

AF: I already told ya, it was whacked. But it was nice. Yeah, I was rockin' and rollin'. I had just come off two high paying jobs. *Dangerous Game* was made for 12 million, and *Body Snatchers* was made for 20 million. I was a millionaire at the time. That's why I was so over the top.

GG: Because you knew you could get away with it?

AF: No, not because I could get away with it! Look, when you have money, you don't care. When you *don't* have money, you gotta worry.

GG: Would you have attempted such an outrageous project if you hadn't just had those successes? It pissed a lot of people off.

AF: It's not about that. I do not pass judgement on the films. When we come up with something, that's what we got. It's not like we got twenty fuckin' ideas, and we're gonna decide which one will make me look best. The one we get the money for, that's the one we do… Watch *New Rose Hotel*, and we'll finish this up tomorrow.

GG: Why did you make a Christmas movie?

AF: That movie had nothing to do with Christmas. It had to do with the reality of dealing drugs.

Abel Ferrara in the little-seen documentary **Abel Ferrara: Not Guilty**. Photo courtesy of Rafi Pitts.

GG: It has a happy ending. it's the only film of yours that has a happy ending!

AF: Did you feel ripped off by that, at the end? 'To be continued'?

GG: No.

AF: Yeah you'll buy any crap I put together.

GG: Fuck you!

AF: I had a tough time with that one myself. All 'to be continued' means is, 'what are they going to do now?' If they keep dealing, they'll be killed. And they have to go back to a life that neither one of them can confront. Alright? You'll need another hour and a half for that one.

GG: Have you ever read Buddy Giovinazzo? He did that film *No Way Home* with James Russo.

AF: Oh yeah, I did read a book. He writes those really hardcore books about the lower east side.

GG: Yeah. *Life Is Hot in Cracktown*.

AF: Sickest motherfuckin' book I ever read in my life. And then he says to me, "you inspired this book."

GG: He loves your films!

AF: He sends me this book, and says I inspired this fuckin' VILE, nasty fuckin' thing, that I wish I had never

fuckin' read. That you can't get out of your fuckin' mind. I mean… something like that'll make ya stop making movies!

GG: You didn't like it?

AF: It's not that I liked it or didn't like it. I'm just saying… let me put it this way. I wish I wasn't the sole inspiration. How does *Life Is Hot in Cracktown* compare to *Bad Lieutenant*?

GG: They ain't that much different. *Bad Lieutenant* is the story of one guy. Buddy's book tells the stories of a lot of people. *Cracktown* has like 12 or 15 main characters. It's all about people in Brooklyn dying and going crazy from crack.

AF: 17-year-old kids who just torture each other. Who cut people up, and kill people, and rape people. They do this 24 hours a day. Behind crack. Which is fine, the guy is a great writer, obviously. And I got no problem with the book, I just wish I didn't inspire things like that. Okay, we're gonna head off now. You gotta watch *New Rose Hotel*. Please.

The Bard of Little Italy

- Nick Tosches -

"If you bring forth what is within you, what you bring forth will save you.
If you do not bring forth what is within you, what you do not bring forth will destroy you."
– The Gospel of Thomas: The Hidden Sayings of Jesus –

Someone who thought they knew more because of higher education once told me that there were exactly 17 types of writers. I stopped listening because he mentioned literary mould-spore Dave Eggers, and because he was wasting his time. Only 2 out of his 17 types do I care to read: those who create from a Christ-like compassion, and those with minds so inflamed by *Weltschmerz* that they are prone to visions of the whole fucking circus being torn down, as a means of being closer to a god they may not even believe in.

Nick Tosches is often of the latter variety: he types lines like poison darts, jackhammer prose, fuming poetry that is never content to remain just as ink, that would attack almost indiscriminately if made flesh. He is one of the last rogues, and without question among the truest ever.

Many working-class men with real intellect find themselves trapped between two opposing worlds. Bohemians may treat such social aberrations like roughnecks, while their native peers will generally mistake the earnest dialogue of these "others" as an exceptionally offensive insult. Surviving in that void, as that type of writer, necessitates a faith in arcane knowledge, like that Gospel of Thomas quote (one of Tosches's favourites). It also requires a frequent re-centring of one's self, through an endless battery of self interrogation during which the writer of unpleasant truths must inevitably ask himself: "there are good days, too, although never in this bilious wasteland… so why can I not look elsewhere for another sort of affirmation?"

Tosches, on page 82 of his transcendent and so-called obscene novel *In the Hand of Dante*, answered that with more directness than I've seen elsewhere:

"*I thought of myself as a tough guy. Writing, in this regard, seemed a respectable racket. Hemingway and others like him had rendered it so: a manly art – whatever the fuck that was. I mean, shit, none other than W.H. Auden had noted, in the late forties, that America possessed 'a culture with dominant homosexual traits.'*

Manly art. Only after I became a writer did I come to see this lie for what it was.

I came to writing through cowardice and fear. Deep inside me, I needed to communicate my feelings, and there was no one to whom I could. In the old neighbourhood, honest expression was a sure means to ostracism. Besides, it wasn't in me. To look someone in the eyes and talk from the heart was beyond me. Writing was thus a way of communicating without looking anyone in the eyes. It was far from a manly art. It was a cowardly art. Then again, maybe the two are the same."

This is hardly an attitude you'll find preached in any but the most cut-throat, outback poetry workshop. But Tosches is no mere contrarian ne'er-do-well. His bent explorations of squalor and viciousness state bluntly that not only will he refuse to pass quietly through a life of corporate sterility like a lobotomy patient, but also, using all that he has seen and felt, he will provide significant reasons for you to follow him. He is one of the last of America's writers to lend laughter to that earth-bound, God-baiting rage espoused by sentient beings that no longer flinch when reminded that they are sick, stranded, broke. Tosches sings the rage of scorned, scourged men, of killers and thieves, and has been writing about them professionally since 1981.

Nick was born in New Jersey (1949) and worked in a bar there until the age of 14. Alongside Lester Bangs, he penned music reviews for various magazines in New York during the '70s. His second book, *Hellfire*, told the story of Jerry Lee Lewis, while playing with the conventions of non-fiction literature. *Rolling Stone* called it "the greatest rock'n'roll biography ever written." He has since written books on Dean Martin, mafia financier Michele Sindona, and boxer Sonny Liston.

His violent, squalid, and profane novels about New York's criminal underworld have left as many exhilarated as repulsed, and the highly controversial, genre-fusing hell ride *In the Hand of Dante* opened with the line, "Louie took off his bra and threw it down upon the casket", proving once again proved that there's no middle ground when it comes to Tosches's work. *The Nick Tosches Reader*, published by Da Capo in 2000, consists of over 100 pieces personally selected by the author, from his first 30 years of writing. Abrasive and hilarious articles on Patti Smith, Jim Morrison, George Jones, Carly Simon, and Debbie Harry are mixed with Tosches's diary entries, letters written to friends over the years, and chunky excerpts from his books to create one rowdy literary street-brawl. *The Reader* is truly unlike anything else out there.

I visited Tosches once, at his apartment in Lower Manhattan. His aura was heavy, coming off like a sandbagged rampart deliberately constructed to save himself breath, to hold in the sacred and force back the profane, as if to say with minimal confrontation: "I might be hung-over, sleep-deprived, over-worked, talking to a ghost, or locked in a thought, and whatever it is, I am more comfortable without your shitty interference and couldn't give a rat's ass if you hate my guts anyhow."

I found that extremely comforting; it meant I didn't have to say much. But we spoke awhile about the state of things: he was fed up with his current book, for which he had already been paid but was having problems completing. I think he described it, in its present form, as "a total piece of shit." He was pissed off about New York having become a theme park, he was pissed off about the new ban on smoking in bars and restaurants, he was pissed off about a dirty look one of his neighbours shot him in the elevator when he returned from the bar drink-in-hand. Nick chain-smoked Camels in his pyjamas while I visited, and laughed a few times. Eventually, there was a long silence. I feared that I'd overstayed my welcome, and so rose from the couch and picked up my bag. The writer recommended a bar across the street and said, "if you tell 'em you're with me, they'll let you smoke."

Recently, I e-mailed a letter to Nick, and found that he had given up, utterly and completely, on America. "I'm sorry to see to you go", I wrote, "I was looking forward to meeting you in New York again. But I understand." His reply was terse and said all it had to: "may Lady Liberty bleed to death through her cunt." Nick now lives in Paris.

Here, like few other interviews I've ever done, was something that needed to happen in real time, in the flesh. But Tosches is a very busy man, and like the best of all those who practice the craft, an introverted one. I sent him a batch of hastily written questions, and what I got back was a far better and more generous series of explanations than I probably deserved. I've still got at least a foot of his work to soak up, and soon as I have all that under my faded leather belt, I'm heading straight to Nick's place in Paris as a dignified journalist for a long night of baptismal bar talk, to further assess the proximity between New York and Disneyland, between America and total oblivion.

Gene Gregorits: Is it true that you were the first to coin the term "punk rock"? And in the '70s, what were your real feelings about that form of music, as opposed to your deeper love of the blues, and country music?

Nick Tosches: Maybe I did coin that term, or at least the "punk" part of it, without knowing it. I don't know. I wrote a long piece called 'The Punk Muse' for a rag called *Fusion* in 1970. The title referred to the spirit of rock'n'roll in general, not to what later became known as punk rock. As for the stuff that did become known as punk rock, it was as with any other music. I never paid much attention to the categories. I liked some of it, discarded most of it. To me, it's all just a bunch of lunatics howling at the moon. Some of them bear me away with them, some of them leave me cold, and some of them, maybe most of them, just make me wish they'd shut the fuck up and go away.

GG: You are repulsed by the sanitizing of New York City, and communicated that very clearly in what might be your most shocking book, *In the Hand of Dante*. Have things improved in any way? Have you honestly considered leaving?

Nick Tosches. Jacket photo from *In the Hand of Dante*, 2002.

NT: No, things have gotten worse. This quality-of-life shit sucks. There is no life here. New York has become the real Mall of America. It's a sterile goddamn petting-zoo of dead souls. And, yes, I will get the fuck out of here: not just out of this dead hick town, but out of this whole damned dead hick fallen nation. All I need is the money.

GG: Did you have even a twinge of regret or worry before, during, or after having written that notorious passage in *Dante* where you and Louie are looking out the window of the apartment and scoff at the sight of planes crashing into the World Trade Center?

NT: No, never. In fact, when someone was interviewing me after that book came out, she brought to my attention the fact that I had referred to the World Trade Center as "the towering tombstones" back in 1988, in my novel *Cut Numbers*. I'd completely forgotten that. Just like I don't remember anybody "looking out the window" and seeing planes crash in the *Dante* novel. I remember the main character seeing it on television in the airport in Paris. Anyway, it's all just people killing other people. It's what defines humanity. What we call "inhumanity": that's what truly defines humanity.

GG: If writing is supposed to liberate the soul, why are writers always in such fucking misery? Do you ever enjoy writing, and how has the act of creation changed for you over the course of the last ten years?

NT: Maybe depression is requisite to writing. Maybe, in some of us, they're the same disease. Maybe misery is the muse. Look at Faulkner. Remember Kirillov, that character in Dostoevsky's *The Possessed*, who kills himself because he's too happy? That says a lot. I remember Henry Miller saying that the one book that he really fucked up was *Black Spring*, and that it was because he was too happy when he wrote it. Those great words of Beckett's: "I can't go on, I'll go on." It all comes down to that. But it also does liberate the soul. It can be an act of exorcism, purification, disease and cure in one. Over the years, writing, like living, has become harder but more honest. Honesty scares ourselves and others. But it's also bullet-proof: the all-powerful sea of the true selves within us. If I were capable of the act of creation, I'd create myself a long, healthy life, a few million bucks, and a beautiful loving wife.

GG: You don't do much writing on rock and roll music these days. Have you grown tired of music? What do you listen to these days?

NT: I long ago came to feel that writing about music was meaningless. One should just listen to the shit or not listen to it. I wrote for rock'n'roll magazines because, in those days, they gave you the opportunity to write about anything. I wrote a review of an album that did not exist. That was the first thing I wrote for *Rolling Stone*. My friend Lenny Kaye, who later became a part of Patti Smith's band, was working in a record store at the time, and he told me that all these kids were coming in looking to buy this record, which did not exist. One time, my friend Richard Meltzer reviewed a bottle of gin. Those were good wild times. You could write whatever you wanted in these rock'n'roll magazines. It was before advertisers had influence over the content. And everybody was broke, so those checks for $25 or $35 meant something. These days, there are no more wide-open little magazines that pay little but allow young writers to write what they want, as they want. It's either nothing or the big time: nowhere to break in in-between. This is unfortunate for young writers today. I've been listening to a lot of Arvo Pärt and Rolling Stones. I leave CD's on for days, weeks at a time now. I'm too lazy, or too disinterested to change them.

GG: Please describe your average day.

NT: I wake up whenever I wake up. I make coffee. Vienna Sumatra. I sit on the couch. I smoke a cigarette. I drink the coffee. I do nothing. I eat lunch. More coffee, more cigarettes. I eat dinner. I watch stupid movies on television. I go to bed, I read a few pages. I sleep. When I'm working, everything changes. I write for twelve to eighteen hours at a stretch. My sleeping, my eating, they're all thrown off. One way or the other, a lot of my time is spent avoiding social engagements and keeping unwanted people out of my life.

GG: Looking back on *Dante*, have you found any faults with it? I ask this because of the enormously polarized critical reaction to the book. It angered so many people... do you find it important to shield yourself from critics and their opinions? What do you feel are the benefits or detriments of reading reviews of your own work?

NT: I find faults with everything I've ever written. That's what the next book is always for: to correct the faults. To tell you the truth, it's been at least twelve years since I've read anything that I've written. I just write, then don't look back. It's freed my writing tremendously. Critics, especially other writers, have been very kind to me. When they're really good, they can tell you something about what you've done that you were not aware of trying to do; that deep down you were trying to do, but without conscious design. This is really rare. I don't feel that it's any more important for me to read reviews of my work than it is for me to read the work. The thing is to just go on. It's not necessarily a bad thing when a book frightens or offends people. Often it means that the book has a leopard-soul of its own; that it's a living beast, threatening and beautiful at once.

GG: Artists – writers specifically – have always, for the most part, been partial to drugs and drink. In your own experience, and you have been very forthcoming in your writing about that kind of chaos, what is the relationship? Must writers create terrible scenes and controversies in their own lives as some form of justification?

NT: Booze and drugs have always been a part of my life. But never when I work. You might say that I live dirty and write clean. Whatever that says about me, or the nature of

Nick Tosches. Photo by Gardabelle.

my life and work, God only knows. I don't believe that I ever set out to fuck things up in my life. It just turns out that way. And I don't believe it's a justification for anything. And I don't believe the writing justifies the fucking-up, either.

GG: What books have you not yet written that you feel are important to write?

NT: My autobiography: my life, my confessions, my indictments. Then again, these days, it's all but legally impossible to tell the unveiled truth. And there are novels and poems, both foreseen and unforeseen.

GG: I was especially moved by your essay on the song 'Sea of Love,' because it's always been one of my favourites too. Have you heard anything that comes anywhere close to a song like that, in the music of the last ten years? Do you pay any attention to pop culture at this point?

NT: No, I've never heard anything like it. Pop culture is just meaningless, fleeting, ephemeral junk. Rarely do I hear or see anything from the commercial marketplace that moves me or even brings a smile to my face.

GG: If you could be anywhere in the world right now, where would it be?

NT: In Suite 511 of the Ritz in Paris, in bed with a good book and the love of my life. Then again, the opium den in Vientiane wasn't bad, either. Maybe somewhere quiet by the sea. Or in the mountains. Anywhere but this fucking repression zone that used to be New York.

GG: Do you often meet fans? Do you do signings and readings, and if so, what is your emotional reaction to such things?

NT: I meet a lot of them. It always feels good to find that you've meant something to someone whom you've never met. It's a gift, and sometimes, when the money's not coming in, it's a payday unto itself, and it makes all this fucking typing worthwhile. It's often a beautiful feeling. Sometimes friends have even entered my life this way.

GG: What was the last thing that made you laugh?

NT: I was in the emergency room with a bad hand injury a few nights ago, and these doctors are giving me this doomsday scenario, and I look away for a moment and see this sign that says: "Artificial Hand Class Meets Here Every Tuesday at Noon."

GG: Hubert Selby was and is very important to you. In what ways has your life or general outlook changed since his passing?

NT: I feel like a certain very important breath has vanished from the air of this life. He was one of a kind, a unique and beautiful character, and the world – my world, anyway – will never be quite the same without him. When I was a boy, his book *Last Exit to Brooklyn* gave me the strength and courage to write. His second book, *The Room*, is one of the great books of the age. He once told me that, after he wrote it, he was afraid to read it for more than twenty years. He was a great guy. His death has been very sad. The other day, some guys making a documentary about him were over here, and right now I'm sort of all talked-out about it.

GG: You have spoken of a novel that you are under contractual obligation to complete, which you are behind in schedule on and loathe. What is the status of that now?

NT: I've resolved that situation. In doing so I learned never to sign paper for money alone.

GG: Describe the overall experience – emotionally, circumstantially – of writing *In the Hand of Dante*.

NT: It was the culmination of something. There was an illumination that led to this book: the illumination that to give people words without wisdom, or without power or beauty, is to give them nothing. In this book, I let nothing stand in my way – neither the forms nor conventions nor conceptions of fact or of fiction – in bringing forth what I could of wisdom, power, beauty. It was as if I loaded six bullets into the chambers of a gun – fiction, truth, poetry, prose, love, hate – then spun the cylinder and began firing. I hope I killed something: something bad inside myself, something bad inside the souls of others, something bad in literature and culture. And I hope I liberated through these shots. Let's just say that I did the best I could. I wrote exactly as I wanted, or exactly as it flowed from me. There is much fear in America now, and people are becoming very afraid of words and the true nature of our souls. The character that I invented and the character that is me share the same heart and soul. The character has my name because, very early in the writing of this book, I saw that I was very much expressing my own feelings, so I decided not to hide behind a persona, but strip away the veils and call my "character" by his true name. It was a great experience, tied to something terrific that emerged within me.

GG: What was the worst day of your life? And what was the best day?

NT: Every really bad day seems like the worst day until the next one comes. As for best days, I've had a lot of them too. All things considered, I've been lucky.

Year Zero

- The Kills -

Majestic Bar, 2 April 2005. I stomp in like a deranged beggar, high on expectation and fear, thinking that my mission is to gain the respect of my favourite band: The Kills. For the last hour, I've been getting thrown from one street to another by brutal winter winds, through the streets of Detroit, ultimate squalor, structural damage, fractured thoughts about tactics and methods, resigned to thinking schizoid mission statements like this: "I must crack their code." Heinous.

"Once in a while, you've gotta burn your lips to keep your feelings alive
Once in a while, you've gotta burn down your house to keep your dreaming alive."
– The Good Ones –

Alison Mosshart and Jamie Hince.
Courtesy of The Kills.

That lyric in particular is a sparkling example of why I've come to be so smitten by The Kills over the last few years, since their debut album *Keep on Your Mean Side* finally convinced me that there is a future for rock music after all. The Kills were what I sought in 1992, publishing *No Future: The Sid Vicious Fanzine.*

I went to pieces in front of them. I threw as many cans of beer as I could carry down on their table, where they waited patiently for me, and promptly dropped my tape recorder from the pocket of my oversized leather coat, a designer label, the kind worn by professional Gotham muckrakers. I went beet red when I realized that my equipment had detached itself from my person: it did shatter. But luck was with me, the guts of the machine remained intact, and the voices of The Kills (Jamie Hince and Alison Mosshart) took to the cassette tape with great clarity.

I've been saying since 2002 that The Kills are the most important thing happening in music right now. Maybe even beyond music, they have weight and like to throw that weight around. Growling, seething, screaming, sobbing: pallid fiends in the grip of psychosis, in the wee hours, in the moment of truth, in the dark, Jamie and Alison… locked in like two dirty secrets. They shot to fame in 2003, after their daring and brutal first tour which was self-financed on a credit card. The buzz was huge, and led to another tour with loudmouth ne'er do wells Primal Scream.

"This ain't no wow now. They all been put down. Who ain't dead yet, fled to die closer to the shore. This ain't no wow no more."
– No Wow –

I've been feeling what they're saying since I was old enough to have wet dreams. And oe'er the wastelands I cruised, on Greyhound buses, in the thought, in Xerox and ballpoint ink, searching for light, life, hard-knocked little creeps with nothing to lose, free enough to say the right words, the smart words, the words that were meant to kill. Free agents, subterraneans, the right vibes, the bad vibes.

So here I am on 2 April, 2005, with The Kills, Jamie and Alison. My saviours! My Romeo and Juliet of True Bad Vibes. When you agree with someone, full total, it's best to stick to the game of devil's advocate, if you want the deeper truths. I utilized what energies were left, in search of objectivity. That approach quickly disintegrated. Fuck objectivity. Objectivity is a lie.

And so…talk about Gratitude / Euphoria / Relief! "What took you so fucking long?" I screamed at them. Perhaps they considered fleeing the bar. "The new galvanizing force, the answer, the cure!" The poor dears had only just woken up on their tour bus, which was parked outside the club.

Jamie and Alison, a.k.a. Hotel and VV, are in fact quite kind, shy actually… in the flesh, you would notice a tenderness exhibited openly in only a handful of their songs. Both extremes are sincere and authentic. They are sexy, nasty, and uncompromisingly innocent. Blacker than ravens, and whiter than swans. The Kills are a profoundly full-bodied experience, and they are as concerned with NOW as any of their outlaw antecedents. They are the sex symbols of a new generation that unfortunately hasn't found its dick yet.

Too classic for words, like a couple of traumatized punks, disused trailer park sweethearts, the rare kind, the most dangerous kind, who've had enough and know what to do about it: lock and load, stay free, stay wired, keep shooting, keep moving. Year Zero, another writer observed of The Kills' emotional and philosophical location… that's where they *live*.

Jamie is British, and Alison grew up in Florida.

Alison Mosshart and Jamie Hince. Courtesy of The Kills.

Gene Gregorits: You two are pure trouble. And this headlong dive into bad vibes, pure nightmare Americana that you've taken… it's bothered me a little bit. Because I've been waiting for it, for a long time. I just didn't expect anyone to come out and do what you're doing. But I think that beyond all that you've got true revolution in mind. What's the general reaction been to your hyper-aggressive attitude?

Jamie Hince: It's kind of split. There's definitely people that think… we're saving their world in some way. [*laughs*] But there's also people that hate it! That's funny in music. You explore things that are weird and dark, you're considered to be underground. But those things have always been celebrated in film and literature. It's almost expected in mainstream cinema, to explore beauty vs. ugliness, and love vs. tragedy. In music, it's very restricted, I think.

GG: I'm more focused on film and literature, not out of any lack of love for music, but I have to say that I am a little let down by it. I've been waiting, since I was a kid for another *Never Mind the Bollocks*. I'm always looking for something that measures up to that standard of ferocity. You delivered that to me and I really appreciate it. Primal Scream, they really got to me as well, with their record *XTRMNTR*.

Alison Mosshart: That's a great record.

GG: You toured with Primal Scream. What did you guys talk about?

JH: Well, we took a lot of drugs. Bobby Gillespie is really intense. Especially with music, he's an absolute obsessive. I find that really exhilarating, finding somebody like that. Rock'n'roll is a weird thing, but there's this paradox, because on one hand, to the people involved in it, it is life and death. Literally. It killed Sid Vicious, and it killed Kurt Cobain… On the other hand, it's totally absurd, and ridiculous. It's weird being in that paradox. You can't talk the life and death conversations that you want to talk about with people, because everybody taps into the fact that it's really just this ridiculous thing, in the context of the world. But then you've got a guy like Bobby, and with him you can totally open up! We had a fistfight about The Doors. Because I don't like The Doors! He strangled me because I said The Doors sucked! He couldn't stand it! And I love that!

GG: But The Kills have a philosophy. I mean, 'No Wow' is meant to say that things have reached a terrible deadness now, right?

AM: What it means is… it's asking for more… It's asking for a scene, and a time, and a community of people having creative chaos again. Something that is uncontainable. So it is a criticism, but it's not a focused one. We are not saying "there's no good bands or good art being made." The way people accept the way records are released and promoted. There's too many lines drawn, and all these little boxes to put these things in. We've grown up being inspired by legends. Just seeing things being really

> **"Rock'n'roll is a weird thing… on one hand, to the people involved in it, it is life and death… on the other hand, it's totally absurd, and ridiculous."**

chaotic, just creating all the time and making a mess. That's exciting. That's what we wanted, and that's what "No Wow" came from. Because everything has become contrived and controlled.

JH: Talking about the Pistols, and also The Velvet Underground, all those scenes… the legend of those scenes is what really inspires us. They seem to have been full of artistic anarchy. Bands weren't about just making records, doing a tour, then making another record. Real creativity can't be tied down like that. You can't read about The Velvet Underground or Warhol or Ginsberg, that whole scene without getting frustrated. Same with the punk movement. Kids from council houses writing poetry and fanzines! All this art and creativity just flying everywhere. I think that record companies have learned to absorb that in a really dull way, and channel it into poster campaigns and promo videos, album artwork. I think that's what's missing, is the chaos. I wanted to ask you about Rockets Redglare, that stuff in your interview about Nancy being murdered in a snuff film, is that true?

GG: I didn't know Rockets that well. I ended up falling in love with Lydia and moving out to California. [*laughs*] And then he died. I'm sure if I'd stayed in New York, a lot of that stuff would have come out. Because I really grilled him about it all the time. I really think that he just liked to freak people out, and that he was cashing in somehow on his past as a friend of Sid's. But I should be asking you guys some questions. I'm off track now. Here's a good question. You've declared war on the zeitgeist, but you don't come across as being brazen or egotistical in the interviews I've read with you. So does The Kills ever seem like something you have to do, that's been thrown in your lap?

JH: Kind of. When we met, we were both so disillusioned with the bands that we'd been in. We were living sort of parallel lives, four thousand miles away. We were both doing art and music and film every day. We had identical bedrooms full of books and movies for no one to watch or

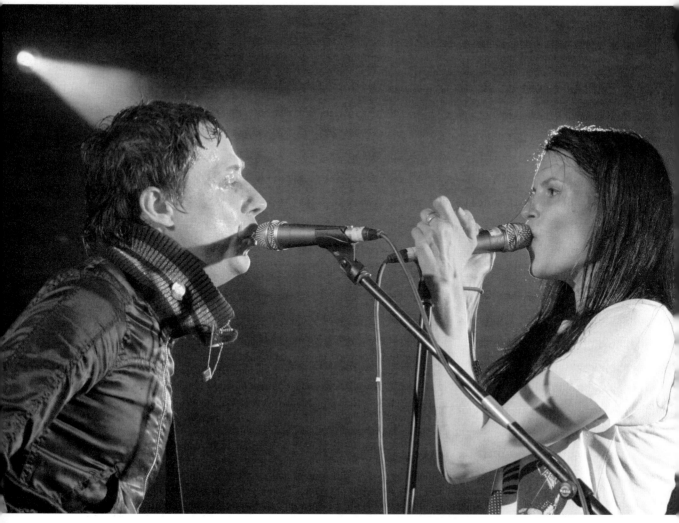

Above and opposite: The Kills live on stage. Photos courtesy of Stefano Masselli.

listen to. In a way, we felt like social outcasts, in our little group of friends. We were the weird ones, staying up all night and doing all this stupid stuff.

GG: Like what stupid stuff?

AM: Recording things, and writing tons. Making little short films in your room.

JH: Making music that was not for anyone to listen to. Doing stuff for our own fulfilment. It did seem like a very natural thing, that we were gonna make our lives into a band, rather than just have a band in our lives. When we met, it just seemed like the natural thing. It never felt like a pact or anything. I feel this real urgency. Music has become a fucking treadmill, it's a pretty good job opportunity now, to be in a band. It's just a really weird thing that that ever happened. I've definitely missed out on something. I felt very urgent about that, that if things didn't change, all this time would be wasted on something that was just a stupid moneymaking thing.

GG: But everyone else will tell you that everything is happening! New York is happening, LA is happening... what is it about you two specifically, that separates you from the pack who doesn't see these problems as being so huge?

AM: I don't know where it came from, I don't know how that happened, but I know that's why we met. I know that's why we work together. Because we finally found that other person who doesn't piss us off in that way. We just do exactly what we wanna do. We don't ever try and stop each other.

JH: You just have that instinct or you don't. And you wanna leave your mark in some way. The whole thing's like a big fucking suicide note, in a way. Just wanting to leave your mark. It goes back to that thing of life and death versus just being ridiculous and absurd. I've always been tapped into wanting to leave my mark. These things that all inspire me though, these scenes and artists and

musicians, are long gone! I don't see any of that around me anymore! I don't see people making their lives into works of art, and wanting to leave their mark.

GG: In Detroit, there is an attitude that you are obnoxious and uncool, that you're going to be ostracized, if you communicate any sentiment of things being not good enough in music or whatever. Have you encountered a backlash, people who hit you with, "who the fuck do you think you are, to say that there isn't any wow now?" You know that kind of thing?

AM: We do have that. People telling us, "you know, you really are just stuck up." There's not that much though. I think that people that hate you don't really tell you very much. But we do get the odd letter where it's just ranting, like "how DARE you?!" That's good. I welcome that. We really want people to love us or to hate us. We don't really want anything in the middle. Because the middle just keeps everything the way it is. If you can have a really good argument with someone, then that's fantastic. Or if you can agree on it, that's fantastic.

JH: I've been extremely successful for years, at living in a bubble. We created a bubble around the band. We've got our idea about what we want to achieve, and I'm not really super-interested in the antithesis of that, so I stay away from it. I hide from the backlash.

GG: Yeah, you're really up against it. It's like the title of your first record, *Keep on Your Mean Side*. That says fucking everything… but now I have a new question!

AM: [*laughs*] Alright.

GG: The drum machine… because you don't have a drummer, you have a drum machine. And it is used, on the new record, as a torture device! It is an obnoxious little demon… You should call him Little Bastard! This is just what hit me when I was listening to *No Wow*, you know? Who is this little bastard? The words are so beautiful on the record. It's heartbreaking. But… this drum machine is driving me fuckin' crazy! It's so efficient, and who the fuck does he think he is? Doing all this great work for you guys, and he doesn't even have a soul!

JH: It does drive people crazy. They come up to us, they say you need a drummer! I like that it pisses people off. I like that it bugs people. All the things I love have a sort of imperfection running through them. The Velvet Underground, almost every song has an imperfection driven through it! They'll write an amazing song, like 'Femme Fatale', and have, like, the backing vocals, [*singing like a retard*] "*FUM FAY-TULLLLLL*!!!!" They have this sort of German machine woman singing. I just love that sort of imperfection.

GG: Well, a drum machine is so very guerrilla.

JH: It's very anti-rock'n'roll as well, and I like that. Rock'n'roll is very much about explosions and tempo changes… the energy! Being able to explode all the time! But we just said, that *was* a torture device, when we started! Intentionally holding back all the time! And what

we found was that the more we held back, the more there was this tension, you know you… you… can never just EXPLODE! So, yeah... we really relied on that.

GG: That is just so fucking great. That's what makes you guys great. That little bastard.

JH: We did a show in Sheffield, and Bobby Gillespie played drums, on 'Kissy Kissy'. It was just mental! It was like watching some old Jesus and Mary Chain footage. [Primal Scream front man Bobby Gillespie was the original, slow, minimalist drummer for Jesus and Mary Chain. –GG] It was just so weird, the dynamics of being held back, just so bizarre.

GG: You guys have taken it upon yourselves [*laughs*] to define... the heart of darkness! Of Middle America! Why?

AM: Part of it comes from travelling a lot. We've driven through Middle America a lot. Is Michigan considered Middle America?

GG: It is. But we're still in the same time zone as New York.

AM: We were living in Benton Harbor, Michigan. It's a ghost town, really. One of the songs on the new record is about that. We went to this Meijers supermarket. This is the only open store in Benton Harbor at night, the only thing going on. There's… nothing there. We're just observing what kids would do there, for fun. And what they did was, they got really fucking dressed up, to go to this grocery store, to try and meet boys, to try and meet respective partners… It's strange to see what happens, when people have nowhere to go. When there are no thriving big cities, and there's only the grocery store. It's strange to see how people fall in love, and meet people. What they do, and what their interests are.

GG: You are very romantically attracted to that. Your first record had a lot of atmosphere of that sort.

AM: I find it really interesting! And I find it very upsetting as well. Sad, and beautiful. I like taking pictures of it. It's a real love and hate thing. It was the same for me, growing

"I'm starting to find it really interesting to see people looking scared, when I look at them."

up in a small town in Florida. I used to travel around with my parents all the time, and see it. It's like glue there, people do not get out, people never make it out.

JH: I think you get a very weird sense, travelling through America… if you're an atheist, and you have no interest in money, there's really nothing left for you. And your observations become really bizarre, if that's the case, you know. If you don't have God, and you don't have money in your life, then what is there here? They seem like the things that stop everyone from rioting. So if you don't have any interest in either one of them, I guess you just turn it into… bullshit art! I don't think there's much left. I think I've been kind of forced into being like this, really. I feel like I'm forced into being nihilist. Just because there's not much beauty in anything, except watching it all come tumbling down, and turning it into music, or writing, or a film, or whatever. Look, *No Wow* was born out of being on the road for a year, touring the first record. It was all our observations, all our emotional conflicts. All the themes of *No Wow* came from the road.

GG: What surprised you most about that year on the road, what came at you from that, that you hadn't presupposed, about America, about Europe, and about where young people are right now…

AM: I thought it was quite fantastic. Because we didn't do that much press. We just didn't do press, for a really long time. What was happening was, people were finding it really hard to track us down. People were just talking about it, there was this very strong word of mouth feeling. Quite exciting, being that the word of mouth thing doesn't exist so much anymore. People were *telling* about the band, rather than *reading* about the band.

GG: That's the impression I get. You guys just drain yourselves on stage every night. I can't even imagine how you can keep up that level of adrenal overload.

AM: It's great. It's so much fun! It's that one moment of the day where you get to be and do whatever you want! It's a stage.

JH: The stakes are pretty high – I mean, I always feel like I overestimate how much you have to do, how much you have to give. I didn't think we did half enough! And people ask us, how do you do it? I just feel like I'm not gonna be happy until I just give 'em *everything*, until I just can't MOVE anymore. Somehow, for some reason, I think my stakes are just a

lot higher. Sometimes, to an embarrassing degree. But they just fucking are! They're high! [*laughs*] I expect more! I want more! I want more out of it!

GG: So how do you guys manage to get drunk every night, and then maintain your electrifyingly sexually intense stage performances without complete breakdown?

AM: We do not get drunk every night. We get drunk every once in a while.

JH: We get drunk every *other* night!

AM: Sometimes, you just can't!

GG: When you're on tour, right…

AM: We've done that before! And it just ends in really bad sickness. Cancellations and stuff. I can't cope with drinking every night, I just can't do it.

GG: What's the worst trouble that you've had so far, on tour? Do you have fans like me, who just scream at you from out of nowhere?…

JH: I don't know what other bands go through, maybe they get all that. One thing's for sure, in music… is that even the shit-est band in the world, is somebody's favourite band. Dunno if that answers your question, but it's true.

GG: Are you attracting the right people?

AM: We got a lot of amazing letters. That's one of the only ways I can tell. Because you can't talk to every single person that came. Usually, you get to talk to five, six, seven people every night, while they are ushering everyone out of the club. So you just get the people that really do wanna talk, and they're just sneaking around, waiting.

JH: This tour, more than any tour before, people are just coming up because they're fans. Whereas before that, you had people who talked about how someone had namedropped us, or about how there was this "sexual chemistry" thing. They'd say, "IT WAS LIKE *FUCKING ON STAGE*!"

GG: Can you deny that though? Because it *is* like fucking on stage! It's the most fucking I've ever seen on stage in my life!

AM: I can't deny it, because that's what people see. But you know, that's the beauty of performance, that's the beauty of being on stage and feeling free to do whatever you want. The stage is the fucking line. That's your space, and all those people on the other side are, well… it's you against them. And they're thinking what they want to think.

GG: Can you honestly say that you didn't expect that reaction when you were writing and rehearsing these songs?

JH: Yes, I can honestly say that.

AM: Look, we don't know what we're like, to other people. We write everything, and it's just the two of us, in a room. We play it on the stage like it's just the two of us in that room. We don't even look at anybody. We never knew, for a really long time, what people were thinking. I don't think you can plan on that stuff. You can't just decide to be that way. On stage, I can't control any of it.

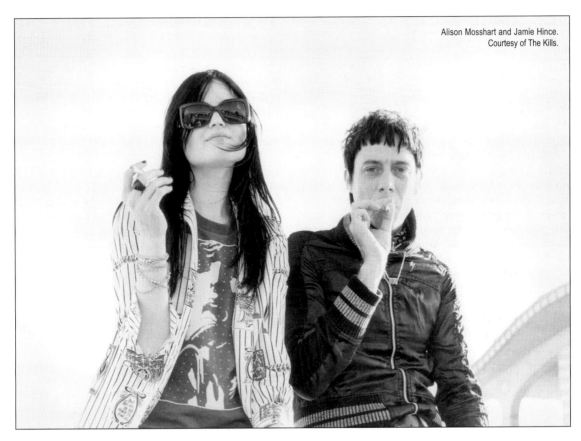

Alison Mosshart and Jamie Hince.
Courtesy of The Kills.

GG: So what's going through your heads, when you're up there?

AM: It's like daydreaming.

JH: I've already cut off the rest of the world, really. We spend 24 hours a day together. We work together, we live together, we socialize together, and everything, to me, is just a build-up to that one hour of being on stage. We just try to get lost in it. We really don't even know what we're doing. I don't build any sort of sexual thing. For people watching it, well if that's what they get then that's what they get. It's definitely not going through my head. I'd love to be able to, some days, just go off the stage and just walk all over everybody and just beat a couple of people with a guitar, but I don't do that so it just comes out in weird ways.

GG: That thing where you don't look at the audience. You're not making contact with them. Would you guys consider yourselves isolationists in a general or explicit sense?

AM: I think we are definitely isolationist as a whole. It's changed over time. It's a look. But we don't talk to them. I'm starting to find it really interesting to see people looking scared, when I look at them.

GG: This may seem like a stupid question, because you're a band, that's what you do, you do music, but have you thought about going beyond that? Will The Kills someday go beyond music?

JH: Yeah. You know, we spend more time doing other things, doing art and photography and writing, than we do doing music. Music just happens to be what we've become known for. So yeah…I definitely want to do things other than music.

GG: Do you think it's possible to bring back the old… in a way that galvanizes now, in a way that has nothing to do with nostalgia, without being romantic about it?

JH: It's very hard in music, like… doing a record of just droning isn't gonna have the same impact as when John Cale did it. Or swearing on TV, is not gonna get you on the front page of every newspaper, like when the Sex Pistols did Bill Grundy. Now, it starts to become a bit abstract. I don't even know what the equivalent would *be* now. I want to get into a situation where I'm not taking anything on board from the past. Because that's one thing that's really stupid about music at the moment, is that it's all so referenced, it's all so nostalgic. Where reference becomes everything. I'd really like to get to a point where I can shut all that out. I don't know if it's possible, but I want to be a forward thinking man! I want to break ground, like those bands who inspired me did. Not just copy them, but really break ground. That's what we're heading for. That's the world we're trying to create.

AM: Something that can be a beginning. That's what we want for ourselves.

At Peace with the Beast

- Patton Oswalt -

I don't think I could possibly be harder to impress when it comes to stand-up comedy, but Patton Oswalt makes me laugh. The first time I caught his act on television, with Close-Captioned subtitles in a noisy redneck pub, I thought to myself, "now here's somebody!" The brouhaha behind me seemed to drop a few decibels and I kept reading those subtitles, following the jokes along, joke after joke.

The grotesquely early death of Bill Hicks left a yawning void in that art form, and Patton is one of the few who's successfully set up camp there. But don't expect the fire and brimstone of Goat Boy Hicks. While the personalized material his repertoire consists of can hardly be seen as harmless (a brilliantly descriptive, sustained spoken word portrait of the Biblical apocalypse – replete with geysers of menstrual blood and Avril Lavigne reciting the screenplay of *Good Will Hunting* – being one noteworthy showstopper), he's really just doing traditional stand-up. One main distinction between him and the others is his exuberance; it's a quality that would charge anyone's material, and it certainly charges his. He's fun to watch.

Far better recognized as an actor, recently having appeared in mega-budget detritus like *Blade: Trinity* and *Starsky & Hutch* (and he can be seen weekly on the hugely popular American sitcom *The King of Queens*), Patton knows his way around the industry like any other highly paid showbiz vet. But for all his professionalism and mainstream visibility, he remains a down to earth punter, unabashedly enthusiastic about rock'n'roll, comic books, movies, and the rest of it. His first comedy album, *Feelin' Kinda Patton*, was released in 2004.

Gene Gregorits: I just watched the documentary *Outfoxed*, about Rupert Murdoch. It's horrifying.

Patton Oswalt: I missed it when it was in the theatres here in LA.

GG: Do you pay a lot of attention to alternative media, for documentaries like *Outfoxed*?

PO: I've got a circle of friends that I e-mail back and forth. We try to keep each other up to date. I'm lucky to live in LA, because there is a documentary association out here, and there are documentary festivals, so I have access to a lot more documentaries that don't get played other places, which is too bad. Because the people that need to see them are the same people that are being directly affected by this stuff. A lot more than I'll ever be. It's weird that I'm the one who gets these things shown to him. There's people that need it!

GG: It's funny that when something finally does reach mainstream shopping mall America, it's propaganda, like *Fahrenheit 9/11*...

PO: Michael Moore... well, yeah, the core of his message is completely valid and completely accurate and true. It's his method of presenting it that gives his enemies, who unfortunately have a daily platform – especially these radio guys and daily columnists – it gives them such an easy way to attack it. Yet, their own methods are ten times more suspect and wrong than his

methods. There are problems with his methods, but they pale in comparison to the validity and the raw fact of his cases, in whatever he presents.

GG: They may be necessary at times, but the ambush tactics don't come off very well.

PO: Yeah, and his satire spilling all the way over into parody sometimes. Because, by using parody, he is admitting that he's chosen the wrong targets. When he showed the montage in *Fahrenheit 9/11*, of the Coalition of the Willing, he used cheesy stereotypical footage to show these different countries, and the problem with that is that it's exactly what the fucking right wingers do. And I'm saying to myself, "NO dude, what are ya doin'?!"

GG: You've talked about living in shitty apartments, in shitty neighbourhoods, earlier in your life, with outlaw ideals. Aside from that bit in your act, what did you gain from that period in your life?

PO: I was able to get away from this obsession of not wanting to be a hack, and also this obsession with this totally innovative, new, raw, DIY sensibility. I found this grey area right in the middle, that I came to realize I wanted to exist within. I decided to be a stone pro. I wanted to be a fucking professional. I don't listen to mainstream hacks who say "you have got to do it this way, this is the formula and this is how it works." And I

Patton Oswalt. This page and page 328, photos courtesy of the artist.

you know I'm on it, why do you care? I ran into a few problems a long time ago. It's a family friendly 8 o'clock sitcom, so… some people would hear about my comedy, thinking "oh, this is the guy from the sitcom!" And found that what I did was totally not what they wanted. There were a lot of walk-outs and a lot of refunds.

GG: Was there anything about the show that you found interesting, anything exceptional?

PO: Your average sitcom is written by hard-drinking, pot-smoking writers who are bitter and cynical and funny about everything… and they just try to smuggle their stuff into a family friendly sitcom. That, to me, is a beautiful thing. Because sitcom work – if you can get it, there's not a lot left, it's all going away – it pays insanely well! So are you supposed to get a job at Blockbuster and just write innovative stuff all the time? What's wrong with making a living?

GG: What came first, the TV work or the comedy?

PO: I did stand-up for about ten years before I ever did a sitcom. I started back in 1988. But I didn't really write anything that I really liked, or was proud of, until about '94, '95, when I finally found a voice.

GG: Who were your heroes early on?

PO: Jay Leno… live, he was amazing! Wasn't into Bill Hicks until much later. There was a local sportscaster named Glenn Brenner, his way of doing things on TV was really bizarre, it was really unlike anything I've ever seen. He died, unfortunately, before he went national. Jonathan Winters, stuff like that. Then as I grew, and as I started seeing more comedy, I would notice small things about comedians, like "oh that was great, he made a mistake and then recovered so well, with that audience." But then I'd see the same guy making the same mistake every night, and recovering from it. It's really too bad, because even when Jay Leno is on a show like *Charlie Rose* or *Real Time*, he's still a sharp intelligent motherfucker, but then he unnecessarily sands his edges off, in order to appeal to the lowest common denominator. He was a great warning of the worst thing that could happen to a really great comedian. Much later, in the early '90s, I got into Bill Hicks right before he died. I worked with him a few times. From that point on, he was pretty much just my friend. I was lucky to have really funny friends to hang out with.

GG: What was the first time you ever wrote a bit that made you realize, "okay, yeah, I'm funny"?

PO: I don't know… I never really wrote down bits. I would just go onstage with a list of topics that I wanted to do, and I wanted to do a lot of stage work so that my bits could be written from that process. I could never tell you at which point, and with which bit in that process where it just hit me, "there it is." It's got to be as much of a surprise to me as it is to the audience. That's just my method. I'm not saying that that's the perfect method, I'm just saying that that's the way it works for me.

GG: What were your first few shows like for you?

also don't listen to these inexperienced amateurs who scream "SELLOUT!" or "what the fuck is this you fucking phony?", because they are people who have never done anything that people wanted to buy in the first place. It's just learning how to ignore two sides. It's like the little fucking suburban boy wanting to live like the edgy poor people, then learning that nothing comes out of poverty but just more poverty, and hatred.

GG: Well, I can empathize with those who really are poor, but that said, I do believe that this sort of punk rock bitterness is just nihilistic and meaningless at this point in time.

PO: It's a pose. I'll get from some people, "what the fuck are you still doing on that sitcom?" And I always think, "what the fuck are you doing watching it? Stop watching it, dude, it's awful!"

GG: Well, what about that sitcom? You are still working in television…

PO: It's fun! It's not that awful, *The King of Queens*, but I always say that in response, because if it is so awful, why do you clearly watch it every single week? Why do

PO: Well, really nerve-wracking. Because I treated them the way most beginners do, like really big deals. Really crucial. Nothing you do during the first ten years of your career, positively or negatively, impacts how the rest of your career goes. So I started taking a lot more risks and feeling a lot more relaxed. But I also think it's part of it, in the beginning, that you have to not be relaxed, so you can figure out on your own that that fear is kind of pointless. You just go up all the time. Just like a writer's got to write every day, or a musician has got to play every day. I don't think I have crucial shows anymore. Getting into that thinking is really bad, and that creates bad comedians. Back in the '80s, there was that mentality of, "you have got one shot to make it work man, and when that shot is over, if you've blown it, FORGET IT. Just close the door on your career." And that mentality is so fucked up. That creates awful comedians. And that's the way a spot on Johnny Carson was regarded. "You have got to get the most killer, clean five minutes… take them on Carson, and then you see where you stand." These guys would engineer their entire stage act, their entire persona, their entire selection of subject matter, which is now being looked at through a tunnel, based on what is going to work on Carson. In '91 the guy retires, and these guys have wasted ten years of their lives.

GG: I'm sure you get young comics coming to you for advice constantly.

PO: I always say the same thing: "get up on stage every night." That's the only advice. Anyone who would tell you anything else, it's just not the right advice. And then they'll ask me about subject matter to which I reply, "that is not my business. It's no one's business but yours." I mean, what if a comedian is pro-Bush but he's really fucking funny? What if his pro-Bush material is fucking brilliant? What am I supposed to do, say "don't do that?" There's a few conservative comedians I've seen who do funny stuff. I remember when Rush Limbaugh started off, before he got all full of himself, he was actually kinda funny. I used to sit there and say, "I don't agree with that but it's pretty funny."

GG: There was a tension in Bill Hicks's performance, which he would usually stretch until it broke, that tension which came from pushing the limits. What are your thoughts on a comedian who is seeing how far he can go? Is that valid?

PO: I think it's valid, but if you are consciously trying to do that, that's just as bad as a hack that's trying not to offend an audience. It's not a conscious thing. I don't think that the true edgy people out there really think they're edgy. I don't think that David Cross thinks he's edgy. The way he is onstage, that's just how he thinks. I doubt that he ever thinks to himself, "I'm gonna say this because it'll piss everyone off."

GG: Is comedy better when it has an element of performance art in it?

PO: No, I don't think so. Comedy is always funnier when it is based on who the comedian is, as a real person. If it really reflects who they truly are, if they are being honest. I mean, someone like Brian Regan is a genuinely decent guy, who just thinks about nonsensical stuff all the time. He doesn't have a political bone in his body, and he embraces that, and he's fucking hysterical! He's just as funny as a David Cross or a Bill Hicks. Again, I don't think we're sitting around saying, "this is what I've got to do." Zach Galifianakis really breaks boundaries performing, in his format, and it really does come close to being performance art. But it's really not a calculated thing. That's just what he thinks is funny.

GG: But what about the notion of a performer being in some way irresponsible if he doesn't in some way, if only as a two minute bit, politicize his work? Is that not in some way necessary, when the nation is divided, when we are seeing before us one lie, one abuse, after another?

PO: The idea of putting responsibility on a performer is very undemocratic to me. You can't have every single fucking comedian that goes on stage giving you a civics lecture. You have to be funny first. I'm not against being political – you should certainly talk about something if you think it's valid. But the trick is to have a fucking joke, because otherwise you're just a pundit. And fuck that! You have to make people laugh! Period. Because you're in a fucking comedy club! It says "COMEDY" on the sign… so you don't just go up there and lecture people! That was the problem that Bill Hicks had towards the end of his life… he was just going up there and lecturing, and he stopped being funny near the end. It was kinda hard.

GG: What are the dangers of you speaking out politically, when you work within the mainstream entertainment industry? How much consideration are you forced to apply to your performance, because of the other gigs being where all the real money is?

PO: Luckily, stand-up comedy is still considered a ghetto art form, so… yeah, there's been a lot of hate mail sent to CBS. I know that, because they've shown it to me. But I can't think about that. I was doing this for ten years before I ever got this gig, so I can't throw away something that I dedicated that much of my life to, for something that I've been doing for a very short amount of time. And no sitcom lasts forever, so… what, do I change what I do, for this temporary gig? I'm never going to stop doing stand-up. Stand-up you never have to stop doing. So why would I just go, "these are the years where I wasn't edgy anymore, because I worked on a sitcom, and that's where my money was"? That's boring.

GG: When CBS showed you these hate mails, what tone did they take with you?

PO: Oh, they were laughing about it. It wasn't like, "Hey, what the fuck?"

"Being onstage always puts me in a better mood... it's fine to go up there and be angry. In fact, the angrier you are, the more jokes you better have."

GG: They can't be anywhere near as right-wing as the Fox network.

PO: No, it wasn't anyone from the network, it was the show's producers and they were laughing. A lot of times, the further you move up the showbiz ladder, the more Zen people tend to be about things. I can remember a weird parallel where, right before I moved to LA, in '94, I was working at a club in Baltimore, me and this other comedian, Blaine Capatch. We both had a great show together, and Friday night the manager called us into his office, and he had this fucking huge stack of comment cards, in his right hand... and in his left hand he's got about six. And the six comment cards he's got in his left hand are harshly underlined, "WORST SHOW I'VE EVER SEEN." He says to us, "we have gotten these horrible comment cards, people fucking hated you!" I asked, "what does the other stack say?" He says, "Fuck you montherfucker! That's six people who are never going to come back!" And I thought, "who gives a shit? Everyone else loved it!"

GG: David Cross goes into very long rants that seem to alienate much of the audience, whereas with you, your nature on stage is to be a lot gentler towards the audience although not in a way that necessarily dilutes the material.

PO: Thanks man!

GG: Because there is still some politics in your work.

PO: I think I changed a bit after the Pittsburgh incident, when I got booed offstage. I've really learned a lot about how to enter into it a bit from their side. I've stopped saying, "Look... you guys are fucking morons and you'd better start thinking the way I'm thinking." What I'm doing now is, I just point out exactly what they think. I'll say, "okay. If Bush said this, wouldn't that mean...", you know? "Am I the only one who sees this?" And then, sometimes they're kinda forced to say, "well shit, that's true."

GG: Could you tell me a little more about the Pittsburgh incident?

PO: I was doing a club there back in early 2003. Onstage, doing my act. I had three shows that night, 7,

9, and 11 o'clock. So I do the 7 o'clock show, which is full of much older people, in their 40s and 50s, and I did great! The show was great. The 9 o'clock show was full of people in their late 20s and early 30s. The first ten minutes is just standard stuff, everybody's laughing. And then I went into some stuff about Bush and the whole room went dead silent. I finished the Bush stuff, went back into some other non-political material. There's been no hissing, no booing for 15, 20 minutes so far. And then I paused long enough for someone in the audience to yell, "why don't you take your faggot ass back to Hollywood?"

GG: [*laughing*] Jesus!

PO: And the whole crowd hears it. I was laughing. And I said, "are you mad about the Bush stuff?" Then, the whole crowd just blew up, hissing like crazy. "FUCK YOU!" It was such an explosion, like the pressure valve just snapped. They all start chanting, "BUSH ROCKS! BUSH ROCKS! BUSH ROCKS!" Pounding their tables. So I'm thinking, "well, I'm not gonna get 'em back now." The amazing thing was, I had done bits along the lines of, "I'm sick of hearing that Bush is stupid!" The crowd loved that, they were cheering. And right there, of course, I knew that this was not going to go well. But I said it. "He's not dumb... he's evil. There's a huge difference between stupid and evil." And then, the crowd went silent. Then I said, "all my friends say that Bush can't even read a sentence, and I tell them that Bush can speak perfectly fine, he's a very eloquent speaker! Just not when he's trying to sound compassionate or caring or concerned about people."

GG: [*laughs*]

PO: Oh, that's actually true you know. He stutters at specific times. He'll say something like, "hey, it's hard to put food on your family." What you must realize is, he's not dumb. He isn't even thinking about that statement when he says it, because he doesn't give a shit! He really doesn't care how fucking hard it really is, for you to put food on the table for your family. But when you ask him about war and death and execution and vengeance, he is really eloquent. No stutter, steely gaze... confident! Like a leader, he looks like a leader. The thing is, if you gave Darth Vader a basket of puppies and asked him, "hey, how do ya like those puppies?", he'd look like a moron! "Sorry, I don't think about puppies." And then you ask, "well, what are you going to do to the rebels?" "The Rebels! We will destroy their palace. Turn them into a trail of dust!" That's George Bush! That's the eloquence of evil, right there. I'm thinking that they should just give him a white cat to stroke, while he's addressing the nation. That was the essence of the bit I gave the Pittsburgh crowd, and they were not into it. Okay, so there's this line that I stole from Blaine Capatch. I said, "whoa folks, calm down... I was comparing him to comic book and TV fucking villains, to movies... it's just a joke, I'm certainly not

expecting you to agree with me." People are calming down. I said, "yeah, I think it was ridiculous that the German asshole at the United Nations compared Bush to Hitler, that was totally out of line!" So people begin cheering, they are loosened up. I said, "he's nothing like Hitler! Hitler was fucking elected!" Then they went nuts. I had to be walked off the stage, walked through the crowd. People were throwing shit at me. It was a fucking circus.

GG: Again, that's odd because your material is in no way acidic the same way that Bill Hicks's comedy was.
PO: That's what confuses me. I did not come off strident, or arrogant, or desperate to get my point across. I was smiling! The worse it got, the more amused I was. There's something even more offensive about that tactic. I read an essay about this CD called *For Segregationists Only*, and it's a collection of white supremacist country songs from the 1930s. The reviewer said, "what makes this stuff more offensive is that all the singers are all so happy and upbeat about the horrible shit they're singing about." They sound genuinely amused. Whereas, some fucking industrial Goth punk band, or some rap or hip hop thing that's angry and strident, it's not as offensive, because they are angry, and you know they're trying to push your buttons... but a guy who is singing about lynching people, who sounds like he's about to crack up, is so much more offensive. The fact that I was just up there kinda grinning, like "okay! whatever!", that just made it worse.

GG: An audience doesn't always know what it's getting into, with a comic. I'm assuming that much of that specific crowd had never seen you before. Whereas with music, it is much easier to make safe assumptions about what you're buying.
PO: Yeah, that's the other thing about stand-up, which is really sad... most comedians have to perform in a comedy club, where there's a cover charge, and a drink minimum. Bands get to do all ages shows, and have bootleg tapes so 14 and 15 year olds can check them out. Smart ones do that. That way, an indie band can build an audience that will stick with them, because they got into them at an early age... whereas comedians have to start off hitting people who are in their 30s, and are already set in their ways. They have very few opportunities to reach younger people when they're starting. And with comedy clubs, it just says "comedy" on the marquee. It doesn't say "Maria Bamford", it doesn't say "Jimmy Pardo", it doesn't say "David Cross."

GG: It doesn't say "right wing" or "left wing."
PO: Exactly. So comics don't have a chance to build their crowd. It's much easier now, because of the Internet, but when I was coming up it was very hard. It's also very hard when I'm going to get people who are going to say, "we saw you on *The King of Queens*, and that is what we expect and demand." That can be very frustrating.

GG: Does that ever put you in a bad mood, while you're performing?
PO: I'll go up in a bad mood sometimes yeah, but being onstage always puts me in a better mood. I've learned that it's fine to go up there and be angry, there's nothing wrong with that, just have fucking jokes ready. In fact, the angrier you are, the more jokes you better have. It doesn't help your cause if you just blurt out, "and this thing? It's fucking bullshit!" And people are just like, "*okaaaay.*"

GG: When did you finally make the move to Hollywood?
PO: I moved to San Francisco in '92 and I moved to Hollywood in 1995, because I got a job working on a show for a couple seasons. I started doing walk-ons, and getting bits in movies, and little shows here and there.

GG: Joe Rogan is another comic who has a parallel career in television, but he's on *Fear Factor*, which is basically a geek show. Morality is a theme in your work, you riff on capitalist excess and shock culture a little bit... what would your response be if you were offered *Fear Factor* or something like it?
PO: I don't know how good I would be at that. Joe Rogan is definitely a lot more self-deprecating, and secure in who he is than I am... he's one of those hosts who can take a lot of the inherent meanness out of that thing. He's supportive, but still in a snarky, watchable way. It would depend on the money. I've gotten beyond the thing of "I would never do that", but I don't know that I'd be any good at it. And I don't hate reality shows, I just don't watch them. I don't care. I get enough reality during the day. I don't want to rush home to watch even more of the people I've been trying to avoid. I'd rather watch something that a talented professional made up in his or her head, and then hired other talented professionals to recreate.

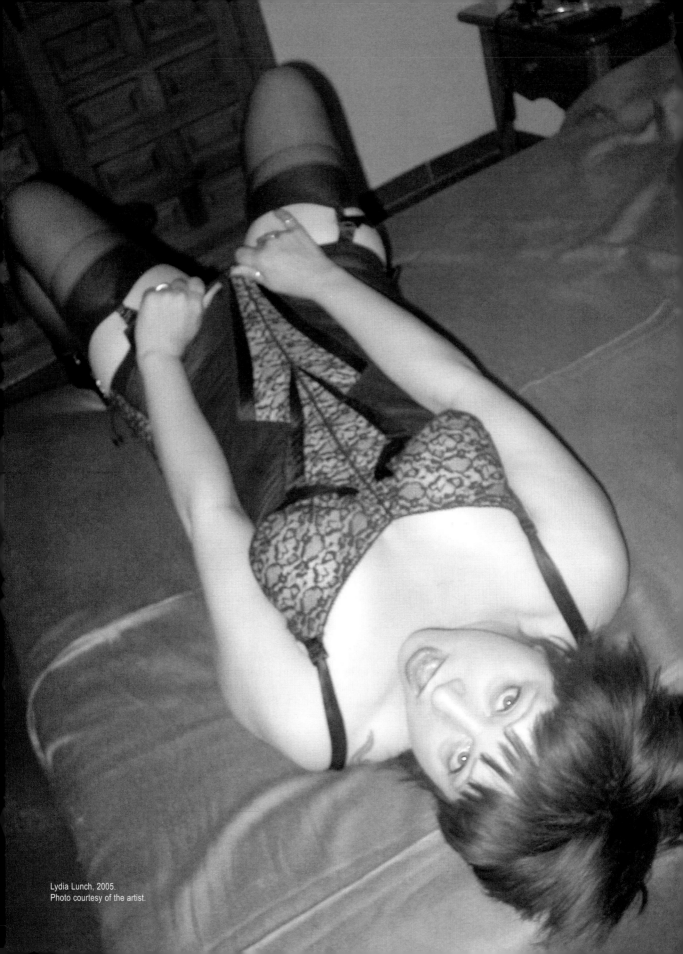

Lydia Lunch, 2005.
Photo courtesy of the artist.

Terminal Frenzy

- Lydia Lunch -

I can't claim to be too keen on all this business about karma, but it only makes sense to me that such extreme personal vilification as *Memory and Madness*, a spoken word performance by Lydia Lunch which brutally focuses on my assholeism, is quite possibly the karmic shoeshine, close-shave, pedicure, and high colonic I've been needing for years. The very thought of a lawsuit never once even crossed my mind… honest!

Memory and Madness was self-released by Lunch in 2003, but sat on my shelf for 2 years before I popped it into my stereo. In 2004, I lied to her about having listened to it, but as was the case with all lies I told during our three year relationship, a mysterious guilt forced me to come clean within 72 hours. Her reaction was one of severe disappointment: "I really wish you'd listen to it. It's the best thing I've ever done. And I did it for you." That claim, combined with the fact that the back cover is a sepia-toned snuff-style portrait of my bloody chest, pushed me to it. I was on my fourth bottle of Bull's Blood and my girlfriend was over, we were hanging out, I said "I have something I want to play for you." (You know, from *Videodrome*.) And I did play it entirely for her, just to watch her expression change under the weight of Lydia's attacks, as I was at that point rendered impotent by a combination of the weather and exhaustion from too much bickering that night. Another reason was Lydia's panties: the girl had been drinking at my place for three days and nights, and earlier, after leaving my bed looking like the scene at Wonderland Avenue in 1981, took a shower to wash off her bright menstrual coating. She stood nude, dripping wet and freezing in front of the TV, on which I was trying to watch Jay Leno. "Can I borrow your panties?" she asked.

"What the fuck are you talking about? You can borrow my UNDERWEAR, as long as you wash 'em…"

"No, your panties." I stared dumbly at her. "Gene, I know you have them. I saw them in your drawer."

"Oh! Those. No no, those are Lydia's. I wound up with them by mistake." (Actually, now all of a sudden I do think I took them on purpose. Who knows, maybe not. I do wear them sometimes, but let's not talk about that right now.)

Well, she ended up wearing Lydia's panties. I vaguely remember her fucked up on wine and giggling about how she was going to write a song for her punk band, called "Lydia's Panties." I reminded her that the Dead Boys had already cornered the market on punk songs about Lydia, and looked for an escape hatch. But I was broke and had a lot to apologize for. We hadn't stopped arguing long enough for me to have time to even remember what I was sorry about. Anyway, I played *Memory and Madness* and we both just shut the fuck up a while.

Inevitably, I stopped smirking about ten minutes in. An hour later, she said, "I have to go now." She hasn't called me since. Well, fuck that whore anyway.

The first words spoken, after the obligatory "I'm Lydia Lunch", are: "we're gonna be talking tonight, about MY war… the battle of sex, as an animal act. Fucked up by my emotions." That line is not a new one, Lydia has used it in many other performances. But then, it was "YOUR emotions." That solitary two letter substitution, "MY", is a dead giveaway that we're about to experience a different Lunch tonight. Perhaps not humbled exactly, but certainly more human than the Manson Family sex beast of *Paradoxia* or *Fingered*. She faces us tonight as a shattered woman.

"Now, I've been told… that I'm too intense for most… lovers. I'm too macho for most men. I'm too aggressive for most women. Most lovers just don't get me. But YOU get me right? You get me, right? YOU get me, right? YOU GET ME, *RIGHT*?"

A woman who readily admits to having multiple personalities, who sneers at the insistence that there has to be a bottom line, somehow, who is so multiplicitous, so multi-everything, is hardly accessible to sane people. On some level, this "difficulty" of hers is a running joke and Lydia, make no mistake, is in on it.

Having enjoyed (and at times resented) an undeniable cultural omnipresence since the 1980s, she does not require an introduction. Suffice it to say, for those still unaware, when Lydia Lunch isn't insulting you, she's terrifying you. Or arousing you. Or depressing you. Or annoying you. Or breaking your heart. Sometimes, it's a combination of all those emotions that you're left with, the result of a consistent and pathologically focused attempt made on the part of the artist to yank you from your own realm of order and health, into her own (often self-induced) state of disorientation and decay; this psychic yank is her *raison d'être*.

You won't have a hard time finding people to tell you that it's impossible to take Lydia or much of her decade-spanning multi-media blitzkrieg seriously, and while it's true that Lydia doesn't make it easy for you, she's as real as they come. I know that, because she has a lot of enemies. Sometimes, you can gauge the integrity of a person based on the degree to which they are hated, loathed, ignored and abhorred by their own culture. Lydia would have to agree with that on general principle... she's the only female equivalent of John Lydon I can think of. Both Lydon and Lunch are from hardscrabble working-class origins. Maybe that's the great divider. There's no doubt that squalor and degradation knock all comfort-born delusion out of your average person after a few decades of such an existence – and even in her most foul moment, Lydia is nothing more and nothing less than she claims to be: belligerent nympho, schizophrenic brat, artistic workhorse, compassionate friend, devoted lover, damaged romantic, philosophical heathen, hot rockin' swamp mama, willing victim, inhuman predator, friend of all underdogs, Sex Kitten of the Hate Generation, the Queen of Mean, the Whore of Babylon... maybe even the Devil's daughter.

Best known for violent onstage tantrums that could be accurately likened to a verbal car crash, Lydia began her career as the pouty, ill-behaved 16-year-old scamp with the Charlie Manson eyes who sang and abused a guitar for the noise outfit Teenage Jesus and the Jerks. Living in a dank NYC storefront, Lydia hustled for cash and left her own small mark on the birth of punk rock during the year 1976. Between all of her ensuing solo projects and collaborations, it's safe to say that she has appeared on well over a hundred records. Then there's her spoken word, an art form she pioneered alongside the likes of Eric Bogosian, Wanda Coleman, Emilio Cubeiro, and Karen Finley. Her nefarious exhibitionism in the films of Richard Kern won't be forgotten anytime soon. Photographer. Novelist. Columnist. Sculptress. Screenwriter. Poet. Con-woman. All that, and she makes great sushi, too.

Now, her traditional theme of gender warfare having received a few treatments far more personalized than usual, Lydia may have finally put it to rest. Her next major project remains uncertain, but she could turn to virtually any artistic medium known to humanity when the new egg hatches itself. In her current home, Barcelona, I suspect that she's taking a much deserved break. Rest and relaxation have never been a traditional artist's ideal state of existence... but traditional artists – and tradition itself – are Lydia Lunch's enemies. Always have been. Always will be.

This interview was recorded in 1997; our first ever in-depth conversation.

Gene Gregorits: There's a great amount of lucidity in your writing that I think is hard to ignore, and sets you apart from many of the people, feminists in particular, that you have been grouped with in the past, such as in RE/Search's *Angry Women* book. I know you don't like the term, but do consider yourself a feminist?

Lydia Lunch: I prefer the term "humanist." Because I'm really dealing with the human condition. I'm dealing with a struggle for equality or justice on many fronts. I don't like any label. I don't like any category. The down to earth nature of my writing alienates people because of how un-florid it is, because I refuse to romanticize the language I use to deal with these situations and circumstances I'm trying to expand upon. I think my lucidity might be a frightening factor to a lot of people, because they don't wanna believe that what I'm saying is the truth. Because I have extreme passion they wanna think the point I'm trying to make is exaggerated, when the most exaggerated thing possible is reality. So how could I exaggerate upon reality? It doesn't make any sense. The world we live in is already so fucking exaggerated there's nothing you could possibly do to outdo it.

GG: So I guess you get really angry when people call you "extreme" or "exaggerated".

LL: Or using shock tactics... I don't think anything I've done has ever been shocking, at least not shocking to me. Because again, I'm dealing with reality, as I see it,

Lydia Lunch and Gene Gregorits, Los Angeles, 2000. Photo by Tom Garretson.

or have experienced it. At this point it doesn't matter to me that people think it's shocking or exaggerated... people that live hard and do not shirk from intense experience know exactly what I'm talking about, and those are the people I'm specifically talking to. And the others, that would like to go around in a vague cloud of denial, don't need to hear my message, and don't need to respond to it. I'm not there to taint or burst the candy coloured cloud. I'm strictly and solely here to speak to the people who I think need to hear it because they felt a lot of the same things and are looking for a way to get over it... or find a way to use the fucking anger and rage that all of us have a complete right to feel.

GG: But there's another side of it too, where you seem to be "at war" with some groups. I mean, do you think that the anger, the outrage that people feel, or have been known to feel, when they hear you, is in any way encouraging?

LL: Yeah, I know you were making kind of a two-pronged question there. And I'm gonna just sub-text from there for a second, and that's that I wish the people that I speak out against could hear my words but they never will. Which is lucky for me, because at this point I have never been censored, incarcerated, interrogated... okay, the down side of that is I may be kept out of the mainstream, which is actually where I wanna be kept out of because, if people knew the threat that I truly meant... it could be a danger to my personal well being, and just the freedom that I have in my life. And I am speaking more on a conspiratorial basis.

GG: Has that ever been an immediate worry of yours, that you could be incarcerated?

LL: No, because I think that I will be kept at the plateau I reached 20 years ago, as far as who knows what about me, and also because – this is what saves me – as an artist my message or what I do can never be popular. First of all, because I'm always changing the formats that I'm working in, I'm always working at a much faster pace than the media could ever keep up with, the media being the enemy, not the friend of someone like me. So in that sense, I'm very happy at the level that I'm at, I'm not looking for a larger fan base, even though we both know there are a lot of people who should be hearing what I'm saying, and probably need to hear it, on both sides of the enemy divide, however, the place that I'm in does offer a lot of freedom in the sense that I do support myself as an artist. That's a really lucky thing. You know, a lot of intelligent, really talented people, with a lot to fucking say, might never be able, as an artist, to support themselves, or even get their stuff out. So I have that kind of freedom that holds no strings to it. Because I'm in a place where some people know about me but I'm left alone by the majority of other people, either trying to get a fucking piece of me, either trying to misinterpret me, trying to put words in my mouth, or just infiltrating my life. So I think I'm in a very lucky position. And I hope I

> **"...it doesn't matter to me that people think it's shocking or exaggerated... people that live hard and do not shirk from intense experience know exactly what I'm talking about, and those are the people I'm specifically talking to."**

stand as a testament to other people, like yourself, that there is a need, and there is urgency to create, and if you have to pass it out from your hand to someone else's, at least put down your feelings, your experiences, on fucking paper or on film, or whatever format you can create from. I think that's the most important message in what I've been doing. It's that anyone can do it, people... and I wish more people would jump on the spoken word bandwagon, or the writing bandwagon, and leave the fucking lousy guitars, and the three chord hard ass riffs in the garage where they belong, and get to the bottom line. And the bottom line is not entertainment, it's emotion. And we will remain a minority, because people don't wanna confess to their emotions, they don't wanna deal with 'em, the whole world's in a state of fucking denial.

GG: What do you think gave you that strength, to just come out and say what you felt to be the hard truth, knowing you'd be suppressed?

LL: It's not just suppressed, I mean, it's not as if I've won any popularity contests, ever, from day one. Yes, I have fans and yes, I have people that appreciate what I say, but at the same time, there's certainly people who would love to just easily dismiss everything I've ever done in any medium, as some kind of "harangue-y lunatic." Where the strength came from, I guess... dealing with victimization, my goal was always to not allow the forces that conspired against us to keep us down. I mean, I've had to play out many of my victim fantasies in full blown black and white glory via my films, as public psychotherapy, but my goal was to get over being the victim, and understand how we're all being victimized, on many fronts. And why we do, also,

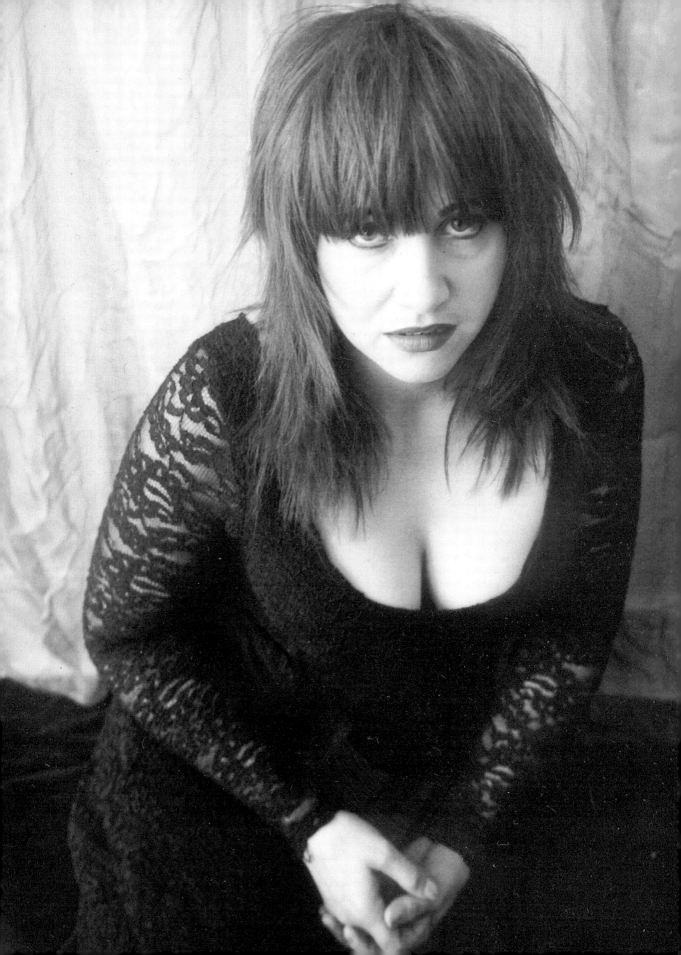

to a degree, enjoy our victimization, because that's all we know, that's all we're familiar with. And of course the victim does become victimizer, and that is a vicious circle which I have tried to explore and crawl out of.

GG: You've talked about a theory of "the willing victim", of consensual victimization. Have you ever felt "willing"?

LL: I was a willing victim for many years of my adult life and the important thing to me was to get to the root of why women like myself will willingly, chronically, get into abusive situations with battering men... who we often... prod... into being that way. I think there's always been this abusive cycle. It's only been 10 or so years that we've been talking about battered women period. "Battered women" is a relatively new public dialogue. Before that became popular or acknowledged, or people were willing to talk about it, I was already developing theories, based on my own cause and response, of what I call the "willing victim." And I think a lot of that comes from being unwittingly victimized as a child. Being so numbed, by pain, physical or emotional, or psychological, or religious. The pain of abuse, and domination, which the family structure is rooted in, pain and domination, on all fronts... Unlike a lot of my contemporaries who became addicted to heroin, or coke, or alcohol, or marijuana, I became addicted to adrenalin, and that is something that the body does manufacture. Speed never did it for me, it made me violent. So, through recognizing and understanding that my behaviour was fuelled by this need for adrenal chaos, it took that for me to understand my own victimization, and how I turned it around, and how as a victim I became victimized... and that's how I got off. It sounds very simple, but it's not that easy to come to the conclusion of what drives you when you're in a relationship, because they make you feel something, when just about everything else makes you feel fucking numb. I don't care what it's about or what's your frame of reference, and if your eyes are fucking wide open, this is a sad fucking world we live in, and it's full of injustice, pain and abuse, on a global level, which starts at the family and I guess works its way up to a global disposition of domination and subjugation. And, to me, it was just trying to understand my own mechanisms because, I think, ritual and habit are very confining. They're prisons we build for ourselves. It's very important to ask the only question: "why?" That's the most important question there is, and it will lead to the answer to everything.

GG: Well do you thi...

LL: I haven't got the answer to everything yet, Gene.

GG: [*laughs*] The ability to facilitate that surge of adrenalin, do you think that has to come from personal tragedy, or violence?

LL: I don't think it has to come from personal tragedy, I think it has to come from, usually, acute I.Q. Or just an over-sensitivity in a certain area. Whether it's just

Above: 'You Are Not Safe in Your Own Home'. Photo by Marc Viaplana.
Opposite: Lydia Lunch, Los Angeles, 2000. Photo by BDF.

intellectual over-sensitivity, or a desensitized reaction to experiences that exist in the world we come in contact with. Whether it's through books, movies, the newspaper, or day to day life. I mean, I specialize in dealing with people who have been battered into numbness, or retaliated by looking for the most dangerous situation possible in order to make them feel alive. And that's just the bottom fucking line. I mean, to feel alive. Because we are death obsessed, especially people that think too much... how can you not be death obsessed? When you're surrounded by it, when it's glorified, when it's the core of the most romantic films out there. When it's the ultimate taboo. I mean, it's a strong fucking trip.

GG: How often do you see a fan of yours go out and really do something that you can look at and say, "Wow, there's someone who's gotten the point"?

LL: Well, I think I've inspired a lot of people. I know I've inspired more people than I'll ever know. At least I hope so, and that is a huge call in doing what I do, but... there's one person for whom I produced a record, a friend of mine, Vanessa Skantze. She was someone I met at one of my shows, who I befriended, and I knew she

was writing, and I kept prodding her, and encouraging her... she started doing spoken word shows. She's absolutely brilliant. So that's a case, where it was manifested in something I could actually directly help. As opposed to just inspire... I mean, I wish I had more facilities to help other people, as far as actually getting records made. But it's difficult enough getting my own documents made, released, and distributed. But still, you know, that's a fight I have waged for many years.

GG: There are other writers, like Charles Bukowski for instance, who had an incredibly rough childhood, especially through adolescence he was very alienated and distanced. Looking back on your own, do you credit any one event with leading you in this direction?

LL: Well, it's strange that you mention that, because in the book *Paradoxia, A Predator's Diary*, for the first time, I actually, throughout the first chapter, thank my father for what he taught me as opposed to resenting, or hating the father as a figure. My father, who was very fucking charming, and no doubt many of the men I've engaged with have shared many of his qualities, for better or worse. But I actually thank him as someone who taught me many invaluable lessons, and ultimately did help me to create myself, and how I am today. It's an interesting twist from someone who's been screaming about "God, the father", "God, the fucker", and "God, the father of our country" for quite a few years... to go back and realize exactly what gifts he gave me. Like, his ruthlessness, to some degree. Which does not mean I am without feeling. It means I can persevere, no matter what anyone, or any company, or set of circumstances, conspire to prevent me from doing what I'm doing. I will still soldier forward. The fact that he never had a steady job... I don't consider what I do a job. And therefore I've never had a steady job. His charisma, his conniving, all of his con artist tricks, I have to thank him for now. It served me wisely.

GG: Do you ever find that people perceive you that way, as someone who is unfeeling?

LL: Oh I'm sure, and I have a great capacity to be that way. I'm also one of the kindest, most sympathetic people you'll ever meet. Because I truly do understand what other people go through. I do understand the gamut of human emotions, from being so oversensitive that even the slightest look wounds you nearly for life, to being someone so incredibly insensitive murder in cold blood is only the blink of an eye away. I think I pretty much understand emotion, I'm very split in two. The things I don't want to affect me, it's very convenient and very easy for me to just turn off. And that saves a lot of unnecessary adult trauma and bitterness and anger. I think that my anger is so well focused, and so focused in the right direction, that it's rare in my day to day reality where I get mad, where I raise my voice, or anything really irritates me. The world situation irritates me. In my day to day life, I'm really devoid of any irritation.

GG: So you can focus to a point where, when you have a show, you can get up there, turn it on, then just leave it behind when the lights go down...

LL: Pretty much so, because 'A', it is a purge, and 'B', this is the focus of my anger. It's not as if I can be consumed, as I was in my early 20's, with anger, and bitterness, every second of the day. I mean, in order to not get cancer, or be led to drink or self medication, I've learned to completely focus those, what are ultimately, very vampiric emotions. Because they eat you alive. When you have a lot of rage and a lot of bitterness, or frustration, or heartbreak, or pain, that's not focus. It does start a psychological cancer and it will make you physically sick. I have had many bouts of physical sickness, and you know, medical pain, and phenomena, which I know in great part were psychologically stimulated. I'm so Zen at this point, at this age, that it only makes sense to know where to focus. I think that I'm basically extremely passionate, very interested in what's going on, and ultimately encouraging. I think that's the overview of my personality... if you know who I truly am. Those are the mainstays of my personality. At this point, I mean it took me a long time to get here. It's been a long struggle for progress.

GG: So 20 years ago, you really believe that 'cancer' was there, in you?

LL: Well absolutely, definitely, I feel I look probably better than I did 10 years ago. I feel much more physically healthy, and psychologically and emotionally healthy. Age is such a meaningless concept. And so is time. Because for instance, when I was writing *Paradoxia*, I had to go back to things that happened when I was 6, when I was 12, when I was 20, I had to look at memories and pieces of time, almost as it they were a postcard, and you had to fill in the back of 'em. Time and experience and memory, they're all so intangible, the years are intangible...what does it mean, because day to day, you're just involved with the next fucking step, the next project, the next prospect, the next state of progress.

GG: Are there a lot of memories you don't hold on to, mementos you don't keep?

LL: Well, no, I wouldn't say that I don't hold on to memories. I'd say that I spent many years documenting my memories, and serving them up as some kind of cross between a light snack and heavy medication. For the public. So I've dredged my memory banks until they no longer resemble a wetland, it's almost an industrial concrete bunker, which I hope I'm putting some kind of closure to.

GG: Have you ever found yourself working at such a fast pace that your memories just couldn't keep up with you?

LL: No, I remember too well, that's the problem. I remember so well I have no choice but to re-tell these experiences. It's all just a learning process, and I'm

Lydia Lunch in Spain, 2003. Photo courtesy of the artist.

trying to understand a sexual and intellectual minority which I belong to, and I'm not the only one in it. I know that my voice, which we know has reason, does speak to people that may or may never experience the same situations, but have a profound understanding of what I'm talking about. And why I'm forced to examine it. Because it's not as if we have a proliferation, of especially women, speaking so intimately about real trauma. And about overcoming it. And about what obsesses and what plagues. I mean, it's really shocking to me that more people aren't up there, you know, screaming their guts out. And I don't mean necessarily in a loud haranguing voice, like myself. I mean, finding a way with just their voice and their realm of experience, to tell it how it fucking is. There are people who want to hear it, there are people who wanna listen, and if that's a handful that's fucking enough.

GG: Have there been enough of those people visible for you to hold on to any faith in the human race?

LL: [*hysterical laughter*] You know, there is hope, but not for us. "Faith in the human race." You'll feel the sarcasm drip... [*more laughter*] Faith, ahhh... no, I have faith in the individual. I am an incredible believer in the individual. I mean, the human race could all drop off the face of the fucking planet right now and I would shed not a tear. Because we are extinct in the way we think at this point, and the way that we're killing the entire fucking thing we call home. However, I have incredible faith in the individual. I think that people are full of surprises, completely unpredictable. There's no telling what course they would take... of course I'm speaking of the minority that interests me. I know there's few of us left, but there are a few of us. And I do pity people in your generation, and I mean, well "pity" is a strong word, but I sympathize, because it seems to me, even living as I did, as a teenager, in a backwood upstate city, which was not fucking cool, that individuals, they seemed to be out there. They seemed to not be afraid...

341

"I think it's even more difficult now, to get information on something that might truly be exciting and new, and original, and important."

at least there wasn't so much of a capitalistic commercialization of all things, a constant commercial battering, which tells people to just acquiesce, and accept the lowest common denominator, because they have no fucking identity, because they're all dressed exactly alike, they watch the same movies, listen to the same fucking music, go to the same concerts, read the same magazines, and it's really just a collective lemminghood. I can't speak for the "twentysomethings", I really can't. But I only know what I see. The conformity, starting on the superficial fashion level, to me, is horrifying. And, to me, it's no more encouraging to see this retro-punk fashion paraded on every other corner. Because I think people can carve out their own identity, their own image, and they don't have to conform to sportswear, nor ghetto wear, nor complete punk rock uniform. So that's frightening, to me. And not that your visage, not that your facade, and what you wear is everything, however it's where it starts.

GG: I see your records as a real contribution of sorts. There are so few people who are gonna hear anything, and when someone does it's almost always a select group of people, who aren't necessarily doing the same thing, who don't work together, or are even aware of each other, but share a common level of truth and an intolerance of bullshit. I grew up in a small town, I've been able to see the prejudice and the fear, as opposed to someone who grew up somewhere in a more trendy area.

LL: See, I don't know what it is, and maybe you know better than I, but they certainly don't want to close everything out that's happening... that's why we need magazines to try and tell us about things that no one else is covering. Because especially in this age of "get-rich-quick", 3 minute, MTV video scam, which so many people have jumped on the bandwagon for, that there's gotta be people like yourself covering whatever is out there, that you obviously have to fucking seek out and find for yourself. Because it's very fucking hard. I think it's even more difficult now, to get information on something that might truly be exciting and new, and original, and important. It's difficult. Where are they? Is everyone so fucking caught up in trying to fucking make money? Are they locked up in institutions? Where? Why? The beauty is this too – not everything has to come from here and now to be urgent, I mean, that's why often things that have been written one hundred years ago, fifty years ago, thirty years ago, can be more pertinent now, and often when the author is dead, than they were at the time they were written. And I'm dealing of course with people I think were intellectual prophets anyway. So, therefore this immediate, twenty second, remote control, sound byte, hooked up to the TV screen and Internet society that we are, I think it's very urgent for people that want to know more and want to seek out different people, to sometimes travel backward.

GG: Yeah, I guess you have to when there's nothing else to look forward to today.

LL: Exactly.

GG: What dictates the regularity, or the frequency, of your tours and show dates?

LL: Well, there's usually no regularity. I sporadically do dates. I basically just try to do enough spoken word shows so that I can support myself. Because that is what supports me especially when I'm doing a variety of other things. I mean I just do spoken word either when I think it's a really urgent time, like it was when Exene Cervenka and I were on tour, or to basically just support myself at ground-level existence, while I juggle creating in all the other formats... that I need to create to maintain.

GG: What kind of immediate crowd reaction are you most satisfied by? Do you like visible controversy?

LL: I prefer complete silence. I prefer to perform in a church, on a Sunday afternoon. That to me is the perfect time. Look, I've been heckled enough to know... I've yet to hear one intelligent sentiment coming from someone that was passionate enough to respond. I'm not saying that people shouldn't... if my words inspire people to be passionate and exuberant, that's wonderful. If they have something to say, they should fucking say it... but usually it's just the drunk oaf in the corner, who can't keep his mouth shut.

LYDIA LVNCH

www. LydiaLunch .org

The Official Web Site

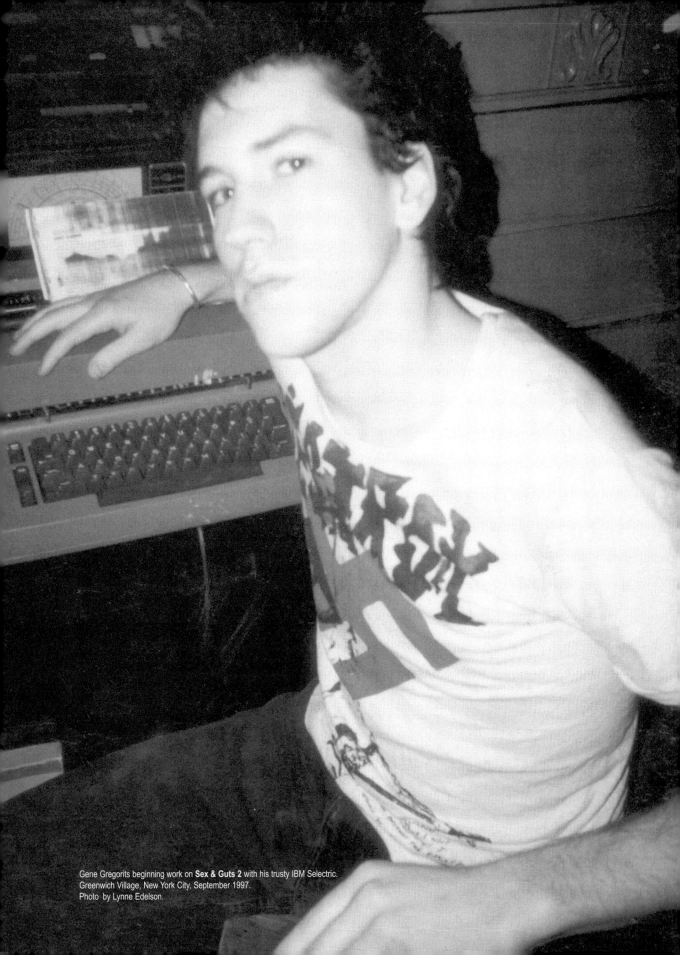

Gene Gregorits beginning work on **Sex & Guts 2** with his trusty IBM Selectric.
Greenwich Village, New York City, September 1997.
Photo by Lynne Edelson.

Index

Page references in **bold** refer exclusively to illustrations, though pages referenced as text entries may also feature relevant illustrations.

index

Quality Books For Cult Connoisseurs from FAB Press

ISBN 1-903254-42-6

ISBN 1-903254-43-4

ISBN 1-903254-36-1

ISBN 1-903254-41-8

ISBN 1-903254-45-0

ISBN 1-903254-39-6

ISBN 1-903254-25-6

ISBN 1-903254-40-X

ISBN 0-9529260-6-7

ISBN 1-903254-23-X

ISBN 1-903254-46-9

ISBN 1-903254-32-9

ISBN 1-903254-30-2

ISBN 1-903254-44-2

ISBN 1-903254-38-8

ISBN 1-903254-33-7

For further information about these books visit our online store, where we also have a fine selection of alternative magazines, T-shirts, DVDs and CDs for sale!

www.fabpress.com

SOUNDS FROM THE UNDERGROUND
Words and Music from Midnight Mavericks

1
Steve Wynn / **Strange New World** (Wynn) - previously unreleased

2
The Kills / **Hitched** (The Kills) - from the album *Keep on Your Mean Side*

3
Jim Van Bebber interview

4
Robbie Edmonstone / **Fuck Art/Let's Kill**
Originally recorded for *Sex and Guts 4*; this new version prepared exclusively for *Midnight Mavericks*.

5
Sturgis Nikides interview

6
Sturgis Nikides / **Room 204** (S. Nikides) - from the album *Man of Steel*

7
Steve Wynn interview

8
Steve Wynn & the Miracle 3 / **Bruises** (Steve Wynn) - from the album *...tick...tick...tick*

9
Joe Lansdale interview

10
Simon Stokes / **Amazons and Coyotes** (Stokes) - from the album *Honky*

11
Larry Wessel interview

12
Steve Wynn & Johnette Napolitano / **Last House on the Right** (Wynn/Napolitano) - previously unreleased

13
Rockets Redglare interview

14
Lydia Lunch / **Portrait of the Minus Man** (Lunch) - previously unreleased

15
Luis Fernandez de la Reguera interview

16
Simon Stokes / **Bob** (Stokes) - previously unreleased

17
Gene Gregorits / reading from '**Johnny Behind the Deuce**' (Gregorits)

18
The Flesh Eaters / **Miss Muerte** (Chris D.) - from the album *Miss Muerte*

19
Patton Oswalt / **The Apocalypse** (Oswalt) - from the album *Feelin' Kinda Patton*

20
Sturgis Nikides / **She Got a Gun** (S. Nikides) - from the album *Man of Steel*

21
Carla Bozulich interview

22
Big Red Goad / **My Bucket's Got a Hole in it** (Jim Goad) - from the album *Truck Drivin Psycho*

23
The Kills interview

24
The Kills / **No Wow** (The Kills) - from the album *No Wow*

25
Simon Stokes / **City of Men** (Stokes) - originally recorded for *Sex and Guts 4*

26
Robbie Edmonstone / **Midnight Mavericks** - recorded exclusively for *Midnight Mavericks*

Compiled by Gene Gregorits and Harvey Fenton
CD mastered by Stephen Thrower